# HISTORY OF

# HISTORY OF

# JAPANESE ART

## Penelope Mason

Florida State University, Tallahassee

PRENTICE HALL, INC.
HARRY N. ABRAMS, INC.

To Warren and Edward, Milly and Bill

Editor: Julia Moore
Manuscript Editor: Caroline D. Warner
Art Director: Samuel N. Antupit
Designer: Lydia Gershey
Associate Designer: Yonah Schurink
Photo Coordinator, New York: Barbara Lyons
Photo Coordinator, Tokyo: Yoshiko Nihei
Rights and Reproductions: Etsuko Hayashi
Indexer: Elaine Luthy Brennan

Library of Congress Cataloging-in-Publication Data

Mason, Penelope E., 1935–
        History of Japanese art / Penelope Mason
            p.          cm.
        Includes bibliographical references and index.
        ISBN 0–13–016395–3
        1. Art, Japanese.          I. Title
N7350. M26          1993b
709'.52—dc20                              92–34428
                                          CIP

Harry N. Abrams, Inc., received support for the publication
of this book from the 1992–93 Publication Assistance Program of
The Japan Foundation.

Published in 1993 by Harry N. Abrams, Incorporated, New York
A Times Mirror Company

Prentice Hall, Inc.
Englewood Cliffs, New Jersey 07632
A Simon & Schuster Company

Printed and bound in Japan

# CONTENTS

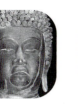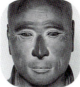

| B.C.E. | |
|---|---|
| 12,000 | |
| 11,000 | |
| 10,000 | |
| 9000 | **JŌMON PERIOD** (10,500–300 B.C.E.) |
| | **INCIPIENT JŌMON** (10,500–8000) |
| 8000 | **INITIAL JŌMON** (8000–5000) |
| 7000 | |
| 6000 | |
| 5000 | **EARLY JŌMON** (5000–2500) |
| 4000 | |
| 3000 | |
| 2000 | **MIDDLE JŌMON** (2500–1500) |
| | **LATE JŌMON** (1500–1000) |
| 1000 | **FINAL JŌMON** (1000–300) |
| 0 | **YAYOI PERIOD** (300 B.C.E.–300 C.E.) |
| C.E. | |
| 100 | |
| 200 | |
| 300 | **KOFUN ERA** (300–710) |
| 400 | |
| 500 | **ASUKA PERIOD** (542–645) |
| 600 | |
| 700 | **HAKUHŌ PERIOD** (645–710) |
| | **NARA PERIOD** (710–794) |
| 800 | **HEIAN PERIOD** (794–1185) |
| | **EARLY HEIAN** (794–951) |
| 900 | |
| 1000 | **MIDDLE HEIAN, OR FUJIWARA** (951–1086) |
| 1100 | **LATE HEIAN, OR INSEI** (1086–1185) |
| 1200 | **EARLY FEUDAL PERIOD** (1185–1573) |
| | **KAMAKURA PERIOD** (1185–1333) |
| 1300 | **KAMAKURA RESTORATION** (1333–1336) |
| | **NANBOKUCHŌ PERIOD** (1336–1392) |
| 1400 | **MUROMACHI PERIOD** (1392–1573) |
| 1500 | |
| 1600 | **MOMOYAMA PERIOD** (1573–1615) |
| | **TOKUGAWA, OR EDO, PERIOD** (1615–1868) |
| 1700 | |
| 1800 | |
| 1900 | **MODERN PERIOD** (1868–PRESENT) |
| | **MEIJI PERIOD** (1868–1912) |
| 2000 | **TAISHŌ PERIOD** (1912–1926) |
| | **SHŌWA PERIOD** (1926–1989) |
| | **HEISEI PERIOD** (1989–PRESENT) |

## Notes to the Reader

In this book, the romanization of of Japanese words is based on the Hepburn system. Certain words that now appear in Webster's dictionaries—biwa, daimyo, geisha, haiku, raku, netsuke, sake, samisen, shogun, shoji—are anglicized. Macrons, diacritical marks that look like hyphens, are used over long vowels except in the case of the words above and four proper nouns that are thoroughly anglicized: Tokyo, Kyoto, Osaka, and Shinto.

Chinese place names, artists and artworks, rulers, monks, monuments, and monasteries are rendered with their *pinyin* spelling; the Wade-Giles form follows in parentheses at the first occurrence. Conforming to current usage, most compounds formed of a root word and suffix are closed; hence, Hōryūji, not Hōryū-ji, and Shōsōin, not Shōsō-in.

The abbreviations B.C.E. and C.E. stand for "before the common era" and "common era," respectively, and correspond to B.C. and A.D.

Until the Meiji period, Japanese artists rarely titled works of art with formal titles. For this reason, named works of art are not italicized unless made after 1868. The Orientation section, which begins on page 8, elaborates on Japanese conventions of language, personal names, dates, and ages.

7

# Orientation

The words *Japanese art* conjure up intriguing images for most people—exotic figures of the woodblock prints, monochrome landscapes associated with Zen Buddhism. Yet for many, the mechanics of studying Japanese culture present a difficult, if not impossible, barrier to overcome. Because this book is intended for the beginning student of Japanese art and culture, the following explanations are offered as aids to orientation.

## The Japanese Language

Until Japan came into close contact with China in the 6th and 7th centuries, the Japanese had not developed a written language. The early written histories indicate that there was a strong oral tradition through which historical events passed from generation to generation. However, the Chinese precedent proved to the Japanese the desirability of having a system of writing, and the obvious beginning point was Chinese characters, known in Japanese as *kanji*. These are ideographs, initially abbreviations of visual images. Two syllabaries *(kana)*, *hiragana* and *katakana*, were developed to represent sounds. Used with *kanji*, the characters convey meaning. Today the *hiragana* is used to supply verb endings to indicate tense and the relationship of the speakers and also to indicate the function of a word in a sentence as subject, object, or indirect object. *Katakana* is used for foreign words. Most of these are English words and are used for their standard meaning. However, there are interesting exceptions. For example, the German word *arbeit* (work) has become *arbeito* in Japanese and means "moonlighting," or a job in addition to one's regular employment.

Pronouncing Japanese is relatively easy because the vowels have constant sounds. The *hiragana* alphabet is as follows:

| A (as in father) | ka | sa | ta | na | ha | ma | ya | ra | wa |
| I (as in week) | ki | shi | chi | ni | hi | mi | | ri | wi |
| U (as in who) | ku | su | tsu | nu | fu | mu | yu | ru | |
| E (as in hay) | ke | se | te | ne | he | me | | re | we |
| O (as in oh) | ko | so | to | no | ho | mo | yo | ro | wo |

The following consonants can be changed by adding small marks, called *nigori*, to the right of the symbol:

| | | | |
|---|---|---|---|
| ka → ga | sa → za | ta → da | ha→ ba → pa |
| ki → gi | shi→ ji | chi→ ji | hi → bi → pi |
| ku → gu | su → zu | tsu→ zu | fu → bu→ pu |
| ke → ge | se → ze | te → de | he → be→ pe |
| ko → go | so → zo | to → do | ho→ bo→ po |

The vowels *o* and *u* are often lengthened when speaking, and this is indicated in English with a macron, essentially a hyphen or bar over the letter.

*Kanji* often have at least two pronunciations: the *on*, or Chinese, reading and the *kun*, or Japanese, reading. For example, the Chinese word for temple is *ssu*. The Japanese pronounce the *kanji* for temple either *"ji,"* the *on* reading, or *"dera,"* the *kun* reading. Two clans fought a civil war in the 12th century, the Minamoto and the Taira. That war is known as the Genpei Civil War from the *on* reading of both clan names.

The traditional way of writing Japanese is to place the *kanji* and *kana* vertically from top to bottom, from right to left. The custom of reading leftward is basic not only to writing but also to the creation of visual images on a horizontal surface. The illustrations in this book have been placed to encourage reading them in the Japanese style.

## Names

A Japanese at birth usually has two names, the family name and one given to him or her specifically. Family names usually have four syllables and are references to places. For example, Yamamoto means "at the base of the mountain," Kitagawa, "the north river", and Fujiwara, "a field of wisteria." Given or personal names are more complicated. Men's names often end in *rō*. Sons are sometimes named according to the sequence in which they were born. For example, Ichirō means the first born; Jirō, the second; Saburō, the third, and so on. Women's names often end in *ko*, written with the symbol for child. However, the symbols for given names can be pronounced in a variety of ways, and it is difficult to know exactly how the individual reads his or her own name. Japanese always give the family name before the personal, and that custom has been followed in this book; for example, Yamamoto Ichirō and Fujiwara Akiko.

In the course of a lifetime individuals may change their names a number of times. Also they may choose an alternate reading of the *kanji* for their given names. Artists often take art names with which they sign their work and may change them as they feel the style of their work has changed. One artist changed his name when the seal he used to sign his work cracked. The woodblock print artist whom we know as Hokusai (1760–1849) took as one of his last art names "Old Man Mad With Painting."

Courtiers serving in the imperial palace often had a palace name different from their original given name, and they usually changed it again when they retired from service. For example, the woman known as Akiko became Shōshi when she married Emperor Ichijō and then Jōtōmonin when she left the palace, became a nun, and took up residence in the Jōtōmonin palace. When someone took the tonsure and became a priest or a nun, it was standard practice to drop one's secular name and assume a religious one, usually of two syllables.

Name-taking is a Japanese custom that is particularly foreign to Westerners. An outstanding artist not only achieves a reputation, but also establishes a family and a studio of disciples. Usually the artist wants to see the accomplishments continued into the next generation and will decide which student can best carry out that role. That person will be asked to take the name of the master. Thus Saburō, the third son, may be asked to take the art name of the father and become Danjurō the Second. If no child within the family can be trained to succeed the father, a promising pupil may be

adopted and asked to take the name of the teacher. In the West, in contrast, we tend to value individuality more than continuity or the preservation of tradition.

Posthumous names are also a part of Japanese culture. An emperor during his lifetime would be known by one name but might choose or would be given another upon his death. A recent example is the emperor Hirohito (reigned 1926–1989), who chose his own posthumous name of Shōwa by which his reign will always be known. His son Akihito has chosen Heisei as his reign and posthumous name. The syllable *go* before an emperor's name indicates that he is the second to be so designated. For example, the emperor Daigo reigned from 897 to 930, and Godaigo was on the throne from 1318 to 1339.

## Dates and Ages

Over time the Japanese have used several different ways of calculating time. The oldest is the sexagenary system adopted from the Chinese in 604 C.E. According to this method of reckoning, a specific year is designated by units from each of two sets of symbols, one with ten units known as stems, *jikkan,* the other with twelve branches, *junishi.* It takes sixty years before a particular pair of symbols is repeated. The ten-stem cycle is based on the *yin* and *yang* aspects of the five elements: wood, fire, earth, gold, and water. The twelve branches are a sequence of animals: rat, ox, tiger, rabbit, dragon, snake, horse, sheep, monkey, rooster, dog, and the boar. The day, which the West divides into twenty-four hours, the Japanese reckon as twelve units named for the same animals as the twelve branches.

In 645 C.E. the Chinese system of era names, *nengō,* was adopted. Eras could be arbitrarily begun and ended without any relation to the accession or retirement of an emperor. An auspicious event might cause an emperor and the court to change *nengō* to celebrate the occurrence, and conversely, an era in which a rebellion had broken out might be renamed once the disorder was put down. Thus translating Japanese dates into the Western calendar requires thought and an accurate chart of *nengō,* including not only the year but also the month in which changes occurred.

Occasionally era names are used to denote the art or literature of a narrow band of years. For example, Jōgan (859–877) is sometimes used as the style name for sculpture of the 9th century. However, in general periods are defined rather broadly and are usually named for the location of the capital. During the Asuka period (552–710), the capital was moved from imperial palace to imperial palace, most of them in the Asuka valley. The Nara and Heian periods take their names from the cities in which the government was located, while the Muromachi period is named for the location within Kyoto of the offices of the shogunate. Alternative names for some periods derive from the clan in control of the government. The period names used in this book are as follows:

| Jōmon | (10,500–300 B.C.E. ) |
| Yayoi | (300 B.C.E.–300 C.E.) |
| Kofun | (300 C.E.–710) |
| Asuka | (552–645) |
| Hakuhō | (645–710) |

| Nara | (710–794) |
| Heian | (794–1185), with the clan name Fujiwara referring to the period 951–1086 |
| Early Feudal | (1185–1573), including the Kamakura and Muromachi periods. An alternate name for Muromachi is Ashikaga, after the clan in control of the shogunate |
| Momoyama | (1573–1615) |
| Edo | (1615–1868), also named for the Tokugawa clan |
| Meiji | (1868–1912) |
| Taishō | (1912–1926) |
| Shōwa | (1926–1989) |

With the Meiji Restoration in 1868 the concept of an era became defined by the reign dates of a ruler and its name the posthumous name chosen by the emperor for himself. In this system, dates can be calculated easily by subtracting one year from the beginning year of a reign and adding the number of the year in that reign. For example, the seventh year of the Shōwa era is 1925 + 7, or 1932.

Until Japan switched to the Gregorian calendar on January 1, 1873, the Japanese had used a lunar calendar to calculate the months, as did most of Asia. Thus the first month began somewhere between late January and early February. It is not correct to assign arbitrarily Western names to Japanese months until after 1873. Unless accurate calendric calculations have been made, months should be called the first month, the second, and so on. That practice has been followed in this book. Frequently the lunar calendar got out of synchronicity with the natural year and an intercalary month of an arbitrary number of days was added. These are problems that need not concern the beginning student beyond being aware that events that took place in Japan in the third month or the fifth month actually occurred according to the Western calendar about one month later. For example, one of Japan's most popular myths, the annual meeting of the stars known as the weaver maiden and the herd boy, an event celebrated at the Tanabata festival, traditionally the seventh day of the seventh month, actually took place in August.

The traditional method by which the Japanese calculate age differs from the Western system. In Japan, regardless of when during the year a child is born, that child becomes one year old on the first day of the first month of the new year. Thus it is necessary to pay attention to which system is being used to establish the age of a particular artist. In this book the Western system is followed.

## Recurring Themes in Japanese Culture

Some traits of Japanese culture are consistently present through time or are at least cyclical in their appearance, disappearance, and reappearance. Being aware of at least a few of them is helpful in approaching the art and culture of Japan for the first time.

### Diversity of Cultural Influences

One of the most important facts to remember about Japan is that it is an island country. Over time it has either opened it-

self up to foreign ideas and artistic expressions or closed its doors to external intrusions. During times of close contact with other nations, the Japanese have made every effort to understand, imitate, and eventually assimilate foreign ideas. In the Kofun era the Japanese looked to Korea, and the similarities between Korean and Japanese grave goods, including ceramics, armor, jewelry, and even tomb wall paintings testify to the close connections between the two regions. With the introduction of Buddhism, Japan began to look further afield to China, and during the late 7th and the first half of the 8th century strove to follow Chinese models in the arts as well as in systems of government. However, by the 9th century the Japanese moved on to develop their own aesthetic preferences. The pattern was repeated in the Early Feudal period, when Zen Buddhism was introduced for the second time into Japan. By the late 1400s the pendulum had swung back toward Japanese taste. After the Meiji Restoration, Europe and the United States provided new concepts which were integrated into the culture of modern Japan. Consequently, at times Japanese architecture, painting, and sculpture reflect Chinese or Western prototypes, but these foreign ideas are quickly reworked into a uniquely Japanese statement.

### Preservation

Another basic quality seen thoughout Japanese history is the high priority placed on the conservation of culture and tradition. In a sense Japan is Asia's attic. There is virtually no Buddhist painting from the Tang (T'ang) period (618–907) surviving in China proper, most of it having been destroyed during the periods in which Buddhism was proscribed. To a lesser extent, the same is true of paintings produced during the Southern Song (Sung) dynasty (1127–1279). Later generations regarded the painting associated with Zen Buddhism as too sentimental. Many of the key pieces that survive today have been preserved in Japan.

Perhaps one reason for this is that over time Japanese leaders have placed a high value on cultural accomplishments. Noblemen and women during the Nara period placed a high value on writing poetry, and in the Heian period devoted themselves almost single-mindedly to poetry-writing, practicing calligraphy, blending incense, and the like. After the Genpei Civil War, when military clan leader Minamoto Yoritomo emerged victorious and established his shogunate, he moved the locus of his administration far away from the effete atmosphere of Kyoto, but he also took immediate action to rebuild two of the most important Buddhist temples in the former capital of Nara, one built by an emperor, the other by a major noble family. By so doing he associated himself with the preservation of cultural institutions and traditional values.

The pursuit of cultural accomplishments became a symbol of a leader's legitimacy as ruler. Ashikaga Yoshimitsu (1358–1409), a strong shogun in his own right, fostered the development of Nō drama. Toyotomi Hideyoshi (1536–1598), who rose from the lowly rank of a foot soldier to Taikō or retired regent in control of the government, invited all of Kyoto to a tea ceremony. Many other examples could be cited.

In the modern era, when the Japanese government realized that some of the country's greatest artistic treasures were being bought by foreigners and taken out of the country, it established a system for designating works as National Treasures and Important Cultural Properties. Any work so identified could not be sold without the permission of the government. Normally an alternate, Japanese buyer would be found for the object. This system has been extended to people as well. Artists, actors, and craftspeople can be named National Treasures or Important Intangible Assets and rewarded monetarily by the government.

### Aesthetic Polarities

A fundamental characteristic of Japanese sensibility is the appreciation of two very different aesthetics: restrained, even understated themes and brightly colored, exhuberant expressions. The modern architect Tange Kenzō traces these two different aesthetics back to earliest times, to the dynamic, volumetric ceramics of the Jōmon period and the restrained, simple shapes of Yayoi vessels. The contrast can be seen clearly in Buddhist painting. The bold reds, blues, greens, and gold of such paintings as the 11th-century Amida raigō tryptych (see colorplate 20, page 92) are at the opposite end of the spectrum from the evocative, monochrome landscapes associated with Zen Buddhism (see figure 211, page 195).

A similar comparison can be made between two buildings constructed in the early 17th century, Katsura Imperial Villa in Kyoto and the Tōshōgū shrine, the mausoleum of the first Tokugawa shogun, in Nikkō, north of Tokyo. Katsura is a cluster of buildings remarkable for its quiet elegance and its unique blend of traditional Japanese elements, while at Tōshōgū, every sculpture-covered surface is a riot of bright colors and gold.

### Buddhism

Buddhism had a profound effect on Japanese art. Before 552, the traditional date for the introduction of Buddhism, the arts of painting, sculpture, and architecture were not highly developed. Sculpture was limited to haniwa, clay images set into the earth near the top of tomb mounds, and painting seems to have been quite limited. However, after Buddhism became established in Japan, the visual arts bloomed. New temples were built, images of divinities were sculpted, and wall paintings were executed. Using Chinese Buddhism as a model, Japanese artists developed new techniques and styles. A new wave of art touched Japan's shores with the introduction of Esoteric Buddhism in the early 9th century—its doctrines so complex that they could best be taught through pictures and sculptural images. Jōdō, or Pure Land Buddhism, required brilliantly colored paintings of the Western Paradise, a realm of many-storied palaces, jeweled trees, and lotus ponds. Finally, Zen required quickly executed images of great teachers, the style of the painting evoking the sudden insight that suggests enlightenment. It was not until the Momoyama period that the Buddhist Church ceased to be the major patron of the arts, and by then it had placed its indelible stamp on the evolution of Japanese architecture, painting, and sculpture.

## Importance of the Natural World

One of the most powerful and significant characteristics of Japanese thought is its interpretation of the relation between nature and human beings. Nature is viewed as a separate element, of equal importance to the human realm. The individual's interaction with it is believed to have soteric value, that is, it prepares the individual to achieve enlightenment and ultimately salvation. From early times, Shinto gods with distinct personal characteristics were intimately related to nature. They were thought to dwell in sites of intrinsic natural beauty such as waterfalls, mountains, and trees, but they could also manifest themselves in specific locations accessible to human beings, often a grove of trees at the foot of a mountain or near a waterfall. Here shrines were built so that humans could worship Shinto deities and call upon their benevolence. The shrine honoring the most important Shinto divinity, the sun goddess Amaterasu, was built at the foot of a mountain near a river, and the buildings were built of wood that was never painted but was allowed to remain in its natural state and to weather and darken over time.

A frequent theme in Japanese literature and art is the maturation of the human spirit through prolonged contact with nature, as, for example, during a long journey or pilgrimage. One of the most important and long-lived genres of Japanese literature is the travel diary. An early example, the 10th-century *Tosa Nikki*, was written by a father whose favorite daughter had died while he was serving as the governor of Tosa province. The purpose of the diary is to express and assuage the grief over his loss, but his feelings are woven into the account of his nearly two-month-long journey.

A particularly sensitive visual depiction of a man's journey through the natural world occurs in the *Saigyō monogatari emaki* (see coloplate 31, page 182). The priest Saigyō spent most of his life traveling, opening himself to interaction with nature in order to perfect his skills as a poet. In a painting made around 1250, he is shown climbing alone through the mountains of Yoshino to see the first cherry blossoms of spring, a tiny figure almost engulfed in the snow-covered landscape. From this experience he is able to touch emotions within himself and produce poems of great beauty.

However, the natural world was not always viewed as a space apart from that normally inhabited by humans. The design of the traditional Japanese house facilitates the interaction of interior and exterior space. Walls consisting of sliding doors can be pushed aside, permitting a view of a landscaped garden. Particularly in the Heian period, the natural world was seen to reflect the emotions of human beings. In a 12th-century illustration, as a man grieves over the impending death of the most important woman in his life, the grasses in the garden outside his room are being whipped violently by a storm (see colorplate 24, page 96), and the man sees them as echoing his own strong emotions.

## Depiction of Human Emotions

Another distinctive quality of Japanese art is its emphasis on human emotions as presented in narrative illustration. The horizontal hand scroll was developed in the 12th and 13th centuries into a sensitive medium which combined a prose narrative with visual images. The placement of the text and space allowed for the illustrations to establish the rhythm of the story, making it possible to depict themes as diverse as battle tales, love stories, folktales and even biographies. The Japanese love of storytelling lived on in the form of Nara picture books, *e-hon*, in a period in which the officially sanctioned art was the monochrome painting associated with Zen Buddhism, and it re-entered the mainstream again in *ukiyo-e* and in particular in the paintings of the 18th-century Maruyama-Shijō school.

Finally, one of the great pleasures of studying Japanese art derives from the fact that not all the questions have been answered. There are still substantive issues to be explored. An archaeological dig will yield new information about life in ancient times. A museum may discover a cache of paintings long overlooked which document a particular artistic project. A scholar may present an in-depth study of an artist whose work is well known but has not been studied systematically. It is hoped that *History of Japanese Art* will encourage readers to learn about Japan and to appreciate its art, and perhaps even to stimulate further study.

# Acknowledgments

A work as extensive as a history of Japanese art from 10,500 B.C.E. to 1945 could not have reached fruition without the help of a great many people. Most important in this regard has been the commitment and support of the publishing house of Harry N. Abrams, Incorporated, and the funding of The Japan Foundation. The Foundation has funded this project twice: through a grant to me in 1978–79 to begin work on the text and through an award to the publisher in 1992–93 to help support its publication. I am most grateful.

The project was originally developed by Margaret Kaplan, and no author could have had a more encouraging and helpful editor in the early stages of writing. Under Paul Gottlieb's presidency, the project was continued, and Julia Moore became my editor. Again, I could not have asked for a finer colleague. Caroline D. Warner as editor was also extremely helpful. From the outset of this project, Abrams has assumed responsibility for gathering the photographs, and as there are 456 illustrations, this was no small job. Two women, Barbara Lyons in New York and Yoshiko Nihei in Tokyo, were responsible for this task. I would like to thank Yoshiko-san particularly for the time she put into picture research and for her help while I was in Tokyo in the spring of 1992. The book was sensitively designed by Lydia Gershey and Yonah Schurink, supervised by Sam Antupit, art director at Abrams.

The manuscript has been read by a number of scholars and teachers of Japanese art, some of whom I know and some who remain anonymous. Of the former I would like to thank John M. Rosenfield, Yoshiaki Shimizu, Stephen Addiss, J. Edward Kidder, and especially Christine Guth for their useful criticisms and helpful suggestions. Finally, I would like to thank Maribeth Graybill whose fifty-page critique helped me significantly in making the final revisions to the text. I very much appreciate her efforts, which went beyond the call of duty.

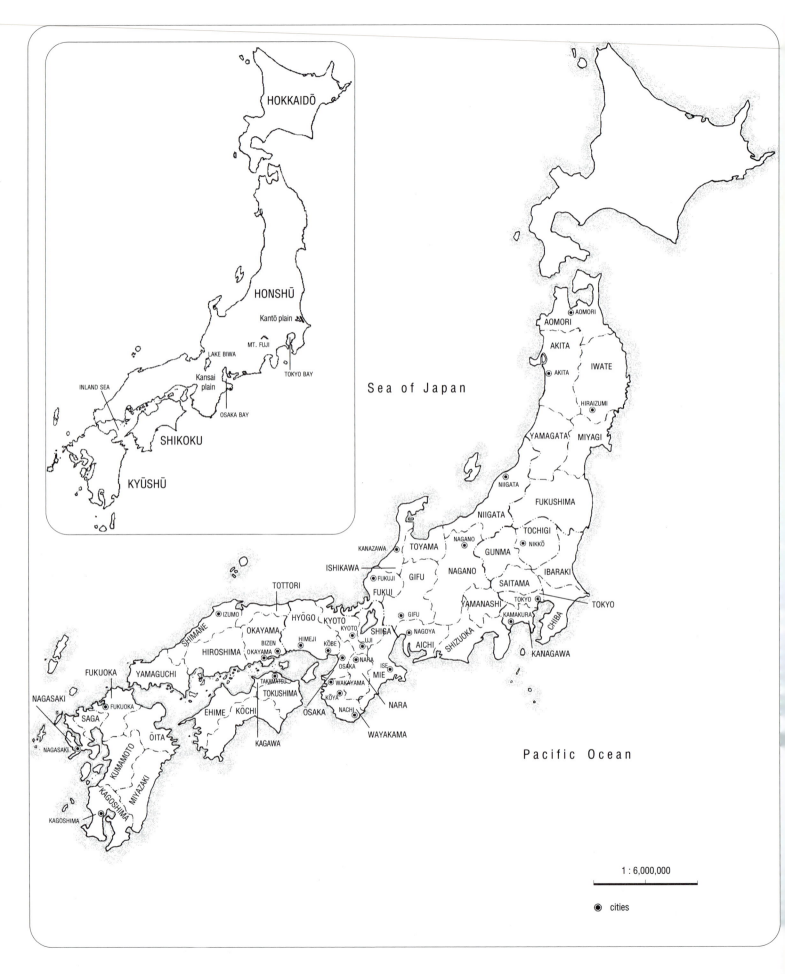

HOKKAIDŌ

HONSHŪ

Kantō plain

MT. FUJI

LAKE BIWA

Kansai plain

INLAND SEA

TOKYO BAY

OSAKA BAY

SHIKOKU

KYŪSHŪ

Sea of Japan

AOMORI
AOMORI

AKITA

IWATE

AKITA

HIRAIZUMI

YAMAGATA   MIYAGI

NIIGATA

FUKUSHIMA

NIIGATA

NAGANO   TOCHIGI

TOYAMA   GUNMA   NIKKŌ

KANAZAWA

ISHIKAWA   NAGANO   IBARAKI

FUKUJI   GIFU   SAITAMA

TOTTORI   FUKUI   AMANASHI   TOKYO

TOKYO

IZUMO   HYŌGO   KYOTO   SHIGA   KAMAKURA   CHIBA

SHIMANE   OKAYAMA   KYOTO   GIFU   SHIZUOKA   KANAGAWA

HIROSHIMA   BIZEN   HIMEJI   KŌBE   UJI   NAGOYA

FUKUOKA   OKAYAMA   NARA   AICHI

YAMAGUCHI   OSAKA   ISE   MIE

NAGASAKI   TAKAMATSU   WAKAYAMA   NARA

SAGA   TOKUSHIMA   KŌYA   NACHI

FUKUOKA   EHIME   KŌCHI   OSAKA   WAYAKAMA

NAGASAKI   ŌITA   KAGAWA

KUMAMOTO

MIYAZAKI

KAGOSHIMA

KAGOSHIMA

Pacific Ocean

1 : 6,000,000

⦿  cities

12

# CHAPTER 1
# The Birth of Japan

## THE JŌMON AND YAYOI PERIODS AND THE KOFUN ERA

Until the end of the last Ice Age, about 12,000 years ago, the islands that now comprise the Japanese archipelago were attached to the main continent of Asia, enclosing the Sea of Japan as a lake. The northernmost island, Hokkaidō, adjoined the coast of Siberia. The other main islands, Honshū, Kyūshū, and Shikoku, were an extension of the Korean peninsula. These two land connections and the chain of islands to the south, including Okinawa—at that time connected—provided paths of entry for peoples migrating eastward from the continent. The preferred route seems to have been through Korea to Kyūshū. However, sometime around 10,000 B.C.E., the earth's climate changed. A warming trend began, and it continued until about 4000 B.C.E. before gradually subsiding. During this time glaciers melted, causing the oceans to rise to a level that covered the lowlands between the archipelago and the continent, and making Japan forever after an island nation.

## The Jōmon Period (10,500–300 B.C.E.)

Coincidental with this warming trend was the emergence of a distinctive culture in the Japanese islands, characterized by the production of pottery. This was a hunting-gathering culture whose people fed themselves on nuts, berries, and shellfish. They hunted deer, wild boar, raccoon, and squirrels, and did deep-sea fishing. The name given to this period and its culture is Jōmon, a translation into Japanese of the term "cord markings." First used by the American scholar Edward S. Morse in his 1879 report on the shell mounds at Ōmori, near Tokyo, "Jōmon" describes a method of decorating the surface of ceramic vessels of the period: the rolling of twisted cord or rope over the surface of the shaped clay (fig. 1). Other materials were used in addition to cord, including bamboo sticks, seashells, and even fingernails.

The Jōmon were not the earliest peoples of Japan. There is evidence from the Kantō district—the area around Tokyo—of a culture whose people fashioned stone tools and spearheads. Japanese scholars date these finds to at least 12,000 B.C.E., roughly paralleling European Late Palaeolithic cultures, but little is known about their origins or whether they were the direct ancestors of the Jōmon peoples. What is significant is that Jōmon was the first culture in Japan to produce ceramic wares. In fact, what are believed to be the world's oldest ceramic vessels come from Jōmon sites in western Japan, such as the Fukui cave in Nagasaki prefecture, Kyūshū. Shards from this find have been securely dated by the carbon-14 radiocarbon dating process to the period between 10,500 and 10,200 B.C.E.

Jōmon culture developed and flourished for nearly ten millennia, peaking around 2500 B.C.E. and continuing until about 300 B.C.E., when it began to evolve rapidly into a more advanced culture, the Yayoi, centered on the production of rice. Because the Jōmon period lasted for such a long time, scholars have divided it into six distinct phases:

| | | |
|---|---|---|
| Incipient Jōmon (Jōmon I) | c. 10,500–8000 | B.C.E. |
| Initial Jōmon (Jōmon II) | c. 8000–5000 | B.C.E. |
| Early Jōmon (Jōmon III) | c. 5000–2500 | B.C.E. |
| Middle Jōmon (Jōmon IV) | c. 2500–1500 | B.C.E. |
| Late Jōmon (Jōmon V) | c. 1500–1000 | B.C.E. |
| Final Jōmon (Jōmon VI) | c. 1000– 300 | B.C.E. |

No complete vessels have been preserved from the Incipient Jōmon period, but on the basis of pottery shards, it is generally assumed that the vessels were small and had rounded bases. The surfaces of the earliest pieces have coarse raised lines or ridges, probably made by pinching together edges of clay slabs. The surfaces are rather like corrugations on a cardboard box and may come from a simple smoothing out of the clay coils from which the vessels were formed. Patterns made by impressing string or fingernails into the soft clay become common later. The pottery was fired in open bonfires.

If Incipient Jōmon wares are in fact the earliest ceramics, their existence raises an interesting issue. Ceramics excavated from Neolithic sites in the Middle East were long regarded as the earliest evidence of vessel-making

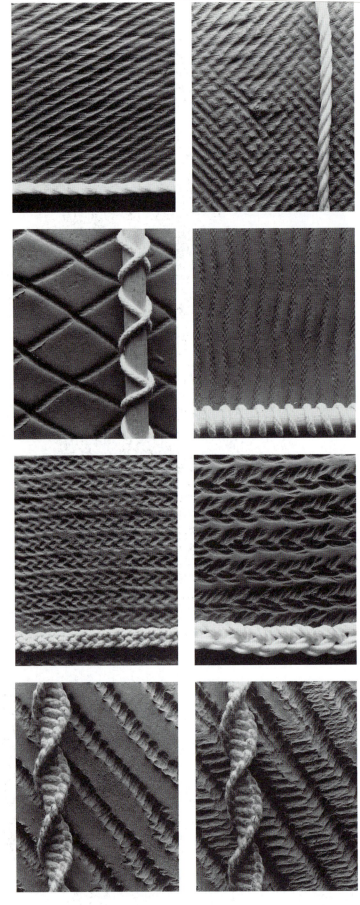

2. Initial Jōmon vessel, from a site in Hokkaidō. Clay; height 6½ in. (16.6 cm). Hakodate Municipal Museum

and traditionally have been associated with the rise of agriculture as a way of distinguishing Neolithic from Mesolithic culture. Yet in Japan, pottery was made by preagricultural peoples, when fishing, hunting, and gathering held sway. This challenges the very definition of Neolithic culture as understood in the West and points to one of the fundamental differences between Japanese and Western lines of development.

By the end of the Initial Jōmon period, a fairly consistent type of ceramic had been developed for boiling food. Many of the typically deep bowls were relatively small, measuring between 8 and 20 inches (20–50 cm), but vessels as large as 27½ to 29½ inches (70–75 cm) are not uncommon. The earliest deep bowls had pointed bases that could be pushed into the ground to hold them steady. One of the most aesthetically pleasing of these cookpots comes from an undocumented excavation, but is generally believed to date from the end of the Initial Jōmon period (fig. 2). The gentle undulations of its rim are echoed by the pattern of the cord markings.

## Early Jōmon (5000–2500 B.C.E.)

It is not until the Early Jōmon period, about five thousand years after the beginning of the incipient stage, that a clear picture emerges of the way the people lived. Traces of villages have been discovered, consisting of pit-house excavations, and along with them evidence of objects for everyday use, such as ceramic pots for boiling water or

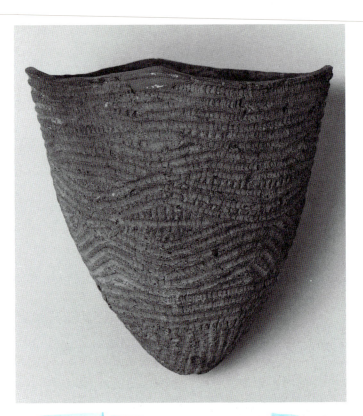

1. Cord-marking patterns. Courtesy Mark Lindquist Studio

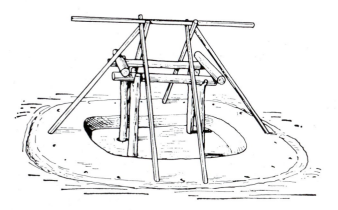

**3.** Reconstruction of Early Jōmon pit house. (Ōta Hirotarō, in *Illustrated History of Japan*, published by Shōkuka-sha)

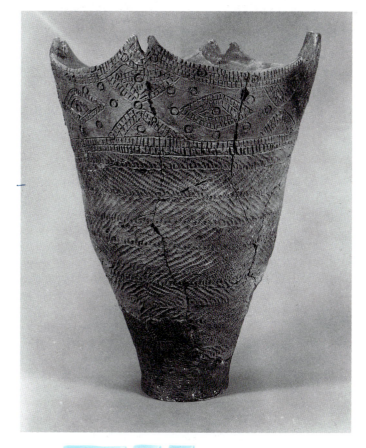

**4.** Early Jōmon vessel. Clay; height 13¾ in. (35 cm). Nanzan University, Aichi prefecture

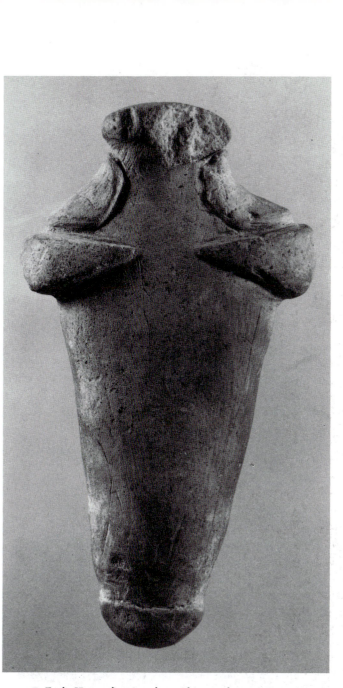

**5.** Early Jōmon figurine, from Akita prefecture. Stone; height 5⅞ in. (14.8 cm). Keio University, Tokyo

cooking food, ceramic and stone figurines, wicker baskets, simple tools made of stone, and sewing implements carved from bone. The pit houses, so-called because their floors were dug approximately 1½ feet (½ m) below the ground, were usually square in plan, about 13 feet by 13 feet (4 x 4 m). They were covered by a roof thatched with reeds or bark, supported by posts and beams toward the center and by leaning posts around the periphery of the pit (fig. 3). Usually there was a post at the very center of

the house, so there could not have been a central hearth.

Pots from this period, in contrast to Incipient and Initial Jōmon vessels, usually have flat bottoms, and the designs are made by a variety of materials, including twisted plant fibers and bamboo stalks. An example from the latter half of the Early Jōmon period shows an attempt at creating an unusually complicated pattern of decoration (fig. 4). The rim of the vessel undulates in waves from sharp peaks to shallow valleys. In the zone immediately below the rim, a bamboo stick has been used to incise diamond shapes and press in circles, while the body of the pot is decorated with cord markings in a herringbone pattern.

Although they are scarce, examples of Early Jōmon figurines have been found, such as the stone carving from a site in Akita prefecture in northern Honshū (fig. 5). The

upper part of the sculpture has a head, long hair, and arms folded at shoulder height, while the lower half of the figure is distinctly abbreviated. There are no specific details pointing to its use, such as breasts or swelling hips to suggest that it might have been intended as a fertility image, so it is difficult to guess its intended purpose.

## Middle Jōmon (2500–1500 B.C.E.)

Probably as a result of the continued warming trend, which peaked toward the beginning of the Middle Jōmon period, the population shifted from humid coastal sites to highland regions, the mountains of the Chūbu district and the northern part of the Kantō Plain. Unlike earlier Jōmon peoples, those who flourished in the 4th and 3rd millennia B.C.E. were much less nomadic. They established large villages and developed tools to store and process the foodstuffs they were able to gather. They harvested abundant nut crops, and there is even some evidence to suggest that they may have engaged in simple cultivation of such edibles as yam, taro, and lily bulbs. Clearly, the quality of their lives was very different from that of their ancestors. The large number of ceramic vessels found at Middle Jōmon sites suggests that these people had a stable economy and sufficient leisure to engage in crafts and to develop an aesthetic sensibility.

In the Middle Jōmon period the pit house evolved into a circular form 15 to 18 feet (5–6 m) in diameter, with a heating and cooking area replacing the center post which had supported the roof in earlier times. These larger dimensions permitted as many as five people—possibly the average number in a household unit—to gather around the central hearth. Some communities added a stone platform on the northwest side of the house, on which were placed stone phalli, ceramic fertility images, or broken pots. The American scholar J. Edward Kidder has suggested that these platforms may be the oldest household altars in Japan and that the new hearth-centered house may be an early expression of family unity, a trait characteristic of the Japanese people throughout time.

The most dramatic difference between the Early and Middle Jōmon periods in terms of artifacts is the production of exuberantly decorated vessels that were individualized according to function, both practical and ceremonial: pots for storage and cooking, lamps or incense burners, and goblets and bowls. The familiar cord markings of the preceding period appear much less frequently, replaced by a new technique: the application of pieces of clay to the surface to build up strongly three-dimensional designs.

Typical of a Middle Jōmon cooking vessel is the fancifully decorated, four-handled pot from Niigata prefecture (fig. 6). Above the flaring cylindrical body, clay has been

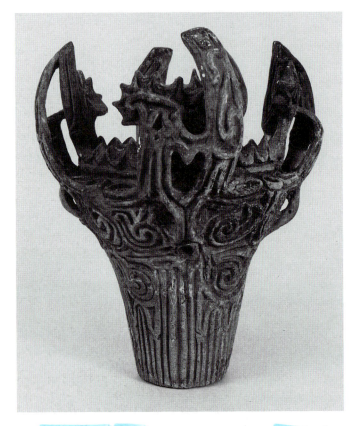

**6.** Middle Jōmon vessel, from Niigata prefecture. Clay; height 12⅛ in. (30.8 cm). Tsunanmachi Board of Education

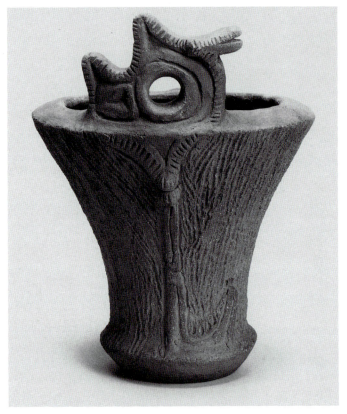

**7.** Middle Jōmon vessel with snake-form handle, from Togariishi, Nagano prefecture. Clay; height 6½ in. (16.6 cm). Togariishi Archaeological Museum, Nagano

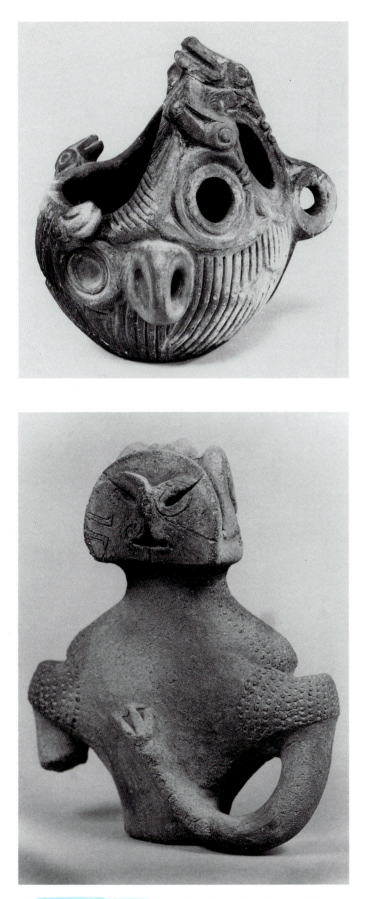

shaped to make four tall, pierced projections that shoot upward from the rim. Although the vessel is only about 12 inches (30.8 cm) tall, it is a strong sculptural form.

Another development in Middle Jōmon decor involves the use of realistic images on the rims of large cylindrical vessels. A snake motif based on the *mamushi*, Japan's only poisonous viper, appears as a rim design first in the mountainous regions of Nagano prefecture and later in Yamanashi prefecture and, less frequently, in the Tokyo area. A vessel from Togariishi in Nagano displays a snake's head and body curving upward from the rim to surround a circular handle (fig. 7). A similar motif is a rodentlike head that appears along the rim of vessels, usually overlooking the contents. In both types of pots, the decoration of the body consists of simple cord markings.

A particularly charming creation of this period is a small lamp or incense burner from Nagano prefecture (fig. 8). It is essentially a sphere with enough of its surface cut away to permit a hand to reach in to fill it with oil or possibly incense. The lower part of the bowl has been decorated with simple vertical cuts in the clay; the upper section is a free-flowing design based on a circle surrounding a hole. Spinning off from the largest circles are the heads of a snake or a long-beaked bird, a motif repeated along the lower rim of the largest hole to the left. The piece clearly demonstrates the creativity of Middle Jōmon potters.

The production of ceramic figurines increases somewhat in this period, and the detailing of facial features becomes specific enough to distinguish between animal and human images. The torso and head of a curiously feline figurine has been preserved from a site in Yamanashi prefecture (fig. 9). The face has an inverted U-shaped outline with holes cut through the clay for slanting eyes and a three-lobed mouth. Incised lines on the cheeks may represent tattoos. Along the shoulders and the upper parts of the arms, a design of repeated circles suggests a spotted pattern on fur. The left arm bends in a curve, pressing a three-fingered hand against the breast. The gesture of placing the left hand on the chest, with the right hand presumably on the hip or abdomen, has been interpreted as indicating a pregnant woman. If this is a female figure, the absence of breasts is puzzling. For now, it remains an interesting but baffling object.

## Late and Final Jōmon (1500–300 B.C.E.)

Following the peak of climatic warming in the Middle Jōmon period, which was some 4° to 6° F (2°–3° C) warmer than today, the subsequent chill, sometimes called neoglaciation, forced the Jōmon people out of the mountains and back toward the lowlands, with the most numerous settlements located along the eastern coast of Honshū.

**9.** Middle Jōmon figurine, from Kurokoma site, Yamanashi prefecture. Clay; height 10 in. (25.2 cm). Tokyo National Museum

"Dogu" ceramic figurine.

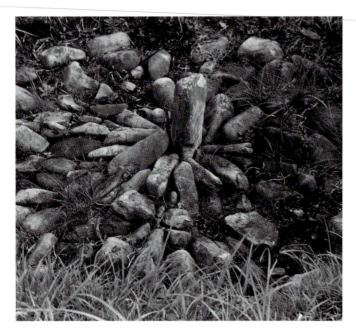

10. Late Jōmon stone circle. Towadamachi, Kazuno City, Akita prefecture

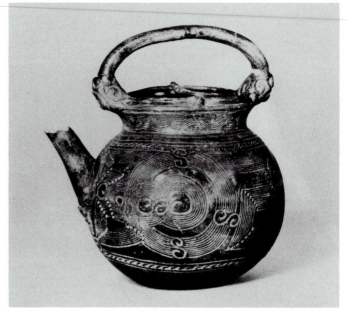

11. Late Jōmon ewer with bridge handle, from Ibaraki prefecture. Clay; height 8¾ in. (22.3 cm). Tatsuma Archaeological Museum, Nishinomiya City, Hyōgo prefecture

The primary food source in the Late Jōmon period was fish, and to improve their catch individual communities developed new and more efficient types of fishing equipment, including the toggle harpoon. The resources of the regions into which these people migrated were, however, insufficient to support their numbers, and by the Final Jōmon period the population had declined to less than half of what it had been at the height of Middle Jōmon times. The numbers of figurines found in Late and Final Jōmon remains are dramatically higher than in earlier sites, suggesting that each household may have had an image of its own. Perhaps these people turned their attention to rituals in response to a high death rate. Because most of these figurines have been damaged, it has been suggested that they may have been purposely broken in a ritual of healing that focused on an injured or diseased body part.

Stone circles also appear at this time, at sites close to but separate from the living quarters of the villages. Figure 10 shows a small one. The most elaborate of these are two circles found at Ōyu in Akita prefecture: one is 151 feet (46 m) in diameter and the other is 138 feet (42 m) across; they are 295 feet (90 m) apart. Each has a single vertical stone in the center, surrounded by long, narrow stones laid on the ground and radiating out from the central pillar in two concentric circles. This configuration is enclosed by a third ring of stones set at right angles to the radials. The majority, however, are simple circles of stone some 30 to 40 feet (10–15 m) in diameter. These sites seem to have been used as burial grounds as well as for communal ceremonies.

The exodus of the Middle Jōmon people from their mountain homelands coincided with the first instance of cultural uniformity in Japanese history. Apparently the newly established Late Jōmon coastal communities kept in

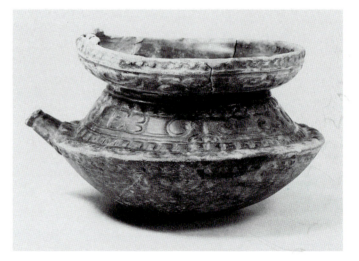

12. Final Jōmon drinking cup, from Aomori prefecture. Clay; height 4⅝ in. (11.7 cm). Tokyo National Museum

closer communication with each other than had been the norm in earlier periods. As a result, vessel shapes—such as pots with slightly flared walls and others with spouts, resembling teapots—became standardized. A decorative design known as erased-cord marking became common in Late Jōmon wares. Zones were drawn on the surface of a vessel, cord markings were applied, and the area surrounding the marked zones was smoothed out.

A particularly fine example of a Late Jōmon "teapot" comes from Ibaraki prefecture (fig. 11). On the swelling sides of the ewer, in a wide zone marked off by a pattern resembling a double-strand cord, bands of incised lines form a circle, within which is a figure eight. S-shapes are

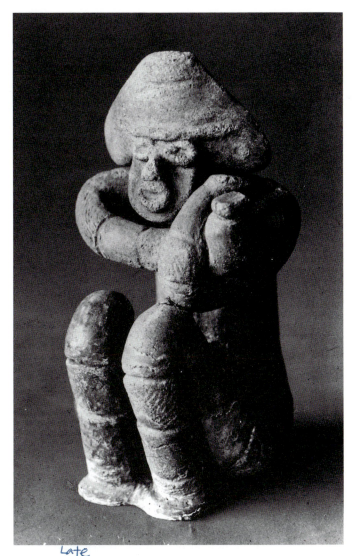

Late

**13.** Final Jōmon figurine, from Fukushima prefecture. Clay; height 8½ in. (21.5 cm). Fukushima Municipal Board of Education

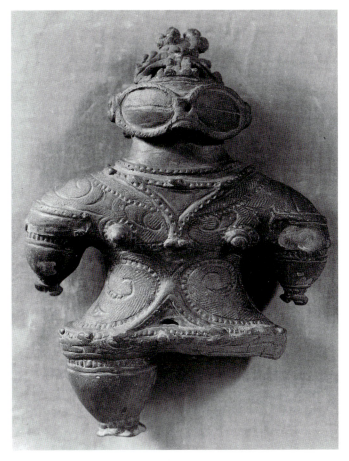

**14.** Final Jōmon figurine, from Aomori prefecture. Clay; height 15 in. (38.1 cm). Private collection, Japan

cut into these bands at irregular intervals, and the whole is framed by a curved and angular zigzag design.

In the Final Jōmon period the Tōhoku region in northern Honshū became the center of traditional pottery production, while the southern and western parts of Japan were subject to outside influences. Kamegaoka, a site in Aomori prefecture, gives its name to the wares of this period. Vessels for both ceremonial and everyday use were produced, and the shapes range from simple cups, bowls, and cooking pots to vases and incense burners. During this period the ceramics were frequently burnished, painted with red iron oxide, or lacquered with a clear resin over pigment, presumably to reduce their porosity as well as to decorate them. A rather elaborate drinking cup is typical of the period (fig. 12). The surface from the bottom of the cup up to its widest point is relatively smooth, but above that a design of curving lines and raised bosses completely covers the vessel. A spout more than halfway down the side

severely limits the amount of liquid the cup can contain.

Two types of figurines are characteristic of the Final Jōmon period: fleshy, female statuettes wearing what look like snow goggles, and seated figures with their knees drawn up to their chests and arms entwined in specific positions. Usually their hands are pressed together, as if in prayer. The best known of the crouching images comes from Fukushima prefecture (fig. 13). It has a U-shaped face, with bulging circles for its eyes and mouth, and a raised triangle for a nose, and it appears to wear a large triangular headpiece. Its arms are bent so that the right extends across the body, while the left draws the right arm close to the chest. In contrast to the goggle-eyed images, it has a charmingly personable quality.

The heavy female figurines are associated with the finds of Kamegaoka pottery in Aomori (fig. 14). The images are hollow, with cord markings in zones over the body implying a decorated garment. The bodies are distorted, as are the faces, which have a tiny down-turned mouth and a single hole for a nose between enormous round eyes bisected by a horizontal line. It has been suggested that the body may have been made hollow to permit the soul to take up residence within, but there is little agreement among scholars about the reason for the eye treatment. Some specialists see them as reflectors of death; others

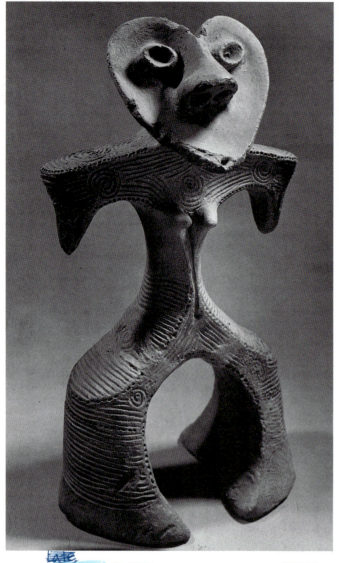

**15.** Final Jōmon figurine, from Gunma prefecture. Clay; height 12½ in. (31 cm). Tokyo National Museum

Although the Yayoi period only lasted approximately six hundred years, from about 300 B.C.E. to about 300 C.E., it was a time of great importance in the formation of the Japanese nation. By the end of it, a class society had developed—the precursor of the clan system that eventually produced the leaders who established a national hegemony. The period takes its name from the Yayoi district of Tokyo, where post-Jōmon objects were first unearthed and identified. Yayoi culture is distinguished from Jōmon by several elements: the manufacture of bronze and iron objects, the cultivation of rice and, in association with it, the establishment of settled agricultural communities, and the development of a new type of architectural structure, the granary. It was once thought that all of these elements were introduced at one time by a new group of people who emigrated from somewhere on the Asian continent and displaced the Jōmon population. There are two problems with this theory. First of all, there is no known culture on the mainland possessing all the attributes of the Yayoi people. Furthermore, there is no evidence to suggest a hostile take-over by better-equipped warriors. Many scholars now believe that the elements that differentiate the Yayoi from the Jōmon were introduced piecemeal over time and gradually assimilated by the indigenous population.

Rice cultivation seems to have begun in Kyūshū before the end of the Jōmon era, from the evidence of charred rice grains found in vessels of the Final Jōmon period. By the middle of the Yayoi period, cultivation techniques had advanced to include systems for regulating the flow of water into rice paddies. These techniques, together with the development of new farming tools, resulted in a rapid increase in the number of villages in Kyūshū. The new rice culture spread first to southwestern Honshū, and later throughout the larger island. The new type of building, the granary, was developed to store rice. Influenced probably by the architecture of a wetland area on the continent, it was a rectangular building made of wood planks and covered with a thatched roof, the whole raised off the ground on stilts (fig. 16). The obvious advantage of this type of

see them as more benign windows of the soul. Like so many other Jōmon pieces, their interpretation remains a puzzle to be solved at some future date.

A particularly engaging and unusual female figurine has been preserved from the Final Jōmon period (fig. 15). Unlike typical Jōmon sculptures, this piece presents a complete, freestanding image. It even has what appears to be a tiny handle at the back of the head. Seen from the front, its curving body, narrow at the waist and wide at the hips, projects an impression of volume, articulated by shallowly cut horizontal lines interrupted at the shoulder and hip joints and at the breastbone by spiral markings. Its most interesting feature is its heart-shaped head on a plane slightly tipped up from the main vertical of the body, with round eyes and a broad thick nose. Individual elements in the figurine are typical of the Final Jōmon period, but as a whole it transcends the craftsmanship and creativity seen in other pieces of the same period.

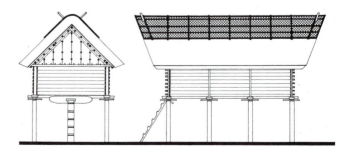

**16.** Elevations of Yayoi raised storehouse. (Pierre and Liliane Giroux, after Ōta Hirotarō, from *The Art of Ancient Japan*, Editions Citadelles, Paris)

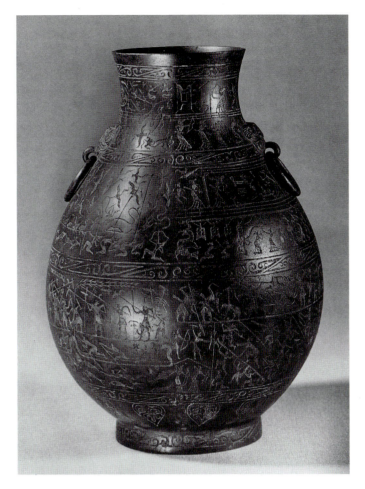

**17.** *Hu* (vase), from China. 5th to 3rd century B.C.E. Bronze; height 15⅝ in. (39.7 cm). Palace Museum, Beijing. Courtesy Zhang Suicheng, *China Today*, Beijing

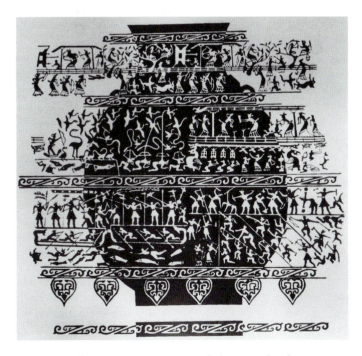

**18.** Schematic reconstruction of scenes on *hu*, fig. 17. Courtesy Zhang Suicheng, *China Today*, Beijing

structure is that it prevented the rice from rotting by providing a layer of air between the stored rice and the moist ground. The building was reached by a set of steep steps, closer in feeling to a ladder than to a staircase. Between the top step and the storage area, and again at the top of each stilt, there was a wooden board intended to discourage rodents from getting into the rice.

Metal objects—bronze weapons, mirrors, and iron tools—were first brought to Japan from Korea and China early in the Yayoi period, and soon afterward the Japanese developed the technology for casting. By the late 3rd and the 4th centuries C.E., the end of the Yayoi and the beginning of the succeeding Kofun era, Japanese craftsmen had advanced enough to reproduce complicated mirror decorations made a century or two earlier in China during the Eastern Han dynasty (25–220 C.E.). The most interesting bronze object surviving from the Yayoi period is the *dōtaku* or bell. Nearly four hundred of them have been recovered, primarily from sites in eastern Shikoku and the Kyoto-Osaka area. The name refers to a type of Chinese musical instrument. An assemblage of *dōtaku* is depicted on a *hu*, a Chinese bronze vessel, dated to the Warring States period, from 480 to 222 B.C.E. (figs. 17 and 18). The right side of the fourth register from the top of the *hu* shows chiming stones and bells suspended from a pole held in place by two elaborate, "dragon"-form upright posts. Clearly the Chinese prototype of bronze *dōtaku* functioned as musical instruments, but over time in Japan they evolved into objects of purely ceremonial importance.

The *dōtaku* range between 4 and 50 inches (10–130 cm) in height and consist of a body that is oval rather than round, a semicircular handle, and a flange that extends from the base of the bell to its apex. Most have geometric designs arranged in bands or blocks over the body, though occasionally a few figural images are used. The most interesting bells, both visually and from the point of view of history, are those showing figures interacting. A bell from Kagawa prefecture in Shikoku has reliefs of people engaged in various activities, as well as animals, birds, and insects (fig. 19). Reading from right to left, in the upper tier of blocks are depicted a praying mantis, dragonflies, and a salamander. In the middle tier there are two cranes and a turtle, a man shooting at a deer, and a figure in midair, identified by J. Edward Kidder as a shaman in the middle of performing a ritual involving leaping. The bottom tier of illustrations is perhaps the most interesting. A man aims a bow and arrow at a wild boar held at bay by five small animals, perhaps dogs trained to hunt. Next, a turtle and a salamander are shown together, and finally there are two village scenes showing a storage house and two people pounding rice. The treatment of the human figures is too abbreviated to include gender distinctions, but as Kidder has pointed out, the heads of the shaman, the hunter, and one of the two rice pounders are suggested by outlines, while the head of the second rice pounder is solid, possibly representing a woman. Although the pictures are

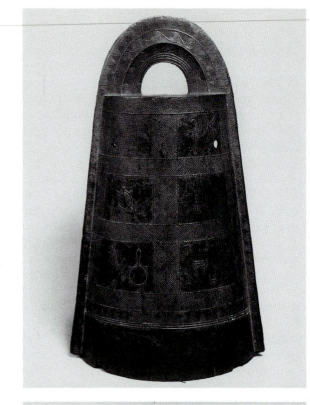

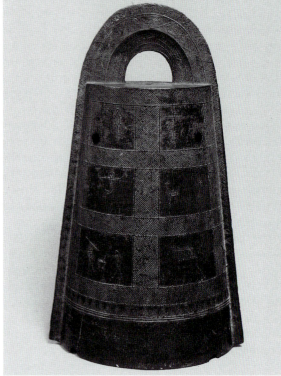

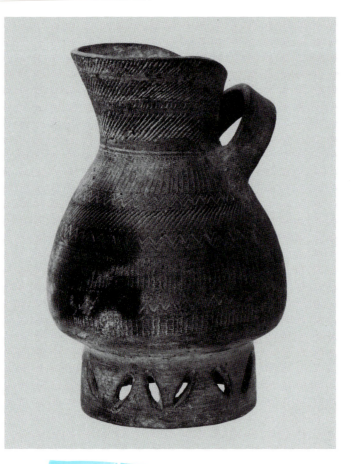

simply, even crudely executed, they are interesting for the view they give us of the life of the Yayoi people.

The objects most commonly found at Yayoi sites are ceramics—unglazed earthenware used both as ritual objects in ceremonies and for everyday living. Their shapes are standardized and are limited primarily to tall, narrow-necked vessels, pitchers, wide-mouthed cooking pots, storage jars, and bowls, some with pedestals. These pieces are simple and elegant in design, emphasizing the basic shape of the vessel. Built of stacked coils of clay, like the earlier Jōmon wares, they were sometimes given their final shaping and embellishing on a rotating wheel, and were usually fired in open stacks, more rarely in pit kilns. Although many Yayoi vessels are simply painted red, some are decorated with incised geometric designs such as zigzags, pricked lines, and patterns made by a comb—a tool in use by the middle of the Yayoi period. Others have raised appliqués that run the gamut from a simple row of buttonlike shapes around the neck of a vessel to raised shapes symbolizing a human face.

A clay vessel from the Kansai, the western plain of Honshū in the region of present-day Kyoto, Osaka, and Nara, is a particularly fine example of the drag-and-press technique of decoration (fig. 20). To make this pattern, the comb is pressed into the clay vertically and then is dragged across the surface. The vessel sits on a rather tall base, into which leaf-shaped holes have been cut. The belly swells outward above the base and the form narrows again at the neck. The surface of the vessel has been divided into registers, four on the neck and seven on the

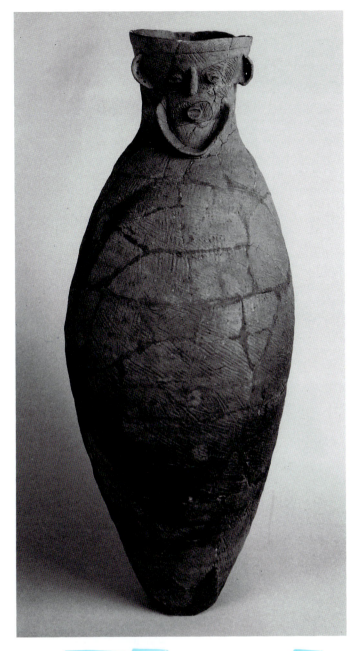

21. Middle Yayoi vessel, from Ibaraki prefecture. Clay; height 27⅝ in. (70.2 cm). Tokyo National Museum

the individual pieces share a common characteristic: the depiction of a human face on the neck or body of the jar. Kidder has suggested that large vessels with short necks may have been used for storing grain, with the face intended as a protecting presence. Other theories revolve around burial customs, in particular the practice of a secondary burial. After a body had been buried for a certain period of time, it would be exhumed, the bones washed and possibly painted with red ocher and reburied in a large earthenware jar. A vessel with a long narrow neck and a face just below the rim may have contained water and have been used in the bone-washing ceremony, while a large, wide-necked storage jar may have been recycled as a burial urn. As these pieces with human faces are usually found singly in a cemetery among many plain jars, the protecting presence symbolized by the face may have been intended to protect the spirits of all the deceased buried around it.

The storage vessel in figure 21, the function of which has yet to be determined, was found in a cemetery with forty-one separate burials. It is unusually tall, measuring 27⅝ inches (70.2 cm), has a flat base, and swells to its widest point midway between the base and the rim. On one side, beginning at the neck and extending to the rim, is the representation of a human face, suggested by a thin ridge of clay that curves below the mouth at the jawline, two earlike projections, and nose, lips, and eyelids indicated by raised shapes. The areas around the eyes and mouth are scored with diagonal lines cut into the clay.

Finally, the discovery in 1989 of the Yoshinogari site in Saga prefecture, Kyūshū, adds to our picture of life in this period. The largest settlement found to date, Yoshinogari consisted of some 300 pit dwellings—one significantly larger than the rest, presumably the house of the village headman—enclosed within two moats. Inside the inner moat were four watchtowers estimated to be about 33 feet (11m) tall, and outside the outer moat were twenty raised storehouses. More than two thousand burial sites were found to the northwest of the village. Occupation of the site began in the 2nd century B.C.E. and peaked around the 1st century C.E. Yoshinogari demonstrates that by the middle of the Yayoi period relatively large agricultural communities had formed in Kyūshū and that the villages needed protection from attack, presumably by aggressive neighbors.

## The Kofun Era (300–710 C.E.)

From about 300 to the early 8th century C.E., large mounded tombs, or *kofun*, were constructed. For this reason, these four centuries are sometimes referred to as the Kofun period. This can be confusing, since the last 250 years of the era of the *kofun* overlap with the succeeding Asuka and Hakuhō periods. The first *kofun* (literally, "old tombs") appeared in the Kansai region and gradually spread throughout Japan; their diffusion from the Kansai

body, and these in turn have been decorated with a variety of motifs: zigzag lines, diagonals pricked in the surface, and a design the Japanese call the bamboo blind, a combination of wide horizontal and thin, raised vertical lines. A handle is attached horizontally below the lowest curve of the lip. The shape of the pitcher is sturdy but refined, contrasting the smooth surface of the cylindrical base with the natural swelling and narrowing of the body, which is embellished with shallowly impressed comb markings.

Although they are relatively rare, there is a group of vessels from Yayoi excavations that present interesting problems of interpretation. While varying greatly in shape,

to other parts of Japan suggests the extension of political power, and certainly it is true that during the period of *kofun* construction, a loosely organized hegemony of regional chiefdoms gradually coalesced into a unified state with a central government located in the Osaka-Nara area. The terminal date of 710 for the Kofun era refers to the year in which a permanent capital was established at Heijōkyō (later Nara), and coincides with the beginning of the Nara period. Also, by this time the Buddhist practice of cremation had largely replaced tomb burials.

During the Kofun era, the Japanese maintained close contacts with the continent and became aware of many aspects of Korean and Chinese culture. That Japan's contact with Korea was particularly close is evidenced by the similarity of grave goods—objects such as headdresses, jewelry, weapons, and armor—found in Japanese *kofun* and in Korean royal tombs. Furthermore, the similarity between the construction of Korean and Japanese tombs suggests a linkage, proof of which is the 8th-century Takamatsu Tomb (see pages 31–32). There is considerable debate about the role Korea played in late Kofun-era developments, but there can be no doubt that the connection between Korea and Japan was close.

A crucial Chinese influence on Japanese culture in this period was a system of writing in ideographs, and, along with it, the practice of recording events, both mythological and actual, in the form of histories. Although few Japanese records remain from this period, memories and myths were preserved through oral transmission from one generation to another, and were finally committed to writing in 712 in the *Kojiki* and in 720 in the *Nihon shoki*, the oldest official histories of Japan.

## *Kofun* Construction

*Kofun* construction began abruptly at the end of the 3rd century C.E. in the Kansai and probably developed out of the late Yayoi custom of burying the dead on hills overlooking rich farmland. Kofun-period tumuli were usually round or shaped like a keyhole—the combination of a circular mound (tumulus) with a triangular one that suggested an old-fashioned keyhole to Western archaeologists.

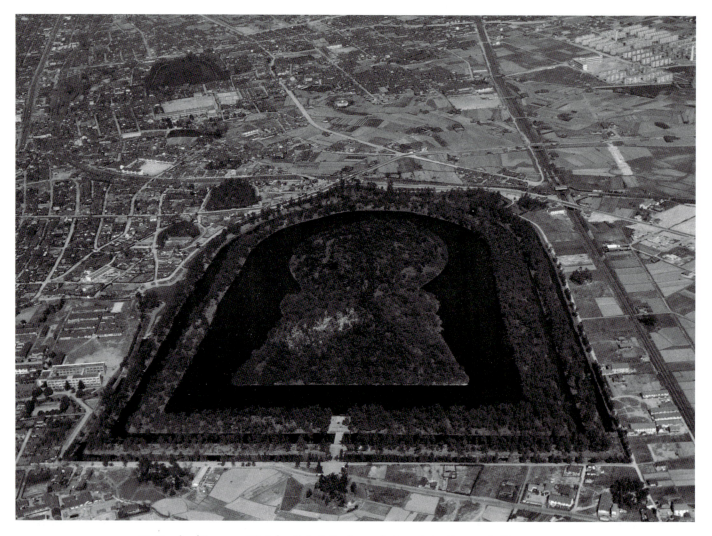

**22.** Tomb of Emperor Nintoku. Sakai, Osaka prefecture. Late 4th to early 5th century C.E.

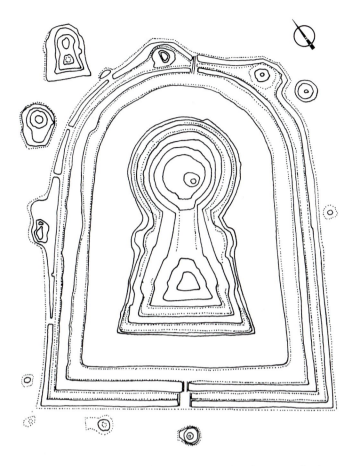

**23.** Contour plan, Tomb of Emperor Nintoku. (Pierre and Liliane Giroux, from *The Art of Ancient Japan*, Editions Citadelles, Paris)

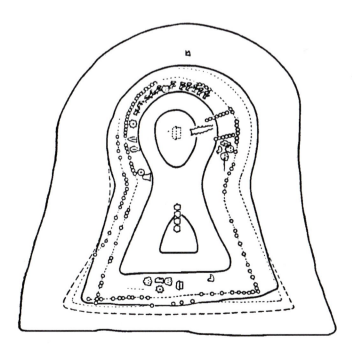

**24.** Diagram of *haniwa* placement, Futatsuyama Tomb, Gunma prefecture

These keyhole tumuli were built over pit-shaft graves, in which the burial chamber, an earthen-floored room with stone walls, was usually located near the top of the mound. Once the wooden coffin and the appropriate grave goods were in place, the chamber was closed with ceiling rocks and earth was then mounded over it. The objects placed in the tombs to accompany the deceased into the next life were usually iron weapons, bronze mirrors, and ornaments made of jade and jasper. Clay cylinders called *haniwa* were distributed on the surface of the mound.

By the 5th century, *kofun* had increased considerably in size and complexity. Instead of existing hill sites as burial grounds, artificial mounds of earth were constructed on flat land and marked off from the surrounding area by moats. The most impressive of these *kofun* were built for the imperial family, which suggests that by this time they had the political and economic power to command the large work force required. The largest tumulus in Japan is in Sakai, near Osaka, and is thought to be the tomb of Emperor Nintoku, who reigned in the late 4th and early 5th century (figs. 22 and 23). The central keyhole shape is 90 feet high and almost 1,600 feet long (27.4 x 487 m) and is surrounded by three moats; the entire monument, including its moats, covers 458 acres. It is estimated that some twenty thousand *haniwa* were distributed over the surface of the mound.

Toward the end of the 5th or the beginning of the 6th century, the Korean corridor tomb also came into use. It consisted of a horizontal hallway leading from the slope of a mound to a stone-lined burial chamber. The chief advantage of the corridor tomb as opposed to the pit-shaft grave was that it was easier to re-enter and could be used for multiple burials. By the 6th and 7th centuries, family tombs became popular, along with the practice of decorating the stone walls of the main chamber with either painted or incised designs.

## Haniwa

*Haniwa* (*hani* means "clay" and *wa,* "circle") appeared first on *kofun* in the Kansai Plain. Typically, there was a house-shaped *haniwa* directly over the deceased, with others distributed in concentric patterns at midslope, at the base of the mound, and at the entrances to burial chambers. Over time, *haniwa* production declined in the Kansai and shifted eastward to the Kantō, the eastern plain surrounding modern Tokyo. The pattern of *haniwa* placement on tomb mounds associated with the new corridor style of burial can be seen in the Futatsuyama tumulus in Gunma prefecture (fig. 24). The largest *haniwa* house appears at the center of the circular mound over the deceased, and along the top of the triangular section is a neat line of four additional houses. Simple cylinders outlined the entire keyhole shape; inside this border figural images were placed around the curve and also along the straight edge of the mound.

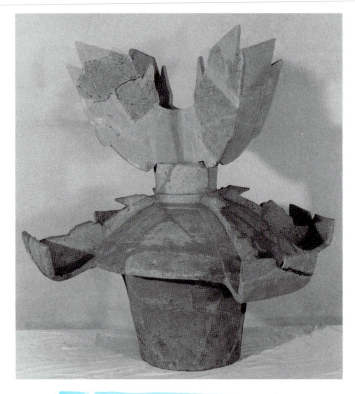

25. Kofun sunshade-shaped *haniwa,* from Anderayama Tomb, Uji, Kyoto prefecture. Clay; height 36 5/8 in. (93 cm). Archaeological Museum, Kyoto University

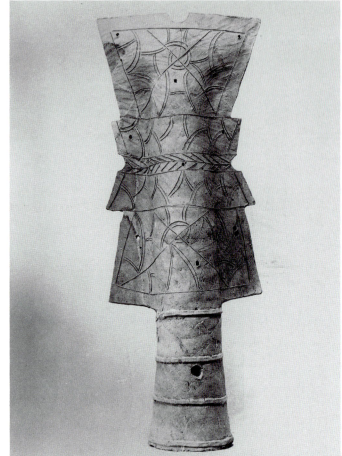

26. Kofun *haniwa* shield, from Nara prefecture. 6th century B.C.E. Clay; height 58 5/8 in. (149 cm). Tokyo National Museum

It is thought that *haniwa* evolved out of hourglass-shaped jar stands used in conjunction with burials in the Yayoi period, perhaps to support vessels containing offerings. These early *haniwa* were unglazed ceramics fashioned out of slabs or coils of clay and fired at low temperatures by the same craftsmen who made the everyday ware, or *haji;* the materials and techniques were the same for both. The *haniwa* ranged in shape from the simplest cylinders to detailed renderings of architecture and military equipment, and included shields decorated with incised patterns, quivers, helmets, ceremonial parasols, and, occasionally, human figures.

An episode contained in the *Nihon shoki* (or *Nihongi*) suggests how lifelike these *haniwa* must have appeared. A man riding past the tumulus of Emperor Ōjin in the moonlight

fell in with a horseman mounted on a red courser, which dashed along like the flight of a dragon, with splendid high springing action, darting off like a wild goose. . . . In his heart he wished to possess him [the red horse], so he whipped up the piebald horse which he rode and brought him alongside. But the red horse shot ahead, spurning the earth, and, galloping on, speedily vanished in the distance.

W. G. Aston, trans. *Nihongi,* London, 1896, pp. 357–58.
Reprinted London, 1956

However, the rider of the other horse intuited the man's desire, returned, and exchanged horses with him. Happy, the man returned home, foddered the horse and went to

bed. The next morning he found the red courser to be made of clay and upon going back and searching around the tomb found his own piebald, for which he exchanged the *haniwa* horse.

The function for which the *haniwa* were intended is still being debated. The need for an explanation of their use was apparent by the early 8th century, judging from a passage in the *Nihon shoki.* It states that an emperor, perhaps Suinin, requested that a substitute be found for the live burial of attendants after the death of a member of the imperial family, and that, in response, the clayworkers' guild produced images of people and horses to be used instead. There is no evidence to support the idea of mass sacrifices near a Japanese imperial tomb. However, during the much earlier Shang dynasty in China, circa 1523–1027 B.C.E., numerous people were killed and buried with rulers. When the *Nihon shoki* was written in 720, the Japanese were trying to model their culture after the Chinese, which may account for this particular idea.

It has also been suggested that the *haniwa* were intended to keep the earth of the artificial mounds in place, but the placement of the clay cylinders, at least as known today, would not have prevented erosion. The most workable theory is that they served two functions: to separate

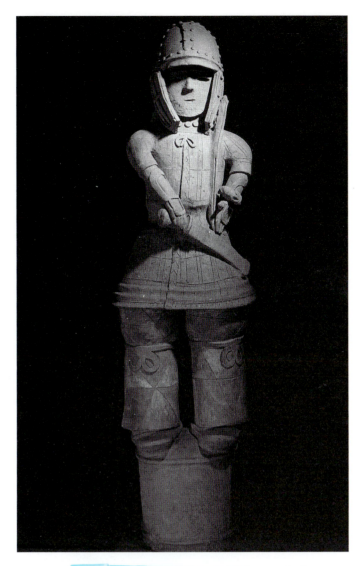

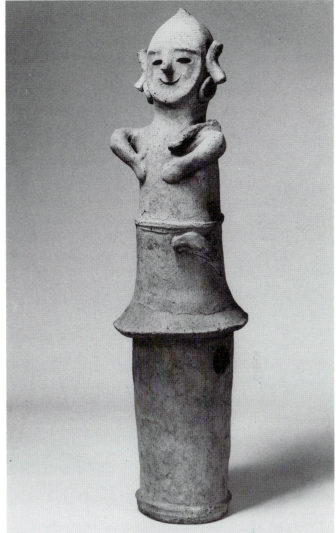

27. Kofun *haniwa* figure of a warrior, from a site in Gunma prefecture. Clay; height 49¼ in. (125 cm). Aikawa Archaeological Museum

28. Kofun *haniwa* figure of a farmer, from a site in Gunma prefecture. Clay; height 36⅜ in. (92.5 cm). Tokyo National Museum

the world of the dead from that of the living, and to protect the deceased and provide their spirits with a familiar resting place.

The early *haniwa*, those produced in the Kansai, are very limited in type, as though the clayworkers were required to adhere to a narrow standard that allowed little room for creativity. Nevertheless, the pieces are well, often superbly, made, and some are striking in appearance. The sunshade, or *kinugasa*, from Anderayama *kofun* (in a suburb of modern-day Kyoto) is an object of great formal strength (fig. 25). The basic shape is that of a round umbrella set on a cylindrical base, probably deriving from the sunshade held over people of importance at outdoor rituals. The drama of the piece is considerably heightened by the four featherlike shapes that rise up from a ring at the top, and by the four flanged pieces that extend down from the ring to the edge of the umbrella and then curl back again. Carved on the surface of the

piece is a design known as the *chokkomon*, a geometric pattern of curves and intersecting lines. Another shape frequently found in the Kansai is the shield (fig. 26). The protective shape, of what might have originally been a leather object, is set on top of the cylinder typical of *haniwa* sculpture. The surface of this piece, too, is decorated with the *chokkomon* design.

The variety of later *haniwa* shapes from the Kantō is much richer. Figural *haniwa*—men, women, singers, dancers, soldiers, and animals—are found throughout the region in such numbers and different types that Japanese scholar Miki Fumio has called them genre sculpture. The frequency with which armor-clad figures appear suggests that warfare was not uncommon in the area (fig. 27). This warrior wears full-body armor over wide-legged pants, gauntlets, and a helmet. In contrast, the farmer, with a hoe over his shoulder and a wide grin on his face, is the epitome of a happy-go-lucky peasant (fig. 28). The sculpture

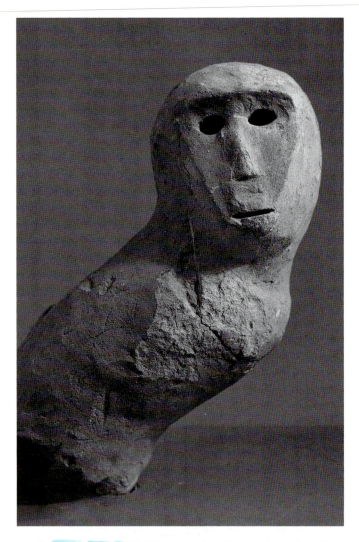

**29.** Kofun *haniwa* figure of a monkey, from a site in Ibaraki prefecture. Clay; height of entire figure 10¾ in. (27.3 cm). Private collection, Tokyo

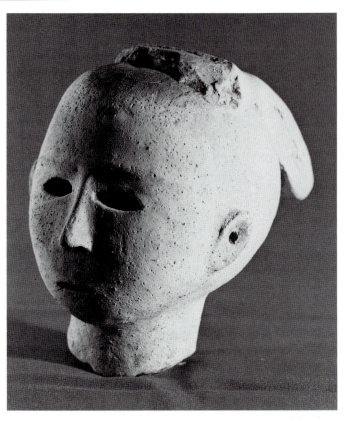

**30.** Kofun *haniwa* female head, from Tomb of Emperor Nintoku. Late 4ᵗʰ to early 5ᵗʰ century C.E. Clay; height 7⅞ in. (20 cm). Imperial Household Agency

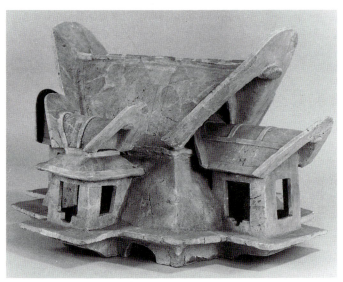

**31.** Kofun *haniwa* house, from Miyazaki prefecture. 5ᵗʰ century C.E. Clay; height 21½ in. (54.5 cm). Tokyo National Museum

of a monkey is a true masterpiece (fig. 29). From one angle she appears to turn her head as if to speak to an offspring. From another she seems alert and watchful, as if danger were at hand. The piece testifies to the skill and sensitivity of its anonymous Kantō maker.

Two sculptures of particular interest, not only because of their craftsmanship but also for the information they provide about Kofun culture, are a female head from the tomb of Emperor Nintoku and a large house found in northern Kyūshū (figs. 30 and 31). Since the tombs associated with emperors are under the protection of the Imperial Household Agency and are not available for excavation, this piece in the public domain offers a rare glimpse into the quality of objects still hidden from view. Furthermore, because Emperor Nintoku's dates can be established—scholars now generally place him between 395 and 427—the head provides an early example of the figural images produced in the Kansai. The house *haniwa* from Kyūshū provides important information about residential architecture for the affluent. Its basic shape is that

of a roofed pit dwelling. Additions on the long sides permit access to the interior by way of ramps. The structures on the short sides represent secondary, shorter houses set into the main building. The sculpture seems to present a stage in the evolution of the house from pit dwelling to a single-story structure with walls.

## Mirrors

Another type of object associated with burials in the Kofun era is the mirror. Oriental bronze mirrors have one flat side, polished so it can show a reflection, and a reverse on which raised designs ring a central boss, which is provided with a hole through which decorative cord can be strung. Mirrors seem to have first come into Japan from China in the Yayoi period, and by the 4th century C.E. were being reproduced by local craftsmen. In Japanese mythology, as recorded in the *Kojiki* and the *Nihon shoki*, references to mirrors can be traced back to indigenous Japanese legends about Amaterasu, the sun goddess, the central mythological deity who ruled the world with her brother, Susanoo no Mikoto. At one point, angered by the irresponsible and destructive actions of her brother, she retreats into a cave, which she closes with a rock behind her, thus taking the light out of the world. To lure her back, myriads of gods gather, and various objects, including a mirror, are hung from a sacred *sakaki* tree outside the cave. When she agrees to come out, the mirror is put in the cave in her stead. Later, when her grandson, the August Grandchild Ninigi no Mikoto, is sent down to earth to establish his rule, she gives him three objects symbolic of his divine origins: a curved jewel (*magatama*), a sword, and a mirror. Amaterasu charges him:

> My child, when thou lookest upon this mirror, let it be as if thou wert looking on me. Let it be with thee on thy couch and in thy hall, and let it be to thee a holy mirror.
>
> Aston, *Nihongi*, p. 83

Thus the mirror carries several associations: the magic power to reflect an image even in the dark, the symbol of the sun goddess, and the extension of her power to others. It is in this last sense that the mirror seems to have functioned in the Kofun era. Given the pattern of dissemination of mirrors through the country, scholars believe that some were bestowed on local chiefs as a reward for forming a political alliance and as a symbol of the transfer of authority.

Of the many hundreds known, two mirrors must be singled out for special attention: a mirror with a design of four buildings and one from a group of mirrors, all from the same tomb, ornamented with the *chokkomon* design (figs. 32 and 33). Both are pieces that could have been made only in Japan. The first mirror, from the Takarazuka Tomb in Nara prefecture, illustrates four separate pieces of architecture. Most probably the buildings should be identified as three residences—a three-bay house raised off the ground on piles, a dwelling with walled sides and a gabled roof, and a pit house—and one storehouse, a two-bay building on piles. (A bay is the space between vertical posts.) The question of whether the design was intended as a depiction of existing buildings or had a less literal meaning has not yet been resolved, but the mirror certainly provides an interesting view of the diversity of archi-

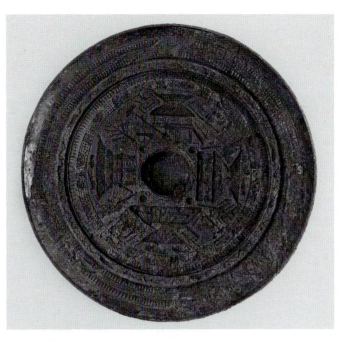

**32.** Early Kofun mirror with image of four buildings, from Takarazuka Tomb, Nara prefecture. Bronze; diameter 9 in. (23 cm). Imperial Household Agency

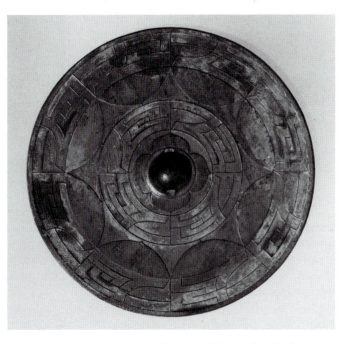

**33.** Early Kofun mirror with two *chokkomon* bands, from Ōtsuka Tomb, Kyūshū prefecture. Bronze; diameter 11 in. (28 cm). Imperial Household Agency

tecture in use in the Kofun era.

The mirror with the *chokkomon* design comes from the Ōtsuka Tomb on Kyūshū, along with two others bearing the same type of motif. The name *chokkomon* means "pattern of straight lines and arcs" and was coined in the 20th century to describe this motif. The bands with the *chokkomon* design are divided into segments, almost pie-

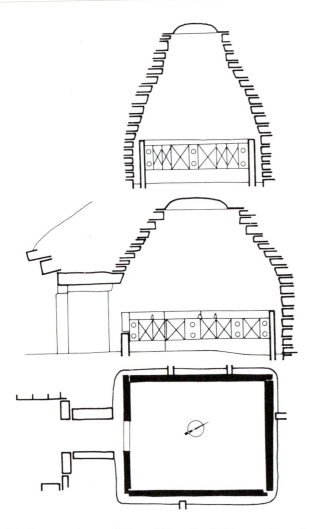

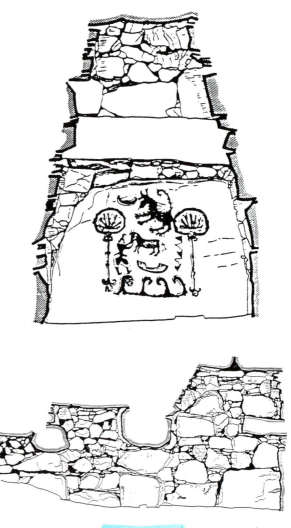

**34.** Cross sections and plan of Idera Tomb, Kumamoto prefecture. Late Kofun. (Pierre and Liliane Giroux, after Kobayashi Yukio, from *The Art of Ancient Japan*, Editions Citadelles, Paris)

**35.** Cross sections of Takehara Tomb, Fukuoka prefecture. Late Kofun

shaped wedges, eight in an outer band and four in an inner one. These units of arcs and lines in the two zones are similar except for their size, two in the outer band equaling one in the inner band. The design in this context is particularly pleasing, with its emphasis on fine raised lines disposed delicately between flat zones.

## Ornamented Tombs

In the 6th and 7th centuries more tombs were built than in the preceding eras. They were smaller in size, and sometimes ornamented, constructed not just for the emperor and local leaders but for other people as well. The most interesting of the ornamented tombs are in Fukuoka and Kumamoto prefectures in northern Kyūshū. The Idera Tomb, named for the village in Kumamoto where it is located, is remarkable for the complexity of its construction (fig. 34). The corbel vault is the finest known in Kyūshū and the *chokkomon* pattern chiseled on stone slabs at the base of the walls in the burial chamber is the most ad-

vanced example of the design known today (colorplate 1). Japanese scholars have classified these patterns of arcs and lines into two basic types: the A-type, in which a spiral is superimposed over crossing diagonals, resulting in four units that are further divided by curving lines; and the B-type, in which the spiral is no longer evident, but a strong sense of circular motion is still conveyed. Various suggestions have been made about the origin of the *chokkomon* design, ranging from the idea that it is an abstraction of something in common use, a utensil, or perhaps a plaited rope, to the theory that it is a symbolic motif, a net to bind the spirit of the dead within the tomb chamber, an abstraction of Chinese Han-dynasty cosmic symbolism. The *chokkomon* motifs on the wall screens are painted red, blue, and white, further emphasizing their abstract quality. Because of the advanced building techniques used at Idera, the tomb is usually dated to the 7th century.

The Takehara Tomb in Fukuoka is remarkable for the figural painting still preserved on the rear wall of the burial chamber (fig. 35 and colorplate 2). The tomb is

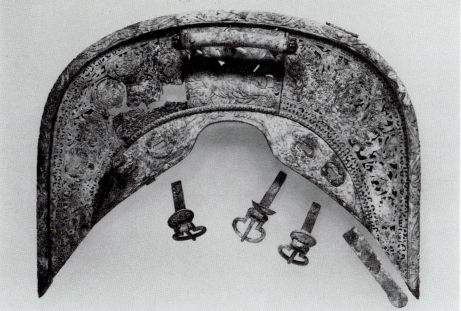

Kofun period

**36.** Rear saddle bow, from Fujinoki Tomb, Ikaruga, Nara prefecture. Late 6th century C.E. Gilt bronze; 16⅞ x 22½ in. (43 x 57 cm). Nara Prefectural Kashihara Archaeological Institute, Kashihara

much smaller and not nearly as complicated in construction as the one at Idera, but the striking red and black painting stands out among the known ornamented tombs. The composition is framed by two large, standing ceremonial fans, and the pictorial elements are distributed in three loosely defined registers. At the top, a red-spotted, black quadruped with wiry hairs extending from the body, particularly from the tail, gallops full tilt to the left. Directly in front of it is a small boat. Below and to the right is a vertical row of triangular shapes, perhaps an abstraction of a mountain pattern, and to the left is a groom tending to a horse placed above a boat. At the bottom, a stylized pattern of cresting waves forms a base line for the boat and the groom. The spotted quadruped is undoubtedly a spirit, while the horse below exists in the here and now. Possibly the upper animal is the spirit of the horse. The groom may be a shaman. The presence of landscape elements suggests movement through space and may refer to the journey of the soul after death. Whatever its exact meaning, the painting, on a crudely smoothed stone at the back of the chamber, is a strong reminder of the mythic and spiritual dimension of Kofun culture.

## Two Late Kofun-Era Tombs

Two tombs of great importance uncovered in recent years shed light on the cultural and political climate of late Kofun times: the Takamatsu Tomb found near the village of Asuka, south of Nara, in 1972; and in the Fujinoki Tomb in Ikaruga found in 1985.

Dating to the late 6th century, the Fujinoki Tomb is one of the longest corridor tombs to be excavated, and it held a large quantity of fine grave goods. The sarcophagus contained the remains of two people, a small figure pre-

sumed to be a woman and a larger one, probably a male, approximately seventeen to twenty-five years of age, who was placed in the coffin after the woman in what was clearly a secondary burial for him. Some of the bones were painted with vermilion, and the remains were surrounded by a great assortment of opulent objects, including openwork gold crowns, gilt bronze shoes, a belt, and silver daggers. More than eight different candidates have been suggested as the male occupant of the tomb. J. Edward Kidder has proposed that he was Emperor Sushun, assassinated in 592. Kidder suggests that after his death Sushun was given a temporary burial, and that when his wife died, they were buried together.

Two of the most unusual objects found in the tomb are sheets of openwork gilt bronze fashioned to ornament the wooden front and back bows of a saddle (fig. 36). Both are decorated with hexagonal shapes enclosing animal and floral motifs: Chinese symbols such as the dragon, the phoenix, the lion, and the elephant; the *makara*, a crocodilelike animal found in Indian Buddhist art; and the Central Asian artistic motif of the palmette. Clearly, at the time these ornaments were fashioned Japanese artisans had a rich repertoire of continental motifs available to them. The Fujinoki Tomb has yielded so many objects yet to be evaluated that it will be years before any final conclusions can be drawn about the tomb and its occupants.

The Takamatsu Tomb, once identified with the emperor Monmu (reigned 697–707), was excavated in 1972 after it had been dropped from the list of imperial tombs. It had been looted in the distant past and as a result the surface of the south entry wall has been badly damaged. Nevertheless, what archaeologists found upon opening the Takamatsu Tomb was a set of wall paintings that provides the first direct link between the painted tombs of China and

1 constellations
2 moon
3 group of men
4 white tiger of the west
5 group of women
6 dark warrior of the north
7 sun
8 group of women
9 blue dragon of the east
10 group of men

**37.** Diagram of Takamatsu Tomb, from the south

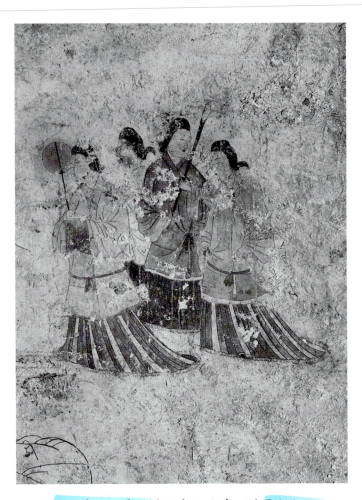

**38.** Female attendants (number 5 in fig. 37). Painting on west wall of Takamatsu Tomb, Nara prefecture. Late 7th to 8th century C.E. Color on plastered panel *Kofun period*

Korea on the one hand and those of Japan on the other.

The motifs depicted consist of three types of images: four groups of four human figures; three of the four Chinese animals symbolic of the four directions; and representations of the sun, the moon, and the constellations (fig. 37). Chinese directional symbols, the blue dragon of the east and the white tiger of the west, appear between two groups of figures on the east and west walls. The dark warrior symbolic of the north, that is, the tortoise entwined with a snake, appears by itself on the north wall (colorplate 3). (The red phoenix of the south, which should appear on the entry side of the tomb, has not survived.) Above the dragon is a golden circle for the sun on a pattern of thin red cloud lines of irregular length, and on the opposite wall above the tiger is a silver circle for the moon. The constellations are represented on the ceiling by seventy-two circles, once covered with gold leaf but now too damaged to be appreciated. Of most interest are the groups of men and women, the men to the south side of the tomb—the bright, warm, positive side—the women to the north—the dark, cold, negative side, according to Chinese theories of yin and yang. Among the figures the most important is the deceased, positioned at the head of the group of men on the east side, facing south. The other male and female figures are attendants and hold traditional Chinese symbols of status, such as round fans with long handles. The paintings are too damaged to permit a closer identification of the figures.

The tomb is extremely small, too low for the artist to have been able to stand while working. Nevertheless, the stone walls have been prepared in the continental fashion, with fine layers of plaster applied in order to build up a proper surface to bind the pigments. The best-preserved section of painting shows the women on the northern end of the west wall (fig. 38). They are full-figured court ladies, all about the same height, but placed at different levels along the wall and interrelated by their positions rather than their actions. The women wear long jackets over what appear to be pleated skirts, a style of garment that is Korean in flavor. The faces and costumes are delineated by distinct, slightly calligraphic outlines, brush lines that vary slightly in width, depending on the pressure applied to the implement. The colors are bright yellow, orange, red, and light green, as well as darker blues and greens.

From the skeletal remains of the deceased, experts have judged him to be a man in his forties, and from the evidence of a Chinese mirror ornamented with a lion and grape-leaf design and datable to 698, the tomb must have been closed near the end of the 7th century. The most likely candidate for the deceased is generally thought to be Prince Takechi (654–696), the son of Emperor Tenmu and a woman other than the empress Jitō, his principal wife. At any rate, the tomb was clearly made at the end of the 7th century for someone of importance, a person who could plan for himself and arrange for a resting place in consonance with Chinese Taoist principles for burial, a space decorated in the best continental styles and techniques available in Japan at the time.

# CHAPTER 2
# Encounter with China and Buddhism

## THE ASUKA, HAKUHŌ, AND NARA PERIODS

The 6th century marked the beginning of close cultural ties between Japan and the continent—China and the three kingdoms of Korea, namely, Koguryō, Paekche, and Silla—and witnessed the first of several all-out efforts on the part of the Japanese to assimilate foreign ideas and institutions. One result of this intense interest in continental culture was the introduction of Buddhism from China and Korea. Simultaneously with the imported religion came many attributes of Chinese culture, including writing, the compilation of histories, and the concept of statecraft under a single ruler, all of which had a profound effect on the island country. Buddhism changed Japan, and it profoundly affected Japanese art. At the same time, Buddhism, too, was influenced—both by its encounter with Shinto, the indigenous religion of Japan, and by Japanese culture—and it rapidly assumed characteristics that have made it different from the Buddhism of other Asian cultures. Not surprisingly, the Buddhist arts of Japan also ran their own course of development, producing a great body of work with distinctly Japanese qualities and aesthetics.

## Shinto

"The way of the gods" *(kami no michi)*, Shinto was originally centered on the needs of an agrarian culture. *Kami,* supernatural beings, are unseen, awe-inspiring, and mostly beneficent spirits believed to dwell in such natural phenomena as rocks, trees, waterfalls, and mountains, as well as deities embodied as gods and goddesses. The focus of worship is not only the spirit or deity but also its temporary or permanent residences. These sites, known as *iwakura,* are considered sacred, and they are sectioned off from the mundane world, usually by tying straw ropes around them or by enclosing them within wooden fences. Such deities with a fixed place of residence are primarily of local significance and are worshiped in rituals related to the cultivation of crops and the passage of the seasons. However, Shinto has also functioned on a countrywide, political level by providing godly ancestors for the various local clan groups who participated in the formation of a unified state. At the fulcrum of the alliances that led to unification was the strongest clan, the imperial, which traces its origins to the sun goddess Amaterasu. Already the heaven-illuminating ruler of the world, she came to dominate other clans' *kami* as an extension of her role as ancestor of the imperial clan—the same lineage from which emperors still descend in the modern era.

The origins of Shinto are difficult to substantiate before the development of agrarian communities in the Yayoi period. During the Yayoi and Kofun eras, Shinto was formulated as a concept explaining the relationship between human beings and the forces of nature. In the Kofun era, the symbols of god-bestowed authority, namely, the *magatama* (a comma-shaped jewel), the sword, and the mirror, appear in conjunction with the imperial clan and are also found in the tumuli of the group leaders with whom it formed alliances. These are the same three objects that were given by Amaterasu to the August Grandchild, Ninigi no Mikoto, before he descended to earth to rule the Central Land of the Reed Plains, understood to be Japan, and they became the imperial regalia, symbolizing the divine right of an emperor to rule. According to tradition, the mirror was transferred from the imperial palace at the request of the legendary tenth emperor Sujin, and under his successor Suinin it was enshrined at Ise, the worship complex dedicated to Amaterasu on the south coast of Honshū. Ise, still today Japan's imperial shrine, and the shrine at Izumo, on the west coast in Shimane prefecture, which may predate Ise, are considered the most important Shinto shrines in Japan.

The introduction of Buddhism in the 6th century, and the aspects of Chinese culture it made available, brought about an emphasis on the elements within Shinto that fostered the power of the central government. When the *Kojiki* and the *Nihon shoki* were compiled, they recorded the mythic origins of the country and served to authenticate the right of the imperial clan to govern. Later

in the century, efforts were made to demonstrate a harmonious relationship between Shinto and Buddhism. One such exercise in rapprochement occurred in 743, when Emperor Shōmu pledged the building of a major temple, Tōdaiji, intended to rival anything in China and dedicated to the supreme Buddha. An imperial messenger was sent to Ise to ask the will of the sun goddess. As reported, her response was favorable; she allowed that she and this buddha were aspects of the same reality. This was only one among many interactions between Buddhism and Shinto in the Nara period (710–794) and the succeeding Heian period (794–1185) that facilitated harmony between the two religions. Finally, in the Kamakura period (1185–1333), the system of Ryōbu Shinto was formulated, which made a direct connection between Dainichi, the esoteric alter ego of Birushana, the quintessential buddha, and Amaterasu.

The constructed elements essential to worship of a *kami* are first of all the *iwakura*, the natural site at which he or she takes up residence. Today the *iwakura* is usually represented by a wooden shrine within an enclosure to which a gate, or *torii*, gives access. The actual ritual of worship consists of three elements: prayers, obeisance, and offerings. The worshiper climbs the steps to the upper level of a shrine and pulls a cord that rings a gong to alert the god. Prayers are then offered, followed by a deep bow of perhaps a minute in length, and finally offerings are made. Today these consist of food and drink and sometimes a piece of paper cut in a widening zigzag design and attached to a stick of new wood or a twig from the sacred *sakaki* tree, intended to symbolize the cloth that was once included in the gifts to a deity.

The precinct of the shrines at Ise, encompassing unpainted wooden buildings and thickly wooded hills traversed by pebble-covered pathways, is the classic example of a Shinto worship complex (fig. 39). The enclave consists of an outer shrine, or Gekū, dedicated to the provider of grain, and an inner shrine, or Naikū, dedicated to Amaterasu. To reach the Naikū, one must pass beneath a *torii*, cross an arching stone bridge over the Isuzu River, and walk through another *torii* at the other side. The pathway to the shrine runs parallel to the river, and immediately to the right in front of the first *torii* is a long, narrow stone basin filled with water for rinsing the mouth and hands. Alternatively, one can continue farther into the precinct and perform the same purification ritual in the clear waters of the river. (Originally, worshipers waded through the shallow river to reach the shrine, an even more dramatic act of purification.) Next, one climbs a gentle slope through a forest of cedar trees to the foot of a flight of stone-bordered steps that lead up to a solid wooden gate in a wooden fence. This outermost wooden fence of the enclosure at the top consists of boards so closely fitted together that it is impossible to see inside to the actual buildings, which are, in any case, enclosed within three additional fences and accessible only through

1 bridge *torii*
2 arched bridge
3 Isuzu River
4 first *torii*
5 roofed area for hand washing
6 river site for hand washing
7 enclosure gate
8 west site for main shrine
9 east site for main shrine

**39.** Plan of the Naikū shrine at Ise

gates in the center of the short sides and only to the shrine priests and specially designated members of the imperial family. The *honden*, or main hall of the shrine, is in the center of the innermost enclosure, and behind it are two treasure houses called the east and the west halls.

To one side of the enclosure is an open, pebble-covered plot of the same size, where the former shrine was constructed. Since the reign of Empress Jitō (686–697), it has been customary to rebuild the shrine every twenty years. The last reconstruction at Ise in 1973 was the sixtieth, the tradition having been suspended during several times of internal strife. In addition to the main enclosure, there are many smaller shrine buildings within the precinct, a ceremonial rice storehouse, a hall for the performance of the sacred dance known as the *kagura*, and a stable, as well as support buildings for the priesthood and the administration of the shrine. The Ise complex evolved over centuries, and many of the buildings were added in the Tokugawa, or Edo period (1615–1868).

The Izumo Taisha, or Grand Shrine, is dedicated to Ōkuninushi no Mikoto, reputedly a fifth- or sixth-generation descendant of Susanoo no Mikoto, the rambunctious brother of the goddess Amaterasu. He ravaged her rice fields and created an uproar in her palace, causing her to prick her finger with a sewing needle. The sun goddess was so angry that she retreated into a cave, taking with her the

**40.** *Honden* (main hall), Izumo, Shimane prefecture. Rebuilt 1744

light of the world. For his disruptive actions, Susanoo was banished from heaven, and he descended to Izumo on the west coast of Honshū. There he slew an eight-tailed dragon that had eaten eight of the nine daughters raised by an old couple who lived upstream from the spot where he had landed. In one of the dragon's tails Susanoo found a magnificent sword, known as Kusanagi (grass cutter), which he gave to Amaterasu as a sign of goodwill. This became one of the three sacred treasures she bequeathed to her descendant. Ōkuninushi no Mikoto, the deity to whom the shrine is officially dedicated, is credited with the introduction of medicine, fishing, and sericulture, the production of silk from cultivated silkworms.

The building styles of both shrines derive from the raised granary developed in the Yayoi period. It is thought that the structure, elevated above the ground and thus higher than the surrounding structures, was first appropriated as a residence by a householder of importance,

perhaps the shaman, and subsequently became the obvious choice for the dwelling place of a *kami*. The main hall at Izumo is very close in style and orientation to the raised granary and is said to be modeled on the palaces of early rulers, in other words, on secular architecture associated with high position (fig. 40). Its size, considerably larger than the one at Ise, is sometimes attributed to its palace prototype and sometimes explained by the idea that at some point in time Izumo was given the responsibility for governing religious affairs, while Ise oversaw secular matters.

Raised on round piles set directly into the earth, the building has two square bays—a bay is the space between two vertical posts—with eight pillars framing the enclosing walls and a central pillar. The whole unit is surrounded by a veranda and is capped by a curved, gabled roof. The staircase leading to the veranda is off center and the entry door pierces the gable end of the structure in the right bay.

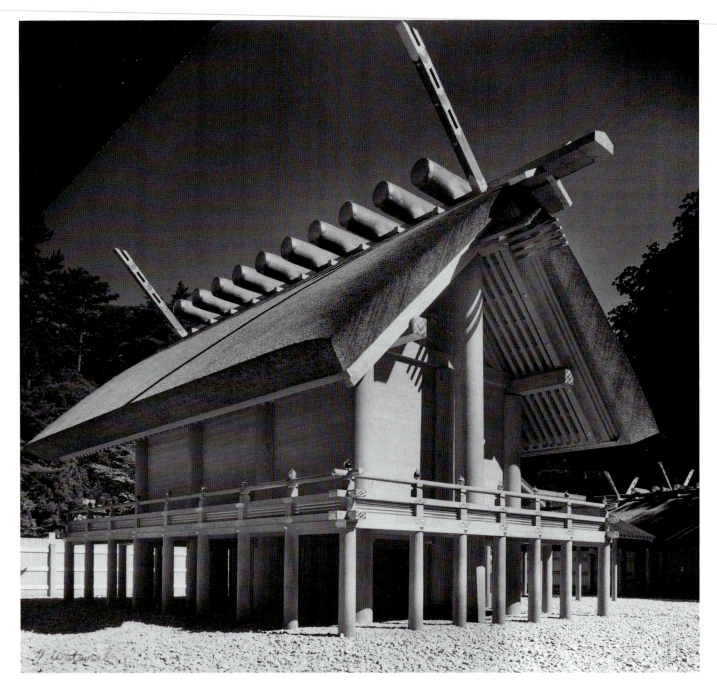

41. *Honden* (main hall), Ise, Mie prefecture

This configuration of elements is known as *taisha zukuri*, and is thought to be the oldest of the known architectural shrine styles (see note page 117). The Izumo *taisha* has not had the same history of rebuilding as that of Ise, and the present buildings date, by and large, from 1744.

The style of the buildings at Ise is known as *shinmei zukuri*, and because of the complex's connection with the imperial family, no other shrines may be built following the same pattern. Set up above the ground on round piles, the *honden*, the main hall, is three bays wide by two bays deep, with the entrance on one of the long sides (fig. 41). Surrounding the upper level is a veranda, and the whole is capped by a gabled roof of miscanthus reeds. Freestanding pillars at the short ends of the building add further support for the roof, and along the ridgepole are ten *katsuogi*, logs intended to weigh down the roofing material, originally thatch, today the bark of the cypress tree. Extending up from a point near the ends of the roof are

42. *Opposite page:* Shinto shrine types. Façades, side views, and ground plans, left to right: 1. *shinmei* (shrine at Ise); 2. *taisha* (shrine at Izumo); 3. *nagare* (shrine of Kamo in Kyoto); 4. Kasuga (Kasuga Shrine in Nara); 5. Hachiman (Usa Hachiman Shrine, Oita prefecture); 6. Hie (Hie Shrine at Shiga). (Studio of Enzo di Grazia, after Ōta Hirotarō)

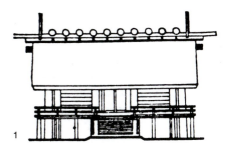 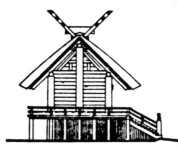 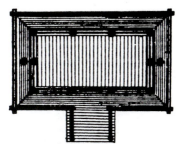

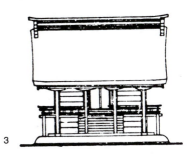 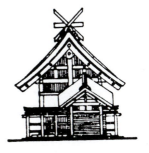 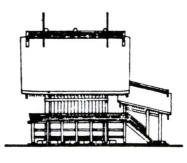 

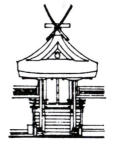 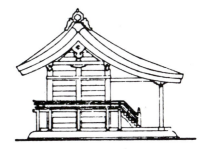 

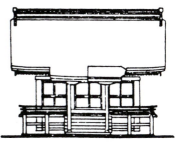  

two thin-sawn boards with gold-leaf ornamentation. These are *chigi*, originally extensions of the outermost rafters at each end of the gable, and a common feature of shrine architecture. A similar motif at Izumo appears as two X's sitting on the ridgepole. Ise Shrine displays a Japanese taste for the look of aging wood. The buildings are beautiful when new, and also as they darken with time, until twenty years down the road the gray, weathered wood must be replaced to renew the *iwakura*. Later shrines, following the example of Buddhist temples, were painted red.

In addition to the *taisha* and *shinmei* configurations of Shinto *honden*, three more were developed by the end of the 9th century, the *nagare*, the Kasuga, and the Hachiman (fig. 42). The most important differences between these three and the *taisha* and *shinmei* styles are the modifications made to accommodate worshipers. The *nagare* and the Hachiman *honden*, like the *shinmei*, are three bays wide by two bays deep and have the entry door on a side parallel to the ridgepole. However, in the *nagare* type the front section of the roof extends forward to shelter the stairs leading to the upper level. In the case of the Hachiman, a whole new, roofed building has been added in front of the main hall, the two joined at the eaves. This appended hall for worship may have derived from similar modifications in Buddhist temple construction in the Heian period (794–1185). The Kasuga type, named after the four small, aligned buildings in the Kasuga shrine complex at Nara, consists of a one-bay–square building raised on piles and capped by a gabled roof, and, on the gable end, a shed roof extending forward and downward in a sloping curve over the stairs. The later *honden* are much smaller than those of Ise or Izumo and, though more conveniently located for worship, give little of the impression of the earlier shrines, which are truly magnificent structures.

Shinto shrines continued to be built long after Buddhism was absorbed as the dominant religion of Japan. Some were incorporated into Buddhist compounds. Shinto sites are visited, used, and venerated today, as Shinto is very much a living religion in Japan. Shinto's foundation in a direct and harmonious relationship between human beings and nature was, and is, completely compatible with Buddhist values, and the Japanese have modified the imported religion to accommodate their ancient, indigenous system of beliefs.

## Buddhism

The religion of Buddhism reached Japan nearly a thousand years after its beginnings in India and after it had transformed the cultures of India, China, Central Asia, and parts of Southeast Asia. By the time of its importation, Buddhism was not merely a religious system, but a powerful, fully integrated cultural expression—with a number of different emphases reflecting various major and minor schools of thought and systems of belief. Within a mere century after its introduction in Japan, Buddhism became Japan's principal artistic stimulus. Under its patronage, the pictorial arts flourished, and the wide range of ritual implements required in Buddhist ceremonies encouraged the development of Japan's arts. In fact, from the 7th through the 15th centuries, the Japanese arts were primarily Buddhist arts. The various schools of Buddhism that were imported in rapid succession stimulated a proliferation of subjects, themes, styles, and even new techniques.

The traditional account of the introduction of Buddhism into Japan set forth in the *Nihon shoki*, the more detailed and accurate of the two earliest extant national histories, states that in 552 the king of Paekche, on the southwest corner of the Korean peninsula, sent to Japan Buddhist scriptures known as sutras, accoutrements for worship, and an image of the founder of Buddhism, Shakyamuni Buddha (Shaka in Japan).❖ His apparent reason for doing so was to forge a close religious tie with Japan in order to secure Japanese military assistance in his battle against the other two kingdoms on the Korean peninsula, Koguryō and Silla. Today scholars suggest that 538 is a better choice for the introduction of Buddhism. The fall of the Northern Wei dynasty in China in 535 sent a ripple of political unrest throughout the continent and seems to have caused people who felt themselves at risk to emigrate. Nevertheless, the year 552 is still cited as the "traditional" date for the introduction of Buddhism into Japan.

The founder of this religion was Siddhartha Gautama, an Indian prince born about 563 B.C.E. as the son of King Suddhodana and the heir apparent of the Shakya clan, which had its capital at Kapilavastu, located in present-day Nepal. Although raised as a prince, Siddhartha at the age of twenty-nine renounced his noble position and devoted himself to solving the enigma of human existence. After six years of meditation and austerities, Siddhartha went to Bodhgaya and sat through several nights and days under a bo, or *bodhi*, tree after which he attained a profound understanding of the nature of reality, or enlightenment. He then went to the Deer Park near Benares, modern-day Varanasi, and preached his first sermon, an act that is known as "setting the wheel of the law in motion." For the rest of his life, Shakyamuni, also called the Buddha, the one who has awakened to the truth,

---

❖ Shakyamuni is the Sanskrit term for the historical Buddha. The man before his enlightenment is referred to as Siddhartha Gautama, Siddhartha being his given name and Gautama a branch of the Shakya clan. After enlightenment he is referred to as Shakyamuni, the sage of the Shakya clan, or as Gautama Buddha. Shaka—often Shaka Nyorai—is the Japanese term for Shakyamuni. Nyorai is the Japanese translation of the Sanskrit Tathagata, meaning one who has attained perfect wisdom, a buddha, and was originally synonymous with the Japanese term *butsu*. In this book, Shaka is used when referring to Japanese Buddhist images; Shakyamuni or Shakyamuni Buddha is reserved for references to the historical Buddha.

traveled in the plains surrounding the Ganges and Yamuna rivers, sharing his wisdom with all who would listen. It is thought that he died at about the age of eighty (483 B.C.E.) near the town of Kushinagara.

Shakyamuni's teachings were based on the concept of interdependent origination. Each moment arises out of a multitude of causes and conditions and in turn conditions the next moment, so nothing can exist independent of anything else. The world as we know it is impermanent, constantly changing and causing changes. Nothing that exists in this climate of experience can be said to be permanent, and thus there is nothing that one can truly call "the self." If one wishes to transcend the human cycle of reincarnation—birth, pain, disease, old age, death, and rebirth into the same world—one must deeply understand the Four Noble Truths, that (1) life is suffering, (2) the reason for suffering is craving, (3) liberation from suffering comes from the cessation of craving, and (4) there is a path to freedom, called the Middle Way, between the extremes of self-indulgence and self-mortification. This path is most often expressed as the Eightfold Path of right understanding, right purpose, right speech, right conduct, right livelihood, right effort, right awareness, and right concentration. The person who achieves this level of understanding attains nirvana, the freedom that is the extinction of greed, hatred, and illusion. For such a person there is no further painful incarnation in this world, as the bonds leading to rebirth have been cut. But the attainment of nirvana can take many lifetimes.

While he lived and in the centuries immediately following, Shakyamuni was regarded as a great teacher but not a divinity. However, over time a new doctrine developed that elevated Shakyamuni to the position of a deity and postulated the existence of other cosmic buddhas with their own heavenly realms.❖ In addition, there arose the concept of the bodhisattva, beings who represent an aspect of the Buddha's personality. The bodhisattva develops spiritually until able to attain liberation from the bonds of this world, but out of compassion for all beings vows to delay his or her final entry into nirvana until the enlightenment of all beings has been accomplished. This system of Buddhist thought is known as Mahayana (Greater Vehicle) Buddhism. The earlier form is sometimes called Hinayana (Lesser Vehicle), or Theravada Buddhism.

In the early centuries of Buddhism, Shakyamuni was depicted only indirectly in art, through such symbols as the *bodhi* tree, the wheel of the law, footprints, or an umbrella. It was under the Kushan rulers of the 1st and 2nd centuries C.E. in northwest India that the first figural images of the Buddha and of bodhisattvas were made. The formulation of Mahayana doctrine had a profound effect on Buddhist art because it required the direct depiction of deities—buddhas (J. *butsu*) and bodhisattvas (J. *bosatsu*) as well as a host of secondary beings, including guardians of the faith and figures efficacious in particular circumstances.

Buddhism, primarily Mahayana Buddhism, mi-grated northward from India into Central Asia and eastward along the trade routes, known as the Silk Road, that linked the Mediterranean with China. By the 1st century C.E., a monastic community had been established in China, but it was not until the late 5th century C.E. that it was promoted by the rulers of the Northern Wei dynasty. From there Buddhism continued into Korea and, in the 6th century, into Japan. In order to gain the support of local rulers, the advocates of Mahayana Buddhism often stressed the supernatural, magical powers rulers might achieve through belief in the Buddha. The king of Paekche, in a letter accompanying the statue of Shakyamuni he sent to the Japanese emperor, stated:

This doctrine can create religious merit and retribution without measure, and so lead on to a full appreciation of the highest wisdom. Imagine a man in possession of treasures to his heart's content, so that he might satisfy all his wishes in proportion as he used them. Thus it is with the treasure of this wonderful doctrine.

Aston, *Nihongi*, p. 66

If the account in the *Nihon shoki* (the *Nihongi*) is to be taken literally, the Japanese at first valued or feared Buddhism for its supernatural powers. An epidemic that broke out in Japan the year the Korean king sent the statue was attributed to the wrath of the native Shinto gods against worship of this foreign divinity, and the religion was proscribed by the emperor. The small temple that had been erected for Buddhist worship was burned down, and its image was broken into pieces and thrown into the Naniwa canal in Osaka.

A second attempt to establish Buddhism in Japan was made in 584. Two emissaries from Paekche brought an image of a buddha, perhaps Shaka, and another of Miroku, the Buddha of the Future. Umako, head of the Soga clan, asked for the images and sent a man by the name of Shiba Tatto, a Chinese immigrant who worked for the craft guild that made horse trappings, to scour the country for practicing Buddhists. A former priest was

---

❖ The addition of other buddhas besides Shakyamuni to the Buddhist pantheon was gradual. Early scriptures refer to the seven buddhas of the past—of whom Shakyamuni is the last, providing him with a set of spiritual forebears—and also to Miroku, (Skt. Maitreya), who will be the next buddha after Shakyamuni. In the first centuries C.E., the Buddhist vision enlarged to include all of space, and buddhas were said to inhabit buddha fields, or pure lands, associated with the cardinal directions. The best known is Amida, (Skt. Amitabha), the buddha of immeasurable light and infinite life who rules the Western Paradise. Yakushi, (Skt. Bhaishajyaguru), inhabits the Eastern Paradise and is the master healer. Still later, a supreme, archetypal buddha, the essence of buddhahood, was adopted, who is called Birushana, (Skt. Vairocana), and who is known in Esoteric sects as Dainichi Nyorai or (Skt. Mahavairocana).

found, and three young women, including Tatto's daughter, became nuns. However, when Umako tried to persuade the emperor to accept Buddhism as a national religion, the leader of the Mononobe clan destroyed the small pagoda Umako had built, burned the buddha images, and had the nuns stripped and publicly flogged. Soon after, according to the *Nihon shoki*, pestilence broke out again, causing its victims to lament that their bodies felt as if they were burned and beaten just as the buddha images had been. The emperor relented to the extent of allowing Umako to worship the Buddha, but not to propagate the faith.

The fate of Buddhism in Japan was decided by the civil war of 587, fought by the Soga clan in alliance with the Ōtomo, hereditary imperial bodyguards, and Prince Shōtoku, a young but influential figure in the imperial family, against the two clans most threatened by Buddhism, the Nakatomi, in charge of Shinto rituals, and the Mononobe, purveyors of weaponry. The Soga-Shōtoku faction won, and in that year Sushun, a nephew of Soga Umako, ascended to the throne. Five years later he was assassinated because he objected to his uncle's interference in government affairs. The Fujinoki Tomb described in Chapter 1 is thought to be his (see page 31).

The mantle of rule next fell to Soga Umako's niece, Suiko. A few months after her ascension, Shōtoku was appointed as her regent and heir apparent, and Umako officially became the chief minister at court. In this favorable climate, Buddhism took root in Japan, quickly growing to a position of preeminence unchallenged until early modern times. Shōtoku, who died in 622, was a leading figure in promoting the adoption of Buddhism and transforming the Japanese perception of it from a cult of magic to a devotional religion. He was a man who valued learning and clearly perceived the benefits to be derived from establishing close religious and cultural ties with Korea and China. He was greatly respected in his own lifetime and revered by later generations.

An anecdote about the young Prince Shōtoku on the eve of battle is recounted in the *Nihon shoki*:

> At this time the Imperial Prince Mumayado [Shōtoku], his hair being tied up on the temples [an indication of his youthfulness], followed in the rear of the army. He pondered in his own mind, saying to himself: "Are we not going to be beaten? Without prayer we cannot succeed." So he cut down a *nuride* tree, and swiftly fashioned images of the four Heavenly [Guardian] Kings. Placing them in his top-knot, he uttered a vow: "If we are now made to gain victory over the enemy, I promise faithfully to honour the four Heavenly Kings, guardians of the world, by erecting to them a temple with a pagoda."
>
> Aston, *Nihongi*, pp. 113–14

The Four Guardian (or Heavenly) Kings, Shitennō, are rulers of the four celestial realms surrounding Mount Sumeru, the world mountain that separates heaven and earth. They serve the Indian god Indra and protect

Buddhism. One of the first Buddhist sutras to appear and find acceptance in Japan was the *Sutra of the Sovereign Kings of the Golden Light* (Skt. *Suvarnaprabhasa*), which proposed the idea that the ruler who espoused Buddhism and facilitated its dissemination within his kingdom would receive the protection and beneficence of these divinities.

> Then the Four Deva [Guardian] Kings, their right shoulders bared from their robes in respect, arose from their seats and, with their right knees touching the ground and their palms joined in humility, thus addressed Buddha: "Most Revered One! When, in some future time, this *Sutra of the Golden Light* is transmitted to every part of a kingdom, . . . if the king of the land listens with his whole heart to these writings, . . . and supplies this sutra to . . . believers, protects them and keeps all harm from them, we Deva Kings, in recognition of his deeds, will protect that king and his people, give them peace and freedom from suffering, prolong their lives and fill them with glory."
>
> Wm. Theodore de Bary et al., eds.,
> *Sources of Japanese Tradition*,
> New York and London, 1958, p. 98

Clearly, belief in the teachings of this sutra and the fulfillment of its directives suggested great benefits for the ruler and his nation. Although the anecdote about Shōtoku may be too simple an explanation, it clearly demonstrates the importance of this doctrine in the early years of Buddhism in Japan.

Whether or not Soga Umako made a similar vow before going into battle, his support for Buddhism became as lavish as it was conspicuous. In the Asuka district of central Honshū, the locus of government at that time, Umako founded the temple of Asukadera (known today as Moto Gangōji or Angoin), the first full-fledged religious complex to be built in Japan. Several political reasons might be suggested to account for Umako's interest in supporting Buddhism and in forging alliances with the imperial family. The Soga was a relatively new clan to be established in Japan. Some scholars believe that the 5th-century Soga Manchi, the first member of the Soga clan to be named in the histories, might be Moku Manch'i, a Paekchean official active in the area of foreign affairs. Being a latecomer to Japanese society, the clan lacked a hereditary function within the state like those mentioned above for the Ōtomo, the Nakatomi, and the Mononobe clans. By the 6th century, the Soga clearly aspired to high position within the court, Umako being one of four family members to be appointed chief minister. Their espousal of Buddhism as introduced from Paekche may have been their attempt to establish a niche for themselves within Japanese society and their attempts at intermarriage with the imperial clan a clear bid for power.

The establishment of Buddhism in Japan had a profound effect on the whole fabric of Japanese culture. Buddhist ritual required the reading and reciting of Buddhist texts, but at the time of its introduction, the Japanese had not developed a system of symbols for writ-

ing their own language. Thus they had to learn to read Chinese characters, known as *kanji* in Japanese, and to adapt this totally foreign set of symbols to the sounds and ideas of their own language. As temples for Buddhist worship were erected, the Japanese had to learn and adapt the technologies developed on the continent for the construction of large tile-roofed wooden buildings, for the sculpting of Buddhist images in gilt bronze, wood, clay, and lacquer, for the decoration of plaster walls and wooden surfaces with the icons and the narratives of Buddhism. However, perhaps the most profound change in this period occurred in the organization of society and the development of a complex system of government by bureaus functioning under the emperor.

At the time Buddhism was introduced into Japan, the country was divided into semi-autonomous regions, each controlled by a single aristocratic clan, the strongest and most advantageously located being the imperial clan based in Osaka and the Asuka valley. The Chinese system of government provided future Japanese emperors with a model for breaking down the clan system and for unifying the country under their leadership. The propagation and dissemination of Buddhism afforded a further mechanism for shaping ideological views among the people and ultimately forging disparate political groups into a nation. The period from 552 to 794, marked by the unification of the country and the development of Buddhism as a state religion, came to an end only when it was deemed that the relationship between the church and the state that had developed in these years was in need of radical revision.

There are nearly as many systems for subdividing the period from 552 to 794 as there are interpreters of these years. However, two political events, The Taika Reforms of 645—which restructured the government on the Chinese model—and the establishment in 710 of the permanent capital at Heijōkyō (Nara), constituted significant turning points in the artistic production of the period, and provide the basis for the periodization followed in this chapter:

| | |
|---|---|
| Asuka period | 552–645 |
| Hakuhō period | 645–710 |
| Nara, or Tenpyō, period | 710–794 |

## The Asuka Period (552–645)

Following the civil war of 587, both Soga Umako and Prince Shōtoku undertook the building of Buddhist temples. Umako built Asukadera in the Asuka district, and Shōtoku built Shitennōji in Osaka and Wakakusadera on the outskirts of present-day Nara. All three temples have suffered with the passage of time.❖ Completed about 593, according to tradition, Shitennōji has burned to the ground many times, the most recent destruction taking place in World War II. However, after postwar excavations of the site, the temple was rebuilt on the foundations of the original buildings with an attempt to simulate the post-and-lin-

tel construction of the wooden structure in reinforced concrete. Asukadera, begun about 588, was completed and functioning by 596, although its main buddha image, a Shaka, was not set in place until 606. It was destroyed by fire in the Kamakura period (1185–1333), but extensive excavations in the 1950s uncovered the foundations of the buildings, roof tiles, and many interesting details about the temple. Wakakusadera was completed in the first decade of the 7th century and its main image, a Yakushi Buddha (Skt. Bhaishajyaguru), the Buddha of Healing, was set in place in 607. However, in 670 it, too, was destroyed by fire. Rebuilding began in the late 7th century and was completed by 711. Much of the history of Wakakusadera can be pieced together from primary sources such as the *Nihon shoki*, inscriptions on extant images of the period, later temple records, and from such secondary sources as recent excavations at the site. What we can gather from the literary evidence is that shortly after Prince Shōtoku took up residence in his palace at Ikaruga in the early 600s, Wakakusadera was erected adjacent to it.

## Early Temple Building

The most important buildings in early Japanese temple complexes were the entrance gate (*chūmon*), which was set within a roofed cloister encircling the principal worship structures, the pagoda, and the *kondō*, or golden hall. Necessary support buildings such as the dining hall, kitchen, and living quarters for the monks were built outside the cloister walls.

The information gleaned from excavations on the sites of Shitennōji, Wakakusadera and its later replacement, Hōryūji, as well as Asukadera suggests that Buddhist architecture in the Asuka and Hakuhō periods drew on a number of different continental models. Asukadera, built on the model of Korean Koguryō temples, Chōnganni in particular, consisted of three large *kondō* arranged around three sides of a square pagoda, the entire cluster surrounded by a roofed corridor penetrated by a single entrance gate or *chūmon* (fig. 43). Outside the main worship

---

❖ In speaking of Japanese Buddhist architecture, the word *temple* can, and usually does, refer to an entire site and all its buildings. The suffixes *-tera* or *-dera* and *-ji* refer to a temple where there are images for veneration and where ritual ceremonies are performed by the monks or nuns living there. (The suffix *-dera* is the native Japanese reading of the Chinese character for temple, *ssu*, while *-ji* is the transliteration of the same Chinese character. Toward the end of the 7th century, it was decreed that all Japanese Buddhist temples should have proper Chinese names, so when Wakakusadera, Temple of Young Grass, was rebuilt, it was renamed Hōryūji, Temple of the Exalted Law.) Often a temple complex will be divided into smaller units, precincts, which are designated by the suffix *-in*. In referring to a Shinto establishment, the word *shrine*, not *temple*, is used.

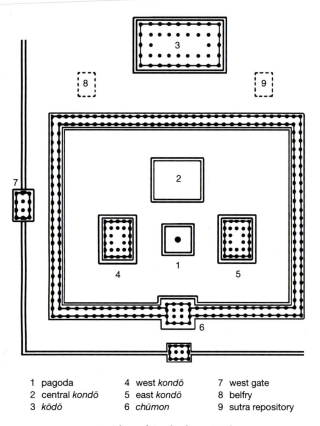

| | | |
|---|---|---|
| 1 pagoda | 4 west *kondō* | 7 west gate |
| 2 central *kondō* | 5 east *kondō* | 8 belfry |
| 3 *kōdō* | 6 *chūmon* | 9 sutra repository |

**43.** Plan of Asukadera, Asuka

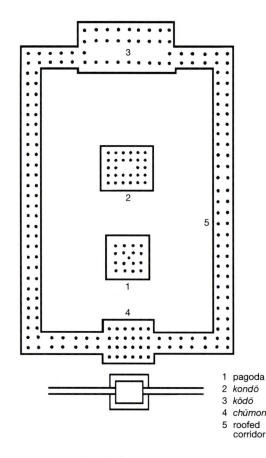

1 pagoda
2 *kondō*
3 *kōdō*
4 *chūmon*
5 roofed corridor

**44.** Plan of Shitennōji, Osaka

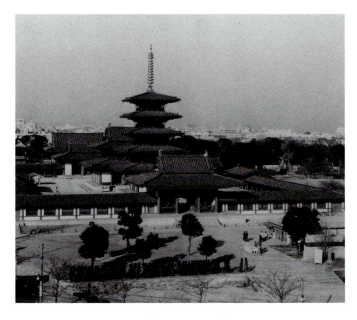

**45.** Shitennōji, Osaka

compound were separate support buildings: a sutra repository (*kyōzō*), a belfry (*shōrō*), and a lecture hall (*kōdō*). Judging by the tiles originally nailed to the exposed ends of the *kondō* roof rafters, they were massive round supports capping a building of impressive dimensions. Some scholars question the construction dates of the eastern and western *kondō*, noting that they seem to have been the products of inferior technology in comparison with the central *kondō* and the pagoda.

Shitennōji and Wakakusadera employed an axial layout of buildings: a pagoda and a single *kondō* distributed along the median line of a rectangle enclosed by a roofed corridor pierced by a single entrance gate (figs. 44 and 45). As was the case with Asukadera, outside the main worship compound were support buildings: a sutra repository, a belfry, a refectory, and quarters for the monks. The Shitennōji and Wakakusadera plans were based on a layout popular in Paekche, as seen in the temple of Kunsuri (not illustrated here).

## Tori Busshi and Early Asuka Sculpture

The one artist of the Asuka period whose name, genealogy, and work have been preserved to the present day is the sculptor Tori Busshi (Tori, the maker of Buddhist images). His ancestry can be traced back to his grandfather, Shiba Tatto, the Chinese craftsman who had helped Soga Umako establish his early Buddhist temple. As a member of the saddlemakers' guild, Tatto had mastery of a wide range of skills, including many of those needed for making sculpture: metal casting, wood carving, and lacquer work. Tasuna, his son and the father of Tori, also belonged to the saddlemakers' guild, and at the time of Emperor Yōmei's last illness offered to become a Buddhist priest and to carve a buddha image out of wood. Tori Busshi appears to

have been the principal sculptor working for Soga Umako and Prince Shōtoku in the early 7th century and is credited with executing the Shaka image for Asukadera in 606 and the Yakushi image for Wakakusadera in 607. There is also surviving at Hōryūji the magnificent Shaka Triad by Tori, the Buddha flanked by two bodhisattvas, dated by an inscription on the back of the halo to 623. To a greater or lesser extent, all three works survive today.

In the single remaining worship hall of Asukadera is a seated, gilt bronze statue of Shaka (fig. 46). Although the image has been much restored, it retains many general characteristics comparable to those of the Yakushi and the Shaka Triad (see figs. 47 and 48). It sits erect, legs crossed, the drapery pulled in sharply defined, regular folds. The right hand is raised, palm outward, in the hand gesture, or mudra, that symbolizes the Buddha's power to grant tranquillity and freedom from fear. The left hand is lowered, the palm turned outward in a gesture of wish-granting, by extension offering the promise that the Buddha's teachings are the true path to release from suffering.❖

The head of the Asukadera Buddha is the least restored and therefore most telling part of the image. The face is long and cylindrical, capped with hair depicted as a mass of snail-shell curls. This type of curl is one of the shōgō (Skt. lakshana) of the historical Buddha, that is, physical symbols that distinguish a perfected being from ordinary mortals. The point of origin for the curls is said to be a moment in Siddhartha Gautama's life before he attained enlightenment. The Indian prince, having recognized that human life is essentially pain and suffering, decided to leave his father's luxurious palace and live a simple, austere life in the wilderness, devoting himself to meditation. After he made good his escape in the dead of the night, he rid himself of the trappings of his secular life. He took off his turban and shaved his head, whereupon the stubble turned into tight little curls.❖❖ The upper part of the Shaka's face has a strongly geometric quality. The smooth curving plane of the forehead descends to form the bridge of the nose, and the nostrils are indicated by what seem almost to be cuts in the metal. The eyes and eyebrows form strongly curvilinear accents flowing horizontally across the face. The style is distinctive and reflects the sure hand of a master sculptor.

Tori Busshi's Yakushi of 607 is represented today by a seated image enshrined in the kondō of Hōryūji (fig. 47). On the reverse of the halo is an inscription that gives many of the circumstances surrounding the production of the original image, attributing it to Tori Busshi. Superficially, the sculpture has many characteristics in common with the Tori Asukadera Buddha and the later Shaka Triad. However, scholars generally agree that the inscription and the halo itself postdate 607. This Yakushi image has probably excited more scholarly controversy than any other statue at Hōryūji. Is the sculpture the original work of 607, with the halo and wooden pedestal being later replacements, or is the entire work a product of the

46. Asukadera Buddha, attributed to TORI BUSSHI, in the Asukadera, Asuka. 606. Gilt bronze; height 9 ft. (2.76 m)

Hakuhō period, when Hōryūji was built to replace the destroyed Wakakusadera, and not Tori Busshi's work? Today

❖ The mudras of individual buddha images carry a particular meaning for the viewer and often derive from hand movements made at a particular moment in the life of the historical Buddha. The gesture the Asukadera image makes with the right hand, the semuiin (Skt. abhayamudra), the fear-not gesture, is traditionally said to come from the moment when Shakyamuni found himself in danger of being trampled to death by an elephant made drunk by an evil cousin. The Buddha raised his hand, fingers together, palm out, and the animal became quiet. The gesture is a universal symbol meaning "stop," but for an individual to put his faith in such a hand movement when confronted with the awesome spectacle of a raging elephant is an indication of great inner strength and fearlessness. The gesture of offering, or vow-fulfilling, the seganin (Skt. varadamudra), is a more general sort of hand movement and seems to have no specific point of origin in the biography of Shakyamuni as a human being.

❖❖ Two other shōgō, signs of a buddha, are readily visible on the Asukadera Buddha: the byakugō (Skt. urna), a small tuft of hair or raised circle just above the nose, and the nikkei (Skt. ushnisha), the cranial protuberance above the normal curve of the head. In all, there are thirty-two shōgō, but these are the ones most strikingly portrayed in sculptures.

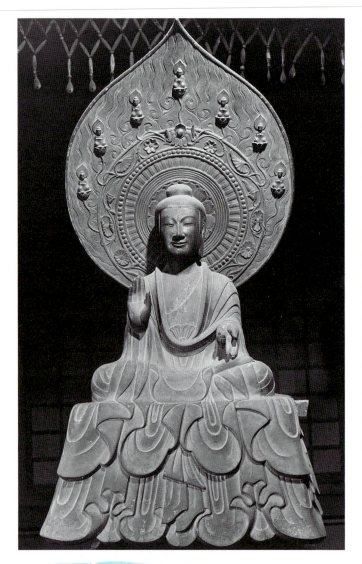

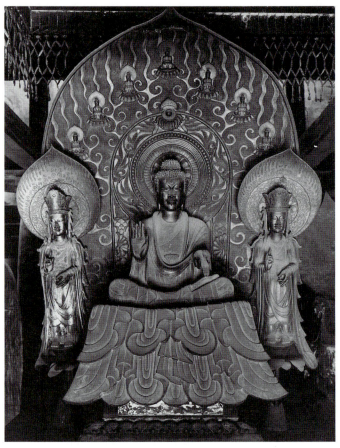

**48.** Shaka Triad, by TORI BUSSHI, in the *kondō*, Hōryūji. Dated 623. Gilt bronze; height 46 in. (116.8 cm)

**47.** Yakushi, in the *kondō*, Hōryūji, Ikaruga, Nara prefecture. 1st half 7th century. Gilt bronze; height 24¾ in. (63 cm)

most art historians support the latter theory. The piece is examined on page 55, in the context of sculpture in the Hakuhō period.

In the Shaka Triad of 623 we see the full flowering of Tori Busshi's art. The Shaka sits serenely atop a rectangular platform (fig. 48). His eyes seem to gaze straight forward, his hands promise the believer tranquillity and an infallible path to salvation. In contrast to the severe and immobile quality of the body, the long skirts flow over the front of the platform like the spills of a waterfall. Further animation is suggested by the flickering flame patterns in the outer border of the halo. Small seated images of the seven buddhas of the past can be seen superimposed on the flames, almost as if they were becoming visible through the golden light emitted by Shaka's radiant body. Just above the head of the Buddha is a raised circle, the flaming jewel of Buddhist wisdom, enshrined on an inverted lotus blossom. Emanating from it is a lotus vine that grows in gently undulating curves to contain elegant

leaves encircling the Buddha's head. The delicate linear patterns of the flames and lotus leaves form a strong contrast to the calm and enduring presence of the deity.

An inscription on the reverse of the halo explains under what circumstances the triad came to be produced. The deaths of two important court ladies in 621 and the illness of Prince Shōtoku and his consort in the following year moved Empress Suiko and members of the court to commission Tori Busshi to execute a buddha image. The statue was intended as a votive offering to promote his recovery or his rebirth in paradise. That year both Shōtoku and his consort died, and in 623 the statue was completed and dedicated to their spiritual well-being. It is not known where at Wakakusadera the triad was installed, since the Yakushi of 607 was already the main icon of the *kondō*. Various theories have been put forth, but since it is beyond question that the statue is a work of the early 7th century, the inscription is generally accepted as valid, and the assumption is made that the piece was housed outside the main worship complex of the temple in a place untouched by the fire of 670.

The Shaka Triad reflects a style of sculpture developed in China in the first quarter of the 6th century, preserved today primarily in the rock-cut cave temples of Longmen (Lung Men) in Henan (Honan) province. A par-

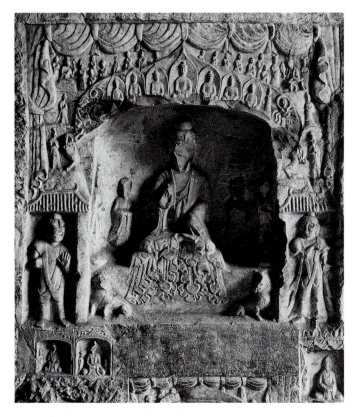

**49.** Seated Buddha, in cave 13, Longmen, China. 527. Stone

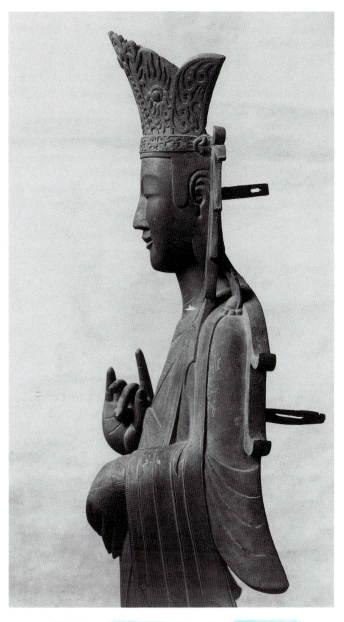

**50.** Side view of bodhisattva figure, from Shaka Triad, by TORI BUSSHI, in the *kondō*, Hōryūji. Gilt bronze; height 35¾ in. (90.7 cm)

ticularly good example of the style can be seen in a sculptured niche from cave 13, dedicated in 527 C.E. (fig. 49). The strong plasticity of the images transmitted along the Silk Road from India to China has been tamed by the Chinese love of linear patterning. The bodies of the Buddha and the bodhisattvas are barely revealed beneath their garments. Instead, their skirts and scarves splay out on either side, creating serrated outlines that contradict the apparent volume of the figures. No clearer demonstration of this could be made than the side view of one of the Tori bodhisattvas (fig. 50). It is not a complete figure in the round, but instead a half image, terminated at the tips of the flaring scarves. The triad was intended to be viewed only from the front, like the relief carvings of the walls of rock-cut cave temples. Tori Busshi's accomplishment in this group of figures is remarkable. Working in a style he could have known only at second hand, he has breathed life into his forms and created an elegant and expressive group of figures.

A statue not directly attributable to Tori Busshi, but clearly within the limits of his style, is the Kannon❖ image in the Yumedono (Hall of Dreams) in the eastern precinct of Hōryūji (colorplate 4). The sculpture has always been one of the most treasured images at Hōryūji, and was hidden away for so many years in a closed wooden shrine that even the priests of the temple had lost memory of it. The shrine was opened in the late 19th century on the occasion of a visit by the American scholar Ernest Fenollosa, one of the Americans most influential in encouraging the Japanese

❖ Avalokiteshvara, (J. Kannon, Ch. Guanyin or Kuan-yin), often called the Bodhisattva of Compassion, is the most important of the bodhisattvas. This figure represents the compassionate aspect of the Buddha and may be depicted in a number of different forms. He is frequently portrayed with eleven heads and a thousand arms, the better to see and aid a person in trouble, and may even assume the shape of a white horse, to save people who are about to be shipwrecked. The prototype for representations of the bodhisattva was the Indian prince, a figure clad in elegant skirts, bedecked with elaborate jewelry, and possessing long curly tresses and the mustache of a man. In later centuries East Asian images of bodhisattvas, especially Avalokiteshvara, became more and more feminine.

to preserve their cultural heritage at a time of strong pressures toward Westernization (see Chapter 7, page 324). Because it was so seldom exposed to view and to the elements, the camphor-wood statue is in a remarkable state of preservation. Made of a single shaft of wood—only the lowest ends of the drapery scarves and the lotus pedestal are made of separate pieces—the image still retains much of the gold leaf that was applied over the entire surface, as well as the red pigment applied to the lips, the black of the eye pupils, and the dark blue of the mustache.

The Yumedono Kannon is a superb example of the Tori style, its broad body articulated by curved, flaring lines. The quality of movement around the stable core of the image is beautifully suggested by the halo with its flame tongues, and in the band just inside, an undulating vine enclosing triple palmettes within each curve. This impression is further heightened by the delicate tracery of the bodhisattva's tall, openwork metal crown.

## The Tamamushi Shrine

The Tamamushi Shrine is one of the most important objects surviving from the Asuka period, not only because it affords us a three-dimensional glimpse of an accurately detailed building from this period, evidence that cannot be gleaned from archaeological digs alone, but also because it is the only example of painting surviving from the period (fig. 51). This portable shrine in the Daihōzōden, or Great Treasure House at Hōryūji, consists of a *kondō* in miniature atop a tall, rectangular base, which is raised off the floor by a broad, sturdy pedestal. The outer surfaces of the *kondō* and the four sides of the base are decorated with paintings of bodhisattvas and Guardian Kings and with some narratives of early Buddhism. The edges of the panels and the projecting upper and lower horizontals of the base are decorated with elaborate strips of openwork metal. The name of the shrine comes from the iridescent wings of the *tamamushi* beetle, which originally underlay the openwork metal strips. One can imagine that the iridescence of the beetle wings must have made a striking contrast with the strong, pure colors of the paintings— reds, yellows, light brown, and greens applied to a black ground. Over the years questions have been raised concerning the provenance of the shrine, but scholars now generally agree that the piece was made in Japan. The types of cypress and camphor wood out of which it is crafted are native to Japan, and the materials used in the paintings —lacquer mixed with red or black pigment and vegetable oil from the *shiso* plant added to lead oxide— are common in indigenous work.

The miniature *kondō* is the earliest extant evidence of Japanese Buddhist architecture. The shrine can be dated only on the basis of stylistic comparisons, but it is probably a work of the later part of the Asuka period. It clearly precedes the *kondō* of Hōryūji, dated after 670. The miniature building is constructed using a post-and-lintel

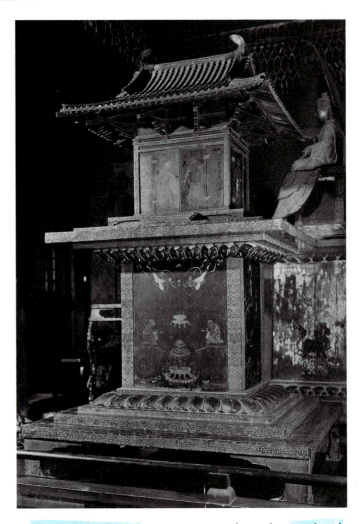

**51.** Tamamushi Shrine. c. 650. Cypress and camphor wood, with lacquer; height 7 ft. (2.13 m). Now in Hōryūji Treasure House, Hōryūji

system, with bracket arms extending outward and upward from the top of the post to support the wide overhanging eaves. The tiled roof is of the hipped-gable type, in other words, a gable surmounting a truncated hipped roof. A simple hipped roof can be seen on the *kondō* or golden hall of Tōshōdaiji (see fig. 99). The hipped-gable roof (*irimoya*) is the most common form in Japanese Buddhist architecture. The unusual features of the Tamamushi Shrine roof are the way in which the tiles are applied to the surface, the fact that the understructure of the roof employs a single rafter system, and the use of *shibi*, fishtail-like ornaments, at the ends of the ridgepole. The roofing tiles are applied to the gable in such a way that the joining point of the gable and the hipped roof is clearly indicated by the round tiles at the end of the upper rafters. This style of tile application is believed to have been used at Asukadera, but by the time Hōryūji was rebuilt, the curve of the gable flowed gently into the hipped section without any break. *Shibi* are said to represent sea-dwelling mammals like the dolphin. They are found on the roofs of temples and castles in the Tokugawa period (1615–1868) but are quite rare in

52. Cloud bracket, *kondō*, Hōryūji. Late 7th century

53. The Hungry Tigress Jataka, wall painting, cave 254, Dunhuang, China. Early 6th century. (Courtesy China Pictorial, Beijing)

the 7th and 8th centuries, appearing only on the Tamamushi Shrine and the *kondō* of Tōshōdaiji. Another unusual detail of the Tamamushi building is the cloud shape of the bracket arms under the eaves. This type of bracket appears on temples of the Asuka and Hakuhō periods but is not found afterward (fig. 52).

The shrine building was intended to suggest a main worship hall and therefore compresses into a small space the icons normally found on the central altar of a *kondō*. On the two front doors of the shrine are two Guardian Kings. These armor-clad images seem to sway in space as though they are stepping forward, their scarves swinging out behind them. Normally there are four Guardian Kings, the Shitennō, and they are often placed at the four corners of a *kondō* platform. On the two sets of side doors are graceful bodhisattvas, each holding a lotus blossom, a symbol of Buddhist wisdom. The interior walls of the building are decorated with rows of tiny seated buddhas, suggesting the one thousand buddhas of the past who accompany some Shaka images. The sculpture now contained in the shrine, a Kannon, is clearly a later replacement.

The rectangular base supporting the miniature *kondō* is decorated with traditional Buddhist themes: on the front, relics are worshiped by two monks offering incense; on the back is Mount Sumeru, the mountain at the center of the universe that holds apart the heavens, the earth, and the oceans. The two side panels depict *jataka* tales, stories of the previous incarnations of Shakyamuni before the lifetime in which he achieved enlightenment. The Hungry Tigress Jataka is typical of the general theme of self-sacrifice these tales present (color-plate 5). The buddha-to-be was riding through a forest and came upon a starving tigress and her cubs. Distressed by her plight, he offered his own body as food, but she was

too weak even to take the first bite. He climbed a nearby mountain and jumped so that the smell of blood from his shattered body would rouse her. In the panel, he first appears up on the mountain, taking off his robe. He is next seen flying downward through the air, and in the lower right, behind a screen of bamboo trees, the tigress and her cubs begin their meal. The circular movement of the narrative is particularly appropriate for a vertical panel painting, because even though the viewer is standing still in front of the work, she or he can sense the sequence of the story's episodes. This method of storytelling can be found on the balustrades of Indian stupas such as Bharhut (2nd century B.C.E.) and on the walls of Chinese cave temples such as cave 254 at Dunhuang (early 6th century C.E., fig. 53). Both types of monuments were designed to permit devotional circumambulation. Thus the worshiper, walking clockwise around a stupa, cave pillar, or perhaps even this shrine, receives instruction from the illustrations of traditional stories and by extension learns the tenets of Buddhism.

## The Hakuhō Period (645–710)

The Hakuhō period began with the Taika Reforms of 645. These included attempts to centralize government and to nationalize agricultural land and labor, which had previously been controlled by individual aristocratic clans. The period ended in 710 with the establishment of the emperor, the bureaus of government, and the major centers of Buddhist worship in a single permanent capital, Heijōkyō,

present-day Nara. It was an era marked by rapid expansion of the Buddhist Church and by a growing awareness of the complexity of both the religion as it had developed in China and the art forms associated with it. Some idea of the rapid dissemination of Buddhism in Japan can be gained from a count of the temples. According to the *Nihon shoki,* in 624 there were 46, while by 694 there were 545. In addition it is clear from Hakuhō temple buildings and their artifacts that new styles of architecture, painting, and sculpture were being imported, and new techniques were being mastered by Japanese craftsmen. In the secular realm the Hakuhō period witnessed strong efforts on the part of the imperial clan to unify the country under its leadership, by weakening the power of the other aristocratic clans, and to reshape the government according to the Chinese model. Toward the end of the 7th century these two movements began to draw together. Emperor Tenmu (ruled 673–686) and his successor, Empress Jitō (ruled 686–697), strongly supported Buddhism as an instrument of the state. The power and wealth of the court were mobilized for the construction of large and elaborate Buddhist temples. A distinction was made between the metropolitan region, the embryo of a permanent capital, and outlying districts. Governors were appointed for the latter, and all official residences were required by imperial edict to have a Buddhist altar with an image and appropriate sutras. The expansion of the Church facilitated the consolidation of power under the imperial clan, and both Tenmu and Jitō were pleased to promote the spread of Buddhism.

The concept of a permanent capital was set forth in the Taika Reforms of 645, but it was not until the reign of Emperor Tenmu that a site was selected and laid out in a formal design. This was the city called Fujiwara, in the Asuka valley, which was actually built by Empress Jitō and occupied in 694. From roughly 500 C.E. until the late 7th century, almost all the official residences of the rulers had already been located in the Asuka valley, and as the impulse to build elaborate temples materialized in the latter part of the 7th century, it was there they were constructed. When Fujiwara was laid out as the capital, the four major temples of Asukadera, Kawaradera (built 662–667), Daikandaiji (pledged in 673), and Yakushiji (pledged in 680) were already in existence and were incorporated into the plan of the city.

Of the four Hakuhō-period temples, only Yakushiji has survived in anything like its original form. After the removal of the capital to Heijō in 710, it was rebuilt within the limits of the new city following exactly the scale of the original temple. The only other temple surviving from the Hakuhō period is Hōryūji. Because of its age, its state of preservation, and its association with Prince Shōtoku, Hōryūji has been accorded greater importance by art historians than it was by the leaders, both Buddhist and secular, of the late 7th century. By their standards it was a provincial temple. Had the Wakakusadera not been the private temple of a great and revered statesman, undoubt-

edly it would not have been replaced. Hōryūji and Yakushiji, together with the paintings and sculptures preserved within their precincts, exemplify the two poles of Hakuhō art, the conservative, moving slowly away from the norm of Asuka art, and the innovative, the full flowering of the styles of the Early Tang period (618–683) in China re-created in the Japanese idiom.

## Hōryūji

Hōryūji is seven miles south of present-day Nara, near a rural village (fig. 54). The entrance to the temple grounds is the Great South Gate, the Nandaimon, at the foot of a gentle incline. The approach to the main worship compound is a broad, pebble-strewn avenue that passes beside roofed walls enclosing lesser temple enclaves. The *chūmon* (middle gate), set within the roofed plaster perimeter cloister wall, is a two-storied structure four bays wide (fig. 55). In the outermost bays of the gate are the fierce Niō, deities belonging to a group known as *kongōjin,* beings who are sworn to guard Buddhism and its adherents. The east guardian is Ungyō, defender of the night, a black-skinned figure with clenched teeth, and the west guardian is Agyō, guardian of the daylight hours, a creature with red skin and open mouth. Once inside the broad, open courtyard, the visitor encounters the two main structures of the compound, the broad, squat *kondō* and the tall, buoyant, five-storied pagoda.

There is an atmosphere about a Buddhist temple compound that is unique. There is a sense of separation from the outside world, a feeling of refuge and quiet. The visitor has a sense of open space in which to move at will, yet the immense scale of the buildings brings to mind the vastness of the spiritual universe and offers a quiet invitation to worship, to enter the Eightfold Path to enlightenment and salvation. At Hōryūji the contrast between the

**54.** General view of Hōryūji complex, Ikaruga, Nara prefecture. 7th century

**55.** Middle gate, Hōryūji. 7th century

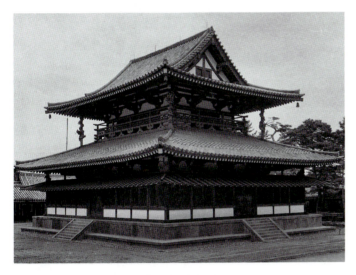

**56.** *Kondō,* Hōryūji. 7th century

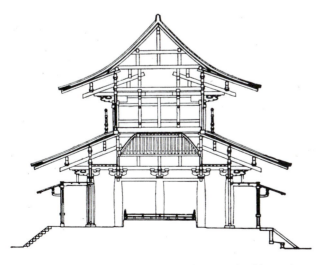

**57.** Elevation of *kondō,* Hōryūji, showing double-roof system of rafters

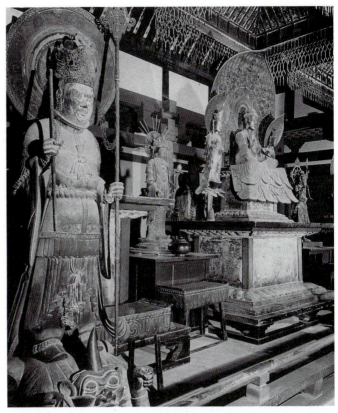

**58.** View of the altar, *kondō,* Hōryūji

wide, open courtyard enclosed by a single-story cloister and the vertical projection of the *kondō* and pagoda contribute to this experience.

In the Hōryūji temple compound, as with other Japanese Buddhist temples, the *kondō* and the pagoda serve different functions. The *kondō,* or golden hall, is a building dedicated to active worship (figs. 56 and 57). One enters it, stepping over a high, thick threshold, to find oneself before an array of huge statues on a raised altar platform that fills a large proportion of the space (fig. 58). The room is dark, in contrast to the brightness of the open spaces of the compound one has left behind, but there is sufficient light to illumine the gilded and painted images of buddhas, bodhisattvas, and guardian deities. The worshiper performs the rite of circumambulation clockwise around the altar platform, pausing before the statues, whose very presence seems to demand a spiritual encounter.

The *kondō* in a sense fulfills one of the purposes of the very ancient *chaitya* (Skt.) hall in Indian Buddhist worship complexes, which had a form very much like a Christian church, with a central nave and two aisles set apart by a row of columns. At the very back of the nave was a small stupa, a symbol for the historical Buddha. The monks could assemble in the open area of the hall, but they could also individually perform the rite of circumambulation around the sacred construction. In India this rite is fundamental to Buddhist worship and may have been

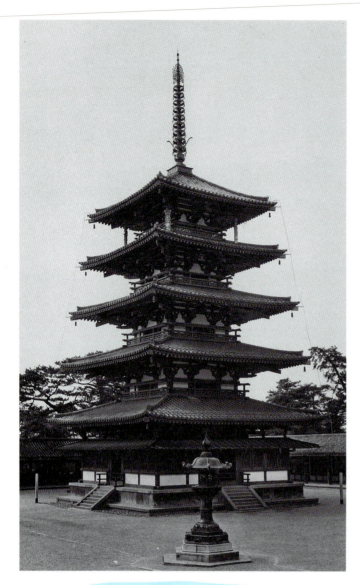

59. Five-storied pagoda, Hōryūji. 7th century

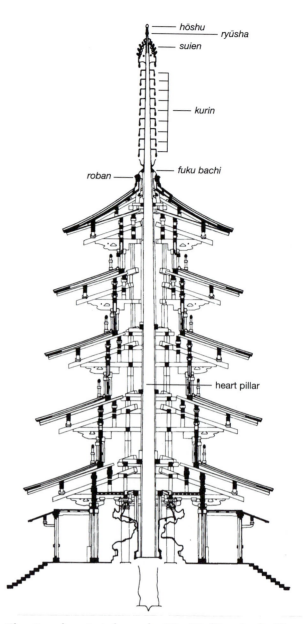

60. Elevation, five-storied pagoda, Hōryūji. (Drawing by Pierre and Liliane Giroux, after Ōta Hirotarō, from *The Art of Ancient Japan*, Editions Citadelles, Paris)

derived ultimately from the Vedic practice of walking clockwise around a village, repeating the path of the sun across the sky, to ensure a fruitful harvest. Early Japanese *kondō*, which were based on the post-and-lintel construction of Chinese residential buildings, did not provide a place for assembly, but the placement of the altar in the center of the hall, with an open area around it, facilitated circumambulation.

The pagoda acted as both a reliquary for holding sacred remains from the past and as a diagram in wood, tile, and plaster of the relation between heaven and earth, the Buddha and humans. It makes manifest the invisible path of the ordinary person's aspiration, which rises along a vertical axis, the heart pillar of the structure, to unite with the absolute (figs. 59 and 60). Similarly, the bright light of truth can penetrate downward along this vertical axis to illumine the deluded world of humans. The pillar, a single piece of wood that extends from below ground to the peak of the highest roof, is set on a foundation stone

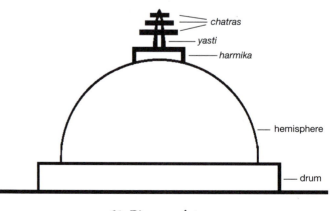

61. Diagram of stupa

in which there is a cavity for various Buddhist treasures, such as sutra rolls. These accoutrements of worship represent the aspect of humanity that aspires to rise from the finite world of material existence to the infinite realm of reality. Extending skyward from the top of the pillar and the uppermost roof of the pagoda is a copper structure called a *sōrin* consisting of an inverted bowl shape *(fuku bachi)* on a saucerlike "dew basin" *(roban)*, and above it a shaft that projects upward. Attached to the shaft are nine rings *(kurin)* topped by an openwork "water-flame" design *(suien)*, a form known as the dragon wheel *(ryūsha)*, and at the very top the sacred jewel of Buddhist wisdom, the *hōshu*.

The pagoda was a Chinese adaptation of the watchtower, and was developed to fulfill the function of the Indian stupa, which was characteristically a hemisphere set on a drum (fig. 61). The Chinese replaced the stupa with the pagoda, a building form that to them more clearly suggested the idea of verticality as a pathway to communication with divinity. The origins of the stupa extend back to the Vedic period in India, long before the historical Buddha's time. It was the custom in the age of the Vedas, circa 1500 to 800 B.C.E., to place the ashes of an important political figure at a crossroads and to build a mound of stones over these relics. Embodied in the Buddhist stupa that grew out of this tradition are two basic ideas: the structure as a memorial to an important person, and the structure as a physical diagram of a spiritual universe. The relics of a buddha or a saintly person are contained within the stupa hemisphere, which in India is capped by the *harmika* (Skt.), or little palace, intended as a residence of divinity. The origin of the pagoda's *sōrin* is the configuration of the *harmika* and the *yasti* pillar with three or more *chatras*, or umbrellas, the symbol for both royalty and divinity.

### Architecture

The plan of the Hōryūji compound is an example of beautifully balanced asymmetry (fig. 62). It was a remarkable departure from the earlier models of Shitennōji, Asukadera, and Wakakusadera (see pages 41–42). The middle gate into the cloister, instead of establishing a median line across the length of the compound, has been set slightly off center into one of the long walls. Since the dimensions of the *kondō* and pagoda are not at all the same, careful placement was required to preserve harmony in this lateral plan. At first it was thought that some specific accident of history must account for the odd pairing of these two buildings, but as new excavations have shown, in the latter half of the 7th century there was a good deal of experimentation with temple layouts, and when the rebuilding of Shōtoku's private temple was undertaken, it was apparently not felt necessary to duplicate the plan or even the specific location of the original structure of Wakakusadera.

Although the *kondō* occupies more ground space than the pagoda, the soaring height of the latter balances

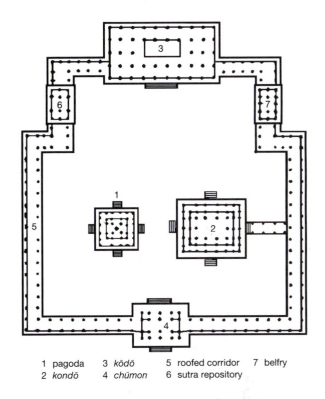

1 pagoda    3 *kōdō*    5 roofed corridor    7 belfry
2 *kondō*    4 *chūmon*    6 sutra repository

**62.** Plan of existing compound, Hōryūji

the low proportions of the former. Originally the *kondō* and the pagoda were oriented along a line just north of the longitudinal median line of the compound. In other words, the distance from the front cloister to the façade of the *kondō* was greater than the distance from the rear wall of the temple to the back of the compound, thus permitting a better vista of the buildings from inside the middle gate. Today that feeling has been lost due to the extension of the cloister to accommodate a belfry, sutra repository, and *kōdō*, or lecture hall.

The oldest structures at Hōryūji are the *kondō*, perhaps completed by 680, the pagoda, the middle gate, and parts of the cloister. The proportions of the pagoda and the *kondō* are particularly satisfying because of the strong diminution from one story to the next. The fifth story of the pagoda is approximately one-half of the width of the first story, giving the structure a feeling of lightness and stability not found in later buildings. The roofs are made with square rafters, not the round ones seen in the Tamamushi Shrine, but the roof construction employs the same single-rafter system. At present the lower story of the building has a *mokoshi*—a porchlike, roofed layer added later around all four sides—diminishing somewhat the impressiveness of its proportions. (The same addition can be seen on the *kondō*.) The pillars of the lower story are massive round wooden columns, decreasing in diameter toward the top, a device called entasis that was also used in Greek architecture to counteract the impression of concavity at the top of tall, round pillars. The brackets supporting the eaves are cloud-shaped and have a strong three-dimensional presence.

**63.** Tamonten, in the *kondō*, Hōryūji. c. 650. Wood, with paint and gold leaf; 52⁷/₈ in. (134.2 cm)

### Sculpture

The sculptures preserved at Hōryūji, apart from the Shaka Triad discussed above, span the years from the close of the Asuka period to 711, when the rebuilding project was officially completed. Of these the earliest in date and style are the Four Guardian Kings, the Shitennō, installed at the corners of the altar, which dominates the central area of the *kondō*.

Each king is distinguished by the attributes he holds. Tamonten, later Bishamonten, the king of the north, the direction from which the most dangerous forces come, holds a halberd and a reliquary (fig. 63). Zōchōten, guardian of the south, holds both a longer and a shorter halberd (see fig. 58). Jikokuten, defender of the east, supports a jewel in his upraised right hand and a halberd in his left, and Kōmokuten, protector of the west, holds a scroll of paper and a brush. The images at Hōryūji are made of single blocks of wood—the conquered demons and the halo are separate pieces, as are the forward-flaring scarves at the feet of each figure—that have been colored with pigment and gold leaf. The crown and the strips of openwork metal attached to the halo and the skirt of the armor are made of cut gold. The kings stand flat-footed on the backs of the demon-monsters they have subdued. There is no suggestion of movement in the figures, a very different treatment from that of the gentle Guardian Kings on the front doors of the Tamamushi Shrine barely visible in figure 51, yet the images project a strong impression of volume, unlike the slender, sinuous Yumedono Kannon (see colorplate 4). Furthermore, the scarves at the base of the statues flare forward instead of to the sides, as did those of earlier bodhisattva sculptures, giving a stronger sense of roundness and three-dimensionality.

The closest continental equivalent to this set of the Guardian Kings is found in the columnar style of the Northern Qi dynasty (550–577). Though slightly more elaborate than the kings, a bodhisattva from Xiangtangshan (Hsiang T'ang Shan) is good example of the style in China (fig. 64). The Hōryūji pieces are dated to around 650, on the basis of an inscription on the back of the Kōmokuten halo and a separate entry in the *Nihon shoki* for 650 mentioning a commission given to Ōguchi Aya Yamaguchi Atai. Since the name of another craftsman, Tsugi Konmaro, is also inscribed on the halo, it is open to question what role the two men played in the creation of these images. Nevertheless, the date of 650 seems appropriate for these figures.

The Kudara Kannon preserved in the Great Treasure House of Hōryūji (fig. 65), a 20th-century museum hall for some of Hōryūji's treasures, has several points in common with the Guardian King images of the *kondō*. It is a tall, slender image of wood, the details of its drapery

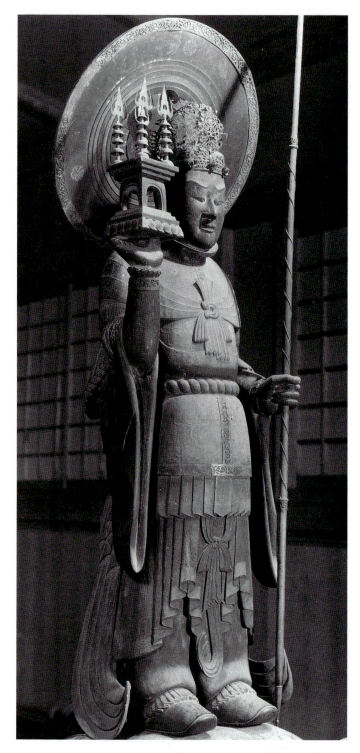

shallowly indicated on the surface, the drapery scarves at its feet curving forward instead of flaring out to the side. Although it does not project the same sense of volume as the Guardian Kings, the figure was clearly conceived in the round. In profile it displays a gentle curvature that suggests a more naturalistic treatment of the body. The statue possesses a number of puzzling features, starting with its name, the Kudara Kannon. Kudara was an alternate name for Paekche, leading some art historians to speculate that the sculpture may have been made in

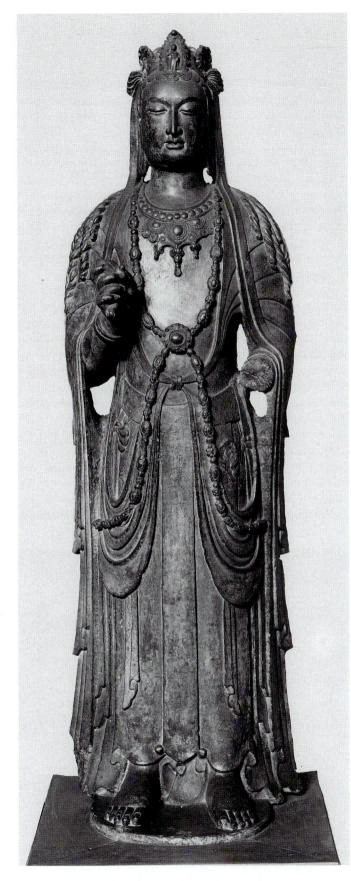

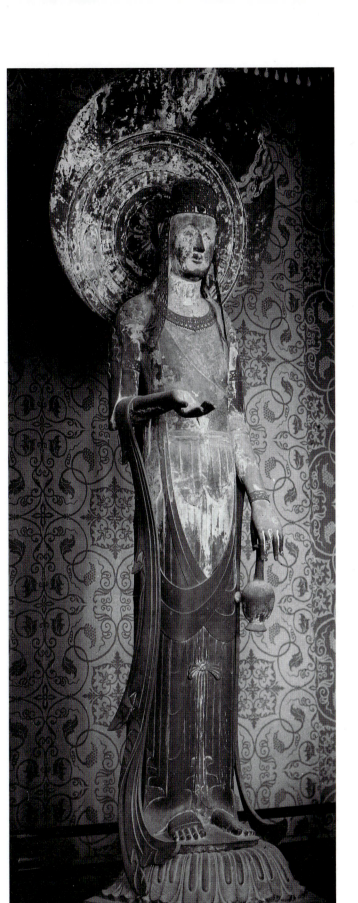

**64.** Bodhisattva, from Xiangtangshan, Heibei-Henan, China. Northern Qi dynasty, 550–77. Stone; height 6 ft. (1.82 m). University Museum, Philadelphia

**65.** Kudara Kannon. Early 7th century. Wood, with remains of paint; height 6 ft. 11 in. (2.1 m). Hōryūji Treasure House, Hōryūji

*Asuka Period*

*The Asuka, Hakuhō, and Nara Periods* 53

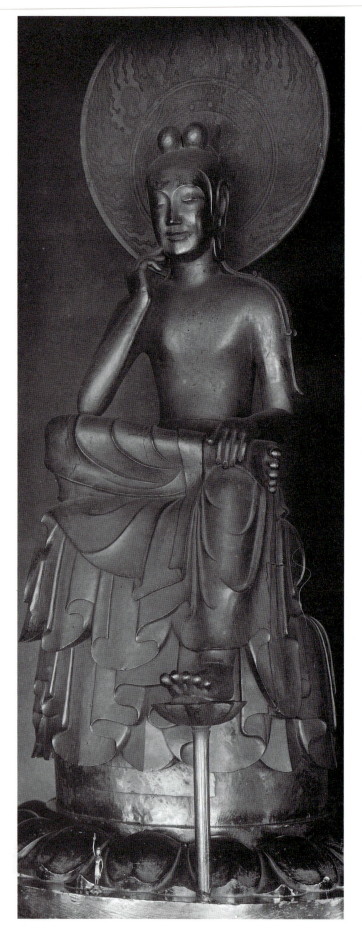

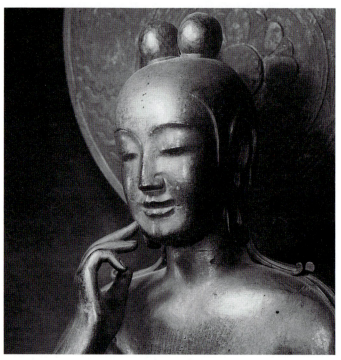

**66.** Chūgūji Miroku. 7ᵗʰ century. Camphor wood; height 52 in. (132 cm). Treasure Hall, Chūgūji convent, near Hōryūji

Korea. However, the camphor wood used for the body, and the cypress used for the lotus pedestal and the water vase attached to the left hand are indigenous to Japan. The garment covering the torso of the figure is unique in that it crosses from the right shoulder to the lower left rather than the reverse, which is the norm. The crown and necklace are made of openwork metal, but the designs are heavier, less exuberant than those of the king images. Despite these atypical details there is no reason to think that the statue is of foreign origin. Kudara was the name of a region to the north of the Asuka valley as well as a synonym for Paekche. The image is remarkable for the grace of its pose and the serenity of its expression.

An image that conveys some of the same grace and gentility as the Kudara Kannon is a Miroku image preserved in the convent of Chūgūji just to the east of Hōryūji (figs. 66 and 67). Miroku (Skt. Maitreya) is the Buddha of the Future, who waits meditating in the heavens until the time when he will be born in his last human incarnation to achieve enlightenment, teach, and become the buddha of the next eon of time. The figure is shown seated upon a throne with one leg pendant and the other bent, the ankle resting on the knee, on which its right arm is propped, the hand raised to the face in a pensive gesture. Chūgūji was originally the residence of Prince Shōtoku's mother and was converted to a convent after her death. However, the statue is clearly a work of the Hakuhō period, with its gently swelling torso, its softly modeled face, and its naturalis-

**67.** Chūgūji Miroku, detail of fig. 66

Tori Bushi – Shaka

Yakushi – Hakuho

**68.** Comparison of the skirts of *(right)* Yakushi (fig. 47) and *(left)* TORI BUSSHI's Shaka (fig. 48)

Shaka Triad.

tic pose. Today the Miroku is housed in Chūgūji's brightly lit concrete Treasure Hall, where it can be seen clearly and is protected from the fires that all too frequently have destroyed wooden buildings in Japan. In its former setting in the convent, softly illuminated so that only a few details were highlighted, the image had a mysterious but gently human quality.

The Yakushi statue in the *kondō* of Hōryūji should be considered in the context of the Chūgūji Miroku (compare figs. 47 and 66). Today the Yakushi statue is installed as one of the main images on the central altar, placed to the right of the Shaka Triad of 623. The halo bears an inscription that attributes the statue to the sculptor Tori Busshi and dates its completion to 607. However, the language of the inscription is clearly not appropriate to describe a living patron, raising doubts about the accuracy of the information contained in it. Further, although there are superficial resemblances between the Yakushi and the Tori Busshi Shaka Triad, there are also strong discrepancies. The face of the Yakushi is more softly modeled, and the eyes have neither the linearity nor the teardrop shape found in the Shaka Triad and the Asukadera Buddha. The patterns of the skirts as they fall over the bases on which the images are seated are similar, but the Yakushi's skirt has fewer folds and conforms more closely to the rectangular shape beneath it. It lacks the shallow linear patterning, the serrated outline, and the buoyancy of the Shaka's garment (fig. 68). Most scholars have concluded that the Yakushi is a work of the Hakuhō period, made to replace the Tori Busshi statue lost in the fire of 670. The style of the image makes clear reference to the earlier work but overall displays the soft naturalism popular in the second half of the 7th century.

A group of sculptures technically and stylistically more advanced than the wooden pieces discussed above are the six bodhisattvas preserved at Hōryūji, one of which is seen in figure 69. The images are each crafted out of single blocks of camphor wood and have been coated with lacquer and gold leaf, a common technique, but in addition certain details such as the jewelry, the tresses of hair, and the hair ornaments have been modeled solely out of lacquer and affixed to the pieces before the gold leaf was applied. This is the first known use of lacquer in Japanese sculpture for a purpose other than a surface coating. In the succeeding Nara period, whole images would be constructed out of lacquer-soaked cloth, and in the 9th century, when Japanese sculptors returned to wood as the preferred material, lacquer would be used again in just this way to build up surface details (see figs. 120 and 121).

Originally, the group of bodhisattvas consisted of eight, not six, statues, and it has been suggested that they were produced as flanking images for a group of buddhas of the four directions. The images stand flat-footed, without any shift of weight, yet they have a strong three-dimensional presence. Their draped shoulders swell outward below the neck, while the torsos have a gentle inward curve. Their garments flow around and between their limbs. Their faces, too, are more naturalistically modeled, with high brows and full cheeks. The six bodhisattvas are youthful, serene figures projecting the idea of compassion for the believer.

The last group of sculptures to have been installed at Hōryūji during its rebuilding are clay figures in tableaus on the first floor of the pagoda and the Niō images in the middle gate, described on page 48. The latter preserve little of their original flavor, having been extensively restored, but the images in the pagoda are in better condition. Strictly speaking, these figures, completed in 711, belong to the Nara period, but their installation so soon after the removal of the capital in 710 suggests that the technique used in their manufacture—clay modeled over a wood and metal armature—was coming into popularity in the last years of the Hakuhō period. The sculptures in the pagoda are placed informally in groups set against fantastic rock shapes, which have been built up around the heart pillar of the pagoda.

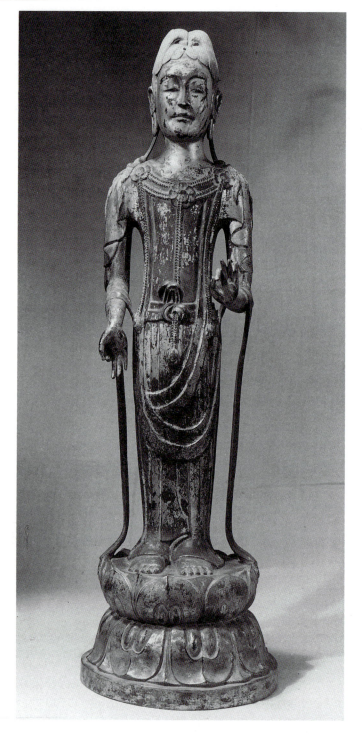

**69.** Kannon Bosatsu. 2ⁿᵈ half 7ᵗʰ century. Camphor wood, with lacquer and gold leaf; height 30⅝ in. (77.9 cm). Hōryūji Treasure House, Hōryūji

sit calmly watching the scene.

The west tableau (not illustrated) depicts the distribution of the relics after Shaka's body has been cremated. Human figures are arranged in groups on either side of a reliquary, waiting for the Buddha's remains to be parceled out among them. The tableau in the south quadrant (also not illustrated) depicts the paradise of Miroku, with that buddha sitting majestically overlooking his realm.

The tableau to the east (fig. 71) comes from one of the most important and popular Buddhist narratives, the *Vimalakirtinirdesha Sutra* (Skt.), *Yuima kyō* in Japanese, and depicts the debate between the wise Indian layman Vimalakirti (J. Yuima) and Manjushri (J. Monju), the Bodhisattva of Wisdom. Vimalakirti was a wealthy businessman and a Buddhist teacher residing in Vaishali, to the north of modern-day Patna in Bihar State.

> He wore the white clothes of the layman, yet lived impeccably like a religious devotee. He lived at home, but remained aloof from the realm of desire, the realm of pure matter, and the immaterial realm. He had a son, a wife, and female attendants, yet always maintained continence. . . . He was honored as the businessman among businessmen because he demonstrated the priority of the Dharma. . . . He was honored as the aristocrat among aristocrats because he suppressed pride, vanity, and arrogance. He was honored as the official among officials because he regulated the functions of government according to the Dharma.
>
> Robert A. F. Thurman, trans.
> *The Holy Teaching of Vimalakirti: A Mahayana Scripture,*
> University Park, Pa., and London, 1976, pp. 20–21

In other words, Vimalakirti did not imitate the life-pattern of Shakyamuni in renouncing his wealth, his responsibility to the state, and his family. Rather, Vimalakirti continued to live in the world, applying the Dharma—the teachings of the Buddha—to everyday concerns. One of the strongest barriers to the acceptance of Buddhism in China was the Confucian idea that an individual had a role to fulfill, a responsibility to discharge, to his parents and his ruler. Thus Vimalakirti, who embodied many of the characteristics valued by Chinese Confucians, became an important figure in the international dissemination of Buddhism, demonstrating to the Chinese that one could be a good Buddhist without violating basic Confucian principles.

To continue with the Vimalakirti story, at some point in his later years, through his superior mental powers, he manifested a serious, perhaps mortal, illness. When commoner and king alike came to visit him, he turned the occasion into an opportunity to instruct them in the teachings of the Buddha. As this situation developed, Vimalakirti wondered why he had not heard from the Buddha himself, and the Buddha, reading the old

Each tableau recounts a particular Buddhist theme. The north tableau depicts the death *(parinirvana)* of Shaka (fig. 70). The golden Buddha lies on a platform, while his disciples and various bodhisattvas look on. Even his mother, Queen Maya, has come down from heaven to witness her son's moment of joyous release; she sits on a ledge at the left of the scene. Disciples who have not fully mastered the Buddha's teachings grieve for him, some quietly, some wailing and beating their chests. Those who understand that Shaka has just passed into a state of nonbeing, and is at last free of the cycle of reincarnation,

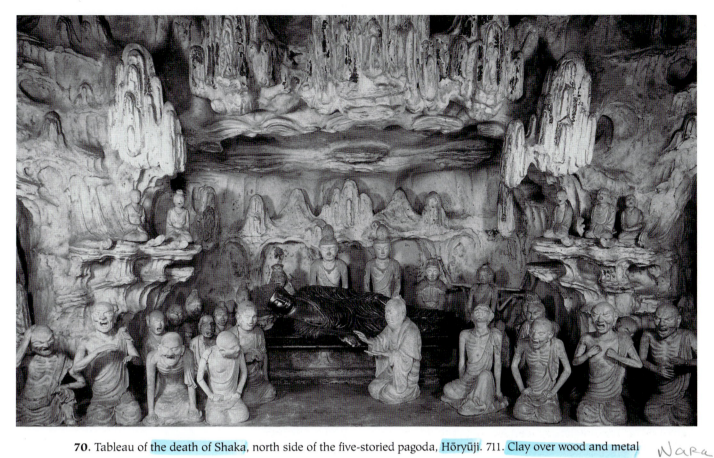

**70.** Tableau of the death of Shaka, north side of the five-storied pagoda, Hōryūji. 711. Clay over wood and metal *Nara*

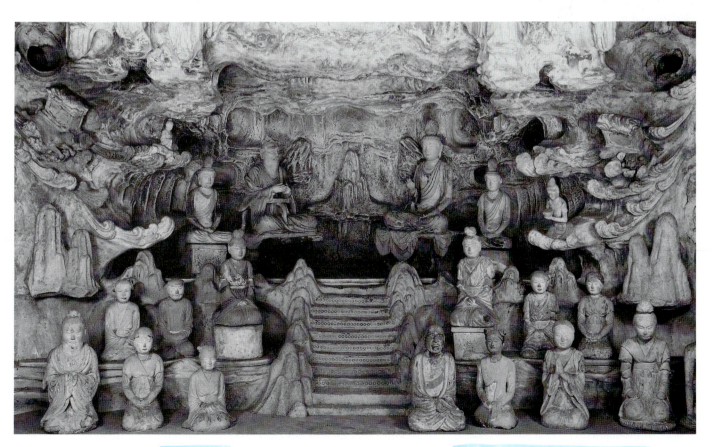

**71.** Tableau of the Yuima-Monju debate, east side of the five-storied pagoda, Hōryūji. 711. Clay over wood and metal

man's mind, wanted to make some response. He tried to find among his disciples and the deities with him in heaven someone who would pay a sick call on Vimalakirti. Each demurred, until finally the Buddha turned to Manjushri, who replied,

> Lord, it is difficult to attend upon the Licchavi Vimalakirti. He is gifted with marvelous eloquence concerning the law of the profound. He is extremely skilled in full expressions and in the reconciliation of dichotomies. His eloquence is inexorable, and no one can resist his imperturbable intellect.
>
> Thurman, *Vimalakirti*, p. 42.

However, Manjushri at last agreed to go, and everyone, both deities and mankind, knowing that a great debate would take place, assembled at Vimalakirti's house to witness it.

The tableau shows the two main characters opposite each other on the highest platform, the wise layman seated, his legs crossed, his two hands resting on a one-legged lap table, the bodhisattva also seated, with one hand raised as though emphasizing a point in his discourse. Below are the human and divine listeners. The treatment of the two main figures is typical of the style seen throughout the pagoda sculptures. Monju (Manjushri) is a long-waisted, slender figure clad in thin draperies that fall in pleasantly irregular folds about his body. His face is fleshy, with an emphasis on the contrast between the fine details—the eyes, nose, and mouth—and the full, rounded curve of the cheeks. The Yuima (Vimalakirti) image is a particularly good example of the Japanese interpretation of Early Tang realism. The face is modeled so carefully that one has a sense of the bone structure beneath the skin, the wide mouth, the bushy eyebrows, and the furrowed brow. This sensitive treatment of forms was made possible by the technique in which layers of ever finer clay are built up over a wooden armature wound with rice-straw rope. This technique permits the sculptor to model his image rather than carve it.

### Painting

Also at Hōryūji are preserved the best of the few examples of painting from the Hakuhō period. Originally, on the interior walls of the *kondō* there was a series of twelve murals, the wide panels depicting four buddhas enthroned in their respective paradises, and the narrower surfaces supporting eight individual bodhisattvas. A disastrous fire in 1949 left most of the paintings too blackened to be readable.

There is some disagreement about the identification of the various buddhas because, although they should appear in the four cardinal directions, the space used by the entrance doors in the façade causes a slight skewing of the whole arrangement. The one painting about which there is general agreement is the wide panel on the west wall,

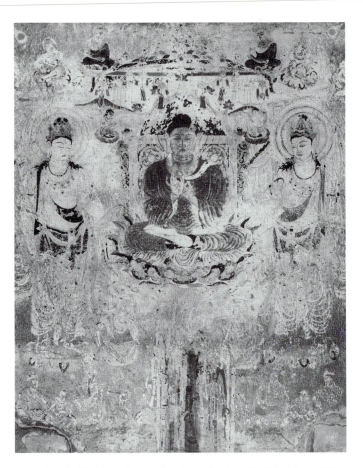

**72.** Amida Triad, wall painting from the *kondō*, Hōryūji. c. 710. Hōryūji Treasure House

which has been identified as Amida (Skt. Amitabha), Buddha of the Western Paradise (fig. 72). Amida sits on a high-backed throne festooned with jewels. To his left is the bodhisattva Kannon (Skt. Avalokiteshvara), recognizable by the buddha image in his crown, and Seishi (Skt. Mahasthamaprapta), normally paired with Kannon as bodhisattva attendants to Amida.

The technique employed in the execution of these paintings, although sometimes compared to the Western fresco, is in fact quite different. The surface of the plaster wall was built up using ever finer and finer layers of the material, which were allowed to dry. Next the design was transferred from cartoons on to the wall surface using the technique of pouncing. Holes were pierced in the paper along the outlines of the figures and the lines marking drapery folds, and colored powder was pushed through the perforations. Finally, pigments were applied to the dry wall. The style of the murals is more advanced in terms of the naturalistic delineation of figures than any other works of the Hakuhō period. This is a phenomenon often found in Chinese and Japanese art: new styles find expression in painting before they appear in other media. There are two traditional technical elements of Buddhist painting in these works: the use of red rather than black to outline the figures, and a kind of line called iron wire, a line that does not vary in width and lacks all calligraphic flourishes.

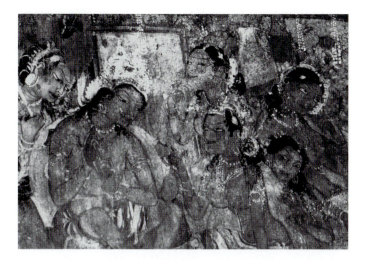

**73.** The Mahājanika Jātaka, wall painting, cave 1, Ajanta, India. c. 600–50

1 west pagoda    4 *kōdō*    7 roofed corridor
2 east pagoda    5 refectory    8 *chūmon*
3 *hondō*    6 living quarters    9 south gate

**74.** Plan of Yakushiji temple. (From Sekaikōkogaku Taikei)

There is a strong admixture of Indian elements in the luxurious jewels adorning the figures and in the treatment of the hair as separate snaky tresses. This mannerism is particularly evident in the wall paintings found in the later cave temples at Ajanta in India (fig. 73). However, in all other details the style of the Hōryūji murals relates to China in the Tang dynasty, suggesting direct stylistic importation in the late 7th century.

## Yakushiji

The history of Yakushiji is a Japanese tale of two cities. In 680 Emperor Tenmu pledged to build the temple when his consort Jitō was afflicted with an eye disease and it was feared that she might go blind. For some reason the actual building of the temple was deferred until after Tenmu's death in 686, but it appears to have been completed by 697, when the eye-opening ceremony was held for the principal statues. This ritual was essential, because by drawing in the eyes of a statue, the wood or metal was converted from base material into a divinity.

The capital of Fujiwara was probably planned by Tenmu before his death even though it was constructed by Empress Jitō, and Yakushiji, though only in the planning stages during Tenmu's lifetime, was accorded a prominent position within the new city. Of the twenty-four temples integrated into the design of the capital, Yakushiji was one of the most important. Hence when the capital was relocated in 710 to Heijōkyō, usually called by its later name of Nara, Yakushiji was included there. Activity at the new site commenced in 718 and was completed by about 730. The question that has most troubled scholars is the relationship between the temple at Fujiwara and that at Nara. Were the original buildings dismantled and rebuilt at the new site, or was a totally new set of buildings erected? Current scholarship based on information gleaned from the excavations of the 1970s supports the theory that the Nara Yakushiji was newly built following the model of the original structure exactly.

It is interesting to contrast the attitude of the court toward the rebuilding of Yakushiji with its ideas concerning Asukadera and Daikandaiji, which were also transferred from Fujiwara to Nara. In the case of these other temples, new and more up-to-date structures were erected in the capital, and staffed by monks from the old temples. The buildings remaining in Fujiwara were designated as subtemples and quickly fell into disrepair. The new temples bore little relation to their prototypes. Even their names were altered, the Asukadera becoming Gangōji, the Daikandaiji becoming Daianji. Clearly Yakushiji, being an imperially pledged temple, had a unique significance, both historical and religious, for the court in the early 8th century.

The main worship compound of Yakushiji consisted of a *hondō*, two freestanding pagodas, and a lecture hall incorporated into the cloister that surrounded the open courtyard (fig. 74). Of these buildings only the east pagoda remains from the early-8th-century construction, but recently the *hondō* and west pagoda have been reconstructed, restoring the compound to something close to its original appearance.

The plan of Yakushiji was a remarkable departure from earlier temple complexes. The emphasis was placed on the *hondō*, a towering two-storied structure immediately visible as one enters the temple precinct (colorplate 6). The pagoda, once as important a building in the worship complex as the *hondō*, was diminished in the Yakushiji plan. Here, there are two pagodas, placed near the perimeter of the cloister, on either side of the path leading to the main hall. Finally, the new plan provided room for a large

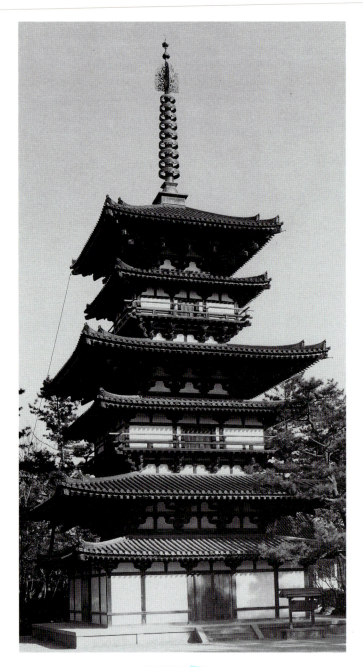

**75.** East pagoda, Yakushiji, Nara. 1st half 8th century

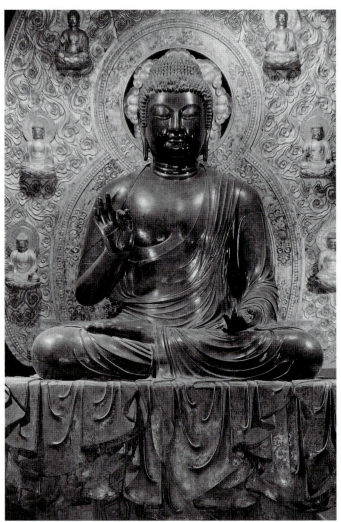

**76.** Yakushi, central figure of Yakushi Triad. Bronze; height 8 ft. 4 in. (2.54 m)

assembly of worshipers in the open area in front of the *hondō*.✦ As noted before, this was a feature of the Indian *chaitya* hall that had not been incorporated into earlier Japanese temples. At Yakushiji the faithful could gather within the cloistered courtyard, in front of the *hondō*, and when the three double doors in the center of the façade were opened, they could see three magnificent golden images, as if in a vision: a gilt bronze Yakushi Buddha seated cross-legged on a large dais, and two separate freestanding images, of Nikkō (Skt. Shuryaprabha) and Gakkō (Skt. Candraprabha), the bodhisattvas of sunlight and moonlight.

The most striking stylistic innovation in the buildings of Yakushiji is the use of a double-roof system for each story. The east pagoda, the only original building still

standing on the site, is a three-storied structure with a *mokoshi* added at each level (fig. 75). The result is a building at the same time more stable and yet more buoyant than the Hōryūji pagoda (see fig. 59). Enhancing this impression are the system of three-stepped brackets and the latticed ceilings beneath the rafters, which allow more light to penetrate under the eaves. Today the Yakushiji pagoda stands as a unique example of this style.

Still extant at Yakushiji, the statues of Yakushi and his attendants, to the right Nikkō, to the left Gakkō, are three of the most beautiful sculptures ever produced in Japan (figs. 76 and 77). Cast in bronze, these figures have acquired a rich black patina made particularly striking by

---

✦The terms *hondō* and *kondō* refer to the same building within a temple complex: the main hall for worship containing sculptures of the principal buddha and bodhisattvas to which the temple is dedicated. There is a tendency to use the term *kondō*, or golden hall, for structures of the 7th and 8th centuries and *hondō*, or main hall, for main halls built from the 8th century onward.

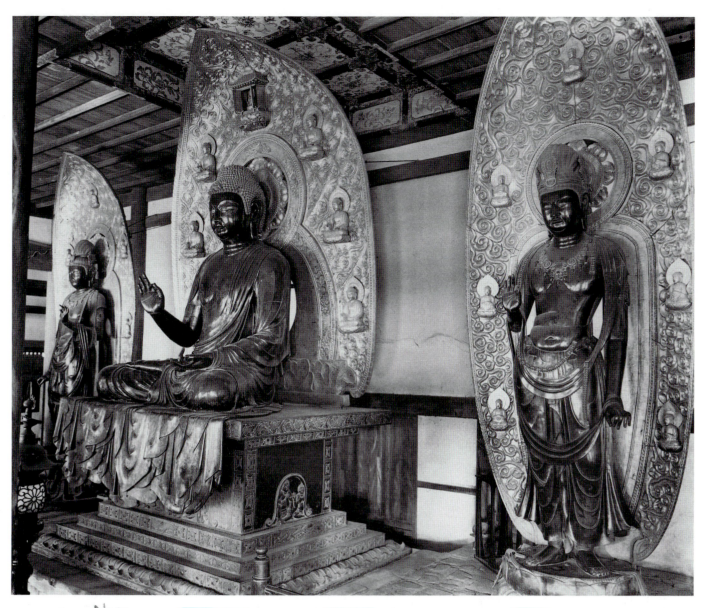

Nara

**77.** Yakushi Triad, in the *hondō*, Yakushiji. Late 7th or early 8th century. Bronze

medicine Buddha - healer

the contrast with their bright gold halos, Tokugawa-period replacements for the original ones, which had been damaged repeatedly by fires and earthquakes. A 1954 analysis of the bronze alloy revealed that it contains a particularly high proportion of tin and arsenic. No doubt the rich color of the images today is due to oxidation of the tin.

The Yakushi and the two bodhisattvas are full, fleshy figures, conceived in the round and treated as completely natural forms, the Nikkō and Gakkō displaying a hip-slung pose (Skt. *tribhanga*, or triple curve) which suggests that they are actually moving in space. They are clothed in skirts and scarves that cling like water-soaked cloth, revealing the bodies beneath. The bodhisattvas also have rich jewelry, intricate necklaces, jeweled strands accenting the flow of the scarf, and crowns with three large jewel motifs. The buddha, as is the norm with such figures, wears no jewelry, and his long robe flows over the edge of

the platform on which he is seated in a rich pattern of thin, irregular folds. His left arm is extended, the fingers crooked to hold a medicine jar, now lost, and his right hand is raised in the *aniin* mudra (Skt. *vitarkamudra*), a gesture of argumentation. He sits on a rectangular throne decorated with a variety of designs, on the uppermost horizontal band a *rinceau* of grape leaves, a motif frequently found on Chinese mirrors of the Tang dynasty, and rich jewel patterns on the other narrow horizontal and vertical strips.

On each side of the platform, in the center of the band just below the main part of the platform, are the Chinese astrological symbols of the four directions: the blue dragon of the east, the white tiger of the west, the red phoenix of the south, and the tortoise entwined with a snake, the symbol for the north. The most interesting motifs on the pedestal are the pairs of squat, fat figures contained within bell-shaped arches on the four sides of the platform.

No completely satisfactory theory has been advanced to explain these images. However, since there are twelve figures in all, two on the short sides and four on each of the long sides, they may well be atypical representations of the Twelve Heavenly Generals associated with Yakushi.

The date of the triad has been the subject of scholarly debate over the years. The controversy arises from the problem, discussed above, of the relationship between the Fujiwara Yakushiji and the Nara reconstruction. A record in a history of Yakushiji written in 1015, three hundred years after the rebuilding of the temple, states that the statue of Yakushi in the *hondō* was made as the result of a vow by Emperor Tenmu and was brought by wagon from the old Yakushiji, a trip that took seven days. Some scholars take this statement at face value and conclude that the Yakushi Triad was made for the original temple at Fujiwara and therefore was completed sometime before 697. Others question the accuracy of a record set down so long after the fact.

In the absence of solid documentation, art historians must turn to an examination of style. Here the preponderance of evidence is on the side of the earlier date for the images. They have the controlled fleshiness of early Tang Chinese sculptures and are comparable to the figures seen in the Hōryūji wall paintings. The Yakushiji compound and its principal images represent a new and potent reinterpretation of the function of a temple compound and the style appropriate to its main images.

## The Nara Period (710–794)

The Nara, or Tenpyō, period is delimited by two political events, the transfer of the capital from Fujiwara to Heijōkyō (Nara) in 710, and eighty-four years later the transfer of the capital to Heiankyō, the city known today as Kyoto. This short era can well be called Japan's most Chinese period, because during this time Japan came as close as it ever would to adopting a Chinese system of government based on a centralized bureaucracy, to establishing a nationwide system of Buddhist religious centers rivaling those of China, and finally to using Buddhism in the Chinese manner as an instrument for effecting national policy.

The system of government the Japanese adopted was a rigidly ordered and symmetrically apportioned division of responsibilities, a system imposed on the nation rather than one developed in response to the needs of the people. The entire bureaucracy was divided into two departments, the Department of Worship, which oversaw Shinto affairs, and the Department of State, which was concerned with all aspects of secular government. The latter was further divided into eight ministries, four under the control of the Sadaijin, or Minister of the Left, and four under the Udaijin, Minister of the Right. The country was organized into provinces, each with a governor, into districts within the provinces, each with its own administrator,

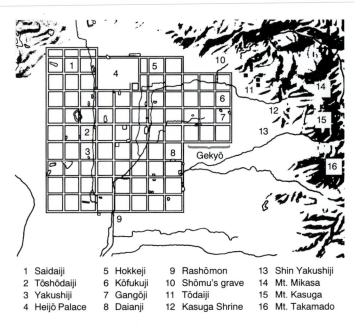

| 1 Saidaiji | 5 Hokkeji | 9 Rashōmon | 13 Shin Yakushiji |
| 2 Tōshōdaiji | 6 Kōfukuji | 10 Shōmu's grave | 14 Mt. Mikasa |
| 3 Yakushiji | 7 Gangōji | 11 Tōdaiji | 15 Mt. Kasuga |
| 4 Heijō Palace | 8 Daianji | 12 Kasuga Shrine | 16 Mt. Takamado |

**78.** Map of Heijōkyō (Nara)

and finally into townships consisting of fifty households governed by a headman responsible to the district leader.

In similar fashion the new capital was designed in a rigidly ordered and symmetrical plan based on the Chinese model of city planning for a national capital (fig. 78). A broad, flat plain surrounded by mountains to the east, north, and west was chosen as the site because, according to Chinese principles of geomancy, this topographical configuration was the most propitious, offering protection against evil forces coming from the more dangerous of the cardinal directions. The city was laid out as a rectangular grid with ten lateral avenues and nine longitudinal ones, both called *ōji*, literally big roads. The ten east-west avenues divided the grid into *jō*, or wards, which were numbered from north to south, while the nine longitudinal avenues further divided the grid into *bō*. These were counted outward from the central avenue, the Suzaku Ōji, which bisected the city, dividing it into left and right halves, Sakyō and Ukyō. The Heijō palace enclosure, which contained the residence of the emperor and buildings for the various bureaus within the government, occupied the four north-central blocks of the city, and it was from the vantage point of the emperor looking southward over his capital that the determination of right and left was made. When a subject located himself within the city, he automatically placed himself within the social structure, establishing his position vis-à-vis the emperor and the government. The Chinese conception of capital design did not take into account organic growth outward from a central core, and shortly after Nara was laid out, exceptions to the plan were made. The Gekyō, or Outer Capital, an extension on the left side of the city, was created to accommodate the temples of Kōfukuji and Gangōji in the foothills of the eastern mountains. The city of Nara today is centered in this area, with its interesting natural topog-

raphy. The flat areas that once contained the Heijō Palace enclosure and the Suzaku Ōji were later turned back into farmland, and are now gradually being annexed by the city to build housing for its ever-growing population.

The idea of Buddhism as the protector of the nation had first been enunciated in the Asuka period during the regency of Prince Shōtoku, but events in the early years of the 8th century spurred the government to take stronger measures to advance the religion. The country was by no means unified by the time the capital was established in Nara. In the next two decades uprisings staged by rival factions throughout the provinces became so numerous that travel outside the city was hazardous. However, the catalyst for the change in policy was an epidemic that spread through the country, leaving dead in its wake several high-ranking members of the aristocracy. In 741, and again more strongly in 743, Emperor Shōmu (701–756) decreed the establishment of a monastery and nunnery in each of the provinces, and later in 743 he ordered the construction in the capital of a colossal Birushana Buddha (Skt. Vairocana), the Buddha who embodies the essence of buddhahood and who presides over the myriad buddha worlds, an apt metaphor for the relationship between the emperor and his appointed governors in the provinces. The production of this buddha image and the temple to house it, Tōdaiji, became the major focus of interest for the court, the clergy, and the nation in the mid-Nara period. The apogee of the Tōdaiji project came in 752, in the eye-opening ceremony. Prior to this rite, in a very public ceremony, Emperor Shōmu presented himself before the Birushana and humbly declared himself to be a servant of the Three Treasures of Buddhism: the Buddha; the Law, or Teaching; and the Monastic Community. Never again would a Japanese emperor, no matter how devout, come so close to denying his ancestors among the Shinto gods and his own role as divine ruler of the country. The precedent for Shōmu's policy of constructing a series of provincial temples linked with a central temple in the capital can be found in China under Empress Wu (ruled 690–701), who instituted the practice in order to take advantage of the support for her among Buddhist adherents. It is not at all surprising that Shōmu should have advocated a similar system in Japan, given the political instability of the early Nara period.

The comfortable alliance between church and state began to slip in the years after Shōmu, as the six Buddhist schools that were active in Nara in this period became increasingly politicized.❖ The priesthood began to play an important role in secular affairs, a trend that culminated in the relationship established by the priest Dōkyō with Empress Kōken, Shōmu's daughter. Kōken served as empress twice; during her first reign, from 749 to 758, she was known as Kōken, and during her second, from 764 to 770, as Shōtoku. Not content with his position in the government, Dōkyō attempted to persuade the empress to appoint him as her successor on the throne. The leaders of the most powerful clans joined forces to block his ambition and, following the death of the empress in 770, forced him into exile. (Thereafter it became policy that no woman should have the throne, a precedent that has been followed with two exceptions to the present day: Meishō (ruled 1630–1643) and Gosakuramachi, who ruled 1762–1770.) Further inspired by these events, government leaders began to consider rebuilding the capital at a new site where the number, size, and location of Buddhist temples could be strictly controlled.

Paradoxically, considering the powerful influence of the Chinese governmental system at this time, the Nara period witnessed the first full blossoming of Japanese culture. Spurred on by the Tōdaiji project, the visual arts flourished as they had not before. The written word also took on greater importance. In the early decades of the 8th century the two histories of Japan were compiled, the *Kojiki* and the *Nihon shoki*. In the latter half of the century, the *Manyōshū, Collection of Ten Thousand Leaves*, an anthology of poems, was compiled. It contains over four thousand poems, ranging in sentiment from verses written to commemorate official events, such as the poem "On the Occasion of the Temporary Enshrinement of Princess Asuka," to more personal lyrics; from short, thirty-one-syllable love poems to longer pieces lamenting the absence of a loved one, the pains of old age, and the rigors of poverty. One of the most poignant verses in the collection, "A Dialogue on Poverty," written by the nobleman Okura Yamanoue, ends,

> No fire sends up smoke
> At the cooking-place,
> And in the cauldron
> A spider spins its web.

(poem continues on page 64)

---

❖ The six Nara schools were the Sanron (Three Treatises), introduced to Japan circa 625 and based on the work of the Indian philosopher Nagarjuna and his disciple Āryadeva; the Jōjitsu, introduced from Paekche, as was the Sanron with which it soon merged; the Hossō, introduced about 650 by the student monk Dōshō, who had studied in China, and which espoused an idealist philosophy of the Mahayana type; Kegon, based on the Kegon sutra and holding that Shaka is the manifestation of the supreme, universal, and omnipresent Birushana Buddha; Kusha, which appeared about the same time as Hossō; and Risshū (C. Ritsu), introduced by the Chinese priest Jianzhen (J. Ganjin) in 754. In general, the first four schools stressed philosophical doctrines of the Hinayana type. Kegon developed elaborate rituals that appealed to the monarchy (Emperor Shōmu decreed that the Kegon sutra was the authoritative scripture and built Tōdaiji to honor worship of the Birushana Buddha). Under Ganjin, the Ritsu school concentrated on religious precepts and discipline, carefully controlling ordination of members.

With not a grain to cook,
We moan like the "night thrush."
Then, "to cut," as the saying is,
"The ends of what is already too short,"
The village headman comes,
With rod in hand, to our sleeping-place,
Growling for his dues.
Must it be so hopeless—
The way of this world?

<div align="right">

Nippon Gakujutsu Shinkōkai, *The Manyōshū*,
New York and London, 1965, pp. 206–7

</div>

The poet, a wealthy aristocrat, is clearly not describing the quality of his own life. Instead, he is empathizing with a common peasant taxed by the court and his village into abject poverty. As the system of taxation adopted in the Taika Reforms of 645 began to fail, peasants were increasingly crushed by the government's demands for goods and labor. Yet the poem is not a political tract, but rather a sensitive interpolation of the reactions of a simple man to the almost intolerable facts of his existence, and reflects an open-mindedness, an intense curiosity on the part of the nobility about every aspect of life around them.

## Kōfukuji

Of the many temples erected in Nara between 710 and the commencement of construction of Tōdaiji in 747, Kōfukuji affords the best glimpse of Buddhist art and architecture in the first half of the century. Kōfukuji, built as a private clan temple under the direction of Fujiwara Fuhito (659–720), was clearly the largest and most impressive temple in Nara in the pre-Tōdaiji years. The Fujiwara clan, founded in the 7th century by Fujiwara Kamatari, played an important role in the politics of the Nara period, and in the succeeding Heian period held control of the government from 858 to 1086, clan leaders serving as regent and as civil dictator for the emperor. Members of the Fujiwara family also made significant contributions to the arts in the Heian and Kamakura periods.

The site chosen for the temple complex was a sixteen-block area on a plateau at the foot of Mount Mikasa in the Gekyō, or Outer Capital, section, overlooking the city to the west. Two of the other major temples in Nara, Yakushiji and Gangōji, occupied only nine blocks each, while temples of the second rank such as Tōshōdaiji, the main post-Tōdaiji construction project, occupied only four blocks, and minor temples were allotted only one. Fujiwara Fuhito was one of the most influential men of the day. He participated in the drafting of two codes of government, for which he was rewarded with high ranks, the most prestigious being Udaijin, Minister of the Right. He was also successful in marrying several daughters into the imperial family. Thus he had the freedom to build his clan temple in as magnificent a manner as he wished, without censure from the emperor. As originally conceived, the temple consisted of three *kondō* in addition to such sup-

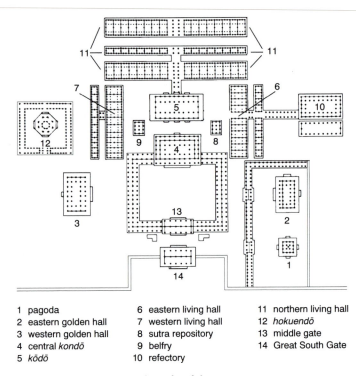

| | | |
|---|---|---|
| 1 pagoda | 6 eastern living hall | 11 northern living hall |
| 2 eastern golden hall | 7 western living hall | 12 *hokuendō* |
| 3 western golden hall | 8 sutra repository | 13 middle gate |
| 4 central *kondō* | 9 belfry | 14 Great South Gate |
| 5 *kōdō* | 10 refectory | |

**79.** Plan of Kōfukuji, Nara

port buildings as a lecture hall, a sutra repository, a belfry, a refectory, and quarters for the monks (fig. 79). The layout of the main temple buildings achieved the goal forecast by the plan of Yakushiji. The focal point of the main cloister is the central *kondō*. The one pagoda at Kōfukuji is located to the east, in a separate enclave with the eastern golden hall. The western *kondō* is also located outside the main enclosure. Thus when worshipers passed through the Great South Gate and the middle gate, they entered a cloister dominated by a single *kondō*. In 721, the year after the death of Fuhito, a new type of building, the so-called round hall, actually an octagon, was built to the north of the western *kondō* to honor him. A similar hall, also dating to the early 8th century, the Yumedono, or Hall of Dreams, was built at Hōryūji to honor Prince Shōtoku and today houses the Yumedono Kannon discussed on pages 45–46. This type of building seems to have usurped the function of the pagoda as a reliquary.

The Kōfukuji complex was intended not only as a place for worship, but also as a monastic center for learning, what today might be called a learning center with an outreach component. The monks lived together in groups, studying under the guidance of a religious teacher—a program not unlike the modern university seminar system—with the belfry's bells tolling the hours of the day. In addition to these religious activities, the temple also staffed a Mercy Hall, which offered aid to the needy, orphans, and the elderly, and a Medicine Hall, the forerunner of the modern-day clinic. The garden, in which flowers for the many altars in the temple were grown, was open to the laity for their enjoyment and recreation. Kōfukuji must have had a profound socio-political as well as religious im-

pact on the residents of the capital.

Although today's visitor to the temple can sense something of the magnitude of the original complex, none of the extant buildings date from the Nara period. Two sets of sculptures have survived and afford us a glimpse of the magnificence of altar decoration at Kōfukuji. These are six images from a set of the Ten Disciples of Shaka and eight sculptures of the Eight Classes of Beings, who have dedicated themselves to the protection of Buddhism, and are depicted at Kōfukuji as guardians of the Buddha. Originally these sculptures belonged to a group of twenty-seven images, including a Shaka flanked by the bodhisattvas Monju (Skt. Manjushri) and Fugen (Skt. Samantabhadra), the Four Guardian Kings, and the divinities Bonten and Taishakuten, installed in the western kondō, the first of the main worship halls to be built, at the request of Empress-consort Kōmyō and dedicated to her mother, Lady Tachibana Michiyo. According to reliable records, the images were completed in 734 by a group of craftsmen including a busshi, a sculptor of Buddhist images, by the name of Shōgun Manpuku, a woodworker, a painter, a metals specialist, and a craftsman in paper, probably members of a guild of artisans attached to the temple. The most interesting aspect of these sculptures is the new technique called hollow dry lacquer, or dakkatsu kanshitsu, used to craft them. Over a rough clay model of the image, layers of hemp cloth soaked in lacquer were applied one by one and were bonded together by the sticky substance. Once the cloth shell had dried thoroughly, the clay core was broken out and replaced by a wooden armature. Additional details on the surface of the image were modeled out of a mixture of sawdust, flour, and powdered incense combined with lacquer. Once the sculpture had been completely formed, pigments and gold leaf were applied to its smooth surfaces.

It is not known precisely why this technique, which had been developed in China, was adopted in the early Nara period. Dry-lacquer sculpture is not only durable, it is also light enough to permit it to be moved easily; for example, hollow lacquer images could be carried in temple processions. However, there is no evidence to suggest that these sculptures were ever used in such a way. It has also been suggested that copper was in short supply at the time the images were commissioned, prompting use of the new technique. Whatever the reason, the craftsmen attached to Kōfukuji were fully conversant with the dry-lacquer process, and the works they produced display great sensitivity in the modeling as well as a charming, youthful naiveté. Of the six extant images from the set of ten disciples, that of Kasenen is of particular interest (fig. 80). All six stand flat-footed on rock-shaped bases, and all are clad in simple priestly robes. However, the face of Kasenen is contorted, in contrast to the expressions of the other five, which are merely pensive. His mouth is open as if he were crying out and his emaciated chest and his grimacing face suggest prolonged self-denial.

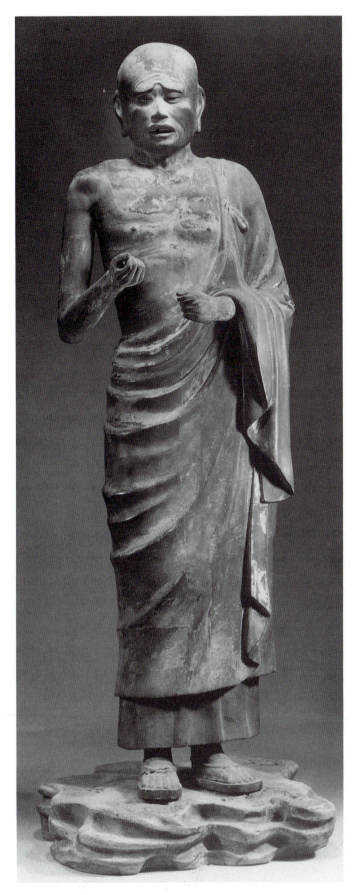

**80.** Kasenen, in the *saikondō* (western golden hall), Kōfukuji. Dry lacquer, with paint; height 58½ in. (148.8 cm)

Three favored techniques for making temple sculpture in 8th-century Japan were hollow-core dry lacquer (*dakkatsu kanshitsu*), wood-core dry lacquer (*mokushin kanshitsu*), and clay (*sozo*). Lacquer (*urushi*) is a varnishlike resin obtained from an Asiatic sumac bush (*Rhus verniciflua*). All three techniques are additive processes, meaning that the forms are built up, not carved away.

Introduced from China during the early 7th century, hollow-core dry lacquer begins with a wooden form (A), an armature, which is then covered with clay (B). Next, layers of lacquer-soaked hemp or linen cloth—from three to ten of them—are applied and modeled (C). Each layer must be completely dry before the next one is applied, a time–consuming process. Before the final details are added, the sculpture is cut open at the back and the clay is removed. The original wooden armature may be left in, or it may be replaced by another. Large members, such as arms and feet, are modeled out of wood and joined to the armature (D). Details such as earlobes and fingers are modeled over iron wire and attached. The finest, most subtle details—including facial features, tresses of hair, jewelry, and raised fabric patterns—are modeled

# DRY-LACQUER AND CLAY SCULPTURE

from a paste called *kokuzo urushi*, made of kneaded lacquer, incense and clay powders, and sawdust. Finally, the image is coated with either black lacquer, over which gold leaf may be applied, or with a compound of fine clay mixed with animal glue (*hakudo*), on which colors made of mineral pigments and animal glue may be painted.

Wood-core dry-lacquer sculpture, which is simpler to make than hollow-core, was developed toward the end of the 8th century. It uses a roughly carved piece of wood (E) instead of a clay-covered armature to support the *kokuzo urushi* surface (F). To discourage cracks in the lacquer surface caused by the expansion and contraction of a solid block of wood, sculptors usually hollowed out the core (G). Otherwise, the surface treatment of wood-core and hollow-core images is the same.

The fabrication of large-scale clay sculpture is comparable to that of dry lacquer. A wooden armature is wrapped in rice straw filaments to give it bulk. Three layers of clay are applied to this support: first, a coarse clay mixed with rice straw fibers; second, a finer clay; and third, a very fine clay mixed with paper fibers. The sculpture is allowed to dry thoroughly, but it is not fired. Colors and gold leaf are applied to the surface.

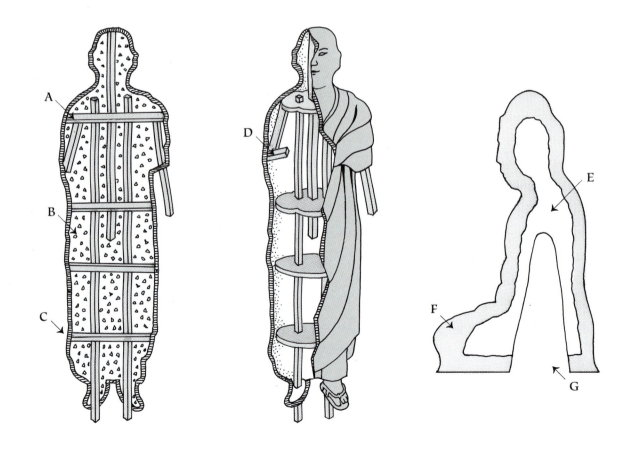

## Tōdaiji

Up the hill from Kōfukuji stands the magnificent complex of Tōdaiji. The building of this temple and the casting of its Birushana Buddha were the most important projects undertaken by the court, the clergy, and the Japanese people in the 8th century. The temple and its colossal buddha image were pledged in 743 by Emperor Shōmu as a last-ditch effort to bring peace and unity, economic prosperity, and physical and spiritual well-being to his people. At the time the two were pledged, Shōmu was living at a place called Shigaraki in Ōmi province, in present-day Shiga prefecture, and work on the buildings was begun there. However, in 745 he moved back to Nara, the land surrounding the hermitage of the monk Rōben was selected for the new temple, and shortly after that bureaus for construction and the production of sculptures were set up. The major casting for the image was completed in 749, but the manufacture of the snail-shell curls and the gilding of the statue took two more years. In the spring of 752 a magnificent eye-opening ceremony was held for the Birushana. Not only did court and government officials participate, but also Buddhist dignitaries from China and India were present, including a priest from China and an Indian monk, who performed the painting in of the buddha's eyes. Work on the halo was not completed until 771.

The area allotted for Tōdaiji was sixty-four city blocks in the Gekyō section of the capital (fig. 81). Two pagodas were included in the original plan, enormous seven-storied structures 330 feet tall, each contained within a separate roofed-wall enclosure. To the north of these was the main worship compound, which consisted of the *hondō* or main worship hall—known as the Daibutsuden—and two roofed cloisters enclosing, respectively, front and back courtyards.❖ Directly behind the Daibutsuden was the lecture hall (*kōdō*), surrounded on three sides by quarters for the monks. The refectory was a separate building with its own enclosed courtyard. The Shōsōin, a large storehouse belonging in part to the imperial clan, is located far to the northwest of the Daibutsuden, while the Hokkedō, or Hall of the Lotus Sutra, the oldest building in the Tōdaiji complex, is a short climb up the hill to the east.

### Hokkedō

In the years preceding Shōmu's move back to Nara and the selection of the site for Tōdaiji, that area was remote from the center of the capital and a favored location for small, private hermitages. Among these, the residence that was later given the temple name Konshōji was the most important. Something of this temple's origins can be adduced from a story included in the *Nihon ryōiki*, a collection of Buddhist narratives compiled around 820 by the priest Kyōkai. According to the text, an ascetic by the name of Konsu had installed an image of Shūkongōjin (Skt. Vajrapani) in his hermitage east of Nara. When he read his sutras, holding a rope he had tied around the leg of the image, the leg glowed and the light reached the Imperial Palace. Shōmu sent an official to discover its source. Learning that when it appeared, Konsu had been praying to become a monk, Shōmu granted him permission and had a temple built for him. The ascetic (689–773) took the name of Rōben and went on to become the first abbot of Tōdaiji and one of Emperor Shōmu's most trusted religious advisers. The year 733 is mentioned in some documents as the date of the founding of Konshōji.

Scholars generally agree that the temple building erected for Rōben was included in the Tōdaiji complex and is the building known today as the Hokkedō, Hall of the Lotus Sutra, or the Sangatsudō, Third Month Hall (figs. 82 and 83). In the Kamakura period (1185–1333), the building was remodeled; a *raidō*, or worship hall, was added in front of the main sanctuary, and the roofs of the two structures were joined.

Among the statues preserved in the Hokkedō, one of the oldest is certainly the Shūkongōjin, a glaring, grimacing figure clutching a diamond thunderbolt (Skt. *vajra*), installed in a lacquer cabinet in a screened-off area behind the main altar (colorplate 7). The deity belongs to the same *kongōjin* group of defender figures as the Hōryūji *chūmon* Nió (see page 48). Because of its special status as a secret treasure of the temple, it is displayed only once a year and therefore is in very good condition. The image,

---

❖ A *butsuden* is any temple hall where a buddha or bodhisattva is enshrined. Tōdaiji's *hondō* is called the Daibutsuden, the hall of a great buddha statue (*daibutsu*).

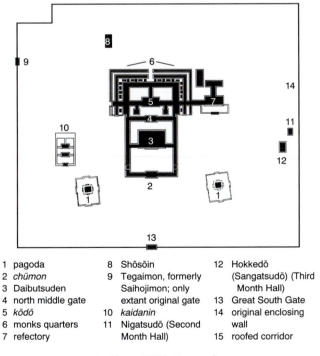

1 pagoda
2 *chūmon*
3 Daibutsuden
4 north middle gate
5 *kōdō*
6 monks quarters
7 refectory

8 Shōsōin
9 Tegaimon, formerly Saihojimon; only extant original gate
10 *kaidanin*
11 Nigatsudō (Second Month Hall)

12 Hokkedō (Sangatsudō) (Third Month Hall)
13 Great South Gate
14 original enclosing wall
15 roofed corridor

**81.** Plan of Tōdaiji complex

**82.** Hokkedō (also known as Sangatsudō), Tōdaiji, Nara.
1st half 8th century

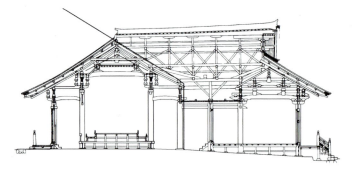

**83.** Cross section of Hokkedō, Tōdaiji, showing Nara-period section on the left and Kamakura-period addition on the right

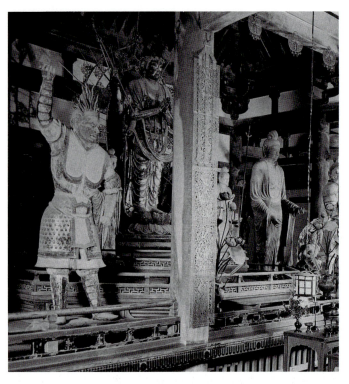

**84.** View of the altar, Hokkedō, Tōdaiji. Early 8th century

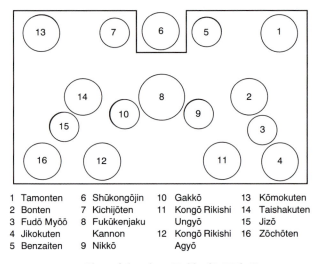

| 1 | Tamonten | 6 | Shūkongōjin | 10 | Gakkō | 13 | Kōmokuten |
| 2 | Bonten | 7 | Kichijōten | 11 | Kongō Rikishi | 14 | Taishakuten |
| 3 | Fudō Myōō | 8 | Fukūkenjaku | | Ungyō | 15 | Jizō |
| 4 | Jikokuten | | Kannon | 12 | Kongō Rikishi | 16 | Zōchōten |
| 5 | Benzaiten | 9 | Nikkō | | Agyō | | |

**85.** Plan of the altar, Hokkedō, Tōdaiji

about lifesize, is made of clay, and is coated with gold leaf and pigments which retain much of their original splendor. The Shūkongōjin is clad in a robe decorated with brightly colored floral patterns under Chinese-style armor in the manner of the Guardian King figures, but his face has more of the exaggerated qualities of the Niō images. Although the deity stands with both feet flat on the ground, he seems to move in space, his scarves swinging out behind him. The sinews of his neck are taut, and his left fist is clenched so that the veins of his arm pop up on the surface. He is in a state of tension, ready to leap forward and strike the enemy with his *vajra*. Because of the Shūkongōjin's association with the founding of Konshōji, some scholars date it to around 733, but there is not universal agreement on this point.

The statues on the main altar of the Hokkedō are something of a hodgepodge in terms of both the iconography of the images and the sculptural techniques employed (figs. 84 and 85).❖ The central image is a Fukūkenjaku Kannon, an eight-armed figure representing one of the thirty-three forms Kannon can assume (fig. 86). A large statue crafted in the hollow dry-lacquer technique, this Kannon is thought to have been made in the 740s, in response to Emperor Shōmu's decree that provincial temples should install statues of the divinity. There is further evidence that in 746 a studio for making Buddhist sculpture

❖ Below the enlightened buddhas and bodhisattvas of the sutras range a wide variety of deities who were incorporated into Buddhism from other religions, and who have not yet achieved liberation from the bonds of this world. The humblest ones are the *kongōjin,* unenlightened the beings who have turned to the service of Buddhism as protectors and guardians, and who are generally portrayed as fierce muscular deities, like Kongō Rikishi (often presented as a pair and called the Niō, or Two Kings) and Shūkongōjin. Above them are the *ten* (Skt. *deva*), celestial beings, a large group that includes the Shitennō. Higher yet are Bonten and Taishakuten, who as Brahma and Indra are among the highest gods of Hinduism.

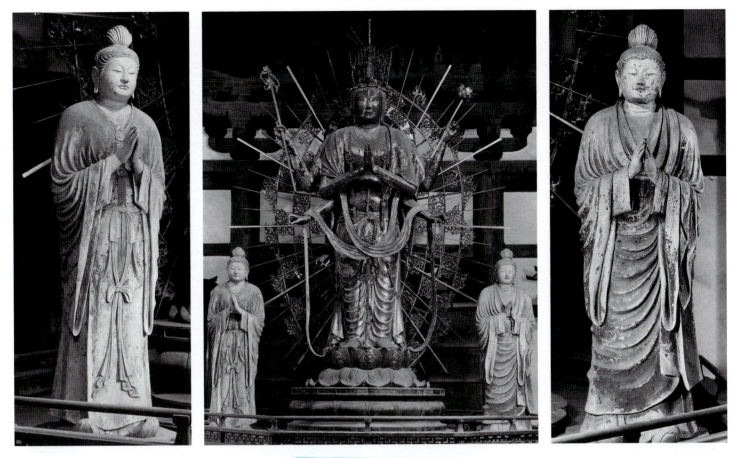

**87.** Gakkō, in the Hokkedō, Tōdaiji. Mid-8ᵗʰ century. Clay, with remains of paint; height 6 ft. 9½ in. (2.07 m)

**86.** Fukūkenjaku Kannon (flanked by Gakkō and Nikkō), in the Hokkedō, Tōdaiji. 740s. Dry lacquer, with gold leaf; height 11 ft. 10 in. (3.62 m)

*new tech. in Nara period.*

**88.** Nikkō, in the Hokkedō, Tōdaiji. Mid-8ᵗʰ century. Clay, with remains of paint; height 6 ft. 9¹⁄₈ in. (2.06 m)

was set up at the temple under the direction of Kuninaka Kimimaro (died 774).

The Fukūkenjaku Kannon is one of the most powerful and austere manifestations of Avalokiteshvara from the Nara period. The name means the never-empty lasso and derives from the concept that this figure has the strength to lasso beings ensnared in delusion and bring them to the safety of enlightenment. To further emphasize his power, the deity has an additional eye in the middle of the forehead, and eight arms. Two are pressed together in front of the chest, the other six radiating out around the figure, holding symbols of this persona: the lotus blossom of Buddhist wisdom, often carried by Kannon; a pilgrim's staff; and the lasso associated with this particular form. Behind the figure is an openwork metal halo consisting of flame patterns attached to metal bands that repeat the oval outline of the figure and to smaller straight wires that radiate out, suggesting the golden light its body emits. The Fukūkenjaku Kannon wears an openwork silver crown, to which is attached a silver image of a standing buddha. Such details as the eight arms clearly reflect the influence of Esoteric Buddhism, which had been developing in India for a century or more. Regardless of any foreign influence on the iconography of the Kannon, the statue is a beauti-

fully realized image creating the impression of a springy tension, particularly in such details as the hands, which touch only at the base, the fingers being rigidly held apart.

The quality of the materials used and the technical perfection of the figure suggest that it was made in the official government-controlled Buddhist atelier under the direction of Kuninaka Kimimaro, mentioned above. This artist's name appears frequently in the documents of the mid-Nara period. He was the second-generation son of a Korean from Paekche who emigrated to Japan in 669. Because Kimimaro received a number of significant promotions during the time work on the main images for the Daibutsuden, the Great Buddha Hall at Tōdaiji, was being carried out, it is assumed that he played a major role in that project as well as in the dry-lacquer sculptures for the Hokkedō.

Two images flank the Fukūkenjaku Kannon; they are known today as Nikkō and Gakkō. However, they were probably intended to be representations of Bonten and Taishakuten, the Indian gods Brahma and Indra, who in Japanese Buddhism became chiefs among the king figures (figs. 87 and 88). The names Nikkō and Gakkō were attached to these two images at a later time, when a second pair of Bonten and Taishakuten figures, large dry-lacquer

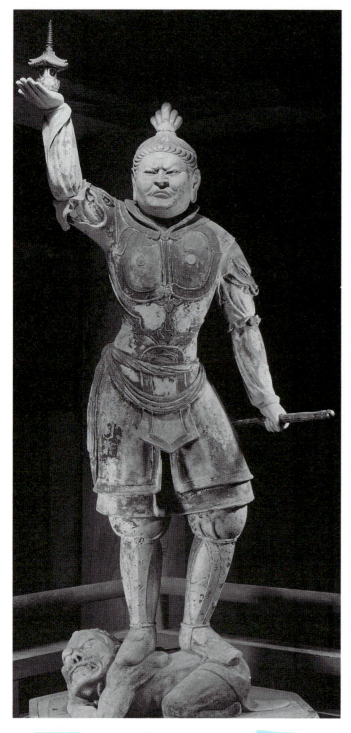

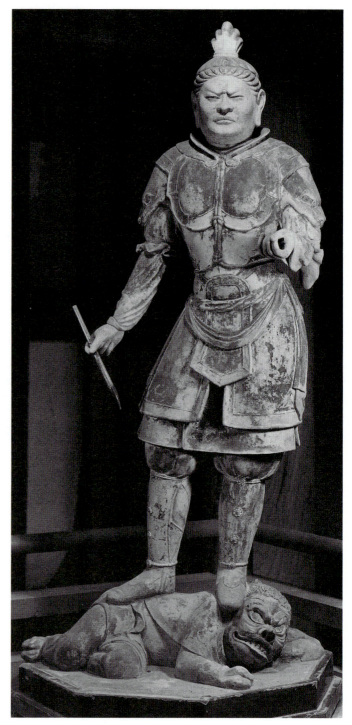

89. Tamonten, in the *kaidanin* (ordination hall), Tōdaiji. Mid-8th century. Clay, with remains of paint; height 64¾ in. (164.5 cm)

90. Kōmokuten, in the *kaidanin*, Tōdaiji. Mid-8th century. Clay, with remains of paint; height 64 in. (162.7 cm)

images, were added to the Hokkedō altar, but the later nomenclature will be retained here for the sake of clarity.

The Nikkō and Gakkō, crafted in clay over a wooden armature, are superb examples of mid-Nara–period clay sculpture. However, they are much smaller than the Fukūkenjaku Kannon and are made of a different material. Therefore, Japanese art historians regard them as "guest" sculptures on the platform, images not originally intended for the Hokkedō. They are serene and gentle, their smooth, round faces articulated by elongated, barely opened eyes and closed, full lips, their bodies covered by an undergarment with narrow sleeves and an outer robe that falls in soft, pleasantly irregular folds. Yet the images have been subtly individualized. Nikkō wears a garment that is open across the chest and closed toward one side like a priest's robe. His crown is placed low on his head, so the jewel in

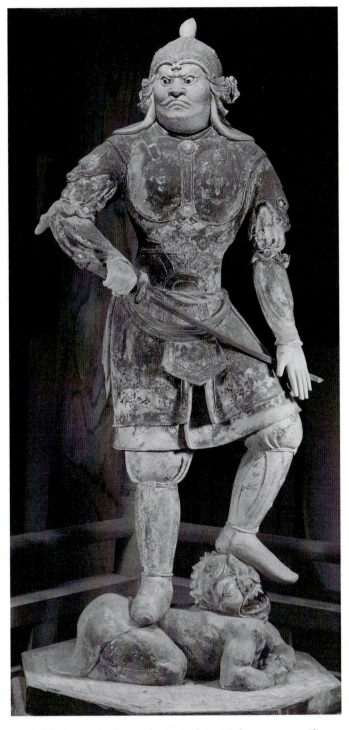

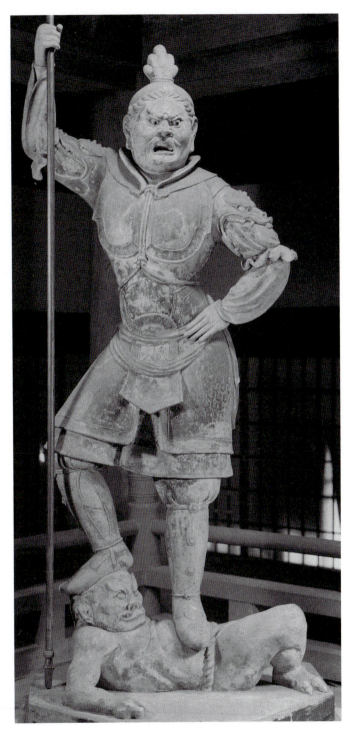

91. Jikokuten, in the *kaidanin*, Tōdaiji. Mid-8th century. Clay, with remains of paint; height 60 in. (152.4 cm)

92. Zōchōten, in the *kaidanin*, Tōdaiji. Mid-8th century. Clay, with remains of paint; height 64¾ in. (164.5 cm)

the center just touches his forehead. Gakkō wears an outer robe caught at the neckline by a lotus-blossom ornament and tied at the waist with a long ribbon that falls almost to the ground. His crown is placed higher on his head, and the central jewel touches only his hair. One of the reasons scholars have identified these two images as Bonten and Taishakuten is the bulky appearance of their bodies beneath the drapery, which has led to the speculation that

they are wearing armor under their robes. The suggestion that, as protectors, the Bonten and Taishakuten wore clothing over armor is certainly plausible.

In the *kaidanin* (ordination hall) at Tōdaiji is a set of the Four Guardian Kings, the Shitennō, (figs. 89 to 92) that bear a striking resemblance to the Nikkō and Gakkō in the Hokkedō. Like those images, the Four Kings in the *kaidanin* are modeled in clay over a wooden armature, and

have roughly the same dimensions, about 64 inches (1.63 m) tall, compared to the Nikkō and Gakkō, about 81 inches (2.06 m). The Shūkongōjin, the hidden clay image of the Hokkedō, is about 68 inches (1.74 m) tall.

The Four Guardian Kings are superb sculptures, displaying great sensitivity of handling and an effort on the part of the artist to create individualized images. The figures all wear armor over—rather than under—cloth robes, and no two images are quite the same. Each figure holds his specific attribute, Tamonten the reliquary, Kōmokuten brush and scroll (original is lost), and Jikokuten a long sword. Zōchōten's right arm is raised as if to hold a lance ready to throw; the original weapon has been lost. Two of the figures stand in hip-slung poses, one foot on the back of a demon, the other on his upraised head; the other two kings stand with both feet firmly planted on the backs of evildoers. The figures of the north and south both have raised right hands, and those of the east and west keep their hands at waist level or below. Undoubtedly these pieces were made for a small platform with intimate viewing conditions, where the similarities and dissonances of form could be appreciated.

This set of the Four Guardian Kings in the *kaidanin* share with the Nikkō and Gakkō and Shūkongōjin of the Hokkedō a quality of naturalism expressed through taut, springy forms. Whether or not these seven images were made to be placed together on a particular altar cannot be established, but it seems likely that they were made in the same atelier and should be dated to the middle of the 8th century. They are truly some of the finest pieces produced in the Nara period.

On the main altar platform of the Hokkedō, with the Fukūkenjaku Kannon and its flanking Nikkō and Gakkō images, are the Bonten and Taishakuten, a set of the Four Guardian Kings, and two Kongō Rikishi figures. The Kings and the Rikishi images, executed in hollow dry lacquer, are about the same height, 117 inches (3 m), and share a common style. They display solid, three-dimensional bodies and drapery that falls in graceful patterns, and their faces are molded convincingly into scowling expressions. However, in contrast to the clay Shitennō, these images are a little stiff.

The Bonten and Taishakuten (fig. 93) form a sharp contrast with the other images on the altar, mainly because of their size—they are both about 13 feet (4 m) tall—but also because of their poses. Whereas the Fukū-kenjaku Kannon suggests springy tension, and the Kings, controlled aggression, these two figures stand quietly, with their arms gracefully extended forward. They are impressive because of their over-life-size dimensions, not their inner vitality. Bonten and Taishakuten figures began to appear in conjunction with the Four Guardian Kings in the 8th century. This large pair was probably made in the official Buddhist workshop, but whether or not they were intended specifically to accompany the Kannon, the four Kings, and the two Kongō Rikishi in the Hokkedō is diffi-

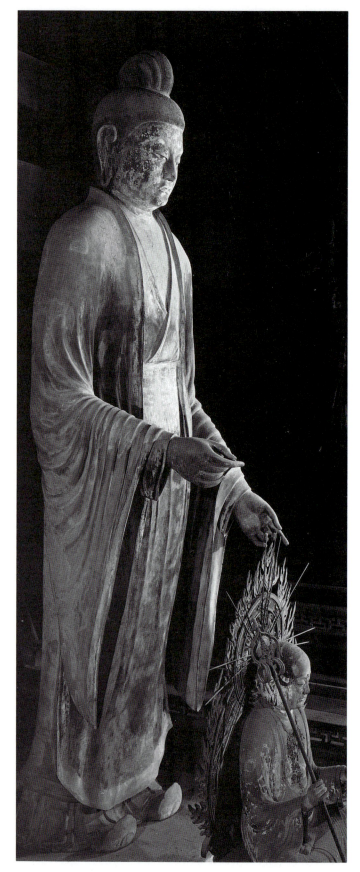

93. Taishakuten (with Jizō below), in the Hokkedō, Tōdaiji. 2nd half 8th century. Dry lacquer, with paint; height 13 ft. 3 in. (4.01 m)

cult to say. Many scholars place the dates for these images in the late 750s, on the basis of slight differences in style from the Kannon, which was made in the 740s, and on the assumption that work on the statues in the Daibutsuden demanded so much time and money that no other projects were undertaken until the work on the main worship hall was finished.

### Daibutsuden

Some idea of the scale and the magnificence of the Daibutsuden and its colossal buddha can be gained from a 12th-century narrative scroll, the *Shigisan engi emaki* (colorplate 8). The last section of the story, told in words and pictures, deals with an elderly nun who journeys to Nara to pray to the Great Buddha (the Birushana Buddha at Tōdaiji) for a revelation of her younger brother's whereabouts. We see her to the right at the doorsill, looking up reverently as she prays to the Buddha. Next she sleeps through the night near the base of the statue, and the next day makes her farewells, having been told in a dream where to look for her brother. The story and the illustration have a charmingly naive quality, but they also testify to the importance of Tōdaiji and the authority of the Birushana. Burned in 1180 in the Genpei Civil War, the Daibutsuden was a huge building by any standards, eleven bays long by seven bays deep, a rectangle 285 feet (87 m) long by 170 feet (52 m) deep and 154 feet (47 m) high. The Birushana Buddha is some 52 feet (16 m) tall, its size augmented by the large gold halo behind it, which is decorated with innumerable seated buddhas and bodhisattvas.

The image enshrined in the Daibutsuden today is a reconstruction of 1692. Additional evidence for the original appearance of the Birushana can be found in the engravings on the bronze lotus petals surviving from the original pedestal. Each petal, according to the *Kegon kyō*, or *Kegon Sutra* (also known as the *Flower Ornament Sutra*, Skt. *Avatamsaka Sutra*), represents a universe administered by Shaka and his attendant bodhisattvas (fig. 94). Here Shaka appears as a fleshy figure with a swelling chest and the suggestion of a double chin above the three beauty rings of his neck. A surprising detail is the elaborateness of the Buddha's garment, which falls in a welter of swirling folds over his lap. Nevertheless, the figure preserves the naturalism and the elegance common to sculptures of the period.

### Shōsōin

In 756 Emperor Shōmu died, and his consort, Empress Kōmyō, donated to the temple hundreds of objects associated with the imperial family, as a memorial to him. These and the articles used in the eye-opening ceremony are housed in a building known as the Shōsōin. The secular objects presented by Kōmyō are kept in the northern room of the structure and provide scholars with valuable information about the lives of the nobility in the late 7th and early 8th century. Some idea of the importance of the

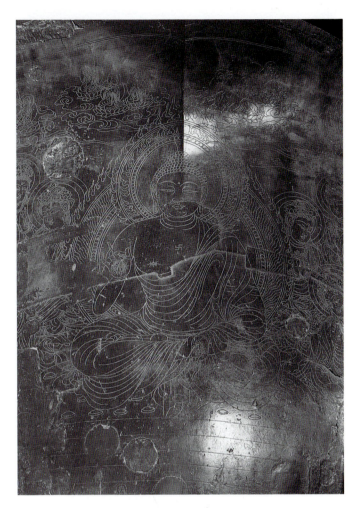

**94. Shaka on a lotus petal,** engraved on the base of the Daibutsu (Great Buddha), Daibutsuden, Tōdaiji. 8th century

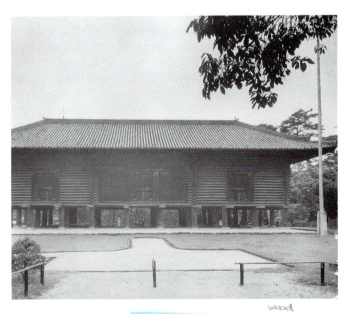

**95. Shōsōin,** Tōdaiji. 756

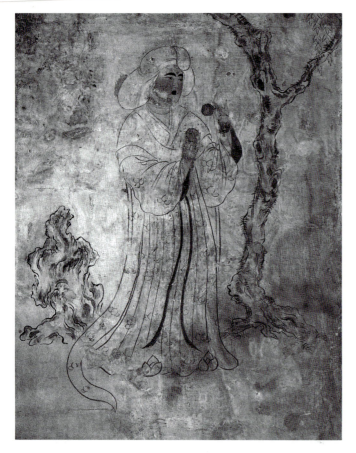

**96.** Lady under a Tree, detail of screen panel, in the Shōsōin, Tōdaiji. c. 752–56. Ink and color on paper; height 49½ in. (125.7 cm)

functioning storage facility by 761. From 1883 until 1953, when the first of two new concrete storage facilities was built to house the collection, each autumn after the typhoon season had passed the contents were removed from the building and aired in the dry fall air, a homey but essential process known as *mushiboshi*. A certain kind of homage is paid to this rite each year in the autumn, when a special exhibition of the collection is held in the Nara National Museum.

A particularly valuable group of paintings preserved in the Shōsōin is a set of six panels from a folding screen, each depicting a beautiful woman standing under a tree (fig. 96). The screen can be dated between 752 and its donation to the Shōsōin in 756, because a scrap of paper bearing the date of 752 was pasted to the backing of one of the panels, and is attributed to a Japanese rather than a Chinese artist. The screen is remarkable for the fact that the faces and other exposed areas of the women's bodies were painted in strong pigments, but the hair and the garments were sketched in black ink, or sumi. Originally, pheasant feathers were pasted to the screens to cover the undetailed areas, imparting to the surface a rich coloration and a tactile quality. However, the importance of the screen is that it documents the knowledge the Japanese had of Chinese figure painting in the 8th century. The theme, young court ladies under gnarled old trees, was popular in the Tang dynasty, and apparently a Japanese artist was familiar enough with it to create images of plump court ladies with full, pink cheeks, thick eyebrows, and elegantly elongated eyes.

Another work of great interest is a biwa, a lute, with a landscape painted on its leather plectrum guard (colorplate 9). In the foreground is a group of entertainers, a Central Asian, recognizable by his bony, Occidental face, and three young children, riding on an elephant. Such figures are found often among the ceramic sculptures included in Chinese burial chambers of the Tang dynasty. However, the great interest of this piece lies in the treatment of the background. To the left, tall mountains with deep crevices rise sharply from the gorge through which the elephant and its cargo are passing, and in the distance to the right, hills cut occasionally by flat plateaus can be seen. This topography, frequently represented in Chinese painting, formed the point of departure for Japanese artists depicting landscape scenes. A reference to the fact that the Japanese saw this configuration of mountains as "Chinese" can be seen in the pictorial biography of Prince Shōtoku of 1069 (fig. 144 and colorplate 21).

## Tōshōdaiji

In 754 the Chinese priest Jianzhen (688–763), known in Japanese as Ganjin, arrived in Nara with the expressed purpose of bringing to the Japanese clergy the teachings of the Ritsu (Skt. Vinaya) school of Buddhism and, more importantly for the Japanese, the correct, complete ritual of

Shōsōin and its links with the imperial family can be gleaned from the fact that the north storage room and its contents are today overseen not by the temple but by the Imperial Household Agency.

The style of the Shōsōin building is of considerable interest (fig. 95). It is constructed in a style known as *azekura,* or granary, in which pieces of wood triangular in section are placed one above the other in such a way that at the corners of the building the logs of one side interlock with those of the adjacent wall, obviating the need for the standard post-and-beam construction. The triangular shape of the timbers forming the walls results in a smooth surface on the inside of the building, a corrugated one outside. In order to reduce moisture damage to the contents of the storehouse, the body of the structure is raised off the ground by round logs almost 8 feet (2.4 m) tall, which are set on stone bases. The *azekura* style of building is frequently seen in temple complexes as a sutra repository, but such structures are rarely as large as the Shōsōin, which consists of three separate units joined together. The north and south sections are built in the *azekura* style, while the middle, possibly a later addition, is made of sawn planks stacked horizontally, and the whole structure is covered by a hipped tile roof. The exact year in which the Shōsōin was completed is not known, but it was a

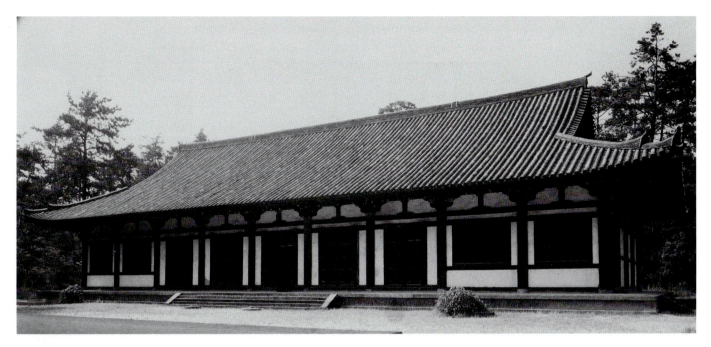

**97.** *Kōdō* (lecture hall), Tōshōdaiji, Nara. Mid-8th century

ordination for the clergy. According to Buddhist law it required a properly ordained cleric to perform the ritual for another, and despite the fact that monks from the continent visited Japan, some taking up residence, there seems to have been no one who could construct a proper platform and conduct a traditional, full ordination ceremony. In addition, the hierarchy of the clergy felt the need to establish rules of monastic governance based on Chinese precedents. The Church had long sought a priest fully ordained according to the traditional rules to introduce into

the monastic community, but Ganjin was the first to agree to undertake the commission. The journey from China to Japan across the China Sea was hazardous, and although he made his first try in 743, it was only on his sixth attempt in 753 that Ganjin finally arrived in Japan. By then an accident had rendered him blind.

In 755, an ordination platform was built at Tōdaiji, and some four hundred people, including the imperial consort Kōmyō, were properly ordained. Whatever the reason, Ganjin preferred not to take up residence at Tōdaiji,

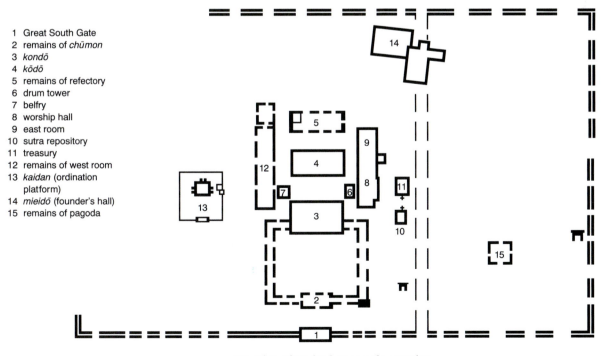

1 Great South Gate
2 remains of *chūmon*
3 *kondō*
4 *kōdō*
5 remains of refectory
6 drum tower
7 belfry
8 worship hall
9 east room
10 sutra repository
11 treasury
12 remains of west room
13 *kaidan* (ordination platform)
14 *mieidō* (founder's hall)
15 remains of pagoda

**98.** Plan of Tōshōdaiji temple complex

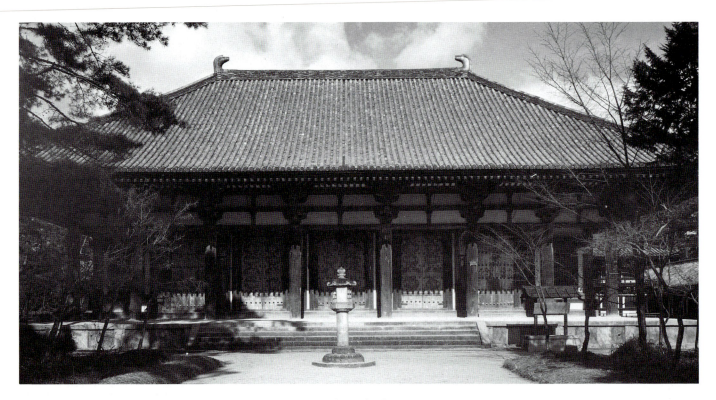

**99.** *Kondō, Tōshōdaiji.* 759

but rather to retire to a separate temple of his own. In 759 the first steps toward building his Tōshōdaiji were taken.

Although Tōdaiji was the premier building project of the Nara period, the style of architecture created by its builders—the craftsmen who were assembled by the bureau of construction—is best preserved at Tōshōdaiji, a private temple built with donations from aristocratic families, primarily the Fujiwara. It occupied a four-block site in the western part of Nara, very near Yakushiji. There are no clear records concerning the dates at which specific buildings were completed. The logical choice for the first building would have been the *kondō*, but it is quite possible that instead it was the *kōdō*, the lecture hall (fig. 97). This building was first constructed as the East Morning Hall in the Imperial Palace, but was subsequently dismantled and donated to Tōshōdaiji, possibly before Ganjin's death in 763. However, it is certain that the complex was not finished until the 9th century. The main area for worship consisted of the *kondō* and an entrance gate, linked by a roofed cloister that enclosed a rectangular courtyard between the two buildings, in the manner of Kōfukuji and Tōdaiji (fig. 98). Unlike earlier worship halls, the *kondō* has been modified to create a better harmony between interior and exterior space (figs. 99 and 100). The building is seven bays wide by four bays deep. The first bay, fronting on the courtyard, was treated as an open porch, making a gentle transition between the unroofed space of the yard and the enclosed space of the *kondō* proper. The rear bay of the building was screened off from view, as was the case at the Tōdaiji Hokkedō, while the space of the two central bays was dominated by the altar, which occupies about two-thirds of the area, the remainder allocated as an aisle. The long, low silhouette of the building projects a feeling of horizontality and stability, which is further emphasized by such architectural details as the bracketing system and the hipped roof. The three-stepped brackets represent the final development of the Asuka-Nara period. They are much more compact than earlier systems. The roof is a simple hipped shape with no crowning gable. The height of the ridgepole was raised 8 feet (2.5 m) in the Tokugawa period, making the pitch of the roof steeper. The Nara-period roof complemented the horizontality of the building, whereas the later roof gives it a more ponderous

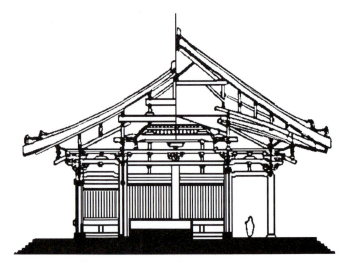

**100.** Split elevation showing the original *kondō* of Tōshōdaiji on the left and the Tokugawa-period rebuilding on the right

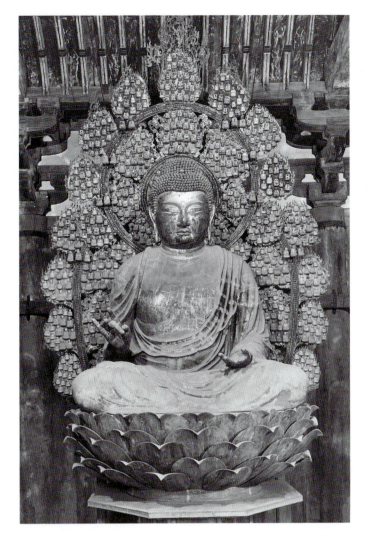

**101.** Birushana Buddha, in the *kondō*, Tōshōdaiji. 2ⁿᵈ half 8ᵗʰ century. Dry lacquer, with gold leaf; height 10 ft. (3.04 m)

**102.** The priest Ganjin, in the *mieidō* (founder's hall), Tōshōdaiji. 763. Dry lacquer, with paint; height 31¾ in. (80.6 cm) Nara

feeling. *Shibi* were attached toward the ends of the ridge-pole, in the manner of the building represented by the Tamamushi Shrine.

Two sculptures at Tōshōdaiji that can be dated to the third quarter of the 8th century are the central image on the altar, a Birushana Buddha probably made around 759 when the temple was first pledged, and a representation of Ganjin in the Founder's Hall, dated to the year of his death in 763. Both statues were made by the hollow dry-lacquer technique. The Birushana is a large image, some 10 feet (3.04 m) tall, completely covered with gold leaf (fig. 101). It is the largest dry-lacquer, seated buddha extant from the Nara period, and thus represents something of a technical breakthrough. However, it is the style that truly distinguishes it from contemporary images. The body is heavy and fleshy, but it is not modeled with the attention to naturalistic detail—the curving of the waist, the swelling of the chest—seen in earlier statues. The neck is short and almost as thick as the head. The profile of the face curves up and outward from the receding chin to the eyes and eyebrows, which are greatly elongated, extending

almost to the hairline near the ears. In contrast to the abstraction of the body and the face, the drapery flows in a simple pattern of irregular folds across the torso and the lap of the figure. The buddha is set against a wooden halo covered with hundreds of tiny images of seated buddhas, and the petals of the lotus-flower base originally had painted representations of buddhas and their attendant bodhisattvas.

Another unusual attribute of this Birushana Buddha is the fact that we know something about the people who made it. In 1917, when repair work on the statue was undertaken, an ink inscription was uncovered, listing the names of Mononobe Hirotari, Nuribe Otomaro, and Jōfuku. The Japanese scholar Sugiyama Jirō has interpreted this evidence to mean that Hirotari was an administrative assistant in the government-controlled Buddhist workshop who supervised the workers, probably Korean, who actually did the job. He suggests further that Nuribe Otomaro was responsible for the lacquer work and that Jōfuku was the monk from Tōshōdaiji who oversaw the progress of the project. Thus Sugiyama concludes that the Birushana was made in the official Buddhist atelier sometime in the early 760s, a conjecture supported by the quality of the image and the luxuriance of its halo.

The portrait sculpture of the priest Ganjin preserved in the Founder's Hall at Tōshōdaiji (fig. 102) is the earliest extant example of true portrait sculpture in Japan, although the urge toward capturing a lifelike image can be seen as early as 711 in the Yuima tableau sculpture in the Hōryūji pagoda (fig. 71). Ganjin is shown sitting cross-legged, his hands in the position for meditation, the lids of his blind eyes almost closed. The dry-lacquer medium has been used for maximum effect. The planes of the face, the musculature of the neck, the ribs, and the folds of the drapery have been carefully and naturalistically modeled, but with a minimum of specific detail to detract from the impressiveness of the form. The surface of the sculpture has been painted and the brocade patterns of the outer robe clearly delineated, forming a strong contrast with the flesh tones of the face and the solid red of the undergarment.

## Arts of the Late Nara Period

Two works that can be dated to the years between the late 760s and the early 770s because of their subject matter are representations of Kichijōten, the Indian deity Lakshmi, the goddess of wealth and good fortune. Worship of this divinity became popular in the years after 767, and prayers were offered to her in order to secure adequate rains and an abundant harvest. A clay image of Kichijōten has been preserved in the Hokkedō of Tōdaiji, dated to 772, when full-scale services were held in her honor at the temple, and a painting of the deity, dated to the same general period, exists in Yakushiji (fig. 103 and colorplate 10). Both works depict a beautiful Asian woman dressed in the robes of a Chinese court lady. The sculpture, now much damaged, presents the epitome of female beauty, a full round face, long narrow eyes, tiny rosebud mouth, and a full, elegantly curving body. The painting, in bright colors and gold on hemp cloth, also depicts an ideal Chinese beauty, a seemingly weightless figure moving through the air, her diaphanous scarves trailing behind her. They are superb examples of late Nara painting and sculpture.

Two transitional sculptures, a thousand-armed Kannon and a standing Yakushi, flank the Birushana Buddha (see fig. 101) in the main hall of Tōshōdaiji and show the changes in the treatment of Buddhist images at the end of the 8th century (figs. 104 and 105). The Yakushi can be securely dated to some time after 796, because one of the three coins placed in the cavity of the image is inscribed with that date. The thousand-armed Kannon—particularly revered by Ganjin as the protector of travelers—is thought to be somewhat earlier, perhaps from the decade of the 780s, the determination being based on the style of the image. Both statues are made using a technique new to Japan, dry lacquer over a wood core, as opposed to earlier statues, in which a clay core was used as a temporary

**103.** Kichijōten, in the Hokkedō, Tōdaiji. 772. Clay; height 6 ft. 6 in. (2.02 m)

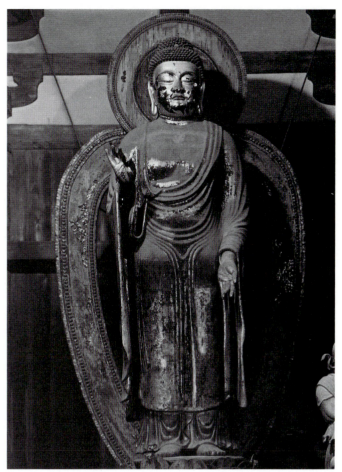

**104.** Thousand-Armed Kannon, in the *kondō*, Tōshōdaiji.
2nd half 8th century. Dry lacquer over wood;
height 17 ft. 7 in. (5.35 m)

**105.** Yakushi, in the *kondō*, Tōshōdaiji, Nara.
Late 8th to early 9th century. Dry lacquer over wood;
height 11 ft. (3.36 m)

body, supporting the lacquered cloth while it dried. Probably the technique was known to the priest-sculptors who accompanied Ganjin on his journey to Japan. Its appearance in the late 700s signals a new direction in Buddhist image-making, a return to wood as the preferred material for sculpture.

The eleven-headed, thousand-armed Kannon is a particularly interesting work. It is the only image in Japan to have had originally a full one thousand arms. Today, forty-seven have disappeared, but the remainder can be divided into three groups according to size. Six arms are normally proportioned for the figure. In addition, there are thirty-four of slightly smaller size, all holding attributes, and 913 tiny hands. Taken together they seem to surround the image like a second halo. Above the crown there are eleven heads, and in the middle a standing image of a buddha, an attribute of Kannon. The multiplication of heads and arms expresses the great efficacy of the deity. Another new element in the treatment of the Kannon is the stylization of the drapery, particularly the skirt. The cloth is pulled tightly over the thighs and falls in thick, regularly curved folds below the knees of the standing figure.

In the Yakushi the stylization has gone a bit further.

The drapery is articulated with deep folds, repeated in groups of three over the chest. Below the waist the robe is pulled tightly over the thighs and falls in vertical folds on either side of the legs. The figure is more corpulent than earlier statues, and has a somewhat square head, which seems to be set directly in the middle of the shoulders with hardly any neck in between. It is only a short step from this Yakushi image to the possibly contemporaneous standing Yakushi at Jingoji, outside Kyoto (fig. 123).

A group of paintings in a format new to Japan, the horizontal, illustrated narrative scroll, or *emaki*, depict scenes suggested by the *E inga kyō*, or more formally *Kako genzai inga kyō*, the *Sutra of Cause and Effect*. The eight horizontal illustrated scrolls depict the life of the historical Shakyamuni Buddha from his youth in his father's palace to his preaching to the faithful after he had attained enlightenment, as well as some episodes from his previous incarnations (colorplate 11). These eight scrolls are fragments surviving from several different sets, each by a different hand. Nevertheless these fragments provide some of the flavor of the original sets.

The *E inga kyō* is the first example of the *emaki* painting format—literally, rolled pictures—that will become

a distinctively Japanese form of expression.✦ In this format, text and illustration appear in close proximity on the surface of a horizontal scroll, which is unrolled from right to left. In this 8th-century scroll, the illustrations appear above the text rather than next to it, as they will in *emaki* of the late Heian and Kamakura periods. Furthermore, the amount of space allotted to each illustration is controlled by the text below, so that the two are strictly coordinated.

One of the most dramatic scenes is the temptation of Mara, the King of Evil, which occurs when Shakyamuni has been meditating and performing religious austerities in the desert for six years. Mara fears that once he attains enlightenment, the Buddha will be too strong a force for good in the world, and therefore tries to deflect him from his chosen path. First he sends his horde of demons to try to frighten him and when that does not work, he sends his beautiful daughters to tempt him. However, Shakyamuni is firm in his resolve and touches the ground in front of him, asking that the earth be witness to his spiritual growth. As he says this, a spring of water begins to flow on the ground in front of him. This episode in the life of the historical Buddha is the point of origin for the earth-witness mudra (Skt. *bhumisparshamudra*, J. *sokuchiin*). It is one of the most popular iconographic forms of Shakyamuni Buddha, particularly in Southeast Asia.

The scene is depicted in the upper part of the scroll, beginning with a tall mountain capped with trees and ending with a very similar landscape motif. In other words, the artist has created a space cell, the area between the two mountains, and peopled it with human and demon forms, Shaka in the center, Mara to the right, his two daughters to the left. The colors used are unshaded areas of red, orange, green, white, and black.

It is generally accepted that the *E inga kyō* scrolls belonging to the temples of Jōbonrendaiji and Daigoji were based on a Chinese prototype from the Sui or early Tang dynasty and were copied sometime during the years between 749 and 756. The illustrations have a fresh, naive quality that suggests the attitude toward Buddhism in Japan when the teachings of the historical Buddha were still new and still the focus of believers, a stage consonant with the middle of the Nara period.

---

✦ Since *emaki*, also called *emakimono*, can be held, opened, and perused, they are called hand scrolls in English. Hanging scrolls, *kakemono*, are vertically conceived scrolls intended for hanging on walls. *Kakemono* are often left open, although they may be kept rolled up and hung only for special occasions, while *emakimono* are routinely stored rolled up.

**Colorplate 1**. Painted wall with *chokkomon* design, Idera Tomb, Kumamoto prefecture. Late Kofun

**Colorplate 2**. Painted wall, Takehara Tomb, Fukuoka prefecture. Late Kofun

Kofun Period

**Colorplate 3**. Dark Warrior of the North, painting on north wall, Takamatsu Tomb, Nara prefecture. Late 7th to 8th century C.E. Color on plastered panel

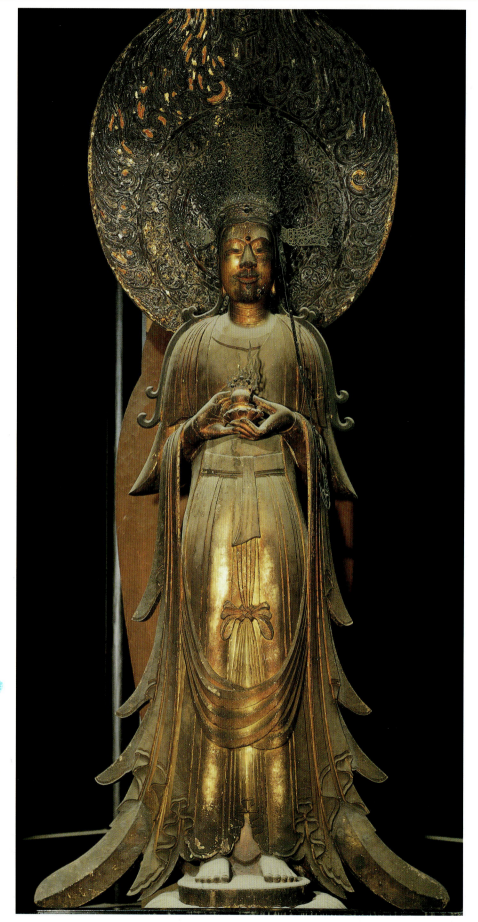

**Colorplate 4**.
Yumedono Kannon,
in the Yumedono
(Hall of Dreams),
Hōryūji, Ikaruga,
Nara prefecture.
Early 7th century.
Gilt wood; height 6
ft. 5½ in. (1.97 m)

**Colorplate 5**. Hungry Tigress Jataka panel, from the Tamamushi Shrine (fig. 51). c. 650. Lacquer on wood, with open metalwork borders. Hōryūji Treasure House, Hōryūji, Ikaruga, Nara prefecture

**Colorplate 6.** View of *hondō*, Yakushiji, Nara. Rebuilt 1980s after original of c. 730

**Colorplate 7.** Shūkongōjin, in the Hokkedō (Sangatsudō), Tōdaiji, Nara. 733. Painted clay; height 68½ in. (173.9 cm)

**Colorplate 8.** Daibutsuden at Tōdaiji, detail from *Shigisan engi emaki*, scroll 3. 2nd half 12th century. Ink and color on paper; height 12½ in. (31.8 cm). Chōgosonshiji, Nara

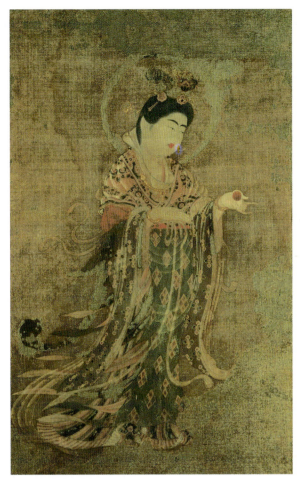

**Colorplate 9.** Entertainers Riding an Elephant, on plectrum guard of a biwa. 8th century. Painted leather; length 16³⁄₈, width 6³⁄₈ in. (41.7 x 17.5 cm). Shōsōin, Tōdaiji

**Colorplate 10.** Kichijōten. 3rd quarter 8th century. Color on hemp; height 20⁷⁄₈ in. (52.9 cm). Yakushiji, Nara

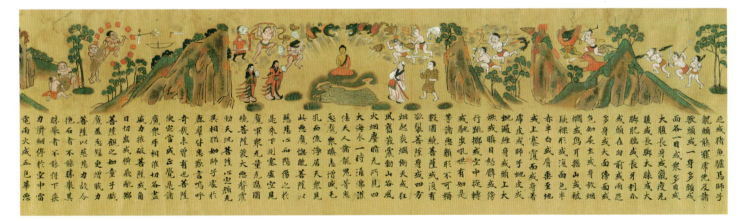

**Colorplate 11.** Temptation of Mara, detail from *E inga kyō*. Mid-8th century. Sutra scroll, ink and color on paper; height 10³⁄₈ in. (26.3 cm). Daigoji, Kyoto

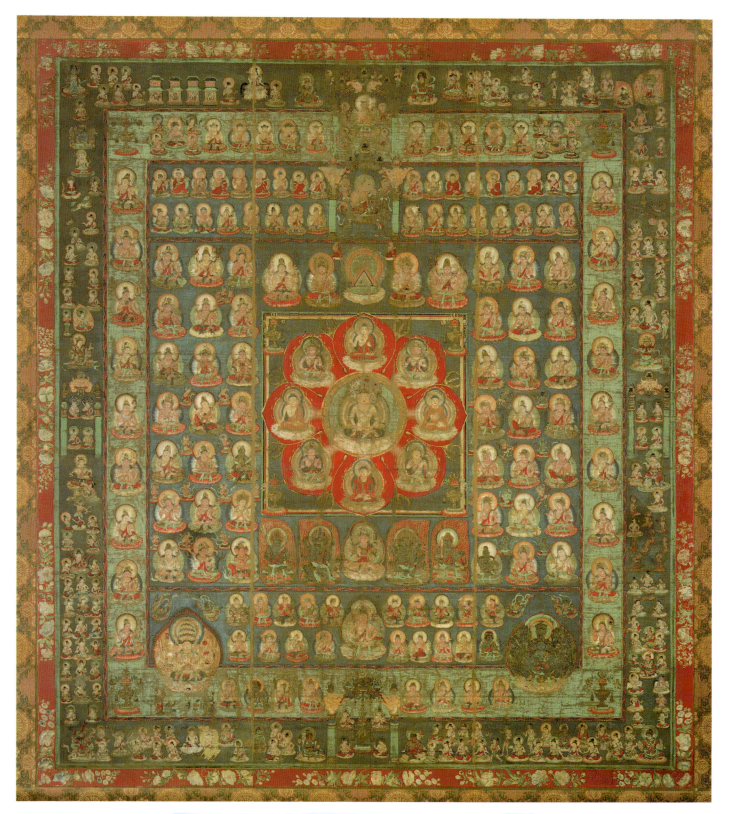

**Colorplate 12.** Taizōkai (Womb World) of Ryōkai Mandara, Kyōōgokokuji (Tōji), Kyoto. 2nd half 9th century.
Hanging scroll, color on silk; 72 x 60⅝ in. (183 x 154 cm)

Heian Period

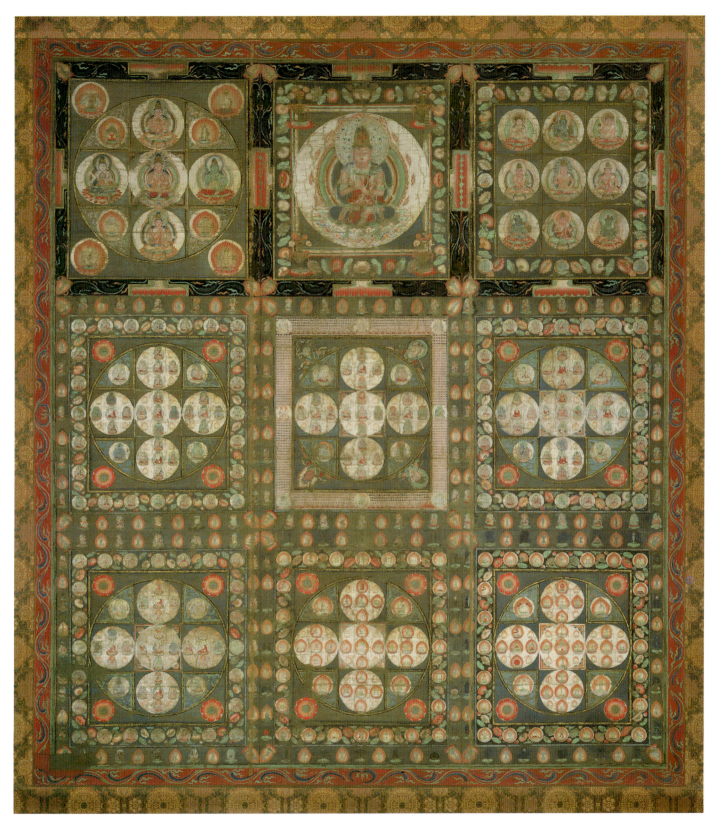

**Colorplate 13.** Kongōkai (Diamond World) of Ryōkai Mandara, Kyōōgokokuji (Tōji), Kyoto, 2nd half 9th century. Hanging scroll, color on silk; 72 x 60⅝ in. (183 x 154 cm)

**Colorplate 14**. Taizōkai Dainichi, west panel of the heart pillar in the five-storied pagoda, Shimo Daigoji. 951. Color on wood; height 8 ft. 8 in. (2.64 m)

**Colorplate 15**. Fudō Myōō. 12ᵗʰ-century copy of 9ᵗʰ-century original at Onjōji. Color on silk; 70¹/₈ x 31⁵/₈ in. (178.1 x 80.3 cm). Manshuin, Kyoto

**Colorplate 16**. *(opposite page, top)* Section of *Nenjū gyōji emaki*, scroll 3, scene 3, showing a cockfight at a nobleman's house. 17ᵗʰ-century copy by SUMIYOSHI JOKEI of the mid-12ᵗʰ-century original by TOKIWA MITSUNAGA. Hand scroll, color on paper; height 12¹/₂ in. (31.8 cm). Private collection, Tokyo

**Colorplate 17**. *(opposite page, bottom)* Hōōdō (Phoenix Hall), Byōdōin, Uji, Kyoto prefecture. 1053 2nd half of 11th c.

Middle to Late Heian

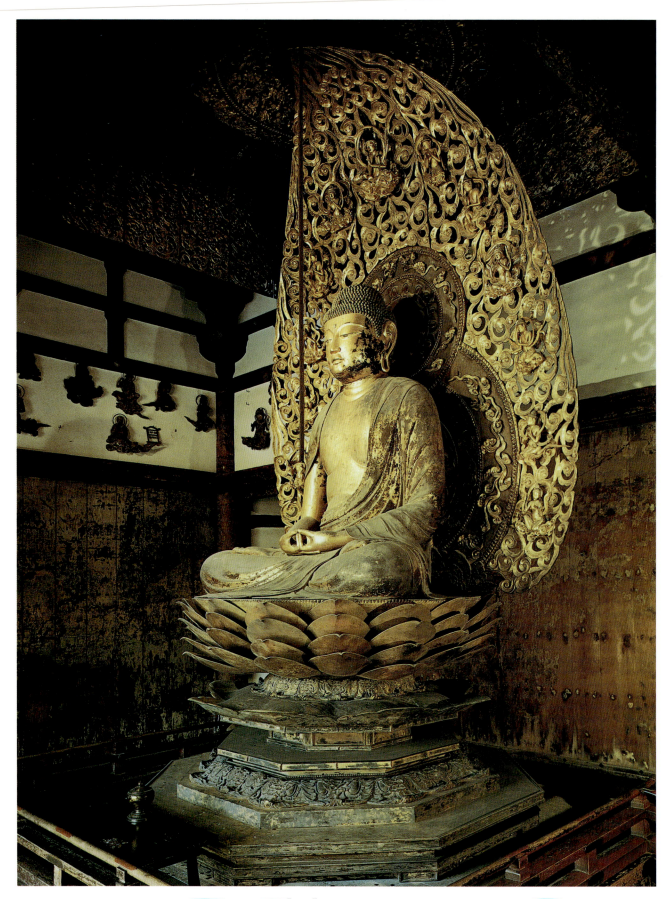

**Colorplate 18.** Amida Nyorai, by JŌCHŌ, in the Hōōdō, Byōdōin. c. 1053. Cypress wood, with lacquered cloth and gold leaf; height 9 ft. 2 in. (2.79 m)

*middle of late Heian*     *Phoenix Hall*

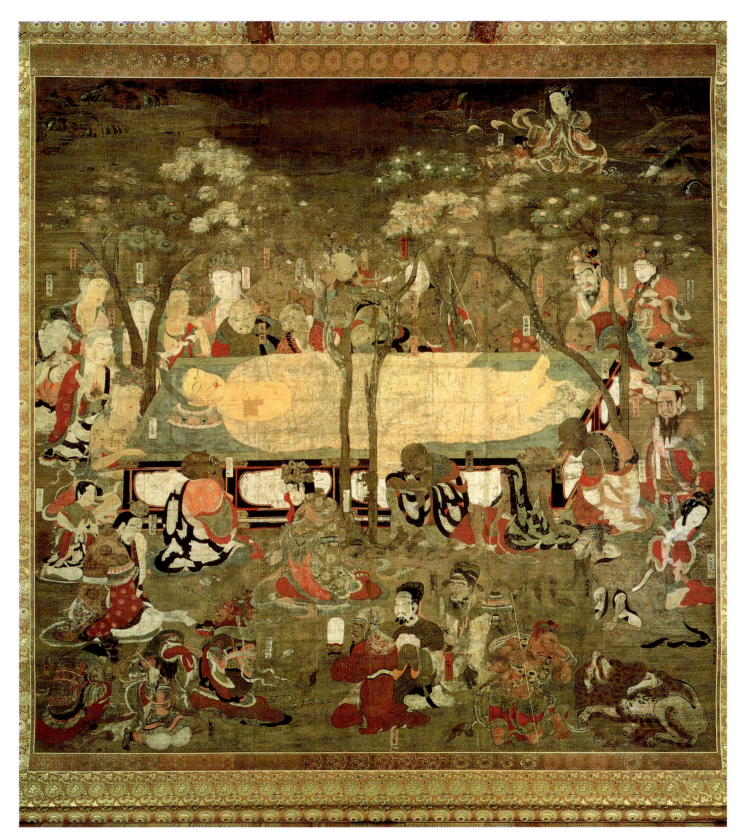

**Colorplate 19.** The Death of Shaka. 1086. Hanging scroll, color on silk; height 8 ft. 10 in. (2.69 m).
Yūshi Hachiman Association of Mount Kōya, Kongōbuji, Wakayama prefecture

**Colorplate 20.** Amida *raigō* triptych. Late 11th century. Color on silk; height 6 ft. 9 in. (2.11 m). Yūshi Hachiman Association of Mount Kōya, Jūhakkain, Kongōbuji, Wakayama prefecture

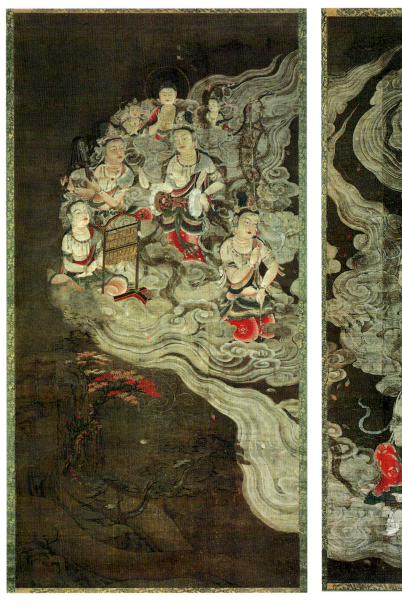

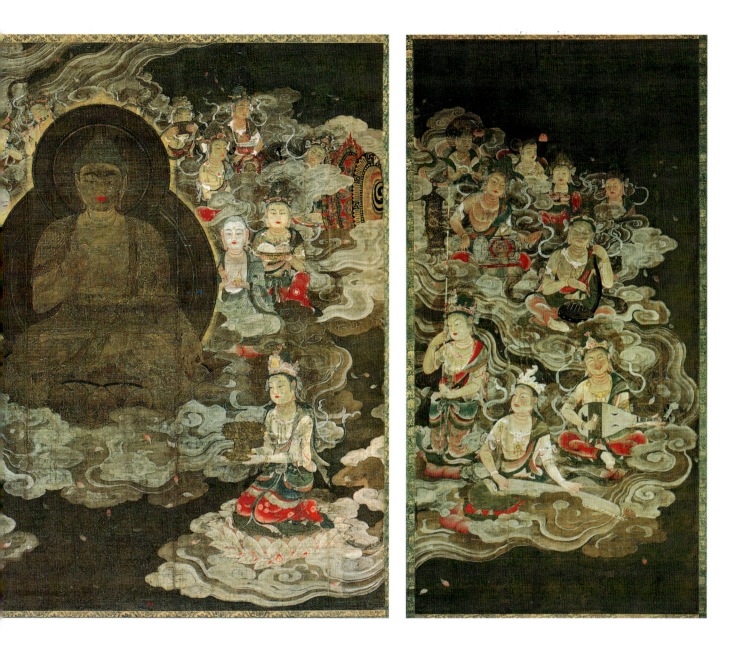

**Colorplate 21.** Section of the fifth panel, showing Shitennōji and, above, Prince Shōtoku
crossing the Japan Sea to China, from the *Shōtoku taishi eden*. One of five panels by HATA CHITEI, originally in
the *edono* (picture hall), Hōryūji. 1069. Color on figured silk; 6 ft. 1 in. x 9ft. 8 in. (1.85 x 2.91 m).
Hōryūji Treasure House, Tokyo National Museum

**Colorplate 22.** Shaka Nyorai. 12th century. Hanging scroll, color on silk; 62¾ x 33⅝ in. (159.4 x 85.5 cm). Jingoji, Kyoto

**Colorplate 23.** Cover of chapter 27 of *Heike nōkyō*. 1164. Color on paper; 10⅝ x 10⅛ in. (27 x 25.8 cm). Itsukushima Shrine, Hiroshima prefecture

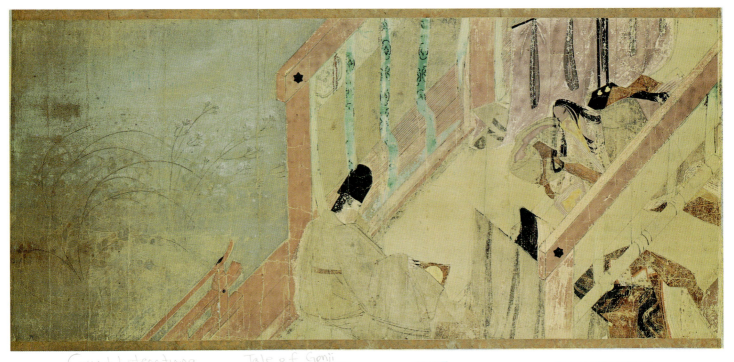

*(handwritten: Court Literature    Tale of Genji)*

**Colorplate 24.** Illustration from the Minori chapter of *Genji monogatari emaki*. 1st half 12th century. Ink and color on paper; 8⅝ x 19 in. (21.8 x 48.3 cm). Gotō Art Museum, Tokyo

*(handwritten: =The Rites    Written by Murasaki Shikibu c. 1000    painting dated to 12th c.)*

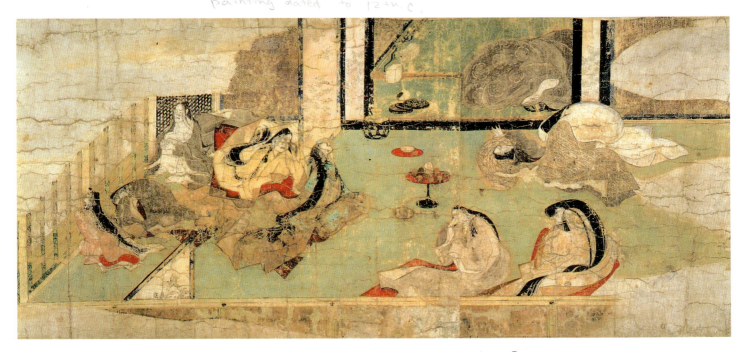

**Colorplate 25.** Scene from *Ban Dainagon ekotoba*, scroll 3, showing the Ōtomo household. Attributed to TOKIWA MITSUNAGA. 2nd half 12th century. Hand scroll, ink and color on paper; height 12⅜ in. (31.5 cm). Idemitsu Art Museum, Tokyo

# CHAPTER 3
# New Beginnings and the Formulation of Court Culture

## THE HEIAN PERIOD

The Asuka, Hakuhō, and Nara periods had been centuries of strong Chinese and Korean influence on Japanese religious and secular institutions. Buddhism—based on doctrines received from China, sometimes by way of Korea—dominated Japanese culture for two and a half centuries from the mid-6th century through the 8th century. The Buddhist Church had come to exert great power in secular politics; simultaneously, the Japanese developed their own distinctive artistic and cultural forms within their evolving Buddhist traditions.

The Heian period (794–1185) takes its name from the new capital established in 794 at Heiankyō, or Capital of Peace and Tranquillity, the city now known as Kyoto. The reason for moving the seat of government from Nara is not known precisely, but it is generally assumed that Emperor Kanmu (reigned 781–806) and the nobility wanted to break the political power of the six Buddhist schools based in Nara by physically relocating the seat of government. A new capital was begun in 784 at Nagaoka, southwest of Kyoto, but ten years later the site was abandoned after a series of fires and other calamities.

The place chosen for the new capital was a gently sloping plain in the Kansai, twenty miles north of Nara, surrounded on the east, north, and west by mountains and flanked by two relatively large rivers, the Kamo to the east and the Katsura to the southwest. The Heiankyō site satisfied the requirements of Chinese geomancy, which held that to ensure harmony and prosperity within the city, there should be protective mountains to the north, east, and west. Over time, the mountains came to be called the Eastern, Northern, and Western Hills (Higashiyama, Kitayama, and Nishiyama). Kyoto remained the capital of Japan for more than a thousand years, until the beginning of the modern period in 1868.

The Heian period has three distinct phases: Early Heian (794–951); Middle Heian, or Fujiwara (951–1086); and Late Heian, or Insei (1086–1185). The period sees a shift in power from the Buddhist Church to powerful clan families, the development of a highly refined court culture, and the flourishing of arts in the secular sphere. Buddhism was revitalized as a less political but more popular and widespread religion through the development of Esoteric sects and an increasing emphasis on devotionalism. The court at Kyoto, though small, dominated the religious arts through its patronage and the secular arts through both sponsorship and creative control.

## The Early Heian Period (794–951)

The period began with a close adherence to Chinese secular and religious precedents, but it ended with an overwhelming sense on the part of the Japanese that they had nothing more to gain from contact with China, that their country had surpassed its model. In 894 imperially sponsored embassies were abolished. Furthermore, as a new spirit of religious revivalism spread through the country, the Japanese people began to look afresh at their artistic environment—their architecture, painting, and sculpture—and to rework old styles and techniques to suit a newly emerging national taste. Two major events gave shape to the Early Heian period: the introduction from China of two schools of Esoteric Buddhism, Tendai and Shingon, and the building of the new capital at Kyoto.

## Kyoto and the Imperial Palace

Heiankyō was laid out in a rectangle that measured 2.8 miles (4.5 km) from east to west and 3.2 miles (5.2 km) from north to south (fig. 106). Its streets formed a grid pattern, following the design of the Chinese capital of Chang'an, modern-day Xi'an, with wide avenues running from north to south and smaller streets crossing from east to west. The rectangles formed by these major streets were numbered from *ichijō* the first ward in the north, to *kujō*, the ninth ward in the south. The palace enclosure, which included government buildings as well, occupied the four central blocks at the extreme north of the city, while the commercial districts were relegated to the seventh ward. The two temples allowed within the boundaries of the city, Tōji and Saiji, were in the ninth ward, guarding the southern boundary of the city, but also positioned as far away from the emperor and the bureaus of the government as possible. The Kyoto of today looks very different from its Early Heian ancestor. The city has shifted to the east and centers on the Kamo River, with its shallow, swiftly running water and cool summer breezes. Nevertheless, Kyoto retains its feeling of antiquity and is still one of the most beautiful cities in Japan.

| A | Daidairi (Greater Imperial Palace) | 6 | Rashōmon | 10 | Nishi Sanjōdono |
| 1 | Dairi (Imperial Residence) | 7 | Shinsenen | 11 | Western Market |
| 2 | Chōdōin | 8 | Ukyō-tsukasa (office of the right side of the capital | 12 | Eastern Market |
| 3 | Burakuin | 9 | Sakyō-tsukasa (office of the left side of the capital | 13 | Saiji (Western Temple) |
| 4 | Shingonin | | | 14 | Kyōōgokokuji (Tōji, Eastern Temple) |
| 5 | Suzakumon | | | | |

**106.** Plan of Heiankyō (Kyoto) as originally laid out

**107.** Shishinden, Imperial Palace, Kyoto. Rebuilt 1855 in Early Heian style

None of the original buildings in the palace enclosure still stand. The palace complex that exists today is located to the east of the original site, but research has established the original layout of the 9th-century imperial residence. The most imposing building within the walled enclosure was the Shishinden, used for major ceremonies of state. To the northwest of the Shishinden, connected by roofed corridors, was the Seiryōden, where the emperor lived and held informal audiences. Other buildings, housing the emperor's consort and ladies-in-waiting as well as such essential structures as the kitchen, a doctor's office, and storerooms for the imperial regalia, extended to the north and east of the two main buildings and were linked to them by covered walkways.

The current Shishinden and Seiryōden date to the 19th century and not the early 9th century, but at the time of rebuilding every effort was made to reproduce the originals. The contrast between the two structures offers considerable insight into the way in which Tang culture was assimilated in Japan in the 9th century. The Shishinden, being intended for ceremonial use, is an imposing building supported on tall pillars and capped with a massive double roof of cypress bark (fig. 107). The interior has a wood plank floor and large wooden platforms; panels depicting Confucian sages stand behind the platforms, forming a wall.

The Seiryōden, on the other hand, is much more intimate in scale. It is set on low pillars and has a single cypress-bark roof. Inside, tatami (woven straw mats) cover the wood floor. The back wall is formed by sliding doors (*fusuma*) decorated with Japanese-style landscapes. Some idea of the original appearance of the room can be obtained from an illustration in a 12th-century narrative scroll, the *Ban Dainagon ekotoba* (fig. 108). In this scene, the emperor, conducting an informal audience with the retired Fujiwara prime minister, sits on a pillow placed on a low, tatami-covered platform. His back is to a wall composed of sliding doors decorated with elaborate landscapes. Outside, on the veranda, an official messenger waits to hear the decision of the two lords. Behind him is a standing screen decorated with a Chinese-style, or *kara-e*, painting of Lake Kunming, the lake to the south of the Tang emperor's palatial retreat in Chang'an. In the last analysis, the Japanese looked to China for models for offi-

**108.** Illustration from *Ban Dainagon ekotoba,* scroll 1, scene 2, showing the interior of the Seiryōden, Imperial Palace, Kyoto. Attributed to TOKIWA MITSUNAGA. 2nd half 12th century. Hand scroll, ink and color on paper; height 12³⁄₈ in. (31.5 cm). Idemitsu Art Museum, Tokyo

cial public buildings, but their private rooms were distinctly indigenous in flavor, with occasional Chinese touches, such as the Lake Kunming screen.

## Esoteric Buddhism of the Tendai and Shingon Schools

The other major event of the Early Heian period, the introduction into Japan of Esoteric, or secret, Buddhism, was precipitated by the same loss of direction on the part of the Buddhist Church that had led to the relocation of the capital. The exoteric, or revealed, teachings and rituals of the six schools based in Nara were aimed at securing material benefits for the state and for their wealthy aristocratic patrons—spiritual attainment and enlightenment were not their main concern. The study of Buddhist texts was accessible only to a privileged few, usually the sons of the nobility, because to study them required a knowledge of the Chinese language and a well-trained mind. Furthermore, the government had limited the number of priests to be ordained in an effort to control the growth of the clergy. Common people turned to the Church for the performance of magic rituals that would bring their world under control, prevent calamities, promote a good harvest, and above all ease the path of loved ones into the next world.

There is little question that Emperor Kanmu wanted to curtail the power of the monastic community in Nara. He singled out and gave strong support to Saichō (767–822)—who is also known by his posthumous title of Dengyō Daishi—a Buddhist priest who rejected the worldly atmosphere of Nara Buddhism. Saichō was ordained in Nara, but he withdrew to Mount Hiei in 788, founding a hermitage in the pure mountain air far removed from the secular world of the court. Mount Hiei is to the northeast of present-day Kyoto, and when the capital was relocated to Heiankyō in 794, Saichō's temple, today the extensive complex known as Enryakuji, was in a most propitious location for guarding the city, according to Chinese principles of geomancy.

In 804, Emperor Kanmu gave Saichō permission to join an imperially sponsored embassy to China so that he could study Tendai Buddhism at its source, Mount Tientai (T'ien-t'ai), and bring back to Japan copies of as many Tendai texts as possible. Because Saichō had already achieved imperial recognition as one of ten Japanese priests allowed to serve in the palace, before he left for China he received all due formalities, a stipend, and a specific directive from the emperor. In China, where he focused on Tendai doctrine, Saichō also studied Ritsu, Shingon, and Zen Buddhism. But ultimately he preferred

the all-encompassing teachings of Tendai, which were centered on the *Lotus Sutra*, in Japanese the *Myōhōrenge kyō*. Also known by its Sanskrit name, *Saddharmapundarika*, the *Lotus Sutra* is one of the principal Buddhist sutras, a dramatic text presenting the all-embracing concept of Buddhist salvation. Basic to Saichō's thought was the concept that all human beings possess buddha nature—the inherently enlightened true nature of beings—and can become enlightened by realizing this nature within themselves. This can be done by widely available means—through meditation and diligence in living a moral life—and by such acts as initiation, which consists of confessing one's ignorant and harmful acts, and taking refuge in the Triple Treasure: the Buddha, the Dharma (teaching), and the Sangha (community of followers). Because Tendai doctrine is syncretic, synthesizing the sometimes competing doctrines of all the schools and texts of Buddhism into a unified system, it has been hospitable to new schools of Buddhist thought. Over the centuries Tendai, far more than Shingon, has proved to be fertile ground for the development of later schools.

On the same voyage of 804 that took Saichō to China, there was a student-priest by the name of Kūkai (774–835)—also known by his posthumous name of Kōbō Daishi—who journeyed to the Chinese capital of Chang'an and studied Esoteric Buddhism with Huiguo (Hui-kuo, J. Keika, 746–805). Huiguo was a great master who had gathered the elements of Esoteric Buddhism in China into a coherent system, but not into an independent sect, and who is considered the eighth patriarch of the Japanese Shingon sect. Shingon, or True Word teaching, is based not on the *Lotus Sutra* but on two other sutras, the *Mahavairocana Sutra* (Skt.), or *Dainichi kyō* (J.), and the *Vajrasekhara Sutra* (Skt.), or *Kongōcho kyō* (J.)

The philosophical basis for Esoteric Buddhism was developed in the 1st or 2nd century C.E. in India and presented the idea that the Buddha possessed two aspects: the phenomenal body (Skt. *nirmanakaya*), manifested by specific buddhas such as Shakyamuni, and the absolute or ineffable body (Skt. *dharmakaya*). The concepts of Esoteric Buddhism were brought to China in the early 8th century and transmitted to Japan a century later. The concept of the nonduality of the Buddha, that the phenomenal and the transcendental bodies of the Buddha were not separate entities but rather different manifestations of the same absolute principle, found expression in the Esoteric Mandalas of the Two Realms, in Japanese Ryōkai Mandara, or diagrams of the two worlds.❖ The Vajradhatu Mandala (Skt.), known in Japanese as the Kongōkai (Diamond World), presents the transcendental buddha Dainichi Nyorai in relation to the various phenomenal buddhas who have appeared at different times in different places. The Garbhadhatu Mandala (Skt.), or Taizōkai in Japanese (Womb World), depicts the phenomenal appearance of the various aspects of buddha nature: the merciful side is frequently represented by bodhisattvas with many heads and arms,

and the aspect symbolizing the power to subjugate evil is expressed often by wrathful figures with ferocious expressions and multiple eyes, heads, and limbs.

According to Shingon doctrine, the true mandala is the full perfection of buddhahood, enlightenment itself, and the Womb and Diamond mandalas are diagrams of this spiritual universe. Kūkai said that any person could attain enlightenment in this very existence through contemplation and rituals using the paired mandalas. The believer learns to visualize the symbols of the spiritual world that are depicted in the mandala and in so doing learns the three mysteries of body, word, and thought, which cannot be expressed in words. In early Shingon, the ability to read Buddhist texts was not necessary, but a good teacher and diligent attention to his instruction were crucial. The believer was encouraged to establish a personal relationship with the mandalas by tossing a blossom at each one. The image touched by the flower then became the believer's personal deity, and the teacher would give the student a special mantra, a group of mystic syllables, for recitation, and particular hand gestures, mudras, to be used in meditation. Through the repetition of a mantra, anyone could become one with Dainichi Nyorai and achieve enlightenment. Shingon contained the essential elements for developing a code of ethical behavior, but the ritual of worship and the recitation of one's mantra provided an easy and aesthetically pleasing way of striving for enlightenment, and the hard discipline of practices that expressed the philosophy Kūkai developed was often ignored by adherents.

Saichō returned to Japan in 805 and immediately began to teach the Tendai doctrines he had studied in China. He already had the backing of the emperor and so was able to move quickly to establish a monastic community at Enryakuji. Since he had been reordained at Mount Tientai, Saichō rightly believed that he could ordain others, and in 807 on Mount Hiei he performed the first Esoteric ordination ceremony in Japan, the *ichijōtai kai*, ordaining some one hundred followers. Although this ritual was very similar to ordination in the exoteric schools, in Tendai it was more of an initiation, necessary before the believer could commence studies. The Nara clergy objected strenuously, and further ordinations were not sanctioned by the court until 827, five years after Saichō's death. Nevertheless, in the years after that first ordination, Saichō was able to attract capable disciples who went on to advance the teachings of Tendai.

---

❖The Sanskrit word *mandala*, originally meaning circle, became *mandara* in Japanese, and is *mandala* in English. In Hinduism and Buddhism, *mandala* refers to a diagram of the spiritual universe, portrayed abstractly in the mind, in three-dimensional sculptural and architectural forms, and in two-dimensional images. In this book, Japanese mandala paintings and groups of sculptures are referred to by the Japanese word *mandara*, as in Takao Mandara.

When Kūkai returned from China in 806, he was not given permission by Emperor Kanmu to go up to the capital, even though in China he had been acknowledged as the successor of the Shingon patriarch. He was eventually permitted to go to Kyoto and was instructed to join the monastery of Jingoji in the mountains northwest of the capital, where he spent a good deal of the next fifteen years lecturing on the doctrines of Shingon and performing Shingon initiation ceremonies. At first Kūkai and Saicho were willing to share their knowledge with each other, and in the years immediately following his return to Japan, Saichō's perception of Buddhism shifted toward the Esoteric concepts of Shingon as preached by Kūkai. However, Kūkai was adamant in insisting that Shingon was the only "true word" of the Buddha, and that Saichō should give himself up to the study of it exclusively, while Saichō held to the Tendai understanding that along with the Esoteric practices of which Kūkai was the acknowledged master, it was also necessary to study meditation and other texts, like the *Lotus Sutra*. In the end a bitter rivalry developed between the two, and they went separate ways.

Saichō had the favor of the court, so it was not until 816 that Kūkai petitioned Emperor Saga for a grant of land on Mount Kōya, to the south of present-day Osaka, on which to build his monastery, Kongōbuji. It was only in 823, the year after Saichō's death, that Kūkai was given a temple in the capital. He converted Tōji, as it is still popularly known today, from traditional Buddhism to a teaching center for the Shingon sect, and renamed it Kyōōgokokuji, Temple for Defense of the Nation by Means of the King of Doctrines. From this time on through the mid-10th century, Shingon remained the dominant school of Buddhist thought in Japan.

### New Elements in Esoteric Worship

The introduction of Esoteric Buddhism brought many new ideas concerning temple planning and the buildings appropriate for Shingon worship as well as new rituals, methods of worship, and new divinities. Since the site for Tōji had been selected long before it was turned over to Kūkai to convert into a Shingon temple, it reflects the symmetrical layout of religious institutions constructed on flat land, rather than Kūkai's new formulation for the school's mountain temples (fig. 109). In 823, when Kūkai became abbot, only the *kondō* and a few other buildings had been completed.

Shortly after Kūkai's appointment he produced a design for the temple enclosure (fig. 110) that included a single pagoda, and a lecture hall (*kōdō*) in which he planned to install twenty-one images in a sculptural mandala. The pagoda was completed in 826, but the lecture hall, unfinished at the time of his death in 835, was not officially opened until 839. Kongōbuji better reflects Kūkai's influence, particularly in the structure known as the *tahōtō* (pagoda of many treasures). The original buildings con-

**109.** Aerial view, looking north, of Kyōōgokokuji (Tōji) compound, Kyoto

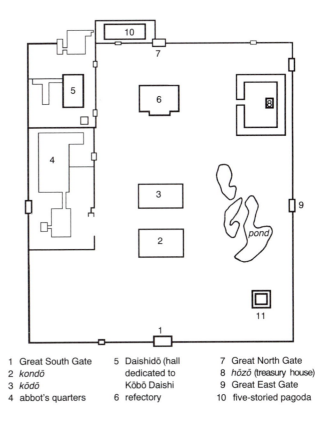

| 1 Great South Gate | 5 Daishidō (hall | 7 Great North Gate |
| 2 *kondō* | dedicated to | 8 *hōzō* (treasury house) |
| 3 *kōdō* | Kōbō Daishi | 9 Great East Gate |
| 4 abbot's quarters | 6 refectory | 10 five-storied pagoda |

**110.** Plan of Kyōōgokokuji (Tōji) compound

structed under Kūkai's direction no longer survive, but in the Kongō Sanmaiin, a precinct of Kongōbuji on Mount Kōya, a *tahōtō* built between 1222 and 1224 has been preserved (fig. 111). The building takes its name from one of the seven buddhas of the past, Tahō (Skt. Prabhutaratna), who is said to have come down from heaven in a similarly shaped reliquary when Shakyamuni began to preach the *Lotus Sutra* on Vulture Peak.

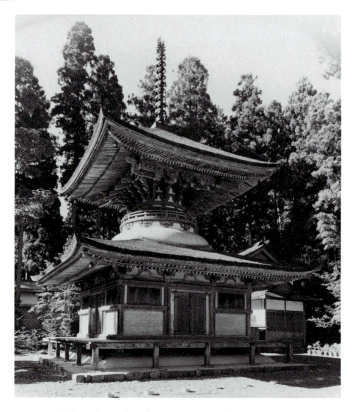

111. *Tahōtō* (pagoda of many treasures). Kongō Sanmaiin, Kongōbuji, Wakayama prefecture. 1222–24

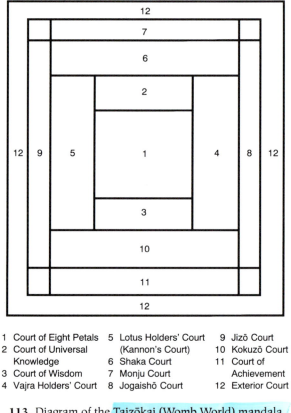

| | | |
|---|---|---|
| 1 Court of Eight Petals | 5 Lotus Holders' Court | 9 Jizō Court |
| 2 Court of Universal | (Kannon's Court) | 10 Kokuzō Court |
| Knowledge | 6 Shaka Court | 11 Court of |
| 3 Court of Wisdom | 7 Monju Court | Achievement |
| 4 Vajra Holders' Court | 8 Jogaishō Court | 12 Exterior Court |

113. Diagram of the Taizōkai (Womb World) mandala (colorplate 12)

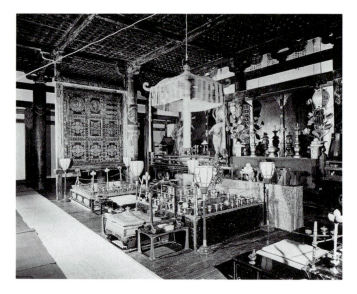

112. Interior of the *kondō,* Kanshinji, Osaka, with Kongōkai (Diamond World) mandala seen left of altar

The structure consists of a square first floor topped by a partial roof. Rising out of this shingled roof is a truncated hemisphere coated with white plaster, a direct reference to the shape of the Indian stupa. Capping this is a round wooden neck with a false gallery. A square shingled roof completes the building. The circle symbolizes the daily movement of the sun as well as the appearance of the earth to the individual looking toward the horizon. The square represents the world restructured to include the cardinal directions. The interior of the building is provided with a single square room on the first floor, and in the center a Dainichi is placed with four other buddhas in an arrangement similar to that in the *kōdō* at Tōji. Directly above the ceiling of the room a heart pillar rises to the spire atop the building.

Among the new Shingon objects for worship were pairs of mandala images, the Ryōkai Mandara, presenting diagrams of the two worlds, the Taizōkai, or Womb World, and the Kongōkai, or Diamond World. Usually these two paintings are hung in the inner precinct of a Shingon temple, the Diamond World to the east, the Womb World to the west of a low altar (fig. 112). The adherent is encouraged to concentrate on the paintings, first the Taizōkai, then the Kongōkai. Through meditating on the meaning of specific Buddhist deities, the worshiper learns to re-create their likeness in the mind's eye and thus internalizes their visual appearance and the concepts they symbolize.

The Taizōkai mandala is composed of twelve precincts or courts arranged in concentric zones and expresses the many facets of buddha nature, and by extension human nature, from the viewpoint of the Buddha's compassion (colorplate 12 and fig. 113). In the Court of Eight Petals in the very center of the rectangular painting, the supreme buddha of Shingon doctrine, Dainichi Nyorai, sits at the center of an eight-petaled lotus flower, his hands in a mudra of meditation. To the north, south, east, and west are buddha images, and on the petals in

|   |   |   |
|---|---|---|
| 5 | 6 | 7 |
| 4 | 1 | 8 |
| 3 | 2 | 9 |

1 Attainment of
   Buddhahood
   Assembly
2 Convention Form
   Assembly
3 Subtle Assembly

4 Offering
   Assembly
5 Four Hand–sign
   Assembly
6 One Hand–sign
   Assembly

8 Gōzanze Karma
   Assembly
9 Gōzanze
   Concentration Form
   Assembly

**114.** Diagram of the Kongōkai (Diamond World) mandala (colorplate 13)

between, there are four bodhisattvas. In the rectangles framing this central court are four additional precincts: immediately above the central rectangle is the Court of Universal Knowledge, and below it is the Court of Wisdom. The former depicts the inner forces that correctly channel the individual's emotions, while the latter presents the Godai Myōō, the Five Kings of Higher Knowledge, who destroy the individual's illusions. Visually enclosing these three rectangles are the Vajra Holders' Court to the right and the Lotus Holders' Court to the left. The images holding *vajra*, symbolic lightning bolts, represent the power of the intellect to destroy human passions, while the figures in the Lotus Holders' Court symbolize the original purity of all beings. The second and third layers of the mandala contain courts of bodhisattvas, and completely surrounding the mandala is the fourth, outermost layer, containing a multitude of guardian figures.

The Kongōkai, or Diamond World, mandala consists of nine rectangles or Buddha worlds and embodies the adamantine, or diamondlike, wisdom that pervades the universe (colorplate 13 and fig. 114). All the deities depicted are fully enlightened beings. In the center of the painting is the Attainment of Buddhahood Assembly, with Dainichi Nyorai in the center of the middle circle, surrounded by four bodhisattvas. At the center of each of the four circles around this central one are additional buddhas, surrounded by bodhisattvas making manifest the multiple functions of the four buddhas. At the center of

**115.** Dainichi Nyorai from the Taizōkai scroll of Takao Mandara, Jingoji, Kyoto. 1st half 9th century. Gold and silver paint on purple silk twill

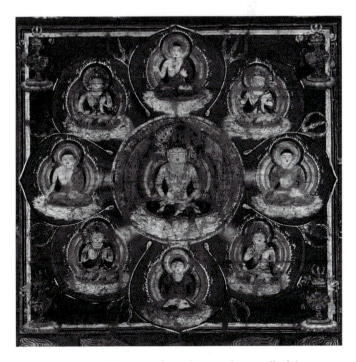

**116.** Dainichi Nyorai from the Taizōkai scroll of the Kyōōgokokuji (Tōji) Mandara (colorplate 12)

the upper register is a single image of Dainichi, his hands in the mudra most characteristic of him, the wisdom fist or *chikenin*. In this gesture the thumb of the right hand is folded into the palm and encircled by the other four fingers, while the index finger of the left hand is inserted from below into the fist. While the Taizōkai mandala's basic symbol is the lotus of compassion, the Kongōkai mandala's is the *vajra*, the diamond scepter of wisdom.

The pair of mandalas described above are owned by Kyōōgokokuji (Tōji) and are considered to be the oldest mandala paintings in bright colors still extant in Japan. Certainly they are the best preserved. Research by Japanese scholar Yanagisawa Taka demonstrates that these are Japanese copies of a set made in China on a commission from Emperor Montoku (reigned 850–858) and brought back to Japan by the Tendai priest Enchin in 859. The only comparable work thought to be older is the Takao Mandara pair preserved in Jingoji (named for Mount Takao, the site of the temple), which were executed in gold and silver pigment on damask dyed a deep purple. According to a temple tradition these were made by Kūkai himself between 829 and 833 in response to a request from Emperor Junna (reigned 823–834). Whether or not one believes the attribution to Kūkai, the figures in the Takao Mandara do reflect an earlier style than the Tōji Mandara and may be considered to have a more direct relationship to the mandalas Kūkai brought back from China. Scholars generally agree that the Tōji paintings were made sometime after the Takao Mandara, probably in the late 9th century.

A comparison of the Dainichi Nyorai figure from the Taizōkai scroll of the Takao Mandara and the Dainichi from the Tōji Taizōkai Mandara provides an excellent index to the changes in style that occurred during the second half of the 9th century (figs. 115 and 116). In the Takao painting the figure is given volume and solidity through the use of iron-wire lines in gold and silver, which describe the visible parts of its body and drapery. The deity is a gentle but elegant image sitting in a relaxed pose. The images in the Takao Mandara reflect the style of Chinese painting during the Tang dynasty as it was interpreted in Nara-period Japan. In contrast, the figures in the Tōji mandala project a tense energy. They are defined by red iron-wire lines, but they do not have the three-dimensionality of the Takao images. Shading is used, but rather than modeling the figures, it seems to create a decorative pattern over the surface of the painting. Some of the deities in the Tōji Ryōkai mandala are depicted with animated hand gestures, but their bodies display no capacity for movement. The Takao figures project some of the soft sensuousness of images produced in the Nara period, while the Tōji divinities reflect the new direction taken by Buddhist imagery in the 9th century.

While the Takao Mandara reflects the Tang dynasty style, at Tōji there is a group of paintings that were actually executed in China during that same period. This

117. The patriarch Amoghavajra, by LI CHEN (Chinese, active c. 800), from the set of seven portraits of Shingon patriarchs. Hanging scroll, ink and color on silk; height 6 ft. 9 in. (2.11 m). Kyōōgokokuji (Tōji), Kyoto

set of seven paintings depicts the Shingon patriarchs, both legendary and historical figures, who played important roles in the formation of the Shingon sect. Such paintings legitimated the age and authenticity of Shingon teachings and served as nonverbal confirmations of the importance of the master-pupil relationship. A set was given to Kūkai by his Chinese teacher Huiguo sometime before 806, when the Japanese priest left for home. However, in 821 Kūkai commissioned two additional portraits. In all probability Kūkai received a complete set, given that the seventh patriarch was Huiguo himself, and simply commissioned a Japanese artist to replace two paintings that were damaged.

From an inscription on one of the best-preserved paintings, that of the sixth Shingon patriarch Amoghavajra (fig. 117), we know that the Chinese artist Li Chen (active circa 800), a painter who worked in the traditional Buddhist style of the period, was associated with the production of the Chinese set. Amoghavajra (J. Fukūsanzō, 705–774) was born in India but was taken by his mother to Chang'an, where he studied with Vajrabodhi (J. Kongōchi), the fifth Shingon patriarch, until the latter's death in 741. He devoted the last years of his life to the translation of Buddhist sutras from Sanskrit into Chinese and is regarded as one of the four greatest translators of Buddhist texts in China.

**118.** The patriarch Nagabodhi, by a Japanese master, from the set of seven portraits of Shingon patriarchs. 1st half 9th century. Hanging scroll, ink and color on silk; height 6 ft. 9 in. (2.13 m). Kyōōgokokuji (Tōji)

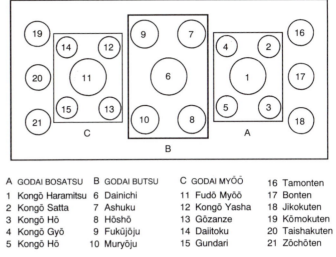

| A | GODAI BOSATSU | B | GODAI BUTSU | C | GODAI MYŌŌ | | |
|---|---|---|---|---|---|---|---|
| 1 | Kongō Haramitsu | 6 | Dainichi | 11 | Fudō Myōō | 16 | Tamonten |
| 2 | Kongō Satta | 7 | Ashuku | 12 | Kongō Yasha | 17 | Bonten |
| 3 | Kongō Hō | 8 | Hōshō | 13 | Gōzanze | 18 | Jikokuten |
| 4 | Kongō Gyō | 9 | Fukūjōju | 14 | Daiitoku | 19 | Kōmokuten |
| 5 | Kongō Hō | 10 | Muryōju | 15 | Gundari | 20 | Taishakuten |
| | | | | | | 21 | Zōchōten |

**119.** Diagram of the sculptural mandala, in the *kōdō* (lecture hall), Tōji

Given a gap of more than thirty years between Amoghavajra's death and Li Chen's effort, it is unlikely that the artist considered this or most of the other paintings in the set to be portraits in the Western sense of the word. Nevertheless, he has created a very realistic image which, given the identifying inscriptions on the painting, was understood by believers to be a representation of the person named. The depiction presents a monk deep in meditation. He has removed his shoes and sits on a rectangular raised dais, his hands in the "outer bonds" or *gebakuin* mudra, the hands pressed together, the fingers crossing on the outside, a gesture signifying release from the bondage of the passions. His head and hands are delineated by black iron-wire lines, and his protruding cheekbones and large nose are modeled through the use of gray over the flesh tones. The shading of his robe, dark blue to black, suggests the volume of the body. This portrait, if we may call it that, is not a flattering one. The revered priest is depicted as a non-Chinese with a knobby head. The artist even shows a tuft of hair growing in the patriarch's right ear. However, the painting succeeds on its own terms in presenting the image of a great teacher meditating intensely, his thoughts symbolized by the position of his hands.

Two paintings of Shingon patriarchs made in Japan present a remarkable contrast in execution to the Amo-

ghavajra. Nagabodhi (J. Ryūchi), the subject of one of these portraits, was an Indian priest who became the fourth Shingon patriarch (fig. 118). Not much is known about him except that he was thought to have been the best pupil of Nagarjuna (J. Ryūmyō), the second patriarch and the subject of the other Japanese-made portrait, a priest who lived from the mid-2nd to the mid-3rd centuries in India (not illustrated). Nagabodhi is also said to have taught Amoghavajra sometime after 741, making him several hundred years old. It seems most likely that he stands as a surrogate for the many teachers who transmitted Shingon doctrine from Nagarjuna, the first human to teach it, to the 8th-century patriarchs.

The painting depicts a portly Japanese-looking monk, sitting on a raised dais. The figure wears a red robe with narrow bands of black and in his right hand he holds a notebook, symbolic of the teachings he is transmitting; his left grasps a piece of his garment. His head is outlined with the same type of iron-wire line as the Amoghavajra painting, but there is very little shading to suggest the bone structure of the face. The garment is likewise described in terms of line with very little shading. Finally, the ear of Nagarjuna is rendered as an abstract pattern of curves undulating under and over each other. The ear canal is indicated by a gray tone applied in the upper part of the design, but the cartilage formation just to the right is treated as a linear design without any shading. The painting is a study of flat forms, lacking the intensity of the Chinese portraits.

Another group of works that demonstrate the transition from a classic Nara style to that of the Early Heian period are the twenty-one sculptures set on a large altar in the *kōdō*, the lecture hall, of Tōji (fig. 119). The nearly life-sized images represent buddhas, bodhisattvas, and Myōō (Kings of Higher Knowledge), as well as the Shitennō (the Four Guardian Kings) and Bonten and Taishakuten (Brahma and Indra) and are arranged on a

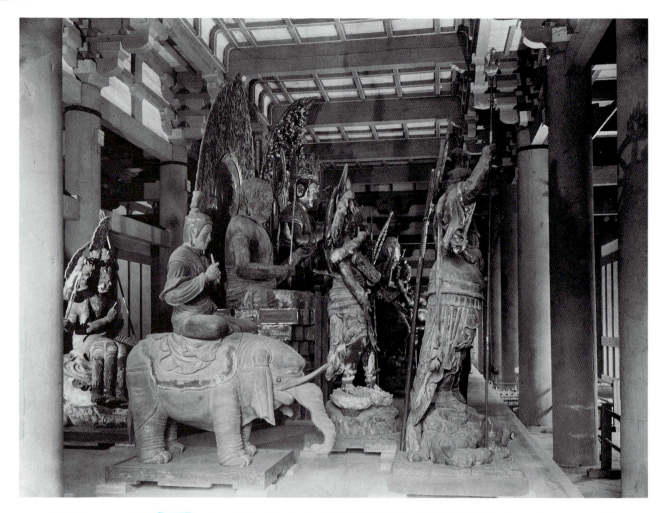

120. View toward the Myōō precinct of the altar, in the *kōdō*, Kyōōgokokuji (Tōji). Zōchōten is at the extreme right

1/2  9th c.

low altar as a kind of sculptural mandala. In the center of the platform is Dainichi Nyorai surrounded by four other buddha images.❖ To the east is a set of the Godai Kokūzō Bosatsu (Five Limitless Wisdom Bodhisattvas, Skt. Akashagarbha Bodhisattva), with four of them arranged around the most important one, Kongō Haramitsu (Skt. Vajraparamita). To the west on the altar are the Godai Myōō (the Five Kings of Higher Knowledge), again with four of them grouped around a central figure, here Fudō (Skt. Acala, the Immovable One), the most important of the Myōō. At the four corners of the dais are the Four Guardian King figures, and between them Bonten and Taishakuten. This arrangement, combining Esoteric deities with traditional figures from Nara Buddhism—the Four Guardian Kings, Taishakuten, and Bonten—is not based upon any known sutra and therefore probably represents Kūkai's own concept. His inclusion of deities prominent in exoteric Bud-dhism may have been an attempt to combine the old and familiar with the new in order to make the Shingon deities more acceptable. The *kōdō* in which they are installed was envisioned in Kūkai's original plan of Tōji, formulated shortly after he was appointed abbot in 823, but the eye-opening ceremony for the sculptures was not performed until 839, four years after his death.

Of the original twenty-one images, the five buddhas and the Kongō Haramitsu are later replacements. Today all of the images face south. However, the altar is located in the middle of the *kōdō*, facilitating circumambulation of the entire set of sculptures, and we know that in earlier times the statues to the extreme east and west of the mandala faced the viewer, who moved around the periphery of the hall and experienced more immediately the physical reality of the Shingon world of divinities.

Because the Myōō precinct of the altar, seen in figure 120, preserves all of its five original statues, it provides us

---

❖ New deities continued to enter Japanese Buddhism in the Heian period: the Myōō and the Godairiki Bosatsu, Five Power Bodhisattvas, are Esoteric Buddhist deities who are like traditional bodhisattvas in being fully enlightened, but differ in being wrathful forms of compassion: they use their great powers and terrific energy to vanquish evil. The Godai Kokūzō Bosatsu are the five Esoteric manifestations of aspects of the Kokūzō Bosatsu, known in Japan since the 8th century. Kokūzō is associated with wisdom as vast as the limitless sky.

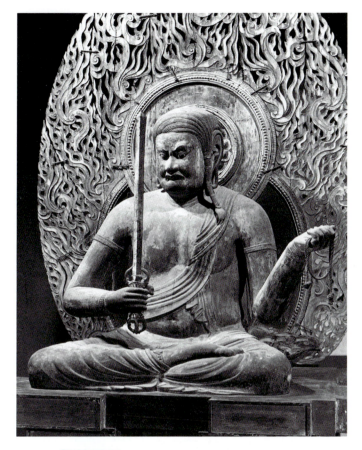

**121.** Fudō Myōō, in the *kōdō*, Kyōōgokokuji (Tōji). c. 839. Wood, painted; height 68¼ in. (173.2 cm)

1/2 9th c.

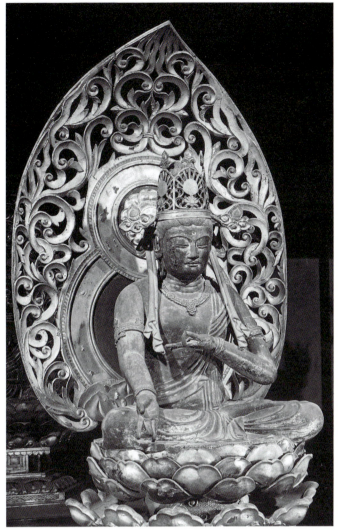

**122.** Bodhisattva Kongō Hō, in the *kōdō*, Kyōōgokokuji (Tōji). 1st half 9th century. Wood, with lacquer and gold leaf; height 37¾ in. (96 cm)

with the best idea of Kūkai's original concept for this sculptural mandala. This idea was to surround the huge, awe-inspiring central Fudō (the Immovable One) with the four other Myōō: Gōzanze (Skt. Trailokyavijaya, Subduer of the Three Worlds), Gundari (Skt. Kundali, Treasure-Producer), Daiitoku (Skt. Yamantaka, Great Awe-Inspiring Power), and Kongō Yasha (Skt. Vajrayaksha, Diamond Demon)—making these companion deities seem delicate by comparison, despite their strong poses and animated drapery.

Fudō presents the wrathful aspects of Dainichi, a parallel to Kokūzō bodhisattvas, who represent limitless generosity. The Fudō sits on a base composed of rectangular shapes intended as an abstraction of a rock formation (fig. 121). In his left hand he holds a lasso, and in his right he holds a sword with a *vajra* handle. His hair is pulled into a braid on one side of his head, and he has two tusks, which point upward. His eyes are wide open, but they appear to be looking down rather than at the viewer, and the expression on his face suggests power that is alert but held in check. His head is slightly turned, so he seems to be looking to his right. In spite of his frightening appearance, this divinity projects an impression of solidity and calmness. He is indeed the immovable one.

The Bodhisattva Kongō Hō (Skt. Vajraratna), in the southeast corner of the bodhisattva precinct, is very similar in appearance and technique to some sculptures of the

Nara period (fig. 122). Seated in the lotus position on his throne, the calm figure creates the impression of a gentle, compassionate deity capable of turning and bending in order to reach out to the believer. The elaborate patterns of his necklace, arm bands, and crown, combined with the gentle, natural folds of its garment, give the bodhisattva an elegance that rivals that of similar Nara-period deities.

The technique of the Myōō and the bodhisattvas is very similar. The majority of each sculpture—the head, the body, and the heart of the pedestal supporting the figure—is carved from a single block of wood, with cavities scooped out of the back of the head and the torso to prevent the wood from drying unevenly and causing surface cracks. The forearms and the fronts of the knees are carved from separate pieces of wood and joined to the central part of the statue. More pieces of wood were used for the Fudō than for the bodhisattvas, undoubtedly because of the size of the image. Details of the hair, the face, the upper part of the body, and the feet have been modeled in

*The Heian Period* 107

lacquer and adheared to the plain wood surface. Next, the bodhisattvas were coated with lacquer and covered with gold leaf, while the Myōō were covered with *gofun* and decorated in bright colors and rich textile patterns. This technique is very similar to that used for wood-core dry-lacquer statues such as the late-Nara-period standing Yakushi in the *kondō* of Tōshōdaiji (see fig. 105). It seems highly probable that the sculptors of the Tōji pieces were artists trained in a temple atelier at the end of the 8th century.

However, despite the stylistic and technical similarities between the Tōji bodhisattvas and the classic sculpture of the Nara period, there are several points of difference. The Tōji bodhisattva figures have grander bulk and more solid volume than earlier works. Also they have a sensuality that the earlier works lack. One Japanese art historian, Sawa Takaaki, associates this latter characteristic with Kūkai's preferences in sculptural style. A group of Buddhist statues reputed to have been installed at Kongōbuji by Kūkai himself were destroyed in a fire there in 1926, including two bodhisattvas, a Kongō Satta (Vajrasattva) and a Kongō Hō (Vajraraja), with much the same sensuality as the Tōji figures.

The Myōō, being new to the Buddhist pantheon, derive from a separate tradition of images probably imported into Japan in the form of iconographic drawings. It has been suggested that the Fudō in particular may have been sculpted following a drawing Kūkai might have brought back from China. The slight twist of the head is a device frequently found in such drawings, but one that makes little sense in the treatment of a sculpture used as the central motif in a constellation of five statues. The major characteristics of the image, the treatment of the hair and the tusks, and the pose of the figure on a rectilinear rock formation, constitute the beginning of a unique tradition of Fudō paintings and sculptures known today as the Daishi (Kōbō Daishi) lineage of images, which have been handed down in the Shingon sect.

## Jingoji

The earliest temple to reflect Esoteric teachings is Jingoji, near Mount Takao, in a beautiful, mountainous region to the northwest of Kyoto and far from the secular atmosphere of the clergy in Nara and the court in Kyoto. The temple had been pledged by Wake Kiyomaro (733–799) in connection with his efforts to block the priest Dōkyō's ambition to become emperor. Kiyomaro had been asked by Empress Shōtoku to travel to Kyūshū to ask the divinity of the Usa Hachiman Shrine about the propriety of making Dōkyō emperor (see note page 145). At that time Kiyomaro pledged to build a temple and make a buddha image, in addition to having certain sutras copied and some ten thousand other sutras chanted. However, when the god's negative reply was reported to the court, Dōkyō had Kiyomaro stripped of his ranks and sent into exile. It was not until after Shōtoku's death in 770 that he could begin

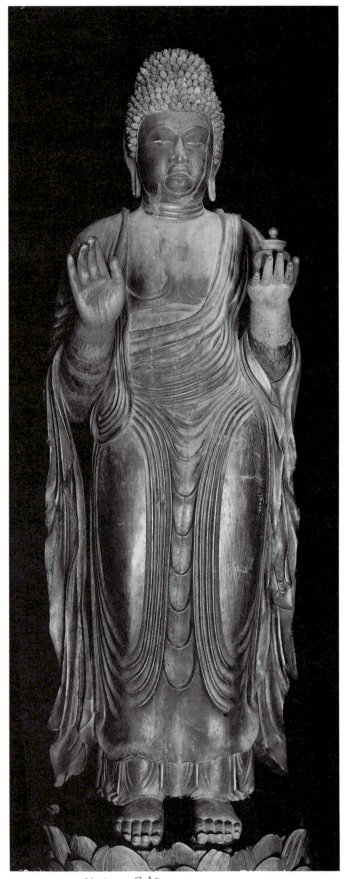

Medicine Buddha

**123.** Standing Yakushi, at Jingoji, Kyoto, c. 793. Cypress wood, with traces of paint; height 67 in. (170.3 cm)

JINGOJI

construction. The temple he built, Jinganji, was completed by 793, but in 824 it was combined with the temple on Mount Takao and renamed Jingoji.

In 809, when Kūkai was finally allowed to return to the capital after his trip to China, he was ordered to take up residence at Jingoji—because it was outside the city. In the next few years the temple provided the facilities for Kūkai's performance of *kanjō* (Skt. *abhisheka*), initiation rituals, the first for Saichō and the sons of the founder, Wake Kiyomaro, in 812. This ritual is performed several times as a pupil advances, and is intended to confer an aptitude for further study. Jingoji received considerable attention in the 9th century, but by the middle of the 12th century the temple was so dilapidated that it required the nearly superhuman efforts of the priest Mongaku to make it a viable religious institution again.

A standing Yakushi image in Jingoji is thought to be the main icon of Kiyomaro's Jinganji, probably completed by 793 and later moved to Jingoji (fig. 123). This figure of the healing Buddha is life-size and corpulent, its drapery cut into deep folds but pulled tight over the widest part of the thigh. It holds a medicine jar in its left hand and makes the fear-not gesture (Skt. *abhayamudra*) with its right. At first glance the Yakushi may appear to be facing directly forward in a flat-footed stance, but in fact there are subtle facets to its treatment that suggest it is actually turning slightly to the left. The left shoulder is a bit higher than the right, and the drapery folds on the left part of the torso are placed just a bit above those on the right. In other words, this Yakushi is possessed of a body apparently capable of normal movement, but at the same time it has a strange and unnatural appearance which, coupled with the brooding expression on its face, makes beholders reassess their first impression and rethink their approach to this divinity in order to receive its healing powers.

The sculpture is carved out of a single block of *hinoki* wood (Japanese cypress), and because cavities were not hollowed out of the back of the sculpture, the surface has sustained some serious cracks, now repaired. Traces of paint remain on the face: red on the lips, black over white for the pupils of the eyes, and blue on the snail-shell curls over the top of the head, with the remainder of the body left unpainted. This use of pure, unadorned wood worked in a technique of carving (described on page 110) that is pure *ichiboku*, or single-block construction, suggests to scholars that it may be one of the earliest works reflecting a movement to revitalize Buddhist imagery.

A number of theories have been advanced to account for the appearance at this time of *ichiboku* as a sculptural technique. The fact that single-block sculptures appear primarily in rural temples gives rise to a number of possible explanations. These temples lacked the monetary resources of such establishments as Tōji, having perhaps a single patron, and wood was the most available material from which to fashion images. A corollary to this explanation is the notion that provincial and untrained artisans,

perhaps even monks, carved these sculptures, thus accounting for the crudeness of their execution and their ungainly proportions. A more likely explanation is that a movement to revitalize Buddhist sculpture went hand in hand with the return to basic teachings encouraged by Emperor Kanmu, an attempt to make images unlike anything that had come before, imposing and awe-inspiring deities that challenged worshipers to rethink their relation to divinity.

This plain-wood style of sculpture seems to have begun in the Nara workshop at Tōshōdaiji in the late 8th century. The standing Yakushi on the altar of the Tōshōdaiji *kondō*, dated to the years after 796, has a wood core with dry lacquer applied to the surface, but preserved in the *kōdō*, or lecture hall, is another standing Yakushi dated to 760 that is completely without paint (not illustrated). Because of the temple's association with the Chinese priest Jianzhen (J. Ganjin), the Tōshōdaiji workshop had access to information about styles and techniques of sculpture being produced on the continent. In both China and India there is a long tradition of plain-wood sculptures executed in aromatic sandalwood. According to legend, the first image of Shakyamuni was carved in sandalwood for King Udayana of Kaushambi, and there is a lineage of Shakyamuni sculptures thought to duplicate that image. Indeed the Shaka statue brought to Japan in 987 by a Chinese monk, Chōnen, now installed in Seiryōji in Kyoto, was thought by the Japanese to be Udayana's sculpture. The Jingoji Yakushi, with its heavy facial features and fleshy body, and its distinctive drapery patterns, clearly reflects this continental plain-wood style.

Another factor contributing to the appearance of *ichiboku* as a sculptural technique at this time, besides continental influence, was the fact that new rural mountain temples of Esoteric Buddhism were returning to Japanese taste in the asymmetrical placement of their buildings and in the materials out of which they were made. Plank flooring was replacing stone, and cypress-bark shingles were preferred to ceramic tiles. Wood was readily available and cheap, and therefore a logical choice for sculpture as well as for architecture. A third factor was that there was undoubtedly a perceived need for a revitalization of Buddhism at this time: Wake Kiyomaro played a major role in blocking the further secularization of the religion under Dōkyō. The Yakushi is a visual statement of religious renewal—an austere and brooding, fleshy image which required serious efforts at communication on the part of the worshiper. Further, the fact that it was fashioned in the Indian and Chinese tradition of plain-wood sculpture made it a more authentic image, closer to the roots of Buddhism than more Japanese-style statuary. Lastly, since it was carved out of native Japanese *hinoki* and not painted, it retained something of the Shinto *kami* spirit of the original tree. The Yakushi is a perfect statement of the spirit of religious renewal prevalent in Japan in the late 8th and early 9th centuries.

There are two main techniques associated with wood sculpture in Japan: *ichiboku zukuri,* the carving of a single block, and *yosegi zukuri,* the assembly of multiple carved blocks. In carving an image from one block of wood, the sculptor must determine the final size of the piece before seeking the single wood block. This stage is known as *kidori,* literally, taking from the tree. Next, at the *arabori* stage, the sculptor subtractively carves away what is not needed and produces a rough approximation of the final image. The block is carved into nearly final form in the *kosukuri* stage. Finally, at the *shiage* stage, delicate details, such as drapery folds and facial features, are carved and the surface is usually coated with lacquer and gold leaf or *gofun* (gesso) and paint.

*Ichiboku* sculpture has one major flaw. The exterior of the image dries faster than the core and causes unsightly cracks, particularly if the surface has been treated, for example, with paint or lacquer. In order to

## SINGLE-BLOCK AND MUTIPLE-BLOCK WOOD SCULPTURE

prevent or minimize such damage, two other methods were developed: one involves cutting into the block either from behind or below and removing the wood at the center. With the other method, the finished statue is split once or several times along the grain of the wood and each section is hollowed out.

The technique that most effectively dealt with the cracking problem was *yosegi zukuri,* in which several rectangular blocks were individually selected and carved into the needed shapes: back of the head, back and front of the image, crossed legs, and so on. This multiple-block technique had many advantages. It produced a sculpture that was much lighter than an *ichiboku* work. Each type of piece could be assigned to an artisan-specialist (the carver of knees, for example), permitting the development of a true studio and of a kind of assembly-line production. This, in turn, enabled a studio to turn out large-scale images in a relatively short time.

## Murōji

Another mountain temple roughly contemporary with Jingoji, but better preserved than Jingoji, is Murōji, located in the mountains to the southeast of Nara. Even before the site was chosen for the construction of a Buddhist temple, it was considered sacred by the locals because of its unusual configuration of rocks and streams, created by volcanic action. The site was reputed to be the home of the dragon spirit Ryūkesshin and an efficacious place at which to pray for rain. In the late 700s the priest Kenkyo from Kōfukuji, the Nara temple of the Fujiwara clan, founded Murōji there largely because of the auspiciousness of the site. Through most of its history the temple has maintained this connection with Kōfukuji.

The buildings of the temple have been laid out in three levels (fig. 124). At the base of a mountain next to the Murō River are the residence halls for the monks. Midway up the mountain are the main buildings for worship: a *kondō*, or golden hall; a Mirokudō, or Miroku hall; a building for Esoteric initiation rites, known as the Kanjōdō, or Initiation Hall; and a five-storied pagoda. At the top of the mountain is the inner precinct. Of these

buildings only the *kondō* and the five-storied pagoda in the middle precinct have survived from the Early Heian period. They are attractive buildings sensitively fitted into small plateaus carved out of the mountain face. In Murōji we have excellent evidence for the actual appearance of an Early Heian mountain temple.

The five-storied pagoda is considered to be the oldest structure in the temple complex, dating to the late Nara period or the early years of the 9th century (fig. 125). The building is extraordinarily slender and about half the height of most pagodas, but because it is fitted into its own niche in the mountain, a setting that does not invite comparison with other buildings in the temple complex, it can be appreciated as a separate entity. Furthermore, the use of native materials such as cypress-bark roofing gives the pagoda a more informal appearance than the tiled roofs of earlier buildings and enables it to fit naturally into its environment. An architect with a high degree of talent and aesthetic sensibility must have created this building, because it is surely one of the most successful structures of the 9th century.

The *kondō*, like most buildings of a comparable age, has undergone innumerable repair efforts over the

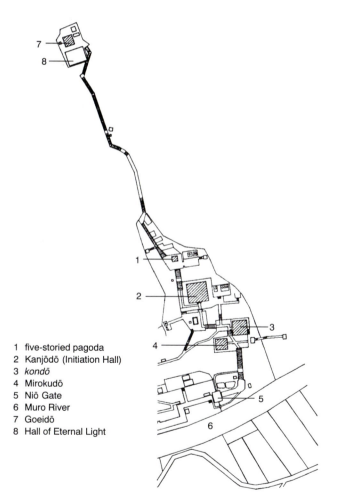

1 five-storied pagoda
2 Kanjōdō (Initiation Hall)
3 *kondō*
4 Mirokudō
5 Niō Gate
6 Muro River
7 Goeidō
8 Hall of Eternal Light

**124.** Plan of Murōji, Nara prefecture

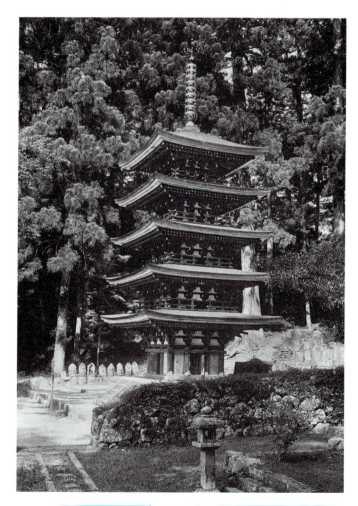

**125.** Five-storied pagoda, Murōji. Late 8th or early 9th century

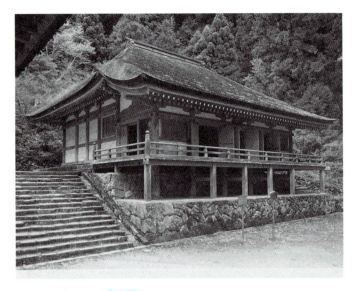

126. *Kondō*, Murōji. Early 9th century, with modifications of the early 13th century

[handwritten: Golden Hall]
[handwritten: Heian Period]

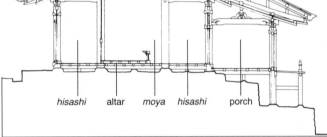

hisashi   altar   moya   hisashi   porch

127. Cross section of the *kondō* of Murōji, showing *moya*, *hisashi* (corridors), and added front porch

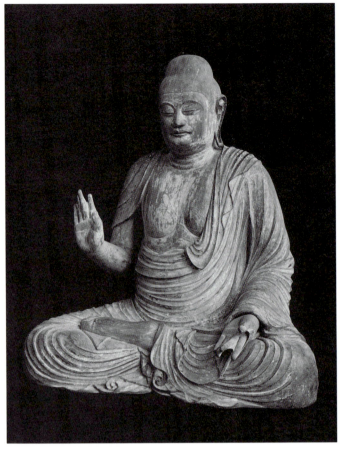

128. Seated Shaka, in the Mirokudō, Murōji. 2nd half 9th century. Cypress wood, with traces of *gofun* and paint; height 41 in. (104.1 cm) [handwritten: Muroji]

centuries and no longer has the graceful outlines and balance of the original structure (fig. 126). The hipped-gable roof and the façade of the first building are gone, because by the late Kamakura period (late 13th to early 14th century) a *raidō*, or worship hall, actually a one-bay-wide porch, was added across the front and the roof line was extended in an ungainly manner. Nevertheless, the building provides us with at least a glimpse of its appearance in the Early Heian period. It is set into a recess sculpted out of the mountain, the front supported by a masonry foundation. The original hall consists of a central rectangle, the *moya*, three bays wide and one bay deep, encircled by a one-bay-wide corridor (fig. 127). This central rectangle is further distinguished from the remainder of the hall by a separate latticework ceiling, in contrast to the exposed underside of the roof rafters visible above the porch. Dominating the space of the *moya* is a low altar, backed by a

tall wooden screen, on which five large standing images have been installed, with diminutive images of the twelve generals of Yakushi in front of them. The impression one gains from the interior is that of an intimate space, articulated by simple wood forms and a flat bracketing system parallel to the walls and supported on round pillars.

Murōji houses several major sculptures of the Early Heian period, but surely the most impressive among them is the seated Shaka installed in the Mirokudō (fig. 128). The figure, except for the knees and the forearms, is carved out of a single piece of *hinoki* wood. However, this image, unlike the Jingoji Yakushi, has cavities hollowed out of the head and the chest, the holes covered with pieces of wood sculpted to fit neatly into place. In the constricted space of this satellite building, the Shaka seems austere and overwhelming. The horizontal line of the crossed legs provides an ample base for the figure, but the heavy, massive torso and the huge head—which would have been even larger had its snail-shell curls not been lost—create a strong vertical. The fact that the sculpture is just barely in balance—he tilts as if falling forward—creates a tension between the viewer and the image, and this very tension makes the viewer look at the sculpture in a new way. In carving the statue, the sculptor has used a

pattern of folds known as the rolling-wave style, *honpa shiki,* in which one drapery fold is thick and sharply undercut at the crest of the wave, and the next is a shallow, single fold. The insistent repetition of this motif over the torso and legs creates an artificial pattern in contrast to the smooth surface of the body. Again the viewer is made aware of the unnatural supraworldliness of the deity. Finally, the statue was painted, first with white *gofun* and then with colorful textile designs. Today only the white undercoat and a patch of vermilion remain on the figure. Even so, the seated Shaka of Murōji testifies to an advance in the *ichiboku* technique, and to a new decorative emphasis in the treatment of details such as the drapery, in the second half of the 9th century.

## Daigoji

The complex of temple buildings known as Daigoji, or Temple of Buddha's Excellent Teachings, represents the last major construction of an Esoteric temple in the Early Heian period. The founder of the temple was Shōbō (832–909), a priest trained in the Sanron sect, one of the major schools of Nara Buddhism, who later turned to Shugendō, or the way of the mountain ascetic. Followers of Shugendō believed that through the solitary practice of religious austerities such as fasting, immersion in ice-cold streams, and the recitation of sutras in the mountains, they could achieve magical powers. In 874 Shōbō established a seminary at the top of Mount Kasatori, to the southeast of Kyoto, for the teaching of Shugendō, and thereafter he received the support of Emperor Daigo (reigned 897–930). (So great was the latter's involvement with the temple that after his death the temple name became his posthumous name.) This seminary was the beginning of Daigoji, which eventually became a major center of Shingon worship.

Unfinished at the time of Shōbō's death in 909, the temple at the top of Mount Kasatori was not completed until 913. Its location proved to be a problem for its imperial sponsor, since it was situated on a peak fifteen hundred feet high. Consequently, a Shimo, or Lower, Daigoji was commissioned, and its first building, a Shakadō, or Shakyamuni Hall, was completed in 926. Work on the Shimo Daigoji proceeded slowly even though the project received the sponsorship of the next two emperors, Suzaku and Murakami, and the complex was not completed until 951. All that survives today of the original Kami, or Upper, Daigoji is a Yakushi Triad—Yakushi Buddha and his attendants, the bodhisattvas Nikkō and Gakkō—begun around 907 and completed by 913. Even the Yakushidō (Yakushi Hall) in which the three statues are currently installed is not the original structure, but one dating to 1121, making it the second oldest building at the temple. Of the original Shimo Daigoji, a five-storied pagoda completed in 951 has been preserved, along with its elaborate wall paintings depicting the Ryōkai Mandara and portraits of the Shingon patriarchs.

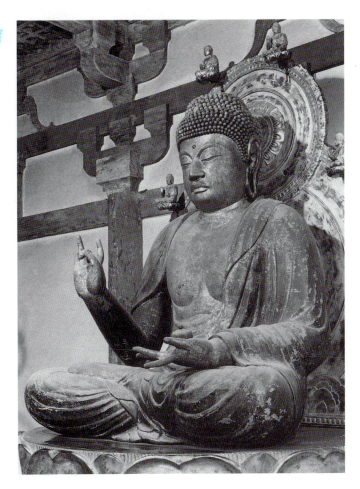

**129.** Yakushi, in the Yakushidō, Daigoji, Kyoto. 907 to 913. Wood, with lacquer and gold leaf; height 69½ in. (176.5 cm)

Because the Yakushi Triad is securely datable to the earliest years of the 10th century, it provides an excellent benchmark in the development of Buddhist sculpture (fig. 129). The Yakushi is a large statue, a seated figure slightly taller than the standing Yakushi at Jingoji (see fig. 123). Its size is further emphasized by its placement on a tall lotus-flower base, in contrast to the flanking bodhisattvas, who stand on much lower pedestals. The head and the body seem almost like blocks, the transition between them made by the shortest and widest neck imaginable. However, the spread of the knees creates a very solid base for the vertical projection of the body, and the drapery falls in gentle folds over the legs, creating an irregular but completely natural pattern over the crossed feet. In the final analysis the Yakushi seems to be a powerful, calm, enduring, if remote, figure as it looks beyond the entrance doors to the hills and valleys below the Kami Daigoji. The flanking statues of Nikkō and Gakkō, not illustrated here, are much shorter than the Yakushi, and although somewhat plump, they are graceful figures standing in gently hip-slung poses. Their faces, particularly the lips, are less full than the buddha's, giving them a softer, less dour expression. Their garments fall in decorative folds over the body, complementing the linear patterns of the

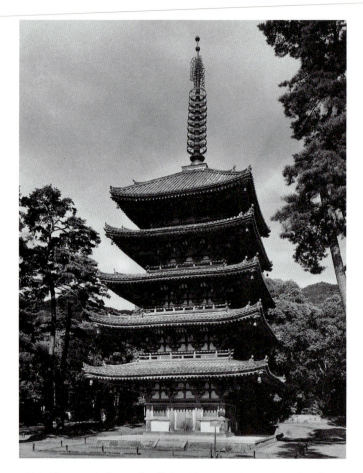

130. Five-storied pagoda, Shimo Daigoji, Kyoto. Completed 951

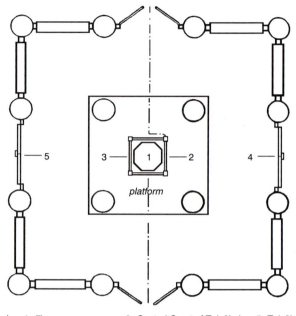

1  heart pillar                        3  Central Court of Taizōkai    5  Taizōkai
2  Central Court of Kongōkai    4  Kongōkai

**131.** Diagram of five-storied pagoda, Shimo Daigoji,
locating parts of mandala

jewelry, the necklaces, and the arm bracelets. They add a soft, decorative accent to the solidity of the Yakushi.

The technique employed in sculpting the Yakushi Triad is primarily *ichiboku,* but more of the volume of the statues is rendered in added blocks than was the norm in earlier years. In this work, the sides of the hips are made of different pieces of wood, as are the forearms and the knees. Large cavities have been scooped out of the back of the torso and head of the Yakushi, and out of the flanking bodhisattvas. Finally, the sculptures were painted with lacquer and covered with gold leaf. What has been accomplished in these three sculptures is a marriage of advanced *ichiboku* technique with a new expressive formula, in which the Buddhist deity asserts power through his calm demeanor and over-life-size dimensions alone, without artificial patterning of drapery or exaggerated treatment of the body, as seen in the Jingoji Yakushi (see fig. 123) and the Murōji Shaka (see fig. 128).

The five-storied pagoda at Shimo Daigoji, completed in 951, is an impressive building standing apart in the temple grounds (fig. 130). Its placement is such that in ascending a gentle incline toward the heart of the Shimo Daigoji complex, the visitor sees its soaring dimensions. Yet it cannot be seen from above, which would diminish its architectural effect. Each story is slightly smaller than the one below, so the viewer has a sense of the vertical projec-

tion of the building with no sacrifice of its apparent stability. Although the pagoda breaks no new ground in terms of its design, it is a thoroughly satisfying building and the only example of its type remaining from the 10th century.

The interior of the pagoda presents a striking contrast to the dull red of the building's skin. Wooden casings have been placed around the four sides of the central pillar, the heart pillar, to square it off, and these casings and the wall surfaces, even the insides of the doors, are decorated with luminous paintings of the Ryōkai Mandara and the eight Shingon patriarchs (fig. 131), Kūkai's portrait having been added to the seven preserved at Tōji. A hierarchy of deities is established by the placement on the heart pillar of the central motifs from the two mandalas, the Taizōkai Dainichi on the west face, the Kongōkai Dainichi on the east face. Secondary motifs from the two realms, the Womb World and the Diamond World, are depicted on the inner sides of the window shutters, while the patriarchs, clearly based on the portraits at Tōji, are placed on the lower panels of the wainscoting.

Best preserved of the mandala paintings is the Dainichi from the Taizōkai (colorplate 14). The figure is defined by the red iron-wire lines typical of traditional Buddhist painting, but a palette of cool greens and reds and quiet flesh tones has been used instead of the bright reds and oranges of the Tōji mandala. Evidence of *kirikane* (cut gold), fine lines of gold foil applied to the painting surface to suggest textile designs, can be found. Coincidental with the gentle harmony and richness of the pigments is a new calmness in the treatment of the figures. The Dainichi sits cross-legged, holding the wheel of the law, a traditional image of the Buddha's teachings, sup-

ported by both hands. Soft shading is used to model his form, but the figure displays a quietude in sharp contrast to the springy vitality of the Tōji mandala figures. Indeed, the Daigoji murals reveal a new direction in Japanese painting toward decoration and elegance.

## Fudō and the Godairiki Bosatsu

Works that bracket in date the Ryōkai Mandara paintings at Daigoji are a painting of Yellow Fudō, the most important of the Myōō, or Kings of Higher Knowledge, preserved as a secret treasure (hibitsu) of Onjōji, on the southwest shore of Lake Biwa, and the three paintings surviving from a set of five scrolls depicting the Godairiki Bosatsu, the Five Power Bodhisattvas, in the Jūhakkain of the Yūshi Hachiman Association on Mount Kōya. The Yellow Fudō is first mentioned in the *Tendaishū Enryakuji Enchin den*, a biography compiled in 902 of the priest Enchin (814–891), a great scholar who was the fifth head abbot of the Tendai school at Enryakuji. The painting is said to be an artist's re-creation of an image of Fudō seen in a vision by Enchin in 838, while he was in deep meditation. The image is unique among surviving examples of Fudō. He stands solidly facing the viewer, his powerful body filling the picture plane, his feet wide apart and apparently supported by thin air. Because this painting is a sacred icon of Onjōji, the temple no longer permits its reproduction. The best alternative for study is a copy from the early Kamakura period, in which a rock has been included to provide a base for the image (colorplate 15). The Fudō's hands hold the traditional attributes, a *vajra*-handled sword and a lasso, but his hair is treated as a halo of ringlets around his head, rather than as a single braid hanging down one side of his face, as is usually done. His features display a ferocious expression, and his eyes, which are outlined in *kirikane* and have pupils made of gold leaf, appear to glow as they stare straight at the viewer. His body, too, appears to give off a yellow radiance against the dark gray ground. The deity could well be a midnight apparition, in view of the way he seems to materialize from out of the shadowy background. Considering the dates mentioned in the available documents, 838 and 902, it seems most likely that the original painting is a work of the second half of the 9th century.

The set of paintings of the Godairiki Bosatsu preserved on Mount Kōya are dated to the second half of the 10th century on the basis of style (fig. 132). These wrathful deities, unusual in the Buddhist pantheon, are the focus of worship in the ceremony of the Benevolent Kings, performed to assure the protection of the nation, and they find their scriptural derivation in the *Benevolent Kings Sutra*, the *Ninnōhannya haramitsu kyō*. Of the three sur-

**132.** Three Power Bodhisattvas, from a set of five paintings. 2ⁿᵈ half 10ᵗʰ century. *left:* Ryūōku Bosatsu; *center:* Muijūrikiku Bosatsu; *right:* Kongōku Bosatsu. Ink and color on silk; center about 10 ft. x 7 ft. 10 in. (3.05 x 2.40 m), right and left each about 10 x 5 ft. (3.05 x 1.80 m). Yūshi Hachiman Association of Mount Kōya, Jūhakkain, Wakayama prefecture

viving paintings, the right one presents a static, seated image, Kongōku, or the Adamantine Howl, while the other two bodhisattvas, Ryūōku (Dragon King Howl, center) and Muijūrikiku (left), raise their right hands and legs in a dramatic stance.

Ryūōku Bosatsu, his body stretched to fill the entire surface of the huge painting, seems to have been caught in a moment of suspended animation. He looks intently to his left, his three eyes white against the burning red of his face, while he raises his right leg off its lotus-blossom footrest as if to leap into space. In his right hand he holds a ritual dagger, and with the index and middle fingers of his left hand he points dramatically upward toward it. He wears a tiger skin over a bright red skirt, and swirling around the upper part of his body are two scarves, both decorated with elaborate textile patterns. Behind the figure, an aureole of red flames glows against the background. Black, moderately calligraphic lines define the body, adding an impression of vitality, yet in the treatment of the drapery there seems to be a conscious effort to deny the three-dimensionality of the image. For example, the scarf pulled tight over the torso seems to be made of red and beige stripes, until one looks at its profile against the flames to the left, where it is treated as a series of raised folds, contradicting the apparent flatness of the design. The floral decorations on the scarves are placed so that they overlap the drapery folds. The artist has created a marvelous tension between the volume and vitality of the deity and the flat patterning of the drapery and flame halo. He has blended the awesome strength of the Onjōji Fudō with dynamic movement and decorative detail.

If we can assume that the five deities were intended to be viewed in a symmetrical grouping, it seems likely that the extant paintings of figures in dynamic movement were originally hung to the left of the seated bodhisattva, while those to the right have been lost. A similar set of Myōō paintings can be seen in an illustration of the Shingonin, a hall used for the performance of Shingon rituals, in the Imperial Palace in Kyoto (see fig. 158).

## The Middle Heian, or Fujiwara, Period (951–1086)

The Fujiwara clan dominated Japanese government from the late 9th century until the end of the 11th century, and continued to be powerful until the middle of the 12th century; it gave its name to the era: the Middle Heian, or Fujiwara, period (951–1086). In 858 the Fujiwara established a new form of government in direct opposition to that of the Taika Reforms of 645. They had themselves appointed regent (Sesshō) and civil dictator (Kanpaku) and ruled in the name of an emperor. A cornerstone of this new practice was intermarriage with the imperial clan. Once a Fujiwara daughter married to an emperor produced an heir apparent, the emperor was encouraged to abdicate and his Fujiwara father-in-law was named first, Sesshō for the new emperor, and then, Kanpaku when the young man came of age.

This structure enabled clan leaders to circumvent the mandate for government taxation by the emperor as it was set out in the Taika Reforms: in order to avoid paying onerous taxes to the central government, powerful clan leaders and Buddhist temples pressed to have their lands made tax-exempt. They established shōen, estates in the provinces, to which individuals could offer their land in exchange for protection from government intrusion. The shōen were owned by aristocratic proprietors, who in turn had patrons who were even more highly placed heads of major clans or religious institutions. Under the proprietors were local estate managers—the shōen consisted of separate holdings scattered over a large area—and under the managers were the peasant farmers. The donors received the patronage of the clan lord or Buddhist temple, and the arrangement enabled the lord to tap into wealth generated outside the capital. Through the shōen system, the Fujiwara gained control not only of the government, but also of the best source of revenue at the time.

Under the Fujiwara, Japanese culture flourished as never before. From the advent of their control over the government in 858 until the mid-12th century, when succession disputes broke out in both the Fujiwara and the imperial clans, peace prevailed in Heiankyō, and the nobility had the leisure and the financial means to undertake aesthetic pursuits such as writing poetry, playing the biwa (a lute) and the koto (a Japanese harp), blending incense, and religious activities such as copying Buddhist sutras and making preparations for elaborate Buddhist ceremonies. Poetry became an essential means of polite communication between noblemen and noblewomen, and prose, most notably Tale of Genji or Genji monogatari, achieved a very high level of literary expression. The Fujiwara period also witnessed the construction of lavish temples, modeled to a large extent after mansions built for the nobility. These times have been described by the historian Sir George Sansom as "The Rule of Taste."

During this period of just over one hundred years, the nobility living in Kyoto probably numbered no more than one thousand people, but the choices they made about where and how they lived, what they did with their abundant leisure time, and even how they worshiped set the tone for artistic creation in the Middle Heian period and permeated almost every aspect of life in the capital. The aesthetic of the waka, a thirty-one-syllable poem, provides a metaphor for the attitudes of the nobility at this time. This one is by Ki Tomonori.

This perfectly still
Spring day bathed in the soft light
From the spread-out sky.
Why do the cherry blossoms
So restlessly scatter down?

Donald Keene, ed., Anthology of Japanese Literature, New York, 1955, p. 80

The poet looks out of his comfortable abode, sees the cherry blossoms, and projects his own feelings onto the scene in front of him, with nature serving as a mirror in which he contemplates his own reflection. In the Middle Heian period, when such feelings were encouraged, the arts and literature reached a level of refinement scarcely equaled in any period of human history.

Because the nobility had such a pervasive influence on the visual arts of this and the succeeding Late Heian period, it is essential to know something about the way they lived. Much of the unique flavor of court life in this era derives from the practice of polygamy. For several reasons, it was desirable for a man to have more than one wife. Women often died young in childbirth, and a man losing his only wife would have to begin again the work of looking for a suitable woman to marry and carry on his family line. It was essential that he have many children, because the best way for him to gain advancement in rank was through the arrangement of an advantageous marriage between a daughter and a courtier of higher rank than himself. Also, noblewomen, although they were allowed to inherit property and were taught reading, writing, and the cultural pursuits of the day, did not oversee the administration of their economic affairs, the management of their estates, the upkeep of their houses, or the regulation of their retainers. A woman needed the help of either a husband or male relatives, lovers, or retainers to survive. Thus polygamy was not only an accepted custom among the Heian nobility, it was considered a social responsibility and a political necessity.

Another practice that went hand in hand with polygamy derived from the quasimatrilocal nature of Heian society. The status of a man's wives was strictly governed by their rank within the society of the court. A man was expected to take on as principal wife a woman whose family rank was at least equal to his. The marriage was usually arranged between the parents of the couple, who were often mere children at the time. The preferred minimum age for marriage was fourteen for a boy, twelve for a girl, but it was not uncommon for the bride or groom to be younger. A man was also free to take other women as secondary wives, in openly announced and accepted marriages. He might also have dalliances with women he had no intention of taking under his wing. The example of Fujiwara Kaneie (929–990) is instructive. In addition to his principal wife, he had eight others, and we know from the diary of one of them, a nameless woman known only as the mother of Michitsuna and the author of *Kagerō nikki* or *Gossamer Years*, that he had at least one affair with a noblewoman of embarrassingly low rank and probably a good many more that the diarist did not bother to record.

Normally, a nobleman did not at first establish his own household, but rather visited his principal and secondary wives in their own or their parents' residences. However, if after the death of his father the husband succeeded to the position of head of the family or leader of

**133.** Diagram of *shinden zukuri*-style architecture. (After Dr. Mori Ōsamu)

the clan, he would build his own palace and install his wives in separate apartments within the residence. To accommodate live-in wives, a nobleman's *shinden*, or mansion, consisted of a series of halls and smaller buildings linked by covered walkways (fig. 133). The lord's own quarters were to the south of the other halls, facing an elaborate garden. Directly behind and to the north was the hall allotted to the principal wife, the residence from which she derived her title of *kita no kata*, or the person to the north. Behind her hall were the kitchen, servants' quarters, and storerooms. Other wives might be housed in separate halls to the east and west of this central unit, linked to it by covered walkways. In front of each residence hall was a small courtyard garden, and to the south of the lord's quarters was a magnificently landscaped one centering on an artificial pond.

Because Kyoto is situated on a slightly sloping plain, it was possible for these *shinden* to be provided with a stream flowing southward to feed a pond merely by digging down in the right spot. Usually a stream was made to flow underneath the short pilings on which the residence was built, and to curve gracefully through the yard to the pond. In a scene from the *Nenjū gyōji emaki*, a scroll depicting annual ceremonies and celebrations observed by Kyoto patricians and plebeians alike, there is an illustration of a cockfight in the garden of a typical *shinden zukuri* mansion (colorplate 16).❖ The latticed walls on the south side of the lord's own quarters have been raised, and he and his guests, all men, can be seen seated, the lord in

---

❖ The term *zukuri*, or *tsukuri*, appears in several different contexts in the history of Japanese art. The *kanji* used to write *tsukuri* carries the meaning of construction and building up. Thus the same word can mean both the way in which a *shinden* or a *shoin* is built—*shinden zukuri* and *shoin zukuri*—and the painting technique in which pigment is built up on a painting surface, *tsukuri-e*.

**134.** Section of *Murasaki Shikibu nikki emaki*, Fujita scroll, scene 5, showing Michinaga
on a veranda observing two boats. 1ˢᵗ half 13ᵗʰ century. Hand scroll, color on paper; height 9⅝ in.
(23.9 cm). Fujita Art Museum, Osaka

formal court dress, holding a fan in one hand, the others well positioned for watching the activities in the garden. On the left side of the hall, through lowered bamboo blinds, female faces are visible between the panels of a white cloth curtain that has been placed to shield them from public view. Just to the right of the *shinden* veranda stands a tree with gnarled branches and lush pink blossoms, and to the left is a cherry tree in full flower. A cockfight is traditionally held on the third day of the third month according to the lunar calendar, when all the trees are bursting into bloom.

Covered walkways attached at right angles to the lord's quarters in a typical *shinden* extend east and west toward the pond, and the west corridor usually ends in a small building that functioned as a boathouse. If the lake was large enough, boating parties might be held using craft with fancifully carved prows. A scroll illustrating the diary of a lady-in-waiting in service to Empress-consort Shōshi (988–1074), a daughter of Fujiwara Michinaga (966–1027), who was the most powerful leader of the Fujiwara clan, depicts just such a festivity. Celebrating the birth of an imperial heir, Michinaga stands on the veranda of his boathouse watching courtiers enjoying themselves in the elaborate boats he has provided (fig. 134).

The quality of life for a noblewoman in the Heian period was not one most 20th-century women would envy. From diaries, we know that custom required her to remain hidden from the eyes of all men except her father and her husband. Consequently, she rarely went outdoors, and indoors she lived in the shaded world of the *shinden*, with its large overhanging eaves, its screens of state (portable cloth hangings), and the folding screens used to partition inner space. Since she had a household of servants, she was seldom troubled with routine housekeeping or the raising of her children, and she was rarely called upon to care for her husband beyond preparing for his occasional visits. Festivals and ceremonies provided a welcome break, and calligraphy practice and music lessons occupied some of her hours. Fortunately she could while away many hours reading romances called *monogatari*, or "tales told." Some women proceeded from reading to creative writing, keeping diaries, like Michitsuna's mother, or recording vignettes of experience, like the lady-in-waiting in the court of Empress-consort Teishi (976–1001), Sei Shōnagon (965?–after 1000). The lady in service to Shōshi not only kept a diary, but went beyond its format to create a novel that captures the quality of life among the nobility. We know her today by the name of the novel's heroine, Lady Murasaki, in which her contemporaries recognized the author. Her novel was *Tale of Genji*, or *Genji monogatari*, which was written over a period of years at the beginning of the 11th century. The tale of Genji, the Shining Prince, represents a high point in Japanese literature, and has given rise to numerous works of art, among them an illustrated version of the story produced in the first half of the 12th century, discussed on pages 137–141.

### Religious Architecture

The way in which the nobility approached religion had a profound effect on the creation and design of Buddhist temples, Shinto shrines, and objects produced for worship. In this realm, as in the secular, the leader among the nobility in the Middle Heian period was Fujiwara Michinaga, and the foremost example of his activities was the now-lost Hōjōji in Heiankyō. Begun in 1019, when Michinaga,

in poor health, resolved to "renounce the world"—he became a monk—the temple evolved over the next forty years into the first great Buddhist structure undertaken by the Fujiwara regency and the standard against which all later temples would be measured. Unfortunately, it was destroyed by fire in 1058, but enough documentary material remains for us to recognize what a monumental project it was (fig. 135). From the very beginning, the temple was designed according to the precedents of the nobleman's residence. A pond fed by a natural spring was excavated, leaving an islet in the middle; hillocks were built up, shrubs and trees were planted, and the temple buildings were distributed around this central focal point. The first hall to be completed was the Amidadō, or Amida hall, a long, narrow building to the west of the pond, designed to house nine over-life-size Amida images. Year after year, buildings were added. Then, in 1027, when Michinaga was near death, he was taken to the Amidadō, where he died holding a cord made of threads tied to the hands of the nine buddhas on the platform in front of him. After his death, the temple became a memorial to him, with new halls being added by his heirs, until the whole compound was destroyed by fire.

**135.** Plan of Hōjōji, Heiankyō (Kyoto). 1st half 11th century
(no longer extant)

| 1 | south main gate | 11 | lotus meditation hall | 21 | southwest main gate |
|---|---|---|---|---|---|
| 2 | south inner gate | 12 | *godaidō* | 22 | west main gate |
| 3 | *kondō* | 13 | Amida hall | 23 | Tohokuin |
| 4 | *kōdō* | 14 | Amida hall (1025) | 24 | Saihokuin |
| 5 | monks' quarters | 15 | Yakushi hall | 25 | east inner gate |
| 6 | north main gate | 16 | Shaka hall | 26 | west inner gate |
| 7 | sutra repository | 17 | Jissaidō | 27 | instrumentalists' |
| 8 | belfry | 18 | inner gate | | stages |
| 9 | octagonal hall | 19 | meditation hall | 28 | stage islet |
| 10 | pagoda | 20 | east main gate | | |

Some idea of what the Heian nobility thought about religion can be seen from a passage describing a dedication ceremony at Hōjōji found in the *Eiga monogatari, A Tale of Flowering Fortunes,* a narrative about the Fujiwara clan at the peak of its splendor.

Very much at ease, the Emperor gazed at the scene inside the temple compound. The garden sand glittered like crystal; and lotus blossoms of varying hues floated in ranks on the fresh, clear surface of the lake. Each blossom held a buddha, its image mirrored in the water, which also reflected, as in a buddha domain, all the buildings on the east, west, south, and north, even the sutra treasury and the bell tower. . . . Next the monks filed in from the south gallery, forming lines on the left and right; and tears came to the eyes of the speechless spectators at the sight of that great multitude of holy men moving forward in unison, each group headed by a marshal. . . . Not even the bodhisattvas and the holy multitude at the assembly on Vulture Peak could have rivaled those monks in appearance and bearing. Nor could one restrain tears of joy at the thought that even the sermons of the Buddhas of the Three Periods were unlikely to have equaled these ceremonies.
Innumerable bodhisattva dances were presented on the platform, and children performed butterfly and bird dances so beautifully that one could only suppose paradise to be little different—a reflection that added to the auspiciousness of the occasion by evoking mental images of the Pure Land.

William H. and Helen Craig McCullough, trans., *A Tale of Flowering Fortunes,* Stanford, Calif., 1980, pp. 553–57

The nobility, even when they looked at temples and attended religious ceremonies, saw reflections of the world around them. They wishfully assumed that paradise would be just like home. The concepts of religion motivating the leaders of the Middle Heian period were very different from those propelling Emperor Shōmu or Emperor Daigo.

First of all, the focus of worship had shifted from Roshana and the one thousand buddhas of the past, as well as Dainichi and the mandalas of Shingon Buddhism, to a belief in rebirth in the Western Paradise, or Pure Land of Amida Buddha. This buddha had been a familiar figure in the Buddhist pantheon from the Asuka period on, but in the 10th century, through the efforts of several messianic priests, attention came to be focused on Amida and worship of him as a separate and more compelling rite than praying to a whole host of divinities. One of these teachers was Kūya (903–972), a priest of the Tendai sect who preached a doctrine of universal salvation through belief in Amida and the recitation of the *nenbutsu,* "Namu Amida Butsu," or "Hail to Amida Buddha," a prayer invoking the name of this particular divinity. Another, and for the nobility more influential, figure was Genshin (942–1017), a monk of the Tendai sect at Enryakuji who codified

belief in Amida and the Pure Land in a work known as *The Essentials of Salvation*, the *Ōjō Yōshū*. This work, which was widely disseminated among the clergy and the nobility, set forth in graphic terms the delights of the Western Paradise and the rigors of the afterlife if salvation were not achieved.

The nobility—and it must be remembered that a significant number of the clergy had been noblemen before they became monks—read *The Essentials of Salvation* and received the teachings of the Church. They assumed that they would be going to paradise and that it must be as rich and colorful, and as decorative and elegant, as the world of the court, their world here on earth. Taking this idea a bit further, they believed that death must be a glorious ceremony, called a *raigō*, during which Amida would descend from heaven and joyously welcome the deceased into paradise. As Genshin described it,

welcoming approach of Amida Buddha

> The great vow of Amida Nyorai is such that he comes
> with twenty-five Bodhisattvas and the host of one
> hundred thousand monks. In the western skies purple
> clouds will be floating, flowers will rain down and
> strange perfumes will fill the air in all directions.
> The sound of music is continually heard and the golden
> rays of light stream forth . . . . At the time of death, the
> merciful Kannon, with extended hands of a hundred
> blessings and sublimity and holding out a lotus seat of
> treasures, will appear before the believer. The
> Bodhisattva Dai-Seishi and a numberless host say in one
> voice: "Blessed art thou!" . . . . Uttering these words, he
> places his hand upon the believer's head and with the
> other hand draws him to himself. At this time the
> believer beholds Amida with his own eyes and his heart
> is filled with great joy. His mind and body are at
> ease now and he is happy as in a state of ecstasy.
>
> A. K. Reischauer, "Genshin's *Ōjō Yōshū:* Collected
> Essays on Birth into Paradise," *Transactions of the
> Asiatic Society of Japan*, 2nd. ser., vol. 3 (December
> 1930), pp. 68–69

## The Phoenix Hall

The extant structure that best illustrates the Heian court's belief in Amida and rebirth in his Western Paradise is the Phoenix Hall, or Hōōdō, of Byōdōin, a temple situated on the banks of the Uji River to the southeast of Kyoto (colorplate 17). The site had been purchased by Fujiwara Michinaga in 998 and was inherited by his son Yorimichi (990–1074) upon Michinaga's death in 1027. For the next twenty-five years it was used as a summer retreat from the heat and humidity of the capital, but in 1052 Yorimichi converted it into a temple, and in 1053 the Hōōdō was dedicated.

The Phoenix Hall houses a famous Amida image, and in its overall concept attempts to make manifest on earth the totality of the *raigō*. The hall is situated on a semidetached island in the center of a large artificial pond, with land bridges on either side of the hall, and a much later addition, an architectural bridge to the rear. This con-

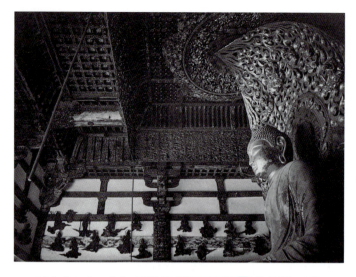

**136.** Interior of the Hōōdō (Phoenix Hall), Byōdōin, Uji, Kyoto prefecture, c. 1053

figuration is an interesting departure from the precedent of buildings surrounding a lake and islet, established in the *shinden zukuri* style of secular residences and also in the Hōjōji. A second feature of the Hōōdō's placement is that it is close to the edge of the pond and is reflected on the surface of the water. Further, although the structure is actually a single-storied building, its exterior is treated as though it were two stories, with covered walkways extending on either side of the central hall and then turning forward at right angles toward the pond directly in front. Following the precedent of the central-hall façade, the walkways are treated like two-storied structures, with single-storied towers at their turning points. When this total image is reflected in the pond, it has an appearance similar to the many halls of Amida's paradise as they were depicted in Chinese paintings and relief carvings. Further, the walkways on the sides of the hall suggest bird wings. It is as if a gigantic red bird has flown down from the sky, just as Amida and his host would do, and has alighted by the pond.

The interior of the Hōōdō further contributes to this concept (fig. 136). An over-life-size Amida Buddha is installed in the center on a tall lotus-blossom pedestal, and attached to the upper part of the walls are Amida's host, small wooden images of angels, monks, and musicians. The insides of the doors are decorated with paintings depicting the welcome given to the nine categories of humans who are permitted to be reborn in the Western Paradise (fig. 137). Every aspect of the building contributes to the concept of the *raigō*. When the doors of the hall are open, the visitor standing on the opposite side of the lotus pond can see Amida and his host enthroned in a many-storied building hovering at the opposite shore.

The Amida image inside the Hōōdō was created by the foremost sculptor of the period, Jōchō (died 1057), one of the most innovative artists Japan has ever produced. Jōchō's reputation must have been established by 1020,

because Michinaga commissioned him to produce most of the sculptures for the Hōjōji, and then rewarded him by giving him the title of Hōkkyō, Master of the Dharma Bridge, a rank within the Buddhist hierarchy that was rarely accorded a sculptor. Later he was promoted to the rank of Hōgen, Master of the Dharma Eye, a great honor for this outstanding artist. Unfortunately, none of his early works have survived, but the Byōdōin Amida is a more than adequate example of his achievement (colorplate 18). First of all, Jōchō has created a new canon of proportions for this figure. The height of the head from the chin to the brow at the hairline is taken as a basic unit for the entire figure, and the vertical projection of the statue from the bottom of the legs to the hairline is exactly equal to the distance between both knees. This new canon gives the figure a remarkable feeling of stability and calm.

The Amida image is sculpted using *yosegi*, or multiple blocks, a technique probably developed from the Chinese split-and-rejoin method of construction (see box, page 110). Instead of using a single piece of wood for the main part of the body (*ichiboku zukuri*) and scooping out the core in the chest and the head, the sculptor created his image using fifty-three pieces of wood. This image by Jōchō demonstrates both the advantages and disadvantages of *yosegi zukuri*. As it was first used, the multiple-block technique did not permit deep carving of drapery or facial details. Jōchō made this work to his advantage by creating a style of sculpture that was light and ethereal, rather than heavy and overbearing like the style of the Daigoji Yakushi. There were two advantages to the technique. It permitted a sculptor to create an image in dynamic movement, a capability not needed for this Amida image. The second advantage was that it facilitated the production of a work in the studio tradition. The master could sketch an image, indicate where the joining parts should be, and entrust to his apprentices the preliminary sculpting of the various parts. When that was done the pieces could be transported to the temple site, assembled, and finished by the master sculptor.

This Amida is a truly remarkable work. It sits serenely on its pedestal, its hands in the meditation mudra, its eyes in an unfocused gaze. Behind the figure an open-work gold halo of flames rises upward to meet a round canopy suspended beneath a square baldachin. The contrast between the smooth, undecorated surfaces of the Amida and the multiplicity of decorative motifs on the halo and the canopy above serves to underline the calm, quiet demeanor of the image itself.

The small sculptures attached to the walls around the buddha figure reflect Jōchō's basic style. They sit or stand on cloud forms, some playing musical instruments, some dancing, some merely contemplating the scene. A dancing *apsara* (Skt.), a celestial nymph, is a particularly lively and graceful piece (fig. 138). Her foot is slightly raised, as though she is about to step forward in time to a stately tune.

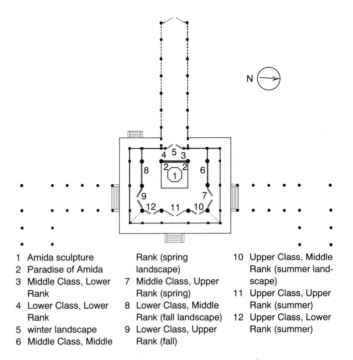

1 Amida sculpture
2 Paradise of Amida
3 Middle Class, Lower Rank
4 Lower Class, Lower Rank
5 winter landscape
6 Middle Class, Middle Rank (spring landscape)
7 Middle Class, Upper Rank (spring)
8 Lower Class, Middle Rank (fall landscape)
9 Lower Class, Upper Rank (fall)
10 Upper Class, Middle Rank (summer landscape)
11 Upper Class, Upper Rank (summer)
12 Upper Class, Lower Rank (summer)

**137.** Plan of the Hōōdō, showing locations of various *raigō* paintings

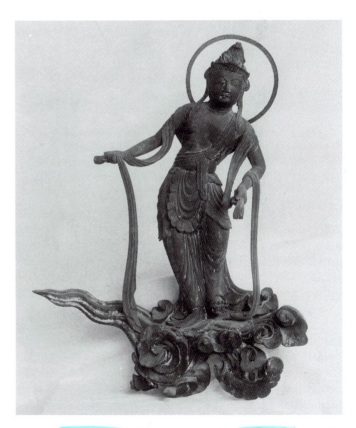

**138.** Dancing *apsara* (celestial nymph), by JŌCHŌ, in the Hōōdō, Byōdōin. c. 1053. Wood, with traces of *gofun* and paint

The final element completing the *raigō* in the Hōōdō is the set of paintings that originally decorated the inner surfaces of the doors depicting the nine types of welcome accorded the deceased, depending on the degree of piety expressed in life. Included with each picture was a long inscription, an excerpt from the *Kanmuryōju kyō*, the

**139.** Section of a painted wood door of Middle Class, Upper Rank rebirth, in the Hōōdō, Byōdōin, showing Amida and a celestial host descending toward the house of the deceased. c. 1053

**140.** Section of a painted wood door of Middle Class, Upper Rank rebirth, in the Hōōdō, Byōdōin, showing landscape with horses in *yamato-e* style. c. 1053

**141.** Section of a painted wood door of Upper Class, Lower Rank rebirth, in the Hōōdō, Byōdōin, showing ascending Amida and celestial host. c. 1053

*Buddha of Infinite Life Sutra*, known as the *Amitayus Sutra*, explaining its significance. Unfortunately, the years have not been kind to these paintings, and in an effort to preserve what little remains, they were removed from the Hōōdō. Copies were made and mounted as long paper scrolls, and are displayed along with the original doors at various times during the year.

Two of the most interesting and well-preserved paintings depict the welcomes given to those who were accorded the Upper Class, Lower Rank, and the Middle Class, Upper Rank. In the latter we see an Amida Buddha descending on a white cloud toward the veranda of a nobleman's house (fig. 139). Beneath the Amida—that is, on the same door—is a view of the hills of Kyoto, with horses gamboling in the shallow water of a pond (fig. 140). The pine-capped hills are the gentle slopes of Japan rather than the tall, sharply faceted mountains depicted in Chinese painting, and the motif of horses not only indicates the scale of the painting, but also creates a sense of the habitability of the landscape. The *raigō* paintings in the Phoenix Hall provide some of the earliest datable examples of *yamato-e*, or Japanese-style landscapes, in combination with a Buddhist theme.

The *raigō* accorded a person of the Upper Class, Lower Rank, is particularly interesting, because here the artist depicts not the descent of Amida but his ascent after the soul has been placed inside a lotus bud (fig. 141). In this painting, the home of the deceased (not visible in this

**142.** Amida *raigō* triptych, a set of three hanging scrolls. 1st half 11th century. *center:* Amida 72 1/8 x 57 1/2 in. (183.3 cm x 146.1 cm); *left:* Kannon and Seishi 73 3/8 x 68 3/8 in.; (186.5 x 173.6 cm); *right:* Celestial Boy Attendant 72 1/8 x 21 3/4 in.; (183.3 x 55.2 cm). Hokkeji, Nara

detail) is not the *shinden* of a nobleman, but rather a small house with a thatched roof—a very simple, countrified building—the sort a gentleman might build when he retired from the world and became a lay priest, a priest who shaved his head and wore priestly garb but did not join a monastery. Above the hut is another structure that looks like a run-down temple, perhaps an old worship hall the lay priest has chosen to maintain as best he can. While not an unlikely Japanese landscape, the sharp mountains and steep waterfalls depicted in this painting make a more formidable environment than the grounds of a Kyoto mansion and suggest that this person had secreted himself deep in the mountains to follow the teachings of Amida.

In summary, the Phoenix Hall presents the worshiper with a complete materialization of the *raigō*, from the exterior of the building reflected in the pond to the Amida sculpture on the central platform, where the host of celestial attendants is suggested by the figures attached to the walls. The paintings on the doors offered the final touch, depicting as they did the nine levels of welcome accorded believers admitted to the Western Paradise. The building is remarkable for the consistency of planning it displays; it is a perfect microcosm of a complex religious concept.

### Independent *Raigō* Paintings

Two sets of *raigō* paintings that demonstrate the development of this genre are the set of three hanging scrolls owned by Hokkeji in Nara and the set preserved in the Jūhakkain of the Yūshi Hachiman Association of Mount Kōya. The former is usually dated to the first half, and the latter to the end, of the 11th century, thus bracketing in date the Byōdōin paintings.

The Hokkeji set presents an unusual, asymmetrical arrangement of the Amida triad (fig. 142). The bodhisattvas Kannon and Seishi, who usually flank Amida Buddha on his left and right, are here both to the left of the Buddha, supported by clouds. Seishi holds a canopy aloft over Kannon, in whose hands is displayed a lotus pedestal intended for the deceased. To the right is a small celestial boy, also supported by clouds, carrying a banner on a long pole. There can be no question that these three figures are intended to symbolize Amida's host. Nevertheless, the contrasts between the two flanking paintings and the central one are striking. The Amida in the central scroll is much larger than the accompanying deities and is placed parallel to the picture plane, while the other images are smaller and appear to turn and twist in space. Seishi, whose placement indicates that he is closer to the viewer than is the Kannon, is turned slightly away, while Kannon is seen in a three-quarter frontal view, suggesting a weaving back and forth in space. The little boy to the right is much smaller than the buddha and bodhisattvas and appears to be further back in space. It is difficult to imagine how these figures were originally linked to suggest the descent of Amida. There are also numerous differences in the technical treatment of the four figures. The buddha is delineated with traditional red iron-wire lines and appears to be quite static, while the accompanying figures are outlined by lively calligraphic strokes, their poses animated, their draperies depicted in deep red, blue, and green, as well as gold.

These discrepancies of style have caused some art historians to suggest that the Amida scroll predates the other two paintings. However, the silk of the three hanging scrolls is very similar, and the refinement in the handling of facial features of the divinities, as well as the delicacy of decorative details like the petals scattered across the three panels, are very close. This type of discrepancy, between the free painting style of the secondary figures and the more traditional treatment of a central image, is not uncommon in Buddhist painting and has already been noted in the treatment of the remaining Godairiki Bosatsu on Mount Kōya (see fig. 132).

It seems logical to assume that the concept underlying the creation of this *raigō* predates that of the Byōdōin paintings, and that the actual work was produced before 1053. Finally, although what we see today are cut-down remainders of the original paintings, they present a beautiful and also very moving depiction of the *raigō*, perhaps all the more appealing because the Amida is not surrounded by a host of attendants. Instead he comes without fanfare to give the deceased an intimate, personal welcome to his fabulous Western Paradise.

The second triptych, the paintings preserved on Mount Kōya, depict the *raigō* as a very public ceremony, much more in keeping with Genshin's description of Amida's welcome (colorplate 20). Amida Buddha, a resplendent gold figure seated in a formal, cross-legged position on a golden lotus-blossom platform, faces the viewer directly. However, he is supported by a grayish lavender cloud that seems to have swept first to one side and then to the other as it descended from above. In front of him are Kannon, to his left, holding the lotus pedestal for the deceased, and to his right, Seishi, his hands pressed together in prayer. Directly to the Amida's left is the bodhisattva Jizō (Skt. Kshitigarbha),❖ and to his right is Nagarjuna (see page 105). In addition to these five deities, twenty-eight accompanying figures—priests, bodhisattvas, and angels playing musical instruments—comprise a retinue of welcomers.

The divinities and their angelic host are delineated in red iron-wire outlines, are clothed in garments of bright red, pink, purple, green, and blue, and are ornamented with crowns, necklaces, and arm bracelets of *kirikane*, cut gold. The musicians are depicted in animated poses, their bodies responding to the rhythm of the music, their facial expressions describing the joyousness of the occasion. Beneath Amida and his host is a lake, its wave pattern visible amid marsh grass, and to the left is a gentle hill with pines and maple trees at the height of their autumn color, clearly the landscape of Kyoto. The Mount Kōya *raigō* presents not only a dramatic, fully developed concept of the Amida welcome, but also a comfortable fusion of religious imagery with the secular *yamato-e* theme of the native landscape, characteristics suggesting that the painting should be dated sometime after the Byōdōin door panels of 1053, probably to the late 11th century.

## Shaka Paintings

Two paintings that deal with events around the death of the historical Buddha are the scene of his death, dating from 1086, preserved in Kongōbuji, and Shaka Rising from the Golden Coffin, dated to the second half of the 11th century (colorplate 19 and fig. 143). The former depicts the moment when Shakyamuni died and passed into a state of nonbeing or nirvana. The latter shows a subsequent event, in which Shaka, responding to his mother's grief and that of other unenlightened beings, lifts the lid of his golden coffin and resumes his temporal form in order to explain the most profound meaning of his death, namely that he has at last escaped from the cycle of reincarnation and passed into a higher state of being.

The death of the Buddha is a common theme in Buddhist painting. The Buddha is shown lying on a wooden platform in a grove of sal trees, surrounded by bodhisattvas, his disciples, and the eight classes of beings. The significance of his death is suggested by the different responses of the onlookers. The bodhisattvas, including Miroku, the Buddha-to-be, closest to the Buddha's head, plus Jizō, Kannon, Monju (Skt. Manjushri), and Fugen (Skt. Samantabhadra) nearby, remain calm and impassive, knowing the full reality of what this being has accomplished. The disciples, positioned along the sides of the platform, respond only to their own sorrow at losing contact with their teacher. The lion, representing the animal kingdom, writhes on his back in grief. In the upper right Queen Maya, Shaka's mother, has descended from heaven to watch the momentous event.

In the painting of Shaka Rising from the Golden Coffin, an unusual theme in Buddhist art, the setting is unchanged. In general, the cast of characters is the same, although many more figures are included. The time is shortly after the Buddha's death. Queen Maya has descended to earth and, crouching next to the coffin, grasps the Buddha's walking staff. She looks sadly at the objects her son used in life: his begging bowl which, wrapped in a piece of white, diaphanous cloth, hangs from the branch of a sal tree, and his tattered and often-mended robe, which rests on a table in front of the coffin. Crowded around the figure of Shaka are a great multitude of people still held immobile by their emotions in response to his death. Miraculously, Shaka has pushed back the heavy coffin lid and appears before them to explain once again the deepest

---

❖ Jizō, the last bodhisattva added to the Buddhist pantheon, is represented as a shaven-headed priest in monastic garb. A diety particularly sympathetic to human frailties and the protector of children, he is often worshiped apart from his Buddhist context. In the Japanese countryside, it is quite common to see Jizō represented by a stone tied with a red apron. These informal shrines are actively worshiped, with fresh flowers and fruit left as offerings next to the Jizō stones or figures.

**143.** Shaka Rising from the Golden Coffin. Late 11th to early 12th century. Hanging scroll, color on silk; 63 1/8 x 90 3/8 in. (160.3 x 229.4 cm). Private collection, Japan

meaning of his disappearance from their world.

Although these two paintings are linked thematically, from the point of view of artistic style they are quite different. Both use a rectangular form surrounded by numerous figures as a central motif. However, in the Kongōbuji death of the Buddha, all of the figures are carefully delineated in red iron-wire lines and are made distinctly separate one from another, each with his name written nearby. In the painting of Shaka rising from the coffin, the sight of the radiant Buddha becomes the focus of attention, and the identity of individual figures is given much less emphasis. The figures are skillfully sketched in fine, nearly iron-wire lines, while details such as the Buddha's discarded robe and the cloth in which his bowl is wrapped are drawn with strong calligraphic lines that command our attention. The death scene is a meticulously detailed historical document in the mainstream of Buddhist painting in the late 11th century. The painting of Shaka rising is a dramatic presentation; while using traditional elements, it goes beyond the norm to create a coherent, persuasive evocation of a miraculous event.

### The Rise of *Yamato-e* in Secular Painting

The Heian period was a time in which the Japanese redefined their taste in art and literature, and in their lives as well. No longer were they content to accept without question Chinese models and aesthetic standards. Instead they required cultural expressions that had relevance to their own lives. In painting they wanted to see the world as they knew it, the low hills and gentle valleys of the Kyoto area, the flowering shrubbery they enjoyed in spring, the maple leaves scarlet and orange against the green pines in autumn. In religious art this new requirement could be accommodated quite easily. The artist of the Hōōdō *raigō* paintings had only to incorporate into his design passages of landscape that were clearly Japanese rather than Chinese. He did this and a bit more as well, showing the Kansai landscape, the eastern plains around Kyoto, in the different seasons of the year. Because the themes of secular painting were not required to be didactic, the artist had somewhat more leeway to respond to the changing tastes of his patrons. He could depict Japanese subject matter

rather than Chinese, maple leaves floating on the Tatsuta River—the subject of a 9th-century *waka*—instead of Lake Kunming on the grounds of the Tang emperor's pleasure palace, or he could invent new pictorial techniques, new ways of structuring a painting, or new methods of applying pigments. The terms *yamato-e* and *kara-e* were coined in the Heian period to distinguish between things Japanese and Chinese.❖ *Yamato-e* refers to the colorful, decorative screens and scrolls of the period that presented narratives, landscapes, and urban scenes and were expressive of Japanese subjects, locale, and taste. These were primarily secular works, although some Shinto and Buddhist scenes were also painted in the *yamato-e* way. By the 12th century, format, style, and theme were combined to form a type of expression that is uniquely Japanese: the *emakimono*, the horizontal illustrated narrative scroll. *Kara-e*, Chinese-style painting, refers to the contemporaneous tradition of Chinese painting in which Chinese narrative themes and landscape settings are the chief subject matter.

A large-scale work that demonstrates one stage in the transition from *kara-e* to *yamato-e* is a group of ten paintings on silk, the *Shōtoku taishi eden*, illustrating events in the life of Prince Shōtoku, the imperial prince who played such an important role in establishing Buddhism in Japan. In the 11th century, the veneration of Shōtoku developed into a cult, and pictures depicting important events in his life were painted as wall decorations in temples associated with him. However, these pictorial biographies were complicated paintings and needed to be explained to the faithful. Thus the custom of *etoki* developed. The term is used to refer to either the picture explanation or the explainer. A priest would memorize an account of Shōtoku's life and, much like a museum docent today, would present it orally to adherents as they looked at the pictures. At one time, Shitennōji, the temple founded by Shōtoku after the religious war of 587, possessed a major cycle of Shōtoku paintings, but today the earliest extant pictorial biography is the one originally made for the prince's palace-temple, Hōryūji. This was painted in 1069 on silk panels attached to three walls of the *edono* (picture hall) in the eastern precinct by Hata Chitei, an itinerant painter from Settsu province. We know from documents of the period that the nobility as well as the common folk visited Hōryūji and enjoyed the *etoki*, the biographical explanations.

The paintings, now removed from the walls and fashioned into ten panels installed in the Hōryūji Treasure House of the Tokyo National Museum, present events in the life of Prince Shōtoku in a geographical sequence, moving from right to left, rather than in a chronological one, with each episode labeled in a cartouche affixed to the painting. Thus in one panel the prince is depicted at the ages of sixteen, seventeen, twenty-one, twenty-seven, and thirty-five. The narrative elements are fitted into pockets of open space between mountains, rocks, and trees, and the vertical composition is held together by the landscape,

**144.** Section of the second panel showing Prince Shōtoku teaching the *Lotus Sutra* from the *Shōtoku taishi eden*, five panels on figured silk, by HATA CHITEI, originally in the *edono* (picture hall), Hōryūji. 1069. Color on figured silk; 6 ft. 1 in. x 9 ft. 8 in. (1.85 x 2.91m). Hōryūji Treasure House, Tokyo National Museum

which flows around the episodes and leads the eye upward and back into the distance at the top of the panel. This use of mountain-defined space cells to unify a composition while at the same time separating figurative passages is a Chinese pictorial convention seen frequently in paintings of the Tang dynasty, for example in the wall paintings at the Buddhist cave temples at Dunhuang.

The convention of the space cell and the use of Chinese-style rocks and mountain forms is particularly clear in the episode at the bottom of the second panel (fig. 144). The setting is the Okamoto Palace, the event Shōtoku's lecture on the *Lotus Sutra*. So perceptive was his explanation that the heavens opened and lotus petals rained down into the courtyard in front of him; this can be seen in the middle of figure 144. Enclosing the space around the palace are improbably tall mountains built up of a single rock shape repeated five or six times, with smaller ones, the rock mountains closer to the picture surface, overlapping the larger, creating a feeling of recession into depth and at the same time presenting on the flat surface of the painting a vertical interruption to the open space of the narrative scene.

However, even though the artist uses a Chinese pictorial convention, he also makes a clear distinction between the landscape of Japan and that of China. In the

---

❖ In the broadest sense, *Yamato* means Japan and *Kara* means China. More specifically, Yamato is the name given to the area which is now Nara prefecture and is associated with the legendary Japanese queendom Yamatai mentioned in the 3rd-century Chinese history, the *Wei Zhi* (*Wei chih*). Over time, the word has come to mean that which is quintessentially Japanese.

**145.** Section of the first panel, showing the celebration of the birth of Prince Shōtoku, from the *Shōtoku taishi eden*

two panels to the extreme left of the set of ten panels, Shitennōji is shown surrounded by the low lands of Naniwa, in what is now Osaka (colorplate 21). A sturdy oceangoing vessel is tied up in the harbor, while further to the left three demons of the deep can be seen bobbing among the waves of the Japan Sea. Along the left edge of the painting are the mountains of China, tall and irregularly massed together, some of them displaying the sharply undercut faceting frequently seen in *kara-e* landscapes, but seldom in *yamato-e*. At the top of the two panels

Shōtoku appears in a magical flying chariot, crossing the Japan Sea to China. In a dream he has remembered where, in a previous incarnation, he saw a particularly important Buddhist text, and upon waking he sets off to retrieve it.

Another stylistic element of great interest is the treatment of the Namitsuki Palace in the first panel, in which the presentation ceremony after Shōtoku's birth is performed (fig. 145). The nobles attending the event are shown inside a large room, rendered private by green bamboo blinds, which are lowered. The perspective from which we see them is not the usual horizontal view through an open doorway, but rather a diagonal one, as if we were looking through a transparent roof. This is the earliest datable use of *fukinuki yatai*, the convention of the blown-off roof that provides a bird's-eye perspective, which in the 12th century becomes an important design element in the *emakimono*.

The panels of the *Shōtoku taishi eden* represent a stage in the Japanization of secular painting in which a native theme, the prince's biography, is set forth in a composition that still makes considerable use of a Chinese pictorial convention, the space cell. Nevertheless, new elements, a recognition of the difference between Chinese and Japanese mountain styles, and the use of the blown-off roof, herald the beginning of the Japanese style.

Another secular painting dated to the mid-Heian period that demonstrates a transitional phase in the development of *yamato-e* is the *Senzui byōbu* (fig. 146); *byōbu*

**146.** *Senzui* (landscape) *byōbu*, a six-panel screen from Kyōōgokokuji (Tōji). 11th century. Color on silk; each panel 57⅝ x 16¾ in. (146.4 x 42.7 cm). Kyoto National Museum

means folding screen. The six-panel screen depicts an elderly gentleman, usually recognized as the Chinese poet Bo Juyi (Po Chü-i, 772–846), Hakurakuten in Japanese, seated on a fur rug outside a thatch-roofed hut and holding an ink-dipped brush as though he had just looked up from writing something. The theme of this screen is thought to be the Chinese poet who has retired from life in the capital but still is constantly visited by young men wanting to learn his skills. Approaching from the right is a young gentleman who has just dismounted. In the far right another young man rides away, followed by an attendant carrying an umbrella, and in a badly damaged passage to the far left, near a horse's saddle, another young nobleman can be seen looking back toward the old man.

Bo Juyi was a man who spoke his thoughts plainly and forcefully, and as a result he was banished from the capital for a few years. When he was permitted to return he did so only to retire formally from service to the emperor. He then moved back to the country, built a simple hut from which he could see his favorite mountain, Mount Lu, and devoted himself to the pleasures of writing poetry and drinking wine. So well known did his behavior become that he was nicknamed the Drunken Singing Professor.

Bo Juyi's poetry was greatly appreciated by the Japanese nobility in the Heian period, and Lady Murasaki in *Genji monogatari* makes reference to his poem "The Song of Everlasting Sorrow" as though it was something with which her audience would be completely familiar. The mid-Heian period even produced a Bo Juyi expert, Fujiwara Tametoki (949–1029), who wrote a commentary on his poems and is also known to have commissioned a painting on the theme of the poet in retirement. The *Senzui byōbu* was since the late Kamakura period an essential ritual object in esoteric *kanjō*, or initiation ceremonies, at Tōji, a fact that has long puzzled modern scholars, as its secular literary theme contains no discernible Esoteric Buddhist symbolism. Its acquisition by the temple is best explained by the theory that a nobleman attending a Buddhist ceremony at Tōji, perhaps someone like Tametoki, brought it with him to be set up to screen him from the view of other worshipers, and afterward donated it to the temple. However, its ceremonial importance is probably an accident of history.

The screen represents a transitional phase in the development of *yamato-e* because it combines a Chinese theme and Chinese-style figures in a landscape that is distinctly Japanese. The poet's hut is set among wisteria-covered pines and other trees in spring blossom. In the second panel from the right, willow trees droop toward a stream in which ducks are playing. To the left of the hut is a multifaceted rock, the sort much prized in China. In the upper half of the screen an inlet can be seen, its surface ruffled by a breeze, and on either side gentle green hills are dotted with dark green pine trees. The core of the painting, Bo Juyi outside his hut, is inserted into the Japanese context of these flowering spring trees and low hills, a *kara-e* gem in a *yamato-e* setting. Its multinational character notwithstanding, the screen is very pleasing to look at, capturing so well the quiet mood of spring in the countryside.

## The Late Heian, or Insei, Period (1086–1185)

The imperial clan sought to wrest control of the government from the Fujiwara and to rebuild its own financial strength by developing ways to generate income outside the system of taxation established by the Taika Reforms of 645, a system more honored in the breach than in the observance during the Late Heian, or Insei, period. Emperor Gosanjō (reigned 1068–1072) was the first emperor in many decades to be born of a non-Fujiwara mother. Being relatively immune to the dictates of the Fujiwara clan, he was able to formulate the concept that led to establishment of the *insei*, or government by cloistered, retired emperors. His idea was to abdicate the throne, withdraw to a Buddhist temple of his own founding, and nominally enter the priesthood. However, he expected to continue to govern the country through his son, the reigning emperor. Furthermore, since he no longer held an official position within the hierarchy, he could receive donations of land to the *shōen* he controlled, and thus also the income they generated, through the intermediary of the temples he and his family had founded. At the same time, members of the nobility who wanted to amass merit in both this life and the next could make donations to an imperially sponsored temple, with benefits accruing to all.

Because Emperor Gosanjō died shortly after abdicating the throne in 1072, he was unable to put his concept of government by cloistered ex-emperors into practice. However, his son Shirakawa followed his lead with great success. Ascending to the throne in 1072, Shirakawa ruled as emperor for fourteen years, until 1086, when he retired. For the following forty-three years he controlled the government from the cloister. Shirakawa was without doubt the most effective leader among the three cloistered ex-emperors of the Late Heian period. His son Toba, who succeeded to the position of *insei* in 1129, continued the *insei* government for twenty-seven years, but by the time of his death in 1156, the imperial clan was badly split by a succession dispute. Nevertheless, the courts of Shirakawa and Toba outrivaled in opulence those of the most powerful members of the Fujiwara clan.

After Toba's death in 1156, a series of succession disputes within the imperial and the Fujiwara clans resulted in two rebellions, the Hōgen (1156) and the Heiji (1160), in which the opposing factions sought the aid of two military clans, the Taira and the Minamoto. The disputes among these four groups were finally resolved through the bitter Genpei Civil War, which lasted from 1180 to 1185 and was fought not only in the outlying provinces but in the capital as well. The end of this war, 1185, marks the end of the Heian period.

Throughout the Heian period the court had chosen

to concentrate on problems of government in the capital and had left the control of the rest of the country to local strongmen. As a consequence, clans that valued military prowess above cultural achievement developed in the outlying provinces, and they were called upon to put down local unrest. In the end the Minamoto under Minamoto Yoritomo (1147–1199) emerged victorious and established a de facto seat of government in the seaside town of Kamakura, near present-day Tokyo. From 1185 until the Meiji Restoration of 1868, Japan was governed by a series of military rulers, leaders known as shogun. The system of the *insei* finally ended when the faction of the last cloistered emperor, Gotoba, was defeated in the Jōkyū Rebellion of 1221.

Although the Late Heian period concluded with the demise of the glitter and elegance of court life, it began with an opulence far greater than that seen under the rule of even the most powerful Fujiwara clan leaders. The chief focus of the imperial family was, not surprisingly, on the founding of clan temples. It has been calculated that between the late 11th and the middle of the 12th century the retired emperor, his kin, and his loyal subjects dedicated a new worship hall every year and founded a temple every five years.

During this period a great deal of time and money were devoted to secular projects as well. A lavish set of perhaps one hundred paintings illustrating excerpts from the *Genji monogatari* has survived to the present, and quite probably many more were produced. Poems of the so-called thirty-six immortal poets, the *Sanjūrokunin shū*, were copied onto scrolls made of gorgeous colored papers decorated with gold and silver designs. The Taira family made a richly ornamented set of thirty-three scrolls of the *Lotus Sutra* and four other Buddhist texts, copying the Chinese characters with gold and silver ink onto decorated paper, and in addition frequently designing and painting elaborate frontispieces. The Insei period did not produce a writer of the excellence of Lady Murasaki, but the ladies of the court apparently devoted considerable time to painting. Some of the frontispieces of the *Heike nōkyō*, discussed on page 137, the sutra copies made by the Taira family, were painted by the women of the clan, and in a journal entry for 1130 mention is made of a *nyōbo no edokoro*, a painting bureau staffed by women, within the Imperial Palace. Some nobles in the Insei period, unlike their predecessors in the previous century, took great interest in folktales, in a few cases secular, but most often centering on miraculous events related to temples; and they went so far as to compile them in anthologies. The most famous of these is the *Konjaku monogatari*, an alternate reading of the first two words of each story, "*Imawa mukashi*," "A long time ago." Although the Insei period saw the last flowering of court culture, it was a very rich flowering indeed. Fortunately for later generations, quite a few remnants of that extraordinary Japanese century have survived to the present day.

## Buddhist Temples in Kyoto

The pacesetter for temple building during the Insei period was Emperor Shirakawa, who began in 1077, even before he retired from the throne, by establishing Hosshōji to the east of the Kamo River, in the vicinity of a small stream known as White River or Shirakawa. So closely did the emperor identify himself with this area and the imperially sponsored temples there that he requested Shirakawa as his posthumous name. Unfortunately, Hosshōji, like Michinaga's Hōjōji, which it was meant to outrival, is no longer standing, its only reminder the name of a bus stop near Okazaki Park. However, its size and appearance can be understood from contemporary records (fig. 147). It was built on a plot of land 820 feet (250 m) square, the same size as the site of Hōjōji. Like Michinaga's temple, its grounds were laid out following the design of a nobleman's mansion and garden, with a lake fed by an underground spring and in the center a man-made islet. Hosshōji was provided with a *kondō* situated just north of the pond, where the lord's quarters would be in a *shinden*-style residence, and to the north of that was the lecture hall instead of the *kita no kata*'s residence. Roofed corridors angled from either side of the *kondō* toward the pond and terminated in a sutra repository on the east and a belfry on the west instead of a nobleman's *tsuridono*, or fishing pavilion. In addition, there was a long narrow Amidadō (Amida hall), housing nine buddha images, and the Godaidō, a hall for statues of the Five Kings of Higher Knowledge.

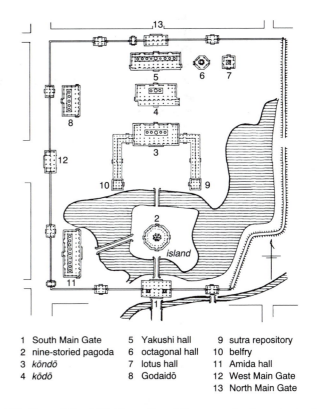

| | | | |
|---|---|---|---|
| 1 | South Main Gate | 5 | Yakushi hall | 9 | sutra repository |
| 2 | nine-storied pagoda | 6 | octagonal hall | 10 | belfry |
| 3 | *kondō* | 7 | lotus hall | 11 | Amida hall |
| 4 | *kōdō* | 8 | Godaidō | 12 | West Main Gate |
| | | | | 13 | North Main Gate |

**147.** Plan of Hosshōji, Kyoto. Late 11th century (no longer extant)

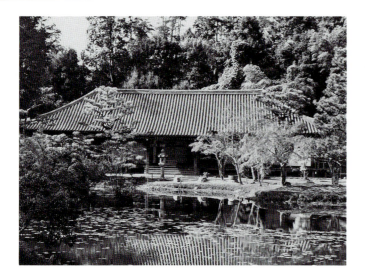

148. Amidadō (Amida hall), Jōruriji, Nara. 1107; moved to present site 1157

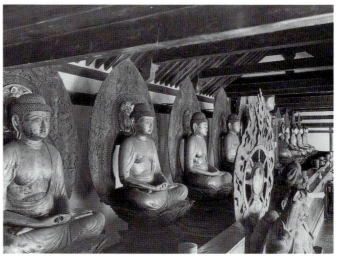

150. Altar with Amida images, Amidadō, Jōruriji

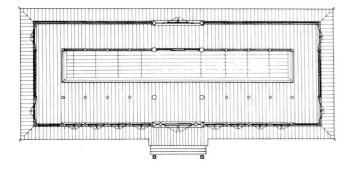

149. Plan of Amidadō, Jōruriji

However, the most impressive building in the complex was surely the nine-storied, octagonal pagoda erected on the islet. Given the fact that the *shinden* residences of the nobility were only a single story, and most temple pagodas had three or five stories, Shirakawa's tower must have been a very impressive structure, visible from all parts of the city, a constant visual reminder of the retired emperor and his power.

None of the temples built for Shirakawa, Toba, their relatives, and their devoted subjects have survived, but Jōruriji, meaning the temple of pure lapis lazuli, in the hills to the north of Nara, still stands, providing us with some idea of the beauty of larger Buddhist complexes. Of the more than thirty halls for nine Amida images built during the Insei period, only the Amida hall of Jōruriji remains intact, and it was probably not built to house the images now installed on the altar. Nevertheless, in its present setting on the west bank of an artificial lake, this Amidadō is a very beautiful building, rather like a *shinden*, with its black lattice and white paper-paneled interior, which is visible when the wooden doors are opened. Had its cypress-bark roof not been replaced with tiles in the Tokugawa period, this impression would be even stronger

(figs. 148 and 149). The building, first constructed in 1107 but moved to the Jōruriji site in 1157, consists of a *moya*, a central rectangle nine bays long and one bay deep, surrounded by a corridor one bay in width and by a veranda, also a single bay in width. An easement was made in the structure in order to accommodate the central Amida, which is much larger than the other eight Amida images flanking it (fig. 150). The central bay is twice the size of the other bays and is marked off as a separate space by two triangular plaster walls between the upper beams and the roof. There is no ceiling; the sloping beams supporting the roof are left exposed.

Little is known about the Amida images in the hall except that they are said to be in the style of Jōchō. The central image is nearly 3 feet (close to 1 m) taller than the side images, and it is further differentiated from them by its mudra, the *raigōin*, a gesture of welcome to the Western Paradise (fig. 151). In style it is very similar to the Amida in the Hōōdō of the Byōdōin, but the horizontal of the crossed legs is smaller than that in Jōchō's work, giving the impression of a figure less solid and placid. Also, the drapery patterns and the facial features are more sharply articulated than Jōchō's. In sum, the figure is a step away from the mid-Heian image and suggests a fresh approach on the part of the sculptor.

Lacking any firm documentation for the date of the nine Amidas, art historians have had to fall back on stylistic analysis to determine the period of production. Because of differences in the technique and the handling of the flanking sculptures and the central Amida, the latter is judged to be somewhat earlier in date than the others. It may have been made for another building, or even for another temple; and the smaller images may have been sculpted to accompany it around the time the hall was first built in 1107, or when it was moved to the Jōruriji site in 1157. It is unlikely that the statue dates to 1047, when Jōruriji was founded, because the image reflects a post-Jōchō style. Though the exact date of production of these

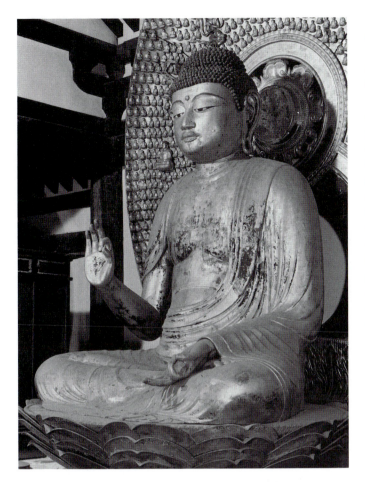

**151.** Amida Nyorai, main image of a set of nine, Amidadō, Jōruriji. Late 11th to early 12th century. Cypress wood, with lacquer and gold leaf; height 7 ft. 4⅛ in. (2.24 m)

ern Honshū, with temples that could rival the most elaborate projects undertaken in Kyoto. His vision was continued by his son Motohira (died 1154) and by his grandson Hidehira (1096–1187).

In its heyday in the late 12th century, Hiraizumi must have been a remarkable sight, its palaces built on the plains bordering the Koromo River, the halls of its temple, Chūsonji, red and gold amid the green pines of the hills to the northwest of the city. Today Hiraizumi is remembered not for its days of glory but for its hour of defeat. At the end of the Genpei Civil War (1180–1185), the rivalry between two brothers, the head of the Minamoto clan, Yoritomo, and his youngest brother, Yoshitsune, came to the point of confrontation when the elder demanded the presence of his younger brother, a handsome, daring, and ingenuous general, in Kamakura. Yoshitsune fled north to Hiraizumi and the protection of Hidehira, and the fate of the cultural capital of the north was sealed. In 1189 Yoritomo's troops destroyed Hiraizumi, only to find that Yoshitsune had taken his own life rather than suffer the humiliation of capture by the enemy. As the historian Ivan Morris has pointed out, Yoshitsune is remembered fondly by the Japanese today as a hero noble in his failure. Hiraizumi was fortunate in having the master of haiku poetry, Matsuo Bashō (1644–1694), write its epitaph:

> The summer grasses
> Of brave soldiers' dreams
> The aftermath

<div align="right">Keene, <em>Anthology</em>, p. 369</div>

In spite of the destruction caused by men and the forces of nature, a single Amida hall at Chūsonji, the Konjikidō (Gold-colored Hall), certainly one of the most extravagant temple buildings undertaken during the Insei period, has survived at Hiraizumi (fig. 152). When it was completed in 1124, the Konjikidō was only one of more than forty buildings on the site, and was not even the main worship hall at that. Originally it followed the pattern of a *jōgyōdō*, or ceaseless-practice hall, that is, a hall constructed so that adherents could recite their prayers to Amida while circumambulating a central altar provided with appropriate images. The hall is square, three bays on each side, capped by a pyramidal roof. The *moya*, a single bay at the core of the building, contains an altar with an Amida surrounded by the bodhisattvas Kannon and Seishi, six statues of Jizō, who was the last bodhisattva to enter the Buddhist pantheon, and two armor-clad guardian figures (fig. 153). When Kiyohira died in 1128, his embalmed body was entombed inside the altar. Two similar structures now occupy the corner bays at the back of the shrine and serve as the tombs for his son Motohira and his grandson Hidehira, and also as the final resting place of his great-grandson Yasuhira's head, the man having been decapitated by Minamoto Yoritomo's forces when they destroyed Hiraizumi in 1189. There is some difference

Amida figures remains a mystery, they clearly belong, along with the building in which they are installed, to the early years of the Insei period.

## Buddhist Temples in the Northern Provinces

During the years that the military clans had been ignored by the government in Kyoto, they had grown in strength in the provinces and had come to believe that they were rivals of the nobility not only in wealth and power, but perhaps also in their ability to surround themselves with the trappings of culture. Not surprisingly, their self-assurance led from time to time to overt acts against the central government. In 940, Taira Masakado, a local military leader, declared himself to be the Japanese emperor of the north, and it required a major military campaign for the government to regain control. In the 11th century two rebellions, minor from the point of view of the government in Kyoto, broke out and had to be suppressed, the Early Nine Years' War (1051–1062) and the Later Three Years' War (1083–1087). A warrior who emerged in a position of strength from the power struggles of the 11th century was Fujiwara Kiyohira (1056–1128), who decided to establish the "cultural capital of the north" at Hiraizumi, in north-

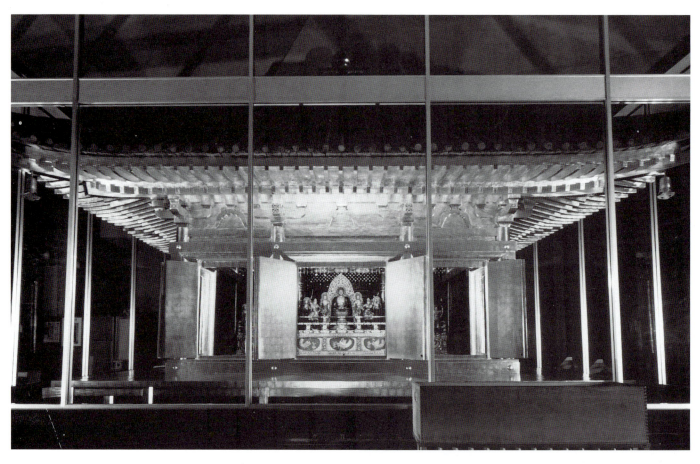

**152.** Konjikidō, Chūsonji, Hiraizumi, Iwate prefecture. 1124

of opinion among scholars as to whether or not the Konjikidō was originally intended as a meditation hall or a mausoleum—which is what it became. However, the use of a temple building as a burial place was not out of keeping with practices in the capital. Exactly how and when the concept of an Amida hall and a mausoleum were combined is difficult to establish. In 1027 Michinaga died facing the nine images in his Amida hall at Hōjōji, and by the time of the *insei* it had become the custom for members of the imperial family to be entombed in or near the temples they had founded. Thus when the northern branch of the Fujiwara family used the Konjikidō as their mausoleum, they may have taken as a point of departure the practice established by the imperial clan in Kyoto.

Although the Konjikidō is small in scale, it is incredibly extravagant in its decoration. Fortunately for visitors today, this small jewel of a building was painstakingly restored by the Japanese government in the mid-1960s. All of the surfaces in the interior were coated with lacquer and gold leaf. The four columns forming the bay at the core of the building, the beams supporting the coved and coffered canopy over the altar, the bracketing system, and even the frog-leg struts under the eaves were lavishly decorated with inlaid mother-of-pearl *hōsōge* (flower of precious appearance), an abstract floral design that richly interweaves jewel and petal motifs. The sides of the altar

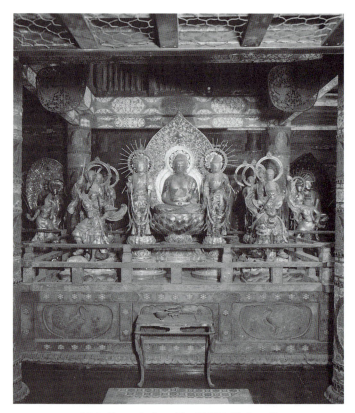

**153.** Central altar, Konjikidō, Chūsonji

**154.** Sanjūsangendō, Kyoto. 1266

**155.** Interior, Sanjūsangendō

below the wooden balustrade were covered with sheets of gilt bronze depicting birds and flowers, while the central pillars were provided with images of Dainichi in *maki-e*, gold and silver lacquer work. To complete the embellishment of the building, the exterior was coated with lacquer and covered with gold leaf. To enter the Konjikidō when it was first built must have been like stepping into a jewel box, and today, even though it is enclosed in a climate-controlled glass shell within a modern concrete building, this gold-colored hall still imparts something of the same impression.

## Sanjūsangendō

The last major innovation in Buddhist architecture in the Late Heian period was the hall built to house a thousand and one images of the eleven-headed, thousand-armed Kannon, the Senju Kannon. Perhaps the idea of merit through conspicuous replication of images grew from the concept of the nine types of welcome into the Western Paradise and the nine Amida statues installed within a single hall to symbolize it. At any rate, as early as 1132 there is a reference to the construction of a *sentai kannondō* (hall of one thousand Kannon images), the Tokuchōjuin, commissioned by the retired emperor Toba and built near his residence temple, Hōjūji. In 1164, shortly after he defeated the Minamoto clan in the Heiji Rebellion, Taira Kiyomori built the Rengeōin (Temple of the Lotus King), a *sentai kannondō* for the retired emperor Goshirakawa. Unfortunately, neither of these mammoth halls has survived, but the Sanjūsangendō, or Thirty-three Bay Hall, that stands today in Kyoto's eighth ward is a reliable substitute. Goshirakawa's hall was destroyed by fire in 1249, but rebuilding efforts were undertaken immediately. Though minor changes were made to accommodate the tastes of the 13th century, the motivation behind the

Sanjūsangendō was the reproduction of the 12th-century Rengeōin and the reinstallation of the Kannon images that had been saved from the fire, along with sufficient replacement statues to complete the arrangement of one thousand deities flanking a central thousand-armed Kannon. The building was finished by 1253, the main image installed in 1254, and the final dedication held in 1266.

The Sanjūsangendō is clearly an architectural oddity, consisting of a central *moya* thirty-three bays wide but only three bays deep, surrounded on all four sides by a corridor one bay wide (fig. 154). From its earliest days, the temple's yard seems to have been used for training imperial guards. In the Edo period archers competed there as well, using the 390-foot (118 m) length of the building as a gauge of distance. An archer would stand at the south end of the veranda and aim for the north end within the space between the floorboards and the eaves. The contest lasted for twenty-four hours and was won by the man who could shoot the most arrows the length of the building without touching any part of it. According to temple authorities, the recordholder shot 13,053 arrows, of which 8,133 met the requirements. This was in 1686.

The interior of the building is treated simply, with heavy beams spanning the three bays of the *moya*, and gently arched rainbow beams, single curved beams that narrow at the ends, connecting the main pillars with those on the outside of the corridor (fig. 155). At the back of the altar is a wood-and-plaster wall marking off one side of the long central rectangle. Behind it is an enclosed corridor formed by the wall. No separate ceiling was provided for the hall. Instead, exposed beams support the roof. The simplicity of construction in the Sanjūsangendō presents a strong contrast to the complicated details of the myriad Kannon images and the twenty-eight powerful statues of Kannon's attendants recently moved from the rear corridor to the front of the stepped altar.

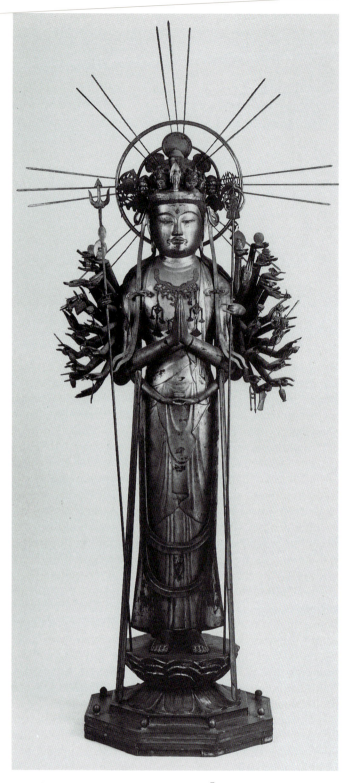

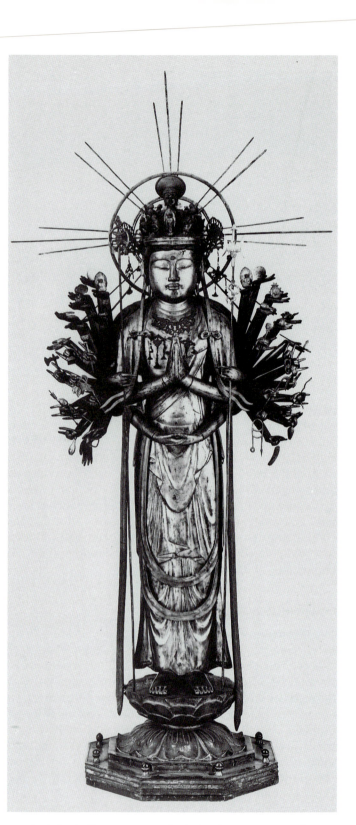

**156.** Senju Kannon no. 390, by SHŌEN. Sanjūsangendō.
12<sup>th</sup> century. Wood, with lacquer and gold leaf; height c. 65 in.
(c. 165 cm)

**157.** Senju Kannon no. 40, by TANKEI. Sanjūsangendō.
13<sup>th</sup> century. Wood, with lacquer and gold leaf; height c. 65 in.
(c. 165 cm)

When the original Rengeōin of 1164 burned down, miraculously one hundred and fifty-six Kannon sculptures were saved, and they formed the nucleus of the Sanjūsangendō installation. Most of the images stand in a frontal position, although some carry the suggestion of a slight shift of weight. The pair of arms largest in size is folded

across the body above the waist, the hands pressed together in prayer (fig. 156). A smaller set of arms is held gracefully just below waist level, one hand cradled in the other, while a third pair holds long-handled implements: a priest's staff and a trident-topped staff, a common Buddhist iconographic symbol of the defense against evil. The rest of

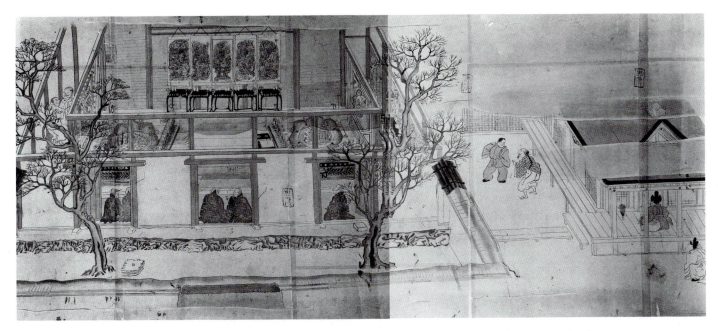

**158.** Section of *Nenjū gyōji emaki*, scroll 6, section 4, showing the Shingonin of the Imperial Palace.
17th-century copy by SUMIYOSHI JOKEI of the late-12th-century original hand scroll by TOKIWA MITSUNAGA.
Color on paper. Private collection, Tokyo

the Kannons' arms are treated separately, their main interest being the implements they hold. The skirts and scarves are shallowly carved and fall in soft folds over the body. There are two main differences between the Late Heian images and those added in the 13th century, as evidenced by a sculpture attributed to Tankei, the master in charge of the new installation (fig. 157). The later images have slightly heavier drapery folds over the legs, and the patterns created by the garments flow over the entire area between the waist and the feet. There are also more gradations in the size of the arms. Those grasping staffs and those held in front of the abdomen are smaller than those in prayer, but larger than the hands displaying attributes. The rescued images reflect the elegant detailing and the abstraction of form seen in Late Heian pieces, while the added sculptures demonstrate the new interest in volumetric figures realistically presented that developed in the Kamakura phase of the Early Feudal period. However, more than anything else, a comparison of images from both periods demonstrates that fidelity to the older forms was a primary concern of the scores of sculptors working under Tankei. The final impression one takes from the Sanjūsangendō is a sense of being overwhelmed by the mammoth size of the hall and the huge number of Kannons packed on the ten stepped levels of the altar. What one encounters is a veritable sea of figures too vast to be comprehended from any single place or even in a long visit.

## Buddhist Hanging Scrolls and Illustrated Sutras

During the Insei period a unique style of Buddhist painting developed that is quite different from that of the Early or Middle Heian eras. Buddhist deities in this period no longer inspire worship with their size and vigorous poses;

instead they charm through their ethereal beauty. They are serene figures clad in garments of the richest fabrics, decorated with gold geometric patterns and bright floral designs. Set against dark backgrounds, they even seem to give off an unearthly radiance. They must have been gorgeous embellishments, completely appropriate for temple buildings frequented by the luxury-loving nobility.

A group of paintings that clearly documents the change in taste that took place in the Late Heian period is the set of Godai Myōō, Five Kings of Higher Knowledge, images made in 1127 for use in the Imperial Palace. Beginning on the eighth day of the new year and continuing for seven days, the Mishihō (The Latter Seven Days Rites) was held in the Shingonin of the palace, and mandala paintings, as well as images of the five Myōō and twelve *deva* (Skt. celestials, or divine beings; J. *ten*), including Bonten and Taishakuten and the gods of wind, water, and fire, were displayed as ritual furnishings. An illustration from the *Nenjū gyōji emaki*, a scroll detailing the ceremonies and customs observed in Kyoto in the 12th century, shows the Shingonin and the paintings hung for the Mishihō service (fig. 158). This ceremony had been initiated in 834 by Kūkai, and was continued through the Insei period. However, by 1040 the original paintings provided by Tōji could no longer be used, and a new set was made. These were lost in a fire in 1127, and immediately another set was commissioned. The first replacement paintings were rejected by Emperor Toba as being too rough and violent, and the present group was executed based on a model other than that provided by Kūkai.

The Kongō Yasha from the 1127 set of the Godai Myōō (fig. 159) is very similar in pose to the Dragon King Howl of the second half of the 10th century—both appear to be leaping into space (compare fig. 132). But there are

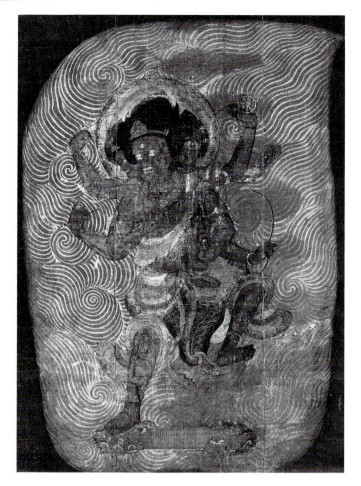

**159.** Kongō Yasha, from a set of five Myōō. 1127.
Hanging scroll, color on silk; 60¼ x 50¾ in. (153 x 128.8 cm).
Kyōōgokokuji (Tōji), Kyoto

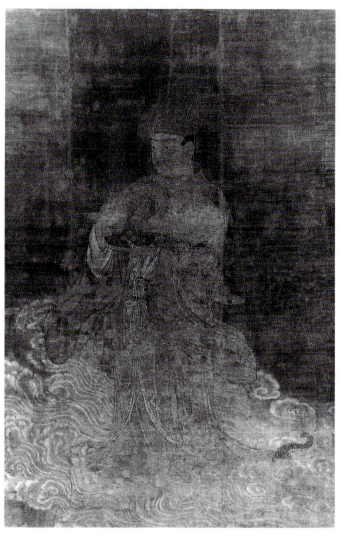

**160.** Dragon King Zenmyō, by JŌCHI. 1145. Hanging scroll,
color on silk; 65½ x 43¾ in. (164 x 111 cm). Kongōbuji, Mount
Kōya, Wakayama prefecture

more differences than similarities between these two paintings. The Dragon King Howl is a tough, powerful deity, set against a background of constantly flickering flames. So dynamic is this figure that he threatens to stretch beyond the picture surface. The Kongō Yasha, on the other hand, seems much smaller and almost childlike with his round face and pouting expression. He wears a garment decorated with *kirikane* adhered to the silk surface, more suitable for a court visit than for a battle against evil, and his aura of flames seems more like a curtain hung behind him than a materialization of the heat of his body. He is an elegant little creature, nothing like his "rough and violent" ancestor.

In the temple of Jingoji in the Takao region northwest of Kyoto, the temple in which Kūkai lived when he first returned from China, a remarkable painting of the historical Shakyamuni Buddha has been preserved (colorplate 22). In paintings depicting Shaka, he is usually shown in some sort of narrative setting, such as his death or rising from the golden coffin (see colorplate 19 and fig. 143). However, in this painting the historical Buddha is shown alone, seated in a cross-legged position on a brightly colored lotus-blossom throne, his mudra, the *se-*

*muiin*, or fear-not, the only key to his message. Although the artist has chosen to ignore the narrative potential of his theme, he has not failed to take advantage of its decorative possibilities. Shaka's body, outlined in red, is painted golden yellow. Set against a dark ground, it seems to give off rays of light, an effect heightened by the *kirikane* floral design of his halo and the actual rays drawn across it. The figure is clad in a red robe decorated with an overall pattern in *kirikane* and circles containing eight-petaled blossoms. While the artist makes no deliberate attempt to render the body as though it had no volume, he does emphasize the play of textile patterns across a seemingly flat surface. The circle motif extends across both legs and onto that part of the garment hanging over the lotus pedestal. The painting presents Shaka as a beautiful, luminous being contained in a net of gold lines.

A work that may be seen as the exception that proves the rule is the painting of the Dragon King Zenmyō owned by Kongōbuji (fig. 160). The artist of this

painting and its date are well documented, a rarity in the Heian period. It was executed by the Buddhist painting master Jōchi, an artist whose name is associated with iconographic studies, and it was dedicated in 1145. The subject is a vision of the dragon king that appeared to Kūkai in 824 when he performed the Rite for Invoking Rain in the Shinsenen, the garden directly to the south of the Imperial Palace. The painting depicts a man in the costume of an official in the Tang court, borne aloft by a richly varied cloud pattern, his identity specified by the scaly tail that appears from beneath his garment in the lower right-hand corner. He holds a shallow bowl containing the rain jewel. Unfortunately, a great deal of pigment has peeled off the surface, but from the notations on an ink copy of the image, it is clear that in its pristine form it was a brilliantly colorful painting. The garment alone combined red, light blue, indigo blue, purple, and yellow. The elements of the work that can still be appreciated today are the springy vitality of the iron-wire lines of the drapery and the fresh and realistic presentation of the deity, a strong contrast to the prevailing style of the period.

During the Late Heian period the concept of *mappō*, the degenerate age of the Final Law, became a pressing religious issue. According to Buddhist teachings, after a set number of years had elapsed following the death of Shakyamuni, the world would pass into a period in which his teachings were no longer followed and souls could no longer achieve enlightenment. The date for the beginning of *mappō* was calculated to be 1052, and by the 12th century, given its political and military upheavals, the members of the nobility were seriously concerned about what might await them in the days ahead and in the afterlife. In an attempt to control fate, they sought to accrue merit by copying chapters of the *Lotus Sutra* on decorated paper, having the pages fashioned into horizontal scrolls, and dedicating them to a particular temple.

Without question the most elaborate and beautiful of the *Lotus Sutra* scrolls produced during the Insei period was the *Heike nōkyō* (Sutras Dedicated by the Heike), the set of thirty-four separate rolls copied by members of the Taira family and donated to the clan's Shinto shrine at Itsukushima, in Hiroshima prefecture. Although questions have been raised about the identities of the scribes, the traditional view is that each scroll text was copied by a different member of the Taira clan and its chief vassals, from the leader of the clan, Kiyomori, and his sons on down, and that they were officially presented by Kiyomori to the Itsukushima Shrine in the ninth month of 1164, the same year in which the Taira leader built the Rengeōin for the retired emperor Goshirakawa.

Each sutra roll in the *Heike nōkyō* consists of separate sheets of lavishly decorated papers, on which the Chinese characters of the text have been copied in gold and silver ink. In order to make these sheets into a scroll, they were joined horizontally, and a decorated backing paper was added to strengthen the roll. Also, to frame the sheets, a binding of decorated paper was added above and below the main sheets. The left end of the roll is attached to a *jiku*, usually a wooden dowel with decorative caps of ivory or other materials at the top and bottom. The right end is provided with a frontispiece, usually a figurative painting, and on the reverse side there is a piece of strong, decorated paper or heavy silk. When the scroll is rolled up for storage, this end sheet becomes its cover, with a label in a cartouche at the top and a woven cord at the midpoint, which is tied around the roll to keep it securely in place. When the roll is untied and opened, the first thing to come into sight is the frontispiece. In carefully planned sutra scrolls, this space and the cover are used to give a visual clue to the meaning of the words to follow.

One of the most carefully considered and movingly executed covers of the *Heike nōkyō* is that of the Myōshōgonō, or King Myōshōgon, chapter (colorplate 23), which is about a king who vowed to attain enlightenment and became a bodhisattva. The circular shape of a huge silver moon can be seen rising behind a low hill and an old gnarled tree. The enormity of the moon, its silver glow barely distinguishable from the hill and the sea, and the barrenness of the tree silhouetted against it, give this picture a lonely, almost eerie quality. Woven into the pattern of the old tree's roots in the lower left are the Japanese letters and characters that mean "that long night." This type of lettering in the midst of a waterside scene is called *ashide*, or reed writing, and was used to add the resonance of a literary allusion to a painting. Here the words refer to the long night of darkness, the *mappō*, before Maitreya Buddha, Miroku, appears and through his teachings restores world order. This *ashide* message added to the image of a luminous moon suggests that the *Lotus Sutra* will help to illuminate that long night of darkness before the dawn of a new era and the rule of Buddhist law. When completely understood, this frontispiece painting is no longer simply a pretty moonlit seascape, but rather a very moving religious message.

## Emakimono

The horizontal illustrated narrative scroll, the *emakimono*, is a uniquely East Asian picture format, and although such illustrated scrolls were produced in China, it was in Japan that the narrative potential of the horizontal scroll was carried to its highest levels of expression. Both the Chinese and Japanese languages have traditionally been written in vertical lines from right to left, so the horizontal format of the *emakimono*, laid out and unrolled from right to left, provided a natural way to relate text to image. This juxtaposition of textual passages of varying lengths alternating with pictorial images proved to be a potent format for conveying meaning.

Four precious *emakimono* fragments have survived from the Insei period: an illustrated version of the *Genji monogatari*; an ink-drawn caricature of animals behaving

*Emakimono* (literally, pictures rolled) are hand scrolls presenting a narrative in both words and pictures. Sheets of paper or, occasionally, silk are joined horizontally; the left end is attached to a dowel around which the scroll is rolled for storage. The other end of the *emaki*, to the right of the first passage of text, bears a frontispiece, usually decorated paper, backed with a fragment of silk which protects the scroll when it is not in use. For viewing the *emaki*, a braided silk cord holding the roll together is untied; the right hand holds the opening section while the left unrolls the scroll, exposing a portion of text and pictures, usually 12 to 18 inches at a time.

An *emakimono* usually begins with a passage of text followed by a picture. It may be either relatively short, depicting only a single scene, or as long as the artist wishes. Narrative illustration programs dealing with love stories are usually less extensive than those of folktales or battle stories, which are longer and may involve the repetition of major characters to suggest a sequence of events and the passage of time. However, whether the illustrations are long or short, they all have one element in common: a leftward momentum established by the direction in which the scroll is unrolled. Japanese artists were particularly successful at realizing the possibilities of the *emakimono* for depicting mo-

### EMAKIMONO AND PAPER MAKING

ments of deep emotion and fast-flowing dramatic action, and the *emakimono* of the Late Heian and Kamakura periods represent the complete Japanization of both religious and secular painting.

*Emaki* are between 8 and 20 inches (20 to 50 cm) high and may be as long as 66 feet (20 m). The individual sheets of paper vary in width from one scroll to another and are joined by a narrow overlap. *Emaki* papers were usually made either from *kōzo*, the bark of the paper-mulberry tree, or *ganpi*, thin rice paper from the *wickstroemia canescens*. The raw material was broken down into fiber, refined into pulp and then suspended in water in a large vat. The main paper-making device, still used today, consists of two frames: the *su*, or deckel, with a bamboo screen and a second frame of identical size but without the screen. With the second frame resting on top of the deckel, the two are dipped into the vat to scoop up pulp. While the screen allows the water to drain off, the upper frame holds the pulp within the rectangle. The paper is then allowed to dry, melding the pulp. Sheets for a particular *emaki* were all the same size. Careful checking of the horizontal dimensions of the sheets of paper in a scroll provides clues to the history of its preservation. If a sheet differs from the norm, the scroll's intactness should be questioned.

like people, the *Chōjū jinbutsu giga*; a folktale relating miracles associated with the founding of a temple, the *Shigisan engi*; and a historical account of intrigue at court, the *Ban Dainagon ekotoba*. Little is known about the production of these scrolls, and in only one case, the *Ban Dainagon*, is the artist identified by a believable attribution. Lacking specific documentary evidence, art historians have been hard put to establish the approximate dates of the scrolls. One approach has been to evaluate the internal evidence: the styles of garments, and the architectural details of the Imperial Palace and well-known Buddhist temples. The style of calligraphy used to copy the texts is also a reliable index for dating the scrolls. Finally, it is not uncommon for an artist to "quote" or "rephrase" passages of images from an earlier scroll. Once this before-and-after type of relationship is established, any documentary information available for the later scroll can establish the last possible date for the creation of the earlier scroll. Using various combinations of the above methodologies, scholars have tentatively concluded that the *Genji monogatari emaki* was produced in the first half of the 12th century, probably before 1140; the *Chōjū jinbutsu giga* before 1150; the *Shigisan engi emaki after 1150*; and the *Ban Dainagon ekotoba*, which is attributed to the court painter Tokiwa Mitsunaga, between 1157 and 1180.

The creation of the *Genji* scrolls must have been a monumental project. The novel in its English translation is nearly one thousand pages long. Today only twenty *Genji* pictures survive, but it is assumed that originally all fifty-four chapters were illustrated, with between one and three paintings per chapter, and that the total number of rolls in the set was about ten.

Scholars trying to determine how the scrolls were made have come to the conclusion that five teams worked on the project, each team consisting of a nobleman noted for his calligraphy as well as his cultural sophistication, and a group of painters, including the principal artist, the *sumigaki* or painter who draws in black ink, and specialists in the application of traditional pigments. Once a particular episode was chosen, the *sumigaki* would plan the composition and sketch it on paper in fine black-ink lines. At the same time he would make notes on the sheet about the colors he wanted used. Then the pigment specialists would go to work, applying layer upon layer of paint within, but obscuring the *sumigaki*'s original outlines. In the final stage the *sumigaki* would look once again at the illustration, perhaps changing a few details, the expanse of a court robe, the incline of someone's head, and would then paint in the details of the faces. These so-called details are minimal, to say the least—tiny red mouths, slit-like eyes, and noses indicated by a single bent line. The men usually had thin mustaches and sometimes short beards as well. This abbreviated treatment is called "a line for the eye, a hook for the nose," *hikime kagibana*, and probably was developed in response to a superstition "the beautiful people" of Heiankyō had about having their facial features recorded in anything like a portrait. The painting technique used in the *Genji* pictures, that is, the application of layers of paint over an underdrawing, is called *tsukuri-e*, a word mostly translated as "makeup." However, the Chinese character usually used to write this term is better translated as "construction," something built up (see note on page 117). This painting technique was used with great success in the Heian and Kamakura periods for illustrating romantic tales.

The *Genji monogatari* deals with the life of an imperial prince born of the emperor's favorite wife, a lady too low in rank for her son to be designated an heir to the throne. Nevertheless, Genji was a handsome, cultured, and sensitive man, a man who not only loved women but continued to care for them even when he no longer loved them. His intrigues and affairs take up two-thirds of the novel; the last third deals with the lives and loves of two young men, Genji's heirs, in Kyoto after his death.

The most important theme of the *Genji monogatari*—*mono no aware*, best translated as the pathos of things or the moving quality of experience—is not an easy idea to convey visually. The five *sumigaki* who planned the compositions used pictorial conventions—possibly invented by them but probably not—that were particularly effective in illustrating moments of high emotional intensity. The blown-off roof, *fukinuki yatai*, was used not just to depict an indoor activity in an outdoor setting, as in the pictorial biography of Prince Shōtoku (see fig. 145). Instead, the odd angles of walls, sliding doors, and folding screens seen from above were used as metaphors for the emotions felt by the characters in the illustrations. The relative absence or presence of space in which the figures could move also contributes insight into their feelings. Finally, colors and patterns heighten the mood of the scene. All of these elements taken together create for the viewer a strong impression of *mono no aware*, the pleasure one experiences looking at a garden bathed in moonlight and hearing the sound of someone playing the flute, the pain one feels at the thought of losing a loved one.

A second major theme in the tale is the karmic effects Genji generated when he committed one great sin against his father. (Karma is one's actions and the consequences that devolve on one as a result.) In his youth Genji fell in love with his father's youngest wife, a woman he was encouraged to see because she looked so much like his mother, who had died while he was still an infant. A child was born out of Genji's liaison, a beautiful baby boy who was passed off as the emperor's own son and who eventually succeeded to the throne. The full force of Genji's karma hits him in middle age. His youngest wife, a woman he was cajoled into marrying but in whom he has no interest at all, has an extramarital affair that results in a son Genji decides he must publicly accept as his own, even as the old emperor had done with Genji's son.

The ceremony of acknowledgment is depicted in the third illustration from the Kashiwagi chapter (fig. 161).

**161.** Illustration 3 from the Kashiwagi chapter of *Genji monogatari emaki*. 1st half 12th century. Ink and color on paper; 8⅝ x 18⅞ in. (21.9 x 48.1 cm). Tokugawa Art Museum, Nagoya

= The Oak Tree

As the scroll is unrolled and the illustration comes into view, the first thing to appear is the brown surface of a courtyard—originally painted silver—and a veranda placed at such a sharp angle that it has nearly the force of a vertical line hindering the eye's movement leftward. Next the wall of the building appears. The lattice panels enclosing the interior space have been removed and their function taken on by thin slatted bamboo blinds and by curtains of state, white cloth curtains hung from horizontal poles, their black tie-ribbons hanging loosely. The next clues to the scene are the bottom of a twelve-layered robe, the garment of a lady-in-waiting, and above, red and black lacquered plates heaped with food. The colors in the costume and the use and careful placement of the lacquered dishes indicate that a ceremony is in progress. Finally, nearly two-thirds of the way across the illustration, figures appear, Genji at the top holding the baby in his arms, ladies-in-waiting below, and in the extreme upper left corner, the baby's mother, her presence indicated by a mound of fabric.

The text accompanying this illustration consists of Genji's thoughts as he goes through the painful ritual. He knows that his wife's attendants are well aware that he is not the child's father. His emotional discomfiture is suggested by the physical awkwardness of his placement at the top of the very sharply slanting floor. Further, the space he occupies is so constricted that should he wish to raise his head from the baby in his arms, he could not do so. In this scene the architecture plays a key role. At first, interrupting the leftward momentum of the illustration and at the same time shielding the figures from view, it suggests the guilty knowledge that reverberates throughout

the room during the ceremony, not only the wife's adultery but also Genji's cuckolding of his father many years before. Next, as it forces Genji into a cramped position, it suggests the pressure of society coercing him to put a good face on a bad situation.

An illustration that brilliantly evokes the sometimes conflicting facets of grief appears in the Minori chapter (colorplate 24). The true love of Genji's life, Lady Murasaki, is dying. A young woman she raised as her own, who is actually Genji's daughter by another wife, has come back from the Imperial Palace to be with her. One stormy evening Genji visits Murasaki, and the three sit together watching as the wind makes whips of the shrubs and grasses in her garden. When Genji first built his Katsura villa, he planned this garden to be beautiful the year round, but to reach its peak in springtime, Murasaki's favorite season. Now, as they gaze at it, it seems to be nothing but a tangled mass of vines.

The text presents Genji's thoughts, his knowledge that Murasaki is gravely ill, his dread that she will die, his sense that his grief will be nearly too much to bear. The architecture is placed at a sharp angle, nearly as steep as that of the scene described above. Here, however, the figures appear almost immediately as the scroll is unrolled, Murasaki near the top leaning on an armrest, her adopted daughter just below in the angle formed by the upper beam of the wall and a cloth curtain of state. Genji appears at the bottom of the incline, nearest to the veranda. Lastly, as the architecture disappears at the bottom of the picture, we see the wind-ravaged garden. The anguish Genji feels about Murasaki as she drifts toward death is suggested by the position he occupies at the bottom of the

**162.** Detail from scroll 1, *Chōjū jinbutsu giga*, showing dancing frogs. Mid-12th century. Ink on paper; height 12½ in. (31.8 cm). Kōzanji, Kyoto

**163.** Detail from *Chōjū jinbutsu giga*, scroll 1, showing animals watching an archery contest

**164.** Section of final scene of *Chōjū jinbutsu giga*, scroll 1, showing a religious service

diagonal, her disappearance from his world by the treatment of the architecture, his fear of being overwhelmed by his own grief by the tangled shrubbery. The artist has used an element from the natural world, the wind-whipped grass, even as poets used the scattering cherry blossoms as a reflector of specific human feelings, emotional turmoil, and restlessness (see pages 116–117).

The first two scrolls of the four-roll set known as the *Chōjū jinbutsu giga*, caricatures of animals and people, provide a striking contrast to the *Genji monogatari emaki*. First of all, the illustrations are presented as a continuous narrative. There is neither an opening text nor passages inserted between the illustrations. The figural motifs flow to the left without interruption. Secondly, the scrolls have no color. They were drawn with black ink on paper. Finally, they are funny throughout and at times bitingly satirical. The first two scrolls depict animals disporting themselves like human beings. A rabbit holding his nose does a back flip into a lake. Two frogs dance to a beat marked by the split-bamboo twangers they both hold (fig. 162). Frogs and rabbits compete in an archery tournament, while a shy bystander, a fox, gets so excited that his tail seems to burst into flames (fig. 163). The final scene of the first scroll depicts what seems to be a memorial service (fig. 164). The animal congregation is arranged in a semicircle behind a monkey clad in priest's robes, who is chanting in front of an altar on which a frog has been enshrined. The scene continues to the left, past a tree in which an owl is perched looking directly out at the viewer. The chanting monkey in ecclesiastical garb, here seen to the right, in the next section sits with a supercilious smile on his face as presents are brought to him in payment for the ritual he has just performed. Can this scene be anything other than a comment on religion and the priesthood? Since no text accompanies *emaki*, we can only guess at what or who the artist intended to satirize. Nevertheless, we can enjoy the humor of individual scenes and appreciate the artist's lively calligraphic strokes.

The *giga* as we know it today is something of a hodgepodge. The first two scrolls have superbly executed drawings of animals cavorting in a natural setting. The third and fourth scrolls are later in date and depict various types of contests between priests and laymen, as well as animals imitating humans, and are clearly by another, less competent hand. Furthermore, there are many passages in the first two scrolls that do not seem to flow together, either because a piece of the illustration is missing or because a mistake was made in the sequence of sheets of paper when the scrolls were repaired over the years. Also, several sections have become separated from the scrolls and have turned up in private collections. Scholars examining the two early scrolls have concluded that originally in the Late Heian period there were three *emaki* in this set, which at some point suffered serious damage that led to the remnants being fashioned into the two scrolls we have today.

The *Shigisan engi emaki* is one of the earliest extant

**165.** Illustration from *Shigisan engi emaki,* scroll 1, showing Myōren ordering a servant to place a rice bale into a begging bowl. 2nd half 12th century. Ink and color on paper; height 12½ in. (31.8 cm). Chōgosonshiji, Nara

*Shoat Story*

examples of a type of narrative that became very popular in the Kamakura period, the *engi,* or history of the founding of a particular Buddhist establishment. Unfortunately, nothing about the artist or the circumstances of production of this *emaki* can be documented. The temple in the *Shigisan engi* is Chōgosonshiji, deep in the mountains north of Nara, and the founder was a monk named Myōren, from Nagano prefecture in the Japan Alps. When still a young boy, Myōren left his family and traveled to Nara to study Buddhism, later building himself a small hermitage on Mount Shigi. The first two scrolls deal with miracles Myōren wrought, first, chastising a wealthy farmer for his greed by making his granary fly through the air to the top of the mountain, and second, healing Emperor Daigo when all other attempts had failed by causing a rare Buddhist deity, a sword boy, to appear to the emperor. The last scroll focuses on Myōren's sister, a nun who comes down from the mountains to search for her brother so they may live out the remainder of their days together. One night she prays in front of the great Buddha of Tōdaiji. The next morning she sees in a vision Mount Shigi encircled by a purple cloud. She takes it as a signpost to her brother's whereabouts, and she goes off to join him (see colorplate 8).

The *Shigisan engi* is a charming tale of simple people and miraculous events, and as such was included in a 13th-century anthology of folktales, the *Uji shūi monogatari.* The text also served as a legitimation of Chōgosonshiji, indicating that worshipers there would be benefited through the magical powers of its founder, Myōren. Because of the odd change of protagonists in the third scroll, from the priest to his sister, it is tempting to seek a

more complex didactic meaning for the work. The scrolls may be suggesting human frailties—greed, self-aggrandizement—to be overcome before the individual can attain enlightenment, the latter suggested by the nun's seeing a purple cloud encircling Myōren's mountain. However, since the artist and circumstances of production of the scroll are undocumented, this interpretation can only be speculative.

The *Shigisan engi emaki* is executed in a style of painting sometimes refered to as *otoko-e,* men's pictures (a term paired with *onna-e,* or women's pictures), which refers to the *tsukuri-e* technique used to illustrate the *Genji monogatari* and similar pieces of romantic fiction. The principal artist of the *engi,* probably the only artist, painted the outlines of his figures, and the natural scenery that served as their setting, in dark gray calligraphic strokes, and for color he used thin pigments that did not obscure his earlier lines. This permitted him to depict figures in active stances and to utilize the character of the calligraphic stroke to suggest movement. In a scene from the first scroll, Myōren stands near the wealthy farmer and directs one of the squire's servants to put a bale of rice into his golden begging bowl so that Myōren can send it and the other bales of rice from the granary back down the mountain to the squire's house (fig. 165). The illustration has a lively, fresh quality in perfect harmony with its subject matter.

The last major *emaki* surviving from the Late Heian period, the *Ban Dainagon ekotoba,* is less of an enigma than the other scrolls discussed above. Although its exact date is not known, and it does not bear an artist's signature, it has been attributed to Tokiwa Mitsunaga. He was active about 1173 and undertook a number of projects for

**166.** Illustration from *Ban Dainagon ekotoba*, scroll 2, showing the children's fight. Attributed to TOKIWA MITSUNAGA. 2nd half 12th century. Ink and color on paper; height 12³⁄₈ in. (31.5 cm). Idemitsu Art Museum, Tokyo

the imperial family during the Insei period, in particular a set of scrolls depicting annual events in the capital, the *Nenjū gyōji emaki*, which was commissioned to celebrate the revival of important ceremonies at court. His original paintings for this set have not survived, but copies from the 17th century go quite far toward re-creating the original work (see colorplate 16 and fig. 158). It is on the basis of the stylistic similarity between the *Nenjū gyōji emaki* and the *Ban Dainagon ekotoba* that the latter has been attributed to Mitsunaga.

The plot of the *Ban Dainagon ekotoba* is well documented. In 866 the Ōten Gate of the Imperial Palace burned down, and after many months facts came to light proving that the head of the Ōtomo clan, Major Counselor Tomo Yoshio—whose name and court title can also be read as Ban Dainagon—had set fire to the gate in an attempt to discredit a court rival, the Minister of the Left, Minamoto Makoto. Once his guilt was established, Lord Ōtomo was punished by being sent into exile. The incident is recorded in a history of the period with approximately the same details. Why this particular story was chosen for illustration at this time is not known, but whatever the circumstances of its production, it can be understood and appreciated today as an excellent example of narrative painting. The opening passage of text has been lost, and the scroll begins immediately with an illustration, a long passage of figures all running leftward with the flow of the scroll, only to be stopped abruptly by the sight of the gate in flames. Inside the palace enclosure to the left, Emperor Seiwa (reigned 858–876) and his grandfather, Fujiwara Yoshifusa (804–872), can be seen in the Seiryōden discussing the rumor circulating at court that "a certain Minamoto lord" was responsible for setting the fire (see fig. 108). The two decide to withhold action until more is known, and a few months later the truth comes out in quite a surprising way. One day in the market district, two boys begin to fight. One boy's father, a retainer of Lord Ōtomo, rushes out to break them apart and beats the other child severely. When the second father, a low-ranking government worker, rages at the first for hurting his son, the retainer assumes an arrogant manner. The second

father, beside himself with anger and anguish, blurts out that if the world knew what he knows about the retainer and his master, Lord Ōtomo, or Ban Dainagon, they would be severely punished. His veiled threat, heard by everyone in the neighborhood, is discussed in whispers in an ever-widening circle of people until it finally comes to the attention of the metropolitan police. The second father tells the authorities that he saw the retainer and his master, Lord Ōtomo, climb down from the palace gate just before it burst into flames.

The artist's retelling of the children's fight and its repercussions is masterly (fig. 166). The scene takes place in a bustling commercial and residential section of Kyoto. People on their way to market fall back as the children begin to fight, creating a diagonal line that serves as a frame to the right of the action. The retainer rushes out of his house and toward the fracas. Next he is seen below, physically separating the two boys and kicking the other man's child. There is no depiction of the later conversation between the two fathers. Instead, five people are shown grimacing at the beating being given to a mere child. Just to the left of this group is a single figure looking away from the fight, his mouth wide open as if he is shouting. By this simple device the artist establishes the next pictorial theme, the whisper passed from one person to another until it reverberates throughout the district. With amazing economy of means the artist is able to suggest where the children's fight took place, what it looked like, who saw it, and how it turned out, the basic who, what, where, and why of good journalism.

Another passage that demonstrates Mitsunaga's skill as a narrative artist comes toward the end of the tale. The sentence of exile for Ban Dainagon has been handed down, and the police have come to his home to escort him from the capital. The women of the household are heartsick at the thought of separation from their lord. Using the convention of the blown-off roof, the artist depicts them indoors, in various postures of grief (colorplate 25). One lady is so overcome she rolls on her back with her mouth open, as if she were shouting out her feelings. In the lower left corner of the scene, Ban Dainagon's principal wife and

son weep openly, while above them is an old woman we may take to be Lord Ōtomo's wet nurse. She sits, her hair and her clothing in disarray, her face in a grimace of pain, hugging her legs, like her grief, to her body. Among the narrative *emakimono* that have survived to the present day, it is hard to think of a more moving depiction of a human being in anguish. In the *Genji* pictures, Genji's grief at the thought of losing Lady Murasaki is discreetly suggested by elements within the composition that become visual metaphors for his emotions. In the tale of Ban Dainagon, on the other hand, the old woman's sorrow at the fate of the child she raised is expressed directly, through her facial expression and her body language.

The *Ban Dainagon ekotoba* uses the human figure as the basic module and the grouping of images in a leftward procession as its primary mode of composition. The figures may be shown running, held in check by an obstacle such as the Ōten Gate ablaze, or even standing still facing left or looking back to the right, but it is consistently on them that our attention is focused. The way they look, their facial expressions, and the way they place themselves speak directly of their feelings. In terms of technique, the *Ban Dainagon ekotoba* is an interesting blend of the *tsukuri-e* seen in the *Genji monogatari emaki* and the free *otoko-e* style of the *Shigisan engi*. The artist uses a calligraphic line to sketch out his figures, a more elegant and controlled line than that of the *Shigisan engi*, but he also uses bright colors applied thickly on the paper, almost the constructed-paint technique of the *Genji emaki*. Finally,

the artist combines in a single illustration a lively, free-flowing outdoor composition like those found in the *Shigisan engi* with a cramped indoor scene dealing with human emotions reminiscent of the *Genji* scrolls.

## Shinto Arts

The climate of the Heian period was a particularly fertile one for new developments in Shinto architecture and sculpture. First of all a new Shinto god was created, and a new type of shrine was built for him. Secondly, the practice of creating sculptures of Shinto divinities or *kami* in the style of Buddhist deities came into wide use.

Sugawara Michizane (845–903), a leading poet and scholar of the Chinese language at the end of the 9th century, was exiled to Kyūshū in 901 through the plotting of the Fujiwara family and died there in disgrace two years later. According to the beliefs of the time, the soul of a person who died with a falsely clouded reputation would come back as an angry spirit or *onryō*. When Michizane's enemies began to die unexpectedly—Fujiwara Tokihira, the head of the Fujiwara clan, at the young age of thirty-eight, and Minamoto Hikaru in a hunting accident—it was thought that Michizane's spirit had returned to wreak vengeance on those who had connived against him. To propitiate his spirit, in 923 he was posthumously reappointed Minister of the Right. However, it was believed that his spirit took the form of the God of Thunder in a black rain cloud that passed over the palace, killing one

**167.** *Haiden* (worship hall), Kitano Tenmangū, Kyoto. Rebuilt 1607 after the original of 947

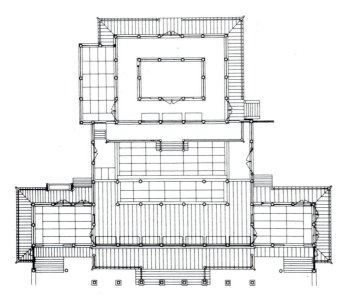

**168.** Plan of Kitano Tenmangū

thought that the *ishinoma* feature of the shrine evolved in the latter part of the Heian period.

The development of anthropomorphic images for Shinto gods in the 8th and the beginning of the 9th centuries represented a particularly important stage in Shinto's evolution as a religion. Before this time, Shinto deities were identified as something—an object, a place, or a person—that generated awe, and they were thought to take up residence on earth in their *iwakura*, natural settings like rocks, trees, and waterfalls. However, in answer to Buddhist practices, the idea developed in the Heian period of representing certain gods in human form rather than as features of nature. Sculptures of these gods were executed in wood, often in the *ichiboku* technique, so the images could be seen as a materialization of the spirit out of the type of material in which the *kami* preferred to reside on earth.

An early example of Shinto sculpture is the set of three images made for the Yasumigaoka Hachiman Shrine on the grounds of Yakushiji in Nara. In the center is a priest flanked by two female figures in court costume (figs. 169–171). The exact identification of the three figures is problematical. The priestly figure is usually identified as Hachiman in the guise of a monk.❖❖ However, a more specific identification is possible. A clan associated with the Usa Hachiman Shrine in northern Kyūshū particularly venerated Emperor Ōjin (reigned 270–310, according to tradition) and his mother, Empress Jingū (who reigned from 210 to 270, according to traditional dating). The clan also venerated a local female deity, Himegami, the protector of sea travel and agriculture. These three images in the Yasumigaoka Shrine may represent Emperor Ōjin, deified as the god of war and dressed in the garb of a Buddhist priest, with his mother, Empress Jingū, and a second female figure, either Himegami or Ōjin's wife, Nakatsu, flanking him. However, whether or not all Shinto triads

nobleman and scorching the face of another, and in 947, the forty-fourth anniversary of his death, a shrine, the Kitano Tenmangū,❖ was built in Kyoto in his honor. Finally, some forty years later he was accorded the designation of *tenjin* or heavenly deity. Eventually, he came to be regarded as the patron god of learning, literature, and calligraphy. Some thirty-five hundred shrines have been erected in his honor throughout Japan, many of them in active use today. It is not uncommon for students facing an important examination to visit a Kitano shrine and pray to Michizane.

What distinguishes Michizane from other Shinto divinities is the fact that he was a historical figure, not a mythic being. The plan of his Kitano shrine developed out of the Hachiman shrine type, but because of its association with Michizane it was used repeatedly in the Momoyama and Tokugawa periods for the mausoleums of other historical personages, such as the shoguns Toyotomi Hideyoshi and Tokugawa Ieyasu, and is now known as *gongen zukuri*, a name taken from an honorific title, Incarnated One, given to Ieyasu, the first Tokugawa shogun. The distinguishing feature of the *gongen zukuri* type of building is the fact that two parallel structures, the *haiden* (worship hall) and the shrine, are separated by a passageway, a small enclosed room with a gable roof and a stone floor joining the two main buildings; it is on the same level as the *haiden* but lower than the shrine (figs. 167 and 168). This space was known as the *ishinoma*, or stone room. As the *gongen* type of shrine evolved over the years, only the treatment of the roofs changed. In the Kitano Tenmangū, the eaves of both halls can be seen inside the *ishinoma*, but in later structures such as the Tōshōgū Shrine at Nikkō, Ieyasu's mausoleum, the connecting room has been provided with its own ceiling. The present Kitano Tenmangū was built in 1607, but it is

---

❖ Kitano means "northern fields," and refers to the area in Kyoto where the shrine to Michizane was built, but the word *Kitano* came to refer to any shrine dedicated to Michizane.

❖❖ Hachiman is an important Shinto deity, traditionally the god of war. He is sometimes seen as a deification of Emperor Ōjin and represented in sculpture as this emperor, but it is not clear whether all statues of Hachiman are representations of Ōjin. Hachiman came to be regarded as a bodhisattva and a protector of Buddhism, as well as a protector of the nation: it was thought that he had vowed to watch over Tōdaiji while the great Buddha there was being cast. In sculptures, Hachiman is often dressed as a priest. He also had a direct relationship with the imperial clan, and it was to Hachiman at the Usa Hachiman Shrine that Wake Kiyomaro reported the priest Dōkyō's ambition to become emperor in the 8th century (see page 108).

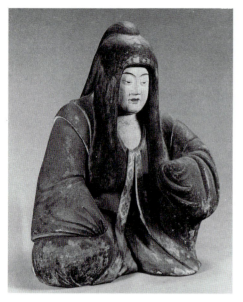

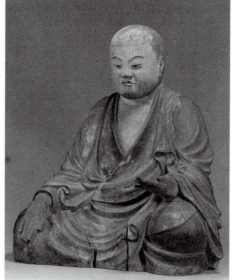

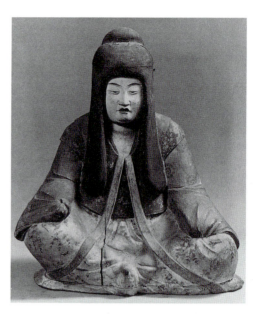

**169.** Shinto goddess personifying Empress Jingū. From the Hachiman Triad, at Yakushiji, Nara. Late 9th century. Wood, painted; height 13 3/8 in. (33.9 cm)

**170.** Shinto god Hachiman as a monk. From the Hachiman Triad, at Yakushiji, Nara. Late 9th century. Wood, painted; height 15 1/4 in. (38.8 cm)

**171.** Princess Nakatsu. From the Hachiman Triad, at Yakushiji, Nara. Late 9th century. Wood, painted; height 14 1/2 in. (36.8 cm)

depicting a priest flanked by two court ladies may be recognized as representations of these specific personages is not clear.

The set of sculptures made for Yakushiji are small wooden images. Hachiman is shown seated in a cross-legged pose, his right hand laid over his knee, his left hand raised. His garment falls over his body in a simple pattern of drapery folds. The figure is quite small and is carved out of a single block of wood. The female figures sit in relaxed poses, their hands tucked demurely into their sleeves. They, too, are executed in the *ichiboku* technique. In fact, it seems that all three statues were carved out of the same tree trunk, perhaps a tree with some special significance. On the basis of the sculpting method and the style in which the figures are carved, they are usually dated to the later years of the 9th century, about the time the original shrine at Yakushiji was built, in the years between 889 and 897.

# CHAPTER 4
# Samurai Culture and the Coming of Pure Land and Zen Buddhism

## THE EARLY FEUDAL PERIOD

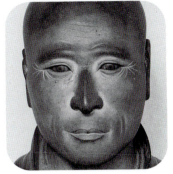

The Heian period had begun with the relocation of the imperial government to Kyoto and a concurrent shift of political power from the Buddhist establishment in Nara to powerful noble families. Over the course of the nearly four hundred years between 794 and 1185, Kyoto had dominated the development of Japanese culture. With few exceptions, the important works of the Heian period were made in the capital city for the aesthetic pleasure of its patricians, whose tastes were highly cultivated and refined—even at times polished in the extreme. Politically, the Heian period had witnessed the beginnings of a trend to maintain the line of succession of the imperial clan, while the seat of actual power moved to other noble clans. In the Middle Heian, the Fujiwara had ruled as regents. In the Late Heian, the imperial clan had reasserted its claim to political dominance, but the effective ruler was the retired emperor heading an *insei* government. Toward the end of the Heian period, the lengthy peace of the era was broken as conflicts erupted over competition for power between the increasingly structured and warrior-dominated clans.

The Genpei Civil War of 1180 to 1185 marks the transition from the relative tranquillity of earlier times to the next, more conflicted long epoch. In this book, the politically complex centuries between 1185 and 1573 are called the Early Feudal period. Included in this designation are three successive eras with names that are perhaps more familiar: Kamakura, Nanbokuchō, and Muromachi or Ashikaga. Much of the Early Feudal period is a time of pessimism and even despair as Japan is torn by a series of rivalries between feudal lords competing for land and for the wealth derived from it. The dominant clans in this period are the Minamoto—who rule from their base in Kamakura until 1333—and the Ashikaga, whose shogunate lasts from 1336 to 1573, with a brief period between, the Kenmu Restoration, when the imperial clan briefly asserts its leadership. The Early Feudal period is characterized by the dominance of the military class, with samurai (warriors and retainers) protecting a complex, stratified organization of constables, stewards, and landholders who manage the land and secure the territorial boundaries of the increasingly autonomous domains. Religion, too, undergoes profound changes with the popular acceptance of the Buddhist Pure Land sects of Jōdo, Jōdo Shin, and Ji, and with the introduction of Zen Buddhism.

## Outlines of Early Feudal Period History (1185–1573)

In 1185 the Minamoto army under the brilliant leadership of Minamoto Yoshitsune (1159–1189) decisively defeated the Taira at Dannoura, a small village near the port of Shimonoseki, bringing to an end the five-year-long Genpei Civil War, during which fighting had stretched from the Kantō to the Kansai, from Osaka to Yashima on the island of Shikoku, and all the way to the southwestern tip of Honshū. The head of the victorious clan was Yoshitsune's older brother, Minamoto Yoritomo (1147–1199), who had sat out most of the war in Kamakura, a seaside town to the south of modern-day Tokyo, where he had established his power base in 1180. When the war ended, Yoritomo launched a campaign to conquer the northern provinces of Honshū, eliminated Yoshitsune, of whom he was jealous, and succeeded in bringing the whole country, except for Hokkaidō, under his control. Finally, in 1192, in recogni-

tion of his power, the emperor granted him the title of Seiitai Shōgun, Barbarian-subduing General. Yoritomo was Japan's first shogun, and the first part of the Early Feudal era is called the Kamakura period (1185–1333) after the town where he was based.

When Yoritomo died in 1199, his two sons, Yoriie and Sanetomo, were too young and untrained to control the Kamakura shogunate, and a power struggle ensued between their mother, Hōjō Masako, her father, Tokimasa, and her brother Yoshitoki. At first Tokimasa won out, forcing Yoriie into exile and assuming the office of regent for Sanetomo, who was elevated to the position of shogun. However, in 1205 Masako joined with her brother and forced Tokimasa into exile, the brother assuming the regency himself. There is a subtle irony in the fact that the Hōjō family, an offshoot of the Taira clan, was able to achieve through guile the supremacy that the leaders of the clan had failed to attain, and a further ironic twist of fate that they, in turn, were eventually toppled by Ashikaga Takauji (1305–1358), a Minamoto descendant who traced his ancestry back to one of the greatest of the Minamoto generals.

By the end of the 13th century, the shogunate in Kamakura had lost control of its feudal alliances, so it was easily overturned in 1333 by Takauji, in league with the emperor Godaigo (1288–1339). There followed a brief period known as the Kenmu Restoration, during which Godaigo ruled the country in his own right from Kyoto. However, in 1336 Takauji took control of the capital, forcing the emperor to flee south to the mountains of Yoshino. Takauji then placed the fourteen-year-old Kōmyō (1322–1380) on the throne and in 1338 assumed Yoritomo's title of Seiitai Shōgun. Godaigo had taken the imperial regalia—the symbols of legitimacy to rule—with him when he left Kyoto, and he set himself up as the legitimate emperor of Japan, ruling from Yoshino while the child-emperor continued on the throne in Kyoto. This dual imperial claim launched the Nanbokuchō period, the era of the Southern and Northern courts, which is generally dated from 1336 to 1392.

The division between the two imperial lines continued until the third Ashikaga shogun, Yoshimitsu, persuaded the ruler of the Southern Court to resign and to turn over the imperial regalia to Gokomatsu, then emperor in Kyoto. He accomplished this reunification in 1392 by promising that the position of ruler would alternate between the southern and northern lines within the imperial family, a promise that was never kept. Yoshimitsu, arguably the most astute of the Ashikaga shoguns, succeeded to that position in 1368 when he was only ten years old, but a decade later he was sufficiently in control to move the seat of his government from the Kyoto headquarters that Takauji had set up to Kyoto's Muromachi district.

After Yoshimitsu, the Ashikaga clan continued as shoguns for almost two hundred years, but without achieving the central authority and military control of the Minamoto. With a less stable coalition of military clans, peace was increasingly elusive, until the Ōnin War of 1467 to 1477 decimated Kyoto, destroyed the shogunate's power, and inaugurated a century of warfare called the Sengoku, the Age of the Country at War. The Ashikaga shogunate survived in name until the warlord Oda Nobunaga entered the capital with an impressive army in 1568. He successfully usurped the powers of government, finally toppling the last Ashikaga shogun in 1573.

Several dates have traditionally been used as benchmarks for this complex early period of feudal rule:

1185  Victory of the Minamoto clan in the Genpei Civil War
1192  Minamoto Yoritomo named shogun
1333  Fall of the Kamakura shogunate; beginning of the Kenmu Restoration
1336  Beginning of the Nanbokuchō period and the Ashikaga shogunate, when Ashikaga Takauji assumes the title Seiitai Shōgun
1392  End of Nanbokuchō period and consolidation of Ashikaga power
1467  Beginning of the Ōnin War and the Sengoku
1568  Oda Nobunaga takes control of the capital of Kyoto
1573  Oda Nobunaga ends the Ashikaga shogunate

Following tradition, the names of the geographic areas in which the shoguns located their seats of government are used as period names:

Kamakura period (1185–1333), with the Kenmu Restoration from 1333 to 1336
Nanbokuchō period (1336–1392), referring to the Southern Court in Yoshino and the Northern Court in Kyoto
Muromachi period (1392–1573), after the location of the shogunate in the Muromachi district of Kyoto or, alternatively, the Ashikaga period, for the clan that held the post of shogun

## Kamakura Culture  1185 – 1333

In the first years after the Genpei Civil War, one of the country's top priorities was renewal: the revitalization of the nation's traditional religious foundations, the rebuilding of Buddhist temples damaged or destroyed during the fighting, and the modification of existing religious institutions to satisfy newly emerging constituencies of worshipers. The aristocracy, still centered in Kyoto, no longer had real power, but retained their role as the nation's cultural leaders. As well as supporting the religious revival, members of the nobility devoted a good deal of their leisure time to creating and enjoying the arts.

### Tōdaiji

The rebuilding project with the highest priority was Tōdaiji in Nara. The Daibutsuden or Great Buddha Hall had been burned to the ground in 1180 by the Taira army as punish-

**172.** The Nandaimon (Great South Gate), Tōdaiji, Nara. 1199

ment for the aid the monks gave to the Minamoto clan and its royal supporters at the beginning of the Genpei Civil War. This wanton destruction of an imperially sponsored and greatly revered temple had shocked the country, and even before the war had ended, the government began the reconstruction process. Placed in charge was Shunjōbō Chōgen (1121–1206), a priest trained in Shingon who later became a proponent of Pure Land Buddhism. With his appointment, a countrywide campaign was initiated to raise funds for the project, and Chōgen, then in his sixties, took to the road to solicit contributions. Even the renowned priest-poet Saigyō (1118–1190) was encouraged in 1186 to make his last pilgrimage to the northernmost provinces of Honshū to collect in the name of Tōdaiji. One of the most generous donors was Minamoto Yoritomo, who traveled from Kamakura to the Kansai in 1195 not only to attend the dedication ceremony but also to pay a formal courtesy visit, military ruler to sovereign. Of the buildings constructed during this restoration campaign, the Nandaimon, or Great South Gate, best preserves the grandeur of Chōgen's concept (fig. 172). It was built in 1199, and the Kongō Rikishi, the guardians of the gate, were installed in 1203.

Chōgen was unusual among the Buddhist clergy for having made three trips to China between 1167 and 1176 to continue his Buddhist training. During his stays he apparently informed himself about contemporary Chinese Buddhist architecture, because the style employed in the new construction at Tōdaiji, known as *daibutsuyō*, or Great Buddha style, had not been seen in Japan before the Genpei Civil War. (The name of the style derives from the fact that it was used in the Tōdaiji hall housing its colossal buddha image.) During his travels to raise funds for Tōdaiji, Chōgen built three provincial temples, including the Jōdoji in Hyōgo prefecture west of Kyoto, in this same *daibutsu* style, before he undertook the Nara project. The physical appearance of this extraordinary man is preserved in one of the most starkly realistic portrait sculp-

**173.** The priest Shunjōbō Chōgen. Shunjōdō, Tōdaiji, Nara. Early 13th century. Wood, with paint; height 32⅜ in. (82.2 cm)

tures of the Early Feudal period (fig. 173). Executed by an obviously talented artist, the sculpture was probably made shortly after the priest's death in 1206 to be used in memorial services in his honor. It shows him as an old man, sitting in a slightly hunched-forward position reciting the *nenbutsu* prayer, "Hail to Amida Buddha," as he fingers a string of prayer beads.❖

The statue is made of *hinoki*, Japanese cypress, in the *yosegi*, or multiple-block, technique and is decorated in the simplest way, with flesh tones for the head and black for the priest's robe. Chōgen's face is a wonderfully realized study of an old man, with prominent cheekbones, wrinkled flesh around his mouth, pursed lips, and deep eye cavities under bony eyebrows. The eye treatment is

---

❖ Strings of beads made of bone, wood, or nuts have long been used in India by Hindus and Buddhists for meditative repetition of a sacred name or phrase. The prayer beads are called *mala* in Sanskrit, meaning garland or rose, and their use spread from India to China and then to Japan, where they are called *juzu*. Buddhist rosaries have 108 beads, said to represent 108 delusions that people are prey to. The Christian rosary is thought to derive from the same Asian cultural source.

**174.** Diagram of *daibutsuyō* bracketing

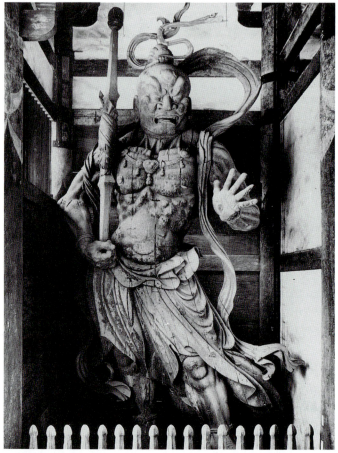

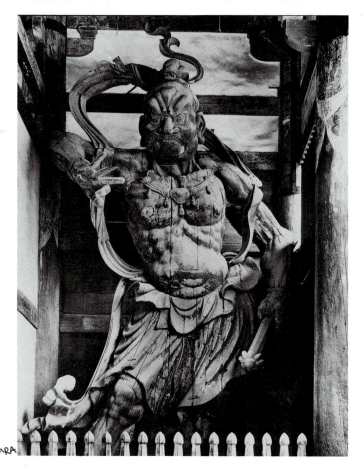

particularly interesting. It became the custom from the late 12th century on to inset crystal for the eyeballs, but here the sculptor has rejected the new technique in favor of an even more realistic depiction of the eyes, with one opened slightly wider than the other. The priest's hands are not the thin, elegant ones of someone dedicated to sedentary pursuits, but instead have the thick fingers of a man used to manual labor. Unfortunately, no artist's name has been recorded for the sculpture, but because it was made at a time when the Kei school of artists, whose hallmark was graphic realism, was active in Nara, it is possible that it may have been made by one of the Kei masters. In any case, the sculpture is a beautifully realized image of an old priest who is physically and emotionally tough and whole-heartedly committed to his religious vocation.

The Nandaimon, or Great South Gate, of Tōdaiji is the exemplar not only of Chōgen's building campaign but also of the union of realistic Kei-style sculpture with new temple construction, in the context of the former capital and its classic Buddhist art. The original gate had been demolished by a typhoon in 962 and never rebuilt, but given Chōgen's vision for the new Daibutsuden, a major entry gate was clearly in order. As mentioned above, the building itself was completed in 1199 and the two gigantic Kongō Rikishi statues, Agyō and Ungyō, both about 27½ feet tall (8.4 m), were installed in 1203.

The style of construction known as *daibutsuyō* refers particularly to the bracketing system used for the Great Buddha Hall at Tōdaiji, in which bracket supports project forward at right angles from the wall post in six increments to the edge of the roof, with two additional levels of brackets supporting the eaves (fig. 174). However, only

**175a and b.** Pair of Niō figures, by UNKEI and KAIKEI.
*a (above):* Agyō. 1203. Wood, with paint; 27 ft. 5 in. (8.36 m).
*b (below):* Ungyō. 1203. Wood, with paint; 27 ft. 7 in. (8.42 m).
Outermost bays of Nandaimon (Great South Gate), Tōdaiji, Nara
Kamakura P.

two brackets project out on either side of the posts, and there are no intercolumnar supports. The result in the Nandaimon is that the vertical dimension of the gate is tall and impressive, but there is a strong contrast between the wooden shapes extending forward and those visible on the wall surface, between complexity and stark simplicity. While the *daibutsuyō* style results in a building of impressive height, it does not provide the rich, decorative texture of white plaster and red-colored wood bracketing achieved in other styles and seems to have met with little favor after Chōgen's death. *guardians of the Gate*

The Kongō Rikishi installed in the two outermost of the gate's five bays are dynamic sculptures that hold their own against the vertical projection of the building (figs. 175a and b). Their placement is unusual in that they face toward the open center of the gate rather than toward the entrance path, a positioning that may have been determined in the early 18th-century restoration of the temple. So great is the height of the gate's first story that a traditional placement of the statues facing the entrance pathway would have afforded them little protection from the elements. The sculptures are the result of a collaboration between two of the most talented Kei-school artists, Unkei (died 1223) and Kaikei (active 1185–1223), and were produced in the incredibly short span of seventy-two days, a testimony to the efficiency of the Kei school's studio system and the potential of the *yosegi* technique. Records indicate that in addition to the two named artists, two other sculptors of master status and sixteen assistants worked on the statues. The two guardians stand in dramatic, hip-slung poses, giving the impression of arrested motion. It is as if they have just seen a potential danger, stepped out, and raised an arm in a strong, protective gesture. Their scarves and skirts sweep out to one side, as if lagging behind the movement of the wearers. The Kongō Rikishi faces, which emphasize strongly three-dimensional features, and the sense of movement in their poses are reminiscent of the clay Shūkongōjin image of 733 in the Hokkedō of Tōdaiji, a work to which Unkei and Kaikei must have had access (see colorplate 7). One of the hallmarks of the Kei school is realism, but another is classicism, a knowledge of the sculptural style developed in Nara in the 8th century, and an attempt to rework it into a mode appropriate for the new age. The primary differences between the 8th-century works and those of the Kei school are a stronger sense of realism in the latter, even to the point of exaggeration, and a heightened feeling of drama.

## Kōfukuji

Kōfukuji, one of the two head temples of the Nara-based Hossō school and the family temple of the Fujiwara, was nearly wiped out in 1180 in the Taira punitive raid that also damaged Tōdaiji. The priests of the two temples bore such great enmity toward Shigehira, the Taira leader of the attack, that at the end of the war the priests of Kōfukuji de-

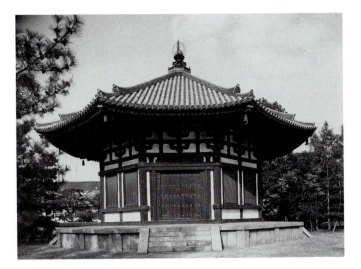

176. Hokuendō (North Octagonal Hall), Kōfukuji, Nara. 1210

177. Diagram of *wayō* (Japanese-style) bracketing

manded he be turned over to them, and they killed him. When the construction campaign for Tōdaiji was initiated, Kōfukuji, receiving the direct support of Minamoto Yoritomo, began to rebuild. The Kei sculptors resident in Nara received commissions not only to repair 7th- and 8th-century sculptures that had been damaged, but also to create new works to replace the most important of those lost over time.

Of the buildings constructed in the early years of the 13th century only the Hokuendō, the North Octagonal Hall, of 1210 survives, but many of the sculptures of the Kei school have been preserved and are today displayed in the Kōfukuji Treasure House. The Hokuendō stands on the site of the memorial hall constructed in 721 for the first anniversary of Fujiwara clan leader Fuhito's death, and although it is executed in the *wayō*, or Japanese style, of the early 13th century, it retains certain elements reminiscent of Nara-period Buddhist temple buildings (fig. 176). On

the four cardinal sides of the hall are full-length wooden doors, and on the walls in between are large, lattice-covered windows. The construction system features heavy round pillars set into the eight corners, with lighter square pillars used in the centers of the window walls and as the frame for each of the doors. The *wayō* bracketing system uses three levels at the corners, with three flat brackets in the center of each wall and single vertical supports in between (fig. 177). The entire structure is set on a stone platform and the interior is dominated by an octagonal platform. The classical echoes in the construction are the heavy round pillars, the large lattice windows, and the complexity of the bracketing system.

The central image installed in the Hokuendō is a seated Miroku Butsu, portraying Maitreya as a buddha, flanked by two standing priests, Muchaku (Skt. Asanga) and Seshin (Skt. Vasubandhu). All three are by Unkei and were set in place in 1212 (figs. 178, 179, and 180). The Miroku image was no doubt chosen because it was the deity enshrined in the original hall, Miroku having been

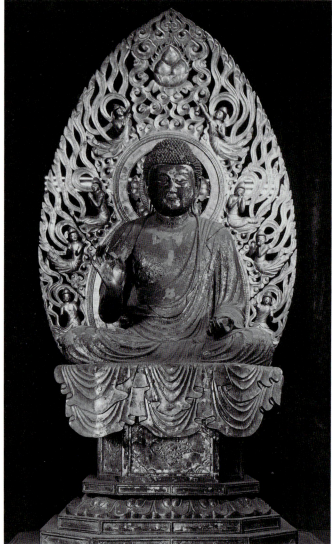

**178.** Miroku Butsu, by UNKEI. Hokuendō, Kōfukuji, Nara. 1212. Wood, with paint and gold leaf, and inlaid eyes; height 55⅞ in. (141.9 cm)

**179.** The priest Muchaku, by UNKEI. Hokuendō, Kōfukuji, Nara. 1212. Wood, with paint and inlaid eyes; height 74 in. (188 cm)

the particular focus of Fuhito's devotions. Originally, it was flanked by two attendant divinities and surrounded by the Four Guardian Kings and the two priests, who are *rakan*, or arhats (from the Sanskrit). *Rakan* are Buddhist adherents who achieved enlightenment following the model of the historical Buddha; Muchaku and Seshin are accorded that rank because they are two of the most fa-

mous figures of early Indian Buddhism. Brothers, they formulated key Buddhist philosophies that have been central to many Buddhist schools, including the Hossō. Of the 13th-century sculptures in the Hokuendō, only these three survive, magnificent exemplars of both the period's, and Unkei's mature style.

The Miroku sits cross-legged on a tall octagonal platform, an elaborate openwork halo behind his head. In contrast to the 7th- and 8th-century treatment of Miroku as a youthful bodhisattva, meditating in heaven while awaiting his time to be reborn on earth, this sculpture presents the mature Buddha of the Future. Furthermore, Unkei has achieved a new balance of proportions, as compared to the Amida Nyorai by Jōchō in the Byōdōin, in which the torso of the figure has a greater vertical projection than the horizontal spread of the legs (see colorplate 18). Yet unlike such earlier statues as the seated Shaka of Murōji (see fig. 128), this figure does not appear top-heavy. The facial features and the drapery are more deeply carved than those of the Jōchō Amida, giving the image a more natural look. The eyeballs are made of crystal, and the pupils seem to be focused downward, suggesting a facial expression the Japanese sometimes describe as melancholy. The technique of carving is *yosegi* and the wood is *katsura*, a dense, even-grained hardwood ideally suited for carving. Using methods pioneered by Jōchō, Unkei has created an entirely new style of sculpture, an image projecting a feeling of approachability, a gentle, almost human deity with whom the worshiper can hope to communicate.

The Muchaku and Seshin flanking the Miroku are masterful sculptures. Muchaku is depicted as a slender figure holding a cylindrical object, perhaps a reliquary, wrapped in a piece of cloth, while Seshin is a more fleshy individual, whose hands appear to be gesturing as he speaks. One appears to be reflective and introverted, while the other is outgoing, seeming to make eye contact with the viewer. Both figures wear priest's robes that fall in deeply carved and irregularly patterned folds. They are completely natural images, freestanding and not frontally posed. Unkei has created imaginary portraits of the two early Indian Buddhists that are completely believable in the context of Japan in the 13th century.

## The Kei School of Sculptors

The Kei school of sculptors traced its origins to the sculptor Raijo (1044–1119), a second-generation disciple of Jōchō. Although Jōchō's studio was located in Kyoto, after Raijo completed a commission from Kōfukuji in 1096, he decided to remain in Nara rather than return to the capital, where he would have to compete for work with the

**180.** The priest Seshin, by UNKEI. Hokuendō, Kōfukuji, Nara. 1212. Wood, with paint and inlaid eyes; height c. 74 in. (187.9 cm)

181. Fukūkenjaku Kannon, by KŌKEI. Nanendō (South Octagonal Hall) Kōfukuji, Nara. 1189. Wood, with paint and gold leaf, and inlaid eyes; height 11 ft. (3.36 m)

was lost in the fire of 1180. Stylistically, the image stands between Jōchō's Amida of 1052 (see colorplate 18) and Unkei's Miroku of 1212 (see fig. 178). The proportions are very much those of Jōchō's statue, having a wide baseline, provided by the stretch of the lower legs, and a comparable vertical projection of the torso. The face, too, retains the squarish shape of the earlier style. New elements have been introduced—for example, the crystal used for the eyes and the urna. Also, the carving of facial and drapery details is deeper than was the case in earlier yosegi sculptures. However, in essence the statue is a graceful reworking of the Middle Heian style established by Jōchō.

Kaikei, who collaborated with Unkei on the Kongō Rikishi of the Great South Gate, when given creative control of his own projects produced gentler sculptures richly embellished with numerous details. Kaikei was a disciple of Kōkei, adopted into the family and the studio rather than a blood descendant, and his life followed a somewhat different pattern from that of the other Kei sculptors. Although both he and Unkei were devout Buddhists, Kaikei involved himself more completely in the teachings of the Pure Land school. He came under the influence of Chōgen, who gave him the Buddhist name Anamidabutsu and also favored him with a number of sculpture commissions. During the last period of Kaikei's life, he seems to have worked primarily on Amida images, and his style at that time is known as anami after his Buddhist name.

One of the most memorable works Kaikei created on commission from Chōgen is the 1201 statue of the Shinto god Hachiman, known as Hachiman in the Guise of a Monk, preserved at Tōdaiji (colorplate 26). The idea of associating Hachiman with the outward appearance of a Buddhist monk developed during the Heian period, and an early but characteristic sculptural representation is the late-9th-century image at Yakushiji (see footnote to page 145 and fig. 170). Kaikei's statue was made for the newly rebuilt Hachiman Shrine at Tōdaiji. Apparently Chōgen had wanted to install in the shrine a painting of Hachiman that was originally owned by Jingoji but in the late 12th century was held by the retired emperor Gotoba. However, before he could get to it, Priest Mongaku of Jingoji had persuaded Gotoba to return it to Jingoji. Kaikei is thought to have based his sculpture on the Jingoji painting. The deity sits cross-legged on a lotus base, one hand in his lap, the other holding a priest's staff.❖ Although the

❖ Known in Japanese as a shakujō, it is a tall walking stick topped by a three-lobed copper ornament to which six metal rings are attached. As the bearer walks using the stick, the rings jingle together, making a sound that is thought to warn insects and other small animals so they can get out of the way and avoid being crushed underfoot. It is also said to repel poisonous insects. The shakujō is characteristically presented in the right hand of standing Jizō bodhisattva figures.

conservative but powerful In and En schools. His descendants continued to produce sculpture in Nara and preserved the connection with Kōfukuji. At the time of the rebuilding campaign in the 12th century, the head of the studio was Kōkei (active 1175–1200), who is generally credited with organizing these artisans into the Kei school. The most prominent artists working under him were his son Unkei and his disciples Kaikei and Jōkei. The next generation of masters were mostly Unkei's sons, Tankei, Kōun, Kōben, and Kōshō. Once the rebuilding campaigns of Tōdaiji and Kōfukuji were completed, Unkei moved the Kei studio to Kyoto. This group of talented men had had the opportunity to work together in heady proximity to the greatest sculptures of the Nara period, and with that powerful influence they created the most innovative and accomplished works of the Early Feudal era.

Kōkei's artistry is represented by the statues he made in 1189 for the Nanendō, the South Octagonal Hall, at Kōfukuji. The central image is a gigantic Fukūkenjaku Kannon (fig. 181), the same type of image, albeit seated, as the main divinity of the Hokkedō platform at Tōdaiji (see fig. 86). The statue was made to replace the original Fukūkenjaku Kannon, thought to date from 746, which

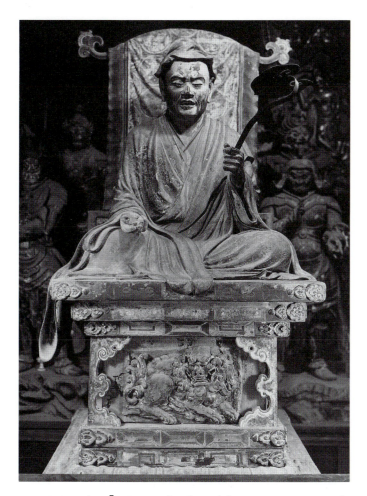

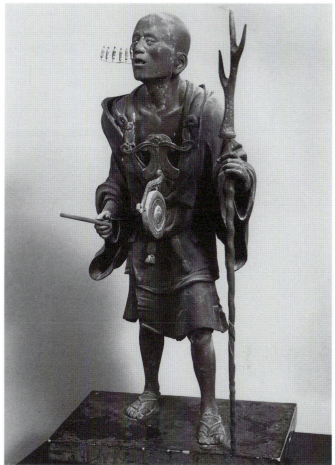

**182.** Yuima, by JŌKEI. East *kondō*, Kōfukuji, Nara. 1196. Wood, with paint and inlaid eyes; 34⁵/₈ in. (87.9 cm)

**183.** The priest Kūya, by KŌSHŌ. Rokuharamitsuji, Kyoto. Early 13th century. Wood, with paint and inlaid eyes; 46¹/₄ in. (117.6 cm) *Kei school work Kamakura P.*

priest's face shows the wrinkles of age, it is the idealized countenance of a divinity. The piece has a strong three-dimensional presence, but the potential strength of the Shinto divinity has been subordinated to the calm, ethereal elegance of the monk.

Like Kaikei, the sculptor Jōkei is believed to have been a disciple of Kōkei's but not a blood relation, although little about this artist can be documented. Indeed, there seem to have been two sculptors of the same name active in Nara in the 1200s, one around the turn of the century, the other toward the middle. From the works that can be securely attributed to the earlier Jōkei, it is clear that he was a talented artist who most probably had seen examples of Chinese Buddhist sculpture of the Song dynasty (960–1279). Perhaps he, like Kaikei, had contact with Chōgen and was able to tap the old man's store of knowledge about Chinese Buddhist art and architecture.

Jōkei's image of Yuima (fig. 182), from a set of Monju and Yuima (Skt. Manjushri and Vimalakirti) statues of 1196 in the eastern *kondō* of Kōfukuji, is particularly interesting for what it reveals about the artist and also about the technical procedures in making a piece of sculpture. The classic theme of the debate between Monju and

Yuima can be traced back in Japanese sculpture to the clay figures of 711 in the five-storied pagoda of Hōryūji (see fig. 71), but Jōkei's treatment of it is entirely new. The Yuima, a robust figure rather than a sick old man, sits on a tall rectangular platform backed with a wooden structure over which a decorated textile of some sort has been draped. This high back and the motifs on the base of the construction, the lion contained within an elaborately decorated frame, are particularly Chinese in flavor. In the chest cavity of the statue is a lengthy inscription by the artist stating that the work was sculpted by Jōkei in 1196 in a period of fifty-three days, and that the surface preparation and the application of colors were executed in a period of fifty days by an artist named Kōen.

Works by two of Unkei's younger sons suggest the poles of representation possible within the context of Buddhist sculpture in this period: the statue of Priest Kūya by Kōshō and the two lantern-bearing demons by Kōben. The Kūya is an exercise in realism taken to the limits of literal representation (fig. 183), the demons a humorous study of imaginary creatures materialized into solid three-dimensional forms. Kūya (903–972) was a devout adherent of Amidism, an early expression of Pure Land Buddhism,

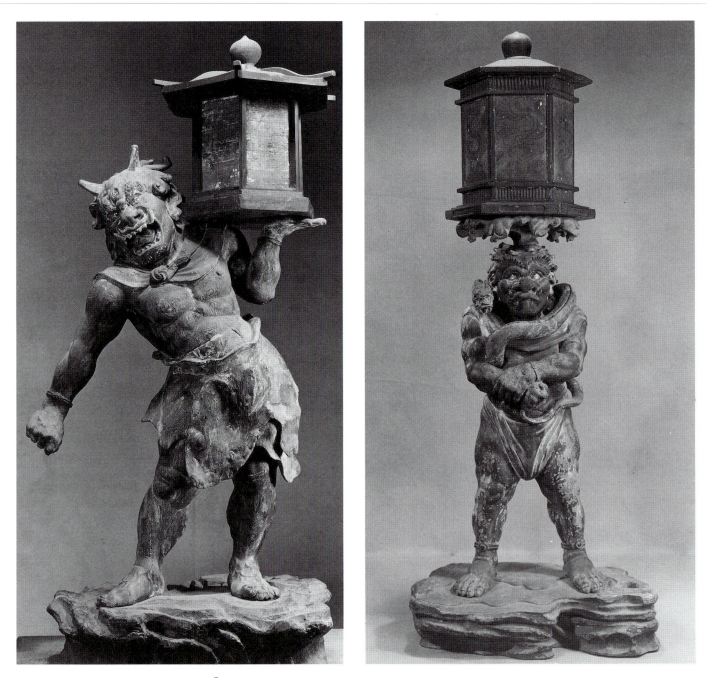

**184a and b.** *a (left):* Tentōki, by KŌBEN. 1215. Wood, with paint and inlaid eyes; height 30¾ in. (78.2 cm). *b (right):* Ryūtōki, by KŌBEN. 1215. Wood, with paint and inlaid eyes; height 30⅝ in. (77.8 cm). Kōfukuji, Nara

who traveled extensively throughout Honshū teaching the *nenbutsu* in a ritual of worship that included the chanting of "Namu Amida Butsu" while dancing to the accompaniment of drums and bells. A story, perhaps apocryphal, has it that Kūya was converted to Amidism after he killed a deer and then realized the enormity of his act. He made himself a pilgrim's walking staff and affixed one of the deer's antlers to the top to remind him of his reason for becoming a priest. Kōshō's statue shows the man in a walking stance, a gong held to his chest by a yoke over his shoulders, the staff topped with deer antlers in his left hand. Attached to a wire coming out of the priest's mouth are six standing Amida fig-

ures symbolizing the Namu Amida Butsu chant. It is a beautifully realized, imaginary portrait of this convert dedicated to spreading the faith. Pure Land Buddhism in Japan is discussed ahead, on pages 165–169.

At the opposite pole are Kōben's depictions of the demons Tentōki and Ryūtōki holding lanterns (figs. 184a and b). According to an inscription on the Ryūtōki, the sculptures were commissioned by Priest Shōshō of Kōfukuji, executed by Kōben, and completed in 1215. Until the building was lost in a fire, they stood as lanterns in front of the main altar in the western *kondō*. Kōben has combined the theme of the guardians of the gate, one open-

mouthed and the other with pursed lips, with that of mischievous little demons, and has treated the result with exaggerated realism. Tentōki, a squat, muscular little fellow, stands in a hip-slung pose and holds a lantern aloft, balancing it on his left hand and shoulder. Two horns sticking out from the curls on his head oddly are treated in two different ways: raised three-dimensional forms and flat painted designs on the surface of the head. His eyebrows are bushy, and there is evidence that wires were inserted in them originally to suggest an even more scraggly texture. The Ryūtōki, standing flat-footed, balances his lantern on the top of his head, while a menacing, spitting snake curls around his body and neck. The facial expressions of the two figures are so realistic that one is tempted to read emotions into an interpretation of them, the Ryūtōki a petulant little boy, the Tentōki a taunting brat. They are remarkably effective sculptures that take grotesque realism to its humorous limits.

A restoration project of significant dimensions undertaken toward the middle of the 13th century was the rebuilding of the Sanjūsangendō, in the southeast corner of Kyoto. As discussed in Chapter 3, page 133, the original building, a *sentai kannondō*, or hall for a thousand images of Kannon, was completed in 1164 and destroyed by fire in 1249. The primary motive in the reconstruction of the Sanjūsangendō, or Thirty-three-Bay Hall, was to reproduce as exactly as possible what had existed before. One hundred fifty-six original images were saved, and the task of replacing the rest of the thousand and one, thousand-armed, eleven-headed bodhisattva sculptures was assigned to Tankei (1173–1256), then in charge of the Kei studio.

Tankei was the eldest son of Unkei and had learned his craft working with his father on the sculpture projects undertaken by the workshop in Nara. He had moved to Kyoto when Unkei decided to relocate, and after his father's death in 1223, he took over the directorship of the studio. The Sanjūsangendō project was of such huge dimensions that Tankei had to reach beyond his own craftsmen and employ members of the rival In and En schools as well. A few of the standing Kannon images have been attributed to Tankei, but his magnum opus in the temple is the seated thousand-armed Kannon in the center of the altar (fig. 185). The figure was begun in 1251 and completed three years later when Tankei was eighty-two years of age; it was his last sculpture and required the help of two assistants. The statue is made in the *yosegi* technique in *hinoki*, or cypress, and is covered with lacquer and gold leaf. The eyes are quartz insets. The thousand arms of the bodhisattva are graduated in size: the six largest arms are placed close to the body and given a completely natural treatment; those in a second group, which are slightly smaller and hold attributes, radiate out around the image; finally, there is a group of much smaller hands. The image projects an impression of dignity and serenity, though its artistic quality tends to be overlooked in the sea of statues around it.

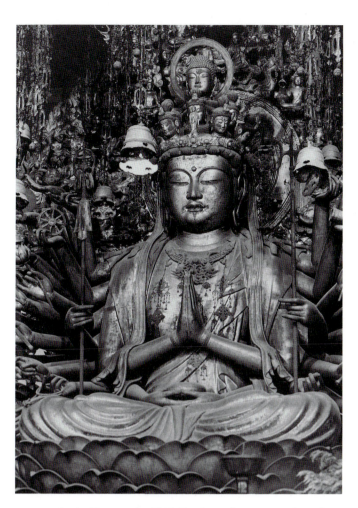

**185.** Senju Kannon, by TANKEI. Central image on altar of Sanjūsangendō, Kyoto. 1254. Wood, with gold leaf and painted and metal details; height 11 ft. (3.34 m)

Much more interesting aesthetically are the two sculptures of the God of Wind (Fūjin) and Thunder (Raijin) that are placed toward the outer ends of the platform in front of the thousand and one bodhisattvas (figs. 186a and b). These statues are usually grouped with twenty-eight additional images of adherents of Kannon who are dedicated to helping true believers. Sculptures of the latter are arranged in front of the standing Kannon images and are assumed to have been made by artists from Tankei's studio in the 1250s while work was going forward on the statues for the altar. Both gods appear to be climbing up out of dark, swirling thundercloud shapes, and their wide-open eyes look down as if on the world, including the viewer, below them. The God of Wind, with four-fingered hands, grasps the ends of a bag of wind slung around his neck. The God of Thunder is surrounded by a ring of small drums which he hits with *bachi*, dumbbell-shaped instruments, clenched in his three-fingered hands. In terms of technique, both figures are standard in their execution: *hinoki* wood carved in the *yosegi* technique and inset crystal eyes. However, in terms of subject matter and expression, their unnamed sculptor has produced some-

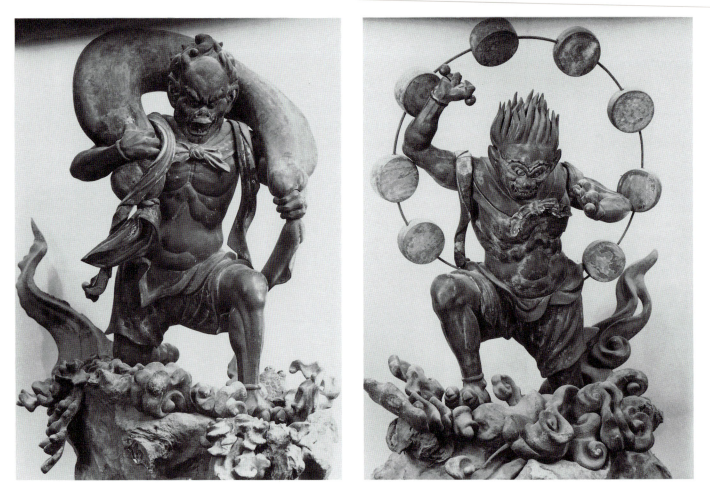

**186a and b.** *a (left):* Fūjin (God of Wind), on altar of Sanjūsangendō. 13th century. Wood, with lacquer, gold leaf, and paint, and inlaid eyes; height from base of right knee 43⅞ in. (111.5 cm). *b (right):* Raijin (God of Thunder), on altar of Sanjūsangendō. 13th century. Wood, with lacquer, gold leaf, and paint, and inlaid eyes; height from base of left knee 39⅜ in. (100 cm)

thing quite fresh and new. He has used Kei school realism to create dramatic, anthropomorphic materializations of the force and sound of a thunderstorm.

### Revival of Jingoji and Kōzanji

Jingoji, on beautiful Mount Takao, was one of the first of the Early Heian-period temples built in a pure-air environment far from the intrigues of Nara and Kyoto (see Chapter 3, page 108 ff.). About a hundred years later, on a neighboring mountain, Jūmujinin, a subtemple of Jingoji and the forerunner of Kōzanji, was established in an area known as Toganō. Dedicated to Shingon worship, Jingoji and Jūmujinin prospered initially, but by the Insei period both had fallen into disrepair. Jingoji was almost completely destroyed by fire in 1149. The project of reconstruction and more fundamentally of revitalization of the two precincts was undertaken in the late 12th century by Mongaku (active circa 1160–1203), a priest of prodigious strength and dedication. Before his conversion to Buddhism, Mongaku was a warrior in service to a daughter of Emperor Toba, who was head of the *insei* from 1129 to 1156.

He fell deeply in love with a married woman and planned to free her by killing her husband. She, a loyal samurai wife, changed places with her husband, and Mongaku, by mistake, killed her. In penance he withdrew from the court and began a wandering existence until finally he took the tonsure around 1168 and settled at Jingoji.

One senses in Mongaku a restless energy that needed to be harnessed and channeled lest it burst forth destructively. So passionately did he press for funds to rebuild Jingoji that the retired emperor Goshirakawa had him exiled to Izu from 1173 to 1178. There he met a fellow exile, the future shogun Minamoto Yoritomo, who was beginning to formulate his plans for rebellion. After he was permitted to return to Kyoto, Mongaku pressed again for support. Through the good offices of Yoritomo, Goshirakawa was persuaded to release funds, and the rebuilding project was completed by 1182.

In the Sentōin, the Hall of the Retired Emperor, at Jingoji are preserved a group of three portraits from a set of five commemorating Goshirakawa's role in the restoration of the temple and the support of his four most trusted advisers. Thought to be early 13th-century copies of a set

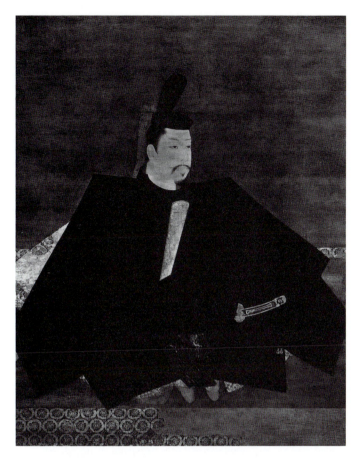

**187.** Portrait of Yoritomo. Late-12th-century copy of the original of 1179 attributed to FUJIWARA TAKANOBU.
Hanging scroll, color on silk; height 54⅞ in. (139.3 cm).
Sentōin, Jingoji, Kyoto

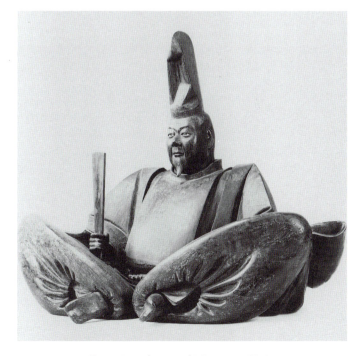

**188.** Portrait sculpture of Minamoto Yoritomo.
13th century. Wood, with paint; height 35½ in. (90.3 cm).
Tokyo National Museum

traditionally attributed to the artist Fujiwara Takanobu, and thought to date about 1179, a year in which all of the subjects were still alive and Goshirakawa was at the height of his power, these paintings are among the earliest extant examples of portraiture in the secular *yamato-e* style. The painting traditionally identified with Minamoto Yoritomo shows a relatively young man—Yoritomo was thirty-two in 1179—dressed in formal court costume and seated on a three-layer tatami mat (fig. 187). The clothing worn by noblemen at this time was heavily starched and stood in patterns that had little to do with the human body beneath. The artist has taken his stylistic cue from the garments and has created a study of interrelated flat planes. Beginning at the bottom of the painting with the brocade borders of three separate tatami mats placed one above the other, the eye can travel up to the lowest corner of the black silk-damask robe, then to the sleeve on top of it. Extending from a fold of the sleeve is a cream-colored *shaku*, a thin piece of wood carried on ceremonial occasions, held by an invisible hand. Only the pale, powdered face of the military leader atop the mass of angular planes appears to have a curving, three-dimensional form.

A sculpted portrait of Yoritomo dated to the end of the 13th century exemplifies the translation of the *yamato-e* style of portrait painting into a three-dimensional form (fig. 188). The shogun is depicted at a stage later in life when his face had filled out, particularly around the jowls. For this portrait he wears less formal attire, an upper robe known as a *kariginu* (hunting jacket) and below it baggy pantaloons over a more form-fitting undergarment. His head is covered by a tall black hat made of starched gauze. Nevertheless, even in this three-dimensional medium the artist has chosen to schematize the drapery into thin planes. In the *yamato-e* tradition of secular portraiture, both painted and sculpted, although the facial features are individuated, the figures remain expressionless and enigmatic beneath the surface.

The revitalization of Jūmujinin in addition to Jingoji was more than Mongaku could accomplish in his lifetime, and it fell to his disciple Myōe (1173–1232) to complete the project. The young man was the offspring of a Fujiwara mother and a father who, as a child, had taken the name of his adopted family, Taira. Orphaned in 1180, Myōe was adopted a year later by his uncle Jōkaku, a monk at Jingoji, and there the child spent his formative years. In 1206, after Mongaku's death, the retired emperor Gotoba granted the site of Jūmujinin to Myōe so that he could establish the Kegon temple Kōzanji. However, Myōe was of a reclusive nature and had no interest in the rebuilding projects that were going forward after the civil war. He preferred to distance himself from the Buddhist establishment and instead to devote his time to forming a new Buddhist doctrine based on a combination of elements from Shingon and Kegon, a blend of esoteric and exoteric practices and beliefs. Most important in his system of thought was meditation, through which the

individual could achieve remarkable states of super-consciousness.

The painted portrait of Myōe Shōnin—Shōnin meaning saint—is traditionally attributed to Jōnin, a monk resident at Kōzanji, and shows Myōe seated on his meditation platform in a tree (colorplate 27). Clad in a black robe, the monk sits in the crotch of a twin-trunked tree, his hands in his lap in a meditative position. All around him are scraggly pines. To his left, hung on thin branches, are his rosary and an incense burner emitting a thin stream of smoke that spirals upward into the pure mountain air. The painting, based on the pattern developed in China for arhat paintings, is almost naive in its composition, nothing like the complicated study of forms seen in the *yamato-e* portrait of Yoritomo. The technique relies heavily on calligraphic ink outlines embellished with thin washes of color, a treatment that contrasts strongly with the fine lines and delicate colors used to describe the priest's face. In sum, the painting is unique in expression, an unforgettable depiction of the priest in meditation.

A sculpted portrait of Myōe Shōnin from the 13th century has also been preserved at Kōzanji (fig. 189). The artist is unknown and the date is thought to be before 1253, when the first reference to it was made. Myōe is shown seated, prayer beads in hand, his robes carefully arranged around him. By all accounts Myōe was a handsome man, and this sculpture presents him as such. It also clearly details the missing tip of his right ear, which he had cut off in 1196 in a moment of despairing grief that he had not been born during the lifetime of the historical Buddha. However, when this sculpture is compared to the

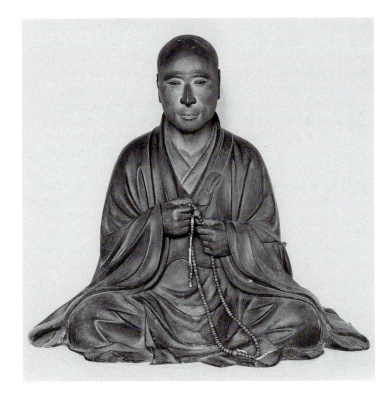

**189.** Portrait sculpture of Myōe Shōnin. 13ᵗʰ century. Wood, with inlaid eyes; height 32⅝ in. (83 cm). Kōzanji

**190.** Illustration from *Kegon engi emaki*, concluding passage of Gishō Scrolls III, showing Zenmyō as a dragon. Early 13ᵗʰ century. Hand scroll, ink and color on paper; height 12½ in. (31.8 cm). Kōzanji, Kyoto

portrait of Abbot Chōgen, it is clear that the sculptor was less interested in capturing the appearance of the real man than in accenting the simple beauty of the face by setting it off with a complicated pattern of curving drapery folds. The potential of the sculptural medium for suggesting the character of the subject has been subordinated to considerations of surface treatment.

Under Myōe, Kōzanji became a center for Kegon worship, and in this connection three remarkable works of art were commissioned: two separate sets of narrative scrolls, one depicting the life of the Korean monk Ūisang (J. Gishō, 625–702) and another set on Wōnhyo (J. Gangyō, 617–686), who together founded the Kegon school in Korea, and a sculpture of Zenmyō, a Chinese woman who became a protector of Gishō during his return journey from China. Traditionally, the two sets of narrative scrolls were thought to belong together, and were identified as the *Kegon engi,* more accurately called the *Tales of Gangyō and Gishō.* Further, it was believed that the text for the scrolls was written by Myōe himself from accounts of the two priests in the *Song gaoseng zhuan* (*Sung kao-seng chuan*), the *Biographies of Song High Priests.* Recent research, detailed below, has caused scholars to revise these traditional explanations of the narrative scrolls.

The tales of Gangyō and Gishō both begin with the two monks leaving the Korean kingdom of Silla, intending to travel together to China. However, after spending their first night in a burial cave, taking shelter from a driving rain, Gangyō decides that his best course of action is to look within himself for wisdom. He has seen a gruesome single-horned demon in his dreams, a vision that con-

vinces him to abandon his travel plans. Gishō, however, continues on to China, where he has many adventures, and just before his return to Korea he meets the beautiful Zenmyō, who falls in love with him. He ignores her, causing her great emotional anguish, but finally she makes peace with the fact of his religious dedication and turns herself into a dragon to protect his ship as it returns to his homeland (fig. 190). Several scenes precede the climax seen in this illustration. First Zenmyō journeys to the port from which Gishō is to depart, carrying a box with vestments and ritual objects as a farewell present. Next, realizing that Gishō's ship has already left, she throws herself down on the embankment and weeps. Then, reconciled to fate, she places her gift on the water so that it may be carried by the waves to the departing boat. Finally, she dives into the water, transforms herself into a dragon, and, swimming under the boat, cradles it on her back for the return voyage. This final scene is a wonderfully dramatic combination of swirling blue waves, the ferocious green and red dragon with its incredibly long "whiskers," and the small boat with its tiny human passengers. The skillful artist of the Gishō pictures is not known.

The Gangyō pictures are quite different in character, more naive in composition, with a stronger emphasis on calligraphic brushstrokes in ink. One of the high points of this set of scrolls is the passage in which an imperial messenger journeys to the bottom of the sea to receive the *Kongō sanmai kyō,* a sutra with the power to heal the queen of Silla, who is gravely ill (fig. 191). The envoy appears behind an old man, who turns back to explain that the sword-nosed fish to the left will not hurt him. The con-

**191.** Illustration from *Kegon engi emaki*, scroll 2, scene 1, of the Gangyō Scrolls,
showing an imperial messenger descending toward the palace of the king of the sea. Early 13th century. Hand scroll,
ink and color on paper; height 12½ in. (31.6 cm). Kōzanji, Kyoto

versational exchange is written in vertical lines above the figure of the old man, and just below his foot is the corner of a palace roof, the residence of the King of the Sea, from whom the sutra is to be obtained. The techniques of painting seen throughout the Gangyō pictures have many points in common with the portrait of Myōe Shōnin in meditation, and therefore were traditionally attributed to the priest-painter Jōnin.

The circumstances surrounding the production of the Gishō and Gangyō scrolls have recently been studied in detail by the American scholar Karen Brock, and they provide a valuable glimpse into patterns of patronage in the early 13th century (Ph.D. dissertation, Princeton University, 1984). Brock identifies the probable patron of the tales of Gishō as Fujiwara Tokiko, known as Lady Sanmi, the sister of one of the retired emperor's favorite consorts. Over the years she formed a close relationship with Myōe and Kōzanji, donating money for construction and for the performance of specific ceremonies. Lady Sanmi's connections with Myōe became particularly close when in 1218 the monk was able to heal her daughter. The second element in the making of the illustrated scrolls was the fact that a number of widows and mothers of warriors in the losing army— the number cannot be established—took shelter at Kōzanji after the Jōkyū Rebellion failed, and to accommodate them a nunnery called Zenmyōji was established.

The Jōkyū Rebellion broke out in 1221, when the retired emperor Gotoba saw an opportunity to overthrow the Kamakura shogunate, which he and the court in Kyoto detested. Hōjō Masako, Yoritomo's widow, and her brother were able to rally the Kamakura forces and to defeat the court faction. Those supporting the retired emperor fared badly, and a good number of noblewomen found themselves widowed and without family support. Because of Myōe's connection, through his mother, with the Fujiwara,

and his own contacts with high-ranking members of the nobility, his temple of Kōzanji seemed a logical place for these women to seek refuge. In 1223 a parcel of land was ceded by Jingoji to Kōzanji for the establishment of the nunnery. Brock argues convincingly that the Gishō scrolls were made at the instigation of Lady Sanmi, perhaps for her own edification or that of the new nuns, around the time of the Jōkyū Rebellion. In any case, with its emphasis on Zenmyō as a protector of the Korean monk, the tale was an appropriate work for a female audience.

An unusual feature of both the Gishō and Gangyō tales is that some passages of the narrative are written next to the figures, in simple syllables with a minimum of Chinese characters.❖ The presence of the dialogue next to the pictures heightens the immediacy of each event. Also, this kind of distribution of the text made it possible for one person to read the more difficult opening passages aloud while the relatively untutored women looked at the pictures and enjoyed the humor of the conversational exchanges.

The Gangyō scrolls clearly have a less didactic tone, and were unquestionably painted by a hand different from that of the Gishō scrolls, probably by the artist of the portrait of Myōe seated in meditation (see colorplate 27). For some time scholars have noted the resemblance

---

❖The Japanese writing system utilizes three different forms: Chinese characters, or *kanji*, which are essentially ideographs, and two alphabets known as *kana*, which were developed by simplifying *kanji*. Both alphabets consist of syllables, but *hiragana* uses curving strokes, while *katakana* uses angular ones. Today *katakana* is used primarily for foreign words that have come into common use, while *hiragana* is multipurpose and is essential in combination with *kanji* for expressing ideas in writing.

**192**. Zenmyō, attributed to TANKEI. c. 1225. Wood, with paint and gold leaf, inlaid eyes, and metal details; height 12³/₈ in.(31.4 cm). Kōzanji, Kyoto

after his death in 1232. She further suggests that the patron of these *emaki* may have been Fujiwara Morikane, who maintained close ties with Myōe and was one of the five people to whom the monk entrusted the fortunes of Kōzanji after his death. While Brock's theories cannot be proved absolutely, they do go a long way toward explaining the circumstances surrounding the making of these two *emaki*.

The third work of art associated with Kegon worship at Kōzanji is a tiny, gemlike sculpture of Zenmyō paired with a statue of Byakkō Jin—a god associated with snowy mountains, originally the Himalayas—commissioned by Myōe in 1225 and attributed to Tankei (fig. 192). Depicted as a classic Chinese beauty, Zenmyō is shown standing on a rock, holding the box containing her farewell gift to Gishō. She appears calm and assured, as if, having brought her grief under control, she is determining her next course of action—becoming Gishō's divine protector. Her clothing consists of a green shawl-collared outer robe with double sleeves and a white undergarment, and attached to her head is an openwork metal ornament with long festoons that frame her face. This image of Zenmyō projects a calm and serene presence, a person at peace with the conditions of her life, her passive demeanor animated by the gentle curving patterns of her sleeves.

## Secular *Emaki*

The 13th century was a particularly lively period for the production of *emakimono*. The Kyoto nobility devoted itself to leisure-time pursuits, including the production and appreciation of illustrated narratives. *Genji* pictures continued to be popular, but interest in Murasaki, the author, also surfaced. According to the *Meigetsuki*, the diary of the noted poet and scholar Fujiwara Teika (1162–1241), in 1233 a group of noblemen centering on the retired emperor Gohorikawa launched a project to make new *emaki* of the *Genji monogatari* and an illustrated version of the diary of Lady Murasaki, the *Murasaki Shikibu nikki*. Surviving today is such an *emaki*, although it has not been established whether or not it is the same one mentioned in Teika's diary. The four scrolls, now in several different collections, correspond to only fifteen percent of the original diary, and as they are not in sequence, it is supposed that the original set of illustrations must have included many more rolls.

Murasaki's diary deals with events at court, including an elaborate ceremony held to celebrate the birth of a child to Fujiwara Michinaga's daughter, the empress Shōshi. Michinaga goes to great lengths to prepare for the event and takes pleasure in supervising everything himself. In one illustration from the diary, he is shown stand-

between the brushwork in the Gangyō *emaki* and the portrait of Myōe discussed above, but Brock goes on to point out the similarities between the two men. Gangyō and Myōe were both reclusive scholars who existed outside the recognized hierarchy of the Church. Here Brock argues that the Gangyō scrolls were made as homage to Myōe

ing on the edge of the palace veranda looking over two boats made specially for the celebration (see fig. 134). In spite of the gaiety and splendor of the central event, the story is permeated with a sense of Murasaki's aloneness and her feeling of being subjected to the will of people who outrank her. On one particularly poignant occasion she has been enjoying the sight of the moonlit garden outside her apartment. Two drunken courtiers come along and try to get into her room, and she must hold her windows firmly shut against them (colorplate 28). The composition is very similar to a scene from the Heian-period illustrations of *The Tale of Genji,* but here the effect is entirely different. The landscape is not used as a reflector of the emotions the characters are feeling. The figures express themselves directly, and the landscape becomes a pictorial element to be appreciated apart from the events in the narrative. The technique of the Murasaki scrolls is the *tsukuri-e* method seen in the Heian *Genji* (see pages 137–141), but the same care has not been lavished on these illustrations. To cite two examples out of many, silver is used less frequently and less attention is given to interior architectural details, such as designs on sliding doors. Nevertheless, to the nobility of the 13th century, the illustrations must have provided the flavor of a bygone era of luxury and power.

Another illustrated scroll set that grew out of the nobility's interest in the recent past is the *Heiji monogatari emaki,* dated to the second half of the 13th century. The tale deals with the events of 1160 that led to the defeat of the Minamoto clan at the hands of the Taira. So decisively were the Minamoto put down that it took the clan twenty years  to rebuild to the point of successfully challenging the Taira again. One of the most dramatic episodes in the Heiji Rebellion is the burning of the retired emperor Goshirakawa's Sanjō Palace. The *emaki* depicting this phase of the uprising is owned by the Museum of Fine Arts in Boston (colorplate 29). According to the text at the beginning of the scroll, the troops of Fujiwara Nobuyori attacked the retired emperor's palace in the middle of the night. Drawing a carriage up to the front door, they took Goshirakawa prisoner, killed the two palace majordomos, and then set fire to the buildings. The servants and ladies-in-waiting in the palace all tried to flee from the flames, many jumping into a well in the courtyard. The first to try this were drowned, the last were burned by the flames. Others of the palace staff were trampled under the hooves of the horses ridden by Nobuyori's men. Finally, their mission to kidnap Goshirakawa accomplished, the soldiers rode out of the palace gates and reassembled in proper formation to escort the carriage containing the retired emperor to the Imperial Palace.

The picture illustrating this episode is unusually long and is uninterrupted by text. In the organization of motifs, the unidentified artist owes a debt to the *Ban Dainagon ekotoba* attributed to Tokiwa Mitsunaga (see fig. 108). The illustration begins with a group of people

moving to the left until they are interrupted by the wall enclosing the Sanjō Palace, an arrangement similar to the opening passage of the older scroll. Also, the climax of the painting is the fire that engulfed the buildings. However, the 13th-century *Heiji monogatari* artist has established a much faster pace for the events, concentrating the flames in the upper part of the scroll, but continuing the human action in a narrow register along the lower edge. The painting technique relies on bright pigments for the armor, the costumes of the women, and, of course, the flames, but the artist allows his brushwork to show in the description of the grotesque faces of the warriors. The burning of the Sanjō Palace is one of the finest extant examples of Japanese narrative illustration. No information can be gleaned about the scroll's artist, calligrapher, or patron, which is unfortunate considering the quality of their collaborative creation.

A scroll set that purports to be a biography of the well-known 9th-century figure Sugawara Michizane, as well as the story behind the founding of the Kitano Shrine in Kyoto, is the *Kitano Tenjin engi emaki* dated to the Jōkyū era, around the year 1219. The scroll set begins with the sad story of Michizane, the poet and scholar of Chinese literature who was falsely accused of a crime against the emperor and exiled to Kyūshū, where he died; his vengeful ghost comes back to kill those responsible for his disgrace (see page 144). The last scrolls in the set are *rokudō-e* (depicting the six realms of existence; see page 173), and have little to do with Michizane's life or his revenge. The most exciting scene in the scrolls depicts the wronged man as a red-skinned God of Thunder and Lightning riding on swirling mass of black clouds and wreaking havoc on his enemies in the palace (colorplate 30). The image of the god draws on the same tradition as the sculptures of Fūjin and Raijin in the Sanjūsangendō (see figs. 186a and b) and is a vivid depiction of a raging demon venting his vengeance.

An illustrated biography of the priest-poet Saigyō (1118–1190), dated to the second half of the 13th century, is an exquisite example of delicate brushwork and colors used to create a lyric view of the human figure functioning in the natural world. Saigyō was a talented poet who at the age of twenty-three decided to become a priest, possibly in order to separate himself from the low courtier status of his family. However, he took his religious commitment seriously and even predicted correctly that he would die on the anniversary of the historical Buddha's death. One of the loveliest passages in the *emaki* is the scene in which Saigyō travels to Mount Yoshino to see the cherry blossoms (colorplate 31). In the text the priest is portrayed wrestling with distracting thoughts of the past as he approaches Yoshino, but after he crosses a swiftly flowing river, he is able to rise above petty concerns and to appreciate the beauty of the cherry trees about to bloom, still slightly tinged with snow. He composes the following poems:

No one has yet
Visited the blossoms at
Mount Yoshino,
Trampled through the moss
Disturbed the ivy on the rocks.

> Penelope E. Mason, trans., " The
> Wilderness Journey: The Soteric Value
> of Nature in Japanese Narrative Painting,"
> in *Art, the Ape of Nature*, Moshe Barasch
> and Lucy Freeman Sandler, eds. New York
> and Englewood Cliffs, N.J., 1981, p. 78

Yoshino Mountain:
White puffs on cherry limbs
Are fallen snow,
Informing me that blossoms
Will be late this year.

> William LaFleur, trans., *Mirror for the
> Moon: A Selection of Poems by Saigyō*,
> New York, 1978, p. 76

The image of Saigyō, a tiny human enveloped in the natural world, captures the essence of the Japanese view of nature as a positive force in the lives of human beings, providing the possibility of cleansing the mind so that it may achieve enlightenment.

## Pure Land Buddhism

In a form that was a precursor to Pure Land Buddhism, Amidism was a popular belief already in the Middle Heian period, notably through the teachings of Genshin (942–1017). A Tendai monk, Genshin wrote a popular religious work, *The Essentials of Salvation*, that stressed faith in Amida as a means of salvation. The dark worldview of the Early Feudal period opened the way for the official establishment of Pure Land sects in Japan. The horror and suffering of war, witnessed alike by educated samurai from the provinces and the cultured nobility of Kyoto, were so terrifying that instead of seeing the world around them as a paradise not unlike Amida's, the Japanese in the 12th and 13th centuries perceived themselves to be living in the age of *mappō*, the decadent age of the Final Law.

According to Buddhist scriptures, the third and last age of Buddhist history is the time of *mappō*, a degenerate period of ten thousand years, during which conflict and corruption are rampant. The events surrounding the Genpei Civil War (1180–1185) seemed proof, if any was needed, that civilization had entered the period of *mappō*. The first of the three ages was a thousand-year period, beginning with the birth of Shakyamuni Buddha, known as the era of Perfect Law, or *shōbō*, when Buddhist precepts were perfectly understood and followed. Between the *shōbō* and *mappō* ages was that of Imitative Law, or *zōbō*, a period when faith had declined and good works were necessary to secure enlightenment. In the age of *mappō*, it was believed, evil was so pervasive that conventional strategies for attaining nirvana—reading and copying the sutras, meditation, and good works—were of no avail.

Responding to this futilistic mood, in the 13th century several religious leaders reworked the concepts of Heian Amidism into Pure Land Buddhism, centered on the belief that enlightenment could be achieved through faith in Amida and the practice of *nenbutsu*, which was the repeated recitation of the formula "Namu Amida Butsu." The work of the three most important Japanese Pure Land religious leaders is discussed in the pages ahead.

Belief in Amida (Skt. Amitabha) reaches far back to India of the 1st and 2nd centuries C.E., where it centered on the larger *Sukhavativyuha* (*The Teaching of Infinite Life*, J. *Muryōju kyō*), and the smaller *Sukhavativyuha*, J. *Amida kyō*), the latter the first sutra to advocate salvation through faith in Amida and recitation of the *nenbutsu*. Another sutra, *The Sutra on the Meditation of the Buddha of Infinite Life* (*Kanmuryōju kyō*), further elaborated on this idea, promising that even the worst sinners could be reborn in paradise if they achieved a sincere conversion to belief in Amida. This sutra and a commentary on it written by the great patriarch of Chinese Pure Land Buddhism, Shan Dao (Shan-tao, 613-681), had the greatest effect on the development of Pure Land teachings in Japan.

An essay that affords us some insight into the climate that gave rise to Pure Land Buddhism in Japan is the *Hōjōki, Account of My Hut*, written in 1212 by Kamo no Chōmei (1156–1216).❖ A poet and literary critic, Chōmei was neither a member of the Kyoto aristocracy nor a samurai. Instead, he occupied a position somewhere in between, accepted by both groups but essentially independent. Probably more than any other writer of the period, he was aware of the whole range of life in Kyoto, not just the doings of the noble families, but the experience of common people as well.

The title of Chōmei's work refers to the ten-foot-square hut inhabited by a recluse who has shaken off all worldly trappings and who devotes himself single-mindedly to the task of achieving enlightenment. The prototypical *hōjō* was the building in which the lay Buddhist Vimalakirti held his famous debate with Manjushri, the Bodhisattva of Wisdom (see page 56). Vimalakirti was a wealthy householder, but when he began to teach the concept of impermanence, he had his house stripped of its trappings and dismissed his servants. The contrast between the hermit's simple house, bare of anything but the essentials, and the well-appointed households of the wealthy forms the leitmotif of the *Hōjōki*, and the essay is

---

❖ Following an increasingly widespread convention in the transliteration of Japanese personal names, this book does not use the preposition *no*, meaning "of," except for names of mythological personages and deities. An exception to this is Kamo no Chōmei. To drop *no* from his name would render it quite unfamiliar.

clearly written against the background of the *Vimalakirti Sutra*. It begins with a classic image of impermanence.

> The flow of the river is ceaseless and its water is never the same. The bubbles that float in the pools, now vanishing, now forming, are not of long duration: so in the world are man and his dwellings. . . . The city is the same, the people are as numerous as ever, but of those I used to know, a bare one or two in twenty remain. They die in the morning, they are born in the evening, like foam on the water.
>
> Keene, *Anthology*, p. 197

Although he includes no details of the battles fought in and around Kyoto during the civil war, he describes at length the natural disasters that occurred during his early years as an adult there, including fires, hurricanes, earthquakes, and the like. His account of a famine followed by pestilence is particularly graphic.

> The people were starving, and with the passage of days approached the extremity like fish gasping in insufficient water. . . . The number of those who died of starvation outside the gates or along the roads may not be reckoned. There being no one even to dispose of the bodies, a stench filled the whole world, and there were many sights of decomposing bodies too horrible to behold. Along the banks of the Kamo River there was not even room for horses and cattle to pass.
>
> Keene, *Anthology*, p. 202

In the second half of the *Hōjōki*, Chōmei describes the small house he has built for himself in the hills outside the capital. He intends it to be nothing more than a roof over his head, so much does he want to divorce himself from material possessions and the sins of pride and desire. But even so, he takes pleasure in the various amenities he has added: the bamboo porch, the altar along the west wall on which he has installed an image of Amida so that "the light of the setting sun shines between its eyebrows." At the end Chōmei questions the sincerity of his detachment:

> One calm dawning, as I thought over the reasons for this weakness of mine [his love for his little hut and his attachment to its solitude], I told myself that I had fled the world to live in a mountain forest in order to discipline my mind and practice the Way. "And yet, in spite of your monk's appearance, your heart is stained with impurity. Your hut may take after Jōmyō's [Vimalakirti], but you preserve the Law even worse than Handoku [the most foolish of Shakyamuni's disciples]. If your low estate is a retribution for the sins of a previous existence, is it right that you afflict yourself over it? Or should you permit delusion to come and disturb you?" To these questions my mind could offer no reply. All I could do was to use my tongue to recite two or three times the *nembutsu*, however inacceptable from a defiled heart.
>
> Keene, *Anthology*, p. 212

In Chōmei's view humans are imperfect creatures and the road to salvation is difficult if not impossible even for the most conscientious of mortals.

## Pure Land Priests and Their Illustrated Biographies

Responding to the intellectual climate of the years after the Genpei Civil War were three religious leaders who founded new Buddhist sects based on the Pure Land sutras: Hōnen (1133–1212), on whose teachings the Jōdo Shū, or Pure Land sect, developed; Shinran (1173–1263), founder of the Jōdo Shin Shū, or True Pure Land sect; and Ippen (1239–1289), whose followers organized the Ji sect. Hōnen was a priest who had begun his religious development within the Tendai school, but feeling dissatisfied with its teachings, had struck out on his own to study Amidism. Hōnen initiated a reformation of Buddhism in the Early Feudal period, making the achieving of enlightenment an act of personal faith, rather than the result of reading sutras or meditating. In 1175 Hōnen discovered the *Kanmuryōju kyō* and Shan Dao's commentary on it. On the basis of these two works he began to openly advocate the *nenbutsu* as the direct path to salvation, and in so doing cut himself off from traditional Buddhism.❖ This is the year in which he is said to have begun the Jōdo Shū. Eventually the Buddhist hierarchy rose against him and had him exiled to Shikoku from 1207 to 1211, until just a few months before his death. Nevertheless, his teachings were carried forward by his disciples and attracted many followers in the 12th and 13th centuries.

An illustration from the *Hōnen Shōnin eden*, the pictorial biography of Hōnen, shows him in the role of teacher (colorplate 32). In a temple room enclosed by sliding doors decorated with landscape paintings, Hōnen, seated with his back to the wall, inscribes a copy of a scroll containing his own portrait to be given to his disciple Shinran. Behind Shinran can be seen the original. In the Early Feudal period, it became the custom for a religious teacher to reward a successful pupil with an inscribed portrait of himself as proof that the student had learned all the master had to teach.

Colorplate 32 is a fragment from an illustrated scroll derived from one of the most elaborate of the *Hōnen Shōnin eden* illustrated priest-biographies, a forty-eight-scroll set compiled over a ten-year period beginning in 1307. It is believed that it was edited by Shunshō, a priest from Mount Hiei, based on earlier records of Hōnen's life and teachings. It had the express purpose of presenting not only a biography of the master, but also the history of the Jōdo sect, and of the Kyoto temple Chionin, as the most important locus for Amida worship. The project,

---

❖ The *nenbutsu* can be performed in several different ways. The words can be spoken silently to oneself or chanted aloud with a group of fellow worshipers. Contemplative *nenbutsu* practice can also be performed, during which the individual tries either to envision the physical characteristics of Amida and his two attendant bodhisattvas, Kannon and Seishi, or to meditate on more abstract concepts of the spiritual qualities of a particular divinity.

**193.** Illustration from *Zenshin Shōnin-e*, scroll 1, scene 4, showing Hōnen inscribing a portrait scroll for Shinran and then presenting his writings to Shinran. Late 13th century. Hand scroll, ink and color on paper; height 12⅝ in. (32 cm). Nishi Honganji, Kyoto

undertaken at the request of the retired emperor Gofushimi, obviously had the support of the nobility, since the calligraphy was executed by eight men associated with the court, including the retired emperor and Gonijō, the current emperor. The primary purpose of the illustrations was to document specific events, which the scene of Hōnen with Shinran does successfully, but they are not particularly telling in terms of narrative technique or expressive potential.

The second of the priests who developed Japanese Pure Land Buddhism was Hōnen's disciple Shinran. So pessimistic was he about one's ability to rise above basic materialistic self-interest, compounded by the accretion of misdeeds over many lifetimes, that he believed one's only hope was to perform the *nenbutsu*. The desire to do so would come as a result of Amida's call, awakening understanding and compassion. The enlightenment would take place not because of an individual's actions, but rather through Amida's inherent benevolence. Shinran's doctrine became the basis of the new Jōdo Shin Shū. The teachings of Hōnen and Shinran are often dismissed as "easy salvation," but in the context of Japan in the post–civil-war period, they offered a sure path to salvation for men and women who could no longer find solace within the traditional Buddhist Church.

Shinran's life, like that of his master, became the subject of an illustrated biography, the *Zenshin Shōnin-e*. The original text was written by his great-grandson Kakunyo in 1295 and illustrated by an unknown artist, most probably a priest-painter. Two separate episodes are represented within the frame of the illustration (fig. 193). To the right, Hōnen kneels before a hanging scroll on which a portrait of himself has been mounted, and writes an inscription for Shinran on a separate sheet of paper mounted below. This first scene is essentially a retelling of the episode depicted in Hōnen's biography (colorplate 32). To the left the master hands Shinran a box containing the *Senjakushū*, a collection of Hōnen's writings on the effec-

tiveness of the *nenbutsu*, which he is allowing Shinran to copy. The honor of being permitted to make his own copy of Hōnen's book, in addition to being given a personally inscribed portrait, indicates the confidence the master felt toward his student. The illustration style is that of straightforward description enlivened only by a passage to the left showing Hōnen's garden, in which a lotus flower blooms.

The third of the great Pure Land teachers was Ippen, a monk who is thought to have founded the Ji school in 1274, when he began his career as a wandering priest carrying the message of the *nenbutsu* throughout Japan. His particular contribution was the development of the *nenbutsu odori*, a type of worship ceremony in which a number of people danced in a circle beating drums, ringing bells, and chanting aloud "Namu Amida Butsu." The ecstasy that might be achieved in such a performance would be a symbol to the believer of the joy of salvation through Amida (fig. 194). This was a kind of worship that had great appeal for the common people, since it did not require reading sutras or meditating alone in silence.

The *Ippen Hijiri-e, Pictures of the Holy Man Ippen,* an illustrated set of twelve scrolls depicting Ippen's life and travels, is arguably the best of the priest biographies of the Early Feudal period. The text was composed in 1299 by Ippen's younger brother Shōkai, himself a priest and an adherent of the Ji sect, and was illustrated by an artist named Eni, possibly a priest-painter or more probably a professional artist employed by Shōkai for this project. Many sections of the scrolls detail Ippen's travels and provide extremely accurate depictions of well-known places, making the set a particularly valuable historical document. Eni has brought to this work a lyric quality not found in most priest-biographies. His treatment of Ippen and his followers crossing snow-covered fields in the Kantō far exceeds the needs of documentation (colorplate 33). A thin layer of snow coats the low hills with their marsh grass and pine trees. The palette of colors is reduced to white and soft shades of brown and green,

**194.** Illustration from *Ippen Hijiri-e*, scroll 6, scene 3, by ENI, showing Ippen leading a religious ceremony. Late 13th century. Hand scroll, ink and color on paper; height 15 in. (38.2 cm). Kankikōji, Kyoto

*1299* : [handwritten annotation]

*written by Shokai* [handwritten annotation]

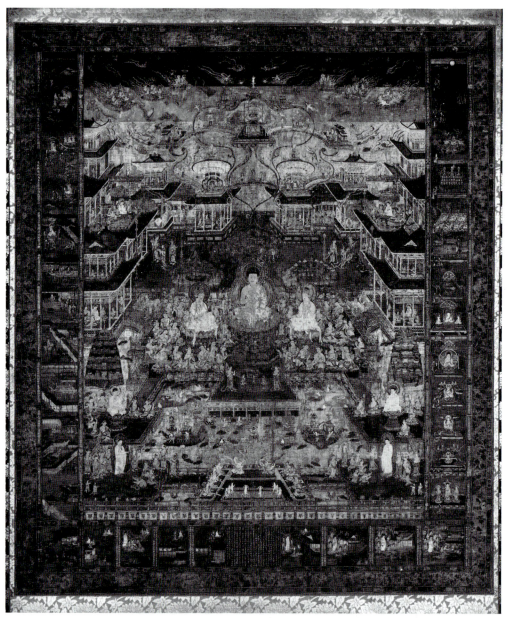

**195.** Taima Mandara. 13th century. Color on silk; 71 3/8 x 70 5/8 in. (181.3 x 179.3 cm). Nara National Museum

suggesting something akin to monochrome landscape painting, while the clear delineation of space within the scene suggests a familiarity with Chinese painting of the Song dynasty. On the other hand, Eni's handling of a *nen-butsu odori* performance is wonderfully Japanese in its focus on the emotions of the dancing figures and the open expressions of the bystanders as well.

## Pure Land Devotional Paintings

As the populariy of Pure Land Buddhist schools increased and as Amida began to replace Shakyamuni as the focus of worship, two types of religious paintings—mandalas and *raigō* paintings—took on renewed importance in devotional practices. Their imagery centers on the depiction of Amida Buddha's Western Paradise. Contemplation of these paintings is intended to aid worshipers in imagining the promised land.

### Taima Mandara

The primary icon of Pure Land Buddhism as taught by Hōnen is the Taima Mandara, and one of the earliest preserved in Japan is the tapestry version in Taimadera, a temple in the village of Taima in Nara prefecture. The traditions associated with the mandala suggest that it was executed in the 8th century during the latter half of the Nara period, but scholars believe it more likely that it was imported from China, perhaps at that time. Furthermore, it is an accurate translation into visual images of the teachings of the Chinese patriarch Shan Dao as set forth in his commentary on the *Kanmuryōju kyō*. Strangely, there is no reference to it in documents of the Nara or Heian periods. It was rediscovered in the Early Feudal period and became the prototype for a series of mandala paintings of Amida's Western Paradise. One of the best documented of these is a work executed in rich pigments, including gold and silver as well as *kirikane*, or cut gold leaf, and was preserved in Zenrinji in Kyoto (fig. 195).

The mandala consists of one central composition surrounded on the sides and the bottom by strips of illustrations (fig. 196). The central design, the Court of Essential Doctrine, or Gengibun, depicts Amida's paradise with a wealth of detail. The deity is seated on a high octagonal throne flanked by the bodhisattvas Kannon and Seishi, who occupy lower lotus-blossom thrones. Numerous smaller deities in skirts, scarves, and with crowns surround the three divinities. Behind this group are multistoried palaces, and in front of them are a large lotus pond with boats being poled back and forth, small children cavorting, and other human figures seated on lotus blossoms, about to take their places in paradise.

In the narrow strips along the sides and the bottom of the painting, the basic ideas of the sutra are given visual form. In the Court of the Prefatory Legend, the Jobungi, in the strip to the left, the specific situation that gave rise to

Shakyamuni preaching the *Kanmuryōju kyō* is detailed. A wicked prince, Ajatashastru, the heir-apparent of the Indian kingdom of Magadha, had ordered that his father, King Bimbisara, be imprisoned and starved to death. However, the old king's principal wife, Vaidehi, who is the young man's mother, schemed to bring him food and kept him alive. Learning of this, Ajatashastru had his mother imprisoned. She prays to Shakyamuni for deliverance, and the Buddha is so moved by her plight that he appears before her and shows her the paradises of the ten directions, from which she selects the Western Paradise of Amitabha.

At the right, in the Court of the Thirteen Meditational Concentrations, the Jōzengi, are detailed the various elements of the Western Paradise—the sun, the water, the jeweled earth, the jeweled tree and so on—which Vaidehi must visualize in order to attain rebirth there.

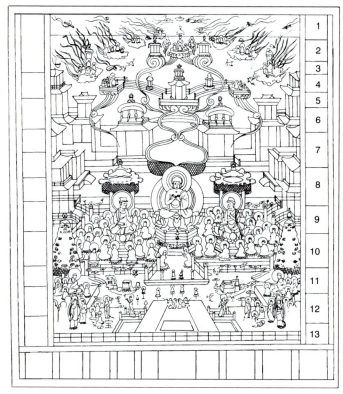

Central design:
COURT OF ESSENTIAL DOCTRINE

Left outer border:
COURT OF THE PREFATORY LEGEND

The story of Ajatashatru's actions against his parents, King Bimbisara and Queen Vaidehi

Right outer border:
COURT OF THE THIRTEEN MEDITATIONAL CONCENTRATIONS
1  The sun
2  The moon
3  The lapis lazuli earth, the jeweled realm of the Western Paradise
4  The trees of Paradise
5  The lakes of Paradise
6  The mulit-storied jeweled towers of Paradise
7  Amida's jeweled lotus throne
8  The Amida triad
9  The Great Body of Amida
10  Amida in the half-lotus position
11  The bodhisattva Shishi
12  Imagining oneself reborn in Paradise
13  The Small Body of Amida

Lower border:
COURT OF GENERAL MEDITATIONS

Meditations on three levels, three degrees of rebirth in Paradise

**196.** Schematic drawing of the Taima Mandara. (From Haruyama, 1949)

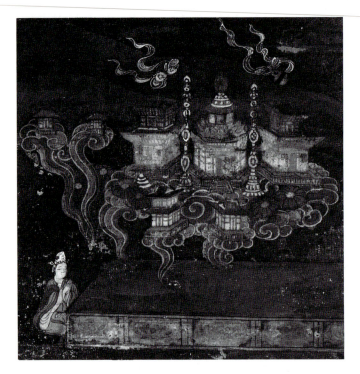

**197.** Detail, Taima Mandara, showing lapis lazuli earth
of the Western Paradise

The lapis lazuli earth of the Western Paradise, the
third section from the upper right, is a particularly beautiful
scene (fig. 197). To the left of a large platform, sits the be-
liever, her hands pressed together in a gesture of worship.
Rising like smoke from the platform are cloud forms that
support five of the buildings in the Western Paradise.
Between the three largest, many-jeweled strands appear,
held aloft by *apsara*.

In addition to the thirteen visualizations detailed in
the right border, there are three more which are included in
the Court of General Meditations, the Sanzengi, illustrated
in the band at the bottom of the painting. These are the
meditations on the three levels of rebirth in paradise, and
each of these three levels is subdivided into three degrees.
This same idea was depicted on the doors of the Phoenix
Hall of the Byōdōin (see pages 121–123). Thus, along the
bottom of the Taima Mandara there are representations of
nine different types of *raigō*. The Taima Mandara is a re-
markable translation of religious concepts into visual im-
ages, a true *hensō*, or transformed configuration.

A narrative painting that sets forth the legendary ori-
gins of the tapestry mandala is the *Taima Mandara engi
emaki*, a set of two illustrated scrolls dated to the mid-13th
century, the artist unknown (colorplate 34). The story cen-
ters on the figure of Princess Chūjō, a devout Amida adher-
ent who lived in the latter half of the 8th century. On
becoming a nun in 763 she made a prayerful vow that she
would not leave the temple until she saw Amida in living
form, and she set herself a limit of seven days in which to
accomplish her goal. She devotes herself single-mindedly to
the worship of Amida, and within the time she has specified
her vow is accomplished. When she dies in 775, no one

doubts that she will be reborn in the Western Paradise.

The setting for the climax of the *engi* is the interior
of the convent. The first room to appear as the scroll is un-
rolled is that of Princess Chūjō. Dressed in her nun's habit,
she sits close to the right wall and listens as an elderly
nun talks to a beautiful young woman whose long black
hair and court costume suggest that she is a member of
the laity and a high-born lady. According to the text, the
topic of their conversation is the thread the old nun has
made of lotus stems provided by the princess and has
dyed five different colors in a magic well she dug herself.
These preparations have been made so the lady can
weave a tapestry. To the left this same weaver can be seen
three more times: first, having passed through a paneled
wooden door, she advances leftward toward the weaving
room; next, she is seated before the loom on which in nine
short hours she weaves the Taima Mandara tapestry.

The last scene of the sequence shows the old nun
seated in a rather masculine pose, leaning with her left
arm on her bent knee, her right hand free to gesture as she
explains the meaning of the mandala to the princess, who
sits before the resplendent gold and brightly colored
tapestry, her hands pressed together in a gesture of wor-
ship. Far to the left, carried upward on a brilliantly colored
cloud, is the weaver, an earthly manifestation of Kannon.
The nun recites a poem, including the following two lines:

You earnestly desire the Western quarter: therefore I come.
Once you enter this place, you eternally forsake suffering.

and goes on to explain that,

I am the Lord of the Western Paradise, and the weaver
was my left-hand attendant disciple Kannon.

Elizabeth ten Grotenhuis, *The Revival of the Taima
Mandala in Medieval Japan*, New York and London,
1985, p. 162

The potentials of *shinden* architecture and the
blown-off roof technique to separate the parts of a narra-
tive episode are well used here to suggest the passage of
time. Also, the contrast between the small size of the
princess's room, enclosed by sliding doors decorated with
a busy pattern of waves, and the openness and plainness
of the weaving room invests the latter with an other-
worldly, almost ethereal quality. In the last scene the bril-
liant gold of the tapestry and the bright red, blue, and
green of the weaver's cloud hint at the beauty and splen-
dor to be experienced in the Western Paradise.

The Taima Mandara and the *Taima mandara engi
emaki*, in addition to providing information about con-
cepts of Pure Land Buddhism in the Early Feudal period
and the legendary origins of the mandala tapestry, also af-
ford a glimpse of the role of women within Buddhism. This
topic has received scant attention from Western scholars
until the recent publication of Diana Y. Paul's *Women in*

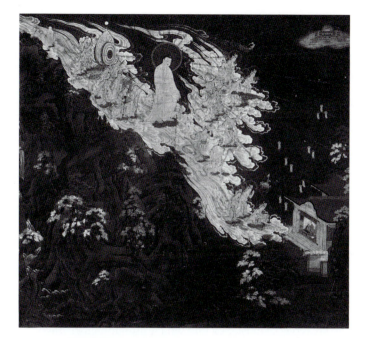

**198.** Descent of Amida and the Twenty-five Bodhisattvas, a *haya raigō*. Early 13th century. Gold and color on silk; height 57 in. (144.7 cm). Chionin, Kyoto

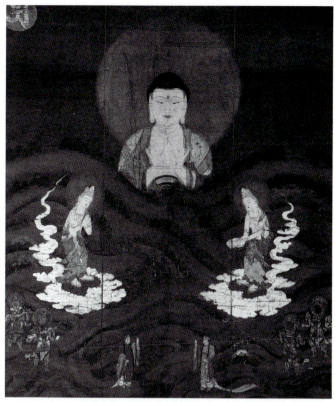

**199.** Amida, a *yamagoshi raigō*. 13th century. Hanging scroll, color on silk; 51 1/8 x 46 1/2 in. (130 x 118 cm). Zenrinji, Kyoto
"Mt. crossing raigo"

*Buddhism* (Berkeley, 1985) and Barbara Ruch's essay "The Other Side of Culture in Medieval Japan" in the *Cambridge History of Japan* (Cambridge, England, 1990). In the prefatory legend in the Taima Mandara, the queen's pleas receive a meaningful response. Although the plight of Ajatashastru's father was similar to that of his mother, the Buddha responded by sending him a disciple who taught him the eight precepts against killing, stealing, lying, and the like. When the mother prays to Shakyamuni, however, she receives visits from two disciples, Maudgalyayana and Ananda, and finally from Shakyamuni himself, who explains the ten paradises into which she may be reborn. Similar favor was given to Princess Chūjō in the *engi*. She prayed for a vision of Amida and was granted not only that but a visitation from Kannon. Furthermore, Amida in his guise as a nun remained with the princess long enough to give her an explication of the Taima Mandara.

It is becoming evident that the Early Feudal period was a particularly favorable time for women to espouse Buddhism. Pure Land sects strove to spread the mantle of Amida's compassion to all, men and women alike. Shinran went so far as to assert that priests should marry and himself took a wife, the nun Eshin (1182–1270), whom he made a party to his work. Zen was also hospitable to women, creating convents headed by abbesses. Barbara Ruch has brought to light the nun Mugai Nyodai, who was so esteemed by her followers that a statue was made of her in the style of the *chinzō* portraits of great Zen masters.

## Raigō

Two types of *raigō* paintings developed in the late 12th and the 13th centuries, due in part to Hōnen's teachings. One is the *haya*, or swift, *raigō*, in which Amida and his host of bodhisattvas descend to earth in the twinkling of an eye. The other is the *yamagoshi*, or mountain-crossing, *raigō*, which depicts only three figures, Amida, Kannon, and Seishi, above the top of a range of mountains that they will cross to complete their descent to earth. The classic example of the *haya raigō* is the hanging scroll showing the descent of Amida and the twenty-five bodhisattvas owned by Chionin (fig. 198). Entering the picture on a diagonal from the upper left corner is a line of white cloud shapes supporting a golden Amida and his host of attendants, including musicians. The procession is led by Kannon, who is kneeling and bending forward toward the deceased, a man clad in a gray priest's robe and seated behind a low table on which indigo sutra rolls have been set out. In the lower left corner of the painting are green mountains dotted with pines and flowering cherry trees, and in the upper right there is a glimpse of a tiny building not unlike the Byōdōin, suggesting Amida's many-storied palace in the Western Paradise. Compared to the Heian-period *raigō* preserved at Mount Kōya, the descent in this painting seems precipitous, and the variety and poses of accompanying figures significantly simplified. The emphasis is clearly placed on the quick and sure descent of the Buddha to gather up the soul of the deceased.

The most famous of the *yamagoshi raigō* is the painting owned by Zenrinji in Kyoto (fig. 199). The golden head and torso of Amida can be seen glowing against a dark sky, his halo suggesting the moon. Below him to the right and left are the bodhisattvas Kannon and Seishi,

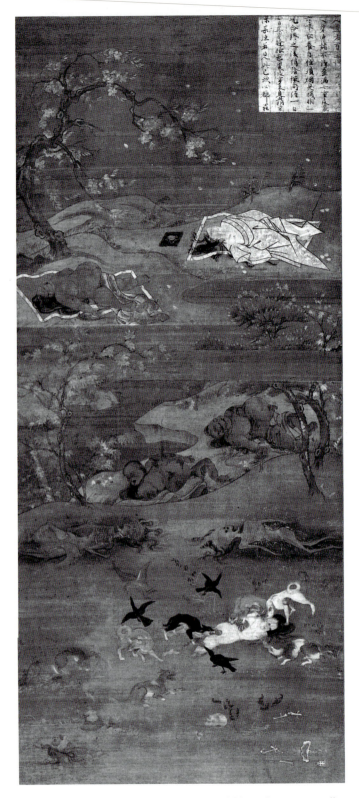

who have already crossed the mountain and are bending forward as if to greet the deceased. In the lower center of the painting can be seen the blue water of a river, and opposite each other on its banks, two boys pointing up at the divinities. To right and left at the side edges of the painting, the Four Guardian Kings are grouped in pairs. Finally, in the upper left corner is the Sanskrit character for the letter *A*, representing Amida's palace in the Western Paradise.❖ The color scheme of the painting is particularly pleasing. The Amida is clad in a white robe with bands of gold and pale green, the bodhisattvas in gold, green, blue, and pink. Subtly placed among the mountains are small trees with the orange and red leaves of autumn.

### Rokudō-e

A grotesque and sometimes shocking type of painting emerged in the years after the Genpei Civil War, pictures of the six types of existence into which human beings might be reborn if unable to achieve salvation. These are the realms of unenlightened heavenly beings, humans, animals, constantly fighting demons, hungry ghosts, and beings in hell.

❖ The use of Sanskrit characters as mystical symbols is essentially a practice of the Shingon sect and was adopted from Shingon by the Pure Land sects. The syllable *A* is seen in Shingon as embodying the universal truth that transcends change and impermanence, and over a hundred *A*-syllable visualizations have been developed to help the practitioner experience that supramundane reality. If a dying person can visualize the syllable *A* or the Amida and his host, that person will be reborn in the Western Paradise—but it is likely to require years of preparation doing such visualizations to be able to perform it at so difficult a moment. Similarly, one completely wholehearted recitation of the *nenbutsu* suffices for rebirth in paradise, but that totally selfless moment may require lifetimes of practice.

**200.** The Six Realms of Existence, one of fifteen hanging scrolls illustrating *The Essentials of Salvation*. 13ᵗʰ century. Color on silk; 61¼ x 26¾ in. (155.5 x 68 cm). Shōju Raigōji, Shiga prefecture

**201.** Illustration from *Yamai no sōshi* (Notebook of Illnesses), scroll 2, showing a woman suffering from insomnia. Late 12ᵗʰ century. Hand scroll, color on paper; height 10⅛ in. (25.8 cm). Private collection

**202.** Illustration from *Jigoku zōshi* (Hell Scrolls). Late 12th century. Section of a hand scroll, color on paper; height 10½ in. (26.7 cm). Nara National Museum

*[handwritten annotations: The Six Realms of Existence; 그중에 6번째 beings in Hell.; Kamakura P.]*

The six worlds of existence had been described in the Heian period by Genshin in his essay *The Essentials of Salvation* (see page 165), but the nobility and clergy of that era had been more influenced by the other side of his presentation:  they were sure they were bound for paradise, and they focused on Amida's joyous welcome of them. However, during the civil war and the natural disasters that occurred around the same time, people saw horrors comparable to those described in Genshin's text. So deep was the pessimism of the postwar years that most people felt it more than likely that they would be reborn into one of the six realms, rather than in the Western Paradise. By contemplating *rokudō-e*, pictures of the six paths, or realms, they hoped to remind themselves of the suffering that might lie ahead, the better to avoid it.

One of the best-known illustrations of the six realms is a set of fifteen hanging scrolls owned by Shōju Raigōji in Shiga prefecture (fig. 200). In small rectangles at the top of each painting are excerpts from *The Essentials of Salvation* explaining the scenes depicted below. Particularly graphic is the treatment of decaying bodies. In the upper right a newly deceased woman has been laid out on a straw mat. She still wears a white-figured garment, but it is in disarray and her hair looks unkempt. To the left under a blossoming tree, the figure appears again. This time the garment has fallen away, and the woman's belly is swollen with the gases of decay. Below a layer of mist, and sheltered under a maple tree in autumn leaf, the same female body is depicted in two further states of decomposition. Finally, at the bottom of the painting three more dead women can be seen, one a fresh body being picked at by black birds and various wild animals, the other two mere skeletons. While this particular scroll has a strong

*yamato-e* flavor, especially in the treatment of the landscape, others among the set display a more Chinese style. Based on this combination of styles, and records of the repairs done on the set, the first dating to 1313, scholars have identified these scrolls as works of the 13th century.

Three separate groups of *emaki* depicting human illness, hungry ghosts, and scenes in hell—subjects appropriate for *rokudō-e*—have been preserved in various collections and are dated by scholars to the end of the 12th century. The small format of these paintings is particularly interesting, the vertical dimension of each sheet of paper being only about 10 inches (27 cm), as opposed to the approximately 12 inches (31 cm) of the *Ban Dainagon ekotoba*, the *Shigisan engi*, and the *Kegon engi*. Clearly these hand scrolls were made for intimate viewing, perhaps by one person alone. It is also clear that these three scrolls were not all made by one artist. Consequently it would seem likely that they represent a genre of painting popular in the period after the Genpei Civil War.

The *Yamai no sōshi*, or *Notebook of Illnesses*, depicts some of the physical problems human beings must endure, from toothaches to hallucinations to a condition  to which most humans are subject at one time or another, insomnia (fig. 201). In a bedroom peopled with three soundly sleeping women, the sufferer props herself up on one arm. Bending the fingers of her other hand in sequence, she appears to be counting, trying to quiet her active mind. To her left is a black stand holding a bowl of oil that has been ignited to give some light. This single vertical motif echoes the position of the woman's torso, reinforcing the impression that she, alone in the house, is awake in the dead of night.

The scrolls depicting the eight sections of hell to which human beings can be consigned, the *Jigoku zōshi*,

are executed in a less accomplished style than the *Yamai no sōshi*, but nevertheless convey a powerful impression of suffering. The hell for those who cheat their customers by short-weighting is overseen by a frightening three-eyed, white-haired old crone who looks on as two women and a man pick metal boxes filled with hot coals from a fire and attempt to judge their weight (fig. 202). The atmosphere in this hell is dark and smoky, the only real light being provided by the fire in the center. The supervisor of this hell is a looming presence in comparison with the smaller human beings, her sagging body described with broad calligraphic brushstrokes. The sufferers are pale, naked figures totally consumed by the pain of their torture.

Among these three sets of scrolls the most eerie is certainly the notebook of hungry ghosts, the *Gaki zōshi*. These ghosts are souls condemned to perpetual hunger, skeletal beings with bulging bellies, grotesque faces, and wispy hair who are fated to eat only human waste: dead flesh, splashes of liquid from a public well, afterbirth. In one illustration a group of noblemen and noblewomen are seated at a banquet, passing the time with food and drink and musical entertainment while tiny ghosts, like ants at a picnic, climb over them foraging for whatever they can find (colorplate 35). One appears to be digging into the ear of the man playing the biwa, probing for ear wax, while to the left another seems to reach for a crumb on a nobleman's cheek. The participants at the banquet, all attractive nobles with round faces and brightly colored garments, make a strong contrast with the bony, gray ghosts.

## Zen Buddhism

The introduction of the Chinese Chan sect of Buddhism, Zen in Japan, at the end of the 12th century was one of the most important religious and cultural events in the Early Feudal period, one that has had a profound effect on Japanese intellectual history and society even into the 20th century. Beginning in the 6th century, the Chan sect had developed in China out of a confluence of Indian Buddhism and Chinese Taoism. In the Kamakura period, as contact resumed with China of the Song dynasty (960–1279), Japanese priests and monks were drawn to the Chan sect, which relied not on scripture, dogma, or conventional ritual, but on the practitioners' direct intuitive perception of reality. Such a belief left room for an uncomplicated code of ethics, just as it demanded a stern self-discipline. Both qualities found a receptive audience among Japan's military class. Of the two Zen sects introduced into Japan in the Early Feudal period—Rinzai and Sōtō—Rinzai was particularly hospitable to the elite among the military and to the arts. Its belief in the possibility of sudden enlightenment, the efficacy of the *kōan* as a teaching tool, and the drinking of tea found acceptance among the leadership of the shogunate. Sōtō, in advocating a balance of meditation and physical activity leading to moments of understanding and gradual enlightenment,

had especially strong appeal in the provinces.

The word *zen* derives, through Chinese, from the Sanskrit word *dhyana*, meaning meditation. The goal of Zen is a deep awareness of truth, often framed as the truth of life and death, to be reached through two main practices: first, *zazen*, meditation while sitting straight-backed with legs crossed, and, second the study of *kōan*, questions or exchanges with a master that cannot be understood or answered with rational thought. The aim of *zazen* is to be completely present in the here and now, with the mind focused yet free of images or concepts—objectless thought. The purpose of the *kōan* is to break through rational patterns of thought to the clarity of intuitive enlightenment. The student must constantly hold the thought problem in mind until the tension between the rational and the irrational produces a breakthrough in understanding. The goal of Zen practice is *satori*, an ineffable experience some have described as the feeling of becoming one with the universe.

Zen masters emphasize person-to-person teaching, intentionally avoiding dependence on written scriptures, thus transmitting Zen principles directly to students through the generations. During the Early Feudal period, they were also influential in matters of state, advising on internal and foreign policy and on trade with other nations. Zen priests and monks, although required to live austerely within the temple complex, were allowed the freedom to engage in cultural activities of a primarily secular nature, such as poetry, painting, calligraphy, the distinctively Zen ink-and-brushwork tradition, and garden design. Over the centuries, Zen thought and practice have had a profound effect on Japanese culture, placing a high value on simplicity, economy of means, and the perception of beauty in the natural world.

### The Aesthetics of *Wabi*

Developing out of the intellectual climate associated with Zen is *wabi*, an aesthetic concept that greatly values pleasure taken in austerity and aloneness, beauty perceived in simplicity, and an appreciation of objects weathered by time. An essay written about 1330 by the lay priest Yoshida Kenkō (1283–1350) is evidence of the evolution of Japanese thought from the isolation and pessimism of Kamo no Chōmei to a positive espousal of life and a system of aesthetic values. By the early years of the 14th century, the pain of direct personal experience with war, pestilence, and famine had softened into a gentle mood of acceptance, the preference for a simple, uncluttered life conducted with sensitivity and elegance. In his *Essays in Idleness*, Kenkō finds virtue in the very impermanence that drove Chōmei to pursue so rigorously his own spiritual well-being:

If man were never to fade away like the dews of Adashino, never to vanish like the smoke over Toribeyama, but lin-

gered on forever in the world, how things would lose their power to move us! The most precious thing in life is its uncertainty.

Donald Keene, trans., *Essays in Idleness: The Tsurezuregusa of Kenkō*, New York and London, 1967, p. 7

Kenkō was born into a family that had traditionally supplied Shinto diviners for the imperial family, and in his early adulthood he served as a steward to a family related indirectly to Emperor Gonijō. However, at some time before 1313 he withdrew from court circles and established himself as a Buddhist monk, although without a temple affiliation. His *Essays in Idleness*, written some twenty years later, provides a perceptive and beautifully expressed statement of the aesthetic ideals that had been formulated by the end of the Kamakura shogunate and that continued to dominate the arts in Japan until the end of the Early Feudal period. The most famous passage of his work sets forth a concept that is a logical extension of the value he placed on impermanence, and also a statement of a fundamentally Japanese aesthetic ideal recognizable even today.

> Are we to look at cherry blossoms only in full bloom, the moon only when it is cloudless? . . . Branches about to blossom or gardens strewn with faded flowers are worthier of our admiration. . . . People commonly regret that the cherry blossoms scatter or that the moon sinks in the sky, and this is natural; but only an exceptionally insensitive man would say, "This branch and that branch have lost their blossoms. There is nothing worth seeing now." In all things, it is the beginnings and ends that are interesting.

Keene, *Essays*, p. 115

Kenkō elaborates on the *wabi* aesthetic of understatement and transcience:

> A screen or sliding door decorated with a painting or inscription in clumsy brushwork gives an impression less of its own ugliness than of the bad taste of the owner. It is all too apt to happen that a man's possessions betray his inferiority. . . . Possessions should look old, not overly elaborate; they need not cost much, but their quality should be good.

> Somebody once remarked that thin silk was not satisfactory as a scroll wrapping because it was so easily torn. Ton'a replied, "It is only after the silk wrapper has frayed at top and bottom, and the mother-of-pearl has fallen from the roller that a scroll looks beautiful." This opinion demonstrated the excellent taste of the man.

Keene, *Essays*, p. 70

The concept of *wabi* initially referred to the quality of the life led by an ascetic, but over time it developed into an aesthetic ideal to be sought after in one's daily life. The element of *sabi*, often paired with *wabi*, adds the nuances of loneliness and old age and also of tranquillity achieved at the end of one's life. These two aesthetic concepts became the standard of performance fundamental to the tea ceremony, which developed in the 15th century out of the Zen practice of drinking tea while meditating and finally reverberated in the literature and painting of the period.

## The Zen Temple

The composition of the Buddhist temple changed fundamentally under Zen. Most importantly, there developed a central complex for public ceremonies and private subtemples, *tatchū*, which were centers for religious leaders, often retired abbots, and their monastic and lay adherents. Today, Zen temples rarely have more than twenty-five subtemples, but it is known that toward the end of the Early Feudal period they routinely had many more *tatchū*; several temples had more than a hundred. These smaller complexes normally had space, either rooms or separate buildings, for the essential phases of daily life: a reception room; quarters for the priests; rooms for Zen study, meditation, and the chanting of sutras; space devoted to the memory of the temple founder; and often a garden for contemplation.

Within the public sector of the Zen temple, many changes were effected in the traditional names, types, styles, and layout of the buildings in the temple compound. A new type of gate was introduced, the *sanmon*, or mountain gate, a two-storied structure with three entrance doors and a functional second story, accessed by covered stairways outside the basic building, that usually contained sculptures of the sixteen arhats, or *rakan*, great lay Buddhists who achieved enlightenment. The main worship hall, the *kondō* or *hondō* in traditional Buddhist temples, was renamed the *butsuden* and used for public ceremonies, while the lecture hall, or *kōdō*, was renamed the *hattō* or hall of the Law—that is, of the Dharma—and was used for regular assemblies of all the monks belonging to the parent temple. These two buildings were placed along a central axis extending from the *sanmon* to the residence of the abbot, the *hōjō*, which served as the headquarters and chief reception building of the temple. The term *hōjō* refers to the small hut of a recluse monk, the kind of residence associated with the layman Vimalakirti and, of course, with Kamo no Chōmei. However, in Zen temples it is usually a large and well-appointed building. Finally, the public complex may be provided with a *shariden*, the relic hall, in which to honor the historical Buddha and revered priests of the sect, and a *kaisandō*, or founder's hall, dedicated to the temple's or precinct's founder.

Tōfukuji, one of the first Zen temples to be built in Kyoto, preserves something of the appearance of an early Zen monastic complex. It was founded in 1236 with the support of the regent Kujō Michiie (1193–1252). Although the first construction campaign was not completed until 1255, in 1243 the noted Zen priest Enni Benen (1202–1280), a central figure in the development of Rinzai Zen in Japan known posthumously as Shōichi Kokushi, took up residence at the temple. Throughout the Early Feudal period Tōfukuji prospered, and when the complex was

**203.** Ink painting of Tōfukuji, by SESSHŪ TŌYŌ. 15ᵗʰ century. Horizontal hanging scroll, ink and color on paper; 32⅝ x 59 in. (83 x 150 cm). Tōfukuji, Kyoto

**204.** *Sanmon* (entrance gate), Tōfukuji, Kyoto. 1384–1425

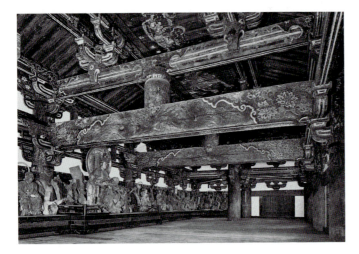

**205.** Second floor of *sanmon*, Tōfukuji

had more than fifty subtemples. Some idea of the earlier complex can be gleaned from figure 203, an ink painting attributed to the 15th-century artist Sesshū Tōyō (1420–1506). Located in the foothills of Kyoto's eastern mountains, the Higashiyama, its buildings are sited over uneven terrain, and a fair-sized stream, the Sengyokukan, is included within its boundaries. The view of the autumn foliage from the roofed bridge over the stream, the Tsūtenkyō, is one of the most famous in Kyoto.

The *sanmon* of Tōfukuji, the earliest extant example of the new type of gate, was built over a period of roughly forty years, from 1384, when materials were pledged by the shogunate, to 1405, when the roof tiles were put in place, to 1425, when the outer staircases were added (fig. 204). The building is two bays wide by five bays long and is capped by a two-tiered, hipped-gable roof. Although the exterior of the gate preserves the appearance of a Southern Song-dynasty (1127–1279) building, the interior of the second floor is brightly ornamented in the Chinese style of the late Yuan (1279–1368) and early Ming (1368–1644) dynasties with designs painted in bright colors—green, red, brown, black, and gold (fig. 205). Enshrined in the single room are sculptures typical of *sanmon*, images of Shaka and the sixteen *rakan*.

The architectural style adopted for Zen temple construction is known in Japan as *karayō*, or Chinese style, in contrast to the traditional manner that over time had come to be regarded as a purely Japanese, or *wayō*, style. *Karayō* buildings use such decorative details as bell-shaped windows with a rippling top line, transom windows with delicate wooden grilles, and an extraordinarily complicated pattern of bracket supports and fanned rafters (fig. 206). Columns in this style usually narrow in diameter toward the top and rest on stone bases set directly on the stone tiles of the floor. The earliest extant example of a building in the *karayō* style is the *shariden* (relic hall) of Engakuji in Kamakura (fig. 207). The hall was built in 1285 as the *butsuden* of a local nunnery, Taiheiji, and was moved to the founder's *tatchū* of Engakuji, the Shōzokuin, in 1563. The core of the building is three by three bays square, with a *mokoshi* added around the perimeter. The roof is a two-tiered, hipped gable; it is thought that the original roof was made of tile in the traditional Chinese style. The rafters, visible from the inside, appear to radiate out from a central point hidden above a flat ceiling panel. The *shariden* of Engakuji has a delicate, almost jewellike interior in comparison with the large halls found in most Zen temples, and the decorative detailing of the *karayō* style seems to add just the right amount of architectural embellishment.

One of the most innovative concepts given expression in the Zen temple is the landscape garden as an aid to meditation. Gardens had been an important element in secular residential architecture at least from the beginning of the Heian period. The Imperial Palace had a rather extensive garden, traces of which are still preserved in the temple known by the same name, Shinsenen. By the

severely damaged by fires in 1319 and again in 1334, rebuilding was undertaken quickly, with the support of government leaders. Although the fortunes of Tōfukuji declined after the Meiji Restoration of 1868, at one time it

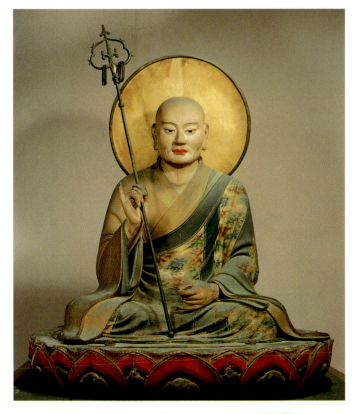

**Colorplate 26**. Hachiman in the Guise of a Monk, by KAIKEI.
Hachimanden, Tōdaiji, Narà. 1201. Wood, with paint;
height 34½ in. (87.5 cm)

Kamakura P. (1185-1333)

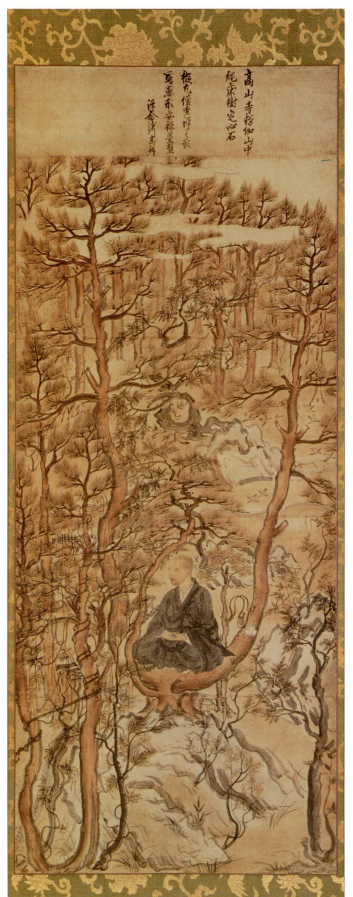

**Colorplate 27**. Portrait of Myōe Shōnin, attributed to JŌNIN.
13th century. Hanging scroll, color on silk; 57½ x 23⅛ in.
(146 x 58.8 cm). Kōzanji, Kyoto

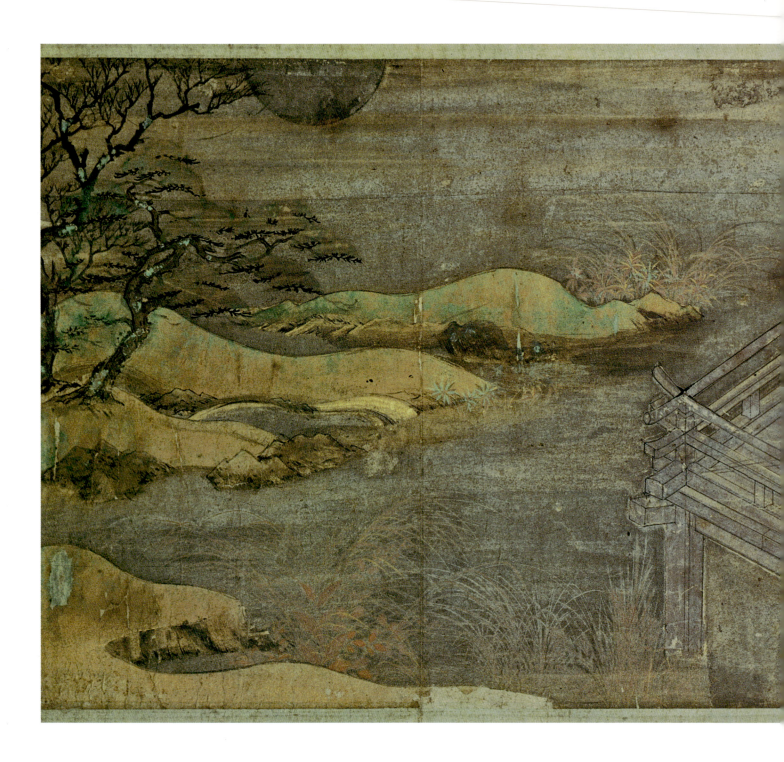

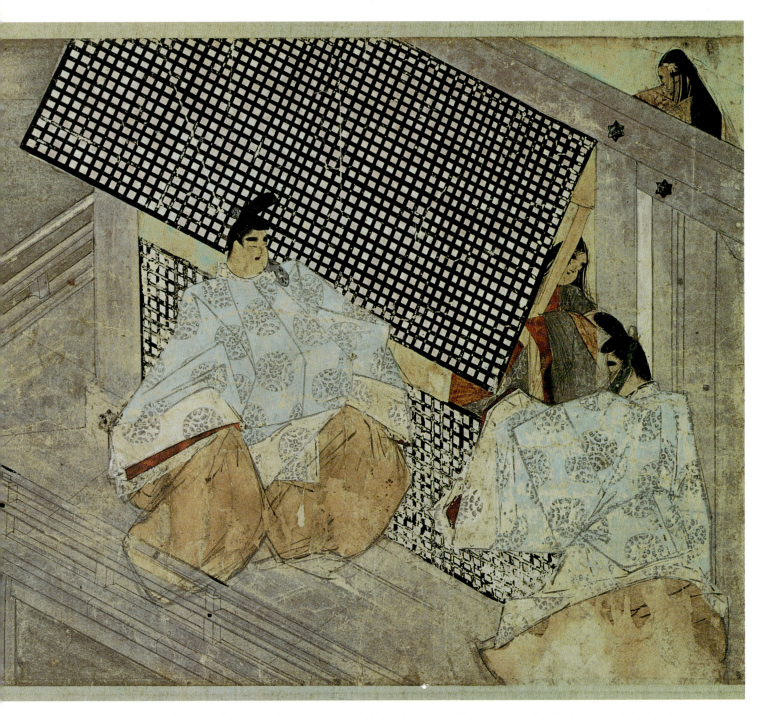

**Colorplate 28.** Illustration from *Murasaki Shikibu nikki emaki* (Illustrated Scroll of Lady Murasaki's Diary), scroll 1. 13th century. Hand scroll, color on paper; height 8 1/4 in. (21 cm). Gotō Art Museum, Tokyo

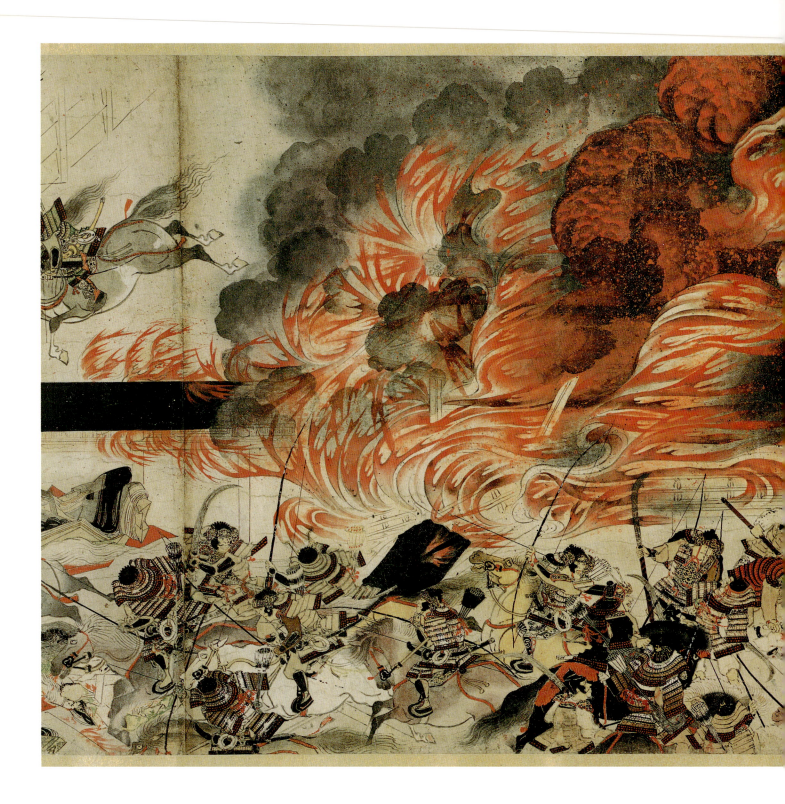

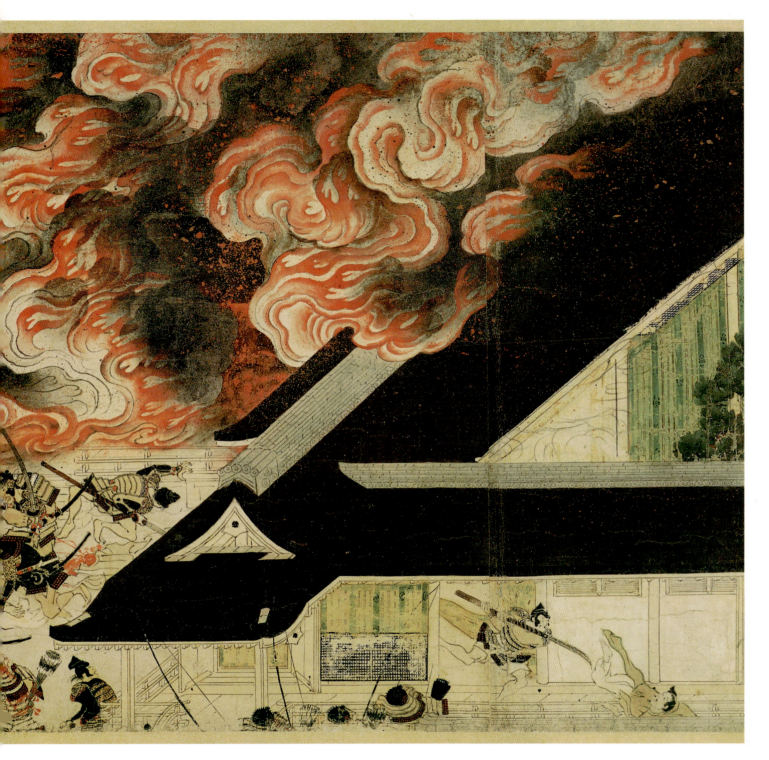

**Colorplate 29.** Illustration from *Heiji monogatari emaki* (Scrolls of Events of the Heiji Period),
showing troops fighting as Sanjō Palace burns. 13th century. Hand scroll, ink and color on paper; height 16¼ in. (41.3 cm).
Courtesy Museum of Fine Arts, Boston. Fenollosa-Weld Collection

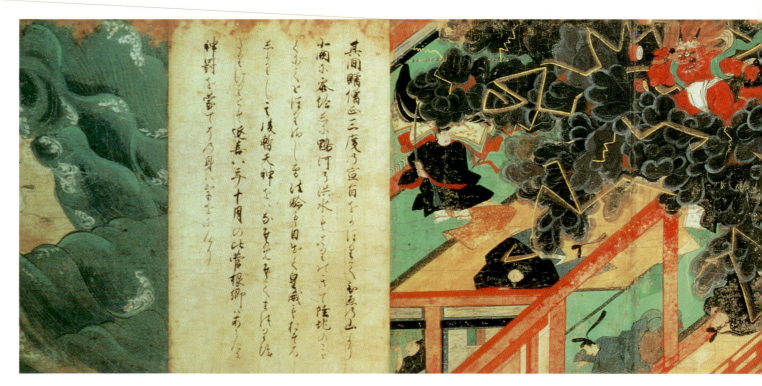

**Colorplate 30.** Illustration from *Kitano Tenjin engi emaki*, Jōkyū version, Ohara scroll 2, scene 3, showing Sugawara Michizane as the God of Thunder and Lightning striking down courtiers in the Imperial Palace. Early 13th century. Hand scroll, ink and color on paper; height 20¼ in. (51.5 cm). Kitano Tenmangu Shrine, Kyoto

**Colorplate 31.** Illustration from *Saigyō monogatari emaki*, Ohara scroll 2, scene 3, showing Saigyō traveling to Mount Yoshino. 2nd half 13th century. Hand scroll, ink and color on paper; height 11⅞ in. (30.3 cm). Manno Art Museum, Osaka

**Colorplate 32.** *(opposite page, bottom)* Fragment of the *Hōnen Shōnin eden*, an illustrated hand scroll mounted as a hanging scroll, showing Hōnen inscribing a copy of his portrait for his disciple, Shinran. Early 14th century. Ink and color on paper; height 16⅛ x 23¼ in. (41 x 59 cm). The Metropolitan Museum of Art, New York. Gift of Mrs. Russell Sage, by exchange, and funds from various donors, 1980 (1980.221)

政家勤旦元師近般患乃勤可在此事同者

早且可被□事う

弘安五年乃春鍾舍にいて□まふそゝ□

**Colorplate 33.** Illustration from *Ippen Hijiri-e,* scroll 5, scene 4, by ENI, showing Ippen and his followers crossing snow-covered fields of the Kantō. Late 13th century. Hand scroll, color on paper; height 15 in. (38.2 cm). Kankikōji, Kyoto    *c 1299  Written by  Shokai    Kamakura period.*

**Colorplate 34.** *Taima Mandara engi emaki,* scroll 2, scene 1, showing Princess Chūjō weaving the Taima Mandara. Mid-13th century. Hand scroll, color on paper; height 19¼ in. (48.8 cm). Kōmyōji, Kamakura, Kanagawa prefecture

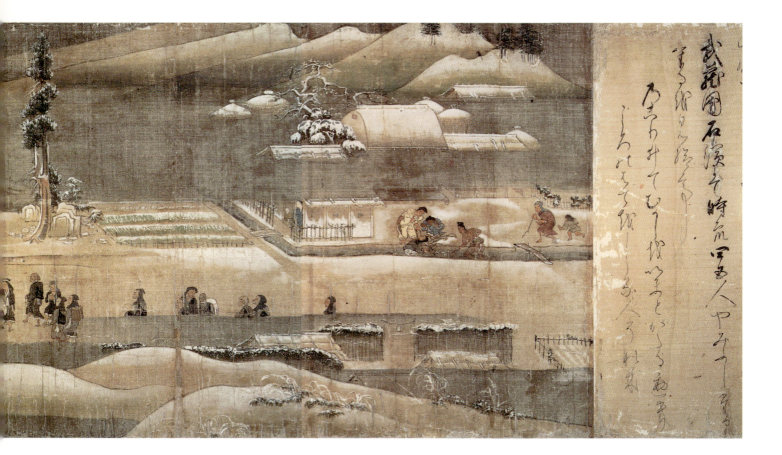

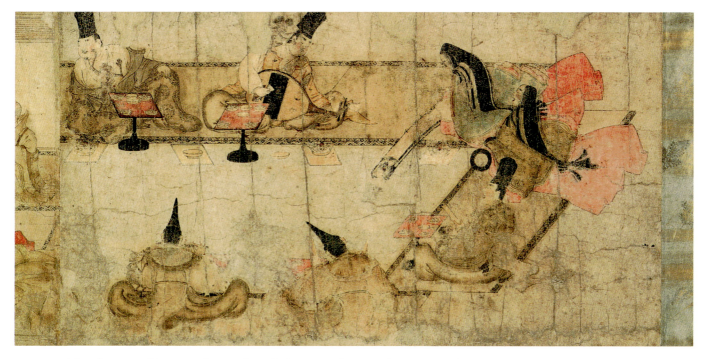

**Colorplate 35.** Illustration from *Gaki zōshi* (Hungry Ghost Scrolls). Section of a hand scroll, ink and color on paper; height 10½ in. (26.8 cm). Late 12th to early 13th century. Tokyo National Museum

Chinzo:

portrait of a master

**Colorplate 36.** Portrait of Enni, by MINCHŌ. Late 14th or early 15th century. Hanging scroll, ink and color on paper; 7 ft. 11 in. x 4 ft. 5 in. (2.42 x 1.34 m). Tōfukuji, Kyoto

Muromachi P. (1392-1573)

**Colorplate 37.** Kinkaku (Golden Pavilion), Rokuonji, Kyoto. Rebuilt 1964 after the original of the 1390s

Golden Pavillion (Kinkakuji -Rokuonji) 14th C. Ashikaga Yoshimitsu

**Colorplate 38.** Pair of six-panel *rakuchū rakugai zu byōbu,* known as the Machida screens. 1520s.
Ink and color on paper; each screen 4 ft. 6³/₈ in. x 11 ft. 3¹/₄ in. (1.38 x 3.41 m). National Museum of Japanese
History, Sakura City, Chiba prefecture

**Colorplate 39.** View of *hōjō* (central room) of the Jukōin, Daitokuji, Kyoto, showing plum tree panels by KANŌ EITOKU. 1566

*Momoyama p.*

*Doors of the Jukō-in Daitokuji temple (Kyoto)* "Flower-and-Bird of the Four Seasons"

**Colorplate 40.** Chinese Lions, on a six-panel *byōbu*, by KANŌ EITOKU. 3rd quarter 16th century. Color, ink, and gold leaf on paper; 7 ft. 4 in. x 14 ft. 10 in. (2.22 x 4.52 m). Imperial Household Agency

*Momoyama p.*

**Colorplate 41.** Plum Blossoms and Camellias, and Pines and Cherry Blossoms, on two *fusuma* panels, by KANŌ MITSUNOBU. East wall of room in Kyakuden (Guest Hall), Kangakuin, Onjōji, Shiga prefecture. c. 1600. Ink, color, and gold leaf on paper; each panel 70½ x 44 in. (179 x 111.6 cm)

**Colorplate 42.** Cedars and Flowering Cherry Trees, on two *fusuma* panels, by KANŌ MITSUNOBU. South wall of room in Kyakuden, Kangakuin, Onjōji. c. 1600. Ink, color, and gold leaf on paper; each panel 70½ x 44 in. (179 x 111.6 cm)

**Colorplate 43.** Winter Landscape with Waterfall, by KANŌ MITSUNOBU.
*Tokonoma*, Kyakuden, Kangakuin, Onjōji. c. 1600. Ink, color, and gold leaf on paper

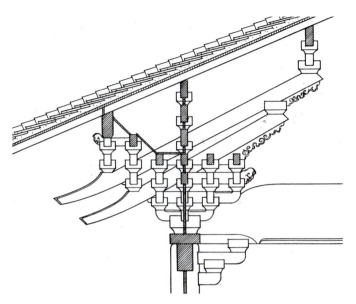

**206.** Diagram of *karayō* (Chinese-style) bracketing

**208.** Garden of Daisenin, Daitokuji, Kyoto. Attributed to KOGAKU SŌKŌ. Early 16th century

**207.** *Shariden* (relic hall), Engakuji, Kamakura. 1293–98

Middle Heian period, gardens were incorporated into temple compounds that were laid out in imitation of the residences of the nobility. However, the gardens associated with Zen temples are very different. They are constructed in a limited amount of space, and this very limitation is used as an asset in their design, which is kept extremely simple. Furthermore, they are intended as aids to Zen practice and as a consequence the objects they contain seem to invite metaphysical interpretation. Finally, most of them are made of small pebbles and rocks, with live plantings limited to moss and simple shrubbery, and are called *karesansui*, or dry landscapes, although a few Zen gardens also incorporate ponds.

Among the most complicated gardens in terms of its design elements is the famous small courtyard enclosure within the precinct of Daisenin, a subtemple of Daitokuji (fig. 208). The Daisenin complex was founded in 1509 by Kogaku Sōkō (1465–1548), and its main building, the *hōjō*, was completed in 1513. The design of the garden is attributed to Sōkō, and it is thought that he had it constructed at the time the hall was being built. The garden extends along the east and part of the north side of the *hōjō* and adjoins the room used for formal gatherings. One of the favorite activities of Zen priests and the upper echelons among the samurai was to get together and compose *renga*, or linked verses, poems whose verses would be composed by a number of people, in units of seventeen syllables alternating with units of fourteen. Thus the room in the northeast corner of the Daisenin *hōjō* was provided with a pleasant garden as a background for such formal assemblages. However, another function underlying its design is its use as an aid to meditation. Gazing at the carefully chosen and placed rocks and the pebbles raked in a pattern of ripples, one can imagine a panorama of nature, a river running from its source in the mountains toward the sea, and this vision helps to free the mind of mundane concerns to better concentrate on spiritual matters.

The river, the organizing motif of the Daisenin garden, begins with two large rocks placed vertically, close to the northeast corner of the enclosing wall. The pattern of the veining in the tallest of the rocks suggests water falling down the side of a mountain, and the pebbles at its base can be interpreted as the river. A thin, flat rock has been

**209.** Death of the Buddha, by MINCHŌ. 1408. Hanging scroll, color on silk; 28 ft. 8 in. x 17 ft. 4¾ in. (8.76 x 5.31 m). Tōfukuji, Kyoto

**210.** White-robed Kannon, by MINCHŌ. 1421. Hanging scroll, ink on paper; 24 x 10⅞ in. (60.9 x 27.6 cm). Museum of Art, Atami, Shizuoka prefecture

laid on two small stones to represent a bridge, and a smooth, humpbacked stone set into the pebbles resembles a fish surfacing as it swims upstream. Not visible in the illustration are two long, thin stones resembling a dam over which the river appears to flow; to the right below the dam, a boat-shaped rock suggests a ship at anchor in a harbor or plying its way upstream, while a smooth round rock in the middle of the river can be seen as a turtle. In viewing it, one can extrapolate endlessly from the themes suggested by these basic shapes to construct whatever view of the landscape one prefers, focusing on the upstream course of the river, the harbor scene, the hoary tur-

tle as a symbol of longevity, the boat as a surrogate for humanity, the river as the passage of one's life.

## Zen Painting

The division of the temple into public and private sectors permitted several different kinds of imagery in Zen paintings to coexist: traditional Buddhist themes being used for objects on public view, motifs and styles more directly related to Zen thought for objects in the subtemples. Zen Buddhism's focus on universal truth expressed in the present moment vastly widened the range of themes painted by priests and for temples—from paintings of famous Zen

**211.** Cottage by a Mountain Stream, by MINCHŌ. 1413. Hanging scroll, ink on paper; 40 x 13⅝ in. (101.5 x 34.5 cm). Konchiin, Kyoto

*[handwritten: Muromachi P.]*

*[handwritten sticky note: Shigajiku: poetry and painting.]*
*[handwritten sticky note: (colorplate 36) Portrait of Enni. Chinzō, portrait of a master.]*

reflecting
connected
e skill at
t kinds of

52–1431),
particular
d of Awaji,
onshū and
land's Zen
Tōfukuji in
*chōdensu*,
the entire
ee that the
public wor-
ship. In this connection he produced two very important paintings, an extraordinarily large depiction of the death of the Buddha to be displayed each February on the anniversary of the historical Buddha's death (fig. 209), and a formal portrait of Enni, the 13th-century founder of the temple (colorplate 36). The Death of the Buddha was executed in 1408, according to an inscription on it. Both paintings are essentially conservative in style and treatment, necessarily so given their use in public worship ceremonies. Even so, the Death of the Buddha displays a somewhat free style of brushwork, using outlines of slightly varying width and some shading to model the old and emaciated faces of the Buddha's disciples, and the color scheme, while certainly not monochromatic, relies primarily on red as an accent against the different flesh tones of the humans and divinities and the black of their hair and robes. The painting of Enni fits easily within the tradition of *chinzō*, portraits of Zen masters. A portrait of Enni made when the priest was seventy-seven has been preserved in Manjuji in Kyoto, and Minchō may have based his painting on that or a similar prototype. The tilt of the old priest's head and the expression on his face are very similar, but Minchō's portrait seems if anything more lifelike than the one actually done from life. A small man with an alert, penetrating gaze, Enni sits authoritatively in an outsize chair. The color scheme in Minchō's painting is much brighter than that in the earlier work and is typical of the *chinzō* genre.

The types of Zen paintings found in the *tatchū* are exemplified by Minchō in his 1421 painting of Kannon in a white robe (fig. 210) and in a monochrome ink landscape of 1413 attributed to him (fig. 211). The White-robed Kannon belongs to the *dōshakuga* tradition of imagery—depictions of Buddhist themes intended to convey the subjective experience of receiving spiritual insights or revelations. The subject matter of *dōshakuga* includes such divinities as Kannon; semilegendary figures such as the Chinese poet-recluse Hanshan (J. Kanzan) and his friend Shide (Shih-te, J. Jittoku), who worked in the kitchen of a Chan temple and embody the Zen concept of the untrammeled soul; the eccentric monk Fenggan (Feng-kan, J.

The *kakemono,* or hanging scroll, consists of a painting or a piece of calligraphy executed on paper or silk mounted on a paper backing strong enough to support the weight of the artwork yet flexible enough to be rolled for storage. To prepare the artwork for display, it is set into a frame of figured silk or brocade. Above and below this rectangle, different pieces of silk are attached. The lower edge of the whole is provided with a round dowel around which the scroll can be rolled; at the top there is a much lighter wooden slat from which the painting is suspended when exhibited. Traditional Japanese mountings have *futai,* two narrow bands of silk that hang from the top of the *kakemono* when it is displayed. Mountings for Chinese-style paintings do not use *futai.*

*Kakemono* produced under the influence of

## KAKEMONO AND INK PAINTING

Zen Buddhism were usually *suibokuga* or paintings executed in black ink, called sumi. This type of ink is made by collecting the soot from burning pine twigs and after the addition of resin forming it into a long, flat-sided inkstick. To produce ink, the stick is dipped in a little water in the well of the flat inkstone and then rubbed on the adjacent slope of the stone. The process is repeated until the desired ratio of pigment to water has been achieved.

The *kakemono* format first appeared in the Heian period in conjunction with Buddhist painting but came into its own in the Early Feudal period in association with Zen imagery and the practice of the tea ceremony. The chief advantage of the *kakemono* is that it is small and lightweight enough to be easily hung or rerolled and replaced by another. Thus it became an important format for interior decoration.

Bukan), who raised Jittoku and liked to ride in the mountains on a tiger; Putai (J. Hotei), a Chinese monk thought to be an incarnation of Miroku; and Bodhidharma, the Indian priest who is thought to have founded Zen—as well as historical figures such as various Zen masters shown at the moment they achieved enlightenment. Minchō's monochrome landscape of 1413 is an example of a *shigajiku,* a hanging scroll combining poetry—often composed and copied by several different priests—with a monochrome image of an imaginary landscape. In these two types of paintings, *dōshakuga* and *shigajiku,* the Zen priest-artist could give his brush and his imagination free rein and create images that embodied his religious beliefs and goals.

Minchō's White-robed Kannon, typical of the treatment of this theme, sits in an informal pose in a rock grotto, her traditional abode, and gazes out over the ocean. The bodhisattva is treated as a beautiful, languid female figure, clad in a simple white robe and bedecked with gold jewelry, her divinity suggested only by the crown she wears and her halo, a perfect circle of mist through which part of the rock behind her can be seen.

The 1413 *shigajiku* of a cottage by a mountain stream, thought to be Minchō's work, is particularly interesting from a historical point of view. It is one of the oldest dated examples of a *shigajiku,* and it constitutes a record of a particular event. Junshihaku, a priest at Nanzenji in Kyoto, in 1413 built himself a study and invited a few of his friends to a celebration. He had named the new construction Keiin, literally "valley shade," and several of his friends wrote poems praising the new study. Their poems are written in the two topmost registers, and a lengthy preface to the painting appears below. The painting at the bottom of the *kakemono,* or hanging scroll, depicts an ideal scholar's study, a simple room extending out over a small mountain stream that meanders through hills. The architecture is simple, with such *karayō* elements as a stone-tiled floor and a bell-shaped window, and a Japanese-style thatched roof. The study is set in a grove of trees, and behind it is a range of tall mountains, the nearest capped with trees. The eye is led back into space by clusters of trees that seem to appear out of the mist. The artist has combined two separate images, the cottage nestled gently into a hilly region and mountains seen from a distance. As the genre of monochrome landscapes developed, one problem artists had to solve was how to link foreground and background space in a believable way. The painting has no inscription identifying it as a work by Minchō, but most scholars accept the traditional attribution.

## Early Zen Priest-Painters

The priest-painters Kaō Ninga (active mid-14th century) and Mokuan Reien (active first half of the 14th century), while less versatile than Minchō, left excellent ink figure paintings in the *dōshakuga* tradition. There is considerable confusion about the exact identity of the painter using the

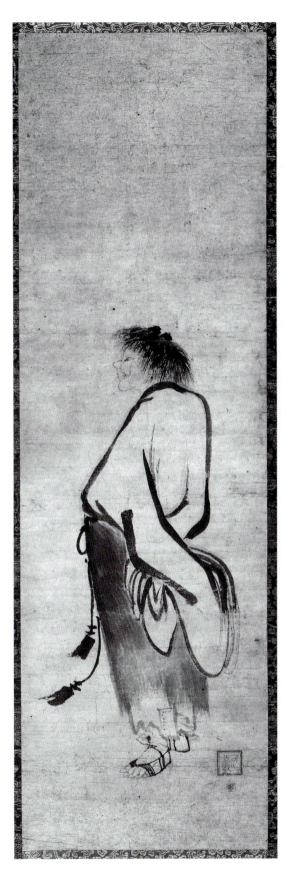

**212.** Kanzan, by KAŌ. Before 1345. Hanging scroll, ink and color on paper; 40³/₈ x 12¹/₈ in. (102.5 x 30.9 cm). Freer Gallery of Art, Smithsonian Institution, Washington, D.C. (60.23)

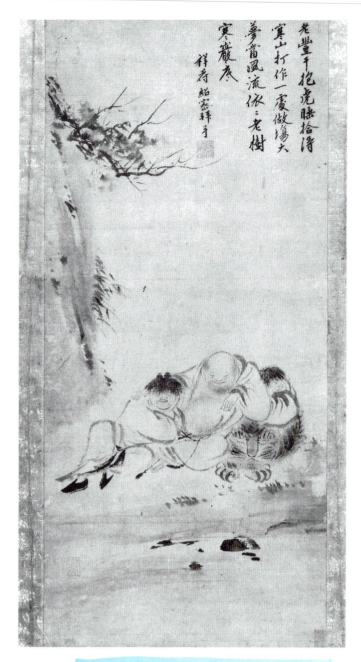

老豐干抱虎眠拾得
寒山打作一霞散場大
夢當風流依二老樹
寒巌辰
祥寿紹密拜手

**213.** Four Sleepers, by MOKUAN REIEN. 14ᵗʰ century.
Hanging scroll, ink on paper; 27½ x 14⅛ in. (70 x 36 cm).
Maeda Foundation, Tokyo

Muromachi P.

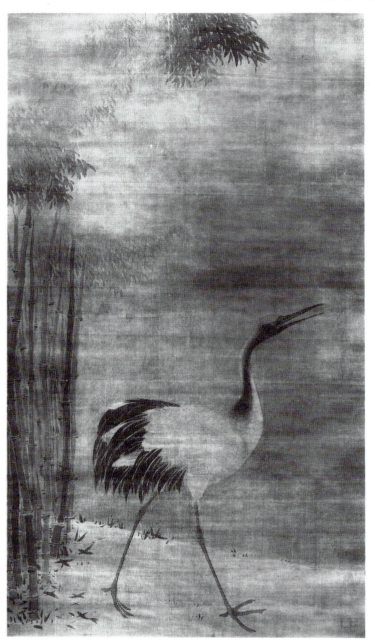

**214.** Crane, Kannon, and Monkey, a triptych of three hanging
scrolls by MU QI (Chinese, active 1279). Ink on silk; height
70 in. (177.8 cm). Daitokuji, Kyoto

Kaō and Ninga seals, and it has been suggested that he
was a professional Buddhist painter affiliated with the
Takuma school of artists. However, judging by the work
bearing his seals, Kaō was not a trained professional artist,
but rather a priest-painter versed in Zen imagery and
Song-dynasty painting styles. His depiction of Kanzan
captures the eccentricity of the man and also his strength
of character (fig. 212). Kanzan lived in a cave behind
Guoqing (Kuo Ch'ing) monastery, Kokuseiji in Japanese,
on Mount Tientai, the locus of Tendai worship in China.
The kitchen worker Jittoku would bring him food from the
monastery, and the two men would amuse themselves in
the evening with poetry and moon viewing. One among
many examples of Kanzan's poetry is the following:

> I divined and chose a distant place to dwell—
> T'ien-t'ai: what more is there to say?
> Monkeys cry where valley mists are cold;
> My grass gate blends with the color of the crags.
> I pick leaves to thatch a hut among the pines,
> Scoop out a pond and lead a runnel from the spring.
> By now I am used to doing without the world.
> Picking ferns, I pass the years that are left.

> Burton Watson, trans., *Cold Mountain*,
> New York, 1962, p. 61

Kaō shows Kanzan standing, gazing upward as if at the moon and smiling at some unknown amusement. Broad, quickly executed brushstrokes define the upper garment, while wide strokes of lighter ink suggest the skirt. Fine, light gray lines have been used for the details of the face and the feet. In this painting no information about the setting is given, but a similar painting in Japan shows a more typical handling of space; in the upper right-hand corner a portion of a tree trunk and limbs are shown. There is a pleasing balance between the dark ink used for Kanzan's unkempt hair, his clothing, and his sandals, and the lighter ink used for the finer details.

More information about Mokuan has survived than about his contemporary Kaō. Mokuan was ordained as a priest in Kamakura before 1323 and journeyed to China about 1327 to perfect his knowledge of Zen. He lived in several different monasteries in south China and died there about 1345. Since most of the paintings bearing Mokuan's seals also have inscriptions by Chinese priests, it is thought that they were first owned by these men and brought to Japan only at a later date. Mokuan clearly had achieved a significant reputation as an artist, because he was identified as "a second Mu Qi," a Chinese Chan priest-painter of outstanding ability.

Mokuan's *kakemono* Four Sleepers depicts Kanzan and Jittoku entwined with the monk Bukan and his tiger, all four sound asleep (fig. 213). (Bukan was the monk who assumed responsibility for raising Jittoku after he was orphaned.) Like his two companions, Bukan was an eccentric man, and he kept a pet tiger. So much was this priest in tune with nature that he could befriend not only the young boy but a wild animal as well. The colophon at the

**215.** Catching a Catfish with a Gourd, by JOSETSU.
c. 1413. Hanging scroll, ink and color on paper;
43⁷⁄₈ x 29⁷⁄₈ in. (111.5 x 75.8 cm). Taizōin, Myōshinji, Kyoto

*Shokokuji temple          Muromachi P.*

top of the painting has been translated as follows:

> Old Feng-kan embraces his tiger and sleeps,
> All huddled together with Shih-te and Hanshan
> They dream their big dream, which lingers on,
> While a frail old tree clings to the bottom of the cold
>     precipice.
> Shao-mu of the Hsiang-fu [temple] salutes with folded
>     hands.

> Jan Fontein and Money L. Hickman, *Zen Painting
> and Calligraphy,* Boston, 1970, p. 73

Mokuan has followed a formula for brushstrokes and ink similar to that seen in Kaō's painting. Medium gray, fairly broad lines describe the bodies of the sleepers, while fine strokes are used for the facial features, and dark ink accents such details as shoes, belt, and hair. Only the briefest of details are supplied about the setting. A light wash sug-

**216.** Reading in the Bamboo Study, by SHŪBUN. c. 1446.
Hanging scroll, ink and color on paper; 53³⁄₄ x 13¹⁄₄ in.
(136.5 x 33.6 cm). Tokyo National Museum

gests rocks beside the figures and the shoreline in front of them, while darker strokes are used for vines, tree branches, and river rocks. The painting evidences a more sophisticated use of ink than Kaō's painting of Kanzan.

Finally a word must be said about Mu Qi (Mu Ch'i, J. Mokkei), a Chinese who was active as a Chan priest and painter in the second half of the 13th century. At first a noted scholar, Mu Qi took the tonsure in midlife and founded the temple Liutongsi, near Hangzhou in south China. Japanese priests who had the opportunity to see his work were greatly impressed and took several of his paintings back to Japan (fig. 214). His triptych of a white-robed Kannon, flanked by a crane striding forward as if from a bamboo grove and a monkey on a dead tree branch cradling her baby, found its way into Daitokuji, where it had a significant influence on Japanese artists, not only in the 14th and 15th centuries, but on later painters as well, extending into the 20th century. No other Chinese artist had such a profound impact on the development of Japanese painting. Further, the imagery of the crane and the monkey became associated in Zen illustrations with the idea of enlightenment, the crane—the Chinese symbol for a Taoist immortal—representing the independent spirit who has achieved satori, the monkey, hugging her child as she sits on the dead tree, expressing the soul still tied to worldly concerns.

## Master Zen Priest-Painters

A contemporary of Minchō was the priest-painter Josetsu, and his major work, Catching a Catfish with a Gourd (fig. 215), was made about the same time as Minchō's Cottage by a Mountain Stream. The picture was commissioned by the Ashikaga shogun Yoshimochi (1386–1428) and executed as a decoration for a small Chinese-style standing screen. When it was presented to the shogun, thirty Zen priests composed poems of praise for the work and copied them onto a sheet of paper that was attached to the reverse side of the screen. The introduction to the collection of poems was written by Taigaku Shūsū, one of the monks, who also added a poem of praise to Minchō's shigajiku, and the painting can be dated to the years around 1413 on the basis of the dates of overlap of the thirty priests. Not long after it was made, the painting and accompanying text were refashioned into a single hanging scroll.

The painting is a dōshakuga of a fairly unusual kind, the depiction of a kōan, the thought problem used as an aid to attaining enlightenment. The puzzle is how to catch a slippery catfish in a gourd. The figure in the center of the foreground is shown holding a pale orange gourd in front of him as if measuring it against the longer length of the wriggling gray fish swimming in the stream at his feet. The man cuts a strange and solitary figure, with his porcine face, his oddly animated clothing, and his stiff-legged stance, placed alone in the flat, barren landscape. Far in the distance the pointed tops of three mountains can be

seen above the mist. One of the inscriptions refers to the new manner of the painting, which scholars usually have interpreted to be a comment on the inclusion of a detailed, multiplanar landscape setting in this dōshakuga; in Kaō's and Mokuan's work, the setting is usually executed in swift brushstrokes, with only the briefest description of a background setting.

Little is known about Josetsu beyond the fact that he was a priest living in the temple of Shōkokuji. A diary reference identifies him as a stonecutter employed by Ashikaga Yoshimochi to carve an inscription on a stone stele for the subtemple of Rokuonin in honor of the Zen master Musō Soseki (1275–1351), founder of Shōkokuji and one of the most influential men of his time. However, Josetsu was obviously an artist of some skill, and is known to have taught one of the next generation's most outstanding priest-painters, Shūbun.

Tenshō Shūbun (died c. 1460) was also a monk at Shōkokuji, serving in one of the top administrative positions within the temple. In 1423 he took part in a diplomatic mission to Korea, specifically charged by the shogunate with securing a printed edition of the Korean Tripitaka, the basic Buddhist canon. He is also credited with designing and painting Buddhist sculptures. Clearly Shūbun was a man of many talents. By the 1430s he had achieved a significant reputation as a painter and received commissions from lay patrons as well as from his own temple.

Few of the paintings attributed to Shūbun are generally accepted as authentic examples of his work, but Reading in the Bamboo Study, of about 1446 is one of the few (fig. 216). The painting is a shigajiku with a long introduction at the top of the scroll and five brief inscriptions, each by a different person. The illustration depicts a scholar's study, almost hidden in a bamboo grove. The building has a thatched roof and a large window through which the scholar can be seen holding something, perhaps a book. Close to the house a sharp bluff is capped by two pine trees, one straight, the other oddly bent near the base of the trunk. The bluff and the trees are painted in a darker shade of ink than the house and bamboo grove, and are echoed at the top of a background mountain by a similarly shaped rock formation sketched in dark ink. The motifs of rocks and the scholar's study occupy the right half of the painting. To the left at the base of the bluff is an expanse of flat land at the edge of a body of water, and on a short bridge an older man appears to walk ahead of a young male attendant toward the bluff, a scholar and his servant boy going to visit their friend in the Bamboo Study. Far in the distance to the left can be seen the other shore, with two fishing boats tied together behind a low spit of land and two more to the right, moving through the water. The tiled roofs of a temple complex may be seen among the trees.

In this landscape Shūbun has clearly solved the problem of believably depicting planes of spatial depth. Indeed, the painting suggests an almost unending procession of motifs carrying the eye far back into space. The

**217.** Winter Landscape, one of four hanging scrolls of the four seasons, by SESSHŪ TŌYŌ. c. 1470s. Ink on paper; 18¼ x 11½ in. (46.4 x 29.4 cm). Tokyo National Museum

MUROMACHI. P.

atmosphere of Shōkokuji, having learned his craft from Shūbun. Sesshū was born in what is today Okayama prefecture and at a very early age made his way to Kyoto and the temple of Shōkokuji. In 1464 Sesshū emigrated from Kyoto to Yamaguchi, Honshū's westernmost prefecture, where he came to the attention of the ruling Ōuchi family. His move was symptomatic of the period. Not a few Kyoto-based artists, sensing increasing political unrest, sought opportunities to withdraw from the confines of their monasteries and the city. Sesshū established a studio, the Unkokuan, but did not affiliate himself with any particular Zen temple. A second factor in Sesshū's decision to leave Kyoto was probably his hope to travel to China with the backing of the Ōuchi family, a trip he was able to accomplish between 1467 and 1469. Journeying with a trading mission privately sponsored by the Ōuchi, he arrived at the port of Ningbo and from there traveled to Beijing, visiting Buddhist monasteries and famous scenic spots along the way. No reliably attributable paintings survive from the period before Sesshū went to China, but from his later work it is clear that he studied contemporary Ming landscape paintings as well as earlier Southern Song and Yuan pictures. When he returned to Japan in 1469, Sesshū at first settled in Kyūshū and established a new studio, the Tenkai Togaro, but eventually moved back to his Unkokuan in Yamaguchi. Throughout his later life, he was a much-sought-after artist and continued to function productively, even making long pilgrimages about the country, until his death in 1506.

One of his most characteristic landscapes is a winter scene (fig. 217), probably part of a set of landscape *kakemono* of the four seasons and thought to date to the 1470s. In this painting Sesshū has woven motifs frequently found in Chinese landscape painting into an original and typically Japanese statement. Beginning in the lower right with the motif of two trees growing at the edge of the water, the viewer's eye is led back into space by the diagonal lines of a stepped pathway, along which a man with a wide-brimmed hat is climbing, presumably journeying toward the temple complex visible above him. The hills through which he travels and the mountains in the background surround the temple buildings, making them seem like a warm oasis in a cold, icy wasteland. The foreground passages of rocks and trees are described with firm, dark brushstrokes, while the distant mountains are only outlined against the gray sky. An interesting detail in the painting is the rock formation that appears in the upper right quadrant. An undercut bluff, similar to the one in Shūbun's painting, appears behind the midground hills. It is described quite accurately toward the bottom in Chinese fashion, but the outline stops short of the top of the painting, as if the upper part of the mountain is immersed in clouds. With this single detail the artist changes our perception of the landscape. It is not an eternal, never-changing scene, but rather one that reveals the immediacy of the moment as the mountain top disappears from view,

brushwork emphasizes short, repetitive strokes that describe the natural elements but also give the painting a somewhat decorative effect. It is clear that Shūbun was familiar with Song-dynasty landscape painting, because he uses several stock motifs such as the scholar and his attendant crossing the bridge, the scholar visible through the window of his study, fishing boats close to land, and the temple buildings in the distance. Also, the dominant motif of crossing pine trees is one frequently used by the Song painter Xia Gui (Hsia Kuei), whose works were highly prized by Japanese collectors. It is also clear that Shūbun was depicting an ideal landscape composed of many different elements, rather than a natural landscape he might have seen around Kyoto. The painting has the flavor of an idyllic view into the past, a quiet life led far away from the bustle of the mundane world.

The greatest priest-painter of the Early Feudal period, Sesshū Tōyō (1420–1506), emerged from the creative

**218.** Landscape in the *haboku* technique, by SESSHŪ TŌYŌ. 1495. Hanging scroll, ink on paper; 58¼ x 12⅞ in. (147.9 x 32.7 cm). Tokyo National Museum

Moromachi P.

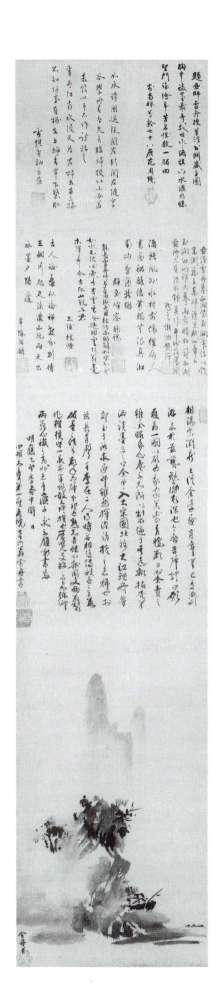

snow on the stairway crunches underfoot, and the warmth of the temple beckons the traveler home.

A work that demonstrates Sesshū's facility with brush and ink is the *haboku* or broken-ink landscape of 1495 (fig. 218). *Haboku* is a term denoting the very free and rapidly executed style in which ink seems to have been splashed on the paper surface of the painting. While this may look easy, it is not. Very few *haboku* paintings are as successful as this one. With incredible economy of means, Sesshū has suggested a passage of land at the edge of water, large trees, and tall background mountains, and has even peopled his composition with two figures in a boat close to shore and a village of houses with the distinctive flag-bearing pole of a sake house.

This hanging scroll has an interesting history. It was executed by Sesshū as a farewell gift for a pupil, Josui Sōen (active 1495–1499), a priest-painter from the Kamakura temple of Engakuji. Above the landscape is a long inscription by Sesshū, giving the date of the painting and the circumstances of its production and also detailing the artist's experiences in China and specifying Josetsu and Shūbun as the artists whose work had most influenced him. The painting functioned almost like a *chinzō* portrait, certifying that Sōen had indeed completed his training under Sesshū and was judged by the master ready to graduate as an independent artist. On Sōen's way back to Kamakura, he spent several years in Kyoto, and during that time six high-ranking Zen priests added colophons of praise for the painting, above Sesshū's own writing.

## Muromachi Culture

As in some earlier periods, the influence of Buddhism during the time of the Ashikaga shogunate (1338–1573) was so pervasive that it is difficult to distinguish between secular and religious art. Nor is it particularly useful to do so. However, in this period two distinct cultural environments grew up around the retirement palaces of two of the Ashikaga shoguns: the villa of Yoshimitsu (1358–1409) in the Kitayama, or Northern Hills, district of Kyoto, which became the temple known as Kinkakuji, the Temple of the Golden Pavilion; and the villa of his grandson Yoshimasa (1436–1490) in the Higashiyama, or Eastern Hills, district, called Ginkakuji, or Temple of the Silver Pavilion. The proper name of Kinkakuji is Rokuonji, the proper name of Ginkakuji, Jishōji. Both of these Muromachi-period buildings were constructed as elegant settings for the shoguns when they wished to withdraw from the pressures of administration and devote themselves to leisure pursuits. Not until after the deaths of the shoguns were they converted into temples and given the posthumous priestly names of their former owners.

The building from which Kinkakuji takes its name is a magnificent three-storied structure covered with gold foil, set at the edge of a large artificial pond (colorplate 37). In 1397, Yoshimitsu took possession of the site, which at one time had a *shinden zukuri* mansion and gardens and proceeded to have various buildings constructed on the property, including the pavilion and two pagodas. He took up residence there in 1399, when he retired as shogun. The original Golden Pavilion was completely destroyed in 1950 by an arsonist, a crazed acolyte protesting the commercialization of the Buddhist Church after World War II. The structure was rebuilt quickly and restored to something like its original appearance. In the 1980s, the gold covering was replaced, and the building was reopened to visitors in the fall of 1987.

The pavilion is a three-storied, double-roofed structure four bays by five, designed to house several different types of activities. It is modeled on the Chinese lakeside kiosk. The first floor, intended for informal relaxation and contemplation of the lake and garden, is provided with hinged lattice panels that can be raised so that the interior is open to the view, in the manner of Heian palaces. The second floor—in the style favored by the samurai—is enclosed by walls and is L-shaped in plan, due to the fact that three bays along the lake side of the building have not been included within the interior. The top floor is only three bays square and was designed as a temple room to be provided with statues of Amida and twenty-five bodhisattvas as well as a buddha relic acquired from Engakuji in Kamakura. The building, with its Chinese-style bell windows and grilled transoms, and its bright, shiny gold covering, seems like a delicate jewel moored at the edge of the pond.

Yoshimasa's Silver Pavilion is nothing like its so-called twin, and the notion that it was to have been covered in silver is false (fig. 219). The second floor was designed as a chapel dedicated to Kannon, and it may have been Yoshimasa's intention to have that interior covered in silver. Ginkakuji is on the site of an abandoned Tendai temple acquired by Yoshimasa in 1465. Most of the twelve buildings of the new retirement palace were completed, and the shogun was in residence, by 1483. The Silver Pavilion is a two-storied, two-roofed building three bays by four on the first floor, three by three on the second. The first floor was used by Yoshimasa for meditation and could be opended up to a view of the garden by moving sliding doors.

Another of the buildings surviving at Ginkakuji is the Tōgudō, which contains a simple four-mat tea room called the Dōjinsai, thought to be the oldest such room in Japan. The building, completed in 1486, was modeled on the western Amida hall of Saihōji and is a single-storied structure capped by a hipped-gable roof (figs. 220 and 221). The interior displays many of the design features that in the succeeding Momoyama period are incorporated into the *shoin* style of architecture: a *chigaidana*, a group of shelves inter-

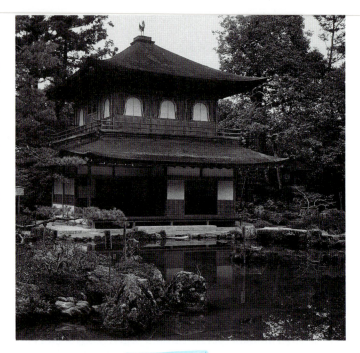

**219.** Ginkaku (Silver Pavilion), Jishōji, Kyoto. 1489
( Ginkakuji - Jishoji )    15th c.    Ashikaga Yoshimasa

connected at different heights, and a *tsuke shoin*, a shallow alcove with a wide ledge used as a desk, and sliding shoji windows (fig. 222).

Finally, the Ginkakuji complex is provided with a beautiful walking garden laid out around an artificial pond, with a pathway that weaves in and out among the trees, providing a sequence of near views and far views. Close to the pavilion is a small *karesansui* garden, added after Yoshimasa's death.

Both Yoshimitsu and Yoshimasa established their retirement palaces as cultural centers and strove to foster the arts, Yoshimitsu encouraging the development of Nō drama and *renga,* or linked verse (see page 193), Yoshimasa lending his support to the development of the tea ceremony and flower arranging. Yoshimitsu affiliated himself with the arts as a matter of policy in an attempt to give himself legitimacy as a national ruler, a military man with the cultural sophistication of a courtier. In these efforts he relied upon a new class of men known as *tonseisha,* men who were ordained because they were dissatisfied with the social ranks accrued to them at birth but who did not affiliate with any particular Buddhist temple. (Yoshida Kenkō, author of *Essays in Idleness,* was a *tonseisha.*) By nominally becoming priests, they removed themselves from the class system and gained freedom of access to the privileges denied them by the circumstances of their parentage. They were able to participate fully in the wide variety of cultural events that occurred under the Ashikaga, unfettered by the duties of class.

Yoshimasa continued Yoshimitsu's reliance on the *tonseisha,* and by the end of the 15th century an entirely new system of patronage had developed. Zen priest-painters like Sesshū left the capital. Taking their place as advisers and curators of the shogun's art collection were

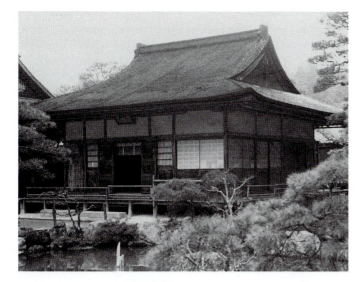

**220.** Tōgudō, Jishōji, Kyoto. 1486

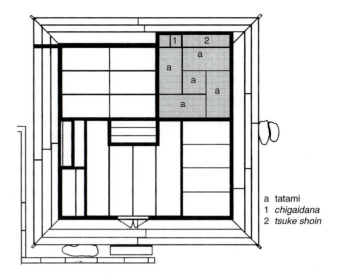

a tatami
1 *chigaidana*
2 *tsuke shoin*

**221.** Plan of Tōgudō, Jishōji, emphasizing Dōjinsai (tea room)

the Sanami, three generations of a family that had affiliated with Pure Land Buddhism and used the suffix *ami* to indicate nominal priesthood. However, these *ami*, Nōami (1397–1471), Geiami (1431–1485), and Sōami (1455–1525), had little to do with the Buddhist Church. They produced a catalog of the Chinese paintings in the collection, and the first volume of art criticism in Japan, the *Kundaikan sayū chōki*, an evaluation and ranking of Chinese artists and instructions for the proper display of their paintings. In addition to their other skills, the Sanami were painters, basing their style on the Southern Song masters Ma Yuan and Xia Gui. Sōami, perhaps the most innovative of the group, developed a second, softer style that combined elements from the paintings of Mu Qi with the dot strokes and gray washes of ink favored by a school of Chinese literati artists who traced their stylistic lineage to Mi Fu (1051–1107) and his son Mi Youren (1072–1151). Sōami's style is well represented by the sliding-door panels in the Daisenin compound of Daitokuji depicting the confluence of the Xiao (Hsiao) and Xiang (Hsiang) rivers in China, a popular theme in Song painting (fig. 223). The mountain forms are modeled with gray washes and given sharper definition with short strokes in darker ink.

Contemporary with the formation of the Ami school of painters was the Kanō school's rise to prominence in the person of Kanō Masanobu (1434–1530). The Kanō continued to be an influence in painting circles well into the modern period. Practically every artist traditionally schooled in Japan trained first under a Kanō master. Eventually their work became the conservative standard against which more innovative artists rebelled, but the Kanō were unquestionably the leaders of the *kanga*, or Chinese painting, style.❖

The Kanō were descended from a low-ranking samurai family from the area around Shizuoka prefecture and had an affiliation not with Zen but with the Nichiren or Hokke sect of Buddhism.❖❖ Masanobu was appointed official painter to the shogunate in 1481, but it was not until

**222.** Interior of Dōjinsai (tea room) in the Tōgudō, Jishōji. 1486

❖*Kanga* and *kara-e* both mean Chinese painting. The difference is the period for which they are used: *kara-e* is used for Chinese styles of the Heian and Kamakura periods, while *kanga* is used for Chinese-style art of the 15th to 19th centuries, particularly for work associated with Kanō school styles. The comparable term for earlier Japanese-style art is *yamato-e*.

❖❖ Nichiren Buddhism began with yet another strong and charismatic 13th-century religious leader, Nichiren (1222–1282). It is based exclusively on one sutra, the *Lotus Sutra*, and emphasizes devoted recitation of the sutra's Japanese title: *Namu myōhō renge kyō*. Nichiren saw himself as a great patriot and savior of Japan, and he vehemently denounced all schools of Buddhism that did not believe in the *Lotus Sutra*, particularly the Pure Land sects—which he blamed for disasters such as the Mongol invasions.

*The Early Feudal Period* 205

his son Motonobu (1476–1559) matured as an artist that a Kanō style was formulated and the school firmly entrenched as the chief painters to the shogunate. Motonobu was a remarkably versatile painter, capable of working in the brightly colored *yamato-e* style of narrative painting, in a meticulous Chinese genre of bird and flower paintings, and in a freer style combining figural and landscape motifs.

This latter style was fully developed by the early 16th century and is well represented in six panels by Motonobu depicting Zen patriarchs, originally designed as wall and door paintings but now refashioned into hanging scrolls. These paintings were executed around 1513 for the abbot's room in the Kyakuden, Guest Hall, of Daisenin, the subtemple within the grounds of Daitokuji that has a *kare-sansui* garden (see page 193). Although these are only a portion of the paintings that originally decorated this room, they represent a continuous sequence moving from right to left. First are four narrow panels, which were mounted on *fusuma* (sliding-door panels) installed along the south side, followed by two wider panels, which were attached to solid, wood panels forming the east wall of the room. With the exception of the second, each section depicts one or two Chinese Zen patriarchs engaged in various activities such as sweeping, gazing at peach blossoms, and bidding a friend farewell, set in strongly delineated Chinese-style landscapes.

The most charming among the six panels is unquestionably Xiangyen achieving enlightenment while sweeping with a bamboo broom (fig. 224). Xiangyen Zhixian (Hsiang-yen Chih-hsien, J. Kyōgen Chikan, died 898) was asked by his master about his life before birth in his present incarnation. Unable to reply, Xiangyen set himself single-mindedly to find the answer. When Buddhist texts failed to help, he burned his library and sought the answer through meditation. Finally, while he was tending his garden, a tile fell off the roof of his house, and at the sound Xiangyan achieved enlightenment. The painting shows him sweeping the area of his yard next to a cluster of bamboo trees; at his feet is the tile shattered into three pieces. Startled by the noise, he has taken a step backward and raised his right hand in amazement at the event and his sudden enlightenment.

To date, the source for this and the other five Zen themes at Daisenin has not been identified, but it is clear from Motonobu's handling of the composition of each panel that he thought of them as separate narrative units rather than as individual figures woven into a continuous and three-dimensional landscape. As a general rule, Motonobu established the center of the composition with a single motif, such as Xiangyan Zhixian's house. Then, to

create a surface tension, he placed secondary elements on diagonals, such as the large boulder to the right and the bamboo trees; this suggests recession into depth and contradicts the stability of the central image. What he achieved is a series of figure-and-landscape compositions based on small-scale Chinese models but enlarged and made dramatic to enliven the walls of Japanese-style architecture.

## Ceramics

In the Early Feudal period three elements coalesced to affect the development of Japanese ceramics profoundly, elevating them from primarily utilitarian objects into a major form of artistic expression. The first element was cultural. Through the renewal of private trade with China and Korea and the transmission of Zen Buddhism from the continent to Japan, the arbiters of taste—the samurai and the priesthood—came to know and appreciate the celadon ware of those two countries.

The second element was technical, the development of a new, more efficient type of kiln. In the Nara and Early Heian periods, ceramics were typically fired in a reduction kiln—that is, a kiln in which no air was permitted to enter the oven after the firing had begun. As the wood fire burned, the oxygen in the combustion chamber was reduced and the strength of the flame diminished. In the 10th century, an oxidation kiln was developed that permitted air to enter during the firing process, making it possible to better control the intensity of the flames, maintaining them at higher temperature levels that yielded a more durable ceramic. However, during the political disruptions of the Late Heian period, ceramic production declined, some kiln sites were abandoned, and the full potential of the oxidation kiln was not realized. With the renewed demand for ceramics in the 13th century, potters made a further modification in the oxidation kiln, separating the combustion chamber from the oven proper, which improved the efficiency and controllability of the kiln, permitting firing at the high temperatures that are needed to produce stoneware, a ceramic that is hard and nonporous.

The third element was also technical: the development of glazes. Natural glazes occurred as an accident of the firing process. Where ashes from the fire fell on the surface of a vessel, a glossy patch was formed. In the Early Feudal period, the decorative potential of glazing utilitarian vessels, both accidentally and deliberately, was recognized. Wood ash suspended in a watery solution was applied either evenly to the surface of the vessel, yielding an overall color, or unevenly, which resulted in an irregular pattern of streaks. When fired in an oxidation kiln, these ash glazes produced a brown or amber surface, in a reduction kiln, a greenish-yellow one.

A narrative, most probably apocryphal, attributes these innovations to the potter Katō Shirozaemon Kagemasa, also known as Tōshirō. In 1223, Tōshirō traveled to

223. *(Opposite page)* Four of the Eight Views of the Xiao and Xiang Rivers, by SŌAMI. Early 16th century. Four *fusuma* panels, of a total of sixteen panels now mounted as hanging scrolls. Ink on paper; each 68 7/8 x 55 in. (174.8 x 139.7 cm). Daisenin, Daitokuji, Kyoto

China in the entourage of the Zen priest Dōgen (1200–1253), founder in Japan of the Sōtō school of Zen, and he stayed on in China for several years after Dōgen's return to study Chinese ceramic techniques. When he came back, he settled in the region known as Seto, near the modern-day city of Nagoya in Aichi prefecture. It is a region rich in the type of clay that makes stoneware. So famous was this region for its wares that its name forms the root for the Japanese word for ceramics, *setomono*. Although we may not accept the Tōshirō story as factually accurate, it does account for a number of the characteristics of Early Feudal ceramics.

Until recently, ceramic production in the 13th and 14th centuries was thought to have been concentrated in six "old" kiln sites: three in the area around Nagoya (Seto, Tokoname, and Shigaraki); two farther to the west (Tamba and Bizen), the former close to Kyoto, the latter near modern-day Okayama; and Echizen on the west coast, not too far from modern Kanazawa. However, in recent years archaeologists have discovered more than thirty centers for the production of unglazed stonewares, ranging from Miyagi prefecture in the north to Okayama in the south of Honshū. Even farther south, on the islands of Shikoku and Kyūshū, two more sites have been uncovered. Of these many sites, Seto is the most important, producing in the last decade of the 13th century a unique style of ceramics known as Ko Seto, or Old Seto, to distinguish it from wares made in the region in succeeding periods. Ko Seto wares exhibit a refinement of shape, a perfection of technique, and an elegance of decoration not found in ceramics from the other kiln sites. In large measure this is due to the receptivity of local potters to the techniques and aesthetics of Chinese Song-dynasty ceramics.

A Ko Seto jar, in a shape most often identified as a wine bottle or sake decanter, displays not only the distinctly Chinese peony design, but also the shape known in China as *meiping* (*meip'ing*, fig. 225). The jar is taller than it is wide, and contrasts a narrow neck, articulated by the horizontal lines formed by an upper and lower lip, with a long body that swells at the shoulder and re-forms itself into a narrow circle at the base. This shape is further embellished by a design of peony blossoms incised in the clay before firing and by a pattern of streaks achieved by the overapplication of the glaze. This particular vessel would not pass muster in China, but the fact that it was produced in the Seto region and preserved over the centuries is a clear indication that Japanese potters were not attempting to copy Chinese ceramics, but rather to adapt interesting elements into a native vernacular.

A vessel typical of the period is a storage jar thought to have been produced in Shigaraki in the 14th to

**225.** Jar with peony design. Ko Seto ware. 13th to 14th centuries. Ceramic, with yellow glaze; height 12 in. (30.5 cm). Tokyo National Museum

15th centuries (fig. 226). The vessel was formed out of coils of clay that were built up and then formed into the final jar shape. Because the clay had a high iron content when it was fired, the unglazed portion became brick colored, but the shoulders of the vessel, which were ash glazed, turned grayish and produced a small, biblike patch of shiny greenish glaze.

## Tea-ceremony Wares

Toward the end of the 15th century, under the stewardship of Murata Shukō (1423–1502), the commonplace act of drinking tea and offering it to guests was formalized into a ritual, *chanoyu*. The space in which the ceremony was held was redefined to express the aesthetic concepts of individual tea masters, Murata's ideas being expressed in the Dōjinsai tea room in the Tōgudō at Ashikaga Yoshimasa's temple, Ginkakuji, in the Eastern Hills of Kyoto (see page 204). Further, the objects used to make and serve the tea, a thick green tea known as *matcha*, were carefully chosen to suggest age and a Chinese aura of simplicity and understated elegance. In response to the changing aesthetics of the times, Japanese potters attempted to imitate the Chinese Jian ware known in Japan as *tenmoku*. The name is derived from Mount Tianmu (T'ien-mu) in China, where

**224.** (*Opposite page*) Zen Patriarch Xiangyen Zhixian Sweeping with a Broom, by KANŌ MOTONOBU. c. 1513. Hanging scroll, ink and color on paper; 67 3/8 x 34 3/4 in. (175.1 x 88.4 cm). Tokyo National Museum

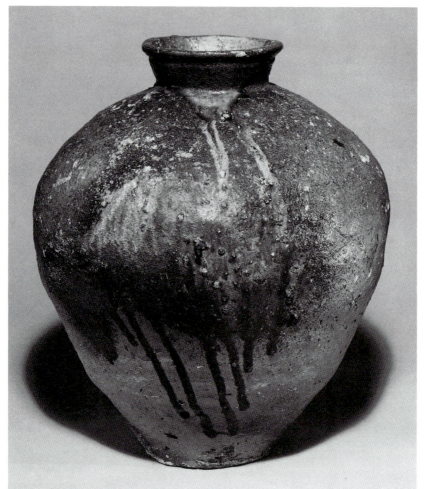

**226.** Storage jar. Shigaraki ware. 14th to 15th centuries. Stoneware, with natural ash glaze; height 18⅜ in. (46.7 cm). The Metropolitan Museum of Art, New York. Collection of Asian Art, Gift of Harry G. C. Packard and Purchase, Fletcher, Rogers, Harris Brisbane Dick and Louis V. Bell Funds, Joseph Pulitzer Bequest, and The Annenberg Fund, Inc. Gift, 1975 (268.428)

**227.** Tea bowl, called Gyōkukan. Black Tenmoku ware. Before 1555. Stoneware, with glaze; height 1¾ in. (4.6 cm). Tokugawa Art Museum, Nagoya

this type of ceramic was first used by Zen priests for drinking tea, and in China it originally designated tea bowls decorated with black and brown iron glazes. In Japan, the term took on a wider meaning, referring to a tea bowl, usually somewhat conical, that could be decorated with any number of different glazes. A tea bowl thought to have once been owned by a successor of Murata, the tea master Takeno Jōō, is of particular interest because it can be dated to the period before Jōō's death in 1555 (fig. 227). The profile of the bowl displays the conical shape preferred in Japan, and it is decorated with a crackled white glaze rather than the traditional black and brown. The glaze seems to be a forerunner of the white Shino ware produced at the nearby site of Mino in the Momoyama period.

# CHAPTER 5
# A Turbulent Transition

## THE MOMOYAMA PERIOD

The Muromachi period had been a time of cultural flowering and political breakdown. The Ōnin War of 1467 to 1477 had initiated a period of political and social disruption unprecedented in Japan's history. The fighting, which began in Kyoto and devastated the city, raged for nearly a hundred years and spread over the length and breadth of the country as the Ashikaga shogunate was gradually destroyed. This hundred-year dissolution of the old order paved the way for the founding of a new one: The emerging elite of the Momoyama feudal system were the daimyo, lords who controlled domains and served as advisers to the shogun. Within each daimyo's *han*, a stable, village-based peasantry was encouraged to be productive—the better to fill the lords' war chests with their taxes.

## Consolidation Under New Military Leaders (1573–1615)

By the middle of the 16th century, the now solidly established, efficient provincial holdings of the daimyo became the foundation of a centralized feudal nation, as a few of these new leaders began to look to control of Japan. Oda Nobunaga (1534–1582), the son of a minor vassal, was the first daimyo to rise to a position of preeminence. By the 1560s he had assembled a formidable army and concluded a series of feudal alliances, enabling him to march with minimum resistance toward Kyoto. He entered the capital in 1568, took control of the government, and within five years had deposed the last of the Ashikaga shoguns. During the fourteen years of Nobunaga's control—he was killed in a surprise attack mounted by one of his generals—he put down some of his more troublesome rivals and considerably advanced the process of national unification.

Nobunaga's attempt to establish the seat of national government at Azuchi, to the east of Kyoto, epitomizes his pride in his newly acquired power and his disdain for historical precedents, specifically those embodied in the nobility and the Buddhist Church. In 1576 he built Azuchi Castle on the eastern shore of Lake Biwa and a city complex at its base, to which he forcibly moved merchants and artisans from Kyoto, as well as his own vassals. Although it was not unusual for feudal lords in the West to found new centers of government, such an action was exceedingly rare in Japan, the only similar moves being the transfer of the capital from Fujiwara to Nara and then to Kyoto and the founding of Kamakura as the de facto capital between 1180 and 1333.

After Nobunaga's assassination, control was assumed by Toyotomi Hideyoshi (1536–1598), a low-ranking samurai who ultimately attained the position of Taikō, or retired regent, in the tradition of Heian-period noblemen. Hideyoshi continued Nobunaga's efforts toward unifying the country through military and administrative means. To prevent the city of Kyoto from becoming once again a battleground for large armies, he commanded the narrowing of the broad avenues laid out when the capital was first built in the late 8th century. Today one questions Hideyoshi's vision, as cars and bicycles choke the city streets, but the narrowed roads and twisting alleys still delight walkers in the old city, which is away from the commercial center. Fundamental to Hideyoshi's administrative policy was his desire to create for himself the image of an effective ruler who governed by virtue of his wisdom, his knowledge of historical precedents, and his respect for cultural tradition. He built two castles at strategic locations near Kyoto, one at Osaka, the other at Momoyama, southeast of the city, which gave its name to the period. He also built the elegant mansion of Jurakudai in the capital and in 1583 entertained the emperor there. To publicize his noble virtues he often engaged in lavish displays: pilgrimages in the company of his daimyo vassals and their servants to view the cherry blossoms at Yoshino, elaborate tea ceremonies for all the people of Kyoto and the surrounding towns at the Kitano Shrine and at Daigoji, on the outskirts of the capital. One measure of his success was that, unlike many feudal lords, he died a natural death.

Hideyoshi left a five-year-old son, Hideyori, as heir to his regency, and a council of daimyo vassals to govern during the child's minority. Disputes soon broke out within the council, and it split into two factions, one loyal to

Hideyoshi's son, the other to Hideyoshi's strongest opponent on the council, the powerful feudal lord Tokugawa Ieyasu (1542–1616). In 1600 the situation came to a head in the battle of Sekigahara, with Ieyasu's men emerging victorious, although his armies did not attempt to destroy the Toyotomi faction in its stronghold, Osaka Castle, until fifteen years later. In 1603 Ieyasu revived the title of shogun for himself, initiating over two hundred fifty years of Tokugawa rule. He avoided the political instability of leaving unprepared heirs by passing the position of shogun to an adult son, Hidetada, in 1605. Ieyasu continued to rule, however, and in 1614 to 1615 he completed the ruin of the Toyotomi family. With that, the Tokugawa attained a position of unchallenged leadership, and their stronghold in Edo, modern-day Tokyo, became the effective seat of government.

## Momoyama Arts

The Momoyama period is traditionally dated to the years between Nobunaga's deposing of the last Ashikaga shogun in 1573 and Ieyasu's destruction of the Toyotomi faction in 1615. The art of this period is notably more secular in its themes than ever before and has two distinct phases. The first is characterized by exuberant expansiveness, the second by self-assurance and a calculated return to historical precedents. The new leaders in the first phase, emerging from the lower ranks of the samurai class—the feudal warriors and retainers—were pragmatic, astute men with little formal education, but with confidence in their military prowess and their administrative ability. They gradually restored political stability to Kyoto and the provinces, and with this came economic prosperity. An element of the exotic was added to Momoyama culture in the years when Westerners began to appear on Japanese soil. Portuguese shipping merchants seeking trade alliances had arrived first, starting in 1542, and in their wake had come Jesuit missionaries who settled in Japan, bringing Christian doctrines for the first time.

The painting most characteristic of the first phase employed brilliant colors, gold-leaf grounds, and strong decorative patterns. The preferred formats were the sliding-door panels known as *fusuma,* and the folding screens, or *byōbu,* which presented large surfaces to be decorated. *Shōbyōga (or shōhekiga)* is the collective term for painting on these two surfaces. The average *byōbu* is about 5 feet (1½ m) tall by 11 feet (3½ m) wide, while *fusuma* are tailored to fit a specific architectural space. The flavor of this art was bold and flamboyant, complementing the audacious new leaders, who sensed in the age an unlimited potential for self-aggrandizement.

The second phase of the Momoyama period began in the last decade of the 16th century, its momentum continuing into the first decades of the 17th century. The earlier exuberance gave way to mature assurance, a spirit of reflective introspection, and the return to established traditions. Particularly important for setting the mood of the later years was the emergence of the *machishū,* a wealthy, educated merchant class. Taking their lead in cultural matters from the nobility, they developed expertise in the tea ceremony and became devoted students of the classics of Japanese literature, the *Tale of Genji* and the *Tales of Ise.* The latter is a collection of poems with prose introductions, presenting the life and loves of the nobleman Ariwara Narihira. It is believed that the collection was formulated sometime before 950, and in the Heian period it became one of the poetry collections the aristocracy of Kyoto were expected to know by heart. In painting, the subjects became more intellectually challenging: Chinese themes, such as those found in the *Teikan zu* or *Mirror of Emperors,* a Ming-dynasty tract on moral conduct, were frequently illustrated. The return to indigenous traditions, however, was to prove the most important development in the second phase. *Yamato-e* themes and techniques were reworked and adapted to the new monumentality of Momoyama art, and genre painting was revived.

## Architecture

The great artistic innovations of the Momoyama period occurred in architecture and painting. Two new forms of buildings were developed by the samurai class to meet their military and social needs: the castle and the *shoin,* the latter a form of residential architecture containing a formal reception room in which art objects, books, and writing materials were displayed.

### Castles

Japanese castles, a unique and wholly indigenous building type, were erected within the relatively short span of one hundred years. Before the late Muromachi period, military fortifications were simple wooden stockades at strategic sites—staging areas from which to launch attacks and in which to take shelter in time of siege. They were not permanent buildings designed to serve multiple functions. It was the constant warfare of the 16th and early 17th centuries that necessitated the construction of permanent strongholds that could serve as the seat of government for the domain, the residence for the local daimyo, a garrison for his army, and a fortress impregnable to arrows, catapults, and, toward the end of the period, the firearms introduced from the West.

The first castles seem to have been built in the late Muromachi period, perhaps as early as the 1530s. Under Nobunaga and Hideyoshi, the castle included a residence in which to conduct business and entertain vassals, as well as a place for the enjoyment of cultural pursuits. Above all, it was a stage set that proclaimed the power and importance of its lord. When a castle changed hands it was often deemed incumbent upon the new lord to enlarge the building as proof of his military superiority.

**228.** Inuyama Castle, Inuyama, Gifu prefecture.
Early 17th century, with various remodelings

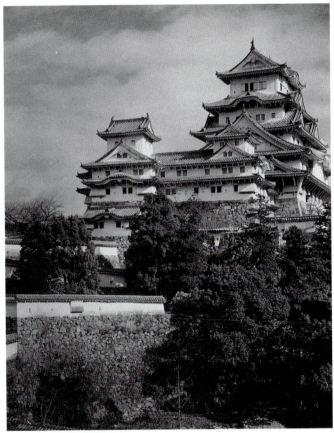

**229.** Himeji Castle, Hyōgo, near Osaka. 1601–9
on White Heron Castle
(Hideyoshi's)

The castle as an architectural form reached its maturity from 1600 to 1615—between the battle of Sekigahara and the final destruction of the Toyotomi clan. Most of the castles surviving today were built during this fifteen-year period of acute political tensions, and those erected after 1615 show a decline in innovative spirit and style. In 1615 the Tokugawa shogunate issued an edict regulating the building of castles, severely limiting the number a single daimyo could maintain. Finally in 1620, when the Tokugawa castle in Edo had been rebuilt and the Toyotomi castle in Osaka had been repaired after the siege of 1615, a ban was put on new construction, and the age of castle building ended.

A structure thought to preserve the flavor of the earlier castles is located at Inuyama, a town on the Kiso River north of Nagoya (fig. 228). Once dated as early as 1469, it is now believed to be no earlier than the late 1500s. Nevertheless, it is thought that the lowest two floors are similar to earlier structures. Castles of this early period were usually built on hills, and they consisted of a *tenshu*, or keep—a defensible residence and refuge of last resort within the castle complex—at the top of the hill and a single watchtower at its base, near the entrance gate in the massive stone wall that surrounded the complex. Only the *tenshu* of Inuyama Castle survives, a four-storied structure set on a tall, tapering stone base. To facilitate drainage, the walls around the castle and the base of the *tenshu* were built of a succession of different materials. The external layer, the outer face of the wall, is roughly dressed stone, the next is smaller crushed rock, then gravel, and finally there is a core of sand. Rain can drain off through the interstices between the outermost stones because no mortar cements them together. The main body of the *tenshu* has two stories constructed of wood and white plaster, and a single, hipped-gable roof. A watchtower much smaller than the main floors of the castle surmounts the *tenshu* and is capped by a hipped-gable roof with its ridge line at right angles to the ridge line of the roof below it. This structure was added during the rebuilding in 1602 and is consistent with the early modifications made in manor houses to accommodate them to warfare. The curved, so-called Chinese gables to the north and south were added in the renovation of 1620. The roofing material today is ceramic tile, but evidence suggests that early castles were roofed with wooden shingles.

Himeji, popularly known as White Heron Castle, is arguably the most beautiful castle surviving in Japan today (fig. 229). In 1581, at the site of the present structure west of Osaka, Toyotomi Hideyoshi built a three-storied *tenshu* on land belonging to a daimyo he had bested in combat. In 1601, after the defeat of the Toyotomi supporters in the battle of Sekigahara, the castle was transferred

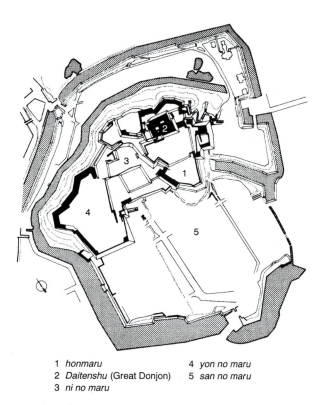

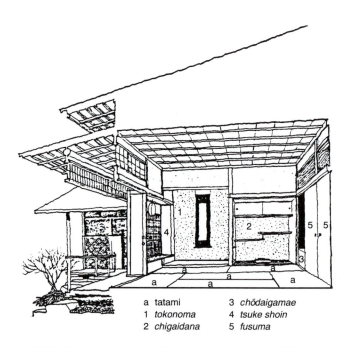

a tatami        3 *chōdaigamae*
1 *tokonoma*      4 *tsuke shoin*
2 *chigaidana*    5 *fusuma*

**231.** Cutaway drawing of main room in *shoin* building

1 *honmaru*          4 *yon no maru*
2 *Daitenshu* (Great Donjon)  5 *san no maru*
3 *ni no maru*

**230.** Plan of Himeji Castle. (Drawing by Pierre and Liliane Giroux, after Ōta Hirotarō, from *The Art of Ancient Japan*, Editions Citadelles, Paris)

by the victorious Tokugawa Ieyasu to his son-in-law Ikeda Terumasa, who was charged with governing the western provinces. Between 1601 and 1609, Himeji was rebuilt in its present form. The scale of the buildings and the complexity of their configuration are significantly different from those of Inuyama Castle, due to the fact that Himeji was built by a succession of the most powerful military leaders in the land. A building the size of Inuyama was not regarded as large enough or impressive enough for lords of their stature.

The entire complex consists of several enclosures arranged like a maze around the central area, the *honmaru*, where the *tenshu* stands (fig. 230). In this period, castle enclosures were arranged in a number of different ways: frequently in a ladderlike progression up a hill, or as a series of rings around the *honmaru*, or in the arrangement of interlocking units as at Himeji, the most effective militarily. To approach the *tenshu* of Himeji Castle, would-be attackers had to cross broad open areas, follow paths at odd angles to the main structure, and pass through narrow gates flanked by strongly fortified watchtowers. The *honmaru* itself consists of four main buildings, three three-storied keeps linked by crossing towers and the five-storied *tenshu*, and the entire rectangular complex surrounds what was originally a working garden. The *honmaru* is virtually impregnable, yet the main *tenshu*, its sequence of tiled roofs punctuated by curved Chinese gables and sharply pointed triangular gables, has a light, ascending rhythm that suggests the graceful white heron, *shirasagi*, the castle's nickname in Japanese.

The third and last phase of castle building was marked by a reworking of the basic design elements. The tall foundations are more finely dressed than those of earlier castles. The number of stories in the *tenshu* increases, and displays less diminution from one story to the next, giving the almost straight-walled buildings a certain heaviness.

## Shoin

The second architectural innovation in the Momoyama period was the *shoin*, an elaborate form of residence. Evolving over several centuries, the *shoin* reached its most complete statement in the Momoyama era. Within samurai society the observance of feudal etiquette was of the utmost importance. Conversations between vassal and lord were formal occasions, not casual exchanges of information, and the vassal was required to behave with proper respect and obedience to his lord. *Shoin* architecture, particularly the formal living-reception rooms, reflects these formalized relationships within the samurai community (fig. 231).

The most important room in a retainer's house, where the master might entertain either his lord or his vassals, consisted of two levels in its most developed form, the floor of the upper section elevated a few inches above the lower. The highest-ranking samurai, whether he was the master of the house or not, sat on the upper level. Behind where he sat was a *tokonoma*, a shallow raised alcove, where a scroll might be hung and a flower arrangement or objects of value might be displayed. Next to the *tokonoma* there was usually another alcove, a recess of comparable depth with compartments above and below, and in the center a *chigaidana*, a group of interconnected shelves at different heights. At right angles to these two alcoves was a small room known as the *tsuke shoin*, or at-

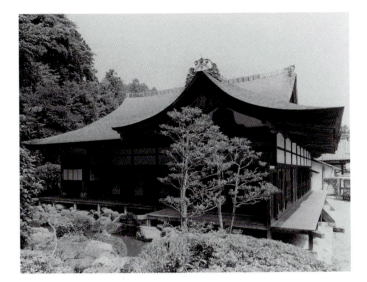

**232.** Kyakuden (Guest Hall), Kōjōin precinct, Onjōji, Shiga prefecture. 1601

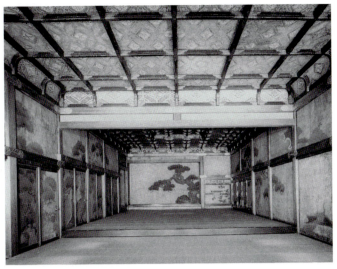

**233.** Ōhiroma (Great Audience Hall), Nijō Castle, Kyoto. c. 1625

tached study, projected onto the wide veranda outside. In the wall facing the veranda was a large window, usually circular or bell-shaped, covered with opaque paper, and below it a set of cabinets, often used as a desk. At right angles to the window wall was another set of shelves, on which books and writing implements could be displayed.

Opposite the *tsuke shoin* there was usually a set of four sliding doors in the wall of the interview room, about two-thirds the height of the wall. The purpose of the area behind the doors, known as the *chōdaigamae*, depended on the needs of the lord. In daimyo mansions the doors might conceal a waiting room for bodyguards. In less elaborate buildings these doors concealed the bedroom, and sometimes they served merely as ornamentation.

A simple form of fully developed *shoin* architecture is seen in the Kyakuden, or Guest Hall, of the Kōjōin precinct within Onjōji, a temple on Lake Biwa (fig. 232). Built in 1601 by a samurai who had been ordained and retired to Onjōji, it is one of the earliest surviving examples of the type of *shoin* architecture used for the houses of the warrior-retainer class. The oblong building is divided into five rooms of differing dimensions. The entrance is on the narrow side. One ascends the stairs in front of a carriage rest—a spot where a two-wheeled carriage can be left once the oxen have been released from their shafts—enters a small vestibule, and then steps into the main room, the master's living room where guests were once received. Opposite the entrance door are a *tokonoma* and *chigaidana*, and at the left a *tsuke shoin* with its own *tokonoma*. To the right of this main interview and living room are smaller rooms, the master's sleeping quarters set behind the *chōdaigamae* sliding doors. A veranda surrounds the building, wider on the long side facing the garden to permit sheltered viewing of nature in its seasonal changes.❖

The Ōhiroma, or Great Audience Hall, of Nijō Castle, the residence of the Tokugawa shoguns when they visited Kyoto, remodeled around 1625, includes the same elements on the grand scale appropriate for formal interviews with the shogun (fig. 233). This room occupies the long side of the building facing the garden and consists of two main areas: the lower level for the shogun's vassals, and the upper level, where the shogun sat, backed by a *tokonoma* painted with a massive pine tree set against a gold ground, a visual metaphor for the strength and enduring nature of the shogunate. To the right of the *tokonoma* is a *chigaidana*, and—on the long wall—a *chōdaigamae* leading to a waiting room for bodyguards and to the left an abbreviated attached study. The ceiling is elaborately coffered, and the panels above the decorated sliding doors are deeply carved and brilliantly painted with flower and cloud motifs.

## Katsura Imperial Villa

One of the most superbly designed buildings of the early 17th century is Katsura Imperial Villa, a palace located on the Katsura River to the southwest of Kyoto at a considerable distance from the main imperial residence (fig. 234). Built originally between 1620 and 1624 for Prince Toshihito (1579–1629), the buildings and surrounding grounds

---

❖ Basic to Japanese architecture from the Muromachi period on is a system of proportions based on the unit known as *kiwari*, the distance between two posts measured from their centers. Gradually, this unit of measurement came to be standardized in Buddhist temples and in dwellings, although the measurements of posts, beams, woodwork, and tatami mats varied slightly from region to region. For example, today the typical Kyoto tatami measures roughly 6 feet 3 inches by 3 feet 1 inch, while the usual size in Tokyo is 5 feet 9 inches by 2 feet 10 inches. A room is usually described as being so and so many mats—a five-mat room, a seven-mat room, and so forth.

234. Aerial view of Katsura Imperial Villa, Kyoto. 1620–63

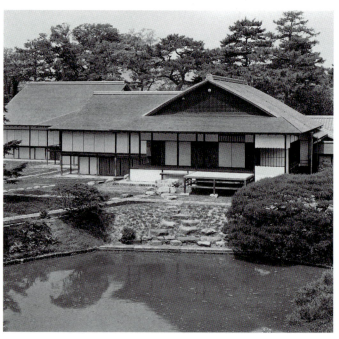

237. General view of *shoin*, Katsura Imperial Villa. 1620–24

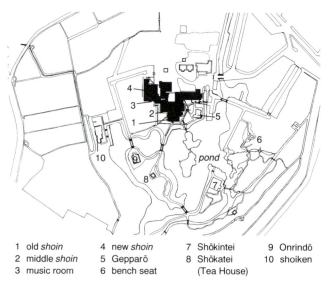

1 old *shoin*    4 new *shoin*    7 Shōkintei    9 Onrindō
2 middle *shoin*  5 Gepparō     8 Shōkatei  10 shoiken
3 music room   6 bench seat    (Tea House)

235. Plan of Katsura Imperial Villa

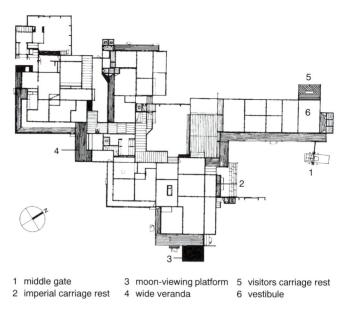

1 middle gate      3 moon-viewing platform  5 visitors carriage rest
2 imperial carriage rest  4 wide veranda        6 vestibule

236. Plan of *shoin*, Katsura Imperial Villa

combine the *sukiya* style of artlessness, a subdued and unostentatious effect achieved through painstaking attention to detail, with specific elements adopted from the *Tale of Genji*, one of the prince's favorite books (fig. 235). The last palace that Genji had built was called Katsura because it too was located along the Katsura River. As described in the novel, it contained a large lake with several artificial islands, a rustic fishing pavilion, and a lodge next to the racecourse for the games held in conjunction with the festival at the Kamo Shrine in Kyoto. The original 17th-century palace consisted of a main *shoin* (known today as the old *shoin,* or *koshoin*) with a bamboo-floored moon-viewing platform, a smaller *shoin,* and a music room set in a garden laid out according to descriptions in the Heian novel (fig. 236). In 1642 a new *shoin* was built onto the southwest side of the older structure, greatly expanding the horizontal quality of the building. Inside, no provision was made for emphasizing the rank of individual guests by different floor levels or by connotative images in the *tokonoma.* The palace was designed for the informal assembly of courtiers and the imperial family, as a place where they could put aside issues of class and in a relaxed atmosphere enjoy the few gentle cultural pursuits the Tokugawa shoguns permitted them.

Especially notable at Katsura are the surprising but pleasing visual and spatial dissonances that occur in the design of the buildings and in the disposition of decorative patterns. Viewed from the front, the *koshoin* appears to be a stable, rectangular structure capped with a hipped-gable roof (fig. 237). However, the section on the extreme lower right, which looks like a solid wall, is actually a wood-and-

**238.** Stonework and path to the left of *koshoin* moon-viewing platform, Katsura Imperial Villa

plaster panel concealing the stairs leading to the moon-viewing balcony. To the left of the balcony are grouped a number of irregular stones (fig. 238) that obscure the base of the building, making it seem to float above the ground. If you follow the path around the pond, you notice similar textural and spatial dissonances. As you pass through a wooden gate, nature at first appears neatly manicured. Moss surrounds the stones of the path, and trees border the area in a regular pattern. The space then narrows between path and trees, and you must duck under the branches. Suddenly the path curves sharply, and through an open vista of the pond you see an island with a replica of the magic Taoist mountain, Mount Hōrai, and Katsura Villa beyond. Along the path around the lake, interesting contrasts of textures arrest the eye. Cleanly dressed stones lie next to irregularly shaped rocks. Different patterns of bamboo are juxtaposed in fences and walls. To see Katsura is to experience an almost symphonic variety of patterns, discordant shapes, and surprising contrasts of spatial elements. No matter how often you visit the villa and its grounds, the experience is never the same. Some new detail or new perspective challenges and delights.

## Painting

The great artistic innovation of Momoyama painting was the development of a boldly decorative mode executed on large-scale surfaces—sliding-door panels, *fusuma,* and folding screens, *byōbu.* Some elements of this style can be found in early-16th-century painting, particularly in the colors and stylized motifs in Kanō Motonobu's *fusuma* paintings (see fig. 224). As the century progressed, however, three distinct types of paintings began to emerge. In the first, which modern scholars have labeled the blue-and-gold style, landscapes and figural themes were depicted on a monumental scale in brilliant colors on a gold or silver background. The second type maintained the monochromatic tonalities and often the Chinese pictorial themes of the Muromachi period, but the compositions were bolder and more decorative. Both of these styles were pioneered by the Kanō school, particularly by Kanō Eitoku. And then other artists—Hasegawa Tōhaku, Kaihō Yūshō, and Sōtatsu—took Eitoku's new aesthetic as a point of departure and developed individual styles of their own. The third major type, genre painting, was to have the greatest longevity. Beginning in the early 1500s with *rakuchū rakugai* paintings (scenes of life within and around the periphery of Kyoto) genre painting continued into the 17th century with depictions of horse races, Kabuki performances,✦ and even bathhouse prostitutes. These paintings, many by artists whose names have long since been lost—independent professional painters and minor artists of the Kanō and other schools—demonstrate the revival of a basic Japanese concern with people and their activities, and with the natural world. They reveal the first stirrings of the spirit that was to dominate artistic expression in the succeeding Genroku period of the late 17th to the early 18th century.

---

✦ Nō, Bunraku, and Kabuki are the three most popular traditional Japanese theatrical arts. The oldest, Nō, is steeped in Buddhist thought and focuses on a single character whose inner conflicts must be resolved before his or her soul can achieve peace in the hereafter. Secondary Nō characters enable the focal character to accomplish this goal. In a Nō performance the plot is narrated by a chorus to the sounds of drums and wind instruments while the actors convey their thoughts and emotions through a combination of chanted dialogue and dance. Bunraku, which employs puppets instead of actors, developed in the 17th century out of simple performances on a level with Western Punch and Judy shows. Today, Bunraku has evolved into a sophisticated art form using lifesize figures manipulated by three puppeteers clad in black to render them inconspicuous. On a small stage separated from the main performance area, a seated chanter recounts the plot and speaks the dialogue while a samisen player provides a musical accompaniment. Kabuki, the most popular of the traditional theater forms, developed along side Bunraku but differs in that it employs live actors, males who specialize in either *onnagata* (female roles) or *tachiyaku* (male roles). It features gorgeous costumes and elaborate sets. Musical accompaniment is usually provided by an offstage musician playing a samisen. The plots of Bunraku and Kabuki plays are very similar, dealing with such themes as historical events, conflicts of moral duty and personal desire, and even ghost stories—frequent summer fare because the shivers they produce trick one into feeling cool.

*Shōbyōga*, paintings on sliding doors, *fusuma*, and freestanding folding screens, *byōbu*, while not unique to Japan, were developed into major formats for painting in the Momoyama and Tokugawa periods. The basic module for both *fusuma* and *byōbu* is a panel consisting of a light wood frame enclosing a lattice of thin wood strips. Over this foundation, pieces of paper are pasted to build up a backing that can support the surface, usually paper, but occasionally silk, on which a painting has been executed. Each *fusuma* door is provided with an outer frame, usually black lacquered wood, and a metal handhold near one edge, enabling the door to be pushed back and forth without damaging the painted surface. *Byōbu* panels are narrower than *fusuma* and are joined together with a complicated system of hinges; The perimeter of the whole is framed, usually with wood that is lacquered black.

During the Momoyama period, *byōbu* and *fusuma* came into wide use in residential architecture for the nobility, the daimyo and samurai, and wealthy townsmen, and in conjunction with this there developed a new aesthetic of bright colors, including gold and silver paint on a ground of gold leaf or occasionally silver leaf. It has been suggested that gold leaf became popular because it reflected and augmented the dim light in castles. Another theory is that specific landscape screens using gold leaf and bright colors were intended to suggest the gold and jeweled environment of Amida's Western Paradise. While both of these conjectures are justifiable, it is also true that gold grounds

# FUSUMA, BYŌBU, AND SHOJI

were a natural expression of the sudden affluence of the Momoyama period. Japanese gold leaf is known to be the thinnest in the world, and the technique for making it is labor intensive. There are basically three stages in the process: the preparation of the alloy and its shaping into squares: the *zumiuchi*, the initial beating process, in which the squares are thinned out: and the final beatings and finishing of the leaves. In the *zumiuchi* stage thin pieces of gold are placed between specially prepared leaves of paper, bundled in paper and then in cat skin, and beaten by hand or machine. This process is repeated about five times. The beating papers alone take six months to prepare.

The application of gold leaf to the papered surface of a *byōbu* changed over time. The size of the individual leaves decreased from approximately 4¾ inches (12 cm) square in the 15th and 16th centuries to 3½ inches (9 cm) in the Tokugawa period. In the 16th century, the paper to which the leaf was adhered was usually painted red to give the gold a richer tint. The edges of gold clouds were scalloped and slightly raised on the surface over a narrow rim of gesso.

Another door and window treatment popular from the Momoyama period on is the shoji. What distinguishes the shoji, whether fixed in place or used as sliding doors, is the translucent white paper pasted over one side of a wood latticework, like that at the core of the *fusuma*. Shoji give a Japanese room a soft, diffuse light and a sense of separation from the outdoors or the adjoining space.

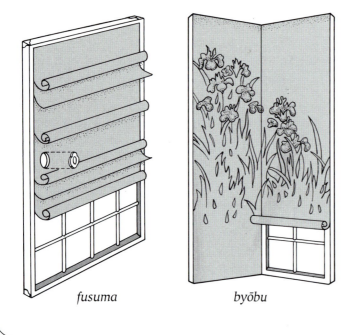

fusuma          byōbu

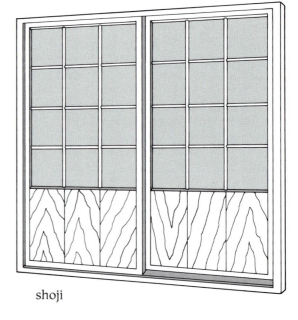

shoji

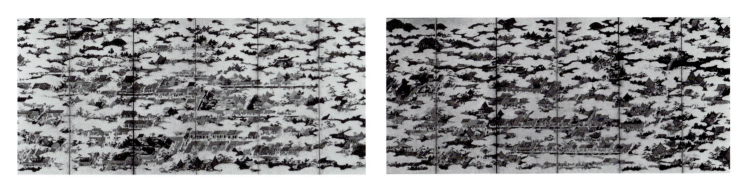

**239.** Pair of six-panel *rakuchū rakugai zu byōbu*, known as the Uesugi screens, by KANŌ EITOKU. c. 1550. Ink, color, and gold leaf on paper; each screen 5 ft. 2¾ in. x 11 ft. 1¼ in. (1.59 x 3.64 m). Yamagata City Office, Uzen prefecture

## Kanō Eitoku

The artist who single-handedly created the major pictorial style of the first phase of the Momoyama period was Kanō Eitoku (1543–1590). Grandson of Kanō Motonobu, Eitoku was trained by him and introduced to the daimyo who patronized the Kanō workshop. However, it was Eitoku himself who consolidated his position by developing a style that appealed to the feudal lords who dominated the latter half of the 16th century. While still in his early twenties, Eitoku received commissions from several of the most powerful daimyo in the shogunate. In 1564 he was commissioned by the Hosokawa family, the governors-general of Kyoto, to paint a set of *rakuchū rakugai* screens, probably the pair of six-panel folding screens that Oda Nobunaga later presented to the Uesugi family in 1574. *Rakuchū* refers to the area within Kyoto boundaries; *rakugai*, to the districts outside the city, Higashiyama and Nishiyama, or the Eastern and Western Hills.

The formula for this type of painting was developed in the late Muromachi period, possibly by Tosa Mitsunobu (1434–circa 1525), the foremost imperial court painter of his day. The earliest extant examples of paintings of Kyoto and its environs on folding screens are the pair owned by the Machida family (colorplate 38). Lacking signature and date, the paintings nevertheless can be linked to the 1520s on the basis of the buildings depicted. The Machida screens show a decimated Kyoto, as it must have appeared following the Ōnin War. The screen on the right presents the east side of the city, from Tōfukuji in the *kujō*, or ninth ward, its southernmost district, to the Imperial Palace in the *ichijō*, or first ward, to the north, and set against the Eastern Hills, shown in their spring and summer foliage. The screen on the left details the buildings and activities of the north and west sides of the city from the Upper Kamo Shrine north of the palace, past Kinkakuji to Tenryūji against the Western Hills and the Northern Hills (Kitayama), presented in their autumn and winter garb of red maples and snow-covered mountain peaks.

Eitoku's paintings (fig. 239) follow the general layout of the Machida screens; they also show a bird's-eye view of Kyoto, but at a later date. One cannot help but be impressed by the plethora of new buildings, testimony to the city's postwar resurgence. Since these paintings are among Eitoku's earliest documented works, it is likely that he used a preexisting formula for his composition. However, even at this early stage of his development, he offers an interesting blend of stylistic elements. Retaining such features of the Tosa style as the contrast of bright colors for the figures and brilliant gold for the clouds separating one scene from another, the thick buildup of paint, and minutely detailed textile patterns, he combines them with a looser and sketchier manner of delineating the faces, hands, and feet of the individual figures, a treatment closely related to the free form of figure sketching found in Zen paintings. In this early work, in a type of screen painting that had distinct pictorial conventions, Eitoku modified the style somewhat toward his own preference for freer brushwork, giving clear signs of his ability to do more innovative painting. Soon he was to create a set of *fusuma* that established a new level of creativity in Momoyama art.

In 1566 Eitoku and his father, Shōei, were commissioned by Miyoshi Yoshitsugu, steward to the Hosokawa family, to paint *fusuma* panels for the Jukōin, a small compound within the temple of Daitokuji in Kyoto (fig. 240). Shōei was the nominal head of the Kanō school, yet Eitoku, the more gifted of the two artists, was given the most important area to decorate, the central room facing the garden. In this three-sided space he created a new architectonic formula for distributing motifs around the three interior walls (colorplate 39). Landscapes of the four seasons are depicted across sixteen panels enclosing the east, north, and west walls of the room. They are executed in vigorous ink brushstrokes against a ground delicately streaked with gold.

Eitoku's formula for *fusuma* decoration differs from earlier treatments in that he chose not to place vertical motifs, such as tree trunks, at the four corners of the room to echo the wooden corner posts. Instead, he used three massive trees—a gnarled plum symbolizing spring, and two pines suggesting winter—in diagonally opposite corners of the room, southeast and northwest, and distributed other motifs—ducks swimming in the water, rocks, and marsh grasses—so as to draw the viewer's eye

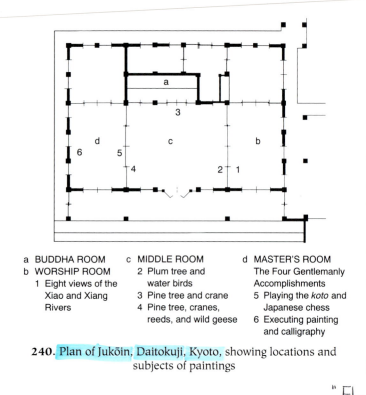

a BUDDHA ROOM
b WORSHIP ROOM
  1 Eight views of the
    Xiao and Xiang
    Rivers

c MIDDLE ROOM
  2 Plum tree and
    water birds
  3 Pine tree and crane
  4 Pine tree, cranes,
    reeds, and wild geese

d MASTER'S ROOM
  The Four Gentlemanly
  Accomplishments
  5 Playing the *koto* and
    Japanese chess
  6 Executing painting
    and calligraphy

**240.** Plan of Jukōin, Daitokuji, Kyoto, showing locations and subjects of paintings

deeper into the pictorial space. Motifs in the middleground and foreground are increasingly emphasized, and the composition climaxes in the pine tree panels (fig. 241). The artist makes dramatic use of large-scale motifs and strong brushwork, and at the same time he subtly depicts space and delicately contrasts gray ink, white paper, and pale gold mists. Quite probably he used some of Motonobu's paintings as his point of departure, but Eitoku's *fusuma* panels go beyond the more reserved spatial formulas of his grandfather's work and establish the direction for later Momoyama painting.

The high point of Eitoku's creativity may have been reached in the screens and wall paintings he made for Azuchi Castle between 1576 and 1579. They perished when the castle was destroyed shortly after Nobunaga's assassination in 1582, but descriptions of the structure

*Momoyama Period.*

**241.** Pine Tree and Crane, six of sixteen *fusuma* panels, by KANŌ EITOKU. Central room facing garden, Jukōin, Daitokuji, Kyoto. 1566. Ink on paper; height each panel 69⅛ in. (175.5 cm), width varies

*"Flowers - and - Birds of the Four Seasons"*

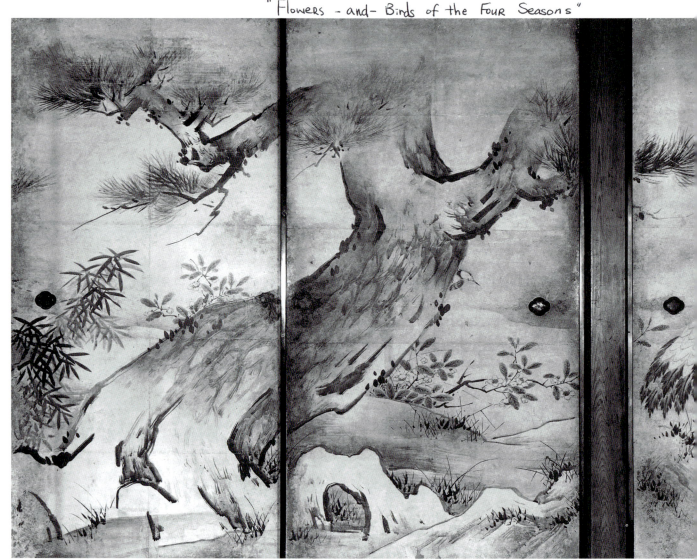

and of Eitoku's paintings are preserved in documents of the period. On the first four floors were decorations with familiar landscape and figural motifs, including birds and flowers and the classic Chinese theme of Confucian sages, mostly executed in bright colors on a gold ground. A hexagonal room on the fifth floor was used as a Buddhist worship hall. The pillars were lacquered in red, and on the walls were paintings showing Shaka and his ten disciples, the path to buddhahood, hungry ghosts, angels, and demons. A small room on the sixth floor was covered inside and out with gold leaf, the pillars decorated with dragons, and the walls ornamented with Confucian themes such as the Ten Wise Men and the Seven Sages of the Bamboo Grove. Eitoku devoted three years to this project, and although he must have relied heavily on assistants for some of the work, one painting is identified in descriptions of Azuchi Castle as his own creation, a depiction in ink of plum trees, presumably against a gold ground. It is interesting to imagine how his style would have changed during the ten years since he had painted the same subject on the *fusuma* panels of the Jukōin.

A work that exemplifies Eitoku's formula for large-scale compositions in the blue-and-gold style is his screen depicting Chinese lions (colorplate 40). It was made as a gift from Hideyoshi to another feudal lord to cement the accord reached by the two men in 1582, just after Nobunaga's assassination, and is thought to have decorated one of the temporary residences established by this lord when he was on military maneuvers. The screen, originally one of a pair, shows two ferocious lions, their manes curling around their heads, their tails curving and flaring outward in stylized flame patterns. As a rule, the theme of Chinese lions calls for the depiction of a male and female, the latter shown with a lion cub. In this painting the lioness exhibits no maternal qualities at all. She strides forward to the left, her glaring eyes never wavering. The larger animal, her mate, also walks to the left, but turns warily to observe his partner's actions. The background is remarkably abbreviated. The figures are silhouetted against flat gold that serves for the ground beneath their feet as well as

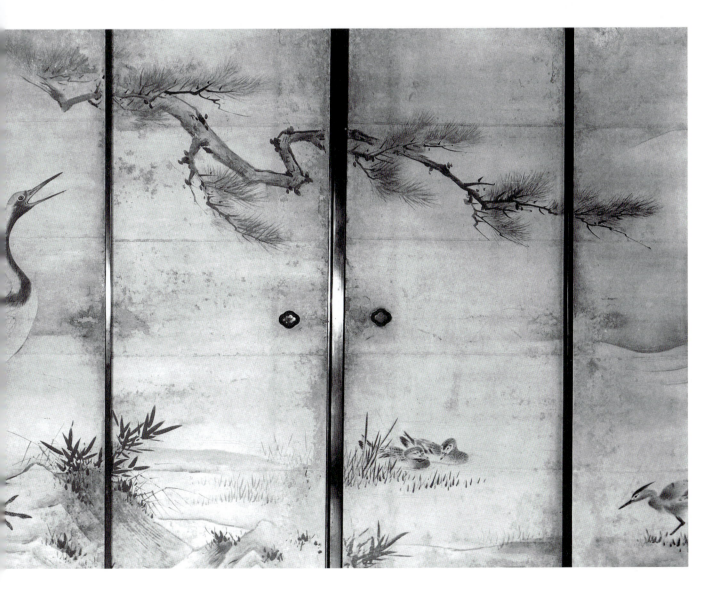

242. Cypress, an eight-panel *byōbu*, attributed to KANŌ EITOKU. 1590.
Color, ink, and gold leaf on paper; Momoyama Period.
66⅞ x 181½ in. (170 x 460 cm). Tokyo National Museum

for the clouds above them. Landscape elements appear to the left, creating a sense of place: a dark rock shape in the foreground, and on the other side of a golden path, the base of what appears to be a sharply rising mountain. This screen is indeed a bold and dramatic backdrop for generals' battlefield negotiations that might affect their lands, their wealth, and even their political futures.

In the last eight years of his life, Eitoku and his studio undertook a great number of paintings for two of Hideyoshi's newly constructed living quarters, Jurakudai in Kyoto, and Osaka Castle. In addition, many daimyo called upon him to paint *fusuma* and *byōbu* for their residences. In 1588 he was asked to restore the enormous ceiling painting in the main worship hall of Tōfukuji, a dragon amidst clouds, first executed about two hundred years before by the Muromachi artist Minchō. Eitoku began the assignment, but became ill and had to turn over the job to his adopted son, Kanō Sanraku. Although Eitoku had the support of a large studio of assistants, the

records of his many commissions make it clear that he was forced to work at an almost inhuman pace during his two remaining years. To meet these heavy demands he developed a formulaic style for his late blue-and-gold works, exemplified by Cypress, a single, eight-panel screen (fig. 242). Scholars question whether this work was executed by Eitoku himself or by a pupil, but it is generally accepted as representative of his late style. It is thought that the painting was executed in 1590 as a series of sliding-door panels for the mansion of Prince Hachijō Toshihito, who commissioned the building of Katsura Villa thirty years later. Subsequently remodeled into an eight-panel folding screen, the painting has been trimmed along its short sides, somewhat distorting our view of the original composition. Today, the right half is dominated by a massive tree, the left by a pond and sharply faceted rocks, and the whole is unified by a gold-leaf ground. The elements are arranged much as in the Jukōin paintings (fig. 241), but the naturalism and playful-

ness of the 1566 work are absent here. Now the emphasis is on solid sculptural forms against a flat backdrop of gold.

Within less than thirty years, Kanō Eitoku had established himself as the commanding artistic presence of the early part of the Momoyama period. He moved from a somewhat predictable combination of elements from the Kanō and Tosa traditions to a new compositional scheme for the Jukōin, and it seems probable that his work at Azuchi Castle was his most mature. Since those paintings have not survived, and the ones extant and associated with his later years are disappointing, Eitoku must be judged a better artist than his late works would suggest.

## Kanō Mitsunobu

After Eitoku's death in 1590, his son Mitsunobu (1561 or 1565–1608) became head of the main branch of the Kanō school and for the next eighteen years played a significant role in painting circles in Kyoto. Prior to emerging into the limelight, Mitsunobu seems to have learned his craft in relative obscurity within the Kanō studio. In 1571, at the age of ten, he was designated Eitoku's direct suc-

cessor, and in the 1570s he worked with Eitoku on the paintings for Azuchi Castle, while Eitoku's brother Sōshu (1551–1601) took charge of the Kanō school. Collaboration with his father seems to have been the pattern of Mitsunobu's activity until Eitoku's death; it is known that they worked together on the decoration of the Imperial Palace and Jurakudai as well as Osaka Castle.

When Mitsunobu took charge of the Kanō studio, it became clear that his was a very different artistic temperament. He was a less ambitious entrepreneur than his father, and though he fell heir to a number of Toyotomi family commissions, he lost some of the prize ones to Hasegawa Tōhaku and to his own adoptive brother, Sanraku. He turned away from his father's dramatic monumental style, preferring to work in a flatter, more elegant and detailed manner, depicting such *yamato-e* themes as birds and flowers of the four seasons. During the first decade of the 17th century, until his death in 1608, he continued to work for the Toyotomi clan, and also, from 1603 on, for the Tokugawa family. His work for the new shogunate required that he make frequent trips between Kyoto, still the imperial, and thus the official, capital, and

**243.** View into room of Kyakuden (Guest Hall), Kangakuin precinct, Onjōji, Shiga prefecture, showing *tokonoma* flanked by *fusuma* panels by KANŌ MITSUNOBU. c. 1600

Edo, the de facto capital and the shogunate seat of government. It was on a return journey to Kyoto that he died.

One of Mitsunobu's most successful paintings is the series of designs he executed for the *tokonoma* and *fusuma* panels in the main room of the Guest Hall in the Kangakuin enclosure of Onjōji on Lake Biwa (fig. 243). The building, commissioned in 1600 by Toyotomi Hideyori, Hideyoshi's son, is very similar in plan to the Kyakuden (Guest Hall) of the neighboring Kōjōin (see p. 215) except that the Kangakuin building lacks a *tsuke shoin, chigaidana,* and *chōdaigamae.* Instead, the room is dominated by a *tokonoma* that occupies the entire west wall. Mitsunobu's solution for decorating this space was the antithesis of his father's preferred formula. Instead of trying to unify the room as a single architectural entity, and to create the impression of walls dissolving into natural space, Mitsunobu stressed the differences between various parts of the room—the tall, wide *tokonoma* and the shorter, smaller *fusuma*—and reasserted the flatness and unitary quality of the individual *fusuma* panels. His pictorial theme, flowers and trees of the four seasons, begins on the east wall to the right of the *tokonoma* with plum blossoms and camellias (colorplate 41) followed on the south by a grove of cryptomeria (cedar) and flowering cherry trees (colorplate 42). The west wall of the room is devoted to the flowers of summer and the russet leaves of autumn. The sequence climaxes in the last *fusuma* panel, on the north wall, and the focal point of the room: the winter landscape of the *tokonoma,* a waterfall descending between evergreens and mixing with roiled waters along a snow-rimmed shore (colorplate 43). Broad areas of flat gold leaf indicate ground or clouds and contain the floral motifs within a shallow space. Through the frequent use of gold, the isolated flowers and trees, and their organization in a sequence that unfolds right to left, against the usual direction, Mitsunobu has stressed the flatness of the wall

surface and the somewhat awkward proportions of the room at the Kangakuin, presenting an interesting counterpoint to his father's handling of a similar space in the Jukōin at Daitokuji some thirty-five years earlier.

## Kanō Sanraku

The most talented artist of the Kanō school who continued to work in the dramatic style pioneered by Eitoku was Kanō Sanraku (1559–1635). Where Sanraku's work differs from Eitoku's, his paintings show the beginnings of trends in later Momoyama painting. Most important is the retreat from Eitoku's dynamism, substituting first a naturalism of expression and then a quality of elegant ornamentation. The second trend is a more intellectual approach to pictorial content, whether in reworking *yamato-e* themes or in interpreting complex and unfamiliar subjects from Chinese literature. Originally Sanraku was a page in the service of Hideyoshi, who recognized the boy's artistic talent and placed him in Eitoku's studio.

Sanraku did not become head of the Kanō school after Eitoku's death, although he remained closely associated with Hideyoshi. From 1590 to 1615 he was kept busy with commissions for the Toyotomi family, including wall paintings for the castle at Momoyama, and for many temples and shrines in the Kyoto area. When the Toyotomi clan was destroyed in 1615, Sanraku removed himself from Kyoto art circles and took the tonsure, changing his name from Mitsuyori to the priestly Sanraku. He spent several years in seclusion in remote country temples, but he was back in Kyoto by 1619, at work on a commission from the shogun Hidetada for *fusuma* panels to be used in refurbishing the Imperial Palace. For fifteen years Sanraku continued to paint in the style he had developed in his heyday, a style less dramatic than Eitoku's, but more natural in composition and more elegant in detail. This style became the model for the Kyoto branch of the Kanō school.

In the early 17th century he was asked by the Kujō family, one of the five houses of the most prestigious branch of the Fujiwara clan, to paint *fusuma* panels depicting scenes from the *Tale of Genji.* Four panels from the set still exist, now refashioned into a single *byōbu.* The episode depicted is The Carriage Fight (colorplate 44) from the Aoi, or Hollyhock, chapter. Sanraku has successfully adapted the techniques of narrative scroll painting to the large-scale format of the *fusuma.* The essentials of the story in these screens are clear from a distance, but a closer view brings a wealth of interesting details. The carriage attendants of Lady Rokujō, a lover of Prince Genji, scuffle with those accompanying his wife, Lady Aoi, as both groups jockey for a good vantage point along the route of the Kamo festival parade. In the right half of the screen the procession of noblemen escorting the vestal virgin of the Kamo Shrine, an unmarried young woman from a noble family, moves leftward, toward the melee of carriage attendants that dominates the left half.

The composition and style of the painting, as well as the figure types and poses, are reminiscent of *emaki* in the *yamato-e* style—not the tightly contained *tsukuri-e* style of the early-12th-century *Tale of Genji* illustrations, but rather the lively, free-flowing manner of mid-13th-century battle scrolls. Government officials and the nobility are clearly distinguished by their fine features, elegant costumes, and stately poses from the coarse-featured, brawling, lower-class attendants clad in plain white garments. But the artist goes beyond class distinctions, individualizing each image. Integrating all of these figures into a composition that moves from right to left, the orderly procession of carriages and official escorts advances slowly through the streets of the city until their way is blocked by the mob of fighting men.

## Hasegawa Tōhaku

A great independent practitioner of the decorative style in the Momoyama period was Hasegawa Tōhaku (1539–1610). His early life is hardly documented. Scholars generally agree that he was born in Ishikawa prefecture in central Honshū and adopted by the Hasegawa family, who were in the cloth-dyeing business. An early work of his, stamped with the seal "Nobuharu," believed to be his first professional name, is a portrait of Takeda Shingen (1521–1573), an aggressive daimyo whose goal was to capture Kyoto, and with it, control of the country (fig. 244). Preserved with the painting is a letter by Shingen's son Katsuyori stating that the portrait was executed during the subject's lifetime. The daimyo is shown seated on a tatami mat, his long sword to his right, a tree trunk with a hawk on one of its branches to his left. Such detail is unusual in the genre of portraiture. Normally, subjects were depicted without any reference to their location, but here, even though the tree is not in correct proportion to the man, there is the suggestion that Shingen is posing out-of-doors. Aside from this, Tōhaku has meticulously rendered every detail of his subject, from his solid bulk to the tiny textile patterns of his clothing. The most freely painted motif is the tree to the right, sketched with thin outlines and subtle washes.

After the death of his adoptive parents, Tōhaku went to Kyoto in 1571 with a letter of introduction to Honpōji temple, and took up residence in the subtemple of Kyōgōin. His Buddhist connections in Kyoto had a lasting effect on his art, for Nichigyō, the eighth abbot of Honpōji, was a noted calligrapher and master of the tea ceremony. Through him Tōhaku came to know the great tea master of the Momoyama period, Sen Rikyū (1522–1591). Rikyū, the son of a merchant family from Sakai, near Osaka, served as tea master to Nobunaga and Hideyoshi and significantly influenced the development of the tea ceremony, moving it toward his own concept of *wabi,* austere simplicity. It was Rikyū who made it possible for Tōhaku to frequent Daitokuji temple and to study there not only the great Japanese paintings of

**244.** Portrait of Takeda Shingen, by HASEGAWA TŌHAKU. 3rd quarter 16th century. Horizontal hanging scroll, color on silk; 15 5/8 x 23 3/8 in. (39.7 x 59.5 cm). Seikeiin, Mount Kōya, Wakayama prefecture

the Muromachi period but also the Chinese masterpieces of the Song and Yuan dynasties in the temple collections, paintings such as Mu Qi's famous and influential triptych of a white-robed Kannon, a crane, and a monkey (see fig. 214). Tōhaku's Monkey Reaching for the Moon (fig. 245) in the teahouse of Konchiin in Kyoto is clearly based on Mu Qi's painting of the female monkey protectively cradling her child. However, Tōhaku has addressed the Zen idea of the monkey as a symbol for the unenlightened human being and has created an allegory of the impossibility of possessing absolute knowledge. The monkey, an impractical romantic, reaches out to catch the moon, believing it to be the reflection on the pond below him. The viewer may intuit the further meaning that the moon itself is made visible on earth through the reflected light of the sun. The animal clings with one long, furry arm to the thin branch of a tree, toes clawing into the bark of the trunk, and reaches futilely with its other arm toward the surface of the pond.

Inevitably, a second influence on Tōhaku's artistic development was the brilliantly colored, decorative style of the Kanō school. He worked in the studio of Kanō Shōei, Eitoku's father, when he first arrived in Kyoto, and though he later gave this up to establish himself as an independent artist, he had to compete with the Kanō school and adopted some characteristics of its blue-and-gold style. Tōhaku had first collaborated with the Kanō in 1587 on the paintings for Hideyoshi's Jurakudai mansion, but Eitoku managed in 1590 to block Tōhaku's maneuvers to win part of the commission for the decoration of the Imperial Palace. After Eitoku's death, Tōhaku received greater recognition as an artist. In 1592 he was given exclusive charge of the painted decoration of Shōunji, a temple built by Hideyoshi for the salvation of his three-year-old son Tsurumatsu. After the fall of the Toyotomi faction the temple was destroyed, and the few paintings that survived were cut down to fit the smaller dimensions of the wall openings at Chishakuin, the temple

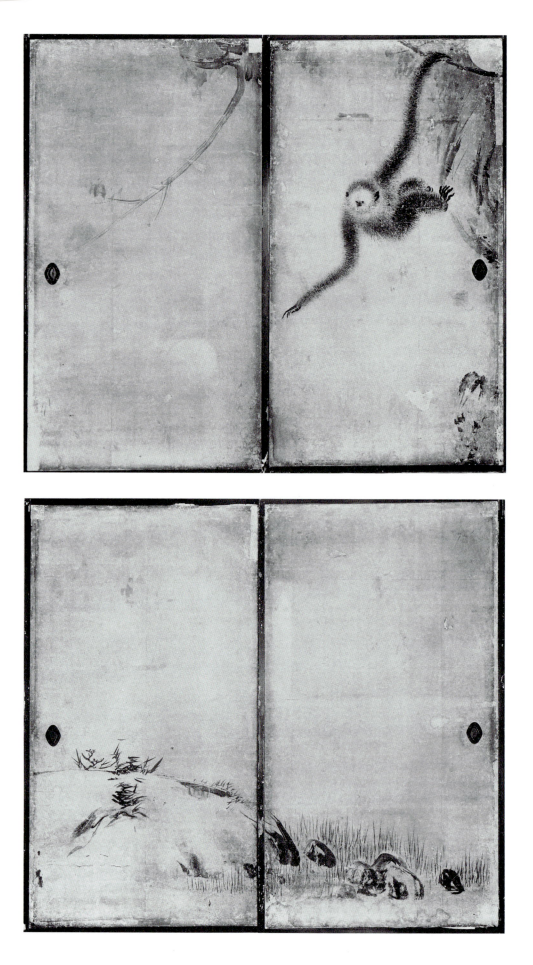

where they were later installed. Unquestionably, these paintings are Tōhaku's masterworks in the blue-and-gold style, as well as an interesting reworking of *yamato-e* themes, particularly the four panels depicting a single maple tree, its leaves just beginning to turn color (colorplate 45).

**245.** *(Opposite page)* Monkey Reaching for the Moon, on four *fusuma*, by HASEGAWA TŌHAKU. Konchiin, Kyoto. Late 16th century. Ink on paper; each panel 67 3/8 x 35 in. (171 x 89 cm)

**246.** Pine Forest, a pair of six-panel *byōbu*, by HASEGAWA TŌHAKU. Late 16th century. Ink on paper; 61 3/8 x 136 in. (156 x 347 cm). Tokyo National Museum

In contrast to Eitoku's location of plum and pine trees near corners of the central room in the Jukōin (see colorplate 39), Tōhaku locates his massive trunk on a diagonal across the two central panels, and the branches are like arms extending gracefully to the sides of the painting. Autumn flowers, including chrysanthemums and cockscomb, form a solid base for the tree, along with a low rock and bush clover, whose green-leafed branches mingle with the green, orange, and brown leaves of the maple. The gold background of the painting, interspersed with passages of deep blue, at one moment appears to be ground, at another clouds obscuring the blue water of a lake or river. The specific elements of the setting are not

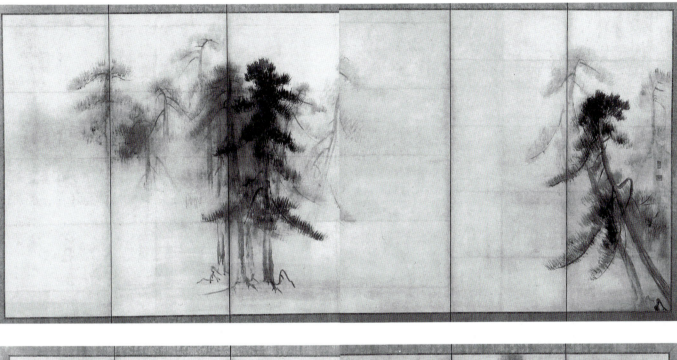

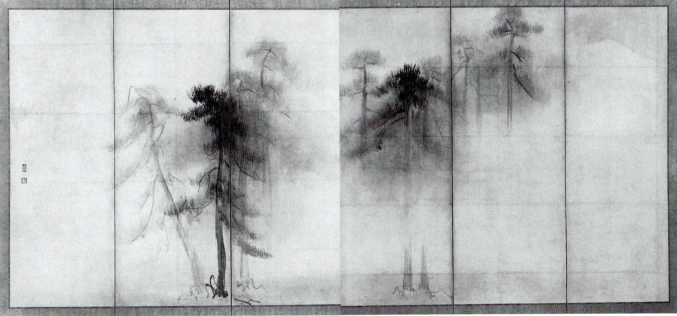

important. The painting shows the maple tree before its leaves have reached their peak of autumn coloring. There is tension between the massive, enduring trunk and the delicate, star-shaped leaves that will soon become brilliant, then fade and fall to the ground. The painting suggests images of Japanese poetry, yet it does not illustrate a specific poem. The artist has created an image in the Japanese tradition that encourages phrases of poetry to surface in the mind, blending with and enriching one's perception of the painting.

Tōhaku's greatest contributions to the development of the decorative style, however, were his amalgam of monumental forms, his subtle use of monochrome ink without additional gold or colors, and his ability to infuse simple plant and tree motifs with a sense of tradition and timelessness. This unique combination appears at its best in his Pine Forest, a pair of six-panel *byōbu* (fig. 246). Tall trees are seen as if from a distance. Thick mist flows in and around them, obscuring the lower half of some, the midtrunk area of others. The viewer knows that when the mist clears, the forest of trees will appear tall and straight, with deep green needles, but at this moment they coalesce into recognizable forms only long enough to disappear again, or they remain partially visible like ghostly gray apparitions. Tōhaku has taken the motif of pine trees, possibly remembering Mu Qi's bamboo trees in mist, and worked it into this monumental format, expressing a mysterious, deeply moving aspect of the natural world. By contrast, his screens depicting the maple tree in its autumn foliage show nature in a joyous riot of color, creating an atmosphere suitable for festivities, dancing, and sake drinking. Nature in both these paintings is gentle and hospitable. It is not meant to overpower or to create an awe-inspiring backdrop for a warlord, but instead to harmonize with and perhaps inspire human activities.

## Kaihō Yūshō

Kaihō Yūshō (1533–1615) is another artist trained initially by a Kanō master, either Motonobu or Eitoku, who developed his own style in both the monochrome and the blue-and-gold modes of painting. The third or fifth son of a samurai—the records are unclear—he was made a ward

**247.** Plum Tree, on four *fusuma*, by KAIHŌ YŪSHŌ. Zenkoan, Kenninji, Kyoto. Early 17th century. Ink on paper; each panel 68⅛ x 46 in. (173 x 117 cm)

of the Zen temple of Tōfukuji as a young child, a circumstance that saved his life when his father and elder brothers were killed in a battle between their feudal lord, Asai Nagamasa, and Oda Nobunaga in 1573. Becoming a monk effectively removed him from the samurai class and therefore from the burden of his family's loyalty to the losing side. Forty-one at that time, Yūshō took the opportunity to leave the temple and begin a career as an artist. He then seems to have developed contacts with a wide circle of people in Kyoto, including the nobility, the Zen hierarchy, and the military, and he executed *byōbu* and *fusuma* for each group.

The Zen influence received in his childhood is evident in his series of twelve *fusuma* paintings (eight of them are illustrated) for the Zenkoan, a subtemple within the Kenninji complex, dated about 1599. The motifs are familiar—a single plum tree (fig. 247), a gnarled old pine (fig. 248), and a grove of bamboo (not illustrated)—as is the technique of quickly executed, calligraphic ink strokes on a white ground. However, Yūshō gives each motif a shape and character of its own. The plum tree is a contained shape, clearly defined by relatively flat ink washes, the thick, round trunk growing vertically except for the ex-

tremely thin, spiky branches jutting out at sharp angles from the upper part of the trunk (fig. 247). This is not the usual plum, but a rough-barked, ancient tree miraculously producing delicate white or purple blossoms, the harbingers of spring each February. It is a trunk onto which young thin branches seem to have been grafted, and they extend almost like swords defending the core of the tree. In contrast, the pine is indistinct, painted with broad, dry brushstrokes (fig. 248). Its thick trunk curves gently upward, and wide sheltering branches extend to left and right. So soft and hospitable is this tree that two black mynah birds perch on a curve of its trunk, enjoying the protection of its branches. The isolation of the trees on the surface of the *fusuma* and the variety of brushwork that depicts them encourage the viewer to distinguish the individual characteristics of each, and in so doing to reaffirm the Zen ideal of unity between humanity and the natural world.

A pair of screens depicting fishing nets and marsh grass along the shore, a work executed in colors on a gold-leaf ground, displays the restraint and yet the elegance of the style Yūshō developed for work in bright colors (colorplate 46). The set of screens begins at the right with a boldly stated stand of marsh grass in bright green and a

**248.** *(Opposite page)* Pine Tree, on four *fusuma*, by KAIHŌ YŪSHŌ. Zenkoan, Kenninji, Kyoto. Early 17th century. Ink on paper; each panel 68⅛ x 46 in. (173 x 117 cm)

narrow band of water above, both set against gold leaf, which serves as the shore and also the sky. The other half of the right screen is dominated by fishing nets hung out on poles to dry. The left screen repeats the same three themes—grass, water, and fishnets—placing more emphasis on the nets than on the grass in the foreground, but restating it as a tangled mass overlapping the water in the background. The natural repetition of grass fronds contrasts with the controlled forms of the nets and the soft, indistinct flow of the water along the shoreline. The screens, devoid of figures, suggest an ethereal realm far from the hurly-burly of a fishing village.

## Sōtatsu

The artist most closely associated with the revival of *yamato-e* themes in the late 16th and early 17th centuries is Sōtatsu (active 1600–1640), an artist who began his career as a commercial painter and proprietor of the Tawaraya fan shop, and who went on to execute superb, large-scale, decorative screen and *fusuma* paintings in the blue-and-gold manner. His major works date to the third decade of the 17th century, technically the Edo period, but they are clearly the last flowering of Momoyama painting. Little is known for certain about his career, not even his birth and death dates. His family name may have been Nonomura or Kitagawa. He is first mentioned in 1602 as participating in the repair of the *Heike nōkyō* sutra rolls owned by Itsukushima Shrine near Hiroshima. He repainted several motifs in gold and added entire new paintings, such as the frontispiece of a gold deer bending down to nibble grass on a silver slope (fig. 249). To be commissioned to work on such an old and valuable set of scrolls, he must already have been known and respected as a technician. (Today, for example, only three or four restorers in Japan have the government's permission to work on paintings that have been designated National Treasures.) Sōtatsu, however, was not a member of the Kanō school, and recognition of his skills came slowly.

Sōtatsu collaborated with the connoisseur and noted calligrapher Honami Kōetsu (1558–1637), who es-

**249.** Deer frontispiece from *Heike nōkyō,* by SŌTATSU. c. 1602. Color and gold and silver paint on paper; height 10⅞ in. (27.5 cm). Itsukushima Shrine, Hiroshima prefecture

**250.** Deer Scroll, a hand scroll, by SŌTATSU; calligraphy by HONAMI KŌETSU. c. 1615.
Ink and gold and silver paint on paper; height 13 in. (34 cm). Seattle Art Museum, Gift of Mrs. Donald E. Frederick

tablished an artistic and religious community, Takagamine, outside Kyoto. Kōetsu was the descendant of a Kyoto family that cleaned, polished, and appraised swords for the military. The Honami family not only dealt with swords, a warrior's most precious possession, but also advised on sword accoutrements and the lacquer stands on which swords were kept, and eventually on other aesthetic matters such as calligraphy. Kōetsu was also devoted to the tea ceremony and is known to have made several tea bowls (see fig. 260). Clearly, he was a man of many artistic accomplishments. He and Sōtatsu produced a series of hand scrolls, with texts of classical works of literature from the Heian and Kamakura periods written in ink across bold floral and figural motifs in gold and silver. Because so little is known for certain about either Kōetsu or Sōtatsu, the role of each in the creation of these scrolls has raised considerable controversy.

The Deer Scroll, one of the last efforts the two men undertook together, offers interesting evidence (fig. 250). Deer, some running, some standing, others feeding gracefully, are depicted in gold and silver paint on paper, and written on the scroll are twenty-eight poems from the *Shin kokinshū*, an anthology compiled in the Kamakura period. Two different artists' hands can be recognized in the underdrawings, one accomplished in using gold paint and adept at rendering delicate nuances of thin and opaque shades, the other a much less skilled artist who lays on gold paint in even, heavy strokes and adds single elements to long passages by the first artist. It has been conjectured that the skilled hand is Sōtatsu's, and that Kōetsu probably commissioned the scroll from Sōtatsu, but was not entirely pleased with the final work. It may be that he added

an occasional deer to fill out the scroll, thinking perhaps that the voids between motifs were too large.

During the second decade of the 17th century, Sōtatsu added a new motif to his repertoire, the human figure. Using several 13th-century narrative *emaki* as models, he reproduced single figures and whole figural scenes in fan paintings. His fan shop, the Tawaraya, was so well known for its fans bearing themes from classical literature that it is referred to in the *Chikusai monogatari*, a novel written in 1622. To adapt figural compositions to the curving shape of the folding fan required careful placing of the motifs and voids in order to achieve balance and yet maintain the dramatic tension of the narrative scenes. His work with the fan format may have led him to experiment with the problem of motifs and voids on the horizontal surface of the Deer Scroll, to the displeasure of his patron and collaborator Kōetsu.

Sōtatsu's use of *emaki* motifs can be understood by comparing a single theme in two of his paintings. The first work is a fan, one of forty-eight pasted across a pair of screens owned by the imperial family. The second is a pair of two-panel *byōbu* in the collection of Kenninji in Kyoto. The fan at the top of the panel shows an episode from the *Tales of Ise* in which a nobleman, who has fallen in love with a girl designated to become the future empress, spirits her off in the night (fig. 251). Caught in a heavy rainstorm, they take shelter in a ruined storehouse, the girl sleeping inside, the man guarding the door from the outside. At dawn he enters to see how his love has passed the night, but she is not there. A demon has eaten her up, the thunder muffling her cries for help. In Sōtatsu's rendering, the demon is to the left, climbing through the air above the

**251.** Section of a screen painted with fans,
from a pair of eight-panel *byōbu*, by SŌTATSU. c. 1630.
Color on paper; height 53½ in. (136 cm).
Imperial Household Agency

storehouse roof, while the young man, barely visible in the lower right corner of the fan picture, sleeps peacefully on the other side of the massive, dark-brown roof. The storehouse dominates the painting, cutting across the surface at a sharp angle and providing a formidable barrier between the demon and the man. The demon is the twin of the God of Thunder and Lightning in the *Kitano Tenjin engi emaki*, a scroll Sōtatsu is known to have studied (see colorplate 30). Sōtatsu has extracted one motif from the earlier narrative scroll and combined it with other pictorial elements to illustrate an episode from a totally unrelated narrative.

The second work that uses the demon motif is monumental in comparison with the fan discussed above. The two panels of a *byōbu* depict Raijin, God of Thunder, and Fūjin, God of Wind (fig. 252). The screens were probably made sometime after 1621, the year in which Sōtatsu was commissioned by shogun Hidetada's wife to decorate certain wooden doors and *fusuma* for the Yōgenin, a building being refurbished as the mausoleum for her father. The fact that Sōtatsu received the patronage of the shogun indicates that he had achieved one of the highest forms of recognition possible for an artist in the Momoyama period. About this time he seems to have turned from decorating fans and scroll papers to creating *byōbu* and *fusuma* paintings for specific patrons. It is generally assumed that Sōtatsu, coincident with this shift in career, turned over the Tawaraya to his successor, Sōsetsu, and concentrated on commissions from the nobility and upper-class townsmen. From his surviving works it is clear that he continued his interest in themes from classical literature.

As the model for his God of Thunder, Sōtatsu used the same demon image from the *Tenjin engi* scrolls. The source of the God of Wind is not known for certain. He may have taken it from a section of the scroll no longer

extant, or he may have taken the pair of Kamakura statues in the Sanjūsangendō depicting the two gods as his inspiration for the theme and the treatment of his God of Wind (see fig. 186). The God of Thunder in the upper left corner of the left screen is a striking white figure against the gold ground and the silver rain clouds. Its garments are depicted in flat, solid colors—blue, green, and orange—but its horns, a subtle blend of beige, sumi, and green, are executed in *tarashikomi*, Sōtatsu's technique of

**252.** God of Thunder (Raijin, *left*) and God of Wind (Fūjin, *right*), a pair of two-panel *byōbu*, by SŌTATSU. After 1621. Color and gold and silver paint on paper; each screen 58⅞ x 69¾ in. (152 x 177.2 cm). Kenninji, Kyoto

Edo Period

applying one color over another that was not yet dry, to make them blend in a rich and irregular fashion. Sōtatsu's god is another direct descendant of Michizane's ghost, here divorced from any narrative. Indeed the composition of the two screens—the God of Wind striding forward to the left and the God of Thunder climbing upward to the left—suggests the course of a thunderstorm, the wind rising, the storm climaxing in the gold void between the figures, and the thunder and lightning disappearing into the distance. It seems that Sōtatsu never discarded an interesting classical image, but played with it in one composition after another as he expanded his pictorial style from small-scale fans to large screen and *fusuma* surfaces.

In one of his masterworks, the Matsushima screens, Sōtatsu has transcended his classical sources (colorplate 47). Matsushima is the name of one of the Japanese *sankei*, the three most beautiful landscapes in Japan, a bay dotted with small, pine-capped islands near Sendai in the Tōhoku region far to the north of Kyoto. It is possible that Sōtatsu was re-creating the scenery of this bay. However, because the artist based so many of his paintings on works of literature from the Heian and Kamakura periods, when there was scant interest in northeastern Japan, this identification seems unlikely. Another possibility is that he was drawing on the tradition of *hamamatsu* paintings depicting pines along the shore, a popular theme during the Momoyama period. However, because the islands in the right screen resemble the Wedded Rocks, an unusual configuration at Futamigaura along the southeast coast of Honshū near Ise, it has been suggested that the screens illustrate a poem from the *Tales of Ise* dealing with the feelings of a man banished from the capital, "gazing at the foaming white surf as he crossed the beach between Ise and Owari provinces."

How poignant now
My longing
For what lies behind—
Enviable indeed
The returning waves.

Helen Craig McCullough, trans., *Tales of Ise*,
Stanford, Calif., 1986, pp. 73–74

To the right, the first screen begins with a richly colored rocky outcropping, the coastline surrounded by raging white-capped water. Toward the left appears a golden cloud, then a group of rocks capped by pines. In the first five panels the seascape resembles the natural formations at Futamigaura except for the strange, cloud-shaped form articulated with wave patterns that projects to the left behind the rocks, between two layers of gold clouds. It is as if the man in his loneliness and longing for home had for a moment lost touch with reality. Normal relationships are restored at the blink of an eye, and in the last panel the gold clouds become clouds again and the water bubbles and boils around a single, pointed rock. In the left screen, reality is completely distorted; what may look like gold clouds turn into island shores from which pine trees grow. In the white-capped water, two golden islands devoid of vegetation are ringed with silver-and-sumi beaches. Throughout, the waves continue to well up, crest, and break, flowing inexorably back toward the capital. If this interpretation can be accepted, Sōtatsu has stepped beyond his classical models in illustrating a specific poem. Heian-period illustrations of works like the *Tale of Genji* used elements of the natural world to reflect the emotions of human beings. In these screens Sōtatsu penetrates beneath the bland, conventional words of the poem to the psychological state of the man alone on the beach, staring at the water and longing to return to his home, his friends, the known world from which

253. Comparison of Gion festival procession from *(above, left)* Machida screens (colorplate 38), *(left)* Uesugi screens (fig. 239), and *(above)* Funaki screens (colorplate 48)

he has been expelled. Magnificent in their own right, these screens, when associated with the passage from the *Tales of Ise,* become an awesome metaphor for the deep emotion of a man who is not depicted, a remarkable innovation within the *yamato-e* tradition.

## Genre Painting

Along with ink wall paintings and brightly colored wall paintings, genre painting is the third, and most popular, kind of representation in the Momoyama period. Its Japanese origins can be traced back to the Heian and Kamakura eras, but the stimulus for its revival as a major art form in the late Muromachi must be attributed to Tosa Mitsunobu and his invention of *rakuchū rakugai* screens. For the next century and a quarter, genre paintings were a favorite form of pictorial expression: viewing the cherry blossoms in spring, the red-leafed maples in the autumn, the Gion festival procession,❖ theatrical performances, the comings and goings of Westerners in their exotic costumes, the activities of the pleasure district, and even depictions of the interiors of brothels. The painting of genre scenes continued well into the 17th century, when the large-scale formats of the Momoyama period yielded to smaller, mass-produced woodblock illustrations. The

❖ The Gion festival is one of Japan's most important and takes place in July in Kyoto. Originally a 9th-century Shinto plea to the gods to stop an epidemic of disease, it became a time of joyful activity whose highlight is the parade of elaborate floats *(hoko)* carrying costumed performers that takes place on July 17th.

*The Momoyama Period* 235

**254.** Pair of six-panel *nanban* byōbu. Early 17th century. Color and gold leaf on paper; each screen 61 x 132 in. *Southern Barbarian* (155 x 334 cm). Imperial Household Agency

revival of genre painting and of *yamato-e* themes represents a return to traditional motifs, the resurfacing of a fundamental Japanese interest in human beings, their activities, and their surroundings.

Various theories centering on the problem of patronage have been advanced to account for the revival of interest in genre painting, particularly *rakuchū rakugai* pictures. In the earlier Machida screens of the 1520s, and the Uesugi screens painted by Eitoku in 1564 on commission for the Hosokawa family, four areas stand out in importance: on the right screen, the Gion festival procession and the merchant district through which it passes, and the Imperial Palace; and on the left screen, the headquarters of the shogunate and the Hosokawa mansion, the latter two given the greatest emphasis (see colorplate 38 and fig. 239). These passages might be seen as references to the three classes present in Kyoto at that time: the townsmen, the nobility, and the samurai. It has been suggested that the daimyo families responsible for the rebuilding of the city after the Ōnin War commissioned the screens to document their achievements.

The Hosokawa family, from whom Eitoku received his commission, served as shogunal deputy during the Muromachi period, and Hosokawa Yūsai (1534–1610) played an important role in mediating between the last Ashikaga shogun and Oda Nobunaga. When the shogun was deposed in 1573, Yūsai sided with Nobunaga and was richly rewarded for his loyalty. It is interesting to note that in 1574 Nobunaga gave the Hosokawa-commissioned screens to the Uesugi family, who served as shogunal deputy for the Kantō region.

The pair of *rakuchū rakugai zu byōbu* known as the Funaki screens (colorplate 48) must have had a point of origin different from the *rakuchū rakugai* paintings discussed above. Dated to the years 1614 to 1615, the time of the Tokugawas' final assault on the Toyotomi in Osaka Castle, on the basis of the architecture represented in them, the screens display a unique organization of motifs and a most unusual manner of depicting human figures. Here the focal point of the right screen is Hōkōji, a large Buddhist temple built in the southeastern quarter of Kyoto by Hideyoshi, with his mausoleum, Hōkokubyō, behind it. On the left is Nijō Castle in the northeastern quarter, the Kyoto residence of the Tokugawa family. By choosing a vantage point different from the traditional one, the artist of these screens dramatically represented the tense political climate in Kyoto at the time. A comparison of the Gion festival procession as depicted on the three *byōbu* makes clear the differences between a traditional rendering, like that of the Machida and Uesugi screens, and that of the Funaki *byōbu* (fig. 253). First of all, the Gion festival is given much more prominence in the later work. Also, the agitated and distorted poses of the figures in the later screens, and the hard black ink lines that seldom vary in width in delineating the people's elongated faces and bodies, heighten the impression of maniacal intensity. It

seems likely that these screens were commissioned not by a daimyo but by a wealthy townsman, and in them the artist has captured the frenzied mood of the people during those tumultuous years.

Another type of genre painting popular in the 16th and early 17th centuries deals with the *nanban*, or southern barbarians—the Japanese expression for the Portuguese—whose presence was an economically important and visually exotic contribution to Momoyama Japan. Tall, mustached Westerners in pantaloons and flowing capes appear occasionally in *rakuchū rakugai* paintings, but they provide the principal subject matter for another type of screen, the *nanban byōbu*. In this category there are several types of compositions, but the most popular, depicted on the left screen, is the arrival in a Japanese port of a many-canvased foreign galleon, and on the right the visit of the ship's crew to Nanbanji, the Jesuit church in Kyoto. Contrary to normal Japanese practice, these folding screens are intended to be read from left to right (fig. 254). The majestic procession of the ship's captain and his crew through the streets of the city to the Christian church in the upper right corner of the right screen must be preceded by the arrival in port of the foreign ship in the left. Why do the motifs unfold in a sequence that reverses the usual Japanese ordering of events? Is it because these southern barbarians are seen as intruders in Japan and their departure is presupposed?

The interest in representing common people in their everyday life, first evident in the *rakuchū rakugai zu byōbu* and in similar paintings containing a great number of figures, later found expression in screen paintings that show a few men and women engaged in interesting activities. An intriguing example of this type is the Hikone screen, a short single six-panel *byōbu* of figures against a gold-leaf ground (fig. 255). The two panels to the right depict an outdoor scene: two courtesans and a child attendant are talking to a samurai, who leans languidly on his sword. The remaining four panels depict male and female figures inside a house of entertainment, passing the time in cultural pursuits. Three pluck the strings of their samisens,✦ another three play a game of Japanese checkers,

---

✦ Traditional Japanese musical instruments include several that are stringed. The lutelike biwa with its teardrop-shaped body became popular with the early court nobility, as did the much larger *koto*, which sits on the floor while the performer moves the bridge and plucks the strings in the manner of a zither. The samisen, sometimes described as a three-stringed banjo, has been popular since the 16th century for narrative and lyrical music, including folk music, and is the main instrument accompanying Bunraku performances. Other instruments include the *shakuhachi*, an end-blown bamboo flute with a haunting, breathy sound, and various drums. Today, a common chamber ensemble consists of a *koto*, whose player may also sing, a samisen, and a *shakuhachi*.

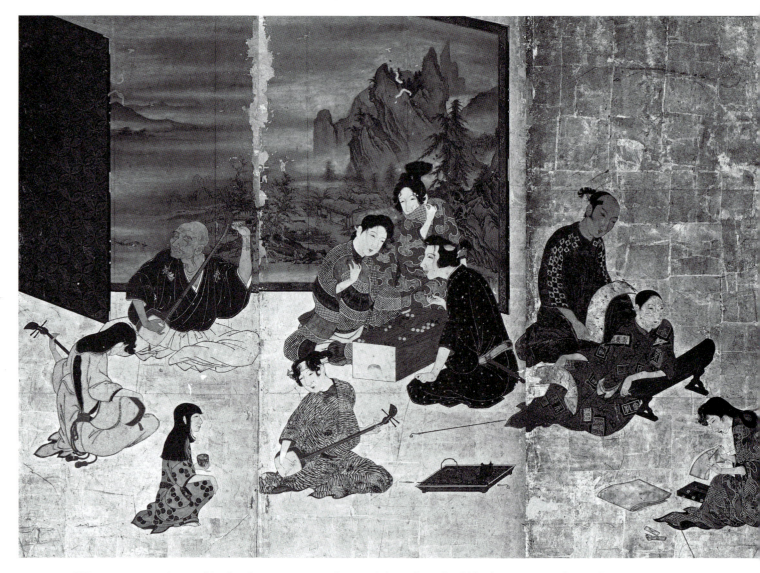

**255.** Hikone screen, a six-panel *byōbu*. Between 1624 and 1644. Color, ink, and gold leaf on paper; each panel 37 x 18⅞ in. (94 x 48 cm). Ii Naoyoashi, Hikone, Shiga prefecture

and yet a third group of three figures is engaged in reading aloud, listening, and writing as if by dictation. The figures in these left panels may illustrate a version in contemporary dress of that favorite Chinese theme, the Four Gentlemanly Accomplishments (music, art, scholarship, and games of skill), but all of the figures are peculiarly devoid of expression, as if they had never smiled or frowned or wept. They act as if they had been imprisoned in a house of pleasure for so long that they can now respond only with sighs of boredom. There are few clues to authorship. However, the superb monochrome ink landscape screen behind the blind musician appears to be in the Kanō style. The subdued and elegant color scheme as well as the controlled and delicate brushwork that delineates the forms, drapery folds, and textile patterns also suggest an accomplished Kanō hand. The Hikone *byōbu*, created between 1624 and 1644, is perhaps the last of the great genre paintings in the Momoyama tradition. Two of

its major themes—the surface expressions that mask powerful human emotions and the pleasure district as a setting for figures—will resurface during the Genroku era (1688–1703), in the floating world of the woodblock print.

## Ceramics

During the Momoyama period, ceramic production underwent several profound changes. First of all, the fighting that took place at the end of the Early Feudal period caused potters to move from their kiln sites in Seto to Mino, a more secluded area to the northeast of Nagoya under the protection of the Toki clan. In the relative peace that followed Oda Nobunaga's assumption of power in 1568, the Mino kilns began to produce a wide variety of glazed ceramics for the tea ceremony, the *chanoyu*, and the associated service of food, the *kaiseki ryōri*, which pre-

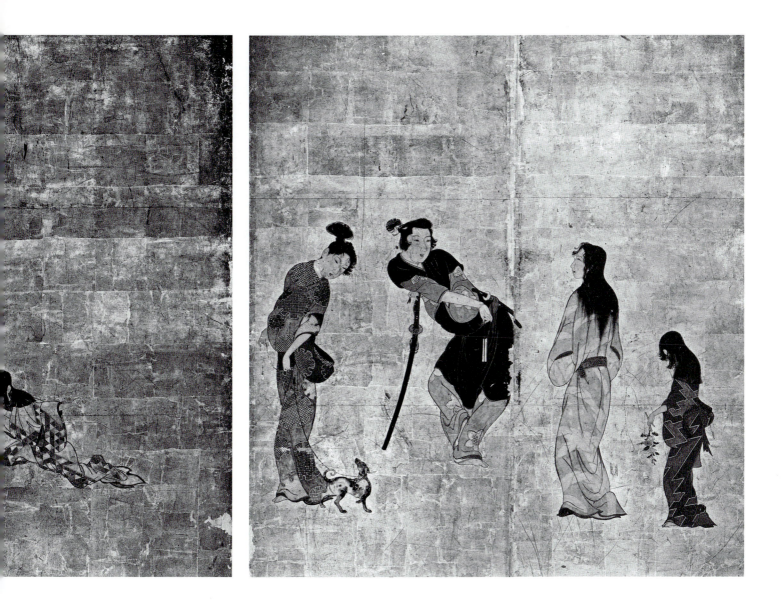

ceded it.❖ Their years of peak production were roughly 1570 to 1625.

Under the influence of such renowned tea masters as Takeno Jōō (1502–1555) and Sen Rikyū (1522–1591), simple utensils such as the bamboo ladle and tea scoop and the tea whisk and locally made ceramics were preferred for use in the tea ceremony. Their goal was to achieve the aesthetic effects of *wabi* and *sabi,* the beauty of simplicity seen in austerity and age. The works produced in Mino in response to their ideas of beauty represent a departure from the controlled shapes and modestly decorated surfaces of Ko Seto and the simply articulated large storage vessels of other kiln sites. The new creative energy at Mino coincided with a rather surprising development, the popularization of the tea ceremony.

In the Early Feudal period, this ritual was practiced primarily by the upper echelon of the samurai and the Zen priesthood, but as the phenomenon of *gekokujō,* literally those below overthrowing those above, was played out in the 16th century, the correct performance of the tea ceremony became an essential attribute of cultural sophistication. Hideyoshi, the classic example of a low-ranking warrior rising to the top level of the military, associated himself with the tea ceremony to demonstrate his appreciation of culture and thereby his right to rule. In 1587, after he returned from his campaign to subjugate Kyūshū, he held a gigantic tea ceremony performance on the grounds of Kitano Shrine in northwest Kyoto, which was planned to last for ten days and was open to the entire population of Kyoto. A proclamation issued before the Kitano event stated that *(quote appears on next page)*

---

❖*Kaiseki ryōri* is a type of light meal traditionally served before the tea ceremony. It normally consists of raw and cooked fish, soup, and rice, although it may be completely vegetarian. The food is served in small portions on dishes, both ceramic and lacquer, chosen for their understated elegance.

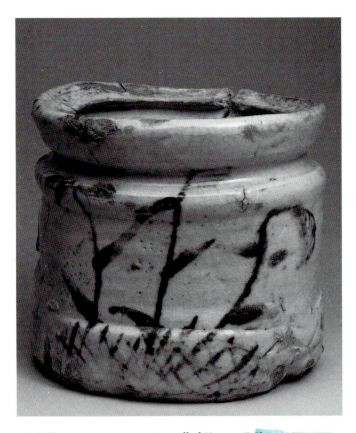

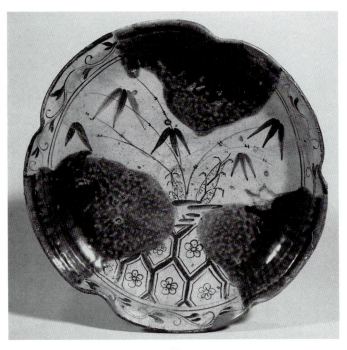

**257.** Lobed dish. Oribe Mino ware. Early 17th century. Stoneware, painted and glazed; diameter 14⅝ in. (37.1 cm). Courtesy the Freer Gallery of Art, Smithsonian Institution, Washington, D.C.

**256.** Tea-ceremony water jar, called Kogan. E Shino Mino ware. 16th century. Stoneware, painted, with feldspar glaze; height 7 in. (17.8 cm). Hatakeyama Memorial Museum, Tokyo

devotees, whether they are military attendants, townspeople, farmers or others should come and each should bring a kettle, a water bucket, a drinking bowl and either tea or *kogashi* [a poorer grade of tea].

> Murai Yasuhiko, "The Development of Chanoyu: Before Rikyū," in *Tea in Japan*, Honolulu, 1989, p. 40

With this kind of stimulation, the production of ceramics for the tea ceremony burgeoned.

The kilns at Mino responded to the demand by developing several new kinds of ceramics, Yellow Seto (Ki Seto) and Black Seto (Seto Guro), which are variations of traditional *setomono*, Shino, and Oribe wares. Among these, Shino ware was the most distinctive and popular in the Momoyama period. Even within the Shino designation there are several different types: unornamented or White Shino; E Shino, decorated with representational motifs; and Nezumi Shino, so called because the surface is the color of a mouse (*nezumi*). One of the most famous pieces of E Shino ware is a tea-ceremony water jar called Kogan, or The Bank of an Ancient Stream, a reference to the design painted on the surface (fig. 256). Like most Shino ware, this piece is made from fine white potting clay and is coated with a thick, crackled, white feldspathic glaze, that is, a glaze containing feldspar. Over this a design of marsh grass has been painted in iron brown. The combination of the simply sketched motif, the thick white glaze that

seems almost like water, and the cracks in the fabric of the vessel, as well as the crazing in the glaze, suggest at once great age and a quality of agelessness.

The other outstanding type of ceramic produced at Mino is Oribe ware, which takes its name from the tea master Furuta Oribe (1544–1615). Oribe, a disciple of the famous tea master Sen Rikyū, was well known for his preference for ceramics newly made in Japan and reflective of Japanese taste. This is an aesthetic preference that may have been put forward by Sen Rikyū himself, but the ceramics associated with Oribe are unique expressions of this disciple's taste. They are the most colorful of the wares used in the tea ceremony, providing a strong contrast with the sober pieces of an earlier age. Oribe ware juxtaposes an unevenly applied, bright copper-green glaze with recognizable designs, such as sailboats or plants, executed in brown against a white or softly colored surface. One of the best extant examples of Oribe ware is a five-lobed dish with floral and geometric designs (fig. 257). A design of bamboo stalks and leaves covers about two-thirds of the flat circle of the dish, while a geometric pattern of hexagons, each with a five-petaled blossom in its center, fills the remainder. The rim is decorated with a garland of vines and small flowers. Irregular flows of green glaze at three places on the surface contrast strongly with the representational aspects of the design. Usually Oribe ware is mold-made and retains traces of the warp and woof of the cloth used to line the form.

Another ceramic innovation of the Momoyama period was raku ware, which originated in Kyoto for use in

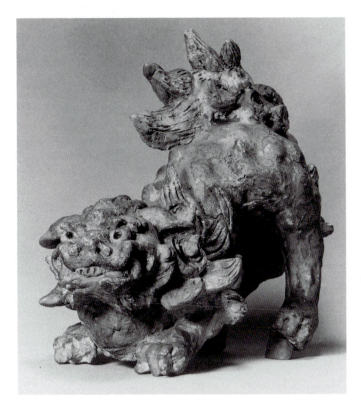

**258.** Chinese Lion, by SASAKI CHŌJIRŌ.
Raku ware. 1574. Earthenware with transparent glaze
14 in. (35.5cm). Raku Museum, Kyoto

**259.** Tea bowl, called Muichimotsu, by SASAKI CHŌJIRŌ.
Raku ware. Late 16th century. Earthenware with
transparent glaze; height 3³/₈ in. (8.5 cm). Egawa Museum,
Hyōgo prefecture

**260.** Tea bowl, called Mount Fuji, by HONAMI KŌETSU.
Raku ware. Early 17th century. Earthenware with glaze;
height 3³/₈ in. (8.5 cm). Private collection

the tea ceremony and was associated with the aesthetic principles of Sen Rikyū. The name *raku*, originally designating both the type of ceramic and also the specific line of potters making it, was bestowed by Hideyoshi. Raku simply translated means pleasure, but it was also the middle character in the name of Hideyoshi's Kyoto palace, Jurakudai. Raku ware is coated with a black, a transparent, or occasionally a white glaze, and is fired in a small, single-chamber oxidation kiln at relatively low temperatures. But unlike most other ceramics, it is removed from the kiln while it is still hot, which introduces an element of chance into the process. The potter cannot know exactly what effect the cooler air outside the kiln will have on a bowl, and can further enhance the unpredictability by placing the vessel in a reduction kiln, submerging it in cold water, or placing it in organic matter like straw, which is ignited by the pot's heat. All these processes affect the glaze and the surface of the vessel. The aesthetic of sudden change seemed to fit in with the idea of Zen enlightenment, and the roughly modeled quality of the raku tea bowl agreed with Sen Rikyū's preference for simple, unelaborated ceramics.

The potter credited with the development of raku ware is Sasaki Chōjiro (1516–1592), who began as a specialist in the making of roof tiles, particularly the animal shapes placed along ridge lines. An ornamental lion figure dated by inscription to 1574 has been preserved and is of particular interest since it bears Chōjiro's name (fig. 258). One of Chōjiro's most famous tea bowls is the red raku piece called Muichimotsu, translatable as "holding nothing" (fig. 259). It is made of red clay, hand-formed rather than wheel-thrown, like all classic raku tea bowls, and

**261**. Plate with pine tree design. Karatsu ware. Late 16th to 17th century. Earthenware with glaze; diameter 14³/₈ in. (36.3 cm). Idemitsu Art Museum, Tokyo

coated with a transparent glaze. It is the epitome of simplicity, rising abruptly from a narrow base to a cylindrical bowl with a wide mouth.

Because the technical means for producing raku ware were relatively simple and did not require large or elaborate kilns, it was possible for "gentleman potters" to dabble in its manufacture. Honami Kōetsu, known for his collaboration with Sōtatsu in the decoration and calligraphy for various poem scrolls (see fig. 250), experimented with raku ware. The tea bowl called Mount Fuji is unquestionably his premier ceramic work (fig. 260). Like the mountain for which it is named, the bowl is white around the top and grayish black below. It has been shaped by hand and the crude marks of the shaving knife around the base and the lip have been allowed to show. To fully appreciate this bowl, it must be visualized at the moment when it is raised to the lips half full of foamy green tea—and the liquid then drunk from within the crater of the volcano.

The last major innovation in ceramics of the Momoyama period is the high-fired, glazed pieces produced in northern Kyūshū and named Karatsu after the city around which the kilns were distributed. Unlike the other ceramics used in the tea ceremony, Karatsu wares were made by Korean, not Japanese, potters, technicians who at some

point in the 16th century, perhaps even before the beginning of the Momoyama period, had crossed the Japan Sea and settled in northern Kyūshū. Exactly what the lure of the Karatsu region was is not clear, nor is the date of the emigration. The earliest dated piece of Karatsu ware is a jar inscribed with the year Tenshō 20, or 1592.

A particularly charming example of painted Karatsu ware is a plate with a slightly raised outer rim (fig. 261). The piece is formed of sandy clay with a high iron content. It has a design of a pine tree painted in an iron-brown glaze, and then coated with a white glaze. The curving lines of the tree trunk and limbs complement the circular depression of the bowl of the plate and its regular, curved rim.

Although its early history in Japan is hard to document, it is clear that Karatsu ware, with its simple painted designs and warm, yellow-brown color, fit very well with the aesthetics of the tea ceremony. That there was considerable demand for it is demonstrated by the fact that in 1592 and 1597, when Hideyoshi launched his campaigns against Korea, feudal lords from Kyūshū and western Honshū accompanied him and brought back artisans with the idea that they would establish local kilns and generate income for their *han*.

# CHAPTER 6
# Peace and Stability in Later Feudal Times

## THE TOKUGAWA, OR EDO, PERIOD

Politically, the Momoyama period had been a violent transition from a weak and decentralized feudal society marked by repeated warfare, to the beginnings of a highly structured and centralized feudalism. In 1603 Tokugawa Ieyasu had become the effective ruler, and had taken the title of shogun for himself. The Tokugawa period, which takes its name from the family that controlled the shogunate for over two hundred fifty years, is dated from 1615, when Osaka Castle fell and the Toyotomi faction was finally defeated. The period ended in 1868, with the abolition of feudalism: the shogunate had collapsed because of the breakdown of the feudal economy. This era is also called the Edo period, after the city that grew up around the Tokugawa castle. While Kyoto remained the official capital of Japan, the process of governing the country went on in Edo, renamed Tokyo and officially declared the capital of Japan in 1868 after the

Meiji emperor ascended the throne.

The first tasks facing the new shogunate were to establish itself as a conservator of tradition and to restructure the feudal system from a fighting machine into a bureaucracy capable of maintaining peace throughout the country. During the first four decades of the 17th century, the shogunate developed and promulgated a system of laws and codes of conduct designed to ensure national political stability and unquestioned rulership for the Tokugawa clan. These measures included forbidding foreigners freedom of movement in Japan, and, ultimately, the proscription of Christianity; the establishment of a rigidly defined class system; and the development of codes of moral and ethical behavior that were imposed on every stratum of society. The successful implementation of these controls brought peace to Japan for the first time in more than a hundred years.

## Politics, Society, and Culture of the Tokugawa Shogunate (1615–1868)

Confucian thought, a tradition of philosophical, moral, and political teachings developed in China, played a significant role in the policies formulated by the shogunate. The ideal society, according to Confucianism, was firmly structured, with the emperor at the top, and a class of highly educated soldier-officials administering the government under him, followed by the primary producers, the agriculturalists, and then by the secondary producers, the artisans. This theoretical hierarchy was easily adapted to fit the circumstances of Japanese feudal society at the beginning of the Tokugawa period, and the use of this ancient Chinese tradition gave legitimacy to Tokugawa rule. The shogun ruled through his daimyo, the high-ranking lords who controlled the often vast individual domains, known as *han*. The *han* were administered by the samurai, who were granted stipends of rice in return for their services. In the Tokugawa peace, the warrior class became

functionally a class of administrative bureaucrats, although the samurai simultaneously intensified their personal identification as warriors. Peasants constituted the next class, just below the samurai, because it was they who grew the rice on which the feudal economy was based. Below them were the artisans who created the objects—the buildings, the clothing, the utensils—essential to life. Finally, at the bottom of the social ranking were the city-dwelling merchants and tradesmen who, according to Confucian thought, merely handled the fruits of others' labors rather than making significant contributions of their own. Because both the artisan and merchant classes lived in the cities and were regarded as the bottom of the social order, they were collectively known as *chōnin*, or city people. Social mobility within the class system was virtually impossible. However, samurai could formally renounce their positions within feudal society and become master-

less servants or *ronin*, functioning outside the class system.❖ Also outside the class system were the small group of court nobility, the much larger group of Buddhist and Shinto priests, and the *eta*, the outcasts of society.

Unfortunately, the Tokugawa shoguns misperceived the changing nature of the Japanese economy in the 17th century and the fact that Japan was in the process of being transformed from a feudal and agrarian to an urban society. By the end of the century, the prosperity generated by the economic expansion possible in times of peace had resulted in a peculiar kind of imbalance, in which *chōnin* were becoming affluent while many samurai, forced to subsist on fixed incomes—their rice stipends—in times of economic expansion and inflation, were on the verge of bankruptcy.

The vitality of the newly emerging *chōnin*, and their exuberant enjoyment of life coupled with their affluence, produced a climate in which the arts prospered. This period of florescence is called Genroku after the calendrical era that lasted from 1688 to 1703, but the culture that characterized the Genroku period materialized in the fourth quarter of the 17th century and lasted until well into the first quarter of the 18th century.

In the arts the desire of the Tokugawa shogunate to associate itself with the ideal of preserving traditional institutions resulted in the first decades of the 17th century in a flurry of building projects. Older Buddhist temples were refurbished and new ones built in order to implement the government requirement that all Japanese register as members of a specific institution and undergo annually an examination of their religious beliefs. In each feudal *han*, schools for the teaching of Confucian doctrine and temples for Confucian worship were erected. A Shinto mausoleum was built for Ieyasu at Nikkō, north of Edo, and small-scale replicas of it were erected in each *han*. Tokugawa conservatism can be seen also in the paintings commissioned by the shoguns and their daimyo, works by established masters of the Kanō school depicting traditional themes from the Muromachi and Momoyama periods—Chinese subjects such as the patriarchs of Confucianism and the *Mirror of Emperors* (a popular treatise on good government), and such Japanese themes as birds and flowers of the four seasons. These paintings created for their owners an ambience of wealth and power, and also of legitimate governance in harmony with Confucian principles.

In the latter part of the 17th century the newly affluent *chōnin* class began to influence artistic production. These people were astute and pragmatic businessmen sensitive to minute political, social, and even climatic changes that could mean financial gain if they were assessed and handled correctly, or ruin if mismanaged. Their attention was focused on the world around them, and they cared little for the glories of the long-dead past. They were well educated and rich in worldly experience, and although they indulged with abandon their fondness for sake, women, and the theater, they were extremely de-

manding about the quality of the entertainment for which they paid their hard-earned money. Their exacting standards served as a stimulus to writers of the Genroku period, notably the novelist and poet Ihara Saikaku and the playwright of the puppet theater Chikamatsu Monzaemon. They looked to painting and to the developing woodblock print for illustrations of scenes from their favorite plays and novels, and of *ukiyo*, the floating, ever-changing world of the theater and the teahouse—depictions of famous male actors, female entertainers, and illustrated guides to the local brothels and to the activities that went on behind their closed doors. The concept of art as a means of expressing philosophical or religious ideals or of capturing the essence of a great work of classical literature was apparently not important to them; the visual arts produced in the Genroku period reflect this. With the notable exception of the Rinpa school of decorative painting, derived from the work of Sōtatsu, the art of this period was essentially a reworking in new formats of the themes favored by their middle-class counterparts in the Momoyama period.

During the second century of Tokugawa rule, from approximately 1716 to 1800, periods of relative economic and political stability alternated with times of severe hardship and political disruption. In spite of this climate of uncertainty and risk, the visual arts flourished as they had not in the previous hundred years. In the 18th century, leadership in cultural affairs passed to the intellectuals within the samurai class and the elite among the *chōnin*. The samurai, encouraged by the tenets of Confucianism, embarked on a quest for knowledge that led them far beyond the boundaries of conventional philosophy. This spirit of inquiry was encouraged by the eighth shogun, Yoshimune (ruled 1716–1745), who lifted many of the restrictions on the importation of foreign books. It is thought that Yoshimune's principal reason for relaxing the curb on foreign materials was his interest in Western methods of calculating calendrical time, which were judged to be more accurate than those used by the Japanese. Whatever his motivation, he opened up new sources of information and ideas, both Chinese and European, to which the cultural leaders of the period turned with enthusiasm.

If the first century of Tokugawa rule can be characterized as a time in which the pictorial themes that had first appeared in the Momoyama period were refined and restated, the following century—from the dimming of

---

❖ *Rōnin*, masterless servants, were members of the samurai class who had lost or forfeited their positions within feudal society. Frequently this happened because the master had somehow disgraced himself and was forced to commit ritual suicide or *seppuku*, but also it might be that the individual wished to free himself from the responsibilities and constraints of service to the daimyo. The word *rōnin* is used today to refer to students who have not passed their college entrance examinations and are temporarily outside the educational system.

Genroku culture in the early 18th century to the beginning of the 19th century—can be described as a time in which a remarkable number of diverse styles flourished, several based on newly available foreign models. That is not to say that genre painting or woodblock prints declined in popularity. Printing techniques had advanced so greatly from the primitive hand-colored products of the 17th century that late in the year 1764 the first polychrome prints, a set of privately printed calendars, were made by Suzuki Harunobu. By 1800 the *ukiyo-e* print had undergone a remarkable metamorphosis from the romantic young lovers depicted in Harunobu's prints (see fig. 312) to gracefully elegant courtesans, insightful depictions of Kabuki actors, and penetrating psychological studies of women. However, the works that excited the greatest interest on the part of the intelligentsia were—and still are—those associated with Confucianism, literati painting (*bunjinga* or *nanga* in Japanese); pictures in Western styles, called *yōfuga*, and paintings by the Maruyama-Shijō school of Japanese Realism. All of these traditions are explored in the pages ahead.

During the first seven decades of the 19th century, the Japanese experienced two severe challenges that brought into question the very foundations of their society. The first was the inevitable breakdown of the Japanese economy because it was based on a single crop, rice. From one year to the next, the value of rice fluctuated wildly. Samurai were hard hit when crop failures resulted in reductions in the rice stipends, literally their government paychecks—cuts sometimes amounting to half of their allotment. In good years, they were nearly wiped out, when rice was so abundant that bartering it for goods and services brought a very low rate of return.

Peasants also experienced grave dislocations because of their dependence on rice as a staple. Famines and epidemics were common occurrences from the mid-18th century on, and many farmers chose to abandon their land and move to the cities. This, of course, only exacerbated the rice problem, leaving fewer hands to produce the crop. The peasants expressed displeasure with their lot through uprisings that at first were aimed at the local administrators of their fiefs but by 1840 were directed against the central government.

Merchants, too, had their complaints against the shogunate. Although they were actually among the wealthiest people in the country, they remained officially the lowest and least privileged class. Furthermore, when the shogunate ran short of funds, it would assess levies on the merchants living in cities such as Osaka, Edo, and Nagasaki, which were under Tokugawa control. In addition, the rulers would invite these same people to lend money to the government, money it often refused to repay, issuing Acts of Grace that amounted to repudiations of all or part of the debt.

The Tokugawa shogunate was certainly aware of the rising discontent in all levels of society, but it seemed powerless to implement a consistent policy to remedy the situation. Indeed, there probably was no solution short of a complete revamping of the social and economic foundations of the country, which would have meant abandoning the archaic feudal system and the use of rice as a medium of currency.

The second element that threatened the stability of the country was the increased presence of Westerners in the Far East. During the first decades of the 19th century, the leading countries of Europe and the United States not only expanded their maritime trade, they also began to develop the whaling industry. It was not uncommon for shipwrecked Western sailors to be washed ashore, or for ships to put into Japanese ports for water and supplies. Thus countries involved in maritime activities had a strong interest in how their citizens were treated in Japan. The Russians were the first to try to establish diplomatic relations with the Japanese, having their ship *Nadiezhda* stop at Nagasaki in 1804 during its voyage of exploration around the world. An accredited Russian envoy tried for six months to persuade the Japanese to permit trade relations with Russia, but to no avail. In 1807 a more serious encounter between the Russians and the Japanese occurred. A Russian ship landed in the Kuril islands (between the northeast coast of Hokkaidō and the Russian Kamchatka peninsula), and an exploration party consisting of the captain and some of his men was captured and held prisoner by the Japanese until 1813.

In the following years the Japanese government vacillated between the hard-line policy it had instituted in 1825, which ordered daimyo with coastal lands to drive off foreign vessels by force and to kill any crew members who came ashore, and the softer policy of 1842 that instructed local authorities to supply foreign ships with food and fuel and advise them strongly to go away. However, the trend of international events was moving against the policy of isolation. In 1842, the English defeated the Chinese in the Opium War and forced the opening of Canton and other ports to trade. Two years later the king of the Netherlands made a strong case to the Japanese for opening its ports, and finally in 1853 Commodore Matthew Perry sailed into Uraga harbor at the mouth of Edo Bay with four warships and a letter from the president of the United States urging that American mariners be given good treatment by the Japanese. The following year the Japanese formally ended the isolationist policy of the Tokugawa government.

Another factor contributing to the pressure for an end to isolationism, and ultimately for the overthrow of the Tokugawa shogunate, was a growing awareness that Western technology far surpassed that of the Japanese. Of great interest were advances in weaponry, and as visits from Western ships became more numerous and more threatening, many factions within Japan began to push for open access to Western technology. Others realized that trade with the West could provide an alternative to the one-crop dependence of the Japanese economy, the source

of perennial economic problems.

Both of these factors, the dislocations within the society and the pressure from technologically more advanced nations from without, led to a mood of discontent and uncertainty among the Japanese that is reflected in the arts of this period, which is known as the *bakumatsu*, the waning of the shogunate. While there were no major artistic innovations in the years before the fall of the Tokugawa shogunate in 1868, the foremost artists of each school of painting were rethinking their approaches to pictorial expression and seeking fresh inspiration in an effort to revitalize their work.

## Architecture

One of the first priorities of the newly established shogunate was to continue the policy of rebuilding Buddhist temples that had been initiated in the Momoyama period by Hideyoshi. Kyōōgokokuji in Kyoto, popularly known as Tōji, received aid for reconstruction from both Hideyoshi's son Hideyori and from the Tokugawa, especially Iemitsu, the third shogun. The main hall and the lecture hall were rebuilt in 1598, and in the early years of the 17th century smaller projects were undertaken to restore the temple to a state approximating its original 9th-century appearance. When its five-storied pagoda was destroyed by fire in 1641, reconstruction began almost immediately and was completed three years later (fig. 262).

The rebuilt pagoda is constructed in the traditional manner and is remarkable for its austerity and restrained eclecticism in comparison to other buildings of the Edo period. It rises upward from a wide platform to a height of 180 feet, making it the tallest premodern pagoda in Japan, but the five stories, each three bays wide, display very little diminution of size from one story to the next. The feeling of weight and solidity this gives the building is further accentuated by the five roofs, which do not project as far beyond the main structure as was common in the Asuka and Nara periods. Finally, unlike most Edo-period structures, the Tōji pagoda is relatively free of surface and sculptural ornamentation. Instead, care and restraint were exercised to produce a building in the ancient temple tradition that would still appeal to contemporary tastes.

A building at the opposite end of the spectrum from the Tōji pagoda and one that more accurately reflects the aesthetic preferences of the shogunate is Tōshōgū, the mausoleum of Ieyasu, the first Tokugawa shogun, at Nikkō (fig. 263). The custom of building magnificent tombs for the remains of a military leader was first initiated by Hideyoshi, who had the Hōkoku Shrine built in Kyoto near Hōkōji. After his death, Ieyasu, the most revered ancestor of the Tokugawa clan, was designated Tōshō Daigongen, Great Incarnation Who Illuminates the East, a Shinto god, and was given a magnificent memorial building that was both a mausoleum and a shrine. Succeeding shoguns made it a point at least once during

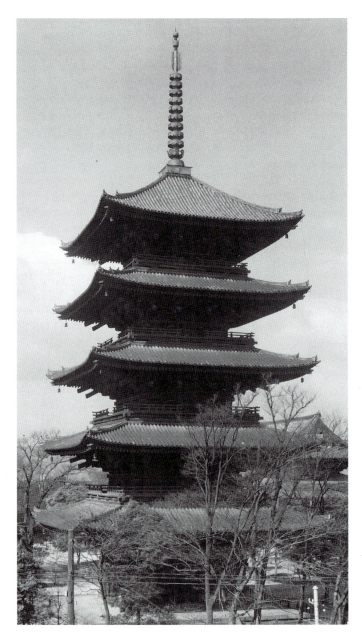

**262.** Five-storied pagoda, Kyōōgokokuji (Tōji), Kyoto. 1644

their tenure in office to undertake a pilgrimage to Tōshōgū in the company of their daimyo and retainers, imitating the ritual of the imperial clan, which paid homage to its ancestor, the Sun Goddess Amaterasu at Ise. In later years it became the custom for local daimyo to build miniature mausoleums in their domains to honor Ieyasu and prove their loyalty to the Tokugawa clan.

Begun in 1636, Tōshōgū is set picturesquely on a hill in a cedar grove at Nikkō. Enclosing the compound is a roofed corridor that can be entered through an elaborate gate called the Yōmeimon. A second, inner closure, marked off by a low tile-roofed wall ornamented with openwork, curvilinear shapes, contains the two main buildings of the shrine: the *haiden* (worship hall), a four-by-nine–bay building, (figs. 264 and 265); and the main hall, a square five-by-five–bay structure, linked by a hall

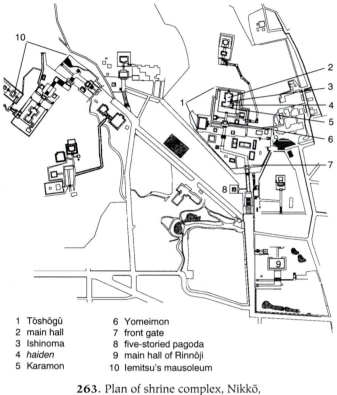

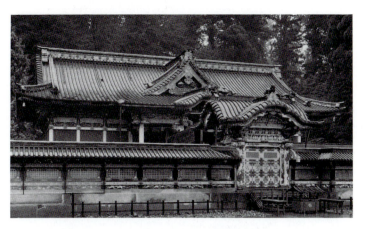

**264.** *Haiden* (worship hall), Tōshōgū Shrine. 1636

| | |
|---|---|
| 1 Tōshōgū | 6 Yomeimon |
| 2 main hall | 7 front gate |
| 3 Ishinoma | 8 five-storied pagoda |
| 4 *haiden* | 9 main hall of Rinnōji |
| 5 Karamon | 10 Iemitsu's mausoleum |

**263.** Plan of shrine complex, Nikkō, Tochigi prefecture. Mid-17th century

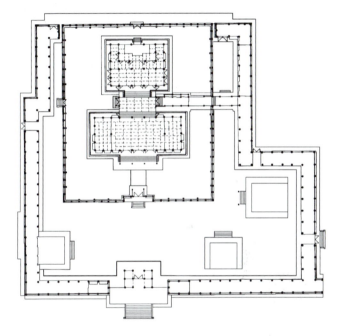

**265.** Plan of Tōshōgū Shrine. (After Kokuhō)

called the Ishinoma (Stone Room). This particular arrangement of buildings is typical of the style known as *gongen zukuri*, mausoleum architecture, of which the Kitano Tenmangū in Kyoto is an early example (see fig. 167). Because the Kitano Shrine was erected to honor a person, its plan was adopted in the Momoyama and Edo periods for mausoleums. The name *gongen* given to the style of building derives from Ieyasu's posthumous name, Tōshō Daigongen. Although the Tōshōgū Shrine complex seems at first glance to be distinctly non-Japanese in flavor, due to the profusion of ornate painted sculptures covering every inch of the external surfaces of the buildings, it actually represents a rather free adaptation of Chinese elements into a context that is essentially Japanese. The style of the bracketing between the walls and the roof is Chinese, as are the railings and the round pillars, but there are also details that are indigenous in character, such as the arrangement of the rafters and the side doors. The interior of the worship hall, with its *fusuma* and heavily coffered and decorated ceiling, is very similar to the *shoin zukuri* style of the Momoyama period. Even the subject matter of the wall paintings reveals a mixture of Chinese motifs—the *kirin* (the mythic beast who appeared when Confucius was born), dragons, lions, and phoenixes—and native ones, chrysanthemums and water birds. Unlike most Japanese buildings, Tōshōgū is painted in brilliant colors, clear bright red, blue, and green, contrasted with white, black, and gold. The entire complex makes a striking contrast to the deep green of the trees surrounding it.

A third type of building necessitated by Tokugawa

policy was the *kōshibyō* or Seidō, a Confucian temple. From Ieyasu on, the Tokugawa believed that Confucianism could provide a moral and ethical framework for national and local government, and they advocated that it be studied and practiced by all members of the samurai class. Under Iemitsu, the third Tokugawa shogun, an academy was founded in Edo for the teaching of Confucian doctrine to the offspring of the samurai serving in the de facto capital, and along with it a hall in which ceremonies honoring Confucius could be performed. The academy, known as the Shōheikō, was located first in the Ueno section of Edo but was moved in the Genroku era to the Yushima district, where a 20th-century replica still stands. In addition to official buildings in Edo, the seat of the shogunate, Confucian academies and worship halls were established in individual domains throughout Japan; few of these buildings survive. A notable exception is the *kōshibyō* at Taku

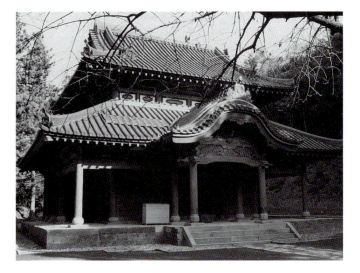

**266.** Taku *kōshibyō* (Confucian temple), Taku City,
Saga prefecture. 1695–1708

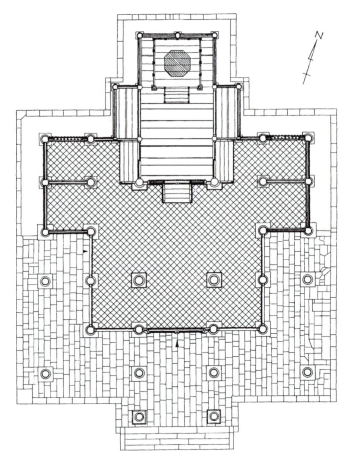

**267.** Plan of Taku *kōshibyō*

City in Saga prefecture on the island of Kyūshū (figs. 266
and 267). Built over a fourteen-year period from 1695 to
1708, the worship hall is a telescoped version of the main
Confucian temple in Peking, which consists of an open
courtyard surrounded by a roofed corridor entered through
the Gyōkōmon, the gate of high aspirations, and climaxed

on the opposite side by the Taiseiden, or Hall of the Great
Sage. In the Taku *kōshibyō* these separate architectural el-
ements are compressed into a single structure. The
Kyōkōmon is a simple stone arch at the entrance to the
enclosure, its shape and function repeated by the Chinese
gable and the wooden arch beneath it that projects for-
ward from the façade of the building. Once visitors climb
the few steps from the ground to the main platform and
pass through the entry porch, they see across a small dirt-
floored vestibule—what would be an open courtyard in a
full-scale temple—the raised dais of the central worship
area, and an elaborately carved shrine containing an image
of Confucius and four sages, including Mencius, one of the
best known of his later interpreters. Despite the Chinese
style of the large curving gable and the decorative carvings
of *kirin*, phoenixes, elephants, and dragons, the shrine is
built in the Japanese style of architecture associated with
Zen temples. Covering the entire building is a steeply
pitched and tiled hipped-gable roof.

The Taku *kōshibyō* is remarkable not only because
it is one of the few Confucian temples of the Edo period
still standing, but also because ceremonies honoring
Confucius and his four disciples have been performed
there almost continuously since the temple was built, at
first under the sponsorship of the feudal lords of Saga and
now under the municipal government of Taku City. Every
year, on the eighteenth day of April and October, celebra-
tions in accordance with ancient Chinese custom are held,
including ritual chanting and a vegetarian feast; important
townspeople, usually school principals, conduct the ser-
vices. In Japan, where there is such a profound reverence
for the past, not surprisingly such a tradition is preserved
to the present day.

A style of architecture that made its first appear-
ance in Japan in the 17th century was associated with
monasteries of Ōbaku Zen Buddhism. The school, an off-
shoot of the Rinzai sect in China, was brought to Japan by
Chinese immigrants who settled in Nagasaki. At first, per-
mission was given by the shogunate for Ōbaku temples to
be built there so that local residents could have burial cer-
emonies conducted according to their native customs.
However, after the dislocations in China caused by the fall
of the Ming dynasty and the establishment of Manchu
rule under the Qing (Ch'ing, 1644–1912), Ōbaku priests not
in sympathy with the new regime emigrated to Japan.
Foremost of these was the priest Yinyuan Longqi (1592–
1673), Ingen in Japanese, who arrived in Nagasaki in 1654
and began a seven-year campaign to found his own tem-
ple. Finally, in 1661, the shogunate gave permission and
the Konoe family donated land southeast of Kyoto for the
building of the temple of Manpukuji; the construction
work, which was to last eight years, then began.

The temple buildings are arranged in a symmetrical
plan, as is the case with most Zen monasteries, but the
buildings included in the Ōbaku enclosure differ some-
what from those in traditional Zen complexes (fig. 268).

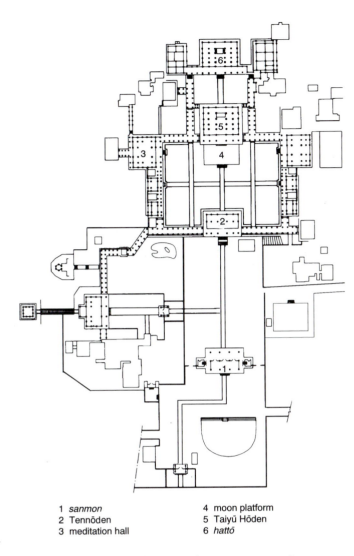

269. Tennōden (Hall of the Guardian Kings), Manpukuji. 1668

1 *sanmon*
2 Tennōden
3 meditation hall
4 moon platform
5 Taiyū Hōden
6 *hattō*

268. Plan of Manpukuji complex, Uji, Kyoto prefecture

Between the *sanmon* and the main Buddha hall, known as the Taiyū Hōden (literally, the great hero's treasure hall), is a secondary building, the Tennōden, the Hall of the Guardian Kings. In the Tennōden are a set of the Four Guardian Kings, a seated image of Hotei, and a standing image of the guardian figure Idaten (Skt. Skanda), who is a protector of food. Extending to left and right of the Tennōden are covered passages that connect with subsidiary buildings, forming an enclosure with the Taiyū Hōden at the rear (fig. 269). Unlike most Zen temple buildings, the bay along the front of each structure is not walled in, but is left open so that it constitutes part of the covered walkway around the main courtyard of the temple. The Taiyū Hōden (not illustrated), which serves as the focal point of the enclosure, is a two-storied building with a hipped-gable roof and hinged doors that have translucent paper inserts above rather tall panels of wood. A Shaka image is installed on a central platform inside, flanked by his two disciples Ananda and Mahakashyapa, and on low platforms along the short sides of the building are a set of

sixteen images of arhats. Behind the Taiyū Hōden is yet another enclosure, with a single-storied structure set on a high stone platform as its focal point. This is the *hattō*, the Zen temple's lecture hall, serving the same function as the *kōdō* in other Buddhist complexes. To the left of the enclosure is a smaller building called the *zendō*, where *zazen* and *nenbutsu* meditation are practiced. In addition to the specific elements—the configuration of the buildings and the combinations of deities—mentioned above, the essentially Chinese flavor of Manpukuji can be seen in such details as the round windows of the Taiyū Hōden and the rather high decorative railings in front of many of the buildings. A final detail of particular interest is the moon platform in front of the Taiyū Hōden, a flat rectangular stone set in an area of raked white pebbles, on which a ceremony is held to punish priests who violate the injunction against eating meat.

Manpukuji was an important addition to Japanese Buddhism not only because it introduced a variant system of Zen thought, but also because it afforded Japanese artists a glimpse of new and different approaches to creative expression in the realm of architecture, sculpture, and painting.

## Sculpture

It is commonplace in accounts of the art of the Tokugawa period to say that there was no sculpture of any significance. However, as with most such generalizations, fault can be found with this one. Naturally, as Buddhist temples were rebuilt, sculptures were made to replace pieces lost in the ravages of the Ōnin War and its aftermath. These were primarily executed by Buddhist sculptors working in traditional styles. The replacement pieces made for the *kōdō* of Tōji by Kōri and his disciple Kōshō reveal a facile smoothness of surface and little understanding of anatomy or the

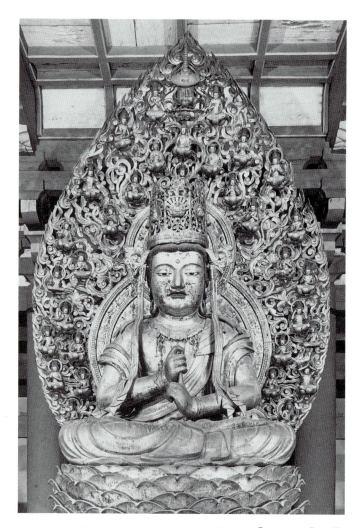

**270.** Dainichi Nyorai, *kōdō* (lecture hall), by KŌRI and KŌSHŌ. Kyōōgokokuji (Tōji), Kyoto. 16th–17th centuries. Wood, with gold leaf, painted eyes, and metal details; height including base 70 7/8 in. (180 cm)

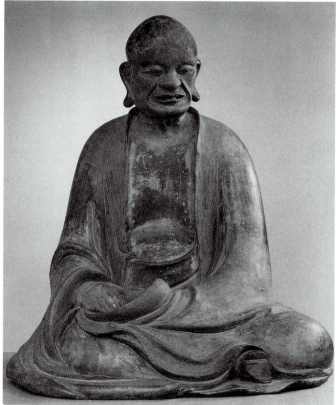

**271.** Arhat, from Gohyaku Rakanji (Temple of the Five Hundred Arhats), from the set attributed to SHOUN GENKEI. Between 1688 and 1695. Wood, with lacquer; height 32 2/4 in. (85.7 cm). The Metropolitan Museum of Art, New York, Fletcher Fund, 1927 (27.69)

possibilities of expressive distortion, though they do impress through size and solidity (fig. 270).

A second school of sculpture in the early Edo period can be traced to its point of origin in the work of a Chinese sculptor, Fan Daosheng (J. Handōsei, 1637–1701), who accompanied the Zen priest Ingen when he emigrated to Japan, and who executed a number of sculptures at Manpukuji in the 1660s. The most outstanding works attributed to him are the eighteen arhats in the Taiyū Hōden of Manpukuji, sculpted between 1663 and 1664. The figures are installed on two low platforms along the walls on either side of the central altar, and worshipers circumambulating the hall pass in front of them. Each arhat sits in a unique pose, relaxed, tensely animated, or inwardly contained, and each has a different facial expression. Many hold prayer beads or the kind of noise-making instruments used to mark stages in the reading of sutras. The impression conveyed by the sculptures is that of individuals responding to religious worship with differing emotions and differing levels of spiritual awareness. The most distinctive figure has

ripped open his torso to expose the head of the Buddha within the cavity of his chest (colorplate 49). The arhat images are constructed of multiple blocks of wood using the *yosegi* technique, coated with *gofun* and painted in various colors with gold-leaf application. The idea of walking among sculpted figures in the act of religious worship in an unfamiliar environment may sound uncomfortable, but the actual experience is quite exhilarating. Every figure is unique: some serious, some comical, and all so totally human that one feels the company of truly remarkable beings.

The Japanese sculptor Shoun Genkei (1648–1710) was directly influenced by Fan Daosheng's work at Manpukuji. Originally a sculptor of Buddhist images in the traditional style, he left Kyoto and took up the life of a wandering priest, traveling around Japan without any clear purpose other than finding an establishment for which he could sculpt a set of the five hundred arhats. Finally in Edo he made contact with an abbot of the Ōbaku sect, who gave him permission to undertake the project for a temple now known as Gohyaku Rakanji, or Temple of the Five Hundred Arhats.

The sculpting took approximately eight years, from 1688 to 1695, and is said to have received some support from the shogun Tsunayoshi. Genkei's sculptures are made of wood in the *yosegi* technique, with bright colors, black

lacquer, and gold leaf applied (fig. 271). However, in contrast to the arhats by Fan Daosheng, Genkei's are not as highly polished; there is more feeling for the original material. Furthermore, although the pose of each individual figure is different from any other and some are quite exaggerated in appearance, still there is a quality about the figures that seems more naturalistic and closer to the tradition of Japanese sculpture in which Genkei was trained. The artist was able to combine elements of the Chinese tradition with indigenous forms to produce a style that was uniquely his own.

A third style of sculpture that appeared in the 17th century is associated with the priest-sculptor Enkū (1628?–1695). In the 1960s and 1970s Enkū studies excited much interest in Japan, and more is known about his life and his artistic development than ever before. Still, many questions remain unanswered. Enkū is thought to have become a priest when he was in his early twenties and to have received instruction in Esoteric Buddhism. Afterward he spent his life traveling around Japan preaching to the common people and providing images to inspire and protect them by virtue of the magic with which the carvings were endowed. Enkū is known to have studied at Hōryūji in Nara and also to have frequented regions in which the Jōdo Shin school of Buddhism was popular. Consequently, there is every reason to believe that after an initial period of training, Enkū formulated his own beliefs and concentrated on conveying them to ill-educated villagers who lived beyond the reach of conventional Buddhist establishments. He preached religious revivalism at a time when the Buddhist Church had lost much of its influence with the people and had become an instrument to counter Christianity. In Enkū's life and work he exemplified two classical traditions: the Heian and Kamakura tradition of wandering priests who devoted their lives to bringing Buddhism to the common people in a form they could understand, and the tradition that flourished along provincial pilgrimage routes of *natabori* sculpture, in which the surface of the wood is left unfinished and the grain of the wood and the marks of the ax or chisel are allowed to show. The exact reasons for the formulation of the *natabori* style or its revival by Enkū are not known, but possibly it was thought that a sculpture bearing clear evidence of the wood from which it was made—and of the process by which it was transformed from the raw material into a representational image—would convey more vividly to the believer the magic of the transformation process and of the divinity itself than would a finished, perfected sculpture. Among Enkū's work are many small, roughly carved pieces now blackened with smoke. Their appearance and condition suggest that they were quickly carved out of wood splinters and hung as amulets in kitchens to frighten evil spirits away from the cooking pot. His larger sculptures reveal more concern for form. His earliest known works were produced in Hokkaidō in connection with a ceremony in which fishermen cast images of Amida and

**272.** Niō, by ENKŪ. Senkōji, Gifu prefecture. Late 17th century. Wood; height 6 ft. 9⅞ in. (2.08 m)

two bodhisattvas into the water so that they might gather up the souls of fishermen lost at sea and carry them to Paradise. After the ritual, the statues were retrieved and installed in a temple dedicated to Amida. Later, Enkū developed the technique of splitting a log into two or four pieces and creating statues that are triangular in cross section. Using the angle formed at the core as the front of his image, he cut in the details, moving from that point to the wide flat surface at the back of the piece. Among his most impressive later works are two Niō images in Senkōji (fig. 272). Only the faces and peculiar featherlike crowns are indicated at the top of a tall, roughly cut vertical piece of wood. Nevertheless, the figures seem to radiate energy and mystical power. To country peasants for whom the lifeless provincial imitations of classical sculptures installed in local temples had ceased to have meaning, these strange, rough, angular images must have been truly awe-inspiring.

## Traditional Painting of the Kanō

In the first decades of the 17th century, painters such as Hasegawa Tōhaku, Kanō Sanraku, and Sōtatsu continued to dominate painting circles in Kyoto. However, by the 1630s all but Sōtatsu were dead, and the new conservative aesthetic of the Tokugawa shogunate had come to prominence, receiving mature expression in the work of Kanō Tanyū (1602–1674), a grandson of Eitoku. From the late Muromachi period on, the Kanō family had maintained the closest of connections with the military rulers of Japan. Some ground had been lost under Mitsunobu, but Tanyū early in his life recognized that the support of the

**273.** Emperor Wen section, from four *fusuma* panels illustrating *Teikan zu* (*Mirror of Emperors*), by KANŌ TANYŪ. South side, *Jōdanoma*, Jōrakuden, Nagoya Castle. Early 17th century. Color, gold paint, and gold dust on paper; each panel 75⅝ x 55¼ in. (192 x 140.5 cm)

Tokugawa clan was essential to the future success of the family academy. In 1612 and again in 1614 he had formal interviews with the shoguns Ieyasu and Hidetada. In 1617, when Tanyū was only fifteen, his efforts bore fruit. He was named official painter to the shogunate, and in 1621 he was offered a tract of land outside the Kajibashi Gate of Edo Castle to establish a residence and studio. Ultimately two other members of the Kanō family, Naonobu and Yasunobu, were persuaded to move from Kyoto to Edo and were similarly granted parcels of land to reclaim as sites for their studios. The last of the Kanō to put down roots in the de facto capital was Munenobu, the grandson of Naonobu, who was also given a tract of land. By the latter part of the 17th century four separate branches of the Kanō family were active in the Edo area and had been given the official designation *oku eshi*, painting master of the inner circle.

The four branches of the Kanō family continued to flourish in the decades after Tanyū's death, producing conservative paintings that were an amalgam of Chinese themes and the decorative style the early masters of the school had developed for covering large wall surfaces. Their patrons continued to be wealthy and high-ranking samurai-officials in the shogunate. For the next two centuries the Kanō school devoted itself primarily to creating works that reflected the policies and ideals of this ruling class. Although the work of the Kanō school is not held in the highest repute today, throughout the Edo period Kanō masters set the artistic standards by which the works of other schools were judged. Most artists began by studying in the Kanō school and only later went on to develop their individual styles.

## Kanō Tanyū

Tanyū's work provides a strikingly good example of the orthodoxy of the Kanō school. In 1634 Iemitsu visited Kyoto, and Nagoya was on the route, so the lord of Nagoya Castle added a new building, the Jōrakuden, to the castle's innermost enclosure in honor of the occasion. Tanyū was commissioned to execute the wall paintings for the Jōrakuden, and for the *jōdanoma*, the most important section of the interview room, he chose the theme of the *Teikan zu*, the *Mirror of Emperors*, the popular Chinese tract on the actions of good and bad emperors judged by Confucian standards. This work, first illustrated in Japan by Sanraku in the early 1600s, had become one of the most popular themes for wall paintings in daimyo residences by the second quarter of the 17th century (fig. 273). For a second area he used another Chinese theme, the

Four Gentlemanly Accomplishments, and for the third, a *yamato-e* subject, landscapes of the four seasons with birds and flowers. One of the best-preserved sections from the *Mirror of Emperors* depicts the story of Emperor Wen, who ordered the construction of a tower but rescinded his order when he found out how expensive it would be, the moral being that such a lavish expenditure of money for a nonessential item was unjustifiable. Tanyū has distributed elements of the composition across four *fusuma* panels, beginning with a gnarled evergreen in the right panel, its upper branches obscured by white mist and a sprinkling of gold dust. In the next panel, the emperor can be seen talking to an attendant who kneels on the ground of the courtyard. At the very bottom of the panel, outside an elaborate gate, a servant stands ready to relay the emperor's decision to his workmen. To the left, motifs of rocks and gold clouds crowd into the corner of this panel and spill into the next, only to split around a plateau on which workmen are standing, near an incomplete wooden foundation. The organization of rocks, trees, and cloud motifs clearly sets off the world of the emperor from that of the carpenters, truly a realm above the clouds, but the individual motifs are more decoratively than logically disposed. A pathway leading nowhere can be seen between rocky outcroppings; a torrent of rushing water appears arbitrarily. The painting has an idyllic quality, not a sense of the dramatic moment.

Another aspect of Tokugawa-Kanō orthodoxy can be seen in Tanyū's *Tōshōgū Daigongen engi emaki* of 1640, an illustrated history of the founding of the shrine, owned by the Tōshōgū Shrine at Nikkō. When Tanyū was called upon to illustrate this text, he chose to revive the *yamato-e* style of classical temple *engi emaki*, complete with armor-clad samurai riding into battle, official ceremonies in buildings depicted with "blown-off" roofs, and individual locations within the shrine complex depicted as luminous, romantic landscapes. Tanyū undoubtedly had ample access to *emaki* of the Kamakura and Muromachi periods. Not only was he the official painter to the shogunate, he was a recognized connoisseur of Japanese and Chinese art and was regularly consulted about the authenticity and value of works of art. Notebooks of quickly executed sketches of the paintings he was asked to evaluate and brief notations of his opinions, as well as the names of the owners, have been preserved to the present day.

A passage from the second scroll, depicting the battle for Osaka Castle (fig. 274), reveals Tanyū's close study of a number of battle *emaki*, including the *Heiji monogatari emaki* (see colorplate 29). Soldiers in armor charge to the left, attacking the defensive gate of the castle. Arrows fly and halberds are wielded vigorously, but there is a curiously bloodless quality about the scene. Numerous details suggest that Tanyū was not terribly concerned with the actual historiography of battle; he combined visually interesting motifs to produce a lively and pleasing composition, without much concern as to factual accuracy. The *Tōshōgū Daigongen engi emaki* is

**274.** Illustration from *Tōshōgū Daigongen engi emaki,* by KANŌ TANYŪ, scroll 2, scene 1, showing the battle for Osaka Castle. 1640. Hand scroll, color on paper; height 19¼ in. (49 cm). Tōshōgū Shrine, Nikkō, Tochigi prefecture

clearly based on the *yamato-e* traditions of the 12th and 13th centuries, but the powerful narrative impulse, the energy, and the passion for realistic detail found in the older works are missing in these mid-17th-century works.

## Seisenin (Kanō Osanobu)

The leading painter of the Kanō school in the first part of the 19th century was Kanō Osanobu, also known by his art name Seisenin (1796–1846), who chose to return to classical Japanese painting, particularly *emakimono* of the Kamakura period, to renew the foundations of his work. He did not use these older scrolls as Sōtatsu had done, as a training manual for figure studies, but rather as a reference point for his own compositions. A recently discovered set of 264 hand scrolls in the Tokyo National Museum illustrates this very well. These scrolls present *kojita-e,* or small-scale preliminary drawings, for the wall and *fusuma* decorations of the Tokugawa palace in Edo. Through an accident of fate these scrolls are all that remains of the rebuilding and redecoration of the palace that took place in the middle of the 19th century.

After the *honmaru,* or main enclosure, of the palace—the structure that served as the locus of shogunate government—burned down in 1844, Seisenin was specifically instructed to prepare preliminary drawings for the decorations in the new buildings "along the lines of what had been there before." The shogunate's directive to its premier artist was to re-create the paintings that were destroyed—to repeat the images that had been fresh two hundred years earlier, when Tanyū had decorated the Edo palace in the mid-1600s. Many of Seisenin's designs present themes familiar in the Kanō repertoire: massive pine, plum, and cherry trees, and scenes from the *Teikan zu* that seem close in design to Tanyū's work for Nagoya Castle. However, in his treatment of *yamato-e* themes, illustrations from such classics as the *Tale of Genji,* and *meisho-e* (paintings of famous places), he brings a noticeable freshness to his subjects.

Seisenin's interest in traditional, even ancient, Japanese themes and painting styles included an in-depth study of the story and illustrations of the *Eiga monogatari, A Tale of Flowering Fortunes,* about the Fujiwara clan at the height of its power in the Middle Heian period. Not only did Seisenin make a copy of the *Komakurabe gyōkō emaki,* a scroll that illustrates an episode of the tale about an imperial visit to the horse races, an *emaki* still extant today, he also studied the Heian-period text of the tale as well as contemporary journals kept by the nobility.

One of the fruits of Seisenin's labors can be seen in a room in the *ōoku,* the inner section of the *honmaru.* For the *tokonoma* he created a drawing based on the first chapter of the *Eiga monogatari,* in which Emperor Murakami at a moon-viewing banquet inspects two artificial gardens prepared for a competition (colorplate 50).

> The contestants from the Office of Painting submitted a painted landscape tray depicting flowering plants of heavenly beauty, a garden stream, and massive rocks. Various kinds of insects were lodged in a rustic fence made of silver foil. The artists had also painted a view of the Ōi River, showing figures strolling nearby and cormorant boats with basket fires. . . . The Office of Palace Works presented an interesting tray, carved with great ingenuity to resemble a beach at high tide, which they had planted with artificial flowers and carved bamboo and pines.
>
> McCullough, *A Tale of Flowering Fortunes,* pp. 92–94

In Seisenin's 19th-century illustration of the scene, the moon-viewing balcony of the Imperial Palace appears through a sea of gold clouds. Emperor Murakami, barely visible behind bamboo blinds, looks on as two men in official court dress make their presentations. The scene was often illustrated in lively black-and-white woodblock prints that accompanied printed versions of the text, but Seisenin has created a scene with only a few figures, described in pale colors and surrounded by open space, that speaks of a far-off and ideal era, a romantic glance backward in time.

**275.** Scenes from Hatsune *(above)* and Momijigari *(below)* chapters, *Genji monogatari (Tale of Genji)*, a pair of eight-panel *byōbu*, by SEISENIN (KANŌ OSANOBU). 2nd quarter 19th century. Color on paper; each screen 39¼ x 160¼ in. (99.7 x 407.9 cm) Hōnenji, Takamatsu, Shikoku

These scrolls also afford a view of the interaction between artist and patron. Seisenin, having received his commission, first made rough drawings in ink that he could change merely by "whiting out" a section and redrawing it. In these we see the artist working through the designing process, changing the curve of a branch, the placement of a figure. Once he was satisfied with his composition, he prepared a more finished drawing, adding color where appropriate. The sketches were glued together as hand scrolls and presented to the patron, who could request changes. These would be made on small pieces of paper, which were then affixed along one edge over the original sketch, so the patron could easily check the new against the old. Once he approved the design, the *kojita-e* would be used as the basis for developing large-scale wall and *fusuma* paintings. Sadly, Seisenin's final work in the palace was lost forever when the building was once again severely damaged by fire in 1863.

An example of the Kanō master's finished product in the *yamato-e* style is a pair of folding screens in Hōnenji, illustrating early chapters of the *Tale of Genji:* Momijigari, or Autumn Excursion, and Hatsune, or First Warbler's Song (fig. 275). The episode from Momijigari is the frequently depicted scene of the dance Waves of the Blue Ocean, performed by Genji and his principal rival at

court, Tō Chūjō, on the occasion of the royal autumnal excursion. Perhaps because this episode was so well known from earlier illustrated versions of the text, Seisenin made no effort to rework the scene. However, in the Hatsune screen he has captured something of the gentle, romantic tone of the text. The time is a cloudless New Year's Day, the setting Lady Murasaki's quarters in Genji's palace in Kyoto's sixth ward.

The scent of plum blossoms, wafting in on the breeze and blending with the perfumes inside, made one think that paradise had come down to earth.

Edward Seidensticker, trans., *The Tale of Genji*, New York, 1976, p. 409.

The painting begins to the right with the tops of several pine trees silhouetted against white clouds. To the left the elegant apartments of Lady Murasaki unfold. A number of ladies-in-waiting are settled around the edges of the main room, and in the center Genji, seated behind a low table on which dishes of rice cakes have been placed, is talking to the elegantly dressed Lady Chūjō, an attendant to Murasaki. Genji has just asked the ladies to tell him their wishes for the future, and Lady Chūjō has come forward to make a graceful reply, referring to the rice

**276.** The Mirror Seller, by REIZEI TAMECHIKA. 1850.
Hanging scroll, ink and color on paper;
40 x 19⅛ in. (100.6 x 48.7 cm). Tokyo National Museum

spring. At heart, Seisenin was a conservative artist working within the guidelines of the four-centuries-old Kanō school. Nevertheless he was not content to repeat the stereotyped themes and painting techniques of his predecessors. He tried to revitalize his work by drawing inspiration from some of the great paintings of the past. Indeed, he was the last of the great Kanō masters of the Edo period.

## The Revival of *Yamato-e*

A painter who went much farther in reworking classical *emaki* was Reizei Tamechika (1823–1864). Tamechika was the most talented member of a school known as *fukko yamato-e*, or revival *yamato-e*. Although adopted into a family of Kanō painters, he was interested only in Japanese-style painting from the Heian and Kamakura periods and made a thorough study of these and of ancient court costumes and ceremonies. In 1850 he achieved one of his greatest ambitions. He was adopted by Okada Dewa Kami, an official in the emperor's protocol department, thereby attaining court rank. After that he began to produce works even more strongly classical in style. His search for ancient paintings led him to the collection owned by the Sakai family, Kyoto deputies for the shogunate who had jurisdiction over the imperial court and the daimyo of the western provinces. Because of his association with high-ranking samurai—even though his interest was solely in the paintings they owned—Tamechika was suspected of being disloyal to the emperor and to the political faction supporting his restoration and control of the government. Tamechika, forced into hiding, took refuge in various temples in the Kansai area, but to no avail. He was murdered in his forty-second year in the vicinity of Nara.

A painting that captures the *mono no aware* of classical Heian works of literature is The Mirror Seller (fig. 276). It is a day during the dreary month of the rainy season. The nobleman Oe Sadamoto, serving as the provincial governor of Mikawa, is asked to look at a mirror which a young woman has brought to sell. When he opens the box containing the mirror, he finds a tattered piece of paper on which a poem has been written.

> Today when I looked,
> the mirror had become
> bright with tears.
> It speaks to us
> of the shadows.

Trans. by Penelope Mason, fom the
*Konjaku montogatari*, section 3, *Secular
Tales of Japan*, volume 24, episode 48

After reading the poem Sadamoto has a sudden realization of the impermanence of life and renews his resolve to become a priest.

Dominating the painting is a horizontal section of a Heian palace and inside the figure of Sadamoto sitting at a low table, reading the poem in the mirror box. There is a

cakes, symbols of the New Year celebrations. Several male courtiers can be seen outside the main room, and to the left is Murasaki's spring garden, ornamented by blossoming plum trees, willows, and a stream with a curved bridge across it. The painting captures the gentle elegance of the scene and even something of the quality of horizontal narrative illustrations. The pine trees to the right of the screen symbolize long life, the universal wish at the beginning of a new year, while the plum trees to the left refer specifically to Murasaki's garden, which was designed to be at its peak of beauty from February through April, the Japanese

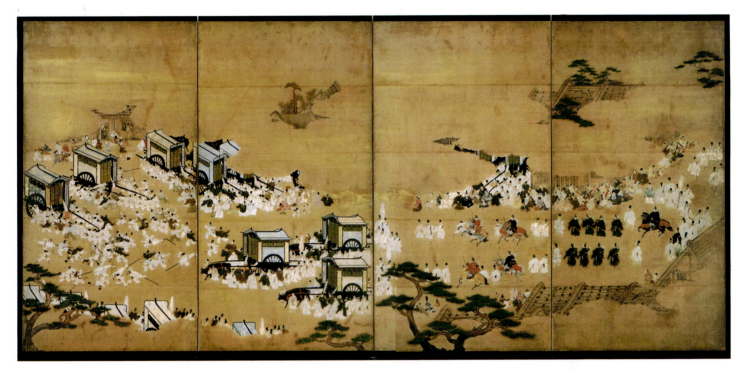

**Colorplate 44.** The Carriage Fight, a scene from the Hollyhock chapter of the *Tale of Genji*, remounted on a four-panel *byōbu*, by KANŌ SANRAKU. Early 17th century. Color and ink on paper; 68⅞ x 145½ in. (175 x 370 cm). Tokyo National Museum

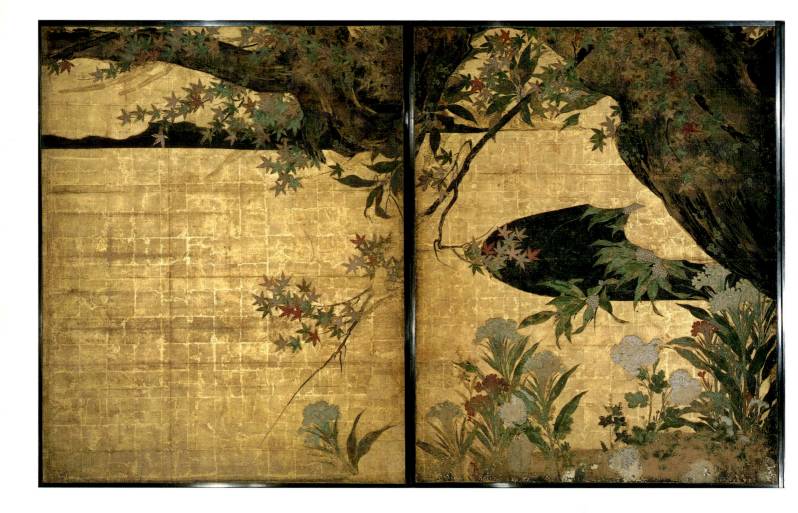

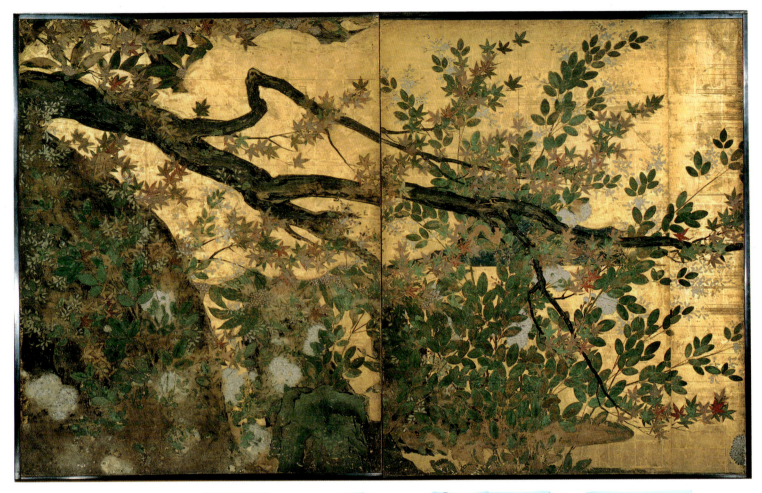

**Colorplate 45.** Maple Tree, on four *fusuma*, by HASEGAWA TŌHAKU. Chishakuin, Kyoto. Late 16th century. Color and gold leaf on paper; each panel 67⅞ x 54½ in. (172.5 x 138.5 cm)

in 1592

Momoyama P.          " Maple Tree and Flowers"

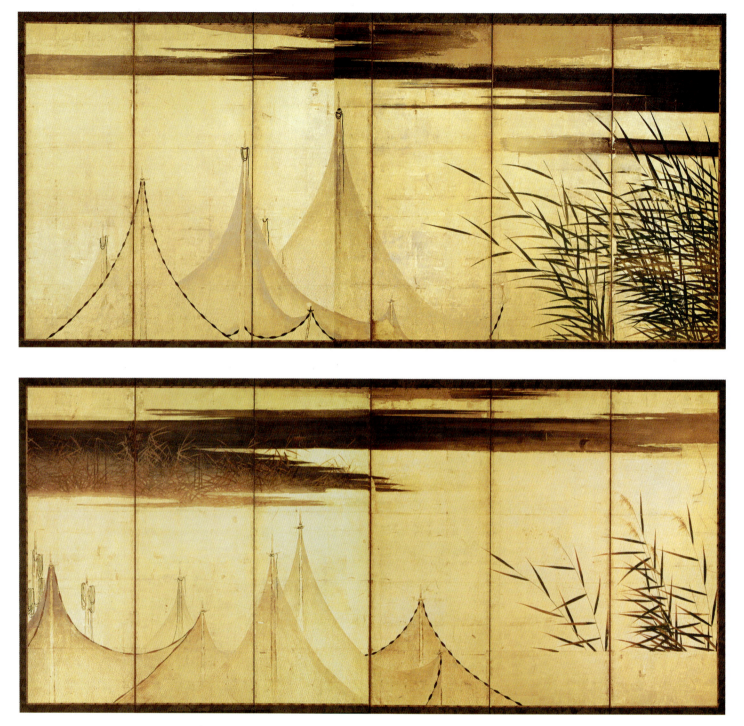

**Colorplate 46.** Fish Nets Drying in the Sun, a pair of six-panel *byōbu*, by
KAIHŌ YŪSHŌ. 17th century. Color and gold on paper; each screen 63 x 138 in. (160 x 351 cm).
Imperial Household Agency

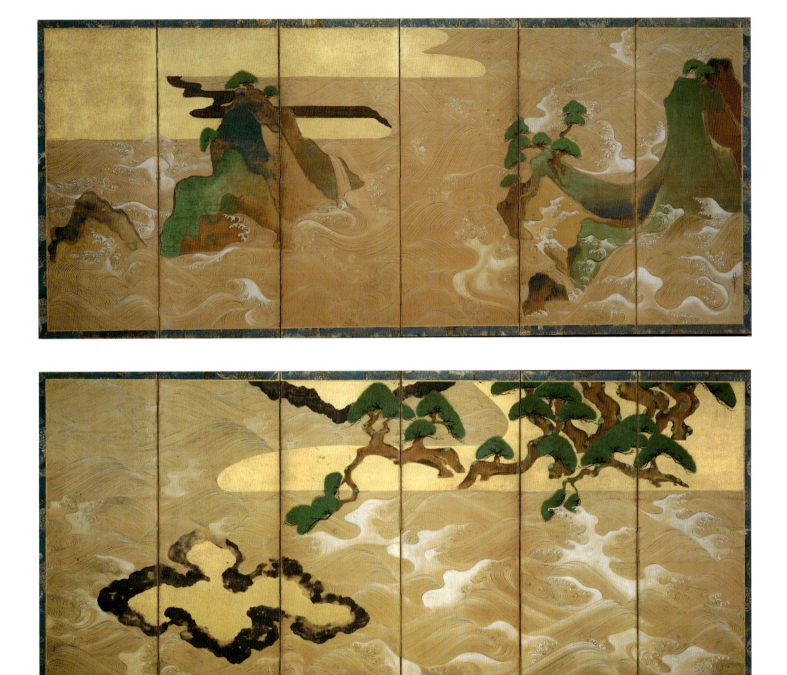

**Colorplate 47.** Pair of six-panel *byōbu,* known as the Matsushima screens, by SŌTATSU. 17th century. Ink, color, and gold leaf on paper; each screen 59⅞ x 140½ in. (151.9 x 356 cm). Courtesy of the Freer Gallery of Art, Smithsonian Institution, Washington, D.C. (06.231 and 232)

**Colorplate 48.** Pair of six-panel *rakuchū rakugai zu byōbu*,
known as the Funaki screens. 1614–15.
Ink and color with gold leaf on paper; each screen 63¾ x 134 in.
(162 x 340 cm). Tokyo National Museum

In and Around Kyoto

**Colorplate 49.** The arhat Ragora, with torn-open torso, by FAN DAOSHENG (HANDŌSEI). 1663–64. Wood, with paint and gold leaf and metal detail; height 51⅜ in. (130.5 cm). Taiyū Hōden, Manpukuji, Uji, Kyoto prefecture

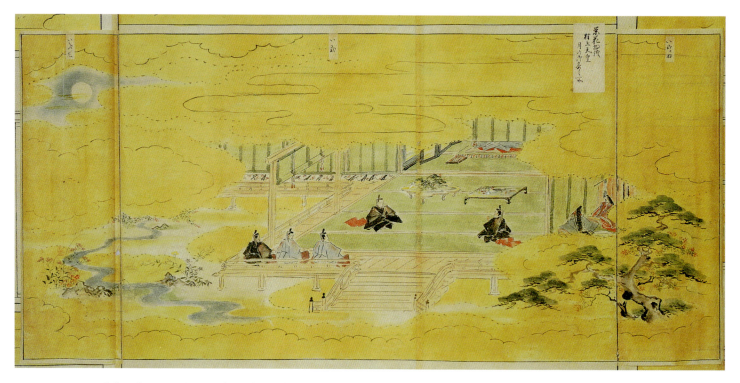

**Colorplate 50.** Section from the preliminary drawings (*kojita-e*) for decoration of Edo Castle, by SEISENIN (KANŌ OSANOBU), showing scene from *Eiga monogatari-e:* Moon-viewing Party with Landscape Tray Competition. 2nd quarter 19th century. Hand scroll, color on paper; height without frame 18 in. (45 cm). Tokyo National Museum

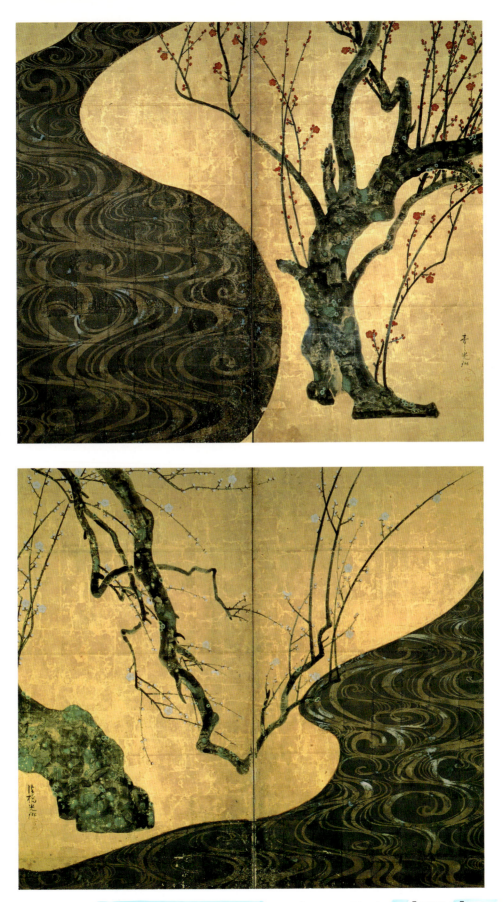

**Colorplate 51.** Red and White Plum Blossoms, a pair of two-panel *byōbu*, by ŌGATA KŌRIN. c. 1710–16. Color and gold and silver leaf on paper; each screen 61⅝ x 67⅞ in. (156.5 x 172.5 cm). M.O.A. Museum of Art, Atami, Shizuoka prefecture

Edo P.

**Colorplate 52.** Pine Trees in Snow, a pair of six-panel *byōbu,*
by MARUYAMA ŌKYO. 4th quarter 18th century. Ink, light color and gold
on paper; each screen 60⅞ x 142½ in. (155.5 x 362 cm).
Mitsui Bunko, Tokyo

Edo P.

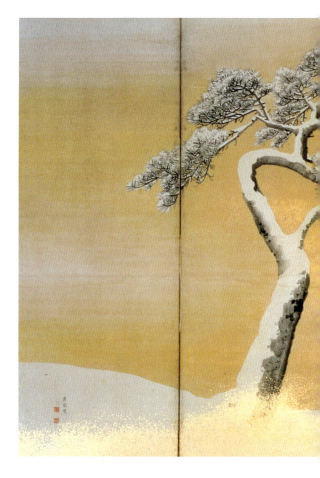

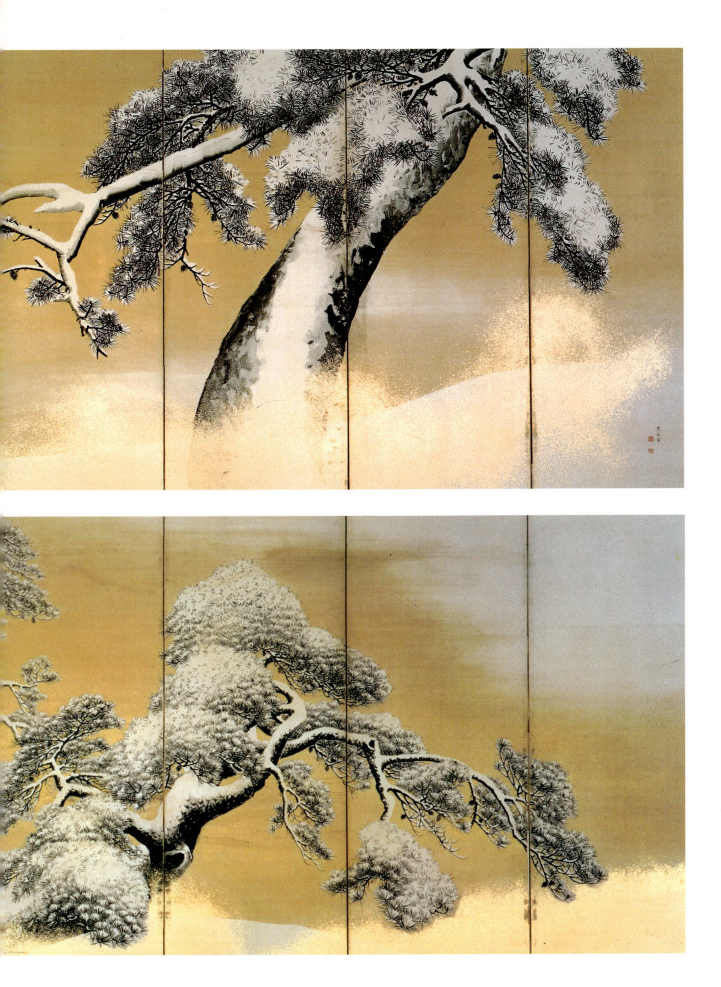

Colorplate 53. White Plum Trees, a pair of six-panel *byōbu*,
by MATSUMURA GOSHUN. 1781–89.
Slight color on silk; each screen 69 x 147 in. (175.5 x 373.5 cm).
Itsuō Art Museum, Osaka

**Colorplate 54.** Orchid Pavilion and Banquet on Dragon Mountain, a pair of six-panel *byōbu,* by IKE TAIGA. 1763. Ink and color on paper; each screen 62¼ x 141 in. (158 x 358 cm). Shizuoka Prefectural Museum of Art

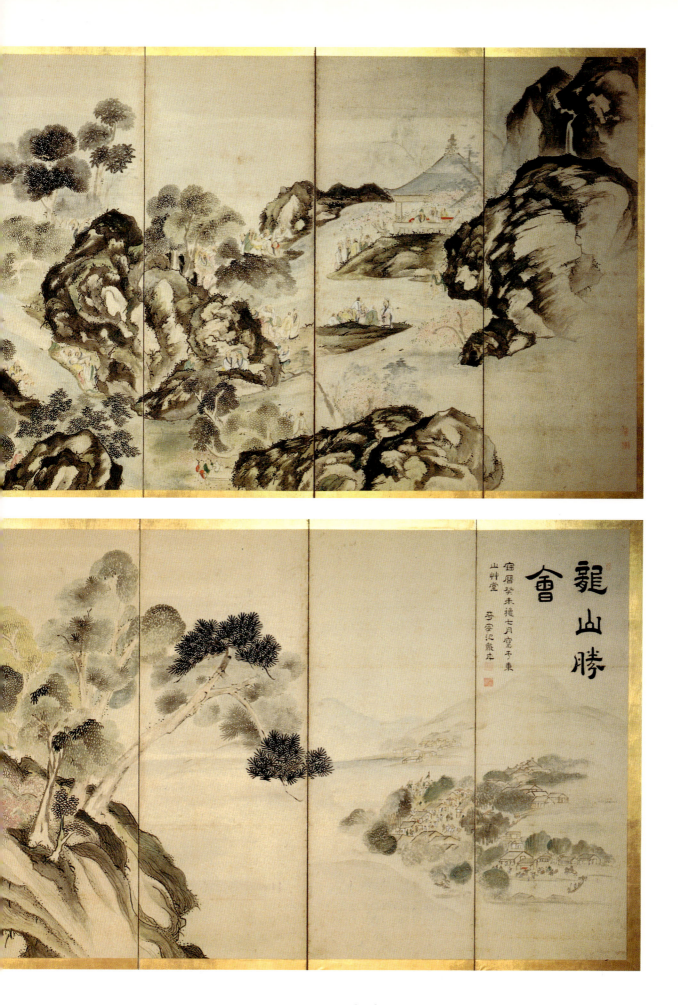

龍山勝
會

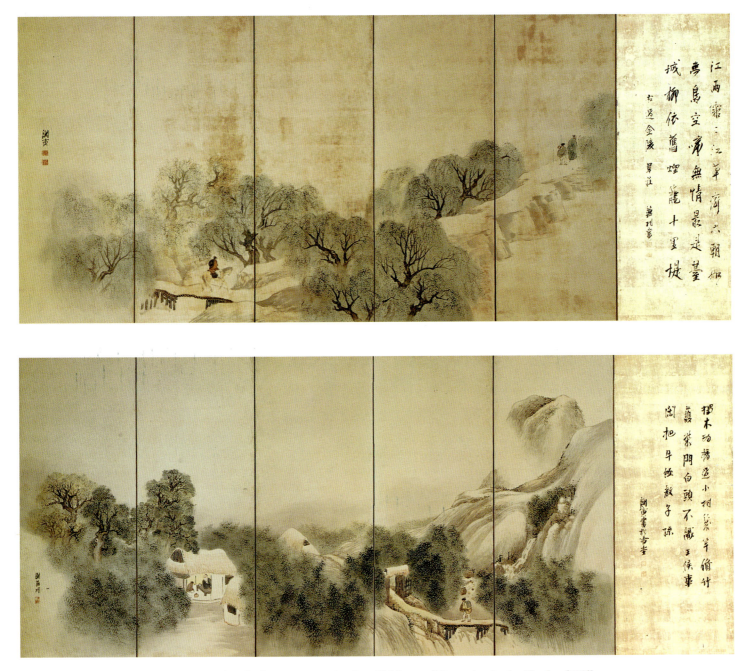

**Colorplate 55.** Thatched Cottage in a Bamboo Thicket and Returning in the Shade of Willows,
a pair of six-panel *byōbu,* by YOSA BUSON. 1770 and 1778–83. Color on paper;
each screen 52³/₈ x 124¹/₂ in. (133 x 316 cm). Collection of a private college, Hyōgo prefecture

**277.** Box decorated with fan paintings, by ŌGATA KŌRIN. Late 17th century. Color on paper, applied to lacquer on wood with gold-leaf ground; height 7½ x width 15 x depth 10⅞ in. (19 x 38.2 x 27.5 cm). Museum Yamato Bunkakan, Nara

claustrophobic quality to the space around the nobleman. Lying heavily on the roof is a thick mist and dripping from the eaves are long spills of rain confining him in interior space. The atmosphere of the painting is moist; even the plants in the garden are bent under the weight of the rain. Further obscuring the horizontal wing of the palace is a corridor set on a sharp diagonal, the young woman at the lower end. All these details serve to suggest how crimped and circumscribed the life of the provincial governor is, and how much the poignancy of the poem has moved him to renew his decision to become a priest. A further touch to suggest the Heian setting is a pair of *shikishi* shapes painted in different colors and used as the background for calligraphy—a reminder of the poem inscription frequently found on *fusuma* and *byōbu* paintings of the period. In this painting, dated 1850, Tamechika has taken an episode that appears in several different Heian texts and without losing the flavor of an incident from bygone times has given it a modern treatment.

## The Rinpa School

The Rinpa school traces its ancestry back to Sōtatsu in the Momoyama period, but it takes its name from Ōgata Kōrin, who was probably a third-generation descendant. Rinpa means literally the School of Rin. Sōtatsu and Kōrin came from the *machishū*, a class of merchants and artists who rose to positions of wealth and power in Kyoto at the end of the period known as Sengoku, the country at war (1467–1568). They allied themselves with the impoverished nobility, frequently lending them money to refurbish their mansions and also absorbing their cultural values. In the subsequent Tokugawa period, the *machishū* became the cultural aristocracy of the *chōnin* class, which developed primarily in Osaka and Edo in the 17th century. Because of their affiliation with court culture, Sōtatsu and

Kōrin both chose to depict themes from the literature favored by the nobility: the *Tale of Genji*, the *Tales of Ise*, the poetry of the thirty-six great poets of ancient times, and so on. Other subjects these artists often treated were the birds and flowers of the four seasons. The Rinpa school is also distinguished by its lavish use of bright colors and gold and silver, reminiscent of the gorgeousness of Heian-period art, when the nobility was in its prime. Surprisingly, neither master produced an heir apparent of significant talent, and when the school was revived in the late Edo period, the leaders—Sakai Hōitsu and Suzuki Kiitsu—were too young to have known Kōrin.

## Ōgata Kōrin

Ōgata Kōrin (1658–1716), though born into the merchant class, stands somewhat apart from the mainstream of Genroku-period art at the turn of the 17th century. His family had long been acquainted with shoguns and daimyo, and had been closely associated with some of the most respected connoisseurs in the country. From the Momoyama period on, the family had owned a textile shop in Kyoto, the Kariganeya, which supplied fabrics and garments to the wives of Toyotomi Hideyoshi and Tokugawa Hidetada as well as to an imperial consort. Furthermore, Kōrin's great-grandfather had been active in Honami Kōetsu's artistic community Takagamine, and had married Kōetsu's sister. In spite of the early prosperity of the Ōgata family, by the time Kōrin's father died, the business had lost its prestigious contacts with the shogunate and the imperial family and was encumbered by bad debts. Consequently, although Kōrin was able to live in an extravagant manner for a few years after he came into his inheritance, he was soon forced to sell family treasures and, in 1696, his large house.

Kōrin and his younger brother Kenzan began to make their living working for newly wealthy *chōnin*, Kōrin by designing textiles and painting *kakemono* and *byōbu*, and Kenzan by making ceramics. Something of Kōrin's feelings about his diminished status can be inferred from a well-known incident in which he and a member of the Mitsui family, proprietors of the Echigoya, a forerunner of the modern department store, were walking together dressed in their finest clothes. Suddenly it began to rain. Mitsui ran for shelter to save his clothing from damage, but Kōrin continued to amble slowly along and even stopped to talk to an old beggar sitting beside the road. His arrogance and his disdain for *nouveaux riches* townsmen like Mitsui, with their down-to-earth pragmatism and their concern for business, must have played a role in his art. He did not cater to the *chōnin's* interest in the theater and the pleasure district. Instead he chose to work in the Kanō style favored by the military class and in the decorative style pioneered by Sōtatsu, thereby maintaining the artistic traditions of his family.

In Kōrin's art three essential elements can be dis-

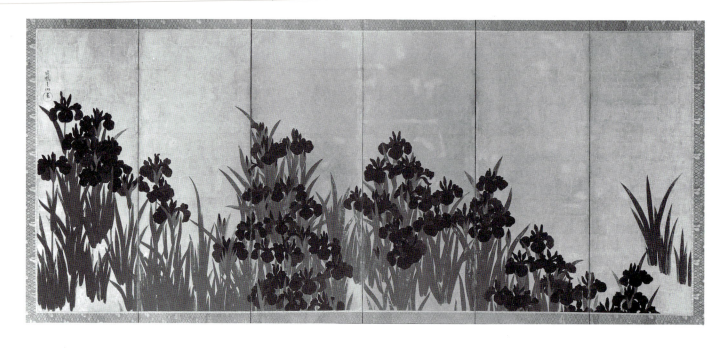

"Yatsuhashi" tale of Ise.

Edo P.

**278.** *(Top, left and right)* Irises, a pair of six-panel *byōbu*, by ŌGATA KŌRIN. c. 1701. Color with gold leaf on paper; each screen 59½ x 133⅜ in. (150.9 x 338.8 cm). Nezu Museum, Tokyo

**279.** *(Bottom, left and right)* Flowers of the Four Seasons, by ŌGATA KŌRIN. 1705. Originally a hand scroll, now mounted on four panels; each 14⅜ x 51¾ in. (36.6 x 131 cm). Private collection

tinguished. Foremost of these is the continuation and re-working of the decorative style and the *yamato-e* themes employed by Sōtatsu in the early 17th century. Several of his paintings are actually copies of designs originated by Sōtatsu. Kōrin painted figural and floral designs on a number of fans pasted on the surface of a gold lacquer box. One fan depicts a man talking to several retainers and gesturing excitedly with his fan (fig. 277). The subject of the painting has not been precisely identified, but it may be an episode from the *Tale of the Hōgen Rebellion,* a frequent source for Sōtatsu's fan paintings, and indeed Kōrin's fan is similar in theme and style to a fan painting on a screen in the Freer Gallery in Washington, D.C., that has been attributed to Sōtatsu's studio (not illustrated).

A second major element in Kōrin's work is the flat, simplified quality of many of his designs. Although he made numerous drawings of plants and birds from life, attempting to capture accurately the visual reality of the natural world, the motifs in his more formal paintings are treated like decorative textile designs rather than re-creations from life. This element of his style is particularly well displayed in the striking Iris screens (fig. 278). Kōrin painted the flowers in *mokkotsu,* the boneless method, a style of painting without ink outlines that had originated in China and had been exploited by Sōtatsu. Clusters of velvety iris—their petals differentiated by flat areas of light and dark blue rather than by shading—are arranged in rhythmically related clusters over the gold-leaf surface of the two six-panel screens. The shapes of the iris and their spiky green leaves appear like silhouettes against the

glowing background. The theme depicted in the Iris screens can be traced back to a passage from the *Tales of Ise* in which the hero, banished from the capital, journeys with several companions to the east. One day they stop beside a marsh, across which there is a simple plank bridge. They all sit down on the bank, along which iris are growing, and the hero composes a poem using the syllables of *kakitsubata*, the Japanese word for a species of iris, to begin each line. These screens represent the Ise theme reduced to its essence, the iris, and that single motif is treated as an almost abstract shape existing in space devoid of real depth, a treatment that would be particularly appropriate in a textile design but that also is extraordinarily effective as a large-scale screen painting. Kōrin created several other, more explicit, versions of the theme. One, a hanging scroll in the Tokyo National Museum, depicts the exiled man, his companions, the iris growing beside the stream, and even the beginning of the bridge across the marsh. A pair of screens in the Metropolitan Museum of Art, New York (not illustrated here), depict the iris and the many turns of the bridge, known as *yatsuhashi*

or eight-plank bridge. The Irises screens in figure 278 represent the final evolution of the theme from representation to abstraction.

A third major element of Kōrin's art is his love of luxury and flamboyant display. Anecdotes abound regarding his penchant for extravagant indulgence, but the one that conveys some of the flavor of his image of himself as an aristocrat among the bourgeoisie deals with an outing he attended in which display was *de rigueur*. Kōrin produced from his picnic basket leaves coated with gold, and he used them as saucers on which to float brim-full sake cups on a nearby stream, in the manner of ancient Chinese noblemen who invented the custom and who required guests to compose a poem before taking a sip. Something of this same love of luxurious display can be seen in the Red and White Plum Blossoms, a pair of screens depicting a plum tree on either side of a curving stream, the surface of which is treated as a series of flat decorative wave patterns in ink and silver (colorplate 51). The plum branches are slender, angular forms with small, barely emerging blossoms, while the stream in the center

is a wide, curvilinear shape, rich in pattern and contrasts of light and dark; the whole design is set against a background of glistening gold.

The chronology of Kōrin's work is not easy to establish with any degree of reliability because so few of his paintings were dated. However, a general distinction has been made between the works produced during his formative period in Kyoto from 1697 to 1703, those painted during his stay in Edo from 1704 to 1710, and those made between his return to Kyoto and his death in 1716. The Iris screens are the best works of his first Kyoto period, produced shortly after 1701, when he was honored with the title of Hokkyō, a Buddhist rank of honor accorded to artists, and reveal a lighthearted touch in the use of brilliant colors against a gold ground that is appropriate in the work of a relatively young man who had only recently turned his hand to the designing of textile motifs and the painting of large-scale screens (fig. 278).

During this period Kōrin became acquainted with Nakamura Kuranosuke, a senior official in the silver mint, perhaps through their mutual interest in Nō drama. Profiting handsomely from the recoinage ordered by the shogunate in 1695, Nakamura began to live on an extravagant scale and apparently became Kōrin's patron. In 1704 Kōrin followed Nakamura when he was transferred to the Edo silver mint, located in the area of Tokyo known as the Ginza, literally seat of silver, and he lived there for six years. At first most of his work was done for a wealthy lumber merchant, but gradually his clientele shifted to the samurai class, who demanded works in the Kanō style. One of the few dated paintings by Kōrin is a hand scroll depicting flowers of the four seasons, dated to 1705 (fig. 279). The scroll consists of numerous types of flowers and grasses—peonies, hollyhocks, iris, chrysanthemums, daffodils, and many others—depicted in ink and pale colors across the entire surface of the *emaki*. The manner in which the flowers are outlined in pale ink and filled in with thin, moist colors, and the leaves painted in the boneless method in ink with frequent use of the *tarashikomi* technique, the color-over-wet-color technique associated with Sōtatsu, strongly suggests that Kōrin was familiar with and influenced by Sōtatsu's designs for the poem scrolls calligraphed by Kōetsu and also with his paintings in ink.

Kōrin's dream of making a fortune in Edo seems not to have materialized, and his independence as a painter, the freedom to develop his talents as he wished, was frustrated by the need to satisfy samurai patrons who wanted works in the officially sanctioned Kanō style. Consequently, in 1710 he renounced this path to success and returned to Kyoto where he could work with fewer constraints. The Red and White Plum Blossoms screens, which are from this last period, reflect his assurance in their successful combination of seemingly inappropriate motifs, their tension between the real and the unreal, and their barely controlled sense of flamboyance.

**280.** Ninth Month, one of twelve hanging scrolls of Flowers and Birds of the Twelve Months, by SAKAI HŌITSU. 1823. Color on silk; 55 1/8 x 19 5/8 in. (140 x 50 cm). Imperial Household Agency

**281.** White Camellias and Autumn Grasses, a "pair" of two-panel screens, by SUZUKI KIITSU.
2nd quarter 19th century. Ink, color, and gold and silver on paper; each screen 59⅞ x 66 in. (152 x 167.6 cm).
Freer Gallery of Art, Smithsonian Institution, Washington, D.C.

## Later Rinpa Artists

Two artists of the *bakumatsu* period—the last decades of the Tokugawa shogunate—who looked back to Kōrin and the paintings of the Rinpa school for inspiration were Sakai Hōitsu (1761–1828) and his follower Suzuki Kiitsu (1796–1858). Hōitsu was born to a high-level samurai family, the feudal lords of Himeji Castle and surrounding Harima province, and received an education appropriate to his station in life. However, he entered the priesthood in 1797 at the age of thirty-six, perhaps due to ill health or because he wished to free himself of the responsibilities of his position within the *han*. Hōitsu was particularly interested in painting and is known to have studied the work of the Chinese academic artist Shen Nanpin (Shen Nanp'in), known for his meticulous and brightly colored depictions of birds and flowers. He also experimented with *ukiyo-e* painting, and even with the styles of traditional Japanese schools, but after 1797 he turned his attention exclusively to the Rinpa style. From 1810 to 1819 he devoted himself to a revival in Edo of Kōrin's style, and even held a ceremony in 1815 commemorating the centennial of Kōrin's death. He also published two sets of volumes on the master, the *Kōrin hyakuzu, One Hundred Paintings by Kōrin,* and the *Ōgataryū ryaku inpu, Collected Seals of the Ōgata School.* During his last years Hōitsu brought his personal style to its full maturity, continuing certain elements of Rinpa painting but combining with them themes and techniques from other contemporary schools.

The most famous of Hōitsu's work is a set of *kakemono* depicting birds and flowers of the twelve months, dated to 1823, when the artist was sixty-two. The painting

for the ninth month is a particularly beautiful example from the set (fig. 280). Four autumn plants—one with white blossoms, two types of autumn grasses, the *susuki* and the *waremokō,* which turn a bright reddish purple with the advent of cold weather, and *kekko* grass—are depicted against a pale harvest moon. The placement of the flowers and grasses is so subtle that they suggest a slight wind touching the plants and causing the leaves to rub together. The work captures not only the decorative quality of the Rinpa school, but also the naturalism of Maruyama painting (see pages 279–281). Hōitsu's major accomplishment was to revive Rinpa-style painting and to establish it, as Kōrin could not, in Edo. However, toward the end of his life he went beyond his sources to create subtle depictions of nature freed from the need to impose references to classical literature onto them.

Hōitsu's follower Suzuki Kiitsu was born into a family of dyers, but was allowed to break with tradition and to study with Hōitsu from 1813 on. When Suzuki Reitan, a retainer and disciple of Hōitsu, died in 1817, Kiitsu married Reitan's older sister, through the master's good offices. He served Hōitsu until the latter's death in 1828, after which he continued to work in an updated version of the Rinpa style.

A particularly interesting example of Kiitsu's mature work is a "pair" of *byōbu* screens depicting white camellias and autumn grasses (fig. 281). Originally these two paintings were pasted on the obverse and reverse of a single two-panel screen; they constitute a remarkable contrast between two aspects of the natural world. The camellia screen is dominated by an area of deep green arching across the top, silhouetted against the bright

camellia blossoms meticulously outlined in pale gray ink. The painting betrays an attention to decorative detail typical of the Rinpa school, but the sharp apposition of flat areas of color and the contrast between abstract shapes and naturalistic details are the product of Kiitsu's own creative sensibility. His painting of autumn grass could not be more different from the Rinpa-style norm. Rows of grasses painted in gray ink appear against a silver ground, which over the years has tarnished, giving it a rich, grayish-brown tone. The regular placement of the grasses is further accented by the remarkably regular edges of the sheets of silver leaf applied to the backing paper. However, a sinuous line of mist softens this impression as it twists across the surface from the upper right to the mid-left and back again to the right. The grasses can still be seen indistinctly through the misty passages, but an element of uncertainty has been added to the painting. The two works complement each other perfectly, suggesting the clarity as well as the mystery of nature. Kiitsu succeeded in taking Rinpa painting a step beyond his master, making it into a more boldly abstract depiction of the natural world. He is generally regarded as the last of the great masters of the Rinpa school.

## Realism in Edo Painting

During the second century of the Tokugawa period a new current appeared in Japanese painting, inspired at first by contacts with Western painting. Various artists, each with different training and a different point of view, attempted to re-create, as believably as possible on a two-dimensional surface, phenomena observed in the real world of three-dimensional space. Even Kōrin, master of the gorgeous pictorial abstraction based on classical narrative themes, was moved to make drawings of flora and fauna from life. However, in the 18th century the interest in realistic rendering of forms and space took two distinct paths: *yōfūga*, or *yōga* as it would later be called, a Western-style painting in oils or Japanese pigments, with an emphasis on perspective and modeling in light and shade; and the Maruyama-Shijō school, in which classic Japanese techniques were combined in new ways to achieve greater accuracy of depiction and a sense of naturalism and everydayness.

### *Yōfūga,* Western-style Painting

The man initially responsible for the popularization in Japan of *yōfūga* was a samurai turned *rōnin*, Hiraga Gennai (1728–1779). The son of a low *han* official and herbalist to the feudal lord of Takamatsu, on Shikoku, Gennai was encouraged by his master to advance his studies by going to Nagasaki, learning Dutch, and searching for whatever information on the natural sciences might be available there. Because the Dutch were the only Westerners allowed by law to trade in Japan, the Japanese turned to books in Dutch as their principal source of

282. The Barrel-maker, by SHIBA KŌKAN. c. 1789. Hanging scroll, oil paint on silk; 18¾ x 23⅝ in. (47.6 x 60 cm). Private collection, Yokohama

Western learning. Until quite late in the Edo period, investigations of Western sciences and the humanities were known as *rangaku,* or Dutch studies. After a year in the port city, Gennai moved to Edo, where he continued his studies and asked for a leave of absence from his feudal post. This was granted, but with such provisos that Gennai renounced his position and his stipend. He continued to live in Edo, but the need to earn a living pushed him into such activities as writing popular novels and plays. He also dabbled in painting, using Western techniques for suggesting space and modeling forms, and made these known to the group of intellectuals in Edo who were involved in Western studies.

The most competent painter to come under his influence was Shiba Kōkan (1738–1818), a many-faceted artist who began his training under a Kanō master but switched at the age of twenty-four to Sō Shiseki, a practitioner of the same Chinese academic style of bird-and-flower painting as Shen Nanpin. About the same time he met Gennai, and it is known that the two men went on a field trip together to find precious minerals. Given Kōkan's talent and interests, there can be little doubt that their conversation often turned to Western methods of painting. Until 1780 Kōkan pursued the study of Western art as an avocation, devoting his primary efforts to the lucrative work of designing woodblock prints. Since Suzuki Harunobu was the dominant presence in printmaking circles until his death in 1770, for a while Kōkan produced prints that imitated the master's style so accurately that he would sometimes affix Harunobu's name and seals and market them profitably. However, in the 1780s two Chinese books on Western painting came into his possession, and from then on he devoted himself to perfecting his control of Western techniques. Some of his scorn for traditional Japanese art can be seen in his text on paint-

**283.** Sketch for hand scroll The Seven Fortunes and Seven Misfortunes, by MARUYAMA ŌKYO. 1768. Ink on paper; height 12¼ in. (31 cm). Manno Art Museum, Osaka

ing, the *Seiyō gaden, Commentary on Western Painting,* of 1799:

> By employing shading, Western artists can represent convex and concave surfaces, sun and shade, distance, depth and shallowness. Their pictures are models of reality and thus can serve the same function as the written word, often more effectively. The syllables used in writing can only describe, but one realistically drawn picture is worth ten thousand words. For this reason Western books frequently use pictures to supplement descriptive texts, a striking contrast to the inutility of the Japanese and Chinese pictures which serve no better function than that of a hobby to be performed at drinking parties.
>
> Calvin L. French, *Shiba Kōkan:*
> *Artist, Innovator, and Pioneer in the Westernization*
> *of Japan,* New York, 1974, p. 171

It is interesting in this context to note that Kōkan was acquainted with the literati painter Gyokudō (see page 297) and on at least one occasion lamented the difficulty of making available to the reclusive artist new information from Europe that was becoming available in Edo.

One example of Kōkan's mature style is The Barrelmaker, painted in 1789 (fig. 282). A man in Western dress stands awkwardly, a hammer in his upraised hand, in his other hand a chisel held against the side of the barrel. Recession into depth is achieved by the placement of buildings and figures of decreasing size on a diagonal line carrying the eye back to the horizon, which is punctuated by a boat and a mountain range. Although the painting purports to depict in realistic fashion the everyday activities of actual human beings, it has the quality of a romantic fantasy about the working class, a quality found more often in Western than in Eastern art. It must be said that Kōkan's technique in this painting is rather heavy-handed. Nevertheless, he took an important first step toward bring-

ing to Japanese art circles an awareness of the potential of Western techniques. Today he is generally regarded as one of the pioneers of 19th- and 20th-century *yōga.*

## The Realism of the Maruyama-Shijō School

The second branch of Edo-period realism, the Maruyama-Shijō school, was founded by Maruyama Ōkyo (1733–1795), the offspring of a farmer who left his land and made a place for himself among the *chōnin* of Kyoto. The Shijō of the school name refers to the second master, whose studio was located in the fourth ward (*shijō*) in Kyoto. In his teens Ōkyo was apprenticed to a toy shop where he learned to paint doll faces and later *megane-e,* the paintings used in stereoscopes.❖ Although Ōkyo mastered the art of painting *megane-e* in his youth, he did not absorb any lasting influence from Western methods of depiction, aside from an increased appreciation of visual realism. Instead his studies of the Kanō style of painting under Ishida Yūtei (1721–1786), an artist affiliated with the court, exerted a more lasting influence.

Another element in Ōkyo's art was his affinity with the urban population of Kyoto. He came from the *chōnin* class and frequently chose as themes for his paintings scenes observable every day within the mercantile district. Perhaps because of his empathy with the common people, he was commissioned in 1768 by Yūjō, the abbot of

---

❖ Originally imported from the Netherlands, and then from China, these optical instruments were eventually manufactured in Japan to show images of famous Chinese, Japanese, and Western scenic places. The production of *megane-e* required a knowledge of perspective and of shading techniques, specifically the network of oblique lines used in copperplate etchings, and it depended on the exaggeration of near and far views.

Emmanin, a temple in Ōtsu, outside of Kyoto, to paint a set of hand scrolls, The Seven Fortunes and Seven Misfortunes, as a pictorial explanation of the blessings and evils that according to Buddhist philosophy result from previous karma. Yūjō stated in his introduction to the *emaki* that if people were to be converted to a genuine belief in the Buddha, they had to be shown real-life phenomena, not the fantastic stories of heaven and hell that were usually offered by the priesthood. The set consists of three scrolls totaling approximately 150 feet in length. It took Ōkyo three years to complete. Two scrolls depict the disasters inflicted on mankind by nature and by other human beings, while the third illustrates the good fortunes possible in this life. Ōkyo treated this commission with the utmost seriousness, searching out as models for his paintings actual examples of even the most unusual scenes. One of the most gruesome sketches executed in preparation for the scrolls depicts a naked man being split apart by two bulls (fig. 283). His legs have been tied to one hind leg of each bull, and their tails set afire so that they will run panic-struck away from each other. Ōkyo has captured with awesome force and accuracy the appearance of two solid, muscular animals leaping apart and in the process tearing open a frail human body.

Another work that demonstrates Ōkyo's mastery of the traditional elements of the decorative style and his unique use of them to achieve greater naturalism is Pine Trees in Snow (colorplate 52). The pair of six-panel screens, painted in ink on a gold ground, was commissioned by a member of the wealthy Mitsui merchant family, a scion of the clan judged snobbishly by Ōgata Kōrin to be *nouveau riche*. In the right screen a single pine tree thrusts upward from roots invisible below the edge of the painting to heights that far exceed the upper edge, its branches extending to right and left of the trunk, filling the broad horizontal space of the screen. At first glance the painting would seem to be a simple recapitulation of the Kanō Eitoku theme, but, unlike Eitoku's Cypress (see fig. 242), Ōkyo's pine tree does not twist impossibly in space. Instead it bends as any tree might in deference to the prevailing winds. The naturalism of his treatment is further emphasized by the left screen, in which two pines are seen in a more distant view, one visible from trunk base to bough tip. They curve and droop as if bent by the weight of the snow that has accumulated on their branches. In depicting the tree trunks Ōkyo has used a technique called *tsuketate* that became a hallmark of the Maruyama-Shijō school. The trunk is not outlined, but instead is modeled by means of daubs of ink, dark over light, applied to specific sections to suggest highlights and shadows on the surface, patches of snow, and areas where the rough bark of the tree can be seen, thus creating a sense of volume. The final impression created by this pair of screens is the still, serene beauty of the natural world.

Matsumura Goshun (1752–1811) was an artist who worked with Ōkyo and established the school as a continuing current in the painting of the Edo period. Born into a family that had worked for the mint in Kyoto for four generations, Goshun began his painting studies primarily as an avocation. However, in 1772, when it had become clear that he had talent as an artist, he began serious work under the guidance of Yosa Buson (1716–1783), a master of the literati style of painting (see pages 292–295). He was not an immediate success as a painter, but Buson helped him stay afloat financially by recommending him as an adviser on literature and the arts to wealthy provincials wishing to acquire an aura of culture. In 1781 Goshun's career took a major turn for the worse. Both his wife and his father died that year, and Buson, near death himself, was apparently no longer able to help his pupil. In that year Goshun left his residence in the Shijō district of Kyoto and moved to Ikeda on the outskirts of Osaka. However, he continued to work in Buson's style. By 1787 it was clear that he had to affiliate with another group of artists, and he joined with Maruyama Ōkyo and his studio to work on the decoration of screens for Daijōji, a temple in Hyōgo prefecture. Events of the following year solidified his decision to throw in his lot with Ōkyo. The two men found themselves living at the same temple, Kiunin, after a fire devastated Kyoto. Apparently, what had been a good working relationship in Hyōgo developed into friendship. In 1789 Goshun moved back to the Shijō district of Kyoto and adopted the basic elements of Ōkyo's style. Ōkyo never looked upon Goshun as a pupil, although in the records of the Daijōji project, Goshun is described as Buson's best pupil. When Goshun offered to join Ōkyo's studio officially as a disciple, the older man refused, preferring that they remain as friends and equals. Thus Goshun was free to develop his own unique blend of Maruyama and literati techniques, and after Ōkyo's death in 1795, he established his own Shijō school.

A superb example of his fusion of the two older styles is a pair of screens depicting white plum trees against a pale blue ground (colorplate 53). The screens bear no date but clearly reflect Ōkyo's influence. Their most unusual feature is the material on which they are painted, a rough yellow pongee silk painted unevenly in gray-blue strokes. Furthermore, instead of running a bolt of cloth vertically over one panel at a time, the silk has been pasted across the screen horizontally, producing four seams in each panel. Obviously Goshun wanted the ground of his painting to have a visual texture equal to that of the images themselves. A ground line is established by a thin gray wash in each screen, establishing a sense of space within the paintings and stabilizing the compositions. In the right screen a single plum tree spreads its thin angular limbs to left and right from a stubby, thick trunk in the second panel. Branches cross each other at sharp, irregular angles, those to the back of the tree almost disappearing into the blue mist. In the left screen two smaller plum trees are depicted with greater clarity, as if silhouetted by the moon against a cloudless night sky. Together,

the two screens create a delicate, luminous view of the natural world. Goshun has combined Ōkyo's techniques of painting, his *tsuketate* brushwork, and his methods for suggesting space, with Buson's delicate, lyrical approach toward the depiction of landscape, to produce a new type of realism. His style was carried on and popularized by his two best pupils, his younger brother Keibun and Okamoto Toyohiko, who made Goshun's Shijō style the dominant form of expression in the *bakumatsu* period.

## Eccentric Painters

Nagasawa Rosetsu (1754–1799), a pupil of Ōkyo, took Maruyama-Shijō realism as a point of departure in the formulation of a unique style that is both sharply satirical and eccentric. Little is known of Rosetsu's personal history before he joined Ōkyo's studio, but he seems to have been an individualist and perhaps something of a troublemaker. While there is some doubt about the accuracy of this story, it has been alleged that on several occasions Ōkyo dismissed Rosetsu for uncontrolled and extravagant behavior, but because Rosetsu was such a good painter, Ōkyo always allowed him to return and even entrusted him with the execution of several paintings in fulfillment of commissions in temples distant from Kyoto, which Ōkyo had accepted but could not complete himself.

In 1793, at the age of forty, Rosetsu changed his art name, his seal, and, with these, his style of painting. The works executed after this date display a softer, more flexible line and a more subjective treatment of pictorial images. One of his most famous paintings from this period is an *ema*, or votive painting, made in 1797 and dedicated to the Itsukushima Shrine (fig. 284). The subject is Yamauba, the mountain woman, and Kintarō, the son she raised to be a warrior of superhuman strength and loyalty.

The Yamauba theme appears in many different forms, ranging from folktales and songs sung to the accompaniment of the samisen to Nō chants, and depending on the context, different elements of the story receive emphasis. Yamauba is either a mountain spirit or a mortal woman who married a great warrior but was left behind when he was wrongfully banished from court. A child is born of this union, and the mother forced to retreat to the mountains to save herself and her son. When they are later discovered by the legendary general Minamoto Yorimitsu, Kintarō, a chubby-cheeked, orange-skinned boy, is wrestling with a bear. The soldier is fascinated and asks to meet the mother. A strange but attractive woman appears, clad in a garment of leaves, her hair long and scraggly. Yet in spite of her rough appearance Yamauba speaks to Yorimitsu in the cultured manner of a noblewoman. The general, impressed by the boy's strength and his unusual upbringing, makes him a retainer, and Kintarō matures into an exemplary warrior who vindicates his father's name.

The theme of Yamauba and Kintarō was popular in the late 18th and early 19th centuries and became the ve-

**284.** Yamauba and Kintarō, by NAGASAWA ROSETSU. 1797. Color on silk; 62 x 33⅛ in. (157.5 x 84 cm). Itsukushima Shrine, Hiroshima prefecture

hicle for expressing a maternal and, in some cases, almost sensual relationship between the beautiful, rustic woman and her rather animal-like child. In Rosetsu's painting, however, the woman is an old and ugly court lady, sloppily clad in garments once gorgeous but now tattered, and the child is more a climbing monkey than a human infant. Compared to conventional treatments of the theme, Rosetsu's painting seems to lay bare the cynically viewed "reality" behind the façade of tender maternal care and nascent heroism.

Two other eccentric masters who are sometimes grouped with Rosetsu are Itō Jakuchū (1716–1800) and Soga Shōhaku (1730–1781). Jakuchū was the eldest son of a greengrocer in Kyoto and in his early years took over the

**285.** Rooster, Hen, and Hydrangea, by ITŌ JAKUCHŪ. c. 1757. Hanging scroll, color and ink on silk; 54⅞ x 33½ in. (139.4 x 85.1 cm). Los Angeles County Museum of Art, Shin'enkan Collection

business, but his heart was not in it. He preferred painting, and in 1755, at the age of thirty-nine, he turned the shop over to a younger brother, took the tonsure, and for the rest of his days lived the life of a priest devoted to painting. Following the lead of most aspiring artists of his day, Jakuchū began by studying the Kanō style, but very quickly rejected it as being too limiting and looked to other sources for inspiration. At first he copied Chinese paintings preserved in various Kyoto temples, which he thought to date from the Song and Yuan dynasties, but which were more probably of the Ming. Next he turned to what is called in Japanese *shaseiga*, copying from nature. He began by raising brilliantly colored hens and cocks, observing them day to day, and then sketching them in motion. From this he went on to study other birds, such as the crane, insects, and fish, as well as flowers and trees. A particularly fine example of his work is a painting of Rooster, Hen, and Hydrangea, dated to about 1757 (fig. 285). Against a background of dark blue hydrangeas and convoluted Chinese-style garden rocks, a cock struts purposefully after a hen, who coyly turns her head as she looks back at him. Although the interrelation of cock and hen is clearly understandable, space in the painting is suggested through superposition, one shape overlapping another. The artist has rendered the birds, the rocks, and the

**286.** Landscapes, a pair of six-panel *byōbu*, by SŌGA SHŌHAKU. c. 1770. Ink on paper; each screen 62⅞ x 138 in. (159.5 x 348.6 cm) Courtesy Museum of Fine Arts, Boston. Fenollosa-Weld Collection

hydrangea as a series of flat patterns. However, the motifs blend to create a brilliantly complex, decorative pattern.

Soga Shōhaku's origins are somewhat obscure. Recent research suggests that he was born in Kyoto to a family with the surname Miura. He began by studying with a Kanō master, but quickly struck out on his own. Rather than concentrating on Chinese painting styles as Jakuchū did, he turned to the Muromachi period, and in addition to using some of the motifs and techniques of the period, he also constructed for himself a fake genealogy going back to the 15th-century artist Dasoku. Nevertheless, his paintings could never be mistaken for works of the 15th century, so strong and free is his brushwork, and so dramatic are his compositions, which depend on the abrupt juxtaposition of pictorial motifs.

Shōhaku is perhaps best known for his eccentric treatment of figures from Chinese history and literature, but he also excelled as a landscape painter. Undoubtedly his most accomplished and dramatic works in this vein are a pair of byōbu dated by Money L. Hickman to the period shortly after the artist's fortieth birthday (fig. 286). At first glance the two screens seem to be very similar in character, employing the familiar motifs of foreground rocks and trees, and soft, hazy mountains at the horizon. Yet the more carefully one examines them, the clearer it becomes that the artist has stretched almost to the limits the juxtaposition of disparate landscape elements within two halves of a harmonious whole. The viewpoint on the two screens is different; space in the right screen is seen from a much lower, more natural perspective than it is in the left screen. In the right screen, a group of Chinese pavilions can be seen in a grove of trees, and to the left is a passage of open water and clouds. The painting concludes with a complex configuration of mountains, trees, and a steep waterfall. The left screen seems at first to be more delicate, perhaps even more Japanese, with its cluster of village roofs and rectangular rice fields. However, to the left the distortions become extreme, with a sharply rising cliff and at the very edge of the screen a mountain that curves downward so precipitously that one wonders how the trees along its edge can keep from sliding off into space. The two screens do work as a unit because of the similarity of their overall compositions and the harmony of the brushwork, but at the same time the contrast of details—some fantastic, some quite natural—surprises us and engages our interest. They are truly two of Shōhaku's finest works.

## Zenga

The long period of peace achieved by the policies of the Tokugawa shogunate caused profound changes within the Buddhist establishment. Although every Japanese was required to register with a particular temple, Buddhism per se played a much less important role in the life of the individual. No longer did average men and women view the events in their lives as the working out of their karma from a previous existence. In the new climate of political stability, Buddhism declined in popularity. As a corollary the demand for Buddhist priest-painters and also for religious subjects in painting diminished. The elite of the samurai class were much more interested in decorating their homes with Confucian themes and colorful genre paintings, and the need for monks with artistic ability dried up. One result of this shift in focus was the emergence of zenga, paintings executed not by priest-painters for wealthy patrons, but rather by Zen masters and monks as a form of meditation or as a visual aid for individual parishioners. Subject matter shifted from the landscape

**287.** The character for *mu,* by HAKUIN EKAKU. Mid-18th century. Ink on paper; 17 1/8 x 16 5/8 in.(43.6 x 42.2 cm). Private collection. Shown with a printed equivalent 無

scenes popular with Muromachi priest-painters to instructional themes: *kōan* and words used in meditation. These simple black-and-white paintings would be hung in one's living quarters as a motto, a reminder of the goal one wished to achieve in life.

*Zenga* reached a particularly high level of achievement in the work of the priest Hakuin Ekaku (1685–1768), arguably the most influential Zen master of the Edo period. Hakuin was a remarkable, multifaceted individual deeply devoted to spiritual endeavors. He was a committed and innovative teacher for students within the temple and for lay persons, from daimyo to commoners, and he was also a painter and calligrapher who, with virtually no formal training, succeeded in producing strong and compelling works. Painting was an activity to which Hakuin assigned a rather low priority in his scheme of life. From the time he was a child, he was concerned with religious values. So great was his childhood fear of the fires of hell, he later wrote, that one day when bathing with his mother in an iron bathtub, his skin began to prickle with the heat, and he felt the cauldron rumble. Recalling the descriptions he had heard of the eight hot hells, he screamed in terror. At fifteen he left his parents' home to become a priest, and for the next seventeen years he endured great physical and psychological hardships until he achieved a state of religious awakening that his teacher would accept, his acknowledgment symbolized by the fact that he no longer called Hakuin a "poor hole-dwelling devil."

At thirty-two, Hakuin returned to the village of his

birth, Hara in Shizuoka, and devoted himself to the rebuilding of its temple, Shōinji. There he attracted many students. His primary method of teaching was through the use of the *kōan*, particularly the *kōan* Mu. The Chinese character *mu* means nothingness and was first used as a teaching device by the famous Chinese master Zhaozhou Congshen (Chao-chou Ts'ung-shen, J. Jōshū, traditionally 778–897). A monk asked Jōshū if a dog has buddha nature and the teacher replied *mu,* not merely no, but nothingness. The student focuses on *mu,* without settling on yes, a dog has buddha nature—and is a dog the Buddha?—or no, it doesn't have buddha nature, which is the trap of dualistic thinking. With continued concentration, gradually the whole body becomes a mass of fiery doubt, until *mu* breaks open, misunderstanding falls away, and the reality of life and death is apparent. Two images Hakuin uses to describe this experience are "a sheet of ice breaking, a jade tower falling."

Among Hakuin's surviving works is the single Chinese character for *mu* (fig. 287). When carefully executed, this *kanji* has three parallel horizontal lines, four verticals, and four marks below the grid. The configuration of strokes suggests a means of counting and after four items have been marked off, they are canceled out by the three horizontal lines. In contrast, Hakuin's *mu* is a jumble of strokes expressing vitality rather than negation, energy rather than meticulous accounting. Possibly Hakuin executed this work as a part of his own meditation and then gave it to a parishioner.

A *kōan* of his own devising is Sekishu no Onjō, or The Sound of One Hand Clapping. In a letter to the lord of Okayama Castle written in 1753, Hakuin explained his *kōan* as follows:

> What is the Sound of a Single Hand? When you clap together both hands a sharp sound is heard; when you raise the one hand there is neither sound nor smell. . . . If conceptions and discriminations are not mixed within it and it is quite apart from seeing, hearing, perceiving, and knowing, and if while walking, standing, sitting, and reclining, you proceed straightforwardly without interruption in the study of this *kōan,* then in the place where reason is exhausted and words are ended, you will suddenly pluck out the karmic root of birth and death and break down the cave of ignorance.

> Phillip B. Yampolsky, *The Zen Master Hakuin:
> Selected Writings,* New York, 1971, p. 164

An ink painting executed two years before Hakuin's death to illustrate the *kōan* employs the figure of the monk Hotei standing on his cloth bag (fig. 288). Instead of holding both hands together in his lap, Hotei has hidden one in the fold of his robe and holds the other up in front of him. In most of Hakuin's drawings of Hotei, his eyes are closed or focused downward and his mouth is relaxed or curved in a slight smile. In this painting, however, Hotei's eyes are focused clearly ahead, the lids curved as if laugh-

ing, and the mouth, too, has a distinct upward arc. The expression engages the viewer, and conveys the sense of joy that accompanies a moment of awakening, which Hakuin knew from experience. The inscription completes the meaning of the painting:

> Young people, no matter what you say, everything is nonsense unless you hear the sound of one hand.
>
> Sylvan Barnet and William Burto, *Zen Ink Paintings*, Tokyo and New York, 1982, p. 54

Hakuin has established a contrast between the rounded forms of the body—the sloped head, the hunch at the shoulders, the black robe pulled in soft curves around the lower part of the body, and finally the ball-like shape of the bag supporting the figure—and the straight vertical thrust of the hand. With the simplest of means Hakuin has created a dramatic visual rendering of his favorite *kōan* and at the same time a view of himself as the teacher.

## *Bunjinga*, Painting by the Literati

In China from the Song dynasty to modern times, the art of *wenren (wenjen, J. bunjin)*, the class of scholars, connoisseurs, and literary men, was prized for its creative freedom. It is also sometimes referred to as *nanga*, or Southern pictures, following the painting theories of the major Ming-dynasty theorist, connoisseur, and artist Dong Qichang (Tung Ch'i-ch'ang, 1555–1636). He established a set of categories of Chinese painting, labeling orthodox, academic painting as Northern, and freely executed, expressive painting as Southern, *nanga* in Japanese. In Japan, *bunjinga* and *nanga* are more or less interchangeable terms for art executed by the intelligentsia. The beginning of *bunjinga* in Japan can be traced to the teachings of several men, most notably the philosopher Ogyū Sorai (1666–1728), who emphasized the Chinese idea that calligraphy and painting were the accomplishments of the truly literate person. Sorai, a scholar of the Kogakuha, or Ancient Studies School, which set itself in opposition to the orthodox Neo-Confucianism of the shogunate academy, studied the written sources of Confucian thought in their linguistic and historical context, and was one of the first theoreticians to place a value on the study of literature, both prose and poetry, and the practice of calligraphy, for the individual Japanese intellectual. This represented a shift in emphasis in education from the aim of producing men skilled in both *bu*, the martial arts, and *bun*, culture, to a focus on culture—a knowledge of history and literature, the ability to write in several different styles, including Chinese prose and poetry, and the skill to write these on paper or silk in a form not only pleasing to look at but also expressive of the writer's character.

From the outset, *bunjinga* was practiced by a broader group in Japan than in China, where it was an exclusive preserve of the administrative bureaucrat-scholar class. Its themes were taken up by a wide range of intellectuals and artists—samurai, *rōnin*, haiku poet-painters, and even professional *chōnin* painters—and as a result the types of painting found under the category *bunjinga* in Japan are infinitely more varied than in China.

Chinese literati painting was introduced into Japan through four different sources: Ōbaku Zen priest-painters who immigrated to Japan after the founding of the Qing (Ch'ing) dynasty in 1644, Chinese professional and amateur painters in the port of Nagasaki, imported paintings, and block-printed manuals of painting styles from China. Ōbaku priests, such as Yinyuan Longqi (J. Ingen) and his successor Mu'an Xingtao (J. Mokuan) at the temple of Manpukuji in Kyoto, probably provided the first contact the Japanese had with contemporary Chinese painting. In addition to being knowledgeable on religious matters, many of these priests were also amateur painters working in the literati and Zen styles prevalent in their native regions. Furthermore, because they had close ties with cultural leaders such as the retired emperor Gomizunoo, these priest-painters had a great impact on Japanese art circles.

Chinese merchants in Nagasaki who dabbled in calligraphy and landscape painting for pleasure, and professional painters who sojourned briefly in the port city, brought the Japanese into direct contact with *nanga* and other contemporary styles of Chinese art. Foremost of the amateur painters was I Fu-chiu, who came to Japan in 1720 and for the next thirty years conducted trading missions between China and Japan. His style was directly related to that of the renowned Dong Qichang, and to the artists who continued the conservative side of Dong's teachings. The most important of the professional painters was Shen Quan (J. Shen Nanpin), the pioneer in Japan of the Chinese style of detailed and colorful depictions of birds and flowers, who arrived in Japan in 1731 and stayed for about two years.

The third and undoubtedly the most important source for Japanese knowledge of *nanga* painting was a group of block-printed manuals illustrating models for depicting plants, trees, rocks, mountains, and human figures in the styles of various Chinese masters. Of these the most influential were the *Bazong huapu* (*Pa-chung hua-p'u*, J. *Hasshū gafu*), *The Eight Albums of Painting*, published in China in the 1620s and the *Jieziyuan huazhuan* (*Chien-tzu-yuan hua-ch'uan*, J. *Kaishein gaden*), *Mustard-Seed-Garden Manual of Painting*, printed in two installments: the first, a set of five volumes on landscape, in 1679; the second, two albums dealing with bamboo, plum blossoms, and bird-and-flower motifs, in 1701. Each of these works found its way to Japan, and the demand for both was such that new editions were printed in Japan, the *Hasshū gafu* in 1672 and the *Kaishien gaden* in 1748. Many literati artists are known to have had copies of one or both works

**289.** Woodblock print from the Chinese *Mustard-Seed-Garden Manual of Painting.* 17th century

and to have used them as guides to the basic theory and techniques of literati painting. In addition, through the research of art historians James Cahill and Tsuruta Takeyoshi, it is evident that there were more original Chinese paintings in Japan in the 18th century than had previously been supposed. This avenue of inquiry may in the future give us much greater insight into the points of departure for individual Japanese artists working in the literati style and, by extension, a further understanding of their unique artistic achievements.

Each of these sources of *bunjinga* had inherent problems for students of the literati style. The Ōbaku priests were not interested in *bunjin* landscapes per se, but rather in favored Zen themes like bamboo and plum trees. As for the Nagasaki enclave, none of them were first-rate painters. Only Shen Nanpin was a trained professional, and he worked not in the literati style, but in the brilliantly colored, minutely detailed, realistic style of bird-and-flower painting popular in China in the Ming and Qing dynasties. The problem inherent in the manuals on painting was the fact that they were illustrated with woodblock prints, which reduced the rich contrast of brushstrokes and ink tones in the original paintings to single lines and flat colors that stood out in sharp contrast to the white background paper (fig. 289). So pervasive was the influence of these block-printed manuals that it was not for many decades that the majority of Japanese artists learned to work in the true Chinese manner of building up brushstrokes to achieve surface texture.

## Pioneers of *Bunjinga*

The pioneers of literati painting in Japan, the two samurai Gion Nankai (1697–1751) and Yanagisawa Kien (1704–1758), and Sakaki Hyakusen (1697–1758), a *chōnin* from Nagoya, exemplify the two polarities of *nanga* artists in

**290.** Plum Blossoms, by GION NANKAI. 1740s. Hanging scroll, ink on paper; 37³/₄ x 20⁵/₈ in. (96 x 52.5 cm). Private collection, Wakayama prefecture

reflects not only his knowledge of Chinese techniques, but also his familiarity with literati themes (fig. 290).❖

In Nankai's work, we see a strong contrast between the vigorous strokes of the branches executed in the flying-white technique, and the small, delicately rendered petals of the plum blossoms. Flying white (J. *hihaku*) is a calligraphic brushstroke in which the dark ink is interspersed with the white of the paper. The inky brush tip is split as the stroke is made, allowing white to show between black outlines. The white areas of paper that appear within the bold ink outer edges of the flying-white stroke form a counterpoint to the white areas enclosed within the round outlines of the petals, emphasizing the delicacy of the blossoms.

The lives of Nankai and his contemporary Yanagisawa Kien are similar in many ways. Born in Edo to the chief retainer of the Yanagisawa family, Kien was well educated and received numerous favors from his daimyo, including the right to adopt the Yanagisawa name. However, in 1728, at the age of twenty-four, he was punished for misconduct and stripped of his inherited position. Two years later he was pardoned and his suspended stipend restored. That the two pioneers of *nanga* painting who came from the samurai class should have been so severely punished for youthful misconduct may indicate that their interest in arts and letters, though sanctioned by one faction of influential Confucian scholars, was not viewed in so favorable a light by their *han* lords. The fact that a landscape painting made by Kien in his late teens or early twenties has an inscription by the scholar and adviser to the shogunate Arai Hakuseki suggests he had the support of a very powerful national figure. Nevertheless his fate was in the hands of his *han* lord, and he was probably penalized for his deviations from the orthodox standard of the soldier-administrator.

As a painter Kien was something of a dilettante. His works range from literal depictions of flowers in the album-leaf format and more relaxed vertical landscapes, to extremely expressive paintings of bamboo executed with his fingers. An example of his bamboo painting is a work executed in green pigment on paper dyed indigo blue (fig. 291). A stalk of bamboo bends across the upper third of the surface, its curve echoed by the down-pointing leaves. Escaping from the leaf cluster, a single thin stem arcs downward, its leaves forming a subtle accent in the lower right area of the picture. Kien's signature in gold and his seals in red—prominent to the left of the thin stem—

Japan: on the one hand the samurai-literatus unappreciated in his own time, and on the other the professional painter. Nankai was the eldest son of a doctor attached to a *han* in Wakayama prefecture. Born and raised in Edo, he received an excellent Confucian education in the shogunal academy, and in 1697, after his father's death, he moved to Wakayama as an official Confucian teacher. Three years later he was stripped of his stipend and exiled from the *han* for some offense never recorded. For the next ten years he lived in exile and supported himself by teaching calligraphy. In 1710 he was pardoned, probably so that he might serve as translator when an embassy from Korea visited Japan. Later he became retainer to a daimyo and was put in charge of educational administration in the latter's domain. After his pardon he began to paint, drawing randomly upon many sources, the printed manuals in particular. One of his most accomplished works, Plum Blossoms, a monochrome ink painting executed in the 1740s,

❖ The plum is one of the Four Gentlemen, the four noble plants, along with the bamboo, the orchid, and the chrysanthemum. They were used as models for calligraphy practice and served as a transition for the literati from the written word to pictorial imagery. Because each plant is so different in shape and character, it is a significant test of one's ability with a brush to be able to render them with proper balance and clarity, let alone with artistic individuality.

**291.** Bamboo, by YANAGISAWA KIEN. Mid-18th century. Hanging scroll, pale green on indigo-blue paper; 37½ x 10⅛ in. (94.5 x 25.6 cm). Private collection

stabilize the composition.

At the opposite end of the spectrum was the townsman Sakaki Hyakusen, son of a family who ran a pharmacy in Nagoya. In all probability, Hyakusen's ancestors were Chinese who had emigrated to Japan only a few generations before his birth. Furthermore, they undoubtedly remained in contact with the mainland through the importation of Chinese herbs and medicines, and possibly of books and paintings as well. At any rate, the sources of Hyakusen's knowledge of Chinese painting were clearly different from those of the samurai Nankai and Kien. Hyakusen was also an accomplished writer of haiku and was active during his twenties in poetry circles in Ise. In his thirties he moved to Kyoto, concentrated on developing his craft as an artist, and gradually became self-supporting as a professional painter.

A pair of folding screens dated 1746 illustrate the scope and quality of Hyakusen's work at the beginning of his maturity as a painter (fig. 292). They deal with a popular theme in literati art, the two excursions made in 1082 by the Song dynasty poet-scholar Su Dungpo (Su Tung-p'o) to a range of cliffs along the Yangtze River. It is the seventh month, early autumn, when Su and a companion make their first trip. The weather is pleasant and there is plenty of food and wine. Su writes:

> Letting the boat go where it pleased, we drifted over the immeasurable fields of water. I felt a boundless exhilaration, as though I were sailing on the void or riding the wind and didn't know where to stop. I was filled with a lightness, as though I had left the world and were standing alone, or had sprouted wings and were flying up to join the immortals.
>
> Burton Watson, *Su Tung-p'o: Selections from a Sung Dynasty Poet*, New York, 1965, p. 87

His friend laments the shortness of life:

> If only we could link arms with the flying immortals and wander where we please, embrace the moon and grow old with it. (p. 89)

Su chides his companion:

> But if we observe the changelessness of things, then we and all beings alike have no end. What is there to be envious about? (p. 89)

The second visit is made with two friends in late autumn, three months later, after frost has set in and the leaves have fallen (p. 91). Food and wine are scarce, and the appearance of the river and the cliffs is strangely changed. Su begins to climb, and his friends cannot keep up. He recounts:

> I gave a long, shrill whoop. Trees and grass shook and swayed, the mountains rang, the valley echoed. A wind came up, roiling the water, and I felt a chill of sadness, a shrinking fear. I knew with a shudder that I could not stay there any longer. (p. 92)

**292.** First and Second Visits to the Red Cliffs, a pair of six-panel *byōbu,* by SAKAKI HYAKUSEN. 1746. Ink on paper; each screen 63⅝ x 144⅞ in. (161.5 x 368 cm). Hayashibara Museum, Okayama prefecture

At the time of the second visit Su is no longer sure that he doesn't envy the immortals. He whoops like a crane and tries to climb to their realm at the top of the cliffs, but becomes afraid and retreats. As he and his friends row away, a crane—Taoist symbol for an immortal—flies overhead and later, in a dream, he is visited by the immortal in human form who asks the poet if he enjoyed his excursion. However, when Su wakes up, he realizes the encounter that might have been.

Hyakusen has beautifully captured the mood of the Chinese scholar's sentiments. In the right screen (top,

above) the mountains to the right are steep and craggy, but not forbidding. Su and his friend, seated in their boat, rock gently on the moonlit summer ripples. The rocks in the first two panels establish a tempo of highlights and deep shadows that is measured and deliberate. In the middle panels the rhythm is slowed, the ink lines lightened, and in the left two panels the theme is concluded with a passage of low rolling hills. In the left screen the moment has passed. The crane is flying away, and we see Su gazing after him, the Red Cliffs now impossibly steep and convoluted behind him. In the staccato treatment of

**293.** First Visit to the Red Cliffs, one of a pair of six-panel *byōbu*, by IKE TAIGA. 1749. Color on paper; 58 3/8 x 138 in. (148.2 x 350.6 cm). Private collection, Tokyo

the dark, heavy forms to the left, we can almost sense the trembling of the trees and the ringing of the mountains that caused him to retreat back to the mortal world. James Cahill has pointed out in a study of Hyakusen how close his work is in style and theme to the paintings of Chinese artists working in Suzhou in the late Ming period (circa 1500–1644). Among the pioneers of *bunjinga* in Japan, clearly Hyakusen was not only the most competent but also the most intimately familiar with stylistic currents on the continent.

## The Second Generation

The first truly great artists to master the literati style were Ike Taiga (1723–1776) and Yosa Buson (1716–1783). Like Hyakusen, they were professional painters who accepted commissions and sold their work for a living. Taiga's family belonged originally to the peasant class, but his father worked for a number of years in the mint in Kyoto. Although he died when Taiga was only four, his wife and child seem to have had financial backing of some kind. At the age of six, the boy began his study of the Chinese classics. A year later he took up calligraphy, at which he was remarkably proficient. Today he is considered to be one of the outstanding calligraphers of the Edo period. In his early teens he and his mother maintained a commercial painting shop, for which he produced fans decorated in the Ming style illustrated in the *Hasshū gafu*.

In 1738 Taiga met and became the pupil of Yanagisawa Kien, with whom he studied for several years. However, during his early period, from 1744 to 1749, Taiga's eye was not fixed exclusively on literati art. Influences of the decorative style of Ōgata Kōrin can be seen in his work, and although no direct evidence linking the two

artists can be found—Kōrin died in 1716 and Taiga was born in 1723—a connection may have existed through Taiga's father, who worked in the mint for a certain Nakamura, possibly the same Nakamura who acted as Kōrin's patron. Another influence, that of Japanese painting of the Muromachi period, can also be seen in Taiga's early work, particularly his six-panel screen of 1749, First Visit to the Red Cliffs (fig. 293). Although the colors on the screen are much brighter than anything to be found in Muromachi painting—red ocher and indigo predominate, with accents of green, yellow, and scarlet—the composition and the brushwork are reminiscent of early-15th-century landscapes, specifically the works of Minchō and Shūbun. The difference between Taiga's and Hyakusen's handling of this theme is particularly striking.

A third influence on Taiga's painting was Western art. In 1748 the artist journeyed from Kyoto to Matsushima and back, stopping along the way to climb Mount Fuji and to spend several weeks in Edo, where he made a name for himself by executing finger paintings. While he was in Edo he also had the opportunity to study examples of Western art. Precisely what he saw is not known, but judging from the style of his painting True View of Mount Asama, it is most likely that he saw copperplate etchings (fig. 294). Using Western techniques of perspective, the hanging scroll depicts in fine lines similar to etched lines and in light washes what purports to be the actual appearance of Mount Asama in Shigano prefecture.

However, as Melinda Takeuchi has demonstrated, this painting has greater importance than just as a reflection of Western models. Its formal title is *Asamagadake shinkeizu*, True View of Mount Asama, and it is the first painting identified as a *shinkeizu*, a genre of landscape painting that combines the idea of factual representation,

**294.** True View of Mount Asama, by IKE TAIGA. c. 1760. Ink and color on paper; 22¹/₂ x 40³/₈ in. (57 x 102.7 cm). Private collection

the long tradition of landscape depiction on which the artist is drawing, and finally the Chinese concept of a painting reflecting the character, the "spirit resonance," of the artist. As Takeuchi points out, True View of Mount Asama combines in a believable composition two different views of a mountain landscape. At the horizon line in the upper right section of the painting there is a reworking of Taiga's sketch of Mount Fuji, while the lower right passage has been taken from a separate drawing of Mount Asama. That this work has been accepted for so long as a literal representation of a particular landscape is a testament to Taiga's artistic gifts. The poem inscribed in the upper part of the picture was composed and written by Taiga after climbing Mount Asama in 1760.

Clouds billow in the four directions;
The mist breaks—ten thousand and eight peaks [appear].
Heian Mumei [the painting name Taiga adopted in 1750]
dedicates/shows this to the esteemed and venerable
Master Gion [either Gion Nankai or his son].

Based on Melinda Takeuchi, "'True' Views: Taiga's
Shinkeizu and the Evolution of Literati Painting
Theory in Japan," in Journal of Asian Studies,
Feb. 1989, pp. 16–20

The second part has been interpreted as a statement of Taiga's belief that this painting is not only a landscape but

a reflection of his character, a response to a "benediction" given to him by his mentor Nankai.

By the time Taiga turned forty, he had synthesized a number of artistic influences into a style uniquely and distinctly his own. The earliest dated works in which his mature style is manifest are a pair of six-panel screens of 1763, Orchid Pavilion and Banquet on Dragon Mountain (colorplate 54). The themes of these two paintings derive from the official history of the Qin (Ch'in) dynasty (221–206 B.C.E.) in China. The first depicts a literary party held by Wang Xizhi (Wang Hsi-chih) by the side of a meandering stream, at which he required each guest—all of them noted poets—to compose a poem every time he plucked a cup of wine from the stream. (It was in imitation of this famous outing that Ōgata Kōrin brought gold-coated leaves as sake-cup saucers to his elaborate alfresco party.)

Banquet on Dragon Mountain illustrates the story of Meng Jia (Meng Chia), who attended a picnic organized by Huan Wen. Much wine was consumed in the course of the afternoon, and when a breeze carried off Meng's cap, the symbol of his high post in the government, he continued to drink and enjoy himself, unaware of its loss. At one point when he had left the group for a few minutes, Huan Wen had the hat retrieved and commanded another member of the party to compose a verse ridiculing Meng. However, the latter replied to this challenge with a poem of

The method used to delineate the trees and rocks in the foreground consists of single ink lines frequently repeated and flat washes of color, a technique derived directly from woodblock prints.

As is the case with most artists whose careers span several decades, Taiga in his last years began to paint in a much freer style. His work Nachi Waterfall, made in the 1770s when he was around fifty, is not a minutely detailed recording of observed phenomena, but rather a re-creation of the impressions made on him by aspects of the natural setting (fig. 295). Rocks and trees in the foreground and midground carry the eye back to a large triangular mountain with a void of white paper, the waterfall, in the center. To the left of the mountain, just beyond the dark ink strokes that mark its lumpy outline, is a glimpse of water and hills in the distance. The brushwork is loose and rhythmic in its application, and washes are used in abundance, giving the painting a wet, atmospheric quality that captures the essence, if not the precise visual reality, of the scene.

The second of the great *nanga* masters, Yosa Buson, came to painting through poetry, specifically haiku, and may have pursued his painting career as a means of earning a living in order that he might write poetry without having to be concerned with its popularity. Little is known of Buson's early years, but around 1735 he appeared in Edo, where he studied haiku with various masters including Hayano Hajin, a follower of the great Genroku poet Matsuo Bashō (1644–1694). After Hajin's death in 1742, Buson left the city and spent the next ten years wandering from one province to another. He obviously preferred this course of action to remaining in Edo and continuing to devote himself to writing haiku in the company of fellow poets whose superficiality and poor craftsmanship he scorned.

In the Genroku era Bashō had succeeded in lifting haiku above the standards set by earlier poets mainly through his remarkable creative ability and his theories of poetic content. He believed that a poem should contrast an element of the eternal with a sudden flash of immediate perception. This is a classic example of his poetry.

An ancient pond
A frog jumps in
Water sound

H. Paul Varley, *Japanese Culture, a Short History*, New York, 1973, p. 134

A haiku more solemn in tone describes Bashō's thoughts as he viewed the Konjikidō of Chūsonji at Hiraizumi (see fig. 152).

The brightness lasts
Undimmed by ages of summer rain:
The Temple of Light.

Earl Miner, *Japanese Poetic Diaries*, Berkeley and Los Angeles, 1969, p. 177

**295.** Nachi Waterfall, by IKE TAIGA. 1770s. Hanging scroll, color on paper; 49¼ x 22⅜ in. (125.7 x 56.9 cm). Tokyo National Museum

such high quality that he won the praise of everyone at the gathering. Taiga's depictions of these two scenes are remarkable for their integrated style and their dramatic compositions. In the Banquet screen a large mountain appears in the foreground to the left, and to the right in the distance a village can be seen. The sharp contrast between the mountain, with its densely packed tree and rock motifs, and the open space and sketchily depicted village creates a strong sense of space and also a feeling of an event out of the ancient past materializing in a modern setting.

**296.** Section of *Oku no hosomichi,* by YOSA BUSON. 1778.
Hand scroll, ink and color on paper; height 11½ in. (29.2 cm). Kyoto National Museum

**297.** Bare Peaks of Mount Gabi, by YOSA BUSON. c. 1778–83. Hand scroll, ink and color on paper; height 11³/₈ in. (28.8 cm). Private collection

Buson, considered by the Japanese to be the haiku poet second in caliber only to Bashō, wrote verse that was very different in character, less gentle in its images, less profound in its content, but at the same time more strongly visual in quality, wittier, and sharper in its contrasts of themes. The following two poems convey something of the range of his verse.

> In a line they wheel
> The wild geese; at the foothills
> The moon is put for a seal.

> What piercing cold I feel:
> My dead wife's comb in our bedroom
> Under my heel.

<div align="right">

Harold G. Henderson, *An Introduction to Haiku:*
*An Anthology of Poems and Poets From*
*Bashō to Shiki*, New York, 1958, pp. 101, 114

</div>

In 1751 Buson established himself in Kyoto, and it is thought that he was in contact with Sakaki Hyakusen, the *chōnin* pioneer of *bunjinga*, who was also a haiku poet. However, Buson was largely self-taught as a painter, basing his work on Chinese painting manuals and on observation of the Chinese and Japanese paintings available to him, and he did not reach full maturity as an artist until late in life. The paintings produced between 1778, when he began to sign himself Shain, and his death in 1783 are outstanding in quality. They blend three stylistic elements with the assurance of a master: the themes and lively brushwork of Chinese painting, the free and lyrical recording of the natural world as he saw it, and, finally, the spontaneity and humor often found in his poetry.

Buson greatly revered the haiku of Bashō, and in homage to him produced several illustrations based on the great man's poetic diaries. They are referred to as *haiga*, a style of painting that attempts to capture the impressionistic and humorous quality of haiku poetry. The most famous of these diary illustrations is his *emaki* version of Bashō's famous work *Oku no hosomichi, The Narrow Road to the Deep North* (fig. 296), which begins:

The months and days are the travelers of eternity. The years that come and go are also voyagers. Those who float away their lives on boats or who grow old leading horses are forever journeying, and their homes are wherever their travels take them. . . .

Everything about me was bewitched by the travel gods and my thoughts were no longer mine to control. The spirits of the road beckoned and I could do no work at all. . . .

My dearest friends had all come to Sampū's house the night before so that they might accompany me on the boat part of the way. When we disembarked at a place called Senju, the thought of parting to go on so long a journey filled me with sadness. As I stood on the road that was perhaps to separate us forever in this dream-like existence, I wept tears of farewell. . . . I could barely go ahead, for when I looked back I saw my friends standing in a row, to watch me perhaps till I should be lost to sight.

<div align="right">

Keene, *Anthology*, pp. 363–64

</div>

The scene in which Bashō and a companion named Sora start out on their journey is sketchily but sensitively depicted in ink lines and color washes. It shows the two travelers, Bashō, a bent old man in priestly robes leading the way, followed by Sora; to the right three friends stand deferentially and sadly bid them farewell. In addition to establishing the two monkish travelers as the protagonists, and their adventures as the subject matter of the scroll, this treatment sets the melancholy, somewhat sentimental tone of the scroll.

A pair of six-panel screens from this period that reveal Buson's more Chinese style are Thatched Cottage in a Bamboo Thicket and Returning in the Shade of Willows (colorplate 55). Each screen presents a scene of figures moving through the landscape on five panels and a Chinese poem written on gold paper on the sixth. The thatched cottage of the left screen is a subject Buson painted more than once, and it can be assumed that the entire scene was based on a section of the countryside around Kyoto, but the theme of a young man coming to visit the scholar who is reading in his simple study is one time-honored in Chinese art. Furthermore, although the final effect of the painting is soft, atmospheric, and evoca-

**298.** The Residence, by OKADA BEISANJIN. 1793. Hand scroll, ink on paper. Location unknown. Courtesy Betty Iverson Monroe

tive of human emotions, the composition is more complex and the brushwork more detailed and dependent on small repetitive brushstrokes than is the rule in the artist's less formal styles.

Buson's most personal style can be seen in the short hand scroll *Bare Peaks of Mount Gabi* (fig. 297). Although the theme of the painting is taken from a poem by the Chinese poet Li Po describing the moonlit appearance of craggy Mount Omei (J. Gabi) in Sichuan province, the style of the painting owes little or nothing to Chinese precedents. Beginning with the boldly written title, followed by Buson's signature and seals, the painting unrolls to the left, revealing the peaks of mountain after mountain—the form of each delineated in dark gray sumi ink, filled in with thin red ocher, and each completely different in shape from its predecessor—until across a narrow void the climax of Mount Gabi is reached, a sharply triangular mountain thrusting upward into the gray, ink-washed sky. At the very end a sliver of a moon is made by leaving one area of the paper untouched by color. The most remarkable aspect of this painting is the element of surprise. The moon, so important in Li Po's poem that he included it in the title, appears in Buson's work as a new motif, following a series of freely brushed mountain peaks. Its introduction in this manner causes one to look back at the earlier parts of the scroll and reappraise one's interpretation of its con-

tent. These were not just mountain peaks, but peaks bathed in moonlight. So that nothing would detract from the impact of the moon as the final element of the scroll, Buson did not include it in his title, and he shifted his signature and seals from the conventional placement at the inner edge of the end of the scroll to the beginning, just to the left of the four-character title. Here, as in the haiku quoted above about the line of geese, Buson played upon his audience's knowledge of *emaki* conventions to jolt them into a new perception of the natural world.

## The Third Generation

The momentum of the literati style of painting continued into the 19th century, and the artists who espoused it created lifestyles for themselves that were much closer than their Japanese predecessors' to the ideal of Chinese literati. Taiga was a professional painter whose work reflected several Japanese styles as well as the imported *bunjinga*, and Buson was a poet who sold his paintings for money so that he might compose haiku poems free of the accepted conventions of the day. The next generation of literati were highly educated men of the samurai class who kept in touch with each other, exchanging ideas and often getting together for an informal evening of painting and writing poetry. Two men of this next generation

who achieved a very high level of quality in their painting
were Okada Beisanjin (1744–1820) and Uragami Gyo-
kudō (1745–1820).

Beisanjin's early life is somewhat obscure. He may
have been orphaned while still a young boy, but by 1775
he was living in Osaka, running a small rice and grain busi-
ness. Reflecting his profession, he chose as his art name
Beisanjin, literally Man of a Mountain of Rice. Soon after
he established himself in Osaka, he was hired by Lord
Tōdō, a wealthy rice merchant, first as a warehouse guard,
a position that carried the samurai's privileges of sword
and surname, and later as his personal secretary. As a re-
sult of his close association with the Tōdō family, he was
given a large house on their estate overlooking the Yodo
River, which in time became a gathering place for literati
poets and artists of the Kyoto-Osaka area.

A painting by Beisanjin that gives us great insight
into the climate in which he and Gyokudō lived and
worked is The Residence, executed in 1793 following a
visit to him by the young scholar-artist Tanomura Chikuden
(fig. 298). Chikuden was a samurai from Kyūshū who,
longing for the life of a literatus free of the constraints of
feudal obligations, visited the master as often as he could.
On this particular visit Beisanjin had assembled a few
friends for a night of intellectual pleasures: the viewing
and discussion of paintings, the writing of poems, perhaps
even the execution of a few paintings, and certainly the
drinking of sake. When the hour grew late, Beisanjin's
guests took their leave. In the painting, which depicts their
departure, we see Beisanjin in the lead pointing the way
through the rice fields, followed by an elderly bearded
gentleman, Gyokudō, and a group of younger men includ-
ing Chikuden and a noted literati poet, Rai Sanyō. To the
right can be seen Beisanjin's house, the room reserved for
guests open to view, and in the garden are a woman and a
boy, probably Beisanjin's wife and son. The horizontal for-
mat of the painting forecasts the departing guests' move-
ment to the left, and the technique contrasts bold strokes
in dark ink with delicate lines in pale tones, suggesting the
quality of vision on a moonlit night. The Residence is a
gentle, quickly executed painting intended to capture the
mood at the end of an evening spent in the company of
good friends and to commemorate an ideal but all too rare
occasion in these men's lives.

A painting more representative of Beisanjin's ma-
ture style is The Voice of a Spring Resounding in the
Valley, a kakemono dated to 1814 (fig. 299). The height of
the vertical composition is emphasized by the overlapping
of rectangular rocks and triangular mountain forms carry-
ing the viewer's eye from the foreground to the deep space
of the background. To the left the strong verticality of the

**300.** Building a House in the Mountains,
by URAGAMI GYOKUDŌ. 1792. Hanging scroll, ink
and slight color on silk; 26 x 12¾ in. (66 x 32.5 cm).
Tokyo National Museum

ral forms that establish a tension between the natural depth of the landscape and its surface texture. Beisanjin was largely self-taught as an artist, working from Chinese painting manuals and what imported paintings came into his hands. Nevertheless he was able to create a strong, personal style in the best *bunjinga* tradition, and to establish a pattern of life in harmony with the values of the literati.

Uragami Gyokudō, Beisanjin's friend and contemporary, also lived the life of a literatus and developed his own unique style of painting imbued with the melancholy intensity of a lonely, displaced human being who projected his immediate feelings on his depictions of the natural landscape. Born into the family of a *han* official serving the Ikeda family, Gyokudō received the standard Confucian education dispensed to the children of samurai at the *han* school. When he was in service in Edo, however, he studied other versions of Confucian doctrine and was particularly attracted to the Ō-Yōmei school based on the philosophy of the Ming-dynasty scholar Wang Yangming. While in Edo, he studied the *qin* (ch'in), or Chinese zither, with a man who served as medical officer to the shogunate, and he took the name of Gyokudō when a particularly fine old *koto* called Gyokudō Seiin came into his possession.

In 1794, when Gyokudō was at a resort with his two sons, he wrote a letter to his *han* lord resigning his post, presumably to avoid ideological conflicts and possible punishment under the edict issued by the shogunate forbidding the teaching of any other Confucian doctrine but that of Zhu Xi (Chu Hsi) as it was taught at the official shogunate college, Shōheikō. After his resignation he wandered about Japan, wearing eccentric clothing not unlike the feathered cloak of a Taoist recluse, his *qin* slung on his back, and made a living by giving music lessons and perhaps by teaching what he knew about medicine. There was about Gyokudō not only an element of the mystic, but also an informed and rational intelligence. He was one of the first in Japan to recommend the drinking of milk as a healthful food and he advocated the touching of cows by children to develop an immunity to smallpox.

Like a true literatus, Gyokudō preferred not to paint on commission, but rather as a means of expressing his feelings. Nothing is known of the sources of his art, but he did not turn to painting in earnest until after the age of sixty. Since he was acquainted with Tani Bunchō, an Edo artist versed in *bunjinga* techniques, it is likely that he studied painting in Edo, but the name of his teacher has not been preserved. It is known that he was friendly with Kimura Kenkadō, one of the leading chroniclers of the literati movement, but nothing about his exposure to Chinese art or art theory has ever been recorded. Yet Gyokudō was one of the first of the major literati painters to utilize the Chinese technique of laying brushstroke upon brushstroke to achieve a dense, rich surface texture. One of his early paintings, Building a House in the Mountains, of

mountains is balanced by the horizontal lines of a bridge, spits of land, and a cluster of houses. Only in this part of the painting do we get any sense of natural space. Elsewhere form overlaps form, creating the impression of a densely filled passage of landscape.

The most unusual feature of the painting is the idiosyncratic treatment Beisanjin gives to the rocks at the base of the composition and the strange angular shapes he uses at the tops of the smooth, triangular mountains. The similarity of the forms at the top—the motifs that appear to be most distant from the foreground images—to those at the bottom seems to pull the mountain rocks to the foreground, working against the sense of recession into depth created along the left edge of the picture surface. In Beisanjin's later years this was one of his favorite devices—the use of strong brushstrokes to create unnatu-

**301.** *Eastern Clouds, Sifted Snow*, by URAGAMI GYOKUDŌ.
c. 1811. Hanging scroll, ink and color on paper; height 49 in.
(124.5 cm). Private collection

the repetition of brushstrokes to suggest foliage. Only in the foreground rocks, and occasionally in the background mountains, is there an attempt to build up strokes and to exceed the basic outlines of the rock forms.

The full force of Gyokudō's mature style can be seen in two works executed around 1811, *Eastern Clouds, Sifted Snow* and an album called "Mist and Clouds." *Eastern Clouds*, a hanging scroll executed in ink and occasional touches of ocher on paper, was painted after Gyokudō had been drinking sake, according to the inscription (fig. 301). Yet the painting displays a remarkable control of both composition and technique, which express through purely visual means the artist's own emotional state on a particular day when the snow was falling in the mountains. The motifs employed are the familiar clichés of Chinese literati painting: the scholar in his thatch-roofed cottage reading, a tiny figure crossing a bridge, a village, and a temple pagoda; but they have been modified by the dense atmosphere of the painting to the point where they are not immediately recognizable and therefore seem new and fresh.

The technique used to achieve the rich density consists of an underlying sketch in light ink, over which increasingly darker shades of ink are applied, until the final accents are added in dark, almost pure-black ink. Also, the shapes of buildings and the bridge have been deformed, and motifs incongruous in size juxtaposed to suggest the poor visibility one experiences when looking through falling snow. The final impression is one of a cold and hostile world in which only the scholar, isolated in his study and unaware of the realities of life, can survive.

The album "Mist and Clouds" offers a somewhat less austere view of the landscape. In the most colorful of the twelve leaves, Verdant Hills and Scarlet Forests (color-plate 56), two groups of trees outlined in black ink in the foreground plane are placed against rounded mountain forms spotted with patches of red and gray in the background. Between the two clumps of trees is an open area, possibly a pond, at the same point in depth as a house visible between the trunks of two trees in the right grove. Thus the eye is offered a series of sharp contrasts, an area in which trees flow into background mountains, a void, and a group of isolated landscape elements—a restless play of forms in space within a whole that can be grasped in a single glance. Gyokudō and Beisanjin were not particularly respected as artists during their lifetimes, but in the reappraisal given *bunjinga* in the 20th century they have emerged as two of the most powerful Japanese artists working in the style.

## The Fourth Generation

The next generation of literati artists, working in the 19th century, marks a new stage in the development of the school in Japan. Men like Tanomura Chikuden, Rai Sanyō, and Okada Hankō, as well as the Nagoya painters

1792, has a greater affinity to the works of Taiga than to Gyokudō's later productions (fig. 300). The painting, executed on silk, derives its character from the extensive use of colored washes in brown, green, orange, and red, and

川影莊々白樹光後營草堂煙未上
淡淡暖部
己丑初冬泛奥稲川写生政見月
拳師景自奇作古山陽小帖二見一展
諳曹肯否祠陰主人光閑品定
竹田生富

**302.** Boating on the Inagawa, by
TANOMURA CHIKUDEN. 1829. Hanging scroll, ink and
light color on paper; 52³/₈ x 18³/₈ in. (133 x 46.5 cm).
Private collection

Nakabayashi Chikutō and Yamamoto Baiitsu, were much
more knowledgeable about Chinese painting and literature
than were their predecessors. More Chinese works were
being imported into Japan, and there was greater access to
Chinese books. Yet this greater access to Chinese culture
made Japanese artists somewhat timid in their efforts to
capture the essence of Chinese literati art, instead of sti-
mulating a new creativity among them.

An artist in the forefront of this fourth generation of
literati painters was Tanomura Chikuden (1777–1835), the
samurai student of Beisanjin. Chikuden was born into a
family of physicians serving the Oka clan in Kyūshū and
succeeded to the position of *han* doctor after the death of
his father, but was ordered by his lord to become a scholar
and to teach at the *han* school. Occasionally he traveled
to Edo as part of his official duties, and there he met Tani
Bunchō, a literati painter and friend of Gyokudō. In 1811
and again in 1813, serious revolts broke out in the *han*,
and on both occasions Chikuden presented formal pro-
posals for remedying the plight of the peasants. His pro-
posals were not accepted, and in frustration Chikuden
finally resigned his post and traveled to Kyoto, where he
could continue his association with his literati friends.

One of Chikuden's most gentle and romantic paint-
ings is Boating on the Inagawa, of 1829 (fig. 302). The oc-
casion for the painting was a day spent fishing with his
companion Rai Sanyō. The two fishermen can be seen in
boats at the bottom of the painting, their lines dangling
idly in the water, their heads turned toward each other as
though deeply absorbed in conversation. Above and to the
right appears the house of the wealthy merchant family
with whom they are staying, and through an opening in
one of the buildings a man can be seen reading in his
study. The other details in the painting suggest the bucolic
quality of life along the river: a cluster of thatch-roofed
cottages, one man poling a boat across the river, another
walking across a bridge, leading his ox through the water.
The pale colors, gray, blue-green, and pale pink, applied in
wet overlapping dot strokes, add greatly to the soft mood
of the painting, a celebration of a sunny day spent on the
river in the company of good friends.

Yamamoto Baiitsu (1783–1856), an artist of extraor-
dinary technical skill and versatility, is considered one of
the most accomplished of the fourth-generation literati
artists. Born in Nagoya, he first studied a variety of styles,
from the realism of Chinese bird-and-flower painting prac-
ticed in Nagasaki to the ink painting of the Kanō school.
At the age of eleven Baiitsu demonstrated his skill by
decorating the *fusuma* of a Buddhist temple. In his teens
he met and became the protégé of the wealthy business-

**303.** Egret Under Flowering Mallows, by
YAMAMOTO BAIITSU. 1833. Hanging scroll, ink and color
on silk; 45⅜ x 16⅛ in. (115 x 41 cm). Private collection

man and collector of Chinese painting Kamiya Tenyū.
While under Tenyū's patronage, he formed a deep friend-
ship with the young artist Nakabayashi Chikutō (1778–
1853), and together they studied the Yuan and Ming paint-
ings in Tenyū's collection as well as instructional texts
such as the *Mustard-Seed-Garden Manual of Painting*. It
was Tenyū who was responsible for giving both men their
art names, Baiitsu, meaning Plum Leisure, and Chikutō,
Bamboo Grotto. In 1802 Tenyū died, and soon after the
two friends left for Kyoto, where they joined the literati
painting group headed by Rai Sanyō. Baiitsu lived and
worked steadily in Kyoto for the next thirteen years. He
traveled to Edo but was soon recalled to Kyoto, where he
met and worked with Tani Bunchō on a new imperial re-
ception room. Later he returned to Edo with Bunchō.
Together they founded the painting society called The
Tower of Eight Hundred Perfections.

Baiitsu traveled extensively in the middle Honshū area
and gained more of a reputation for his decorative *kachō*—
bird-and-flower paintings—than for his quiet *bunjinga*
landscapes. His *kachō*, produced in abundance, were deli-
cately colored and superbly executed in what was soon to
be recognized as Baiitsu's own inimitable style. Unfor-
tunately, his contemporaries grew jealous of his success
and devised a scheme to humiliate him. A story was circu-
lated that a certain geisha wore one of his paintings as an
undergarment, suggesting that it was no better than a tex-
tile design. Their plan succeeded, and his reputation was
tarnished. Two years before his death he returned to
Nagoya, where he was subsequently raised to membership
in the samurai class by the daimyo of Owari.

An excellent example of Baiitsu's mature *kachō* style
is Egret Under Flowering Mallows of 1833 (fig. 303). The
painting depicts a single white bird standing on one leg on
a stone at the edge of a lily pond. The body of the egret is
executed in a spontaneous style, with the feathers built up
in a series of suggestive curves that contrast sharply with
the straight forms of its thin dark legs and elongated beak.
The leaves of the mallows and the lily pads are painted in
a *tarashikomi* technique similar to that pioneered by
Sōtatsu. Using a wash method, he first painted in the leaf
forms, and before the ink had dried completely, outlined
them with a thin brush using various intensities of black.
This method involves bleeding, which results in a grada-
tion of tone and lends vibrancy to the foliage. Finally, the
pink of the flowering mallow adds strength and balance to
the white of the egret's body, completing a highly decora-
tive and satisfying composition.

A man of extraordinary accomplishments, Baiitsu
was a master of the tea ceremony, a noted poet, and a
skilled lute player. His extreme sensitivity, combined with
his exceptional talent, made him an artist able to blend

**304.** Mountain Landscape, by TANI BUNCHŌ. 1794. Hanging scroll, ink and color on paper; 53 1/8 x 21 1/8 in. (134.9 x 53.8 cm). The Portland Art Museum, Portland, Oregon. Margery Hoffman Smith Fund and Helen Thurston Ayer Fund

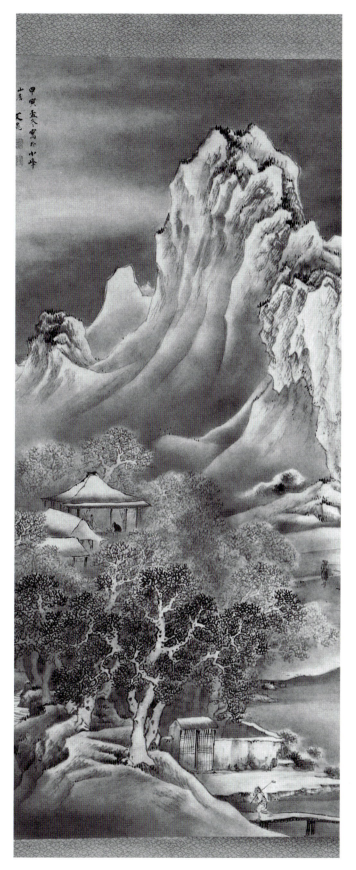

the soft atmospheric qualities inherent in the literati style with the harder, more sharply conceived linear quality of the Kanō, Maruyama, and Nagasaki schools.

Kyoto and Osaka were the centers for *bunjinga* in the Tokugawa period. Even artists of the stature of Baiitsu and Chikutō found it desirable to leave their home town of Nagoya and join the circle of literati in Kyoto. However, Edo painter Tani Bunchō (1763–1840) was an exception to this pattern. Bunchō was a samurai, a retainer of the Tayasu family resident in Edo, and it was he who was chiefly responsible for bringing an appreciation of the literati style to the shogun's capital. Through his friendship with men like Gyokudō and Baiitsu, he gradually turned from the Kanō and Nagasaki styles he first employed to *bunjinga*. Throughout his life, though, he worked in whatever manner suited his subject matter and his mood. He also was something of a scholar of painting, devoting a great deal of his time to copying old paintings and writing about them. In addition he practiced *shaseiga*, painting copied from nature, for which he became so well known that he received several commissions from Matsudaira Sadanobu, chief adviser to the shogun from 1787 to 1793. In 1793 he accompanied Sadanobu on an inspection tour of the defenses of Edo Bay, making sketches of various installations. He also did the illustrations for a catalog of antiquities compiled by Sadanobu. However, it is for his painting in the literati style that he is best known.

A particularly fine example of Bunchō's most Chinese style of landscape is a work of 1794 called Mountain Landscape (fig. 304). The painting depicts a grove of snow-covered trees and a scholar's pavilion, set against towering white mountains. The complexity of the composition and its somewhat impersonal style suggest the Ming tradition of Chinese landscape brought back by Sesshū in 1468, rather than the literati style. Essentially the painting consists of two overlapping right-angle triangles, the foreground triangle slanting to the left, the background one to the right. Balance is achieved by a strong emphasis on the baselines of both shapes. Bunchō has added an element of the literati style by suggesting the misty atmosphere of a gray, snowy day. The trees in the foreground of the grove are sharply delineated in dark strokes, but as the eye moves in behind these first trees, the ink tones become paler, the lines thinner and less distinct. Finally one penetrates to the scholar's pavilion, which is sharply outlined in thin, dark strokes, causing the viewer to focus on the building and its two inhabitants. Finally, above it all one sees the tall, majestic snow-covered mountains, capping and enclosing the scene.

A painting that shows the more eccentric side of

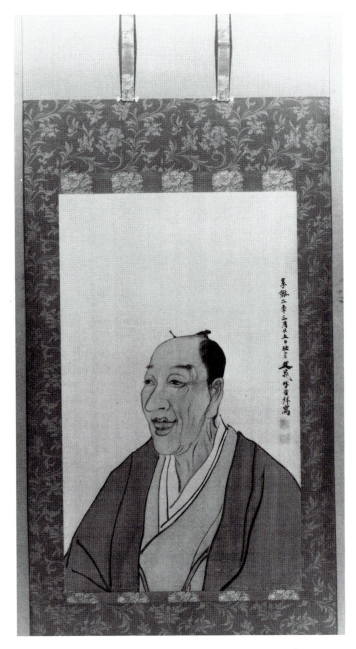

**305.** Portrait of Kimura Kenkadō, by TANI BUNCHŌ. 1802. Hanging scroll, color on silk; 27⅛ x 16½ in. (69 x 42 cm). Osaka Municipal Art Museum, Osaka prefecture

Bunchō's character is the portrait he made of Kimura Kenkadō (fig. 305). Kenkadō was a wealthy sake brewer in Osaka whose fortune was confiscated because he brewed more sake than his government-assigned quota. Ultimately he was pardoned and allowed to open a stationery store in Osaka. Throughout his life he maintained close contacts with a number of literati artists including Gyokudō and Bunchō, and he recorded their visits in his diary. In 1892, when Bunchō in Edo learned of his friend's death two months earlier, he executed this portrait of Kenkadō from memory. It is not a particularly flattering portrait, but it conveys a clear image of the man, a talkative fellow with sharply focused, shrewd eyes.

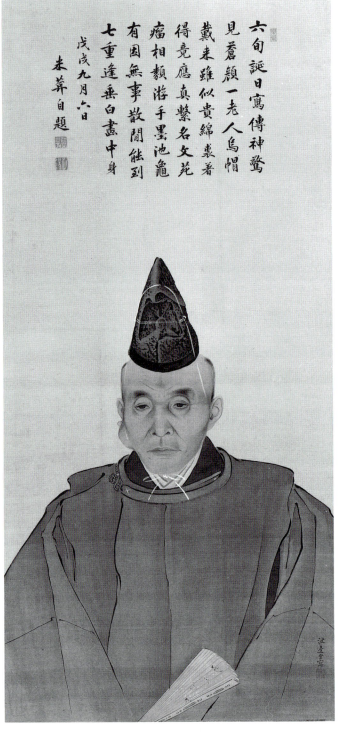

**306.** Portrait of Ichikawa Beian, by WATANABE KAZAN. 1837. Hanging scroll, ink and color on silk; 51 x 23¼ in. (129.5 x 59 cm). Kyoto National Museum

Bunchō was an eclectic artist working in a wide variety of styles. Also, perhaps because he executed so many works, the quality of his production is very uneven, ranging from the two masterpieces discussed above to some very minor pieces. Yet it is precisely his restless energy and his passionate interest in exploring all kinds of art

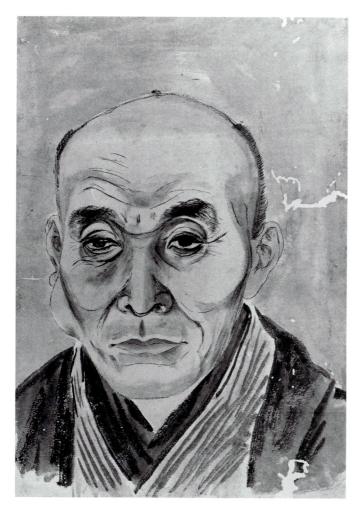

**307.** Sketch for the portrait of Ichikawa Beian, by WATANABE KAZAN. 1837. Mounted as a hanging scroll, ink and slight color on paper; 15½ x 11 in. (39.4 x 27.9 cm). Private collection

paintings in order to develop his technique. Around 1816 he entered the circle of artists working with Bunchō. From then on his painting took a more professional direction. He experimented with the Kanō style and with the academic bird-and-flower style derived from Chinese artists like Shen Nanpin. However, from 1816 until the late 1820s, his work bears the clear influence of Bunchō. At that time his interests turned to *rangaku*, or Dutch studies, the avenue of Japan's contact with the West, and he began to execute portraits using Western techniques, but working with Japanese materials such as silk and Japanese pigments.

One of the best examples of his Western-style portraits is a painting of Ichikawa Beian, completed in 1837 (fig. 306). Beian was a noted calligrapher and Confucian scholar of the day, and although Kazan did not actually study with him, he regarded him as something of a spiritual mentor. In addition to Kazan's formal painting, a preliminary sketch of Beian, executed in ink and colors on paper, has survived (fig. 307). The two works provide a rare glimpse of the artist's technique. The sketch shows Beian in an informal pose. He wears a black jacket over a striped kimono, the kind of garment one might wear around the house. His face, although slightly turned to the right, still reveals a swelling just below his right ear. His eyes, though unfocused, look directly forward, suggesting the thoughtful gaze of an intelligent, middle-aged man.

The painting, by comparison, lacks the immediacy of the sketch. It was intended as a memorial portrait, and in the year after its completion, when Beian turned sixty, laudatory inscriptions were added to the upper portion of the painting. Still, Kazan has remained faithful to the spirit of the Western techniques he admired. The volumes of the face are suggested by highlights and shadows with a minimum use of line. Beian wears a formal court costume and cap, but even here Kazan used details like the white cord holding the cap in place to suggest the volumetric quality of Beian's head.

Kazan's interests in Western studies were not confined to art alone. He also became informed about geography, history, military science, and Western firearms. As a result he was put in charge of coastal defenses, but his vision was much broader. He saw the need to reform Japanese military practices and to bring the country into line with political and technological developments in the West. Joining forces with other *rangaku* scholars, he began to put forth his ideas publicly in such writings as *Shinkiron*, or *Discourse on a Modest Opportunity*. In 1839, as part of a general crackdown on dissidents, he was put under house arrest outside of Tokyo. The positive aspect of his imprisonment was that it gave him a great deal of time to paint. However, the conditions under which he and his family were forced to live were extremely painful, and in 1841 he committed suicide. Traditionally, Kazan has been classified as a literati artist because of his association with Tani Bunchō. Today it is clear that he was also a leader in bringing the importance of Western technology

that make him typical of the late Edo period. Throughout the art world there was a pervasive sense of the need for change either through a return to the origins of a particular style or through the adoption of new techniques.

Watanabe Kazan (1793–1841), a sometime pupil of Bunchō's, exemplifies this spirit of searching and experimentation. Kazan was born into a samurai family serving the Tawara clan. He received a proper Confucian education but had to give up his ambitions to become a Confucian scholar due to the financial difficulties that beset his family and the pressures of working for the Tawara feudal estate. From an early age he was interested in painting and calligraphy, and in 1808, at fifteen, he began formal study. However, his official duties left him little time to paint. Contemporary documents record his life in his late teens. From the age of sixteen on, he was supposed to work on alternate days for the *han*, but in fact he often had to work every day. In order to find any time for his own pursuits, he would rise early, and after finishing his work for the *han*, he would stay up half the night, reading, practicing his calligraphy, and making copies of

to the attention of the Japanese people. His accomplishment in Western-style painting, seen in the realism he brought to portraiture, was an important outgrowth of his *rangaku* studies. However, his ideas were decades ahead of most of his contemporaries, and he paid a high price for his pioneering spirit.

## *Ukiyo-e,* Pictures of the Floating World

The type of pictorial expression most characteristic of the Genroku era depicts the world of the theater, the pleasure district, and the *chōnin* and samurai who frequented both; it is called *ukiyo-e,* or pictures of the floating world. The word *ukiyo* first appeared in the context of Buddhism, where it referred to the impermanence of the world of humans—that all things are illusory and ephemeral—but in the Edo period the word took on a different tone: now the fleeting world was to be savored with gusto by a society devoted to sensual pleasures all the more exciting for their constantly changing nature. In addition *ukiyo* was used to refer specifically to the *demimonde* of the pleasure district—a quarter of the city surrounded by a high wall, within which lived courtesans, their attendants, and the tea shop owners to whom they were indentured—and the theater district, where Kabuki plays and Bunraku performances were presented. In the Genroku era the principal vehicles for literary and artistic expression were the *ukiyo zōshi,* prose stories of the floating world; *ukiyo-e,* paintings and woodblock prints of genre subjects; *bijinga,* paintings and prints of courtesans; and Kabuki and Bunraku plays.

### The Beginnings of *Ukiyo-e*

The artist traditionally credited with parenthood of the *ukiyo* genre of illustration is Iwasa Matabei (1578–1650), although the only extant works attributed to him are paintings. The best explanation yet advanced for the references in Edo-period documents to "Ukiyo Matabei" is that the artist pioneered a style of painting in which wiry black outlines and bright colors were combined with themes depicting human beings in moments of extreme emotion—caught in the noise, excitement, and confusion of a festival, or even confronted with sudden slaughter—and that this mode of painting was transmitted by him from Kyoto to Fukui prefecture, where he worked for the daimyo Matsudaira Tadanao and his son, and finally to Edo when he moved there in 1637. His style, in its final stages of evolution when he made his last change of residence, probably had great appeal for the rough, brawling *chōnin* and low-ranking samurai of Edo, with their taste for action-packed Kabuki plays, and may well have influenced artists there who were working with block-printing techniques, enabling them to create designs of greater intensity and forcefulness.

Matabei was the illegitimate son of the samurai Araki Murashige, a trusted adviser to Oda Nobunaga.

**308.** Kanbun Beauty. 17th century. Hanging scroll, color on paper; 24¹/₈ x 9⁵/₈ in. (61.2 x 24.4 cm). The Mary and Jackson Burke Collection, New York

**309.** Illustration from *Yoshiwara no tei (The Appearance of Yoshiwara)*, a woodblock series by HISHIKAWA MORONOBU, showing a brothel scene. 1678. One-color woodblock print on paper; horizontal *ōban* size: 9¹/₈ x 15 in. Tokyo National Museum

However, the year after Matabei was born his father rebelled unsuccessfully and had to flee for his life. His wife and legitimate offspring were put to death, but Matabei escaped with his wet nurse and was allowed to live in hiding in Honganji in Kyoto. Thus he grew up in the capital and probably established a painting studio there before he left for Fukui in 1615. A group of *emaki* in which illustrations are interspersed between sections of Jōruri texts—an early form of Bunraku puppet plays—and *byōbu* depicting animated scenes of festivals and horse races display a consistency of style that suggests they came from a single studio if not the hand of a single artist. The best of the Jōruri *emaki*, *Yamanaka Tokiwa*, depicts the painful and poignant journey of Tokiwa, the mother of Minamoto Yoshitsune, from her palace in Kyoto to the remote mountainous provinces in the northeast in search of her son, her brutal murder by ruffians, and Yoshitsune's merciless revenge. There is a certain sense of poetry, pathos, and even humor in the scroll, but it is most impressive for its gruesome insistence on bloodletting (colorplate 57).

A second step toward the formation of true *ukiyo-e* was a type of painting, *bijinga*, depicting a single courtesan against a flat, neutral background, which became popular in the Kanbun era (1661–1672). These paintings, executed by town artists who did not sign their works, were presumably produced as expensive souvenirs for purchase by well-to-do *chōnin* or samurai patrons of the pleasure district. In comparison to Matabei's work, Kanbun *bijinga* display delicate brushwork and elaborate textile patterns in restrained colors combined with a characterization of the women as remote and elegant creatures. An excellent example of this style of painting is the *kakemono* Kanbun Beauty (fig. 308). A slender young woman stands with her knees slightly bent, her arms

drawn into her sleeves. Her mouth is hidden by an undergarment that has been pulled out of place, and her eyes are directed to the left. Are they focused on something? Is she drawing her head into her garments to express fear or reluctance, or is she playing the shy virgin to encourage her customer? The question is left to the viewer, and in that lies much of the charm of this type of painting.

A third stimulus to the development of *ukiyo-e* was the rise to popularity of *ukiyo zōshi*, short stories and novellas written in simple Japanese about the life of townspeople and courtesans. Foremost among the novelists working in this genre in the Genroku period, indeed the man often credited with developing this form of fiction, was Ihara Saikaku (1642–1693), the son of an Osaka merchant. Saikaku began his career by writing linked verse, but in his forties he turned to the production of erotic fiction, including *The Life of a Man Who Lived for Love*, *Five Women Who Chose Love*, and *The Life of an Amorous Woman*. The last mentioned, arguably the best of Saikaku's *ukiyo zōshi*, deals with a woman who began life as the daughter of a courtier, an attractive, well-trained girl with a promising future. However, allowing herself to be ruled by her sensual desires rather than by her head, she fell into one disastrous situation after another, until she ended her days as a common prostitute too old to find a customer even in the darkness of night. In Saikaku's hands the story, which could have been a very melancholy tale, becomes light-hearted and humorous. Many editions of this novel and of Saikaku's other works were published, the better editions having illustrations interspersed with the text. Saikaku even tried his hand at designing monochrome woodblock prints both for his own and for friends' books. Illustrated books were first produced and commonly circulated in the early 17th century,

but they gained tremendously in popularity as townspeople became more interested in literature and affluent enough to purchase them. By the Genroku era the quality of the writing and of the illustrations had improved to the point that they were significant art forms.

The man generally credited with bringing the woodblock print artist out of the shadows of anonymity into the light of public acclaim was Hishikawa Moronobu (1618–1694). Born into a family that made its living by designing and executing embroidery designs on textiles, Moronobu began his artistic career making underdrawings on cloth. It was a short step from this to the designing of woodblock prints, utilizing supple black lines on the white ground of the paper. Sometime after the great fire of 1657, Moronobu is thought to have moved from his family home in present-day Chiba, north of Tokyo, to Edo, where he began to design prints. His period of greatest activity was from 1673 to 1687—few works survive from the succeeding Genroku era proper—and he was principally involved with book illustration. His greatest contribution to the development of woodblock prints, however, was the production of sets of single-sheet illustrations without any accompanying text, depicting such themes as the Yoshiwara pleasure district in Edo, flower-viewing at Ueno, and the like. These individual prints introduced *chōnin* to the idea that pictures could be enjoyed for their artistic quality as independent artworks. Furthermore, he was the first artist to append his name to his prints. A particularly fine example of his work is the single sheet from the set *Yoshiwara no tei, The Appearance of Yoshiwara*, of 1678 showing the interior of a brothel, with several patrons sitting on the floor watching as a courtesan dances to the accompaniment of a drum and two samisens (fig. 309). To the left is a two-panel screen with Moronobu's signature clearly visible as part of the surface design.

A group of artists who benefited not only from the new prominence that Moronobu brought to individual woodblock-print designers, but also from certain elements of his style and the new standards of excellence he set for the medium, was the Torii school. Torii Kiyomoto (1645–1702), the founder, was an *onnagata*, a Kabuki actor who specializes in female roles. In 1687 he moved with his famiy from Osaka to Edo, where he was asked to design a poster for one of the Kabuki theaters. His work received such favorable comment that he was asked to do posters for other theaters in the city, and gradually he developed a monopoly on the designing of theater posters and programs.

Kiyonobu I (1664?–1729), Kiyomoto's son, made a singular contribution to the reputation of the Torii family as artists by developing a style of depiction that captured the rough, vigorous manner of acting formulated by the actor Ichikawa Danjurō, then immensely popular in Edo. Kiyonobu's style has been characterized rather unflatteringly as "gourd legs, wormlike," referring to the heavy muscular legs of his male figures and to the strong line, varying considerably in width, that he uses to define the forms.

**310.** Gorō Uprooting a Bamboo Tree, by TORII KIYOMASU I. 1697. Polychrome woodblock print on paper, with hand coloring; *ōban* size: c. 15 x 9⅛ in. Tokyo National Museum

A third, rather mysterious, figure in the Torii family is the artist called Kiyomasu I (active 1697–mid-1720s). The documentary evidence regarding his birth and death dates and his relationship to Kiyomoto and Kiyonobu presents numerous problems of interpretation. However, from the few extant works attributed to Kiyomasu, it would appear that he was a more accomplished and versatile artist than Kiyonobu. An excellent example of his work is the print depicting Ichikawa Danjurō in the role of Takenuki Gorō, Gorō Uprooting a Bamboo Tree (fig. 310). The actor, a stocky man with bulging arm and leg muscles, is nude to the waist, exerting all his strength to pull a thick bamboo trunk out of the ground. The line that marks the contour of Gorō's body is remarkably calligraphic, resembling exuberant brushwork rather than lines cut in a block of wood. On the basis of this print, it is easy to see why the work of Kiyomasu I is greatly appreciated by connoisseurs for its vigorous and forceful style.

Woodblock prints are made by transferring an image carved into the surface of a wooden block—for traditional Japanese prints usually of cherry wood—to a sheet of paper. The artist first makes a design on ordinary paper and has it transferred to a special thin, semi-transparent paper, which is pasted face down on the woodblock. The surface of the block is cut and chiseled away, leaving a design formed of raised lines and solid areas. Ink is applied to this surface and a piece of paper placed over it. The exposed back side of the paper is rubbed with a *baren*, a disk-shaped pad, which causes the transfer of ink from the block onto the front side of the paper.

Early woodblock prints used only black ink, but by the 1760s, techniques for printing in many colors—up to twenty—had been developed and were in wide use. In order to apply several colors to a single sheet of paper by mechanical means, as opposed to hand coloring, a separate block was carved for each color. Further, it was necessary to develop a system for aligning each block so that it would register a single color within the initial black outlines printed on the sheet. *Kentō*, a set of two cuts on the edge of each block, accomplished this. To stand up to many rubbings, the paper used for woodblock prints has to be both strong and absorbent. Traditionally, the favored paper has been *hoshō*, made from the inner bark of the mulberry tree.

The sizes of Japanese woodblock prints were largely determined by stock sizes of papers available for printing. Thus the paper dimensions have provided the terminology for print sizes. Among the most frequently found are *ōban* (large print), approximately 15 x 10 inches (38 x 25.5 cm); *chūban* (medium print), about 10 x 7 inches (15.5 x 18 cm); *hosoban* (narrow print), about 13¾ x 6 inches (35 x 15 cm); and *hashira-e*, or pillar print, approximately 27½ x 6 inches (70 x 15 cm). In the late 18th century and in the 19th century, *ōban* sheets were frequently joined to form triptychs and even pentiptychs.

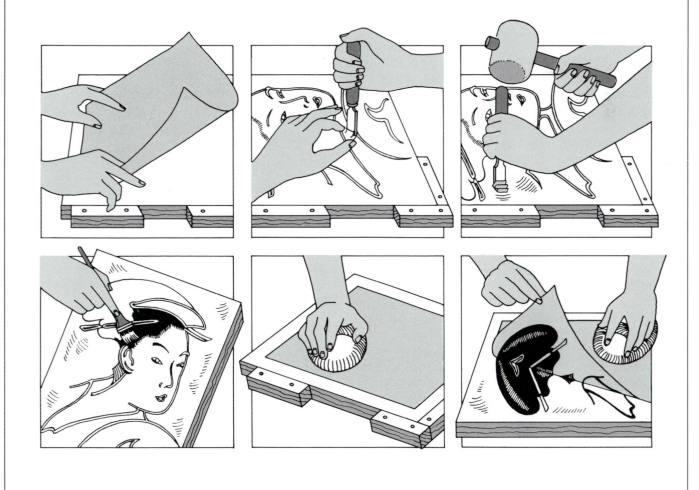

## Polychrome Woodblock Prints

A major innovation in the arts of the second century of Tokugawa rule was the application of polychrome woodblock techniques to the production of single-sheet prints, known as *nishiki-e,* or brocade pictures. The technology for making color prints had existed in Japan since the 17th century and was used in the printing of mathematical and scientific books, but it was not until the mid-18th century that single-sheet polychrome prints began to appear. The first *nishiki-e* were privately printed calendars commissioned by a group of wealthy upper-class townspeople and samurai who shared an interest in the arts, literature, and particularly the composition of haiku, and who indulged in elaborate and elegant pastimes such as the exchange on New Year's Day of ingeniously designed and expensively printed calendars. One of the reasons that amateurs of the arts had to exercise such ingenuity in the creation of these year-end gifts was that the state held a monopoly on the printing of calendars, and it was no doubt this intrigue that made the act so appealing. Since these were privately printed and distributed, they were in violation of the law. Consequently, the symbols for the short and long months were subtly introduced into the composition so that at first glance the prints seemed to be nothing more than pretty pictures.

The first to produce *nishiki-e* was Suzuki Harunobu (1725–1770), an Edo artist with a relatively undistinguished career until he was commissioned by a group of connoisseurs headed by the writer Kyosen to design a multicolor calendar print. Around 1766 it was decided to commercially market these polychrome prints—minus their calendric markings. From then until his death five years later, Harunobu turned out hundreds of multicolor prints dealing with contemporary and classical themes. One of his favorite subjects, of which he made five different versions, was *Fūryū nana komachi,* the seven major events in the life of the most beautiful Heian poet, Ono Komachi, treated in modern style. The basis for the set was a group of Nō plays by the great Muromachi playwrights Kanami and Zeami. One of these plays, *Kayoi Komachi, Komachi of the One Hundred Nights,* focuses on a would-be lover. It seems that in her youth Komachi agreed to a rendezvous with a certain young man if he would visit her house without seeing her for a hundred successive nights. According to Kanami's play, he came faithfully for ninety-nine nights, passing the dark hours on the mounting block of her carriage. He died before nightfall of the last night. Harunobu chose a less melancholy ending: the young man's father died on the hundredth day, and the young man could not come. The next day Komachi sent him the following poem:

In the early dawn
You marked up a hundred nights
On the mounting block—
But the night you failed to come
It was I who counted that.

**311.** Kayoi Komachi, from the series *Fūryū nana yatsushi komachi (Seven Modern Dandified Komachi),* by SUZUKI HARUNOBU. 1766–67. Polychrome woodblock print on paper; *hosoban* size: c. 13 x 5⅝ in. (33 x 14.2 cm). Tokyo National Museum

D. B. Waterhouse, *Harunobu and His Age,* London, 1964, p. 85

In the Harunobu print illustrated here (fig. 311), Komachi is shown as a beautiful and elegant, but heartless, courtesan standing on the veranda of her house while her maidservant counts off on her fingers the number of nights the

**312.** Morning Haze at Asakusa, from the set "Eight Sophisticated Views of Edo," by SUZUKI HARUNOBU. c. 1769 Polychrome woodblock print on paper; *chūban* size: c. 10 x 7½ in. Tokyo National Museum

shop, and Harunobu has made reference to this by including several ginko leaves in the foreground of the print. However, he has gone a step beyond this cliché by placing Ofuji against the backdrop of a willow tree, again a reference to her youth and pliability, and to the "willow world," the world of the pleasure district to which she belonged.

The *ukiyo-e* artist who best depicts the elegant surface of Japanese life in the late 18th century is the great master of the Torii school, Torii Kiyonaga (1752–1815). Although not a blood relation of the Torii family—his official surname was Sekiguchi—Kiyonaga assumed leadership of the Torii school in 1785, when his master Kiyomitsu (1735–1785) died suddenly. At the time there was no male heir who could take over, and Kiyonaga was Kiyomitsu's most accomplished pupil. He accepted the position with reluctance and forced his son to abandon thoughts of a career as an artist, presumably to prevent any disputes about who would succeed him, his own kin or Kiyomitsu's grandson. Clearly Kiyonaga was not a proud or vainglorious man. His work demonstrates a quality of reticence about asserting his own personality and of gentility in the depiction of his subjects.

In the years 1781 to 1785 Kiyonaga developed a style of *bijinga*, studies of beautiful women, which became the preferred form for the genre for the remainder of the century. In his prints the women—whether important figures from history or literature, geisha,❖ or wives of the merchant class—are depicted as tall, elegant creatures engaged in gentle, decorous activities. After 1787 Kiyonaga mainly produced actor prints to fulfill his role as head of the Torii school, and by 1800 he seems to have retired from the active production of prints, contenting himself with drawings that did not cater to the changing taste of the woodblock publishers and the buying public.

A particularly interesting set of two prints shows two groups of women meeting on the Edo bridge called Nihonbashi (colorplate 58). The group on the left is presumably returning from a pilgrimage to Enoshima, an island off the coast of Kamakura—the figure at the head of the group is holding a hat with the word Enoshima written on it. The women in the right half of the diptych cannot be so specifically identified, but they appear to be acquaintances of the returning figures. The setting for their chance meeting, Nihonbashi, affords the artist an opportunity to depict the environs of the Nihonbashi River, with Edo Castle and Mount Fuji in the background.

---

would-be lover has come. The poem appears in a cartouche in the upper right corner written around the shape of the young man shielding himself from the elements as he struggles to meet her demands. This Komachi is a perfect symbol of the superficiality of the floating world in the Edo period.

Harunobu's favorite contemporary subjects were the two great beauties of the day in Edo, Osen and Ofuji, the daughters of shopkeepers, the first a daughter of the proprietor of a teahouse on the grounds of Kasamori Shrine and the second of the owner of a toothpick shop behind Asakusa Kannonji. In the print Morning Haze at Asakusa, from the set "Eight Sophisticated Views of Edo," Ofuji is shown flirting with a young samurai (fig. 312). Like all of Harunobu's female figures, she is depicted as a slender, graceful girl, innocent and untouched by the rigors of life. Harunobu never tries to individualize his young women; they are presented without unique features. Ofuji sits almost in the center of the print, her young, supple body echoing the contour of the stand to the left displaying toothpick boxes. To the right, a young samurai in a black cloak leans appreciatively toward her. Ofuji was known as the "ginko girl" because of the ginko trees near her father's

❖ Geisha are women entertainers, trained in traditional singing, dancing, and playing musical instruments. They are hostesses and companions, providing company and conversation for men at restaurants and at private parties in the "flower and willow world." In Tokugawa Japan, geisha were the pinnacle of the pleasure districts' female society of indentured women—including servants and various levels of prostitutes—and they were the trendsetters for women's styles.

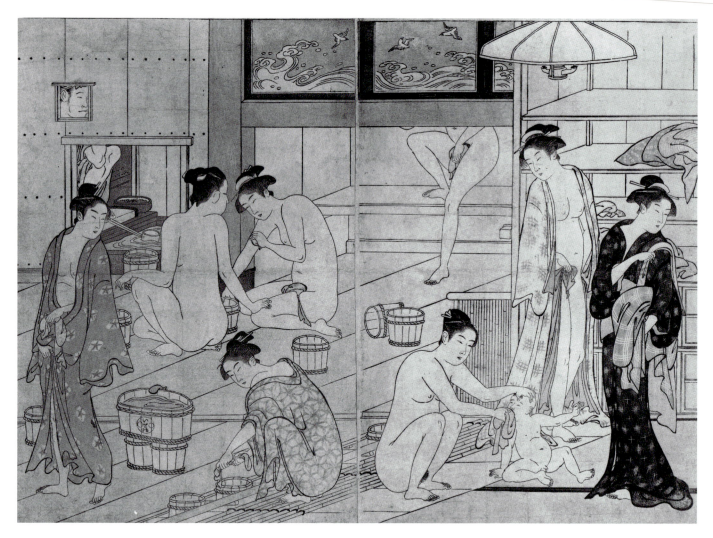

**313.** Interior of a Bathhouse, by TORII KIYONAGA. 1780s. Polychrome woodblock-print diptych, ink and color on paper; *ōban* size: as mounted 15¼ x 20⅛ in. (38.7 x 51 cm). Museum of Fine Arts, Boston. William Sturgis Bigelow Collection, by exchange

Another Kiyonaga diptych, called Interior of a Bathhouse, was of particular importance in the development of the 19th-century French painter Edgar Degas (fig. 313). It is known that Degas owned a copy of this print and that for a while it hung in his bedroom. Clearly he attempted to incorporate some of the print's spatial dissonances into his own work. The diptych depicts a familiar Japanese scene, the public bathhouse. Even today many Japanese, as part of their daily routine, repair to the local *ofuroya*, the bathhouse, where they wash off the dirt and grime of the day and then relax in a bath the size of a small swimming pool, filled with very hot water. A visit to the bathhouse provides time each day to cleanse the body, calm the mind, and chat with neighbors. Kiyonaga has captured beautifully the gentle ritual and communality of the bathhouse. To the right a mother washes her child's face, and in the left panel two squatting women chat as they rinse their bodies. In the upper left the head of the proprietor can be seen. In addition Kiyonaga used several compositional elements that, although natural outgrowths of the Japanese illustrative tradition, were profoundly

challenging to Western artists of the late 19th century. He created an impression of space within the enclosed area of the building by using the oblique lines of the floorboards to lead the viewer's eye into the depth of the inner room. The figures are arranged in an asymmetrical pattern, with a recess at the center of the composition. The inner room is particularly interesting, its upper space covered by wooden panels decorated with scenes of birds flying over roiled waters, its lower part uncovered, revealing the legs of a woman. Kiyonaga has achieved not only a homey depiction of a bathhouse, but also a unique rendering of interior space.

The artists who best reflect the changing mood of the people of Edo at the end of the 18th century are Tōshūsai Sharaku and Kitagawa Utamaro, who attempted to show the popular figures of the *ukiyo-e* world, the actors, courtesans, and geishas, as they really were, even when vain, frivolous, and addicted to sensual pleasures. Sharaku is one of the most famous creators of woodblock prints, and also the most enigmatic—the dates and events of his life are unknown. He appeared on the scene in the

"Kabuki ACTORS"

Onnagata - kabuki actor performing female role.

**314.** Segawa Tomisaburō II as Yadorigi, Ōgishi Kurando's Wife, by TŌSHŪSAI SHARAKU. 1794.
Polychrome woodblock print with mica background on paper; *ōban* size: c. 15 x 9¹/₈ in. (38.1  23.16 cm).
Tokyo National Museum

spring of 1794, produced a series of nearly one hundred fifty print designs depicting Kabuki actors, and disappeared again after the New Year's performance in 1795. However, in that brief period he created a number of extraordinarily insightful pictures of players, showing them in the act of portraying a specific dramatic character and at the same time revealing the personality of the actor behind the makeup and elaborate costumes. The print depicting Segawa Tomisaburō II as Yadorigi, the wife of a townsman, is a superb example of Sharaku's work (fig. 314). The man, often called Nasty Tomi because of his off-stage personality, is shown tight-jawed, glaring meanly through tiny, acerbic eyes as he mincingly pulls up one

sleeve of his kimono jacket. The truthful and unflattering quality of the portrait and the glistening gray mica background combine to create an incisive and vital image, an actor in a *mie* pose—a moment frozen in time expressing the character's emotional state—in the glimmering light of a stage illuminated by lanterns placed along the front edge of the platform, as was done in the 18th century. Caught by the sumptuary law of 1794, one of a series of laws intended to curtail lavish displays of luxury, Sharaku was forced in his later prints to use a flat yellow ground to suggest the atmosphere of the stage on which his figures moved, but it was never as successful as the gray mica grounds. His last works show a distinct decline in quality,

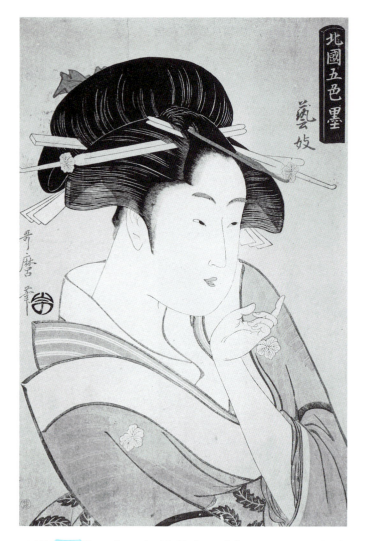

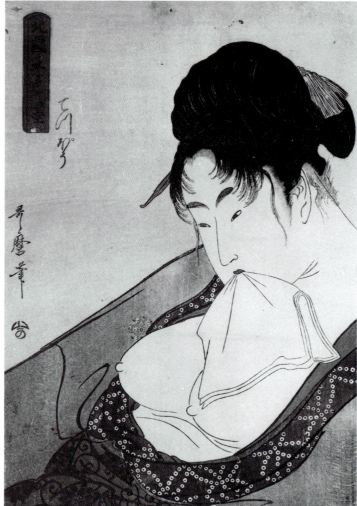

315. *Geigi,* from the series *Hokkoku goshiki sumi (Five Kinds of Ink from the Northern Provinces),* by KITAGAWA UTAMARO. Early 1790s. Polychrome woodblock print on paper; *ōban* size. Private collection

316. *Teppō,* from the series *Five Kinds of Ink from the Northern Provinces,* by KITAGAWA UTAMARO. Early 1790s. Polychrome woodblock print on paper; *ōban* size. Private collection

which may have been the reason he gave up printmaking.

Kitagawa Utamaro (1753–1806), a contemporary of Sharaku, was more lasting and versatile an artist who turned out picture books on insects, the libretti for Kabuki plays, and prints based on the plots of such famous stories as *Chūshingura,* the revenge of the forty-seven *rōnin.* His favorite subject matter seems to have been beautiful women, not only those resident in the Yoshiwara pleasure district but ordinary townswomen as well, engaged in everyday activities such as bathing their children or cooling themselves by the river on a warm summer evening. Little is known about Utamaro's early years, but he studied art with Toriyama Sekien, a dilettante who is known today primarily for his illustrated volumes of humorous verse. With Sekien's death in 1788 Utamaro adopted a signature, which suggested that he considered himself an artist in his own right, no longer a disciple. Throughout the last decade of the 18th century, his was the dominant presence in the production of *ukiyo-e.* In 1804 he made a

three-panel print depicting Hideyoshi in the midst of a party with his five concubines under the cherry blossoms at Daigoji. The shogunate took exception to the print because it violated the prohibitions against identifying famous historical figures and punished Utamaro with a three-day jail sentence and fifty days in hand chains, an ordeal that contributed directly to his death.

Sharaku's forte was the personality behind the makeup of the Kabuki actor; Utamaro's was the female psyche in all its nuances. In his series *Hokkoku goshiki sumi, Five Kinds of Ink from the Northern Provinces* he captures the character of five different classes of prostitutes, from one of the highest, the *geigi,* a charming and coquettish young woman carefully dressed in elegant garments, to the lowest *teppō,* a common whore who plied her trade outside the licensed brothel district (figs. 315 and 316). Utamaro's *teppō* is already involved in sexual activity. Her hair is disheveled, her garments are open to reveal her breasts, and gripped in her teeth are several sheets of

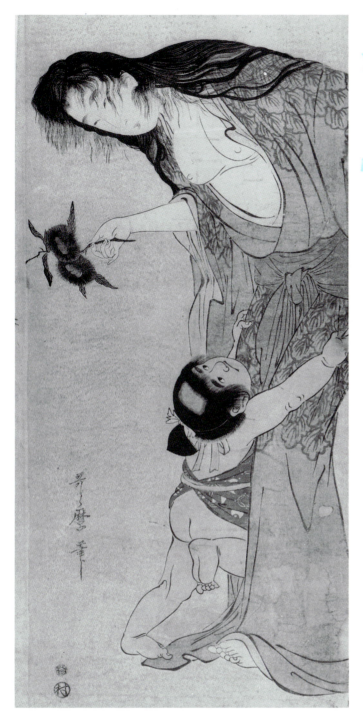

**317.** Yamauba and Kintarō: The Chestnut, by KITAGAWA UTAMARO. 1796–99. Polychrome woodblock print on paper; *chūban* size. Tokyo National Museum

317). One of the most charming prints of the group shows Yamauba teasing the boy by holding a twig with two chestnuts just beyond his reach. Frustrated, Kintarō grabs the cloth of her kimono and tries to climb up her leg. Although she is toying with the child, the gentle protective curve of her body above the child's head suggests that this is merely a game between familiars. In comparison to Rosetsu's handling of the theme (see fig. 284), Utamaro has emphasized the homey relationship between mother and child.

After Utamaro's death, pictures of actors and courtesans no longer retained the master's naturalism and insight into the human character. It was not until the 1820s, when a new group of artists turned to the depiction of landscape scenes in a romantic vein, that woodblock prints regained their popularity.

### Ukiyo-e in the 19th Century

*Ukiyo-e* in the last years of the shogunate took quite a different direction from the prints produced in the 18th century. The most prolific school of the 19th century was the Utagawa, founded in the late 1700s by a rather minor artist, Utagawa Toyoharu (1735–1814), who specialized in prints using Western one-point perspective, *uki-e*. His greatest accomplishment was as a teacher, and he managed to assemble a studio of talented young artists who not only produced commercially successful prints, but were able to attract students who could continue the Utagawa line. Two outstanding printmakers of the 19th century, Toyokuni and Kuniyoshi, though working in their own individual styles, traced their artistic lineage to the Utagawa school.

Utagawa Toyokuni I (1769–1825) was the first talented artist to thrive under Toyoharu's teaching, and by the 1790s, at about the same time that Sharaku made his brief appearance as a printmaker, Toyokuni developed his own style for representing single actors seen in dramatic, full-length poses against a light gray ground. His most impressive work of this period is a group of more than fifty prints titled *Yakusha butai no sugata-e, Views of Actors on Stage,* produced between 1794 and 1796. Given his new-found popularity, by the end of the century he was able to include other subject matter in his prints: beautiful women, young children, and humorous scenes. However, the increasing demand for actor prints forced Toyokuni to work too quickly; toward the end of his life, the quality of his work declined markedly. Nevertheless, in his heyday he produced work of considerable intensity and power.

Typical of his prints depicting beautiful women is a series of fan-shaped designs of 1823 titled *Imayō Juni-kagetsu, The Twelve Months of Fashion,* from which Minazuki, the month without water (according to the Western calendar, late July after the rainy season had ended), is illustrated (fig. 318). Ostensibly the subject is a young woman holding a mirror behind her head so that she can check the appearance of the back of her neck—

paper, a detail often included in erotic prints. She leans back, her eyes fixed with mindless absorption in sexual gratification. The *geigi,* on the other hand, is a gay and animated woman bent on amusing her customer.

Another facet of Utamaro's art can be seen in his prints of Yamauba and her son Kintarō, the warm maternal relationship between the beautiful, if slightly rough and unkempt, mother and the chubby, mischievous child (fig.

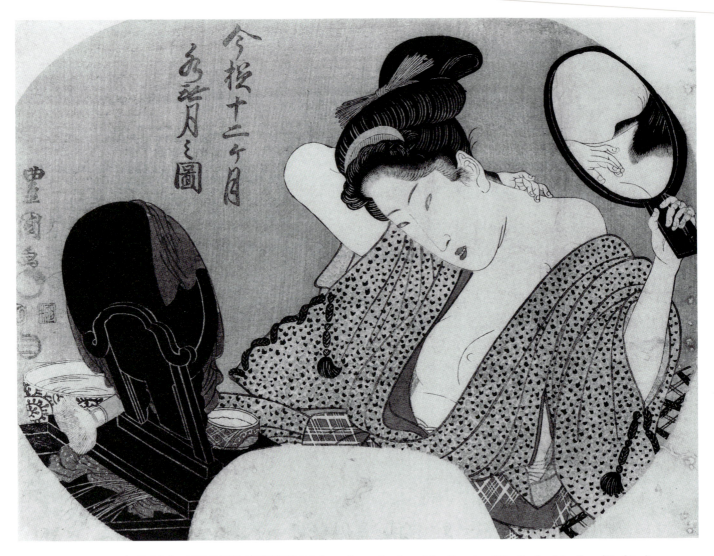

**318.** Minzuki (July), by UTAGAWA TOYOKUNI I, from the series *Imayō Junikagetsu* (*The Twelve Months of Fashion*). 1823. Woodblock fan print; *ōban* size. Private collection

considered by the Japanese to be an erogenous zone—by projecting its reflection onto the mirror in front of her. The double mirror image was a popular theme among Utagawa artists. However, in this scene the table mirror is covered with a cloth. The print would seem to be a pun on the name of the month. *Mi* written with a different *kanji* means to see. Thus this is the month of not seeing, a charming and witty variation on a familiar theme.

Utagawa Kuniyoshi (1798–1861), studied with Toyokuni, but preferred to branch off in his own direction. In 1827 he produced the "Suikoden," a series of warrior prints depicting one hundred eight heroes from the Chinese novel *Shui Hu Zhuan* (*Shui Hu Chuan*). The images, based on sculptures from the Edo temple Gohyaku Rakanji, discussed on pages 250 and 251, were immediately a popular success.

Though Kuniyoshi worked also in other genres of *ukiyo-e*, he is best known today for his *musha-e*, warrior pictures, especially his triptychs. One of his most dramatic and gruesome prints is the triptych Takiyasha the Witch and the Skeleton Specter, of c. 1845 (fig. 319). The subject

derives from the Kabuki play *Soma dairi, The Palace of Soma*, performed in 1844 and based on the story of the rebellion of Taira Masakado. Masakado was one of the first warrior chieftains to rebel against the authority of the emperor in Kyoto. In 930 he started on a rampage to acquire land in the northern provinces around Hitachi, and although efforts were made to bring him under control, the power of the court was largely ineffective in these outlying regions. In 940 Masakado proclaimed himself emperor and appointed governors to the eight provinces he controlled. Within two months he was captured and killed, his head taken back to Kyoto for display. In the mid-1800s this story found its way to the Kabuki stage, focusing not on Masakado's rebellion but on its aftermath. Masakado had left behind two children, a son, Yoshikado, and a daughter, Takiyasha. A local samurai, hearing that a ghost has appeared at the Soma palace, Masakado's former home, goes to investigate and encounters Takiyasha, disguised as a courtesan. When she fails to win the samurai's affection, she summons a giant skeleton to overpower him. Skeletons have appeared in Japanese art from the Kamakura period

**319.** Takiyasha the Witch and the Skeleton Specter, from *Soma dairi (The Palace of Soma)*,
by UTAGAWA KUNIYOSHI. C. 1845. Polychrome woodblock print on paper triptych; *ōban* size, each c. 14 4.8 x 10 in.
(37.3 x 25.5 cm). Spencer Museum of Art, The University of Kansas (Weare-West Fund)

on, but seldom have they been treated as such menacing figures. In this triptych Kuniyoshi has truly captured the late Tokugawa taste for the bizarre.

Another side of popular taste at the end of the shogunate was a fondness for romantic views of human beings and their place in nature. The woodblock-print artist Katsushika Hokusai (1760–1849) was the first to capture the attention of collectors of *ukiyo-e* with visions of the Japanese landscape. Hokusai's personality is well expressed in the signature he adopted toward the end of his life, "Old Man Mad With Painting." Apprenticed to a woodblock-print engraver in his teens, Hokusai learned the technical and interpretive skills involved in translating the stylistic nuances of an original ink drawing into the engraved lines of the print block. As this was a period when polychrome prints were being produced in great numbers, he must also have acquired considerable knowledge of the total process.

In 1778 he embarked on his creative career by becoming a pupil of Katsukawa Shunshō (1726–1792), under whose tutelage he produced a wide variety of works, including single sheets depicting beautiful women, sumo wrestlers, birds and flowers, and even some landscapes in which he experimented with Western perspective. The climate of the art world in Edo at this time was such that affiliation with a particular group of artists was essential to economic survival, and as the Katsukawa school had fallen from its peak of popularity, Hokusai found it advantageous to seek other connections. At one time he studied under the Kanō master Yūsen, but was expelled from the studio for criticizing his teacher's handling of a particular painting. Hokusai dropped from sight in 1794, the year Sharaku produced his actor prints, giving rise to speculation that he briefly adopted the name and style associated with that enigmatic artist. However, today few scholars accept this as a possibility. Later Hokusai assumed the headship of the Tawaraya school, a group of artists dedicated to the revival of the Rinpa style of decorative art.

Finally, in 1799, Hokusai struck out on his own, in spite of the financial losses that entailed, and for the next thirty years he worked steadily and single-mindedly to develop a personal style. His most popular achievement was a series of forty-six prints titled *Thirty-six Views of Mount Fuji*, begun in 1823 and completed around 1831. Several of the illustrations are studies of the mountain under various atmospheric conditions, but the majority depict Fuji as a backdrop against which common people, such as a barrel-maker at Fujimihara, are shown engaged in everyday activities (colorplate 59). In Hokusai's hands the routine task of barrel-making is treated with a typically Japanese lighthearted humor that is a far cry from the stolid romanticism of Shiba Kōkan's Western-style painting (see fig. 282). A tiny man, nude to the waist and wearing the traditional workman's sweatband around his head, kneels inside an enormous barrel, smoothing the joints between the planks. Behind him is a parched and cracked rice field, and in the far distance, the tiny snow-covered tip of Mount Fuji. The circle of the barrel encloses the craftsman and his world, both the bareness of the soil and the beauty of the natural landscape in the distance.

Just as Hokusai reflected the taste of the times for romantic untroubled views of nature, he also had a flare for the bizarre. About the same time he finished the *Thirty-six Views of Mount Fuji*, he began a series titled *Hyaku mono-*

**320.** Sarayashiki, from *Hyaku monogatari (One Hundred [Ghost] Stories),* by KATSUSHIKA HOKUSAI. c. 1830. Polychrome woodblock print on paper, with embossing; *chūban* size: c. 10 x 7½ in. (25.4 x19 cm). Tokyo National Museum

むらきえり雲よ
不二と流
善村葉しき代
うつし江のしは

御簾冨佐子

森羅亭
万象

宅ら汐の
ちらす拾ひて
のちの汐せに
かひある裏り
寺江しの嶋

**321.** Mount Fuji and the Island of Enoshima, from *Shichiri Beach*, by TOTOYA HOKKEI. 1821. *Surimono* polychrome woodblock print on paper, with embossing; *kaku* size: 8¼ x 7⅛ in. (21 x 18.2 cm). The Chester Beatty Library, Dublin

*gatari, One Hundred [Ghost] Stories.* A game popular at this time involved placing one hundred lighted tapers in a shallow oil dish and telling ghost stories. Each time a tale was finished a taper would be extinguished, until the room in which the raconteurs were assembled went dark, and the spirits summoned by the storytelling swirled around those present. For some reason, after Hokusai had executed five prints in the series he stopped. Nevertheless, several of his designs are truly memorable for their bizarre and ghostly quality, none more so than Sarayashiki (fig. 320). In this tale a young girl serving in the house of a wealthy samurai is falsely accused of breaking one of a set of ten valuable blue and white porcelain dishes. She is thrown into a well by her raging master and drowned. Thereafter her voice is heard in the night, counting slowly up to nine and then wailing pitifully. Hokusai depicts the top of the well, its vertical wooden planks bound by stout woven vines, and against a deep blue midnight sky, a woman's head rising from the well on a curving neck of blue and white dishes. From her mouth emerges a thin line of white smoke, suggesting the sound of her counting. These prints are among the finest of Hokusai's work in terms of the quality of carving and inking the block as well as the drama and eerie beauty of the design.

Hokusai's most distinguished pupil was Totoya Hokkei (1780–1850), a fishmonger turned professional artist. Although he designed book illustrations and some commercially published, single-sheet prints, he is best known today for his *surimono*.❖

Usually a poem or two, either the seventeen-syllable haiku or the thirty-one-syllable humorous form called *kyōka*, accompanies the design, as in Hokkei's 1821 *surimono*, Mount Fuji and the Island of Enoshima, from *Shichiri Beach* (fig. 321). Enoshima was believed to be the hiding place of an evil dragon who was eventually tamed by the goddess Benten and turned into a companionable white snake. For this reason the island was frequently used as a symbol for the year of the snake on printed New Year's greetings. Along the lower margin of Hokkei's print is a long sandy beach, the Shichiri, or Seventeen-mile Beach, partially obscured by gray embossed cloud forms. In the white area of water above, embossed lines are used

❖The term *surimono* means something printed and refers to limited editions—each one sometimes no more than a single sheet—of elegantly printed, small-size woodblock prints, used most often for announcements or to be included with a New Year's gift.

東海道
五拾三
次之内

桑名

**322.** Kuwana, Shichiri Watashiguchi, from the series *Fifty-three Stations of the Tōkaidō*, by ANDŌ HIROSHIGE. 1834. Polychrome woodblock print on paper; horizontal *ōban* size: 9½ x 14½ in. (24.2 x 36.7 cm). Tokyo National Museum

to suggest waves rolling toward the shore. At the base of the mountains, which rise sharply from the water's edge, is a village of pale red thatch-roofed houses, and almost hidden in the olive green forest above is a temple pagoda. Finally, in the upper right is the white triangle of Mount Fuji, a delicate embossed accent almost invisible against the pale beige sky. Two *kyōka* appear at the top of the print. This kind of New Year's card is surely one of the finest examples of the Japanese printer's craftsmanship, a quiet gem of pictorial expression.

The most famous printmaker of the Tokugawa period, Andō Hiroshige (1797–1858), achieved recognition as an artist almost overnight, with the publication in 1834 of a series of landscapes called the *Fifty-three Stations of the Tōkaidō*. Hiroshige had undergone a long apprenticeship under Utagawa Toyohiro and had afterward tried his hand at standard *ukiyo-e* themes such as *bijinga*. However, in the summer of 1832, perhaps inspired by the success of Hokusai's views of Mount Fuji, or bewitched by the same travel gods who moved Bashō to undertake his journey to the northern provinces, Hiroshige set out for Kyoto with a convoy escorting a group of horses, an annual gift from the shogun to the emperor. The group traveled along the Tōkaidō, or Eastern Sea Route, the main highway that followed the east coast of Honshū from Edo to the head of Ise Bay and then turned west to Lake Biwa and the terminal point of Kyoto.

From his experiences on this trip and his knowledge of the Japanese landscape in general, Hiroshige produced a series of prints that combine a lyrical view of the country-side in the four seasons with charmingly humorous depictions of the people and the local customs of each post station along the road. One of the most skillfully designed prints in the series presents the port town of Kuwana (fig. 322). In the foreground are two ships, their sails lowered, having just completed the seventeen-mile voyage across Ise Bay from Miya. Directly behind the boats is Kuwana Castle, and to the left, the bay dotted with sailboats stretches to the horizon. Not only does the print convey the flavor of the scenery, the longest water passage along the Tōkaidō and also the most dangerous, but it also utilizes several elements of style, both classical and modern, that would appeal to *chōnin* of the early 19th century. Kuwana Castle is depicted in dark gray and white, as it should be, but the trees behind it are treated in black and pale gray, in the manner of a monochrome landscape. The left half of the print, on the other hand, has a distinctly Western feeling, the very mildly tipped-up ground plane terminating in the far distance with the horizon line.

So popular was the Tōkaidō series that Hiroshige's reputation quickly eclipsed that of Hokusai. Hiroshige devoted most of the remainder of his artistic career to the production of landscape prints depicting two principal types of subject matter: post stations along the two main Kyoto–Edo highways, the Tōkaidō and the Kisokaidō, the inland highway through the Kiso Mountains, and famous scenic spots around the two major cities. For people living with the challenges and uncertainties of the *bakumatsu* period, Hiroshige's romantic landscapes must have cast an idyllic shadow over the realities of the times.

323. Sake bottle with landscape design.
Ko Imari ware. 17th century. Porcelain; height 15 in.
(38 cm). Umezawa Memorial Hall, Tokyo

324. Sake bottle with phoenix and paulownia design, by
SAKAIDA KAKIEMON. Kakiemon ware. 2nd half 17th century.
Porcelain; height 12⅞ in. (32.2 cm). Seikadō Foundation, Tokyo

## Ceramics

During the Tokugawa period there were two major techni-
cal innovations in the production of ceramics that pro-
foundly affected the development of the medium. First, in
1616, Ri Sampei, a Korean potter living in the Arita region
of Kyūshū, discovered a kind of clay that could be fired at
very high temperatures to produce porcelain. Second, at
about the same time, a new and more efficient type of
kiln, the *nobori gama*, or climbing kiln, was introduced
from Korea. This type of kiln consisted of a series of ovens
built along the incline of a hill, and it permitted greater
control of the temperature in any one oven. Porcelain
quickly gained popularity, because it was more durable
than stoneware. Also, when glazed and fired, the clay
turned a clear white color that could serve as the back-
ground for brightly colored designs.

The first Japanese porcelains were almost identical
to wares produced in Korea, but gradually ceramics imitat-
ing the blue and white ware produced in the city of
Jingdezhen (Ching-te-chen) in China became dominant.
The blue designs are achieved by painting with a glaze
rich in cobalt before the final white glaze is applied. These
wares are known as Ko Imari, or Old Imari wares, named
for the port in Kyūshū from which they were shipped.

A typical example of Ko Imari ware is a bottle
decorated with a design clearly based on Chinese land-
scape motifs: a tall mountain in the background, a thatch-
roofed kiosk, and in the foreground tall, angular pine trees
(fig. 323). The landscape design is extended around the re-
mainder of the bottle through a repetition of pine trees and
a ground line in the middle plane.

A significant advance in the decoration of porcelain
was achieved in the mid-1600s by the Arita potter Sakaida
Kakiemon (1596–1666). From immigrant Chinese potters
resident in Nagasaki, he learned how to make and apply
overglazes, a technique that permitted the addition of a
variety of colors other than blue. Characteristic of Kakie-
mon ware is the use of bright hues including blue, black,
green, yellow, occasionally purple, and a particular or-
ange-red, said to be based on the color of the fruit of a
persimmon tree in the potter's garden. A fine example of
his work is a sake bottle ornamented with a design of a
phoenix and paulownia leaves (fig. 324). The bird is de-
picted in midflight, his beak open, his tail feathers spread,

their curves complementing the boldly shaped body of the vessel. Below are clusters of paulownia leaves and flowers; of the ones shown here, the two to the left are much more formal than the one to the right. A stylized design of paulownia leaves was adopted as the family crest of several samurai clans, and it has been speculated that this sake bottle may have been made on commission for a particular daimyo or a wealthy merchant.

Nabeshima ware, the third major category of Kyūshū porcelains, was produced at kiln sites in the Arita region established by the Nabeshima clan, the first one dating to 1628. In the beginning the ware was made only for the use of the family, although they occasionally made presents of it to the Tokugawa shogunate. However, after the Genroku era, distribution was broadened to include other feudal clans and the nobility.

Nabeshima ware was made primarily for use at official functions, and the range of shapes is limited. Most numerous are shallow dishes with a high foot made in sets of ten and twenty. It is thought that the original inspiration for this type of plate was lacquerware. In order to maintain uniformity of shape the clay was pressed into molds, and to insure uniformity of design the motifs were transferred from a single sketch to the clay surface. Various sources were used for the designs, including textile patterns, subjects treated by the Kanō and Tosa schools of painting, and popular decorative motifs. The whole design was outlined on the plate in blue underglaze, and after the plate was fired, colors were applied in overglaze, covering the blue outlines. A particularly striking plate combines a motif from the natural world, a blossoming cherry tree, with an abstract design suggesting the curtains set up outdoors to screen off a group who have assembled for a blossom-viewing party (fig. 325). The plate is further articulated by three color zones, pale blue, pale green, and dark chocolate brown.

The fourth major category of porcelains produced in the Edo period was Ko Kutani, or Old Kutani wares, from the village of Kutani in Ishikawa prefecture on the main island of Honshū, to the southwest of the city of Kanazawa. The history of this type of ware is the most problematic of all of the porcelains. The prevailing opinion is that the Kutani kilns were opened in the late 1650s, when clay appropriate for making porcelain was discovered in the area. The first daimyo of the Daishōji fief was a cultured man with a strong interest in the tea ceremony, but he was also credited with having a head for business. It is not unreasonable to think that when clay for porcelain was discovered, he saw an opportunity to develop an official clan kiln like that of the Nabeshima in Kyūshū. The kilns are thought to have been closed at the turn of the century, following the deaths of the second daimyo and soon after that of the man believed to have been in charge of production.

Because Ko Kutani wares were produced on commission for the clan, and not for popular consumption,

325. Shallow dish with cherry-blossom design. Nabeshima ware, Nangawara kiln, Kyūshū. Between 1664 and 1675. Porcelain, painted in underglaze blue with celadon and iron glazes; diameter 7¾ in. (19.7 cm). The Metropolitan Museum of Art, New York. The Harry G. C. Packard Collection of Asian Art, Gift of Harry G. C. Packard and Purchase, Fletcher, Rogers, Harris Brisbane Dick and Louis V. Bell Funds, Joseph Pulitzer Bequest and the Annenberg Fund, Inc. Gift, 1975 (1975.268.555)

they consist mainly of plates and bowls; pieces used for serving and drinking sake are also numerous. The inspiration for the design motifs is primarily Chinese, although, as always, filtered through the lens of Japanese taste. A distinctive example of Ko Kutani is the plate decorated with the bold, mannered design of a phoenix (colorplate 60). Depicted against a crude gray-white ground is the fantastic bird, his feathers ranging in color from blue to yellow, green, and rust; his pose is taut, one claw clenched, his beak open as if to caw raucously. A comparison with the phoenix on the Kakiemon sake bottle of about the same date is instructive (see fig. 324). Kakiemon's phoenix in flight, while not particularly naturalistic, is much more so than the strutting Kutani bird.

Another important stream of Edo-period ceramics flowed through the old capital of Kyoto. In Momoyama-period Kyoto, the production of raku earthenware developed in response to the taste of tea masters such as Sen Rikyū. In the succeeding Edo period, a very different style of ceramic appeared, largely in response to the burgeoning production of porcelains in Kyūshū. These works were known as *kyōyaki*, and their essential characteristics were a stoneware base decorated with delicate traditional Japanese designs in bright overglaze enamels. It is thought that artisans from the Seto-Mino region were lured to Kyoto by the

**326.** Tea jar with Mount Yoshino design, by NINSEI. Kyōyaki ware. 17th century. Earthenware; height 14 in. (35.5 cm). Fukuoka Art Museum, Fukuoka prefecture

lucrative patronage given to the production of tea-ceremony utensils.

One of the most interesting facets of *kyōyaki* is the appearance of craftsmen identifiable by name and by a stylistically consistent body of work. The first of these potters to achieve recognition as an independent artist was Nonomura Seiemon (circa 1574–1660s). This potter, born in the village of Nonomura in the ceramics center of Tamba, established a kiln around 1650 in the Omuro district on the outskirts of Kyoto, close to Ninnaji temple. The choice of location is interesting. Ninnaji had always had a special cachet because its abbot was traditionally a cadet imperial prince, and while the temple had declined during the 16th century, the third Tokugawa shogun Iemitsu (1604–1651) provided funds for its rebuilding. It has been suggested that Ninnaji was one of several Kyoto temples—such as Rokuonji, which had as abbots members of the imperial family—that became centers for cultural activities, in effect salons. Seiemon clearly valued his association with Ninnaji, creating his art name Ninsei by combining the first syllables of the temple's name with his own.

Ninsei's first products were off-beat designs for tea-ceremony utensils—faceted tea caddies and the like—produced under the influence of tea master Kanamori Sōwa (1584–1656). However, about 1660 a new type of Ninsei ware began to appear: stoneware vessels—both tea bowls and large jars with four "eared" handles for the storage of leaf tea—decorated with traditional Japanese designs such as wisteria, poppies and other floral motifs, and even landscapes. A particularly fine example from this group is

a storage jar based on the shape of Tamba vessels of the Early Feudal period decorated with a design of low, gently rounded hills overlaid with small squares of gold leaf and flowers in the shape of cherry blossoms (fig. 326). The combination of hills and cherry blossoms suggests Yoshino, the region to the south of Kyoto renowned as one of the best places to view cherry trees in bloom (see color-plate 31). The vessel is awash in color, the hills blue, green, red, yellow and gold, the blossoms red and gold. The inspiration for the decoration of this storage jar is clearly the Rinpa school of the Momoyama and Tokugawa periods, and it is a creation completely appropriate as an expression of Kyoto taste. As American scholar Richard L. Wilson has noted, Ninsei wares stand at the turning point in *kyōyaki*, the transition from the *wabi* aesthetic of Sen Rikyū and his disciples to the use of ceramics as a "canvas" for painting and calligraphy.

The next independent ceramics master to appear on the scene was Ōgata Kenzan (1663–1743), the younger brother of the Rinpa painter Ōgata Kōrin (see pages 273–276). Recent research by Wilson sheds new light on this artist's life and career. After the death of his father, Sōken, in 1687, Kenzan (born the third son and named Gonpei), received a generous inheritance that included three houses, the family library, and half the family cash and art collection. However, unlike his profligate brother, Gonpei chose not to become an urban playboy, but instead established himself in a secluded villa in Omuro near Ninnaji temple. He changed his name to Shinsei meaning "deep meditation" and devoted himself to cultural pursuits: poetry, music, the tea ceremony and in particular calligraphy.

In 1699 the young man turned his life in a new direction. He had built a three-chamber climbing kiln on a piece of property in Narutaki, an area adjacent to Ninnaji, and began to produce ceramics under the name of Kenzan, referring to the location of his kiln in the northwestern mountains. The first steps in setting up his kiln followed by one month the last mention of the Ninsei kiln in the Ninnaji records, and Wilson suggests that Kenzan moved in to fill the gap caused by the demise of the older kiln. He also hired a technician, Magobei, who had served as an apprentice to the Oshikōji, a family that produced earthenwares in competition with raku in the Momoyama and early Edo periods. Kenzan, unlike Ninsei, was not a potter; rather he was a person with creative control of the kiln, and the works produced under his direction are best described as pottery imitating art objects. Many pieces are square plates decorated with designs alluding to Heian poetry (the poems are inscibed on the base) and are more like painted *shikishi* and lacquerware than ceramics.

Kenzan made two more major moves in his life. In 1712 he left Narutaki for central Kyoto, specifically Chōjiyamachi, where he established a studio for the production of ceramics fired on a rental basis in local kilns. He also frequently used stoneware blanks and common ceramic shapes, mass-produced with no thought to their

decoration. Some have interpreted this as a decline into commercialism. It can also be argued that it was a realistic commercial decision to leave the inconvenient location of Narutaki for downtown Kyoto, an important distribution center for ceramics to shore up the shrinking income from his inheritance, and to recognise that his strength lay not in the production process but in the surface decoration of individual pieces. A further motivation for Kenzan's move may have been Kōrin's return to Kyoto in 1709. The two brothers had frequently collaborated on the square dishes produced at Narutaki, and the possibility of renewing that relationship may have seemed attractive. However, in Chōjiyamachi Kenzan made a remarkable breakthrough in his style. Using patches of white slip and representational designs such as cranes and grasses or spring flowers brushed in cobalt and iron, he adapted flat Rinpa designs to the rounded surfaces of bowls and plates, wrapping the images around and into the shapes. These works, which combine traditional images from court poetry with a consciously rustic style of painting, are the masterpieces of Kenzan's oeuvre.

His last move was to Edo in 1731, fifteen years after Kōrin's death and twelve years before his own. The reason for this move is perhaps more difficult to intuit than the other two. However, what is clear is that he no longer engaged in ceramic production on a commercial scale. Wilson suggests that in Kyoto, Kenzan was continually compared to Kōrin as a painter, but in Edo he was viewed as a successor and appreciated both for his ceramics and his cultural sophistication.

Kenzan's greatest contribution to the development of kyōyaki was the conversion of quotidian ceramic objects into fields for the expression of classical poetic themes in both pictorial and calligraphed form. Working with both stoneware and earthenware, he developed a technique for applying colored enamels directly on a bisque-fired vessel. When enamels were applied after glazing, they beaded on the surface and created slight projections. However, when they were applied first, the glaze flowed over and around them, producing a bonding of color with the clear, hard surface of the final glaze.

A particularly restrained example of Kenzan's work is a tea bowl decorated with a spray of plum blossoms painted under the glazed suface in rust brown and cream (colorplate 61). The flower petals are so impressionistically rendered that the design seems almost an abstraction from nature. In the final analysis, Kenzan, an heir of a wealthy merchant family, sought to develop his cultural talents, turned to ceramics as an aesthetic outlet and source of revenue, and, after making his mark, returned to the intellectual and artistic pursuits of his early maturity.

Aoki Mokubei (1767–1833), included with Ninsei and Kenzan as one of the trio called the Three Great

**327.** Bowl with peach and melon design, by AOKI MOKUBEI. Kanazawa ware, Kasugayama kiln. 1807 or 1808. Earthenware, painted with color enamel; height 4⅝, diameter 9⅜ in. (10.8 x 24 cm). Museum Yamato Bunkakan, Nara

Masters of kyōyaki, came from a tradition quite apart from the Rinpa that had inspired the other two men. Mokubei made his money as the proprietor of a house of pleasure in one of the licensed districts in Kyoto, but found kindred souls among the group of literati centering on Rai Sanyō, the group that included Tanomura Chikuden, Okada Beisanjin, and Uragami Gyokudō. Mokubei studied ceramics with the potter Okuda Eisen (1753–1811), a craftsman whose major contribution to the development of kyōyaki was the introduction of porcelain techniques, as opposed to the pottery of previous masters. Mokubei combined Eisen's techniques with his own veneration for things Chinese to produce ceramics that ranged from pieces using ancient forms of Chinese script as the main source of decorative patterning to works made in imitation of types of Chinese porcelains, like celadons—vessels decorated with an iron glaze that turns a gray-green color when fired—and Ming-dynasty blue and white wares. Taking Chinese famille noire porcelains—which have decorations, usually flower designs, against a black background—as a point of departure, Mokubei created a bowl with a design of melons and peaches in yellow, green, purple, and beige, against a black ground (fig. 327). However, in contrast to the meticulous detail and highly finished quality of Chinese famille noire, Mokubei has opted for a certain crudeness of execution, which makes the bowl a much more personal statement, that of a Japanese looking back toward a Chinese ideal of expression that he either could not or did not wish to imitate in exact detail. His bowl is a successful layering of meanings, completely in character with the work of the fourth generation of Japanese literati artists.

# CHAPTER 7
# After Feudalism

## THE MODERN PERIOD

In January 1868 the storm of discontent with the Tokugawa shogunate broke, and a coalition of samurai led a coup d'état that toppled the old feudal regime. In its place they put forward the sixteen-year-old emperor Mutsuhito, who had succeeded to the throne only the previous February, as the effective head of an administration that promised a return to the precedents of antiquity, a restoration of direct rule by the emperor himself instead of his delegates. The young ruler chose the name Meiji, or Enlightened Rule, for his reign, and the coup d'état was dubbed the Meiji Restoration. The following year his court moved permanently from Kyoto to Edo, which was renamed Tokyo, or Eastern Capital. The modern period begins with the Meiji Restoration in 1868 and includes the reigns of three emperors: Meiji (1868–1912), Taishō (1912–1926), and Shōwa (1926–1989), the latter better known to Westerners as Hirohito.

This chapter deals with Japanese arts produced between 1868 and 1945, the end of World War II.

The Meiji era began in a spirit of renewal, a return to the wellsprings of Japanese tradition, but in practice the forty-four years of the Meiji emperor's rule witnessed Japan's emergence from the cocoon of seclusion imposed by the Tokugawa and its establishment as a world power. The priorities of the new government, in addition to the establishment of its authority and the maintenance of peace, were the abolition of feudalism and the granting of a voice in the deliberative process of government to commoner and samurai alike. The class system was to be leveled so that "men of talent" could rise to positions in accordance with their abilities. Finally, the new government promised a worldwide search for knowledge "in order to strengthen the foundations of imperial rule."

## Society and Culture from 1868 to 1945 in the Meiji, Taishō, and Shōwa Eras

During the first decade of Meiji rule the mechanisms of the feudal state were dismantled, their functions assumed by the central government. The daimyo were dismissed, and their *han* restructured into modern prefectures. Filling the void left by the former domains, the new regime established a military force loyal to the central government and a system of education with the goal of universal literacy.

It is interesting to note that Japan did not turn as usual to China for policy models. For one thing, Japanese leaders were thoroughly trained in Confucian principles of government. Furthermore, China had dealt ineffectively with Western pressure and had been defeated in the Opium War of 1839–1842. Japan's opinion of China was to deteriorate further by the turn of the century, when the Japanese armies emerged victorious from the Sino-Japanese War of 1894–1895.

In 1871, in a move perhaps unprecedented in world history, some of the most powerful leaders in the new government left Japan on a twenty-three-month fact-finding mission to Europe and the United States to study foreign statecraft and economic development. The group, named the Iwakura Mission after its organizer, Iwakura Tomomi, had as its primary goal the commencement of negotiations to revise the so-called Unequal Treaties, trade agreements forced on the Tokugawa shogunate by the Western powers in the 1850s and 1860s.

The Iwakura Mission made little headway in effecting treaty revisions, but it was extremely successful in its fact-finding efforts. The group's conclusions yielded two major results for the visual arts. First of all, it recognized the role that repositories of knowledge such as museums play in the advancement of a nation.

When one goes to a museum, the order of a country's enlightenment reveals itself spontaneously to the eye and heart. If one studies the basic reasons when a country flourishes, one learns that it is not a sudden thing. There is

always an order. Those who learn first transmit their knowledge to those who learn later. Those who open their eyes first awaken those who wake later. By degrees there are advances. We give this phenomenon a name and call it progress. By progress we do not mean merely throwing away the old and planning the new. . . . There is nothing better than a museum to show that order [in the advancement of progress]. . . . There has been [in Japan] no historical record-keeping of past and present progress to cause people to learn these things. No museums have stimulated the sight. No exhibitions have encouraged the acquiring of new knowledge.

Eugene Soviak, "On the Nature of Western Progress: The Journal of the Iwakura Embassy," in *Tradition and Modernization in Japanese Culture*, Donald H. Shively, ed. Princeton, N.J., 1971, p. 25

The first national museum, opened in 1871 in the Yushima Seidō Confucian shrine, was an oddly matched collection of artistic, historic, scientific, and natural history exhibits, but by 1882 the concept of the museum as the repository of the cultural accomplishments of a nation had developed to the point that the government was ready to undertake the construction of a permanent home for a full-fledged art museum.

One of the Iwakura Mission's main realizations was that the West was far ahead of Japan in terms of technology and progress in general and that the rate of development abroad was accelerating. The mission was convinced that Japan could catch up, but that it must pursue that goal immediately. One quick way to get a leg up was to import European and American experts to teach Japan how to modernize and close the gap with the West. Architects, painters, and sculptors were among the imported experts. To mention only a few of these, the English architect Josiah Conder came in 1877 to teach in the Department of Architecture at the new University of Technology, Kōbu Daigakkō. His students became the leading architects of the late Meiji period. (Two Italian artists who were invited to Japan to teach at the Technical Fine Arts School, Kōbu Bijutsu Gakkō, had a strong influence on later Western-style Meiji painting and sculpture. See page 358.) The school, opened in 1876, was part of the University of Technology, the forerunner of the Tokyo Institute of Technology.

The second decade of the Meiji era was devoted to institution building at home and reputation building abroad. Over a period of nearly ten years, debate on the terms of a constitution continued among the major figures in the government, and in 1889 the emperor officially presented it to his loyal subjects. The other activity that occupied the energies of the administration was a well-orchestrated public relations effort to change the attitudes of the Western powers toward Japan. Inoue Kaoru, who held various posts within the government, the most important being foreign minister, believed that the way to persuade the superpowers to revise the Unequal Treaties was to demonstrate that the leaders of Japan were as civilized and culturally sophisticated as their counterparts in the West. To this end, in 1883 he commissioned Josiah Conder to design and build a structure to house Western-style entertainments. The result was the Rokumeikan, Deer-Cry Pavilion, a two-storied brick building with an exotic Mediterranean flavor. Here the local representatives of foreign powers and their wives were wined and dined. Inoue was no more successful in influencing the superpowers than the Iwakura Mission had been, and he was given the satirical nickname Mr. Rokumeikan.

The days of glory for the Rokumeikan and the policy of rapid Westernization symbolized by it came to an end by the end of the 1880s, victim of a strong wave of nationalistic reaction against discarding Japanese traditions and values in the name of progress. Although this conservative reaction was not universally constructive, in the arts it was responsible for reversing the trend to devalue Japanese art. During the 1870s particularly, the Japanese seemed to have had little regard for the works of art that formed a major part of their cultural heritage. Daimyo, now that they had lost their customary stipends, saw the paintings they had previously commissioned to decorate their castles and mansions as a source of capital. Temples, which over the centuries had acquired paintings and sculptures and the buildings in which to house them, also looked upon these artworks as a means to raise the funds to support their priests at a time when donations from adherents were drying up. Beginning in 1878, private and then public voices were raised in opposition. The next year, a group of government leaders involved with Japan's participation in international expositions formed a private club called the Ryūchikai, the Dragon Pond Society, to promote traditional arts. One of their aims was to encourage the kinds of Japanese arts preferred by foreigners in order to take advantage of the current Western craze stimulated by world fairs for things Japanese. Another voice raised was that of the American Ernest Fenollosa (1853–1908), who with his freshly inked Harvard diploma had come to Japan in 1878 to teach philosophy and political economy at Tokyo University. In a speech to the Ryūchikai in 1882, he strongly denounced the study of Western art, and two years later he joined with several members of the group and a former student, Okakura Kakuzō (1862–1913), also known by his art name of Tenshin, to form the Kangakai, Painting Appreciation Society, to encourage the study of traditional arts.

The collective effect of these individual efforts was a waning of interest in Western art styles and techniques, which forced the closing of the Technical Fine Arts School in 1882 and the intervention of the government in support of traditional Japanese art. In 1889 the Tokyo School of Fine Arts, the forerunner of the present-day Tokyo Geijutsu Daigaku, Tokyo National University of Fine Arts and Music, was founded to foster traditional Japanese art. In consonance with the movement to appreciate traditional arts, Japan's first scholarly art journal, *Kokka*, translated

*Flower of the Nation,* began publication in 1889. Today it is still one of the most important and certainly the most lavishly illustrated magazine dealing with traditional Japanese art.

In the last two decades of the Meiji era—the years between 1889, when the constitution was adopted, and 1912, when Emperor Meiji died—events in Asia conspired to enable Japan to rise above domestic factionalism and unite as a nation to wage war, first against China in 1894 and 1895 and then against Russia in 1904 and 1905. As a result of its victories in both wars, Japan at last achieved recognition from France, Russia, and the United States of its dominance in northeast Asia. Furthermore, the war effort stimulated the development of heavy industry. By the beginning of World War I, Japan's industrial revolution had hit full stride.

In the years between the accession of the Taishō emperor in 1912, and 1945, when Japan admitted defeat at the end of World War II, the country experienced both the benefits and drawbacks of being a world power. As one of the five major victorious nations in World War I, it was accorded a place in the negotiations preceding the Treaty of Versailles and given a permanent seat on the council of the League of Nations.

The war effort had given the last major push to Japan's industrial revolution, fostering the development of such heavy industries as shipbuilding. However, this growth also changed the structure of Japanese society, bringing large numbers of workers into the cities from rural areas. In 1918, as a result of the war and wartime profiteering, the price of rice nearly doubled in one year's time, causing enormous hardships for the newly expanded working class. On the one hand, economic conditions were worsening for the majority of citizens, and rapid social changes were taking place that seemed to threaten the traditional order; while on the other hand the country's leaders, its politicians and big businessmen, were perceived to be corrupt. One effective solution seemed to be reliance on the military, a course of action that ultimately resulted in Japan's position in World War II.

For the arts the picture followed the general cultural pattern. From the time of the Sino-Japanese war of 1894–1895 until the period when the negative aftermath of World War I began to be felt, the nation experienced a new confidence about its capabilities and its position among the world's leading nations. The most important issue for artists and patrons was no longer Japan versus the West, but rather how to formulate an individual, authentically Japanese mode of expression.

In the 1920s the picture began to change. The postwar boom collapsed, and the money to buy art began to dry up. In addition, the public—the police in particular—grew wary about new and seemingly radical art movements. As a result, the climate that had seemed so favorable for individual expression in the arts began to turn inhospitable.

With the rise of militarism in the thirties, freedom of expression in the arts ended. In 1935 the minister of education, Matsuda Genji (1875–1936), took specific measures to bring the art world under government control. His actions had the opposite effect, however, fragmenting the art community into new factions. Finally, World War II effectively accomplished what Matsuda could not. Artistic efforts were strictly regulated. The only subjects the government permitted were the present war, the war effort at home, and war heroes of the past. While some very good works were produced within these constraints—like Yasuda Yukihiko's Camp at the Kise River and Uemura Shōen's *Evening* (see colorplate 70 and fig. 364)—many artists found them too restrictive. Freedom of expression did not return to the arts until the post-World War II period.

## Architecture

Just as the history of Japanese architecture from the beginning of the Heian period in 894 until the fall of Osaka Castle in 1615 was written in the capital city of Kyoto, so the changing styles and techniques of modern architecture until the end of World War II can best be charted in the new capital of Tokyo. Furthermore, two of Tokyo's twenty-three districts became focal points for the public expression of government policy: Chiyodaku (Chiyoda district), including the Imperial Palace and the areas to the east and south of it, and Taitōku to the northeast, centered on Ueno Park.

Chiyodaku is at the physical and ideological center of Tokyo (fig. 328). At the heart of the district is the Imperial Palace, a cluster of buildings set among grass-covered hills and sheltered by old trees, the whole complex enclosed within high walls and wide moats. The Kasumigaseki area in Chiyodaku is the locus of national government, the site of the various ministry buildings and the Kokkai Gijidō, the Diet Building, in which the two houses of the Japanese legislature meet. To the east are the business areas called Marunouchi—an area once within the palace enclosure, or *maru*—and Ōtemachi, which includes Tokyo Station, the hub of the national railway system, and, closer to the palace, the home offices of most of the major banks, including the Bank of Japan. Finally, at the bottom of the hill from the Diet Building and across the street from Hibiya Park is the area planned as an informal meeting place between Japanese officials and foreign visitors, once the location of the Rokumeikan and today the site of the Imperial Hotel.

Ueno was the first of five metropolitan areas designated as public parks in the early years of the Meiji period (fig. 329). The park, the focal point of Taitō district, became the site for officially sponsored displays of modern achievements and ancient traditions. Today its open spaces provide recreation areas for adults and children. Its gentle hills and the lowlands around Shinobazu Pond are dotted with flowering trees and shrubs, giving city dwellers a chance to enjoy the changing seasons. The museums ringing its broad

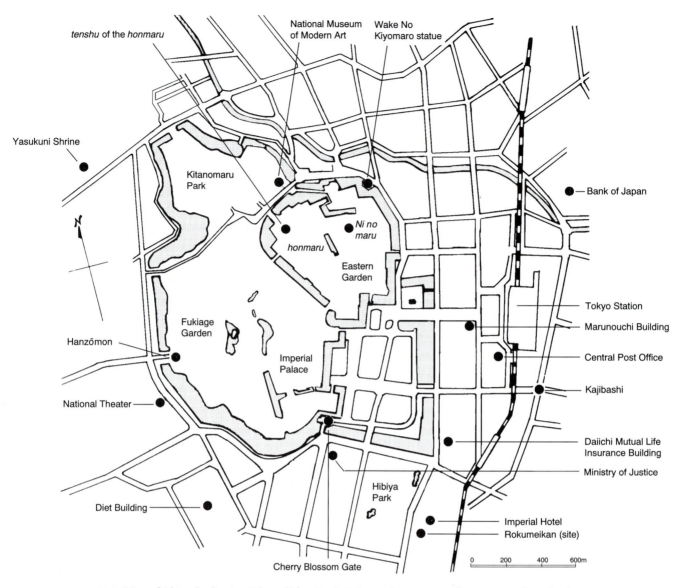

**328.** Map of Chiyoda district, Tokyo. (After Paul Waley, *Tokyo Now & Then*, New York and Tokyo: John Weatherhill, Inc. Copyright © 1984 Paul Waley)

mall offer opportunities for cultural enrichment.

Originally Ueno was the site of Kaneiji, the funerary temple of the Tokugawa clan, but during the fighting that brought about the surrender of Edo to the imperial army, a bloody battle broke out on its grounds, during which most of the nearby buildings were destroyed. Later, in 1873, when the new regime was considering it as a site for a hospital complex, the Dutch doctor E. A. F. Bauduin expressed the view that a hospital could be built anywhere, but the land at Ueno should be preserved as public area for the enjoyment of Tokyo's citizens. Fortunately his wisdom prevailed.

Official use of the site came in 1877 and 1882 when the first and second National Exhibitions for the Promotion of Industry and Commerce were held there. The pavilion built for the second exhibition was designed by Josiah Conder and was converted into a permanent home for the national museum. Toward the end of the century, the imperial family became associated with the park when responsibility for overseeing it passed from the Ministry of Agriculture and Commerce to the Imperial Household Agency. In 1908 a second museum building, the Hyōkeikan, was added to Conder's main hall in honor of the Taishō emperor's marriage, and in 1924 the area was given to the city on the occasion of the marriage of Prince Hirohito, the Shōwa emperor. This transfer of control to the city government may have been motivated by the realization that the park was no longer purely an official preserve but had been annexed by the people of Tokyo. Following the catastrophic earthquake of 1923 and its aftershocks, the homeless congregated in Ueno's open spaces and took shelter under its sturdy trees until they could regroup and begin to reorganize their lives. Again in the 1940s and 1950s the park provided shelter, this time in the railroad tunnels under it linked to Ueno Station, for those left homeless and destitute after World War II.

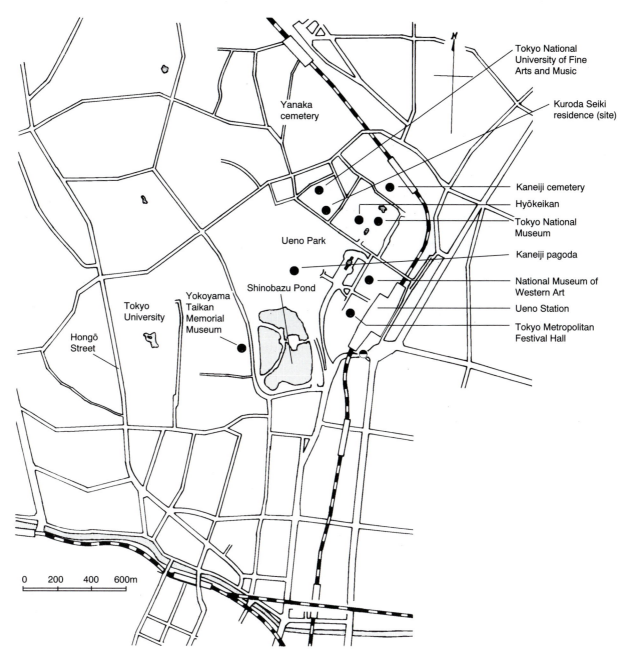

**329.** Map of Taitō district, Tokyo. (After Paul Waley, *Tokyo Now & Then,* New York and Tokyo: John Weatherhill, Inc. Copyright © 1984 Paul Waley)

## Western Architects and Their Students

When Japan opened its doors to receive Western culture, the differences between its own and the newly viewed architecture of Europe and the United States fell into two major categories: technique and style. Steel-reinforced brick and concrete, building materials in use in the West, required different skills on the part of the builder from those needed to erect wooden structures. On the other hand, Western-style pillars and pilasters with their classical capitals were completely foreign to the Japanese. Since the early Meiji era, foreign and Western had meant technically advanced and symbolic of "progress." The Japanese

response to this perceived "progress gap" was to import experts who could train Japanese architects, primarily in Western technology but also in the use of various vocabularies of style. Most influential of these were the Englishman Josiah Conder, mentioned above, and the Berlin architectural firm of Hermann Ende (1829–1907) and Wilhelm Böckmann (1832–1902).

Josiah Conder (1852–1920) came to Japan at the invitation of the government to teach in the new University of Technology, which opened in 1877. He had trained at the Royal Institute of British Architects under William Burges (1827–1881), a man noted for his eclectic combination of building styles and his antiquarianism. Conder

**330.** Ueno Imperial Museum, Tokyo, by JOSIAH CONDER. 1882 (no longer extant)

taught at the government-sponsored school for seven years, from his arrival in Japan until 1884, and again for two years between 1886 and 1888, when the department was made a part of Tokyo University. After that he opened his own firm in Tokyo and continued to design both public and private structures well into the second decade of the twentieth century.

One of Conder's earliest projects was the hall erected in 1882 to house displays in the Second National Exhibition for the Promotion of Industry and Commerce and later converted into the first permanent structure of the Ueno Imperial Museum (fig. 330). The exhibition hall is no longer in existence, having been irreparably damaged in the 1923 earthquake. However, it can still be studied through its plans, old photographs, and depictions in contemporary woodblock prints. Constructed of reinforced brick, the building was confined to two stories to guard against earthquake damage. In order to provide adequate exhibition space, long wings extended to the left and right of a central rectangle containing the main staircases. Additional stairs were provided in the porches that projected forward at the extreme ends of the building. The exhibition rooms were arranged railroad-car style, with primary access openings provided in the center of shared walls. The façade was articulated with motifs in the so-called pseudo-Saracenic style, which drew on Islamic architecture for decorative designs. The windows on the first floor were capped with rounded arches, those on the second with multifoil crenellated, pointed ones. In the center of the façade was a one-bay-deep, two-storied porch crowned with octagonal turrets in the Islamic style.

Conder's major influence on the history of Japanese architecture came through the training he gave his students. Among his graduates in the class of 1879 in the Department of Engineering at the University of Technology were three young men who went on to become the leading architects of the late Meiji period: Tatsuno Kingo (1854–1911), Katayama Tōkuma (1853–1917), and Sone Tatsuzō (1853–1937).❖ Not only did Conder teach these students in the classroom, he gave them opportunity for hands-on experience, allowing them to participate in the construction of buildings he had been commissioned to design.

Of these students, Tatsuno Kingo was undoubtedly the most talented. Upon graduation he was sent by the Japanese government to study with William Burges in England. After the latter's untimely death at the age of fifty-three, Tatsuno remained abroad for a while, traveling in England and France and studying a wide range of architectural styles. On his return to Japan he chose the scholarly route to establishing himself, becoming a professor at Tokyo University. He was instrumental in founding an association of architects, and in 1902 he retired from his teaching position to open his own architectural firm, the first Japanese to do so.

One of Tatsuno's most accomplished designs is the

---

❖ Artists in the pre-modern era were normally known by their given names or, more often, by their art names. For artists prominent after 1868, it has become the custom to follow Western usage and to refer to them by their family names. When an artist's name and dates are first cited, the Japanese convention is to give the family name first. Further complicating things for the Westerner is the fact that some post-1868 artists are called by their art names. There is no simple rule to explain why the art name or the family name is preferred for any individual artist. This book follows common current usage.

**331.** Bank of Japan (foreground), Tokyo, by TATSUNO KINGO. 1890–96

head office of the Bank of Japan, on the site of the Edo-period gold mint in the Ōtemachi district of Tokyo. The building, erected between 1890 and 1896, is a three-storied structure built of reinforced brick faced with stone. Its plan is square, with a central rotunda linked by pillared hallways to the wide, U-shaped space that extends around the sides and the back of the building (fig. 331). The interior space behind the rotunda is matched by the open entry courtyard in front of it. The actual façade consists of two three-storied arms—the front ends of the U-shaped space—joined by a single-storied screen that encloses the entry area. On the first floor the arms are articulated with rusticated stones and heavy, projecting pilasters, while the screen is divided into nine bays by delicate, thin pilasters and is pierced by four arches, the smaller for pedestrians, the larger for horse-drawn carriages. The second and third floors of the arms are treated visually as a single unit, their windows framed by pairs of round pilasters with Corinthian capitals, the whole design topped by triangular pediments. The façade visible from inside the courtyard is a more complex statement of this same theme, with a projecting portico on the first floor, capped by a balustrade instead of the heavy pilasters. Above the three-story-high motif can be seen the octagonal dome over the central rotunda. Photographs of the Bank of Japan give the impression that it is a large and imposing structure, but that is

not so at all. The use of the single-storied screen coupled with the small size of the courtyard, so tiny that horse-drawn carriages could be accommodated only a few at a time, establishes a human dimension to the building, which is continued throughout the interior spaces. The Bank of Japan is an architectural gem, a building in no way prefigured by anything in the oeuvre of Tatsuno or his teacher Conder, a structure that clearly demonstrates the architect's originality and genius.

A Tatsuno building very different in scale and purpose is Tokyo Station, a long, horizontal structure of red brick and stone (fig. 332). In the 1880s and 1890s the Marunouchi and Ōtemachi areas to the east of the Imperial Palace and south of the Bank of Japan began to be developed under the auspices of Iwasaki Yanosuke, younger brother of the founder of Mitsubishi, a business and industrial conglomerate. In response to this growth, the Ministry of Internal Affairs decided in 1893 to build a railway center to service the new district. Tatsuno received the commission and in 1914 Tokyo Station was completed.

Although Tokyo Station served as the terminus of the rail line from Osaka and Kyoto to Tokyo, its major function was as an intermediate stop on the line within the city that linked the district of Shinbashi, to the south, and Ueno Station, to the north. The basic plan of the station was dictated by its function of facilitating access to

**332.** Tokyo Station, Tokyo, by TATSUNO KINGO. 1914

railroad cars. In his final design Tatsuno created a long, low, four-storied structure, and he treated the façade more like a two-dimensional design than the exterior of a volumetric building. Seven vertical units punctuate the surface, projecting upward and forward from the basic rectangle. The central unit, strongly rectilinear in feeling, is defined by twin towers and topped by a hipped roof. The two units near the ends of the building constitute a kind of framing device in the pictorial composition, being larger than the central tower as well as more curvilinear in treatment, and were originally capped by round domes. Today the building is two stories shorter than in Tatsuno's plan and has different capping elements, mainly because the upper floors were destroyed in bombing raids during World War II. Midway between the central and end units are two small structures with independent, pointed roofs, and at the very ends of the building are round turrets. To create a contrasting linear design over the surface of the red brick building, white stone was used for the frames of the windows and doors, and for the pilasters that mark off bays along the façade. Tatsuno may have chosen brick as surface material to complement the brick structures of London Block, a group of office buildings designed by Josiah Conder and his student Sone Tatsuzō and built on neighboring Mitsubishi-owned land in Marunouchi.

To appreciate Tatsuno's skill as an architect, one need only compare the façade of Tokyo Station with that of Conder's museum in Ueno Park. The latter is stolid, Tatsuno's design, ebullient. Even on the dreariest of rainy days the red brick building is a cheering presence on the east side of the square. Today, as Tokyo is reaching up to find more office and living space, some people see the unused air above the station as an unconscionable waste, and the fate of Tatsuno's building is clouded.

Katayama Tōkuma, the second of Conder's prize pupils in the class of 1879, was not chosen by the Japanese government to study abroad. Instead he was made an officer in the Ministry of Technology, where he spent the next two years in the Building and Repairs Department along with Conder. In 1881 he began to gain prominence in his own right, and, thanks to his connection with Conder, he became involved in the construction of a mansion designed by his English mentor for Prince Arisugawa. Next, through his association with the prince, Katayama got a chance to go to Europe as a member of the Japanese delegation dispatched to attend the coronation of Czar Alexander III of Russia in 1883. He spent the next two years abroad studying the architecture of England and France. Upon his return Katayama received commissions from the government and the Imperial

**333.** Hyōkeikan, Tokyo National Museum, Ueno Park, Tokyo, by KATAYAMA TŌKUMA. 1901–9

Household Agency and went on to become architect to the imperial family. His first major project was the Japanese Ministry in Beijing, completed in 1886. In the meantime he was asked to design the buildings to house two imperial museums, one in Nara, completed in 1884, the other in Kyoto, completed in 1885. In both of these buildings Katayama employed a full-blown French style that emphasized mansard roofs and decorative elements such as pilasters in high relief against flat walls. In 1886, in connection with his work on the palace, Katayama had the opportunity to study at first hand the architecture of Germany and Austria. He stayed on for eleven months and absorbed influences that were to have a profound effect on his last two buildings, the Hyōkeikan in Ueno Park and Akasaka Detached Palace.

The Hyōkeikan, begun in 1901 and completed in 1909, was intended as a municipal museum to be given by the people of Tokyo to Prince Yoshihito, the future Taishō emperor, on the occasion of his wedding. Akasaka Detached Palace, begun two years before the Hyōkeikan and completed in 1909, was intended as the crown prince's residence. In other words, both buildings were associated with the future emperor and were conceived and executed in the period of self-confidence the Japanese experienced after their victories in the Sino- and Russo-Japanese wars.

The construction of the palace was funded with reparations Japan received from the Sino-Japanese war, and both buildings were intended as settings for the monarchy, testifying to the Westernism—the progress in technology and intellectual enlightenment—the imperial policies were meant to foster.

The Hyōkeikan, constructed of reinforced brick faced with stone, is a two-storied structure, its first story articulated by rusticated stone courses, its second by thin pilasters against smooth stone (fig. 333). At the top of the bays defined by the pilasters are delicate relief carvings depicting the liberal arts. Across the façade of the building are three projecting bays, the central one being the entry porch leading into the central rotunda, with a less prominent one on either side. At the outer ends of the building are circular additions that house the staircases linking the first and second floors.

Katayama's arrangement of the exhibition galleries is simplicity itself and is much more skillful than Conder's railroad-car treatment in the first Ueno museum building. The halls to the immediate left and right of the rotunda are rectangular, with their median lines parallel to the façade of the building, while those closer to the ends have their median lines at right angles to the main axis of the building. Thus visitors proceeding from one room to another

**334.** Akasaka Detached Palace, Tokyo, by KATAYAMA TŌKUMA. 1909

have a sense of changing patterns of space as they examine the objects on display.

The Akasaka Detached Palace, although contemporary with the Hyōkeikan, could not be more different in its final effect (fig. 334). It is the first Meiji-period building to achieve true grandeur using Western techniques and vocabularies of design. Often called the Japanese Versailles, it boasts a magnificent staircase, a large dining room for state occasions, a ballroom, elaborate ceiling paintings executed by some of the most important Japanese painters of the time, and lavish appointments, such as gilt lamps atop the balustrades on either side of the grand staircase. There are also some distinctly Japanese features, such as the designation of reception rooms as front, middle, and inner. However, its very magnificence was the palace's undoing. When the Meiji emperor first inspected it, he declared it too luxurious for his son, and it was never used as an imperial residence. Until the 1970s it housed the Diet Library—the Japanese equivalent of the Library of Congress—but now it has been restored and is used for official state visitors.

The third of Conder's pupils to make a name for himself as an architect was Sone Tatsuzō. After graduating from the University of Technology and working as a naval engineer, Sone in 1890 joined the Mitsubishi real estate company and became involved with Conder in the design of London Block, the group of office buildings erected to the west of Tokyo Station. London Block consisted of four-storied structures built of reinforced brick, with brick also used as the outer surface material. In 1906 Sone left Mitsubishi to open his own private firm, and from then on worked exclusively for private clients, including Mitsubishi and other newly emerging business conglomerates. Some architectural historians consider him, rather than Tatsuno

or Katayama, the most influential figure in late Meiji and Taishō architecture.

One of Sone's best-known buildings is the Memorial Library of Keiō University, completed in 1912 to commemorate the fiftieth anniversary of the school, which was founded in 1858 (fig. 335). The style Sone used on the surface of the building is called "decorated Gothic" and employs such motifs as pointed arches, truncated flying buttresses, and simulated turrets. These details are given high visibility because they are executed in white stone that contrasts strongly with the red brick of the walls. The main section of the building is two stories tall, containing a memorial hall on the first floor and a reading room on the second. To the right of this is a three-storied octagonal tower, and to the left, a five-storied structure in which the library's books are shelved. Not only is Sone's library, with its asymmetrical placement of architectural elements, a very attractive building, it also gives us some idea of the design elements used in London Block.

With the completion of the main office of the Nihon Yūsen (Japan Mail Line) Building in Marunouchi in 1923, Sone moved beyond the building materials of his mentor, namely reinforced brick, to a new technique developed in America, steel-reinforced concrete (fig. 336). The first office building to use the new technique had been the Tokyo Maritime (Kaijō) Building, completed by Sone's firm in 1918. There, however, the architects had retained the familiar structural plan developed for reinforced brick, namely the use of numerous thick, load-bearing piers. The next reinforced-concrete project to be undertaken was the Marunouchi Building, affectionately known as the Maru Biru, executed by the Fuller Company of Chicago, using its own patent system of reinforced concrete and plans drawn by the real estate section of the Mitsubishi

**335.** Memorial Library, Keiō University, Tokyo, by SONE TATSUZŌ. 1912

**336.** Nihon Yūsen Building, Tokyo, by SONE TATSUZŌ. 1923

Corporation; it was followed one year later by Sone's Japan Mail Line headquarters. The use of steel-reinforced concrete for large commercial structures had been perfected by Chicago-based architects, including most notably Louis Sullivan. At first the Japanese were not completely happy with the new technology. In the earthquake of 1923 the Maru Biru remained standing but sustained considerable damage, while the structurally more traditional Tokyo Maritime Building fared much better. It was said at the time that the Japanese methods of construction used in the Maritime Building were clearly superior to those developed in the United States. Nevertheless,

**337.** Ministry of Justice, Tokyo, by HERMANN ENDE and WILHELM BÖCKMANN. 1895

steel-reinforced concrete was the building material of the future. The superior strength of reinforced concrete used horizontally requires fewer vertical supports and permits the creation of wide expanses of open space. For example, the Tokyo Maritime Building has only 2,943 square yards of office space, while the Japan Mail Line headquarters has 4,740. It remained for Japanese architects to master completely the new technology after World War II in order to produce what, it is hoped, will be earthquake-proof structures, since the Kantō region has a history of severe earthquakes every sixty years or so.

Of the three office buildings mentioned above, Sone's Japan Mail Line headquarters is clearly the most successful as a design. It is a seven-storied structure, the first story being emphasized by the use of rusticated shapes and large window openings and set apart from the upper floors by a balustrade. The next five floors are treated as a single unit, with thin, Corinthian-capped pilasters extending from the balustrade to the architrave that marks off the seventh floor. On that story the windows are treated as the frieze of the entablature and are separated from each other by relief carvings of shields, the whole design concluded with a heavy cornice. In addition, one corner of the building, exposed to a wide intersection, is made to curve gracefully, that part of the surface given crisp definition by thick pilasters. Although the Japan Mail Line building appears to be faced in stone, it is actually covered with terra-cotta tiles, which give the building a rich, almost iridescent color.

At the same time that Josiah Conder was developing the first generation of Japanese architects, the German firm of Ende und Böckmann was shaping the style of buildings to be used for the ministries of government, both national and provincial. The only extant building designed by the firm is the Ministry of Justice (fig. 337), located to the north of Hibiya Park, near the lower end of the broad avenue that leads up to the Diet building. Completed in 1895 and now much remodeled, it is a long, low structure of only four stories—the height deemed in the late Meiji period the greatest a building could have and still be earthquake-proof. Given these height restrictions, in order to have enough floor space the architects had to design a very long building and were faced with the problem of disguising its dimensions through the clever treatment of the façade. Their solution was to create a rectangle broken by three units that projected forward and backward from the basic shape. In the center of the building is a large, seven-bay pavilion, with rounded arches on the second story and a colonnade in the Tuscan order—a plain style based on a classical style that is Roman in origin—on the third story. On either side are simple porticoes providing entrances to the building, and at the ends are additional projections that repeat the theme of the central pavilion.

Ende and Böckmann were also asked to design a layout for the government buildings to the southwest of the Imperial Palace and to submit the design for a building to house the newly created Diet. In 1886 and 1887 both

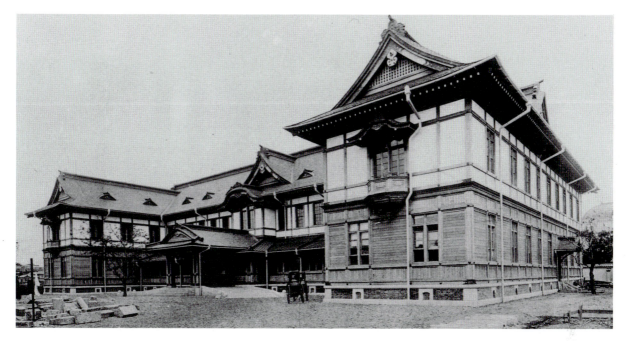

**338.** Nippon Kangyō Bank, Tokyo, by TSUMAKI YORINAKA. 1899 (no longer extant)

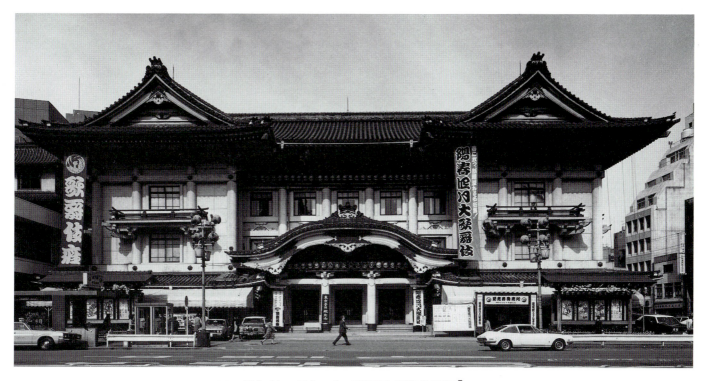

**339.** Kabukiza, Tokyo, by OKADA SHINICHIRŌ. 1924

Ende and Böckmann visited Tokyo, and they took back with them to Germany a group of Japanese architectural and engineering students for further training, including Tsumaki Yorinaka, who later supervised the construction of buildings in Japan designed by the firm. The first design they submitted in 1887 was for a neoclassic building similar to the three-pavilion design they were to use later in the Ministry of Justice offices. When this design was not accepted, they again produced a tripartite building, this time with Eastern motifs such as curving roofs incorporated into the design. Thus began the great Diet Building controversy, which was to rage on until the present structure was completed in 1936.

At the heart of the controversy was the question

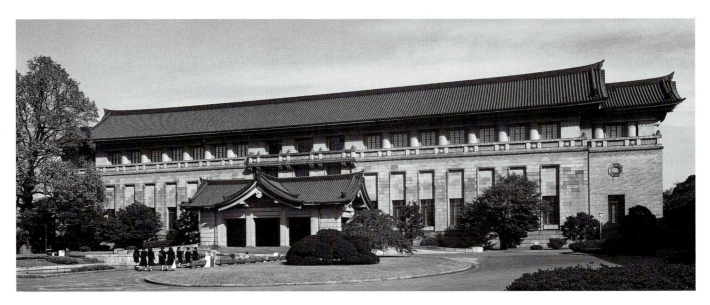

**340.** Tokyo National Museum, Tokyo, by WATANABE HITOSHI. 1937

perennially posed during the early modern period: namely, what was the role of tradition in the arts of Japan—in this case the architecture? Should an indigenous form of theater like Kabuki be housed in a Western-style building? In what style of architecture should traditional painting be displayed? Could a uniquely Japanese style of architecture be developed that would be appropriate not only for institutions of culture but for modern business structures as well?

One of the foremost figures responding to this issue was the Ende-Böckmann protégé Tsumaki Yorinaka (1859–1916), who attempted to create a new all-purpose style of wooden architecture reflecting traditional Japanese forms. His Nippon Kangyō Bank, or Bank for the Encouragement of Industry, across from Hibiya Park—it is no longer extant—was a prime example of his work in what came to be called the shrine-temple style (fig. 338). Completed in 1899, the building had two stories, the first walled in wood, the second in plaster with wood framing that was allowed to show on the surface. Tiled roofs repeated the hipped-gabled and Chinese-gabled shapes found in the Edo period. However, the proportions of the building were new—taller and stockier than most temple buildings—and in addition such European details as a balcony were worked into the design.

In 1924 the architect Okada Shinichirō (1883–1932) designed the Kabukiza or Kabuki Theater in the Higashi Ginza area of Tokyo, in the style of an Edo-period building, again with hipped-gabled roofs and Chinese gables (fig. 339). Being constructed of steel-reinforced concrete, the building cannot rely on the aesthetics of more traditional wood-and-plaster walls, but aside from that, the vocabulary of design motifs employed is purely Japanese.

In 1937, Watanabe Hitoshi's (1887–1973) prize-winning design for the Tokyo Imperial Museum, now the Tokyo National Museum, was built in the so-called Imperial Crown style that in the thirties became a symbol of Japanese nationalism (fig. 340). The most obvious characteristic of the Imperial Crown style is the curving Japanese-style roof, but buildings in this style also often have porte cocheres, small roofed structures extending from the entrance of a building over an adjacent driveway. The front of the Tokyo National Museum has one with gracefully curving gables forward and to the sides. The museum building is actually three stories tall, but the façade is articulated as though it had only two. The lower course of windows provides natural light in the first-floor galleries, which house sculpture, metal objects, and ceramics; the upper illumines staff offices. The second-floor galleries are fitted in between and are illuminated artificially, a necessary feature for displaying light-sensitive paintings. The main gallery of the Tokyo National Museum has a certain charm, but it does not attempt to be an exercise in modern design.

The Diet Building was the most notable victim of Japan's stylistic schizophrenia in the period before World War II. On the one hand it was the seat of representative government in Japan, and many felt it should be housed in a Japanese-style building. On the other hand, the Diet was brought into being by the Meiji constitution, a monument to the enlightened policies of the Meiji emperor, and therefore some believed it should convene in a building in the Western style that had come to symbolize progress in that era. The first Ende-Böckmann design addressed the need for a Western-style building, but by 1887 the desire for an indigenous style of architecture had surfaced and the first design was rejected. The second, "Japanese," design was never built because of budget constraints, and the project was put on hold. In 1906, in the euphoria of victory after the Russo-Japanese War, a new effort was made to find a suitable design, but the project foundered again, this time

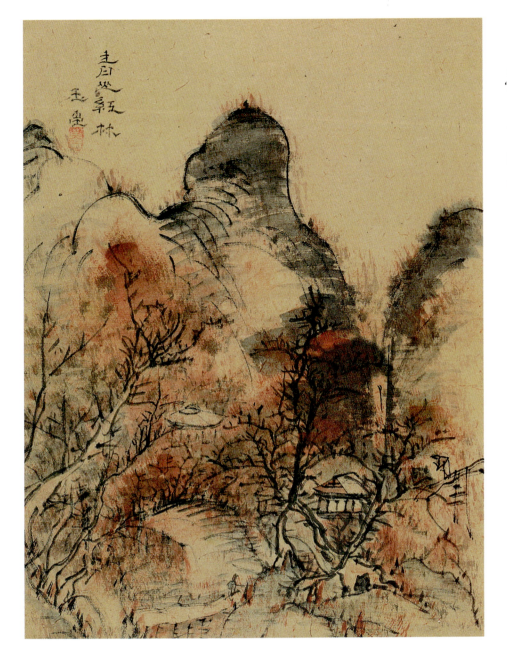

**Colorplate 56.**
Verdant Hills and
Scarlet Forests, from
"Mist and Clouds" set
of album leaves,
by URAGAMI
GYOKUDŌ. c. 1811.
Ink and color on
paper; 11¼ x 8⅝ in.
(28.5 x 21.9 cm).
Umezawa Memorial
Hall, Tokyo

**Colorplate 57.** Illustration from *Yamanaka Tokiwa monogatari emaki*, attributed to IWASA MATABEI, showing the murder of Tokiwa. Hand scroll, color on paper; height 13⅜ in. (34.1 cm). M.O.A. Museum of Art, Atami, Shizuoka prefecture

**Colorplate 58.** New Year's Scene: Women Meeting on Nihonbashi Bridge, by TORII KIYONAGA. 1786.
Polychrome woodblock-print diptych on paper; *ōban* size: 15 x 19¾ in. (38 x 50.2 cm). The Honolulu Academy of Arts.
The James A. Michener Collection

**Colorplate 59.** The Barrel-maker of Fujimihara, from *Thirty-six Views of Mount Fuji,* by KATSUSHIKA HOKUSAI. c. 1830. Polychrome woodblock print on paper; *ōban* size. Tokyo National Museum

**Colorplate 60.** Dish with phoenix design. Ko Kutani ware. 17th century. Porcelain, with overglaze enamels; diameter 13½ in. (34.3 cm). Ishikawa Prefectural Museum of Art

**Colorplate 61.** Tea bowl with plum-branch design, by ŌGATA KENZAN. Kyōyaki ware. 18th century. Earthenware, with underglaze painting; height 3⅛ in. (8 cm). Umezawa Memorial Hall, Tokyo

**Colorplate 62.** *Shinobazu Pond,* by ANTONIO FONTANESI. 1876–78. Oil on canvas; 20½ x 28⅞. (52 x 73.3 cm).
Tokyo National Museum

Meiji P.

TEchnical Art School: 1876 - 1883

**Colorplate 63.** *Harvest,* by ASAI CHŪ. 1890. Oil on canvas; 27¼ 37⅞ in. (69 x 98.5 cm).
Tokyo National University of Fine Arts and Music

Meiji P.

Late 1880's and Revival of Western Style painting

**Colorplate 64.** *By the Lake,* by KURODA SEIKI. 1897. Oil on canvas; 26¾ x 32⅝ in. (68 x 83 cm).
Tokyo National Research Institute of Cultural Properties

Meiji P.

influenced by Raphael Collin

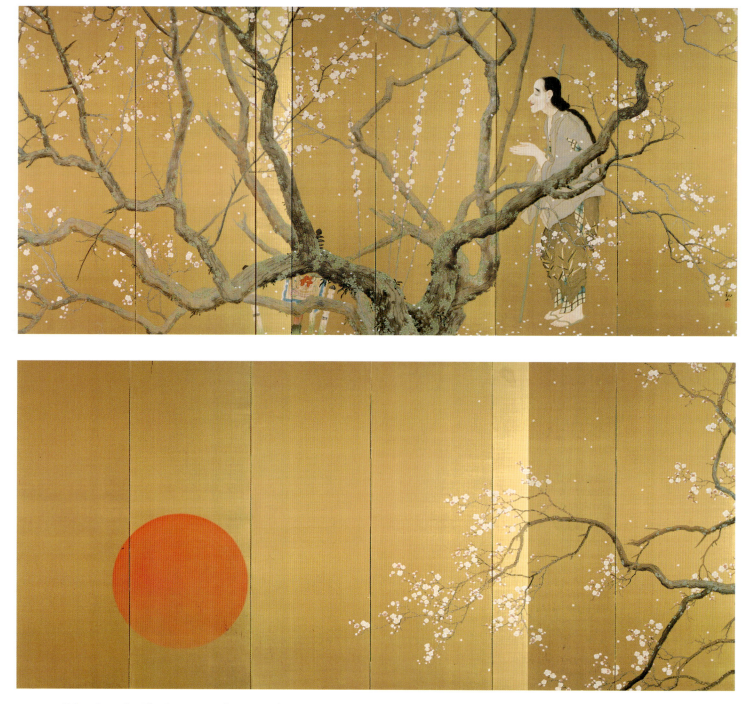

**Colorplate 65.** The Beggar Monk, a pair of six-panel *byōbu*, by SHIMOMURA KANZAN. 1915. Color and gold leaf on paper; each screen 6 ft. 1⁵⁄₈ in. x 13 ft. 4¹⁄₂ in. (187.5 x 407 cm). Tokyo National Museum

**Colorplate 66.** *Seaside Village,* by NAKAMURA TSUNE. 1910. Oil on canvas; 23⅝ x 32⅜ in. (60 x 82.1 cm). Tokyo National Museum

**Colorplate 67**. *Portrait of Mrs. F.,* by YASUI SŌTARŌ. 1939. Oil on canvas; 34⅝ x 26 in. (88 x 66 cm). Private collection

**Colorplate 68.** *Tzu-chin-ch'eng Palace,* by UMEHARA RYŪSABURŌ. 1940. Oil on canvas; 45¼ X 59 in. (112.4 x 149.9 cm).
Eisei Bunko Foundation, Tokyo

**Colorplate 69.** *Horses Among Pines,* by SAKAMOTO HANJIRŌ. 1938. Oil on canvas; 35⅚ x 46⅛ in.
(90.6 x 117.3 cm). Private collection

**Colorplate 70.** Camp at the Kise River, a pair of six-panel *byōbu,* by YASUDA YUKIHIKO. 1940–41. Color on paper;
each screen 65⅝ x 167 in. (167.7 x 374 cm). National Museum of Modern Art, Tokyo

**Colorplate 71**. *Spotted Cat*, by TAKEUCHI SEIHŌ. 1924. Color on silk; 31⅞ x 39½ in. (81 x 100.5 cm). Yamatane Art Museum, Tokyo

**Colorplate 72.** Second Army Attacks Port Arthur, November 1894, by KOBAYASHI KIYOCHIKA. 1894. Polychrome woodblock triptych on paper; each print *ōban* size. Collection Ruth Leserman, Beverly Hills, Calif.

**Colorplate 73.** Sailboat, Morning *(left)* and Sailboat, Afternoon *(right)*, by YOSHIDA HIROSHI. 1926. Polychrome woodblock prints on paper; each 20⅛ x 14⅛ in. (51 x 35.9 cm). M.O.A. Museum of Art, Atami, Shizuoka prefecture

**Colorplate 74.** Kiyomizudera at Kyoto,
by KAWASE HASUI. 1933. Polychrome woodblock
print on paper; *ōban* size. Private collection.
© Shozunurō Watanabe

**Colorplate 75.** Portrait of Hagiwara Sakutarō,
by ONCHI KŌSHIRŌ. 1943. Polychrome woodblock print
on paper; $20^5/_8$ x $16^3/_4$ in. (52.5 x 42.5 cm).
Private collection, Tokyo

**341.** Design for Imperial Diet Building (Tokyo), by SHIMODA KIKUTARŌ. 1919

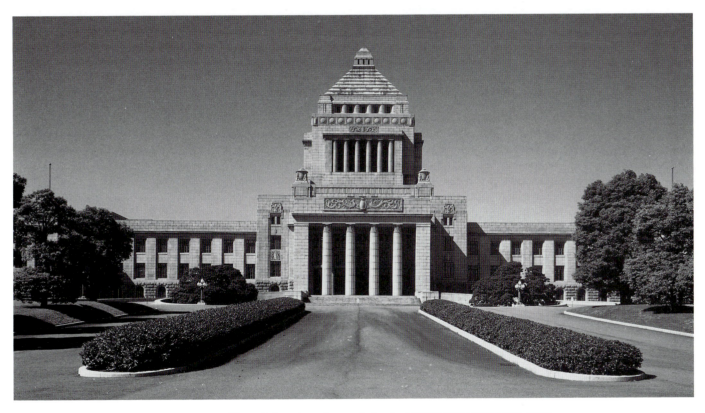

**342.** Diet Building, Tokyo, based on a design by WATANABE FUKUZO. 1936

due primarily to the rivalry between Tatsuno, by now a venerable figure in architectural circles, and Tsumaki, who had become head of the Department of Temporary Construction in the Ministry of Finance. The two men could not have been more dissimilar: Tatsuno trained by the Englishman Josiah Conder, Tsumaki at the German firm of Ende und Böckmann; Tatsuno favoring Western styles of architecture, Tsumaki seeking a Japanese style for modern buildings. Again the project was tabled, and it was not re-

vived until after Tsumaki's death in 1916.

The next phase in the Diet controversy centered on the question of modernism. In 1919 the results of a design competition were announced, and the following year the four winning plans were put on public exhibition. The question of an indigenous design seems to have been settled by opening the competition to Japanese architects only and similarly limiting the judges as well. But 1920 was a year of upheaval in Japanese architectural circles,

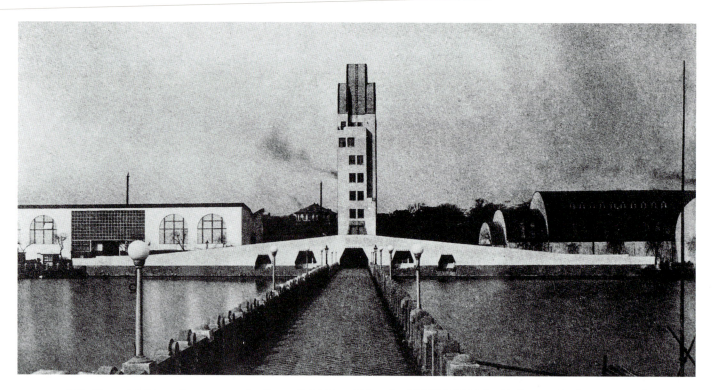

**343.** Memorial Tower, Commemorative Peace Exhibition, Tokyo, by HORIGUCHI SUTEMI. 1922 (no longer extant)

the year in which the rebellious movement led by Horiguchi Sutemi came to the fore, and many young architects were angered by the old-fashioned "Meiji" character of the prize-winning designs. A countercompetition was announced, which produced one of the first examples of the Imperial Crown style, a design submitted by Shimoda Kikutarō (1866–1931), figure 341. Finally, in the interest of expediency, yet another committee was appointed to work out of the public eye to produce a design and oversee its construction. The result is the present Diet Building, completed in 1936, a tripartite, two-storied structure surmounted by a tower, which is topped in turn by a vaguely Egyptian pyramid (fig. 342).

## The Modern Movement

The buildings cited above notwithstanding, Tokyo in the 1920s and 1930s came into the mainstream of an international style of modern architecture, developed in the United States in the years before World War I by such architects as Frank Lloyd Wright (1867–1959). Particularly significant was the commission given to Frank Lloyd Wright to design and build the second Imperial Hotel, close to the site of the Rokumeikan, and like it a meeting place for foreigners and officials of the Japanese government and heads of major companies. His building, completed in 1922, was important in his oeuvre because it demonstrated his stylistic debt to Japanese architecture and at the same time his skill as a structural technician, since the building sustained only minor damage during the disaster of the Great Kantō Earthquake of 1923, which

occurred the day the building was scheduled to open. However, it must be said that Frank Lloyd Wright and his designs for the Imperial Hotel had little impact on Japanese architects. Much more influential was his assistant Antonin Raymond (1888–1976), a Czech-American architect who stayed on in Tokyo after the hotel was completed and opened his own office.

In the second decade of the 20th century a controversy in world architectural circles surfaced also in Japan, namely, structure versus design. Is architecture primarily technology, or is it a marriage of technology and style? The former attitude was given voice by Noda Toshihiko (1891–1929) in his 1915 article postulating that "Architecture Is Not Art." Noda took his undergraduate degree in the Department of Architecture in the School of Technology at Tokyo University under Sano Riki (1880–1956), successor to the university chair held by Tatsuno Kingo and a pioneer in the field of earthquake-proof architecture. Noda's article is thought to reflect the ideas of his mentor, who clearly put a high premium on construction techniques. Five years later a group of six young architects trained at Tokyo University rebelled against Sano's ideas and constituted themselves as the Bunriha Kenchikukai, or the Secessionist Architectural Society, the first architectural movement native to modern Japan. The group continued until 1928 and advanced their ideas primarily through exhibitions at Tokyo department stores, in Japan a respected locus for art shows.

One of the most important architects to emerge from the Bunriha, and undoubtedly its philosophical leader, is Horiguchi Sutemi (born 1895). In 1922, two years

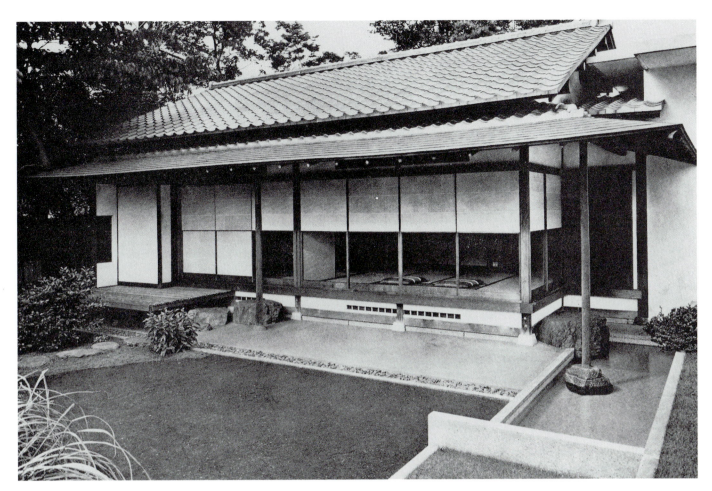

**344.** Okada residence from the south side, Ōmori district, Tokyo, by HORIGUCHI SUTEMI. 1934 (no longer extant)

after his graduation, the young architect's first major design was constructed in Ueno Park: the temporary tower for the Commemorative Peace Exhibition (fig. 343). The structure had two main parts: a long, low building that is U-shaped in cross section, its sides articulated by four large U-shaped projections and numerous small rectangular and U-shaped windows, and a soaring tower, again using elongated U shapes. The two structures are linked by a ramp that slopes upward from the low building to the base of the tower. The structure is strongly expressionistic in character, and, according to the architectural historian David B. Stewart, finds a direct prototype in a tower designed by the Viennese architect Joseph Maria Olbrich (1867–1908) for the Mathildenhöhe artists' colony near Darmstadt, Germany.

In 1923 Horiguchi had the opportunity to travel extensively in Europe and took the occasion to visit many of the most avant-garde architects, including Erich Mendelsohn (1887–1953), Walter Gropius (1883–1969), and J. J. P. Oud (1890–1963). In the constrained economic climate that prevailed in Japan after the earthquake, Horiguchi found that most of his commissions were coming from individual clients desiring modern residences rather than from the government and large companies. Thus he

began to work with the concept of integrating traditional Japanese forms into a modern context. His best-known pre-World War II design is the Okada residence in the Ōmori district of Tokyo, completed in 1934 and no longer extant (fig. 344). Perhaps the most interesting juxtaposition in the structure was the placement of two Japanese tatami rooms next to a Western-style living room. The Japanese rooms projected forward into the space of a garden enclosed by cement walls, while the Western-style room was recessed. The vista from each room was distinctive, the view from the two Japanese rooms being a garden at its peak in the fall, while that from the Western-style room was more geometric, with a flat expanse of green grass punctuated only by a tree to the left and a low shrub to the right. This residence was a particularly sensitive blending of traditional and modern elements.

One public agency that found the modern Western style of architecture compatible with the image it wished to project was the Ministry of Communications. The notion of fast, efficient postal and telecommunications service seemed best served by the clean, unornamented lines of the modern style. The man most thoroughly identified with designs for the ministry is Yoshida Tetsurō (1894–1956), and the best example of his work is

**345.** Tokyo Central Post Office, Tokyo, by YOSHIDA TETSURŌ. 1931

**346.** Design for Tokyo National Museum, Tokyo, by MAEKAWA KUNIO. 1931

the Tokyo Central Post Office on the south side of the square formed by Tokyo Station on the east and the Maru Biru on the west. The building, completed in 1931, occupies an irregular quadrangular block. Yoshida took advantage of the obtuse angle to the northwest to create an extended façade along the square (fig. 345). The principal elements visible on the surface of the building are dark windows with black dividers between the panes and white walls. The latter are given crisp definition by the slight recesses into which the windows are fitted and by the projecting ledge between the fourth and fifth floors. The overall impression of the building is that of stripped-down, unornamented efficiency; the façade is a direct and accurate reflection of the interior.

Among Japan's most talented and, while he lived, underrated architects, was Maekawa Kunio (1905–1986), who began his career in the years just prior to World War II. In his youth Maekawa was a man of sudden and strong enthusiasms. He was first inspired to become an architect when he saw Horiguchi's 1922 Memorial Tower for the peace exhibition in Ueno Park. He became aware of the work of Le Corbusier (1887–1965), and upon graduation from Tokyo University in 1928, he set out for Europe to study with the master. For two years he worked in Le Corbusier's atelier, and after his return to Japan in 1930 entered the firm of Antonin Raymond, the disciple of Frank Lloyd Wright who worked in Japan. After a falling-out with Raymond, Maekawa became an independent

agent, but most of his work until World War II consisted of design competition entries.

A design of particular interest is his proposal for the main gallery of the Tokyo National Museum, the competition won by Watanabe Hitoshi (see page 336). Since one of the stipulations in the contest was that the building should reflect traditional Japanese styles of architecture, Maekawa knew his design had no chance of success. Nevertheless, he submitted drawings of an unornamented structure consisting of six rectangles at right angles to a central corridor, entered through an open arcade created by slender posts supporting the forward projection of the middle rectangle (fig. 346). His was a stark, modern design that would certainly have been stylistically innovative.

By a strange quirk of fate, after World War II Maekawa was given the opportunity to put his and his mentor's modernist stamp on one of the most traveled sections of Ueno Park, the area near the Ueno Railroad Station park-entrance point. After the war the French government agreed to return a priceless collection of Impressionist paintings and Auguste Rodin sculptures assembled in France by the Japanese businessman Matsukata Kōjirō (1865–1950)—on the condition that the building to house the treasures be designed by a French architect. In 1959 construction of the Museum of Western Art was completed according to Le Corbusier's plans. Two years later, on the opposite side of the pedestrian mall, the Tokyo Metropolitan Festival Hall, designed by Maekawa himself, was built. Today the first impression most visitors have of Ueno Park is of innovative modern architecture, as symbolic of progress and enlightenment in the postwar world as Katayama's Hyōkeikan was in the late Meiji period.

## Painting in the Meiji Period (1868–1912)

If the challenge posed for the Japanese by Western architecture was the considerable task of mastering a new technology and new vocabularies of ornamentation, that posed by Western painting was even more fundamental. It involved not only the use of new materials such as oil pigments, stiff, Western-style paintbrushes, and rough canvas, but also a new way of looking at the natural and figural worlds, seeing and reproducing objective details rather than creating a subjective interpretation.

Some of the styles and techniques of Western painting had been known in Japan since the late 16th century, when the Jesuits proselytized among the Japanese, using religious paintings as teaching aids. The issue of representation in painting had been raised by Shiba Kōkan in the 18th century, when he scathingly criticized literati painting (see pages 278–279). Other artists incorporated elements of Western painting into their work: Maruyama Ōkyo employing Western perspective in his *megane-e* and Watanabe Kazan using shading in his portraits to give them more of a three-dimensional quality (again, see page 279). However, it was not until Japan was ready to accept Western culture without reservation that her artists were able to study foreign paintings and to master the concepts and the techniques that permitted the objective representation of subject matter.

At this same time European and American artists and collectors were assiduously studying the Japanese arts and crafts that were trickling into the West. In the decades of the 1860s, 1870s, and 1880s, there was a craze for things Japanese—porcelains, textiles, fans, folding screens, and particularly woodblock prints. The Western art that reflected this influence was known as Japonisme. On one level, Western interest in Japanese objects was quite superficial, the incorporation of Japanese motifs into the design of Western objects. But on a deeper level, Japanese art had a great impact on Western artists, particularly Vincent van Gogh (1853–1890), Edgar Degas (1834–1917), and James A. McNeill Whistler (1834–1903), moving them toward flatter compositions and an emphasis on outline, unusual compositional perspectives, and unexpected figural poses.

### Western-style Painting

One of the first steps in Japanese acceptance of Western realism occurred in 1855, when the government established a bureau for the study of Western documents, first known as the Yōgakusho, Bureau of Western Studies, but renamed in 1856 Bansho Shirabesho, Institute for the Study of Western Books. Here Western styles of painting and drawing were studied not because they were seen to have intrinsic value but rather because mastery of them was considered essential for catching up technologically with the West.

The most important artist to emerge from the training of the Bansho Shirabesho was Takahashi Yuichi (1828–1894). Born in Edo to a low-ranking samurai family, Takahashi, like most sons of the military class, was given lessons in the Kanō style of traditional Japanese painting, along with training in the martial arts. However, Takahashi decided that his talents lay not in the military but in art as a career, and specifically in Western-style painting. Taking the only route then available, in 1862 he entered the Bansho Shirabesho, where he distinguished himself as the first artist to fuse the objective description and subjective interpretation of a visual image in a Western-style painting. Next he turned to the English journalist Charles Wirgman (1835–1891) for further training. Wirgman, a correspondent for *The Illustrated London News*, was not a professional painter, but a very talented amateur who helped Takahashi gain mastery over Western painting techniques. Takahashi went on to open his own school for the teaching of Western art and became a major figure in painting circles in the early Meiji period. He played an important role in the creation of *Kokka*, the first Japanese art journal, and added his support for the establishment of an art museum.

**347.** *Oiran* (courtesan), by TAKAHASHI YUICHI. 1872. Oil on canvas; 30½ x 21⅝ in. (77.5 x 55 cm). Tokyo National University of Fine Arts and Music Meiji P.

A particularly interesting example of his work is the 1872 oil painting *Oiran,* meaning courtesan (fig. 347).❖ According to an account in the *Tōkyō Mainichi Shinbun* (*Tokyo Daily Newspaper*) for April 28 of that year, the painting was undertaken at the request of a fan of the geisha quarters who regretted the fall from favor of the hairstyle known as *hiyōgomage.* The gentleman commissioned Takahashi to paint a portrait of a particular geisha, Koine of the Inamotorō house, as a record of the coiffure style. What the artist achieved in this painting is much more than documentation. The geisha sits in a slumped-over position, her gaze unfocused, her expression enigmatic. The numerous hairpins used to keep the complicated hairstyle in place provide a sharp contrast to the stolid human figure and suggest something of the artificiality of the geisha's life.

The next stage in the promulgation of Western techniques of painting and drawing was the government's establishment of the Technical Fine Arts School. The government was interested in Western art for utilitarian purposes like cartography, drafting, and architectural rendering, but fortunately for the students, the instructors

who were actually brought from Europe were artists. Three Italian artists were invited to join the faculty: the architect Giovanni Cappelletti (died circa 1885), who taught the basic principles of geometry and perspective; Vincenzo Ragusa (1841–1928), who gave instruction on modeling in clay and plaster; and Antonio Fontanesi (1818–1881), who taught drawing and painting. Thus in 1877, at the same time the Japanese architects Tatsuno, Katayama, and Sone were beginning their instruction under Josiah Conder, the Japanese painters who were to establish Western-style painting, or *yōga,* as a viable form of expression in the late Meiji period also began their studies, under Italian masters.

Antonio Fontanesi was an adherent of the Barbizon school of painting, admiring particularly the works of Camille Corot (1796–1875) and Charles-François Daubigny (1817–1878). At the time of his invitation to teach in Japan, Fontanesi had achieved a degree of prominence in art circles, having been appointed professor of landscape painting at the Royal Academy of Art in Turin. By all accounts he was a man of great personal warmth who cared deeply for his students and for their training. So great was the loyalty he inspired that after he was forced by ill health to return to Italy in 1878, his students could find no one who could take his place. After they had appraised his replacement, eleven of them withdrew from the Technical Fine Arts School to form their own study group, which they called the Society of the Eleven.

An excellent example of Fontanesi's work in Japan is *Shinobazu Pond,* an oil painting depicting the small lake to the southwest of the Tokyo National Museum in Ueno Park (colorplate 62). When this was painted, Ueno was still open land. Fontanesi has chosen the moment of sunset as his subject, and he depicts the last rays of pink light glistening on the surface of the pond while the trees and marsh grass around its perimeter begin to fade into brown dusk. Tranquillity and lyric beauty, the hallmarks of Fontanesi's work, pervade the painting.

One of Fontanesi's devoted students was Yamamoto Hōsui (1850–1906), a young man who came to the Technical Fine Arts School from Kyoto, where he had been trained in literati painting. So complete was Yamamoto's conversion to Western art that after a year at the school he journeyed to Paris to study with the academic painter Jean-Léon Gérôme (1824–1904). Yamamoto was the first Japanese artist to study abroad, but he was soon followed by other Fontanesi students. These men found places in the classrooms of academic painters rather than of more avant-garde artists, primarily because it was the academics who accepted students. Thus the Japanese learned Western techniques but inadvertently limited themselves

---

❖ Japanese paintings prior to the Meiji period usually did not have specific titles but rather were called by their subject matter. However, as Japanese artists became familiar with Western conventions, they began to name their own works. Such titles are given in italics in this book.

**348.** *Nude,* by YAMAMOTO HŌSUI. c. 1880. Oil on canvas; 32⅝ x 52⅞ in. (83 x 134.4 cm). The Museum of Fine Arts, Gifu

to working in styles that were already becoming passé. Perhaps Yamamoto's greatest contribution to the development of *yōga* was his conversion of Kuroda Seiki, a young scion of a politically prominent family, from a career in law to one as a painter. Kuroda eventually went on to become one of Japan's most successful practitioners of *yōga* in the Meiji period.

*Nude,* an oil painting executed by Yamamoto around 1880 during his stay in Paris, illustrates both his stylistic accomplishments and the academic character of his pictorial themes (fig. 348). A beautiful young woman lies on her side near a pond set in an idyllic landscape. Her body has a strong volumetric quality achieved by modeling in highlights and shadows, as well as through the use of contour outlines. The treatment of the legs is a particularly fine example of foreshortening. The background grass, water, and rocks provide a strong contrast in shades of blue and green to the flesh tones of the woman's body and the white of the cloth on which she lies. *Nude* is a beautiful, technically accomplished painting, but one that, in terms of style, looks back to a time when this type of idealized representation was fresh and original.

Without question, Fontanesi's most talented pupil was Asai Chū (1856–1907). Born to a samurai family, Asai was first educated in a *han* school where, among many subjects, he was taught painting in the literati style. At the age of sixteen he went to Tokyo to study English,

but he became much more interested in painting. Finally, after a year of study in a private studio, he entered the Technical Fine Arts School and came under Fontanesi's influence. Dissatisfied with the latter's replacement, in 1878 Asai withdrew from the school as one of the Society of the Eleven.

The decade of the 1880s was a difficult time for *yōga* artists, as the pendulum of public favor swung toward traditional Japanese-style painting, so in 1889 a group of artists and intellectuals who believed in the importance of Western-style painting founded the Meiji Art Society to promote their point of view. Asai was a member of the society and a contributor to its annual exhibitions. His painting *Harvest* was included in the 1890 show put on by the society and is one of the finest examples of his mature work (colorplate 63). Within a space cell—a discrete area of a painting, bounded by pictorial motifs—created by a row of bundled rice stalks, a tall column of stalks, and the framework for another row, three figures are engaged in harvesting rice. The woman to the left holds a sheaf of cut rice plants, the woman in the middle shakes the rice kernels in a straw basket to separate the seeds from the chaff, and the man to the right aligns bundles of leftover stalks so they can be attached to the framework in the background on the right, and dried. The farmers seem deliberate in their movements, as if they are in tune with the measured rhythms of nature. Soft golden

**349.** *Autumn at Grez*, by ASAI CHŪ. 1901. Oil on canvas; 31¼ x 23⅝ in. (79.5 x 60 cm). Tokyo National Museum

light pervades the painting, giving the whole a lyric quality. Although Asai was a disciple of Fontanesi, this painting has none of the murky brown shadows so typical of the Italian's work. Instead, the artist has created this picture in his own individual style.

In 1893 Asai's career collided with that of Kuroda Seiki. In that year Kuroda returned from a decade in France, bringing with him a new style of plein-air, or outdoor, painting using the bright colors of the French Impressionists. Suddenly Asai's work looked old-fashioned. For seven years Asai and Kuroda maintained an uneasy truce, and when Asai was given the chance in 1900 to travel to France to study, he took it as an opportunity to sever his connections with Tokyo *yōga* art circles. He stayed in France for two years, painting prodigiously, turning out some of his best work, and after his return to Japan he established himself in Kyoto, accepting a position in the Kyoto Higher School of Design. Overshadowed by Kuroda, Asai was not appreciated in his own lifetime. Today, however, he and Kuroda are recognized as the two most talented masters of *yōga* in the Meiji period.

One of Asai's most famous paintings from his sojourn in France is *Autumn at Grez* of 1901 (fig. 349).

Grez-sur-Loing was a small town to the south of Paris, near Fontainebleau, where Asai spent six months, from October 1901 to March of the following year. The poplar tree is a motif he painted over and over again while in Grez. In *Autumn*, Asai has created a space cell, using trees in the distance and a low wooden fence as the boundaries, and within it he has placed an uneven row of poplar trees, their branches nearly bare of leaves. Yellow, green, and light brown tones dominate the painting, offsetting the gray of the barren limbs and trunks. Again Asai has captured the beauty of the natural world.

Kuroda Seiki (1866–1924), Asai Chū's rival, came from a background similar to Asai's, born into a samurai family. However, at the age of four he was adopted by his uncle, Kuroda Kiyotsuna, a major figure in the Meiji Restoration, and was groomed to play an important role in politics. In 1884 he was sent to Paris to study law, but through the intervention of Yamamoto Hōsui, he was diverted while there to a career as a *yōga* painter. To this end he studied with Raphael Collin (1850–1916), an artist noted for his paintings of nudes and also of large-scale figural works for public commissions. The latter's greatest influence on Kuroda was to introduce him to the light, bright colors used by the French Impressionist school. Raphael Collin was not actually an Impressionist. He used the Impressionists' lighter palette, but his plein-air realism did not follow the Impressionists' theories about natural light and the use of color. However, the young generation of Japanese painters of the 1890s influenced by him—largely through Kuroda Seiki's work—understood that style to be Impressionism, unaware that this was not the core of French Impressionism. Collin also urged Kuroda to go to Grez-sur-Loing and paint directly from nature, which he did for two years along with another Japanese artist, Kume Keiichirō (1866–1934). In this he paved the way for Asai and other Japanese to live and work in France.

The most controversial and also the most accomplished painting produced during Kuroda's stay in France is his *Morning Toilet* of 1893 (fig. 350). It depicts a nude Western woman standing in front of a mirror as she gathers her long hair into a single strand prior to winding it into a chignon. The painting was first shown in Paris at the Société Nationale des Beaux Arts, where it won acclaim for the artist. After Kuroda's return to Japan it was exhibited again and became the subject of much controversy. The frontal female nude had never been the subject of a painting put on public display in Japan, and many considered it at best immodest, at worst pornographic. Acceptance of the nude as a pictorial motif did not come until several decades later. Unfortunately, Kuroda's painting was destroyed during World War II.

The style of painting and the palette of colors Kuroda brought with him from France caused a revolution among the younger *yōga* artists, who were tired of Fontanesi's Barbizon influence but not sufficiently grounded in Western art to define a new style for them-

**350.** *Morning Toilet,* by KURODA SEIKI. 1893. Oil on canvas; 70¼ x 38⅝ in. (178.5 x 98 cm) (destroyed)

view that the Brown school, which followed established rules of shading and composition more closely, was more academic as well as older, while the Purple school was seen as freer, more intuitive, and more subjective. The battle escalated to the point where in 1896 Kuroda and several young artists resigned from the Meiji Art Society to form the Hakubakai, or White Horse Society, which held periodic exhibitions and constituted a powerful force in the art world until 1911, when it was dissolved.

In the second White Horse Society show, Kuroda's *By the Lake* of 1897 was exhibited (colorplate 64). In the foreground of the painting, a kimono-clad woman sits on a rock, her body silhouetted against the blue water of a lake and the green trees and hills in the background. The light colors of Kuroda's palette and the purple he used for shading can be clearly seen in this work. Also, there is a freshness and an element of the dramatic in his treatment of the central figure, focusing on the woman's head and torso and allowing the background details to blur.

While Kuroda Seiki's stylistic contribution to the development of *yōga* in Japan was unquestionably significant, the cultural impact of his advocacy of Western-style painting was far more important, particularly his influence on the 1890s revival of *yōga.* Through exhibitions, first of the Meiji Art Society and later of the White Horse Society, he stimulated an appreciation for *yōga* among the general public, and in 1897 he achieved something that would have been unthinkable in the previous decade. He was invited to teach Western-style painting at the Tokyo School of Fine Arts, the institution dedicated initially to the promotion of *nihonga,* or Japanese-style painting. Prior to 1897, the teaching of *yōga* techniques had been banned from the school, but under Kuroda's influence a rapprochement was effected, and the course of Japanese art in the modern period changed profoundly.

Aoki Shigeru (1882–1911) belonged to the younger generation of artists who benefited from the liberating influence of Kuroda's lighter palette of colors. Born to a family who served as retainers to the Arima clan in Kyūshū, Aoki took no interest in his inherited position. Instead, as soon as his father grudgingly permitted him to do so, Aoki left for the heady intellectual and artistic climate of Tokyo, and the following year, 1900, he was admitted to the Tokyo School of Fine Arts. As a youth, Aoki was attracted to the Romantic movement, then popular in Japan, and to the possibilities it opened for self-expression. In Tokyo he tried to combine his interpretations of traditional Japanese myths with a personal style of painting.

Aoki's masterpiece *Palace Under the Sea,* an oil painting executed in 1907, was not well received when it was shown in the Tokyo Industrial Exposition (fig. 351). Romanticism was on the wane, and the work was not appreciated for its intrinsic accomplishments. The theme derives from Japanese mythology. Two brothers are skilled providers of food, Yamasachibiko hunting in the mountains, Umisachibiko fishing in the sea. One day they de-

selves. Also, it must be said that in Japan the fact that Kuroda was the son of a member of the nobility gave his paintings and his ideas particular importance and contributed to their acceptance. The clash of the two styles was dubbed the "Brown versus the Purple." The Brown school, in which paintings tended to have brown-toned shadows and somewhat heavy, resinous varnishes, was also nicknamed the "northern school." The newer Purple school, following painting influenced by Raphael Collin's plein-air style—which was more colorful and used blues and purples for shadows—was called the "southern school." The use of southern and northern, borrowed from the old distinctions of Chinese painting, pointed to the

**351.** *Palace Under the Sea,* by AOKI SHIGERU. 1907.
Oil on canvas; 71⅞ x 27½ in. (181.5 x 70 cm). Ishibashi
Museum of Art, Ishibashi Foundation,
Kurume, Fukuoka prefecture

**352.** *Butterflies,* by FUJISHIMA TAKEJI. 1904. Oil on canvas;
17½ in. square (44.5 cm). Private collection

cide to exchange their weapons and their normal hunting grounds. This proves to be a disaster for both men. Yamasachibiko loses his brother's precious fishhook and descends to the bottom of the sea to find it. Aoki shows the young man sitting on the branches of a sacred Judas tree in the garden of the fishscale palace, falling in love with Toyotama Hime, Princess of Abundant Jewels, on the left, who is accompanied by her servant. The story has a sad ending. After three years in the palace under the sea, Yamasachibiko becomes lonesome for his homeland. His father-in-law gives him the precious fishhook he came for and the young man returns to earth. At this point Toyotama Hime is pregnant and promises to come to him on land when she gives birth. However, when her husband looks at her during the delivery, against her instructions, and sees that she has taken the shape of a crocodile, she is shamed. Leaving her baby on the shore, she returns to her father's palace at the bottom of the sea. Aoki's life, too, had a sad ending. He was called back to Kyūshū to help his family, which had fallen into poverty after the death of his father, but unable to accept that kind of responsibility, he drifted into a life of vagrancy. He died at the age of twenty-nine of tuberculosis.

The other major artist who gained recognition through participation in the White Horse Society was Fujishima Takeji (1867–1943). Perhaps because both he

and Kuroda Seiki came from Kagoshima in Kyūshū, they developed a close friendship, and Kuroda Seiki made it possible for the younger artist to study the Western paintings he had shipped to Japan during his stay in Paris. When Kuroda was appointed to the Tokyo School of Fine Arts, he designated Fujishima as his assistant. Not surprisingly, the young artist's early works were executed in the style developed by Kuroda. However, through association with the artists of the White Horse Society, Fujishima began to develop his own personal idiom. *Butterflies,* of 1904, is a representative work from this period (fig. 352). A young girl kisses a flower that she has apparently broken off from a plant partially visible along the left side of the painting. She is highlighted against a ground of deep blue, and flying around her are a swarm of butterflies. Some shading has been used to model the girl's face and hands, but the overall impression of the painting is one of flat, two-dimensionality, a thoroughly modern work that nevertheless draws on the Japanese decorative tradition.

In 1905 Fujishima was sent abroad by the government to study painting, first with Fernand Cormon (1845–1924) in Paris and then with Charles Émile Augustus Carolus-Duran (1837–1917) in Rome. When he returned to Japan he was appointed professor by the Tokyo School of Fine Arts, where he had a strong influence on the next generation of artists.

## Japanese-style Painting

In the 1880s, Ernest Fenollosa and Okakura Kakuzō, also known by his art name of Tenshin, worked diligently to promote the objectives of the Kangakai, the organization founded in 1884 whose goal it was to promote an appreciation of traditional art and to encourage the development of a new style of painting to treat Japanese subjects in a manner appropriate to the new age. According to Fenollosa, this new style should combine elements of Western painting such as perspective, chiaroscuro, and the use of bright colors, with the traditional techniques of Kanō-school painting like the use of water-based pigments on silk. Fenollosa and Okakura fostered the study of Japanese art history, and performed the invaluable service of cataloging and authenticating many pre-Meiji works of art; and Fenollosa went on to produce *Epochs of Chinese and Japanese Art,* the first history of Japanese art to be written in English. The two men also collaborated to found the Tokyo School of Fine Arts, the school for Japanese-style painting. As noted above, it was a major coup for *yōga* when the school invited Kuroda Seiki to join its faculty in 1896. After Fenollosa's return to the United States in 1890, Okakura continued as director of the school until 1898, when a dispute with the Ministry of Education resulted in his forced resignation. He and several of his colleagues then founded a private school, the Japan Fine Arts Academy, which took as its goal the synthesis of Japanese and Western art forms.

**353.** *Fudō Myōō,* by KANŌ HŌGAI. 1887. Hanging scroll, color on paper; 62³/₈ x 31¹/₈ in. (158.3 x 79 cm). Tokyo National University of Fine Arts and Music

The first beneficiaries of this revived interest in traditional art were the painters Kanō Hōgai (1828–1888) and Hashimoto Gahō (1835–1908). Hōgai's father, Kanō Seikō, served as a painter for the Mori family, daimyo of Yamaguchi prefecture. In 1846, at the age of nineteen, Hōgai was sent at the expense of the domain to Edo for ten years of study with the Kanō master Shōsenin, son of Seisenin (see pages 254–256). In 1859 he received the commission to do ceiling paintings for the *honmaru* of Edo Castle, which had been destroyed by fire again that year. Yet despite his excellent training, his artistic talent, and

which has been substituted for the more common attribute, a length of rope. So tautly does the Fudō hold himself that the foot of his bent leg does not touch the ground. His dark-gray body and bright-red robe are modeled by highlights and shadows and have a solid volumetric quality. Set against a pale golden light, the image has the aura of divinity, but when it is compared to the Yellow Fudō of the 9th century and the Tōji Kongō Yasha of 1127, its palpable physical presence makes it seem to be very much of this world (see colorplate 15 and fig. 159).

Hashimoto Gahō, who was also a student of Kanō Shōsenin, carried on the stylistic innovations of Hōgai and was responsible for teaching the next generation of *nihonga* painters. Although accomplished enough and well-enough known to be able to open his own studio in 1859, he, like Hōgai, experienced hard times after the Meiji Restoration. He supported himself by painting fans for export to China and drawing maps for the Naval Cadet School. However, Gahō, too, came to Fenollosa's attention and was drawn into the circle of the Kangakai and the American's efforts to create a new traditional style. In 1889, when the Tokyo School of Fine Arts opened, he was given the position of chief professor of painting. Later, in 1898, when Okakura resigned as director of the school to found the Japan Fine Arts Academy, Gahō followed him to become the principal instructor in the new institution.

His *White Clouds, Red Leaves* of 1890 combines Western spatial perspective, in this case the atmospheric perspective preferred by Fenollosa, with a very traditional scheme of pictorial composition (fig. 354). Layers of rock formations overlap, carrying the eye back into distant space, which is obscured by mist and clouds. However, the painting displays the flattening out of forms in space so characteristic of the Kanō school. The rocks along the right edge of the painting, although they are in the foreground, seem to blend in with curving mountain shapes in the midground.

The three men who were to become the leaders of *nihonga* in the late Meiji and the Taishō periods were students of Hashimoto Gahō. Yokoyama Taikan (1868–1958), Shimomura Kanzan (1873–1930), and Hishida Shunsō (1874–1911) forged a lasting friendship during their student days at the Tokyo School of Fine Arts. Yokoyama and Shimomura enrolled in 1889 when the school first opened, and Hishida entered the following year. Throughout their lives, their careers overlapped. All three taught at their alma mater, resigned when Okakura left, and helped him form the Japan Fine Arts Academy. Yokoyama and Hishida were particularly close and frequently traveled together. When Yokoyama accepted a teaching position in Kyoto, Hishida accompanied him, and the two men collaborated in making a study of Buddhist temples in Kyoto and Nara. In 1903 the two traveled together again, this time to India, and the next year they visited Europe and the United States. During these years Shimomura was in England studying watercolor

**354.** *White Clouds, Red Leaves,* by HASHIMOTO GAHŌ. 1890. Hanging scroll, color on paper; 8 ft. 7 in. x 5 ft. 3 in. (2.65 x 1.59 m). Tokyo National University of Fine Arts and Music

his connections with the influential Kobikichō branch of the Kanō family, Hōgai fared badly in the pro-Western climate of the early years after the Meiji Restoration. To survive, he turned to such activities as casting iron and selling writing implements. He came to the attention of Fenollosa in 1884, when the latter saw his work at the Second Domestic Painting Competition and bought several of his paintings. Fenollosa preferred the Kanō school of painting and saw in this artist a means to give reality to his concept of new Japanese-style painting. Hōgai became active in the Kangakai, and in the last four years of his life achieved a synthesis of Eastern and Western elements in harmony with Fenollosa's ideals.

His *Fudō Myōō* of 1887 is a good example of his late style (fig. 353). The deity sits on a flat boulder in a rocky grotto, clenching his sword and a metal chain,

**355.** Fallen Leaves, a pair of two-panel *byōbu*, by HISHIDA SHUNSŌ. 1909. Color on paper; each screen 60 x 60 in. (152 x 152 cm). Private collection, Tokyo

painting, sponsored by the Ministry of Education.

In terms of their painting, Yokoyama and Hishida developed a style that did not rely on outlines, a staple of traditional Japanese art, but that instead defined forms with planes of color. Shimomura was more of a classicist, preferring to draw his themes from Japanese literature and Buddhist narratives and his style from earlier schools of painting. He was particularly knowledgeable about *yamato-e* and the Rinpa school of painting. Perhaps because of his great interest in traditional art as well as his talent as a painter, in 1917 he was appointed Artist for the Imperial Household.

A dramatic and strikingly modern work is Shimomura's Yorobōshi, The Beggar Monk, of 1915 (colorplate 65). The theme is taken from a Nō play of the same name, in which the central figure is a blind monk, Shuntokumaru. Having been falsely accused of a crime, he has been disowned by his family and is leading a wandering existence. The passage depicted on these screens occurs at the end of the play. The blind monk looks to the west, and, holding the image of the sun in his heart, knows that it is about to set. Turning to the front of the stage, he looks out sightlessly but sees in his mind's eye Awaji and Eshima, the beaches of Suma and Akashi, and even as far as the Kii channel, between the islands of Honshū and Shikoku. Indeed, so at one with the natural world is he, so deeply embedded in his heart are the distant blue mountains, that he can see as far as a sighted eye can, and farther.

The composition spreads across the twelve panels of a pair of folding screens, using a flowering plum tree set against a gold ground as the unifying motif. Between its

curving branches the blind priest can be seen, his hands pressed together in a gesture of worship. He is a thin and pathetic figure, slightly hunched over, his angular face resembling a Nō mask. To the left, almost obscured by the trunk of the plum tree, a cluster of grave markers can be seen. The branches with their lush white blossoms extend horizontally onto the left screen and seem to reach toward the orange circle of the setting sun. Shimomura has drawn on the style of the Rinpa school for the design of The Beggar Monk screens. The plum tree is strongly reminiscent of Kōrin's Red and White Plum Blossoms (see colorplate 51). However, the final effect of the screens is not decorative, but rather wonderfully evocative of the mood of the Nō play.

Hishida Shunsō's innovative *nihonga* style, as well as his knowledge of traditional Japanese painting, is clear in his Fallen Leaves of 1909, a pair of two-panel *byōbu* (fig. 355). Only three visual motifs appear in the painting—trees, leaves, and three tiny birds—but with these Hishida has created the modern equivalent of Hasegawa Tōhaku's Pine Forest (see fig. 246). He offers a close-up view of a quiet corner deep in the forest, the trees so tall their lower branches cannot be seen. Orange-brown leaves cover the bare earth, and in the right screen two birds peck among them for food. Hishida uses a minimum of outline, none on the tree trunks and only the thinnest, lightest possible lines on the leaves. Through the overlapping of flat planes of color, he has suggested the volume and texture of his motifs. Fallen Leaves was painted two years before Hishida's death. In 1910 he developed a serious eye infection and went blind in little over a month, and in 1911 he

**356.** *Floating Lights,* by YOKOYAMA TAIKAN. 1909.
Hanging scroll, color on silk; 56¼ x 20½ in. (143 x 52 cm).
The Museum of Modern Art, Ibaraki

died at the age of thirty-seven. In spite of his regrettably short life, Hishida made a major contribution to the development of *nihonga.* The style of painting he formulated is called *mōrōtai,* or murky style, although the work discussed above seems anything but dim and dark.❖

Yokoyama Taikan, the oldest of the triumvirate, followed Hishida's lead in developing the *mōrōtai* style. *Floating Lights* of 1909 shows his handling of the style (fig. 356). The subject of the painting is a kind of fortune-telling practiced in India. When Hishida and Yokoyama were in Varanasi (Benares) they saw this ceremony being performed, and six years later Yokoyama re-created it in this painting. To the right a young woman clad in a pale peach-and-white-striped sari holds an earthenware plate filled with burning vegetable oil, shielding the flame upon it with her hand. In a moment she will bend down and float the plate on the water of the Ganges River. If it does not sink, and the flame is not extinguished, she will have good fortune in the future. The other two women have already placed their plates on the surface of the water and now, hands clasped in a prayerful gesture, watch intently to learn their fate. Yokoyama has placed the women in pale saris against the light gray of the stone steps beside the river, using no outline, only flat areas of color. The atmosphere of the painting is light and clear, almost as though it had been bleached by the hot Indian sun.

Yokoyama's 1898 painting *Kutsugen* suggests the mood of the artists in the newly established Japan Fine Arts Academy (fig. 357). The subject is the 3rd century B.C.E. poet Qu Yuan (Ch'u Yuan) who at first was a great favorite of the king of Qu (Ch'u), but fell from favor and wrote the poem *Li Sao, Encountering Sorrow,* and ultimately drowned himself in the Mi Lo River in Hunan. The figure stands heroically against a hostile wind that whips the shrubbery beside him and raises clouds of dust behind him. When the painting was put on view at the academy's first exhibition, it was recognized immediately as a comment on the battle between Okakura Kakuzō and the hostile Ministry of Education—from which Okakura emerged alone (but for his artists) and scorned by the establishment.

In 1906 the academy had fallen into such financial straits that it was moved from Tokyo to Izura, a fishing village in Ibaraki prefecture to the northeast of the capital. Affiliation with the academy in that location committed an artist to a spartan life. Nevertheless, Okakura's artists

---

❖ Alternatively called "muddled style" by critics, and more neutrally "buried-line technique," *mōrōtai* was an attempt to bring Western techniques emphasizing space and light into Japanese-style art by reducing or eliminating the reliance on line, and particularly on outlines.

357. *Kutsugen*, by YOKOYAMA TAIKAN. 1898. Hanging scroll, color on silk; 52 x 114 in. (132.7 x 289.7 cm). Itsukushima Shrine, Hiroshima prefecture

remained supportive of the school. However, conditions continued to deteriorate, and in 1914, a year after Okakura's death, Yokoyama and Shimomura, along with some younger *nihonga* artists, reorganized and revitalized the academy, which continues to be a viable institution today, holding two shows annually of its artists' work, the exhibition known as the Inten.

## The Last of the Literati Masters

The one traditional school of painting that continued to flourish in the face of *yōga* and *nihonga* was *bunjinga*. There are several explanations for this. First of all the men who led the country in the early Meiji period had been trained in Confucian thought. Confucianism had furnished the philosophical and ethical basis for Tokugawa rule. In a time of rapid change, it is not surprising that a style of painting associated with this deeply ingrained tradition of thought should maintain its popularity. The idea associated with literati art—that painting and calligraphy were a measure of the caliber of the individual—must have been reassuring at a time when "men of talent" were rising from outside the feudal hierarchy. It was not until the early 20th century that *bunjinga* fell from favor.

In the first part of the Meiji period a number of important artists worked in the literati style—Tanomura Chokunyū (1814–1907), Murase Taiitsu (1803–1881), and Tomioka Tessai (1837–1924), to name only three. The most famous of these was Tessai. Born in Kyoto to a merchant who dealt in Buddhist robes and accessories, Tessai was

given a thorough education, including the Japanese classics, history, Neo-Confucianism, poetry composition, and painting, with the aim of making him a Shinto priest. However, he was encouraged to study painting by the Buddhist nun Ōtagaki Rengetsu—a painter herself—and although Tessai actually did serve as a Shinto functionary, he gradually leaned toward painting as a career. He favored literati painting in particular, although throughout his life he explored such diverse styles as the Rinpa and *yamato-e*, as well as a folk style known as *Otsu-e*, from the name of the town most closely associated with it.

One of Tessai's favorite themes was the life and poetry of Su Dungpo, the Song dynasty poet-painter, perhaps because they were born on the same day. A pair of paintings executed in 1922 during his most creative period— when he was in his eighties—treats the subject of Su's visits to the Red Cliffs. The second visit is illustrated (fig. 358). As noted in Chapter 6 (pages 288–289), the two poems were illustrated in Japan as early as the 18th century by Sakaki Hyakusen (see fig. 292). The composition of Tessai's two paintings is almost identical. It is only through the colors, the soft green of the trees and vines and the beige of the mountain in the first-visit painting, and the orange-brown of the second-visit, that he captures the different moods of the two trips, the gaiety of the one in early autumn, the somberness of the one in winter. The way Tessai has added patches of color to motifs delineated in strong strokes of dark sumi constitutes one of his greatest innovations and gives his paintings a vivacity not often found in the work of earlier masters.

## Painting to 1945 in the Taishō (1912–1926) and Shōwa (1926–1989) Eras

Two events conspired to change the climate of painting at the end of the Meiji period. First was the founding in 1907 of the Monbushō Bijutsu Tenrankai, Ministry of Education Fine Arts Exhibition, popularly known as the Bunten and the Japanese equivalent of the official French Salon. Under the auspices of the Ministry of Education, an exhibition was held each autumn of works chosen by a committee of jurors. There were three sections in the show: Japanese-style painting, Western-style painting, and sculpture, each with its own group of judges. Initially the Bunten exhibitions permitted rival factions to exhibit side by side and to receive the approval of the cultural establishment—leaders in the art world and in government. It also provided artists with a showcase enabling them to attract buyers, at a time when patronage by the wealthiest class was scarce. However, over time the judging, particularly in the *yōga* section, became increasingly conservative, and in order to profit from the public exposure their work would receive at a Bunten exhibition, artists were forced to paint to please the jurors.

In 1914 a group of young artists rebelled against the Bunten and founded their own group, called the Nikakai, the Second Division Society, which was in essence the Japanese equivalent of the French Salon des Refusés. Nevertheless, the Bunten provided a forum for artists to see each other's work and to be seen by the public, as well as a standard of approval to accept or rebel against. In 1919 the Bunten was reorganized into the Teiten, the Exhibition of the Imperial Fine Arts Academy, and again in 1935 into the Shin Bunten, or New Bunten. In 1958 the annual exhibition was renamed Nitten, or Japan Art Exhibition, and sponsorship was transferred from the government to a private organization, Nitten, Incorporated. The show still survives today.

The second event that strongly influenced painting, particularly *yōga*, in the late Meiji period, was the founding in 1910 of the magazine *Shirakaba (White Birch)*, which continued publication until 1923. The moving force behind the magazine was a group of writers, including the literary figure Mushanokōji Saneatsu (1885–1976) and the novelists Shiga Naoya (1883–1971) and Arishima Takeo (1878–1923), men who had known each other at the Gakushuin, or Peers' School, in Tokyo. In addition to literary contributions, each issue contained an article on contemporary Western art, providing many Japanese artists with their first exposure to such important European artists as Paul Cézanne (1839–1906), Vincent van Gogh (1853–1890), and Paul Gauguin (1848–1903), and making it possible for them to study the evolving styles of Western masters without traveling abroad. Of the six leading *yōga* painters of the Taishō and pre-war Shōwa period, two men, Kishida Ryūsei and Nakamura Tsune, never left Japan, and a third, Yorozu Tetsugorō, traveled in the

**358.** *The Second Visit to the Red Cliffs,* by TOMIOKA TESSAI. 1922. Hanging scroll, slight color on paper; 57¾ x 16¼ in. (146.6 x 40.4 cm). Kiyoshi-Kojin, Seichoji

United States for only half a year. The other three, Sakamoto Hanjirō, Umehara Ryūsaburō, and Yasui Sōtarō, followed the established pattern of studying for several years with a French master.

The creative ferment of the late Meiji and early Taishō periods that so profoundly affected *yōga* artists also generated new energy in *nihonga* circles. In Tokyo, the catalysts for this were: the Kōjikai, an association that held regular exhibitions and provided a rallying point for young *nihonga* artists; Okakura Kakuzō, who regularly critiqued and encouraged their work, even providing travel money for individual artists, through the Japan Fine Arts Academy; and finally, Hara Tomitarō, a wealthy collector who in 1911 funded a group of the recognized leaders of the new generation of painters to live for a time at his home in Odawara and study the works in his collection with a view toward establishing a new *nihonga* style based on *yamato-e* rather than the traditions of the Kanō school.

Kyoto continued to have activity in painting independent of Tokyo, particularly in *nihonga*. The tradition of the Maruyama-Shijō school had been maintained there, and its early form of realism was a strong influence on the new generation of painters.

## *Yōga* Painting

Some measure of the energy in *yōga* painting circles in the early 20th century can be made by looking at a cross section of the art-related events that took place in 1910. The magazine *Shirakaba* was founded. The poet, art critic, and sculptor Takamura Kōtarō (1883–1956) published in the literary magazine *Subaru*, translated as *Pleiades*, an essay titled "The Green Sun," in which he advanced the idea that truly Japanese modern art could be created only if an individual Japanese artist could learn to express his unique and personal view of the physical world. The re-creation of the artist's authentic vision would make a work more Japanese than the addition of ethnic details. As a by-product of his belief in individual artistic expression, he further supported the cause of antinaturalism:

> If another man paints a picture of a green sun, I have no intention to say that I will deny him. For it may be that I will see it that way myself. Nor can I merely continue on, missing the value of the painting just because "the sun is green." For the quality of the work will not depend on whether the sun depicted is either green or red. What I wish to experience, to savor, as I said before, is the flavor of work in which the sun is green.
>
> J. Thomas Rimer, "Tokyo in Paris/Paris in Tokyo," in *Paris in Japan: The Japanese Encounter with European Painting*, Tokyo and St. Louis, 1987, p. 60

Inspired by Kōtarō's essay, Saitō Yori (1885–1959) organized an exhibition of his own painting, at which like-minded artists including Kōtarō, Kishida Ryūsei, and Yorozu Tetsugorō met. Their discovery of each other re-sulted in the creation in 1912 of the Fusainkai, the Sketching Society, the first organization to rebel against the conservatism of the Bunten. Its avowed aim was to promote Fauvism in Japan.

Unlike the earlier situation in which French Impressionism was not clearly understood and adopted by Japanese artists, in the early 20th century the images, ideas, and techniques of Post-Impressionism, Fauvism, Cubism, Expressionism, and Surrealism appeared in Japan in quick succession. This came about through the greater numbers of painters traveling and bringing back the new styles, their wider opportunities while in Europe, and the new Japanese literary avant-garde's interest, and provided on the one hand endless stimulation and new styles to experiment with and absorb. But on the other hand, the painters had such an array before them that it was difficult to explore in depth and digest each—or any one—new way of painting, and they did not yet have an art-historical context in which to place them.

Kishida Ryūsei (1891–1929) was the son of a well-known journalist, Kishida Ginkō and was raised in an intellectual and culturally rich milieu. He began his study of painting under Kuroda Seiki and achieved recognition at an early age. When he was only nineteen, a painting of his was selected for the fourth Bunten exhibition. Through the *Shirakaba* (*White Birch*) magazine he discovered the Post-Impressionists. He has said of his early work that he "would unabashedly paint in the style of van Gogh." Later he discovered the painting of the Northern Renaissance and was particularly drawn to the work of Albrecht Dürer and Jan van Eyck. Inspired by Takamura Kōtarō's "Green Sun" essay, Kishida formulated a rationale for his own work, independent of the styles of his mentors. In 1914 he founded the Sōdosha, a society for the sponsorship of art exhibitions, which lasted until 1922. After his house was destroyed in the 1923 earthquake, Kishida moved to Kyoto and began to experiment with painting in a more traditional *ukiyo-e* style. He died after a short illness in 1929.

Kishida's best-known work is a series of portraits of his daughter Reiko, including the 1920 *Reiko with a Woolen Shawl* (fig. 359). At the time of this painting, Reiko was six years old. The artist has captured the full cheeks of the young child as well as an intensity of expression in her eyes. The smooth planes of her face contrast sharply with the texture of her crocheted shawl. Kishida has captured the child's immaturity but also a calm patience unusual in such a young child.

Yorozu Tetsugorō (1885–1927) was probably the most cerebral and innovative of the *yōga* artists in the Taishō period. Experimenting with one European style after another, from Fauvism to Futurism and Cubism, he was able to achieve his own personal expression in each of them. He began his artistic training at the White Horse Society studio, and after six months in the United States, he returned to Japan in 1907 and entered the Western-painting section of the Tokyo School of Fine Arts. In 1912, the year of his graduation, he joined Takamura Kōtarō and

**359.** *Reiko with a Woolen Shawl,* by KISHIDA RYŪSEI.
1920. Oil on canvas; 17³/₈ x 14³/₄ in. (44.2 x 36.4 cm).
Tokyo National Museum

Kishida Ryūsei in founding the Fusainkai. Yorozu moved to Kanagawa prefecture in 1919 and began to study and paint in the literati manner. The style he developed in the twenties is a blend of Eastern and Western elements.

*Reclining Woman* of 1912 is an early example of his unique vision (fig. 360). A woman, nude to the waist, lies on a grassy hill. Above her head are trees, a distant mountain range, and a big white cloud. More subtly, the picture contains three separate motifs shown from different perspectives. The grass on which the woman reclines is treated as though it were a receding slanting plane. At the bottom of the painting, the leaves are large and detailed, while toward the middle they are smaller and more impressionistically rendered. Finally, the background details are represented as though the viewer is looking down on them. Yorozu said of this work that he was attempting to meld the styles of Matisse and Van Gogh. Those influences can be seen, but the painting is certainly Yorozu's own vision.

Nakamura Tsune (1888–1924), the third of the major Taishō artists who did not study abroad, turned to painting after he contracted tuberculosis and could not continue his military career. In 1906 he studied with Kuroda Seiki and the White Horse Society, and later went on to work with Nakamura Fusetsu. However, the latter's French academicism proved too inhibiting for Tsune, and he left to work on his own. He was profoundly moved by the work of Rembrandt van Rijn (1606–1669) and exe-

**360.** *Reclining Woman,* by YOROZU TETSUGORŌ.
1912. Oil on canvas; 63³/₄ x 38¹/₄ in. (162 x 97 cm).
National Museum of Modern Art, Tokyo

cuted a self-portrait in the Dutch painter's manner. Throughout his life Nakamura Tsune was plagued by ill health, and to recuperate he often left Tokyo for the country or the seashore. His *Seaside Village* of 1910 was executed on one of those visits (colorplate 66). The painting displays the warm colors and impressionistic treatment of form he had gleaned from studying Cézanne. However, the painting goes beyond that, reversing the traditional composition developed in the Far East for depicting landscape. In the foreground, where one expects to see rocks and water, Nakamura places the tallest motif in the painting, the house and outbuildings on a hill overlooking the sea. In fact, the house itself is not shown, only the shadow it casts on the storehouse and terrace. The viewer's eye is carried down the hill to the water by overlapping planes of grass and the tops of houses. Nakamura's painting is not only a

beautiful combination of images; it also is a startlingly different view of the natural world.

Of the Taishō and Shōwa *yōga* masters who studied abroad, Yasui Sōtarō (1888–1955) stayed the longest. Raised in Kyoto, he studied with Asai Chū following the latter's return from France, and after Asai's death in 1907, Yasui left for Paris, where he studied at the Académie Julian with Jean-Paul Laurens (1838–1921). One of the most formative experiences of his stay was the Cézanne retrospective of 1907, which gave him the opportunity to study the evolution of the master's style. After three years Yasui left the Académie to develop an independent idiom of his own, and in 1914 the outbreak of World War I forced him to return to Japan. For the next fifteen years Yasui struggled to find an authentic style that would combine what he learned in France with a personal and Japanese mode of expression. By his own admission he did not think he had achieved this until 1929. From then until his death in 1955, Yasui further refined his technique and became one of the foremost *yōga* painters in Japan.

One of Yasui's undisputed masterpieces is the *Portrait of Mrs. F.* of 1939, which effectively captures the subject's personality (colorplate 67). Mrs. F. was the wife of a businessman and art collector, and in her own right an articulate woman who launched a career as an essayist after World War II. She has assumed a Western pose, her legs crossed and her body at a slight angle. However, Yasui has placed her against a brownish-yellow ground dotted with green and white Japanese-style medallions, an odd background for such a Westernized woman. It is perhaps a commentary on Mrs. F.'s position between two worlds. The sitter is given some volume, but is placed in a shallow space that tends to flatten out the total image. Yasui has blended such Japanese elements as flatness and decorative motifs with Western details, in this case the costume and pose of the sitter.

Umehara Ryūsaburō (1888–1986), like Yasui Sōtarō, was born and raised in Kyoto and studied with Asai Chū. In 1908 he went to France with the avowed intention of studying with Auguste Renoir (1841–1919). He visited the master at Cagnes-sur-Mer in the south of France and was taken on by him as a pupil. He stayed abroad for five years, meeting some of the outstanding artists of the day, including Pablo Picasso (1881–1973), who encouraged him to travel in Spain to study images in a different kind of light. Two experiences strongly influenced Umehara's painting: the work of Renoir and his own early exposure to the silk-weaving industry in Kyoto. From these two sources he was able to develop a style that combined flat decorative patterns with brilliant colors. In the decades after World War II, Umehara was the dominant presence in painting circles in Japan.

The *Tzu-chin-ch'eng Palace* of 1940 shows Umehara's mature style (colorplate 68). Between 1939 and 1943 the artist made six trips to Beijing, and in this painting he depicts the Forbidden City, the palace of the Qing dynasty emperors. The painting is a riot of color, with the light orange of the tile roofs, the red-orange of the stucco walls, the vibrant green trees, the blue-white of the clouds. Pigment is applied in broad areas with details roughly sketched. Umehara has used a shifting perspective, showing the first palace buildings from above, and the next group from the side. The final effect of the painting is flat and decorative, rather like a gorgeous textile pattern.

Sakamoto Hanjirō (1882–1969) was a contemporary and friend of Aoki Shigeru, and came from the same city of Kurume in Fukuoka prefecture. Unlike most *yōga* artists, he did not go to Paris until he was thirty-nine, his mature style well formed. He began to paint while he was still in Kurume, but in 1902, encouraged by Aoki, he moved to Tokyo and started formal study. By 1912 Sakamoto had developed his own style, and his work *Dim Sun*, exhibited in the Bunten of that year, won high praise from the influential novelist Natsume Sōseki. During the 1910s the artist was active in avant-garde art circles, participating in the founding of the Nikakai and, before 1912, submitting work to *Hōsun*, an art magazine associated with the *sōsaku hanga*, or creative prints, school of woodblock-print artists, who did all the work on their prints themselves, from designing to printing. Sakamoto went to Paris more to refine his own style than to learn to imitate any particular Western school. He studied briefly with Charles-François-Prosper Guérin (1875–1939), one of the major figures in the Société des Artistes Français, but he preferred to continue on his own, gaining new ideas from the works he could see in museums. After his return to Japan he settled in Kyūshū, where he lived like a hermit and devoted himself single-mindedly to his work, painting the things he saw around him, most notably horses. His *Horses Among Pines* of 1932 is typical of his style during this period (colorplate 69). Two horses stand close together in a grove of trees. The title suggests the trees are pines, but only the trunks can be seen. A rope has been tied across the space between two of the trees, and one of the horses holds it in his mouth. He may be tethered to the trees, but the second horse clearly is not. The latter, on the other hand, may be saddled, but the details are so indistinct that it is hard to tell. The painting has an enigmatic quality that begs for explanation. The color scheme, limited to pastel shades of blue, brown, and occasionally lavender, contributes to the mysterious quality of the painting. The final effect is one of haunting, lyric beauty.

## Tokyo *Nihonga*

The Meiji movement to revitalize Japanese-style painting was based in Tokyo, which continued in the Taishō and Shōwa periods to be a center particularly for work inspired by the Kanō school and also by *yamato-e*. The two institutions there that encouraged the young generation of 20th-century *nihonga* painters, the Kōjikai and the Japan Fine Arts Academy started by Okakura, both got started in 1898.

The Kōjikai was founded by Yasuda Yukihiko

361. Yoritomo in a Cave, a two-panel *byōbu*, by MAEDA SEISON. 1929. Color on silk; 59³/₈ x 109¹/₂ in. (150.9 x 278 cm). The Okura Cultural Foundation

(1884–1978), one of the leading figures of the second generation of *nihonga* painters, and during the fifteen years of its existence it attracted such artists as Imamura Shiko (1880–1916), Maeda Seison (1885–1977), and Kobayashi Kokei (1883–1957), who would go on to become the leaders in the field of Japanese-style painting. The society originally consisted of students who had studied with Kobori Tomone (1864–1931), a Tosa-school painter who succeeded Shimomura Kanzan (1873–1930) in the *nihonga* department of the Tokyo School of Fine Arts. When Imamura joined the society in 1901, it was reorganized and opened to new membership. Maeda, who joined in 1907, and Kobayashi, who joined in 1910, were students of Kajita Nanko (1870–1917), a newspaper and magazine illustrator trained in the Maruyama-Shijō school.

The Japan Fine Arts Academy took as its purpose the study of Japanese art and the sponsorship of exhibitions. Yasuda's association with the academy began in 1907, when he and Imamura were invited to work under Okakura, and in addition were funded to study in Nara. In 1922 Maeda and Kobayashi, life-long friends, were given a stipend to travel abroad, and it is known that both men took the opportunity to make copies of a very well-known Chinese painting in the British Museum, Ku K'ai-chih's (active second half 4th century) *Admonitions of the Court Instructress to the Ladies of the Imperial Harem*. But more important than travel grants was Okakura's influence on individual artists whose work he liked. Imamura and Maeda, particularly, adapted their styles to include elements of the Rinpa school at Okakura's suggestion. In 1913, in the wake of Okakura's death, the Japan Fine Arts Academy almost foundered. However, Yokoyama Taikan, with the help of Yasuda and others, reorganized and revi-

talized the school the following year. As noted before, the academy continues to hold the Inten, exhibiting its members' work even today.

Yasuda Yukihiko was profoundly affected by his stay in the Odawara residence of Hara Tomitarō and developed a style based on his study of *yamato-e*, with which he treated themes from Japanese and Chinese history and legends. His Camp at the Kise River, painted in 1940 and 1941, presents his mature style (colorplate 70). On a pair of six-panel screens he has depicted the meeting between Minamoto Yoritomo and his younger brother Yoshitsune, heroes of the Genpei Civil War of 1180 to 1185, at the former's military encampment beside the Kise River. Yoshitsune has just arrived from the northern provinces and is untying the cords of his straw hat while his older half-brother Yoritomo, his armor removed, sits stiffly on a tatami platform. Great care has been taken to render the details of the men's armor and weapons accurately. The formal relationship between the two men is clearly stated by their poses, Yoshitsune being subordinate to Yoritomo, but Yasuda has also succeeded in suggesting the suspicion on the part of the older brother that the younger has been disloyal and is plotting to overthrow him as general of the Minamoto armies.

The two screens have an interesting history. The left screen was painted first and shown in 1940 in the exhibition marking the twenty-six hundredth anniversary of the founding of the Japanese nation. It was a particularly appropriate theme for such an exhibition on the eve of World War II, since it celebrated two of the great warriors in Japanese history. The right screen was completed the following year and shown at the annual exhibition of the academy. The paintings represent one of the most success-

362. The Tropics, section of the hand scroll called Morning, by IMAMURA SHIKŌ. 1914. Color on paper; height 18 in. (45.7 cm). Tokyo National Museum

363. *Amidadō*, by KOBAYASHI KOKEI. 1915. Hanging scroll, color on silk; 7 ft. 1 in. x 35⅝ in. (216 x 90.6 cm). Tokyo National Museum

ful attempts of a *nihonga* artist to create a new Japanese manner of painting that draws on the *yamato-e* style.

A painting often recognized along with Yasuda's *Camp at the Kise River* as one of the finest examples of Japanese paintings depicting historical themes is Maeda Seison's best-known work, *Yoritomo in a Cave* of 1929 (fig. 361). Maeda treats the episode from the *Heike monogatari*, an account of the Genpei Civil War, in which Yoritomo and six of his warriors have retreated from the Taira forces and hidden themselves in a mountain cave. Yoritomo sits surrounded by his men, waiting for the enemy to move out of the area. Maeda's knowledge of the two types of armor worn in the Heian period is clearly demonstrated in the picture, a result of his careful study of old *emaki*. However, the painting has many elements derived from the Rinpa school, for example the monumental size of the figures and the use of the *tarashikomi* technique first developed by Sōtatsu.

Imamura Shikō's major painting, The Tropics, based on his trip to India in 1914, is a splendid blend of Eastern and Western techniques (fig. 362). The work consists of two *emaki* depicting morning and night in that hot, tropical country. The scene of an Indian village in bright sunlight successfully combines the Rinpa techniques of unoutlined hill and tree shapes and the use of gold dust, the *yamato-e* format of the hand scroll, and the free and repetitive brushstrokes of such Post-Impressionist painters as Van Gogh and Gauguin.

Kobayashi Kokei, the last of the Tokyo *nihonga* painters under consideration, created his *Amidadō* in 1915; the dramatic painting is one of the best works from his early period (fig. 363). The picture surface is long and narrow, and very dark. A brightly colored representation of

the Phoenix Hall of the Byōdōin in Uji cuts horizontally across the silk (see colorplate 17). The effect suggests that the moon has suddenly illuminated the temple, splashing light across the upper part of the red posts, leaving the lower part in shadow. Through the open doors, the platform on which the Amida statue is placed can be seen clearly, as if there were a second light source in the building, perhaps the luminous golden Buddha. Kobayashi's vision is wonderfully romantic yet not in the least sentimental.

## Kyoto *Nihonga*

Japanese-style painting in Kyoto centered around artists trained in the Maruyama-Shijō school, rather than in the traditions of the Kanō school or *yamato-e*. Artists of the Maruyama-Shijō school incorporated elements of Western realism—perspective, the modeling of form through the use of highlights and shadows, and drawing directly from nature—into traditional techniques and themes. One of the best, and also the most influential, artists in the Taishō and early Shōwa eras was Takeuchi Seihō (1864–1942). The son of a Kyoto restaurant owner, Takeuchi chose a career as an artist at an early age. In 1881 he became a student of Kōno Bairei (1844–1895), the leading painter of the Maruyama-Shijō school at the time, and with the latter's help he achieved recognition of his talent very early. Later, Takeuchi opened his own private art school and also taught at the Kyoto Prefectural Painting School, strongly influencing the next generation of *nihonga* artists. After Kōno's death in 1895, Takeuchi emerged as the leading figure in Kyoto art circles, the artists' spokesman. So important had he become by 1900 that he was included in the official Japanese delegation to the Paris Exposition, following which he traveled for six months in Europe. Of all the artists whose work he studied, he was particularly impressed by the paintings of Jean-Baptiste Camille Corot (1796–1875) and Joseph Mallord William Turner (1775–1851) and also by Western realism. He kept a skeleton in his studio so that his students could observe human bone structure in motion. Takeuchi was so profoundly affected by his trip that he changed the way he wrote his name, using the character for "Sei" that is the symbol for West. His work in later years was a blend of Western and Eastern techniques, Western three-dimensionality, and Eastern abbreviation of forms.

Takeuchi's *Spotted Cat* of 1924 shows this later style (colorplate 71). Against a subtly shaded ground, a cat sits licking his fur. Takeuchi has used a pale line to indicate the cat's irregular shape as it bends to lick its back, but has painted over it separate strokes of white, black, brown, and yellow, the colors of the cat's fur, partially obscuring it. The texture of the fur is remarkable. In sum the painting presents an image depicted with a Western feeling of volume yet an Eastern sense of space.

One of Takeuchi's students in the 1890s at the Kyoto Prefectural Painting School was Uemura Shōen

**364.** *Evening,* by UEMURA SHŌEN. 1941. Color on silk; 7 ft. ½ in. x 3 ft. 6 in. (214.5 x 99 cm). Private collection

(1875–1949), Japan's most notable pre–World War II female painter, the first woman to receive the Order of Cultural Merit. Shōen was born the second daughter in a family that sold tea, also serving brewed tea to special clients. After her father's death two months before she was born, her mother continued to run the shop as well as to raise her daughters. When Shōen showed a talent for

365. *Ichiyō*, by KABURAGI KIYOKATA. 1940. Color on silk, in form of hanging scroll; 56½ x 31¼ in. (143.6 x 79.4 cm). Tokyo National University of Fine Arts and Music

In the 1930s Shōen returned to the subject of *bijinga*. However, perhaps because of her earlier psychological studies, her *bijinga* are never the bland, attractive characters so typical of the genre. *Evening*, painted in 1941, is typical of her late work (fig. 364). Shōen has said of this picture, in which an industrious and frugal young woman tries to thread a needle by moonlight, that she wanted to depict a young woman of the Tokugawa period reminiscent of her deceased mother, whom she dearly loved. It must also be noted that in 1941 Japan was at war, and as part of the war effort, women were entreated to tend to their families and to conserve the country's resources. Shōen has created a lyric interpretation of this directive.

The other artist known primarily for his *bijinga* in the modern period was Kaburagi Kiyokata (1878–1972). He came to the subject of beautiful women through his first training as an *ukiyo-e* artist, and he went on to train two of the best woodblock-print artists of the next generation, Itō Shinsui and Kawase Hasui. In 1901 Kiyokata began to move from printmaking to painting, and he was so successful in making the transition that in 1919 he was appointed a judge for the government-sponsored Teiten exhibition.

The typical Kiyokata figure is a young, slender, and graceful woman who seems fragile and vulnerable, a woman with a traditional upbringing whose role in the new reality of the 20th century is not clear. A woman whose life fitted Kiyokata's model was the author Higuchi Ichiyō (1872–1896). Ichiyō was a precocious child, writing poetry before she was eleven years old, and as a young adult she went on to make a considerable reputation as a writer. However, after her father's death, the responsibility for the economic support of her family and the strain of trying to write and at the same time shore up the family's finances overburdened her, and she died at twenty-four of tuberculosis.

Kiyokata and Ichiyō never met, but in 1934 he executed a group of paintings illustrating her novella *Nigorie*, translated as *Troubled Waters*, written the year before her death. In 1940 he returned to her as a subject, painting a portrait of her that was shown in the exhibition celebrating the twenty-six-hundredth anniversary of the founding of Japan (fig. 365). This was the show in which Yasuda Yukihiko's painting of Minamoto Yoritomo was exhibited. Given Higuchi Ichiyō's status in the literary world, one might expect to see her depicted writing at a desk. Instead, Kiyokata shows her sitting pensively in the light of an oil lamp, with wrapping paper lying open in front of her revealing swatches of kimono cloth. Two years before Ichiyō's death, her family moved to a low-status neighborhood frequented by prostitutes and there began to do sewing for the locals. Kiyokata has captured Ichiyō's dilemma—the desire to write overshadowed by the need to generate income—and created within the *nihonga* tradition of painting an insightful and moving "portrait of the artist."

painting, her mother encouraged her and made it possible for her to enter the Prefectural Painting School in 1888. Two years later, at the age of fifteen, she won a prize for her painting *Beautiful Women of the Four Seasons*, which she entered in the third National Industrial Exposition. At first Shōen experimented with the genre known as *bijinga*, paintings of beautiful women, but in the first two decades of the 20th century she turned to depictions of famous female characters in Nō plays, aiming at expressing not just their physical appearance but also their innermost feelings. In order to capture the look of a mad woman, she spent time at an insane asylum outside Kyoto, sketching some of the inmates.

# Woodblock Prints

The period between the Meiji Restoration and World War II in Japan witnessed the transformation and eventually the demise of *ukiyo-e* and the birth of two new types of expression using the medium of the woodblock print: *shin hanga,* or new prints, works produced by designers who wanted to revitalize the *ukiyo-e* tradition, and *sōsaku hanga,* creative prints, made by artists who preferred to follow the Western practice of designing and executing their own works.

*Ukiyo-e,* pictures of the floating world, had three basic characteristics: they depicted popular subjects—in the Tokugawa period, geisha, Kabuki actors, and landscapes; they were affordable, and therefore disposable; and they were produced commercially. An artist made a drawing, on the basis of which a publisher had his shop of craftsmen cut the woodblocks and actually make the final print. After the artist submitted his design, it became the property of the publisher. The first element of the woodblock print to change in the Meiji period was the subject matter. Although a measure of censorship continued, depictions of, even commentaries on, current events were allowed under the more progressive Meiji government. Utamaro's design of Hideyoshi and his entourage enjoying the cherry blossoms would probably not have caused his house arrest had it been published after 1868 (see page 312). Also, the climate of the times made acceptable pictures of blood and gore, depictions of grotesque human beings, even ghosts, side by side with scenes of lyric beauty. Some of the subjects came from the Kabuki theater, while others were taken from legends and historical events, but the charming floating world of Harunobu and Kiyonaga ceased to be interesting to the general populace. In an era of rapid social change, the public required pictures with more dramatic appeal.

The print artist who best responded to the changing demands of the time was Tsukioka Yoshitoshi (1839–1892). Born in Tokyo, Yoshitoshi entered the studio of Utagawa Kuniyoshi in 1850 and studied with him until the latter's death in 1861. His early work consisted primarily of triptychs depicting famous warriors in battle and single sheets of famous actors. After the publication of the series *One Hundred Warriors in Battle* in 1869, Yoshitoshi's popularity waned, and he experienced a period of extreme poverty until 1874, when his triptych depicting the assassination of Ii Naosuke began to revive his career. Naosuke was an elder adviser for the Tokugawa shogunate, and between 1858 and his assassination in 1860 he attempted to stem the erosion of shogunal power. The fact that he was killed in front of Edo Castle added a note of drama to the scene. During the five years of Yoshitoshi's dry spell, he was so poor it is said that he and his mistress Okoto had to burn the floorboards of their rented room for fuel. Perhaps due to the privations of this time, Yoshitoshi fell ill both physically and mentally and had long periods in which he could not work at all. However, following the success of his assassination print, he began to be productive again, and by 1887 he was out of debt.

In 1875 Yoshitoshi commenced a second career as an illustrator for the newly expanding newspaper industry. After the Meiji Restoration, government censorship of printed material had been relaxed, and newspapers began to flourish. In 1874, with the intent of enlivening his publications, an enterprising editor hired an artist to illustrate some of the more sensational stories. The idea quickly spread through publishing circles, and not a few woodblock-print artists found employment this way. In addition to simple illustrations, some of the designs were more like cartoons satirizing the foibles of the day. The *Yūbin Hōchi Shinbun (Postal Dispatch)* commissioned Yoshitoshi to design a series of sixty prints illustrating stories reported in the paper. The set includes such titles as A Widower Witnesses His Wife's Ghost Nursing Their Child and A Group of Blind Masseurs in Niigata Injured by a Speeding Rickshaw.

Throughout his life Yoshitoshi was interested in the phenomenon of ghosts. Shortly after Okoto's death, he reported seeing the ghost of his beloved mistress, and inspired by his vision he executed drawings for a series of thirty prints of famous ghosts, which were never published. However, he returned later to the theme and created a masterful set of prints, *One Hundred Ghost Stories from China and Japan.* Particularly effective is his depiction of Kiyohime (fig. 366). An innocent young girl, she fell in love with a priest who did not return her affection. Fleeing from her rage at being rejected, he crossed a wide river and sought asylum at the temple of Dōjōji, where he hid himself inside a large bell the priests were about to rehang. Kiyohime crossed the river, and, intuiting his hiding place, turned herself into a giant snake, which coiled its hot body around the bell and scorched the priest to death. Yoshitoshi has chosen the moment when the beautiful young girl is transforming herself into a snake in order to effect her revenge. The print is a wonderful blend of textures and designs: the girl's long black hair, the rough waves of the river she has just crossed, and, of course, the small repetitive patterns of her kimono suggesting the reptile she is about to become. An interesting detail of the original printing, but missing in figure 366, a later impression, is the apparently worm-eaten margin of the prints, suggesting that they were old instead of newly published. This series was Yoshitoshi's last. The madness that had affected him in the 1870s resurfaced, and he had to be hospitalized. He died shortly after his release.

Kobayashi Kiyochika (1847–1915), eight years younger than Yoshitoshi, occupied a transitional place between the last of the 19th-century masters and the artists who would emerge in the 20th century. Born into a samurai family, hereditary retainers of the Tokugawa clan, Kiyochika was forced to lead a wandering life after the Restoration. However, in 1874 he settled in Tokyo and

**366.** Kisyohime Turning into a Serpent, from the series *One Hundred Ghost Stories from China and Japan*, by TSUKIOKA YOSHITOSHI. 1865. Polychrome woodblock print on paper; ōban size, 15⅝ x 9 in. (39.7 x 22.9 cm). Los Angeles County Museum of Art, Herbert R. Cole Bequest

**367.** Tennōji in Yanaka, Tokyo, from the series *Kiyochika Ponchi*, by KOBAYASHI KIYOCHIKA. c. 1881. Full-color woodblock print on paper; ōban size. Private collection

began his career as a woodblock-print artist. Though he studied briefly with Charles Wirgman, the English journalist, he seems to have been largely self-taught. His early work centered on views of Tokyo, and he was particularly interested in experimenting with the effects of light—gaslights, fireworks, and even a massive fire at the Ryōgoku bridge—against the night sky.

In his middle period, from 1881 to 1894, Kiyochika was chiefly involved in drawing cartoons for the publication *Maruchin*, satirizing contemporary events. His debut in this field was a series of prints called *Kiyochika Ponchi* after the English humor magazine *Punch*. One of his most amusing designs is Tennōji in Yanaka, Tokyo, of circa 1881 (fig. 367). It satirizes the government's attempt to control nudity, a response to the complaints of foreigners shocked by Japanese customs. In the graveyard of Tennōji temple, a skeletal policeman points his finger at two skeletons. One wears a proper summer kimono while the other has

removed all garments but her underskirt and is fanning herself. Even in a quiet corner of a graveyard, the dead cannot escape the long arm of the law.

The two wars near the turn of the century, the Sino-Japanese war from 1894 to 1895 and the Russo-Japanese war from 1904 to 1905, and the use of woodblock prints to illustrate battles for the civilians back home first popularized and then weakened the genre of *ukiyo-e*. Since the woodblock print had been associated with journalism from the 1870s on, it was only natural that newspapers should commission artists to depict the battles that were front-page news. Although some artists actually accompanied the troops and witnessed the fighting at first hand, most did not, preferring to create their designs based on the descriptions sent back by the paper's correspondents and their own imagination. In order to capture the interest of the general populace, the prints had to appear as soon as possible after the actual events. Many fine battle prints were turned out, but the need for fast production inevitably led to crude compositions and rough printing. The

**368.** Nakatani Tsura Sitting Before the Dressing Stand, by HASHIGUCHI GOYŌ. 1920. Woodblock print on paper; *ōban* size, 17⅝ x 11½ in. (44.9 x 29 cm). Courtesy Christie's New York

war scenes were the last of the popular *ukiyo-e*, but they also contained the seeds of their fall from favor.

Kiyochika's three-sheet depiction Second Army Attacks Port Arthur, November 1894, is typical of the war prints (colorplate 72). Japanese soldiers stand along an embankment firing at the Chinese on the opposite shore, silhouetted against the setting sun. A column of fire can be seen to the left, and clouds of smoke appear in the sky. A strong contrast is established between the solid poses of the Japanese men led by their able commander, his heroic profile visible below the flames, and the Chinese running helter-skelter, trying to escape the enemy's fire. Historian Henry D. Smith II estimates that Kiyochika produced over seventy triptychs, probably more than any other artist working at the time, and it was for his war prints that Kiyochika was famous in his day.

Traditional *ukiyo-e* had a revival between 1915 and 1940, under the direction of the publisher Watanabe Shōsaburō (1885–1962), who saw foreigners in Japan and

abroad as a likely market for a new style of print dealing with the traditional themes of *bijin,* or beautiful women—in this case usually not geishas—as well as actors and landscape scenes. Aiming at the production of technically high-quality prints, he established a studio of print technicians, carvers, and printers who could execute works that measured up to his standards. The movement he started was known as *shin hanga,* literally new prints, and the most important artists he recruited to work for him were Hashiguchi Goyō (1880–1921), Yoshida Hiroshi (1876–1950), Itō Shinsui (1898–1972), and Kawase Hasui (1883–1957).

Hashiguchi Goyō, son of a Maruyama-Shijō school painter, was trained to paint in both Japanese and Western techniques, studying first under Hashimoto Gahō, then Kuroda Seiki. In 1915 Watanabe convinced him to try his hand at designing single-sheet woodblock prints. At that time he was already an established artist doing woodblock-printed books and magazine illustrations. This change in artistic direction led Goyō to a reappraisal of traditional *ukiyo-e* methods of depicting women. He was particularly impressed with Utamaro's pensive, enigmatic beauties and succeeded in incorporating something of the earlier artist's style into his own. Goyō continued his association with Watanabe from 1915 until 1918, when he decided to establish his own print shop with carvers and printers to execute his designs. Most of his best prints were produced in 1920. A case in point is Nakatani Tsura Sitting Before the Dressing Stand (fig. 368). Against a light silvery ground of mica, a woman clad in a gossamer black kimono with a white diamond design sits on a cushion on the floor. Had Goyō stopped here, his print would have been practically monochromatic. However, he has added chartreuse for the tatami, dusty rose for the cushion on which the woman sits, dark brick-red for the cloth cover over the mirror, and blue-green and white for the patterned scarf hanging from a knob on the side of the mirror. These tones were popular in the Taishō period, but in this design Goyō has used them around the periphery of the print, keeping his central figure cool and enigmatic, at this moment untouched by the colors of life except for the gold wedding band on her right fourth finger. However, through the use of subtle outlines and the folds of her garments, he has given her a solid, three-dimensional presence. The print is attractive to look at and technically it is of outstanding quality. Further, in terms of *ukiyo-e* expression, the image of the woman, cool and pensive in her colored private world, transcends the immediacy of many prints of that genre.

Yoshida Hiroshi was trained in Western painting techniques, belonged to the Meiji Art Society along with Asai Chū and others, and also submitted paintings to the annual Bunten exhibitions. He worked not only in oil on canvas but also in watercolors, which provided the basis for his early reputation. However, in 1920 Watanabe was able to recruit him to make designs for his studio of crafts-

**369.** Young Girl Washing, by ITŌ SHINSUI. 1917. Polychrome woodblock print on paper; *ōban* size, 17¹/₈ x 11⁵/₈ in. (43.5 x 29.5). The British Museum. Reproduced by courtesy of The British Museum

Through inking alone, using a single set of blocks, Yoshida captured the rose and blue haze of a humid dawn and the blue-green stillness of a calm afternoon. The handling of color is especially masterful in Sailboat, Morning: the gradation of tones in the sails, which are glowingly backlit by the rising sun at their tops and still shaded at their bottoms, and the drawn-in boats at the left horizon. Furthermore, Yoshida has been able to bring some of the softness and spontaneity of the watercolor medium to the woodblock print.

Itō Shinsui and Kawase Hasui both began their studies with Kaburagi Kiyokata during the time he was making prints and were recruited by Watanabe in 1916 and 1918, respectively. Unlike Hashiguchi and Yoshida, these two artists remained affiliated with the studio throughout their lives. It is generally agreed that both men had done their best and freshest work by 1923, the year of the Kantō earthquake. Itō is primarily noted for his *bijinga* and Kawase for his landscapes. Young Girl Washing of 1917 is a particularly fine example of Itō's early style (fig. 369). A female, nude to the waist, squats on a platform to reach the washing bucket on the floor. The strong curves of her back and thigh are moderated by the gentle curvature of her arms. Her neck—for the Japanese a particularly erotic part of a woman's body—is partially obscured, like her breast, hinting at her sexuality. With remarkable economy of means Itō has created a wonderfully sensual image.

Kawase's 1933 depiction of Kiyomizudera in the moonlight suggests the direction later taken by *shin hanga* toward sweetness and sentimentality (colorplate 74). The hillside temple stands deep blue in the moonlight, its balcony projecting out over a valley, affording a view of Kyoto below. A thoroughly modern Japanese man, wearing a visored cap and eyeglasses, stands in the embrace of the old temple, enjoying a view of the ancient city with its modern electric lights. The details suggest a statement on the part of the artist, but what comes through to the viewer is a sentimental view of the famous temple bathed in evening light. Only the light source, the moon, is missing.

*Sōsaku hanga*, the innovative creative-print movement, was the other major approach to Japanese printmaking in the early decades of the 20th century. The Nihon Sōsaku Hanga Kyōkai, the Japan Creative Print Society, founded in 1918, put forth the basic idea of *sōsaku hanga*, that the artist should be responsible for each step in the creation of a print. Artists should, of course, design the image, but they should also cut their own blocks, and ink and print them. Some artists realized the concept to the extent of making their own paper. The movement took its impetus from printmaking in Europe, where artists made their prints themselves, and where they could build a reputation solely on the basis of their print-making.

Two men were instrumental in the founding of the Japan Creative Print Society and the promulgation of its ideals: Yamamoto Kanae (1882–1946) and Onchi Kōshirō (1891–1955). Yamamoto graduated from the

men. Yoshida supervised Watanabe's technicians, but apparently was not satisfied, and after making a total of seven designs, he ended the collaboration. After the earthquake of 1923, he and his wife, also an accomplished painter, traveled to America to sell their own works and those of artist friends who had been devastated by the fires following the quake. In the course of this trip, Yoshida realized how popular Japanese woodblock prints were with Western collectors, and after his return began a study of carving and printing techniques. In 1925 he assembled his own studio and began to produce his prints independently. He supervised his artisans closely and often executed a particular stage in the production process himself in the belief he could do it better than the people who worked for him.

Yoshida's 1926 set of six prints of sailboats at different times of day, created with the same set of blocks inked with different colors, gives clear evidence of his skill and originality as a printmaker. Sailboat, Morning (colorplate 73, *left*) and Sailboat, Afternoon (colorplate 73, *right*) are an impressive tour de force of polychrome printmaking.

**370.** Inlet in Brittany, by YAMAMOTO KANAE. 1913. Polychrome woodblock print on paper; 6 x 8½ in. (15 x 21.5 cm). Yamakoshi Kango, Nagano prefecture. Collection preserved by Yamamoto Kanae Memorial Museum

Western-painting section of the Tokyo School of Fine Arts in 1906, and between 1912 and 1917 he studied in France. In Japan he had received training as a wood engraver, a technique in which boundary lines are cut into the block rather than being raised on the surface, shifting the visual emphasis from black lines to blocks of color. His Inlet in Brittany of 1913 is a good example of his technique (fig. 370). The centrally placed black-and-white cow grazes on the blue-green grass of a hillock overlooking the blue water of a bay. The brick-red sails of four sailboats can be seen, two passing close to the far shore and two partially obscured by the curve of the foreground hill and a bush to the right. The spit of land in the distance is yellow-green, and above it are a band of white clouds and, at the very top, a pale, olive-green sky. Several dissonances keep the print from sentimentality and call on the viewer to appreciate the work on the basis of its shapes and colors. One of these is the olive-green sky, which extends all the way across the top of the print; another is the color of the sailboats; and a third is the size relationship between the cow in the center and the two boats close to shore. Throughout, there is not an outline to be seen, only contour lines created by the placement of one color against another.

Yamamoto's activities after his return to Japan centered more on fostering modern printmaking than actually doing it himself. He is credited with the major effort involved in founding the Japan Creative Print Society and in arranging its first exhibition of prints, in 1919. Earlier he had edited the art magazine *Hōsun*, to which Sakamoto Hanjirō was a contributor. There is no question that he had a profound influence on the moden print movement in Japan, but it came more through his organizational and educational efforts than through his actual work.

Onchi Kōshirō was more active as a printmaker, and from the 1930s on became the acknowledged leader of the *sōsaku hanga* movement. Born to a tutor of the imperial family, Onchi received the best education available to children of the upper class. He entered the Tokyo School of Fine Arts to study oil painting, but rebelled against the restrictions of the program and turned to printmaking. Onchi was also a poet, and in 1914, the year of his rebellion, helped to found the magazine *Shirakaba*.

Throughout his artistic career, Onchi worked in two very different styles: an abstract mode illustrating poetic themes and a representational style. His portrait print of 1943, a depiction of Hagiwara Sakutarō, the nihilist poet and author of *Hyōtō (Frozen Island)*, is one of his most

deeply penetrating figural works, perhaps his master print (colorplate 75). Hagiwara and Onchi had known each other for many years, their friendship dating back to the 1910s, when they were involved in various publishing projects together. The print is the artist's response to the death in 1942 of his longtime friend. Hagiwara had been a deeply troubled man, fighting depression, alcoholism, and bouts with insanity throughout his life. Yet he was able to work through his problems to the point of expressing them in poetry. Onchi shows a three-quarter view of the man with rumpled hair and an intense, unfocused gaze. The wrinkles of Hagiwara's face look almost like the grain in a piece of wood. His head is turned so it closely parallels the line of his shoulder, concentrating visual motifs to the left of the print surface but suggesting their imagined penetration into the space in the lower right. The uneven gray of the background is lightened there, suggesting perhaps the emergence of the poet from a dark milieu into the light, or possibly the force of his vision lighting the area in front of him and reflecting back to illuminate his own face. American scholar Elizabeth de Sabato Swinton, evaluating Onchi's technique in this print, notes that seven separately carved blocks were used, re-inked, and used again through fifteen different stages in the printing process. Furthermore, a variety of pigments were used, ranging from sumi and watercolor, which could be applied in thin washes as well as deep colors, to opaque poster paint, to create a rich definition of the poet's facial features. In the area from the nose to the right ear alone, one can distinguish several different shades of beige and gray. The labor involved in achieving such results is difficult to appreciate at first glance, but it was apparently the creative process that appealed to Onchi. He pulled only seven impressions, and after World War II, when there was interest in the print, he allowed another artist, Sekino Junichirō (born 1914), to make fifty prints using his blocks. Apparently, Onchi no longer felt the need to be personally involved. The print conveys such a strong image of an intense man that it is impossible not to be moved by it even if one knows nothing about the subject of the portrait.

## Sculpture

The Western concept of sculpture proved as revolutionary to the Japanese as did European painting and architecture. Prior to the Meiji period, the Japanese did not conceive of sculpture as a medium for personal expression. Buddhist sculpture was made at the behest of the Church and had to display specific iconographic and stylistic features. Such carved items as another type of sculpture netsuke, tiny objects of ivory or wood used as counterweights for small pillboxes hung from the waist sash of a kimono in the Edo period, were thought of as decorative objects. With the decline of the Buddhist Church, changes in clothing styles, and the introduction of Western attitudes toward the plastic arts, artisans trained in carving had to

**371.** *Kiyohara Tama,* by VINCENZO RAGUSA. 1878. Bronze; height 19⅛ in. (48.5 cm). Tokyo National University of Fine Arts and Music

reorient themselves and redefine the concept of sculpture in the Japanese context.

Leading the way in this effort was the Technical Fine Arts School in Tokyo, in which the Italian sculptor Vincenzo Ragusa taught from 1876 to 1882. He was charged with teaching modeling from life in clay and plaster, and such specialized sculpting techniques as Western methods of bronze casting and the use of wire armatures—the latter a skill practiced in the Nara period but long since lost to the Japanese technical repertoire. A recognized sculptor in Italy in the 1870s, Ragusa was invited to Japan after placing first in a competition sponsored by the Italian government to choose a teacher for the school in Tokyo. Ragusa found teaching his students a difficult task because, he noted in his journal, they seemed to lack the ability to visualize objects in terms of their volume. When the school was closed in 1882, he returned to Italy.

While in Tokyo, Ragusa set up a foundry in his house in order to turn out his own work. The bronze bust of his wife Kiyohara Tama (1861–1939), a painter in her own right, exemplifies his style at this time (fig. 371). The

**372.** *Fukuzawa Yukichi*, by ŌKUMA UJIHIRO. 1892. Bronze; height 47½ in. (120 cm). Keiō Gijuku High School, Tokyo

**373.** *Old Man*, by NAGANUMA MORIYOSHI. 1898. Bronze; height 21⅝ in. (55 cm). Tokyo National University of Fine Arts and Music

piece was completed in 1878. The young woman's face, with its pert, turned-up nose, is rendered accurately in smoothly curving planes that contrast with the raised tresses of her Western-style hairdo. The sculpture is a technically accomplished example of the realistic neo-classic style in which Ragusa had been trained.

Ragusa's most talented student was Ōkuma Ujihiro (1856–1934), who in due course was appointed assistant to his mentor. In response to a commission by an influential family for a bronze sculpture to be installed in front of the Yasukuni Shrine in Tokyo, Ōkuma took the opportunity to further his studies in both Paris and Rome. The final work—a standing portrait of Ōmura Masujirō—was not completed until 1893. However, Ōkuma's masterwork is his seated portrait of Fukuzawa Yukichi (1835–1901), the founder of Keiō University, completed in 1892 (fig. 372). (Fukuzawa is considered to be one of the founders of the new Japan after the Meiji Restoration. Through his teach-ing and his writings, he tried to instill Western concepts that, he believed, had propelled the West to a position of superiority over Japan.) Ōkuma shows Fukuzawa seated in a formal pose, with an alert and inquiring expression, his brow wrinkled in concentration. Ōkuma's treatment of the clothing, too, reveals the sensitivity of his observation as well as his technical ability. The texture of the cloth used for the outer jacket is clearly different from that of the

pants, and the surfaces of both are treated so that natural light on the sculpture creates a believable pattern of high-lights and shadows.

A contemporary of Ōkuma, Naganuma Moriyoshi (1857–1942) was able to go to Italy in 1881 through his connection with the Italian government—he worked for the delegation in Tokyo. He pursued his studies in Venice at the Royal Art School, staying on until 1887. Back in Japan, Naganuma became the leading exponent of Western-style sculpture. In 1888 he joined with Asai Chū and several other artists to form the Meiji Art Society. He taught at the Tokyo School of Fine Arts, for two short periods of time between his return and the end of the cen-tury, but was never content to make it a permanent com-mitment. Still, as the most outstanding sculptor in the field, he was appointed juror for the Bunten, from its first exhibition in 1907 until 1913.

Naganuma's best-known work is the 1898 bronze

head titled *Old Man* (fig. 373). It is said that the model for the sculpture was an old gardener who worked near the artist's house. The old man looks straight forward, his head covered with a kerchief. Highlights catch his furrowed forehead, his bushy eyebrows, the deep wrinkles under his eyes, his nose and the curve of skin under it, and his slightly projecting lower lip. The modeling is both softer and deeper than Ōkuma's handling of the Fukuzawa sculpture. The fact that Naganuma was not striving for a portrait likeness allowed him greater latitude for creative expression, and he has created a work that seems to penetrate beneath the surface of the sitter's features to a deeper reality.

The outstanding talent of the next generation of sculptors working in Western styles was Asakura Fumio (1883–1964). Trained in the Tokyo School of Fine Arts, he went on to win a prize at the second Bunten exhibition, the year after his graduation. In spite of his youth, he continued to win prizes at the Bunten for eight years, permanently establishing his reputation. From 1920 to 1944 he taught sculpture at the Tokyo School of Fine Arts and also directed his own private institute, the Asakura School of the Plastic Arts, thus having a considerable effect on the next wave of young sculptors. His teaching notwithstanding, he remained a productive artist, turning out portrait sculptures on the one hand and serious interpretive works on the other. One theme that Asakura frequently treated was the cat—the cat being held by the scruff of the neck, the cat crouching, lying in wait for its prey, the cat eating its catch. The *Suspended Cat* of 1909 is a particularly fine example of his work (fig. 374). A hand and an arm curve upward from an undefined form that serves as a base. Suspended from the hand, the cat appears to be wriggling, unhappy but powerless in its present situation. Although the modeling of the sculpture is strongly three-dimensional, the most impressive aspect of this work is its fidelity to an observed phenomenon. One senses the cat's discomfort and its frustration as it dangles in midair, and one cannot help but appreciate its sleek, muscular body.

The pendulum swing of taste—from Western-style art to works in traditional Japanese styles, materials, and techniques—that occurred in the 1880s and 1890s affected sculpture as well as architecture and painting. However, because the Western concept of sculpture as an end in itself—a vehicle for the personal expression of the artist—was so different from the Japanese tradition of sculpture, it was impossible for artists to fall back to native precedents. Thus the main difference between Western and Japanese styles of sculpture made by native artists is the material in which it is created.

Takamura Kōun (1852–1934) was a sculptor who came to the fore at this time because he worked in traditional materials such as wood and ivory. Apprenticed in 1863 to the Buddhist sculptor Takamura Tōun (died 1879), and eventually adopted by his family, Kōun was trained to make the kind of statues for which there was a market before the Meiji Restoration. However, he was much im-

**374.** *Suspended Cat*, by ASAKURA FUMIO. 1909. Bronze; height 20¼ in. (51.5 cm). Asakura-Choso Museum, Tokyo

pressed with the realism of Western sculpture and the idea of the work being a vehicle for the expression of his own ideas about three-dimensional forms in space. He therefore tried to adapt Japanese techniques for wood carving to new subjects. He began to show his work nationally in 1877, when he submitted the sculpture *White-robed Kannon* (not illustrated) to the first Domestic Industrial Exposition. He soon came to Okakura's attention, and when the Tokyo School of Fine Arts opened in 1889, he was appointed professor in the sculpture department. His work, like that of Asakura, can be divided into two categories: commissioned portrait sculptures, usually in bronze, and his interpretive works, usually carved in wood.

**375.** *Old Monkey*, by TAKAMURA KŌUN. 1892. Wood; height 36⅛ in. (90.9 cm). Tokyo National Museum

**376.** *Hand*, by TAKAMURA KŌTARŌ. 1918. Bronze; height 15⅜ in. (39 cm). National Museum of Modern Art, Tokyo

An example of Kōun's unique vision is *Old Monkey* of 1892 (fig. 375). A muscular but aging monkey twists powerfully to the right and glares upward into space, grasping a few feathers that were all he could snag when he crept up on an eagle that was too quick for him. His contorted body and fierce expression speak tellingly of his frustration. The sculpture is carved out of a single piece of horse-chestnut wood that Kōun searched out himself. The monkey's body is treated as a long diagonal crossed by the left arm and the left leg, which are parallel to each other. The texture of the fur is beautifully rendered as a mass of wavy curls. *Old Monkey* is arguably one of the masterpieces of pre-World War II Japanese sculpture.

Late in the first decade of the 20th century two sculptors—Ogiwara Morie (1879–1910) and Takamura Kōtarō (1883–1956)—returned from extended periods of study abroad, bringing with them a perceptive understanding of contemporary developments in Western art theory as well as sculpture. Their ideas provided a welcome stimulus to young sculptors and contributed to the artistic ferment of the late Meiji period. Takamura Kōtarō, the son of Kōun, was trained in wood carving by his father and studied Western-style sculpture at the Tokyo School of Fine Arts. He went abroad in 1906, first to New York, then to London, and finally to Paris, returning to Japan in 1909. His experience in Europe and America convinced him of two things: the excellence of the sculpture of Auguste Rodin (1840–1917), and the vital importance of the artist's using his work as a means of personal expression. As a by-product of his beliefs about the purpose of art, he refused to take over stewardship of his adopted father's studio as he had been expected to do, because he was unwilling to accept commissions from wealthy patrons who might limit his creative freedom. (It was Kōtarō's 1910 article, "The Green Sun" that inspired a number of Taishō-era artists to resist the tyranny of Bunten aesthetics and to promote the cause of anti-naturalism in Japan.)

Although he thought of himself as a sculptor, Kōtarō is best known today as a poet, his production of poems far exceeding his sculptures. However, after his return to Japan he produced work in both bronze and wood, small jewellike pieces. His *Hand*, from 1918, is probably his best-known work (fig. 376). It displays the strong sinews of a craftsman and may have been modeled after his own hand. The position of the fingers is taut and mannered, a pose not easy to duplicate in real life. Nevertheless, it is visually a very satisfying piece that defines and articulates the space it occupies.

Of the two men who brought back fresh news of the Western art world, Ogiwara Morie stayed longer and made better contacts with Western sculptors than did Kōtarō. After two years of studying Western-style painting in Tokyo, Ogiwara left in 1901 for New York, where he stud-

**377.** *Mongaku,* by OGIWARA MORIE. 1908. Bronze; height
35¼ in. (89.5 cm). Rokuzan Art Museum, Nagano prefecture

**378.** *Woman,* by OGIWARA MORIE. 1910. Bronze;
height 39 in. (99 cm). National Museum of Modern Art, Tokyo

ied at the Art Students League. For eight months in 1903
and 1904 he studied in Paris at the Académie Julian, and
just at the end of his stay he had an experience that al-
tered the course of his artistic life. He saw Rodin's *The
Thinker* and became converted on the spot to sculpture as
a medium of expression. He returned to New York to con-
tinue his studies, but on his next stay in Paris in the au-
tumn of 1906 he made it a point to become acquainted
with Rodin, who clearly enjoyed his young Japanese
sculptor friend. Ogiwara was a frequent visitor and clearly
absorbed many of Rodin's ideas.

The year he arrived back in Japan, 1908, he entered
three works in the Bunten exhibition, two of which he had
completed in Paris and one, *Mongaku,* which he executed
after his return (fig. 377). Only the latter was accepted for
display, the committee feeling that the other two, *Coal
Miner* and *Torso of a Woman,* had not been completed—a
reflection of their lack of understanding for Ogiwara's
Rodin-based style. However, *Mongaku* not only was ac-
cepted for exhibition, it won third prize and brought the
artist to the attention of the Japanese art world. The sub-
ject of the sculpture, Mongaku, was the 12th-century war-
rior turned Shingon priest who almost single-handedly
restored the temple of Jingoji in 1182 (see page 174).
Ogiwara became interested in Mongaku when, in the

course of studying classical Japanese sculpture, he saw a
wooden image that the priest himself was thought to have
made. Another force motivating his interest in the subject
was that he, like Mongaku, was linked with a married
woman, Kokko, who ran the Nakamuraya teahouse in
Shinjuku, a pleasure district in Tokyo. The event that led
Mongaku to become a priest was his accidental killing of
his beloved Kesa Gozen, the wife of Minamoto Wataru.

Ogiwara has created a striking sculpture. The priest
is shown as a muscular nude down to his torso, his arms
crossed firmly over his chest, his head turned to his right,
staring intensely. The surface of the sculpture gives the im-
pression of a work modeled in clay rather than a bronze
casting. The physical distortions of the body, the very broad
shoulders for example, coupled with such clearly expressed
elements as the strength of Mongaku's gaze, create a power-
ful image. It is easy to understand why this work brought
Ogiwara to the attention of contemporary sculptors.

Ogiwara's most accomplished work, and also his
last, is the bronze sculpture *Woman* of 1910 (fig. 378). A

Artists working in traditional Japanese styles of sculpture in the 20th century, relatively unaffected by developments in Europe, continued to explore expressive possibilities within the limitations of traditional subject matter and materials. Following in the steps of his mentor Takamura Kōun, Hiragushi Denchū (1872–1979) experimented with carvings in wood over his very long career. He began his studies in Osaka, with a craftsman who made dolls for the Bunraku theater. In 1897 he moved to the capital and entered the Tokyo School of Fine Arts to study under Kōun. In 1907 he founded the Japan Sculpture Society together with three other sculptors, and the following year exhibited his work in the society's first annual show. His piece *Archer* (not illustrated) caught the attention of Okakura, who encouraged him to continue working in wood. When the Japan Fine Arts Academy was reorganized after Okakura's death, he joined the sculpture department, and from 1914 until 1961, when the department was disbanded, he was its focal point.

The masterpiece among Hiragushi's sculptures is *Tenshō*, or *Reincarnation*, of 1920 (fig. 379). A male figure clad in a loincloth, scarves draped across his torso, steps forward and leans over as if to vomit. From his open mouth appears the head and upper torso of a tiny human figure, so unpalatable that even a demon would not eat him—a loathsome wretch at best—unworthy of release from the cycle of death and rebirth. The image is reminiscent of a ferocious Buddhist divinity, a defender of the faith—a Fudō Myōō or a Kongō Rikishi. Behind him is a halo of flames, symbolic of his burning energy. Another concept brought to mind is that of officials of hell as described in traditional Japanese religious mythology, who oversee the daily torture of the wicked. The idea of a generic demon and that of a fierce defender of the Buddhist faith have been combined to create a symbol of divine disgust at the human condition. Yet the title of the work, *Reincarnation*, suggests a further meaning, that of being reborn to begin life over again. Using traditional materials and fusing classic Buddhist themes, Hiragushi has created a powerful statement for the modern age.

## Ceramics

The creation of ceramics in the late 19th and early 20th centuries became embroiled in theoretical issues not unlike those that affected architecture, painting, and sculpture. As the industrial revolution progressed in Japan, the question of quality in the production of everyday objects became an issue. One of the formative thinkers of the early 20th century, Yanagi Sōetsu (1889–1961), advanced the idea that true beauty could be achieved only in works that were functional and were made of natural materials

nude figure kneels, her hands clasped behind her, her face turned upward. In contrast to *Mongaku*, this figure is soft and voluptuous, the image of a young woman perhaps gazing in wonderment at the beauty of the night sky. Before the sculpture could be cast, Ogiwara became ill and died suddenly. In spite of the few works he produced after returning to Japan, he nevertheless had a strong influence on contemporary sculptors through the knowledge he brought them of Rodin's work.

**380.** Bowl with design of moon and grasses, by KITAŌJI ROSANJIN. 1950. Stoneware, with glazes; diameter 8½ in. (21.6 cm). Private collection

**381.** Shallow dish with loop designs in black and cream, by HAMADA SHŌJI. 1954. Stoneware, with glazes; diameter 10½ in. (26.7 cm). Private collection

by anonymous craftspeople using traditional techniques. Such an ideal on the one hand denied the validity of independent creativity, and on the other redefined the Japanese aesthetic of simplicity and austerity—*wabi* and *sabi*—in terms meaningful in the 20th century.

An artist who could not fit into the mold of an anonymous craftsperson was Kitaōji Rosanjin (1883–1959). The circumstances surrounding Rosanjin's birth set him apart and no doubt lay at the root of his difficult personality. He was born of a relationship between the wife of a priest at the Kamigamo Shinto shrine in Kyoto and a man who served the shrine, but who was also involved in the defiling profession of cremating the dead. The boy became a pariah, passed from one household to another, and was unable as an adult to form stable personal relationships, or to subordinate his own feelings in the interests of others.

At the age of thirty-two, Rosanjin turned to ceramics as his métier and studied with a maker of Kutani porcelains. Rosanjin's reputation is based on ceramics created during his period of affiliation with the best gourmet restaurants in the capital, wares created solely to complement individual house specialties. In 1925 he established a kiln in Kita Kamakura to produce wares for use in the Hoshigaoka Saryō, the Star Hill Restaurant in central Tokyo, to which he was adviser. A particularly fine example of his work is a bowl decorated with a design of a moon and grasses (fig. 380). The ground of the lower half of the vessel is a medium dark gray, the upper a cream color. A pattern of thin lines suggesting grass is concentrated in the lower register, light against the dark ground, and reversed above. Also on the upper register, and echoed on the inside of the bowl, is a silvery half moon, converting the simple design into a poetic reference, the moon over the plains of Musashino in the Kantō region southwest of Tokyo, a theme that dates back to poetry of the 9th century. The richness of the glazes and the classical reference are reminiscent of the Rinpa school, but the regularity of its shape and the sharp divisions of the surface into two registers give the bowl a distinctly modern flavor.

An artist who espoused Yanagi's idea of anonymous craftsmanship, but could not help standing out as a unique creative personality, was Hamada Shōji (1894–1978). He was a friend and associate of the major figures in the folk-craft movement—Yanagi and Bernard Leach (1887–1979), the English potter who played a major role in the revival of Japanese ceramics in the 20th century. Hamada was so interested in Leach and his ideas that he went to England for three years, from 1920 to 1923, to help Leach set up his community of craftsmen at St. Ives, which included building a climbing kiln. On his return to Japan Hamada established himself at Mashiko, a remote, rural town to the north of Tokyo. Although Hamada believed in Yanagi's folk-craft *(mingei)* movement and never signed his work, his best pieces were a unique blend of modern shapes and abstract designs. One example of Hamada's mature style is a round plate decorated with a traditional loop design called a horse's eye (fig. 381). The pattern, commonly found on folk-art dishes of the Edo period, consists of a number of ovals, one inside another, sharing a common point along the rim. Usually there are six or more sets of ovals drawn in dark brown iron oxide on a light gray-brown ground. Hamada has given this motif a thoroughly modern treatment. The upper side of his plate is a dark rich brown, the underside black, and over its surface black and white glazes have been trailed unevenly, forming two large "horse's eyes." So strong was Hamada's mature style that instead of remaining anonymous, he attracted a legion of imitators and gave new direction to the folk-craft movement. That movement flourishes in Japan today, its varied expressions providing the Westerner with appealing and easily comprehensible insights into a special—yet utterly consistent—dimension of very old Japanese sensibilities.

# Glossary

**Amida** (Skt. Amitabha). Literally, Boundless Light, the Buddha of the Western Paradise; also known as Amitayus, literally, Boundless Life. Amidism refers to the belief in the deity and is found in various forms from the 6th century on. In the Kamakura period several schools of Buddhist thought developed that revered him exclusively. These schools are known as Pure Land, or *Jōdo*, referring to the Western Paradise.

**bakumatsu**. Literally, the end of the shogunate; usually refers to the last decades of the Tokugawa regime.

**bijinga**. Literally, paintings of beautiful women; term originated in the Edo period for portraits of courtesans and other beauties.

**bird-and-flower painting**. See *kachōga*.

**bodhisattva**. See *bosatsu*.

**bosatsu** (Skt. bodhisattva). A Buddhist deity capable of achieving enlightenment, but who postpones it in order to save human beings from suffering. There are many different *bosatsu*: Kannon (Skt. Avalokiteshvara), the most popular of the deities, the *bosatsu* of mercy and compassion, who can assume many different forms; Seishi (Skt. Mahasathmaprapta), often the companion *bosatsu* to Kannon; Monju (Skt. Manjushri), the *bosatsu* of wisdom; Fugen (Skt. Samantabhadra), the *bosatsu* of ethical perfection; Jizō (Skt. Kshitigarbha), the protector of children and rescuer of souls in hell. These deities may be distinguished by their dress—skirts and long scarves, crowns, necklaces and arm bracelets—and individually by their attributes.

**buddha**. See *butsu*.

**bunjinga**. Literati painting; term more or less interchangeable with *nanga*, southern painting; refers to a Japanese school that began in the 18th century. Both terms originated in China, referring to the art of the scholar-gentleman; they do not indicate a Chinese stylistic source for the Japanese school, but rather a common type of artist and concern.

**butsu** (Skt. buddha). Completely enlightened being who has transcended delusion and desire. Capitalized as a part of a particular buddha's title, and in reference to Shakyamuni, the historical Buddha. A *butsuden* is any temple hall in which a buddha image is enshrined, and also the main worship hall *(hondō)* of a Zen temple; a *daibutsuden* is the hall containing a giant buddha statue, referring chiefly to the hall of the great Buddha of Tōdaiji.

**byōbu**. Freestanding folding screens, consisting of from two to sixteen panels, but most often of pairs of six-paneled screens; made of wooden frames hinged together, with paper glued over the surface. Decoratively painted, they are used as movable dividers for large rooms and as ornamentation.

**chigaidana**. Shelves in a traditional Japanese room, set at staggered heights.

**chinzō**. Formal portraits of Zen masters, either paintings or sculptures. Painted *chinzō* were often given to a student as a certificate when leaving the master's temple.

**chōdaigamae**. Doorways fitted with decorative doors that are the sole entrance to a concealed, protected area along the long inner wall of a formal room in a *shoin*-style building. In a small building the doors led to the bedroom of the master. In such structures as Nijō Castle, they concealed the guards' room.

**chōnin**. The artisan and merchant classes who formed the main urban population from the Tokugawa period on; variously used to mean merchant, trading class, or town dwellers in general.

**daimyo**. Territorial lords in the later feudal periods in Japan (from the mid-15th century on), wielding complete control over well-defined lands and populations.

**dakkatsu kanshitsu**. Literally, hollow dry lacquer; technique used to produce hollow sculptures formed of layers of lacquer-soaked cloth, often supported by a wooden armature.

**Dharma**. Sanskrit term referring chiefly to the teachings of Shakyamuni Buddha; also, the absolute Truth, the natural law of the universe.

**dōtaku**. Bronze bells from the early Bronze Age in Japan, usually decorated with outlined designs. The shape developed in China, where *dōtaku* functioned as instruments, while those in Japan were probably only ceremonial.

**emaki; emakimono**. Literally, picture roll and rolled object with pictures, respectively; the two terms are used interchangeably for rolled picture scrolls in a horizontal format, usually called hand scrolls in English; distinguished from *kakemono*, hanging scrolls.

**engi**. History and legends, particularly of temples; illustrated ones, often in sets of scrolls, are among the high points of Heian and Kamakura art.

**Esoteric and exoteric Buddhism**. The teachings of exoteric Buddhism are taught openly, through **sutras**, commentaries, and lectures. Esoteric teachings are the core of certain schools, such as Tendai and Shingon; they are revealed only to initiates and include rituals (and

their meaning) as well as mantra and visualization practices.

**Fudō** (Skt. Acala). Fierce Buddhist deity popular in **Esoteric Buddhism**, and the most important of the **Myōō**, the Kings of Higher Knowledge. Considered a bodhisattva and a manifestation of Vairocana Buddha (J. Dainichi Nyorai), he is actually a benevolent figure, his terrifying aspect being an expression of his energetic fight against evil.

*fusuma*. Interior sliding doors or partitions in traditional Japanese buildings, usually a set of panels, that separate rooms or serve as cupboard doors. Constructed of a wooden frame with layers of heavy paper glued to both sides and decorated, they have served, along with the similarly constructed *byōbu*, as the format for some of the most famous examples of Japanese art.

**Guardian Kings**. Also known as the Heavenly Kings; see **Shitennō**.

*han*. Feudal domain or fief; the territory of a **daimyo**.

*haniwa*. Clay burial figures of the Kofun era that were placed on the surface of the *kofun* mound. Basically cylindrical in form, they were often shaped into helmets, shields, and parasols, architectural shapes, and sometimes human and animal figures.

*hondō*. Main hall of a temple, usually housing its principal statues of buddhas and bodhisattvas. See also *kondō*.

*honmaru*. Central area inside the fortifications of a castle, and the site of the *tenshu*, the keep or donjon, the central tower that would be the last refuge in case of attack.

*ichiboku*. Literally, one piece of wood; sculpture carved from a solid block of wood, rather than made up of several joined sections. See also *yosegi*.

*insei*. Late Heian system of rule by the retired, usually cloistered, emperor.

**iron wire**. An even line, unvarying in width, often used to outline figures and landscape elements in traditional, continental Buddhist painting, particularly associated with India and Tibet, rather than with China.

*Jōdo*. Paradise presided over by a buddha, a transcendent realm of bliss in which devotees aim to be reborn and after which, in the succeeding birth, **nirvana** will certainly be realized. Pure Land Buddhism consists of several main schools that focus on **Amida** Buddha and his Western Paradise.

*kachōga*. Pictures of birds and flowers, a theme popular in both China and Japan.

*kaidanin*. Ordination hall in a Buddhist temple, containing a special ordination platform.

*kakemono*. Hanging scrolls with pictures or calligraphy or both in a vertical format, suspended from a wooden rod; distinguished from *emakimono*.

*kami*. Deities and spirits of Shinto. *Kami* are the supernatural inhabitants of mountaintops, rocks, waterfalls, or other natural phenomena, and also deified mythological figures, heroes, and revered rulers.

*kanga*. Japanese term for Chinese painting styles, used in the Muromachi period and later.

*kanshitsu*. Technique used to produce sculptures formed of layers of lacquer-soaked cloth shaped over a wooden armature (*dakkan shitsu*) or a solid, roughly carved piece of wood (*mokushin kanshitsu*).

*kara-e*. Japanese term for Chinese painting styles popular in Japan, originating in the Heian period.

*karayō*. Chinese design or style; term applied primarily to architectural styles, especially that of the Zen temple, which was introduced to Japan in the 13th century from China; in contradistinction to *wayō*, Japanese design, which refers in particular to the earlier style of Buddhist architecture that had by then come to be seen as a native style.

*karesansui*. Dry-landscape garden, using just a few natural elements, such as rocks, shrubs, moss, and raked sand; traditionally associated with Zen Buddhist temples.

*kirikane*. Decorative technique employing cut pieces of gold leaf, sometimes elaborately shaped; used on both paintings and sculptures.

*kōdō*. Lecture hall; a common feature of Buddhist **temple** compounds—often located behind the *hondō*, or main hall—where monks assembled to hear talks on the **Dharma** and **sutras**.

*kofun*. Literally, ancient tomb or mound; refers to the large burial tumuli of the period 300 to 710 C.E., and to the period itself. The mound was typically keyhole-shaped, was decorated with clay cylinders or *haniwa*, and contained a burial chamber.

*kondō*. Golden hall; term used for the main hall of some early Buddhist temples (into the 8th century). See also *hondō*.

*kyō*. Buddhist scripture, or **sutra** (from the Skt. *sūtra*); occurs as suffix of **sutra** titles.

**literati painting**. See *bunjinga* and *nanga*.

*machishū*. Wealthy merchant class of Japanese cities, who in the Momoyama and Edo periods became major patrons of art and financial supporters of the increasingly impoverished aristocracy.

*maki-e*. Lacquerwork in which gold and silver dust, or occasionally powdered pigment, is sprinkled onto lacquer that is still tacky, creating subtle shading effects.

**mandala**. See *mandara*.

*mandara*. A diagram of the spiritual universe. The Taizōkai Mandara depicts aspects of the deity Dainichi, the Kongōkai the many buddha fields throughout the universe. A *mandara* (mandala) is usually a painting, although sculptures may be placed to show the relationships among aspects of divinity.

**mantra**. Sacred series of words or sounds, commonly chanted in many repetitions, that serves to unite the practitioner with the creative essence of a deity.

*mappō*. Period of the Final Law of the

Buddha, or age of the decadent **Dharma**. According to some scriptural sources there are three periods of Buddhism: first, the period of the true Dharma, in which enlightenment can be reached; second, the period of the imitative Dharma, in which the teaching is no longer pure and one can practice Buddhism sincerely, but without the possibility of enlightenment; and third and last, the period of the decadence and degeneration of the Dharma, lasting perhaps ten thousand years, in which the teaching still exists but there is no true practice of it.

*mokoshi*. Roofed porch that is a subsidiary section of a building, especially of a temple hall or of a *tahōtō*, a type of **pagoda**; with a pent shed roof attached to the main structure, it typically surrounds the main section of the building.

*monogatari*. Tale, or novel; a prose genre that developed in Heian-period Japan and was often the subject of *yamato-e* paintings on hand scrolls.

*moya*. Central, rectangular part of a building, particularly of a temple hall; it is usually an odd number of bays wide (three, five, seven, or nine) and two bays deep (a bay being the space between two nonbearing interior posts).

**mudra**. From the Sanskrit, a sacred hand gesture, representing such qualities as unity, fearlessness, giving, and teaching; buddhas and bodhisattvas are generally shown with hands held in one or more mudras; mudras are also part of religious practices.

**Myōō**. The Kings of Higher Knowledge, fierce guardian deities of **Esoteric Buddhism**; the most important one is **Fudō**.

*nanga*. Literally, southern painting; the word comes from a Chinese school associated with the literati and opposed to the more formal academic style of China. In reference to Japanese art, it is equivalent to *bunjinga* and refers to literati painting of the 18th century and later.

*nenbutsu*. Literally, the thought of the buddha; the name of **Amida** Buddha, recited as a devotional religious exercise, as "Namu Amida Butsu" (Hail to Amida Buddha). A central practice of Pure Land Buddhism.

*nihonga*. Literally, Japanese-style painting, particularly of the Meiji, Taishō, and Shōwa eras, in contrast to *yōga*, and *yōfūga* Western-style painting. Based on both the Kanō and the *yamato-e* styles and adhering to traditional Japanese media, some *nihonga* also utilizes concepts and techniques of Western art.

**nirvana**. State or realm of perfect enlightenment, beyond all suffering and limitation; the goal of spiritual practice in Buddhism. Some schools consider it a separate realm, while in other traditions it is understood as the union of transcendent wisdom with the world of desire, joy, and pain.

*onna-e*. Women's pictures, a term used in the Heian period to indicate subject matter, such as that of the *Tale of Genji* and similar romances of interest to women.

*otoko-e*. Men's pictures; the Heian-period style typified by the *Shigisan engi* (see fig. 165), notable for its ink-line drawing and action-packed scenes, probably the work of professional painters of the imperial court.

**pagoda**. Buddhist sacred site, a memorial reliquary containing remains of the Buddha or jewels symbolic of such relics. Developed out of the Indian **stupa**, it is a slender structure with several stories, each marked by the characteristic wide-eaved roof, capped by a tall spire.

**Pure Land**. See *Jōdo*.

*raigō*. Welcoming to the Western Paradise of a devotee after death, by **Amida** Buddha and possibly one or more bodhisattvas.

*rakan* (Skt. arhat). Enlightened disciple of the Buddha, one who—in the system of early Buddhism—has attained freedom from rebirth.

*raku*. Literally, comfort or pleasure; a type of ceramic ware that is lead-glazed and fired at low temperatures and that traditionally is hand formed. Originally the work of one family of Kyoto potters who produced tea bowls and decorative wares.

*rangaku*. Literally, Dutch studies; the study of Western sciences and humanities in the Edo period by means of the Dutch language, the only Western language in which books were available in Japan at that time.

*renga*. Linked verses, alternating between fourteen and seventeen syllables, in which each verse is composed independently, yet is connected to the preceding and succeeding verses in strict accordance to a set of conventions. The seventeen-syllable haiku form derives from it.

*sabi*. Taking pleasure in the old, tarnished, and imperfect for their own sake, and as expressive of the ideals of harmony and simplicity; often carries a connotation of loneliness. Like *wabi*, it infuses the aesthetic of the tea ceremony, and is seen in the tea garden's mossy rocks and the tea bowl's uneven shape and rough glaze.

*sanmon*. Two-storied inner gate to a temple complex, called the mountain gate or the enlightenment gate, reached after entering the main gate; corresponds to the *chūmon*, the middle or inner gate, of other styles.

**Sanskrit**. Classical language of India that evolved a refined terminology for spiritual concerns, earning for its alphabet the name "language of the gods." The sacred texts of Hinduism and Buddhism have both come down to the present in Sanskrit (Buddhism also in the related dialect of Pali), as have the names of their deities.

*satori*. Enlightenment, spiritual awakening; a term of Zen Buddhism.

*sesshō*. Appointed head of state governing in the name of an emperor; in the Middle Heian period the Fujiwara served as regents, then called *sesshō*, the first to come from outside the imperial family; when they functioned as regent-head-of-state for an adult emperor, they took the title of *kanpaku*, or civil dictator; later, there were at times regents for **shoguns**, called *shikken*.

*setomono*. Pottery of all types, including

earthenware, stoneware, and porcelain.

**Shaka.** Japanese name for Shakyamuni Buddha, often given as the more respectful Shaka Nyorai; commonly used in reference to paintings and sculptures of the Buddha.

*shariden.* Relic hall, where relics associated with the historical Buddha, ahistorical buddhas of the past, Buddhist holy persons, and temple founders are preserved and venerated.

*shaseiga.* Drawing or sketching from nature.

*shinden.* Heian-period mansion style, or *shinden zukuri,* is characterized by a central hall, the *shinden* proper, where the master lived and received guests. It faced south to a courtyard, garden, and pond; hallways extended out on the other three sides to subsidiary buildings where family members and retainers lived. Wide corridors led from these buildings to the pond, terminating in waterside pavilions.

*shin hanga.* New prints; the 20th-century printmaking movement associated with the Taishō era that joined traditional *ukiyo-e* themes, *bijinga,* and landscapes with Western printing concepts; e.g., limited, numbered editions made to high standards in technically proficient print workshops.

**Shitennō.** Four Guardian Kings, armored protectors of Buddhism associated with the four cardinal directions, who, according to Buddhist cosmology, rule realms on the flanks of Mount Sumeru, the mountain at the center of the universe that is the meeting place of the gods.

*shōen.* Large provincial estates, composed of many independently owned parcels clustered under the patronage and protection of powerful aristocratic families; the main form of landholding in the Heian and the Early Feudal periods.

**shogun.** Effective ruler of Japan, from the beginning of the Early Feudal period through the Edo period. As head of the most powerful military family of the day the shogun acted in the name of the emperor, who was largely a figurehead.

**shoin.** Style of residential architecture that developed in the Muromachi and Momoyama periods, characterized by tatami floors, *fusuma* screens, and interior decorative features such as *tokonoma*

and *chigaidana.* See also *tsuke shoin.*

**shoji.** Originally doors, freestanding screens and *fusuma.* The term now refers to sliding screens covered with translucent white paper, usually serving as windows and doors to the exterior; probably developed in the late 15th century and characteristic of the *shoin* style.

*sōsaku hanga.* Creative prints; the 20th-century printmaking movement associated with the Shōwa era, based on the artist's personal involvement in all stages of print production; influenced by contemporaneous Western printmakers who produce their own work singlehandedly.

**stupa.** Buddhist memorial monument containing relics of the Buddha or of a holy sage. Developed in India, where the traditional shape was a hemisphere on a circular base, topped with a spire; origin of the **pagoda** of China, Korea, and Japan.

**sumi.** Black ink used in Japanese calligraphy and painting, introduced from China. A stick of carbon soot held together with glue is rubbed on an indented stone block with a little water to make ink.

**sutra.** Sacred scriptures of Buddhism, in the form of discourses of the Buddha. See *kyō.*

*tahōtō.* Term for a building that replaces the **pagoda** in temple complexes associated with **Esoteric Buddhism.**

*tarashikomi.* Technique, associated with the painter Sōtatsu, in which colors are applied over still-wet colors to achieve subtle variations in shading.

*tatchū.* See temple.

**temple.** Japanese Buddhist temples (J. *ji; dera; tera*) range from modest single buildings to great monastery complexes; major temples, both urban and rural, contain numerous buildings within an enclosure, commonly including gates, a main hall or golden hall, lecture hall, guest hall, founder's hall, monks' quarters, and support buildings. Important temples often have subtemples at other locations; in the case of Zen temples there are *tatchū,* subtemples on the grounds of the parent temple where retired senior priests live.

**tenjin.** Shinto term denoting both all heavenly beings and the deified spirit of Sugawara Michizane, the Heian-period nobleman who became a popular god (in the latter context usually spelled with an initial capital letter).

*tenshu.* Donjon, or keep, of a castle, i.e., the central fortified area; a multistoried building rising above the rest of the castle complex; in some cases a single tower; elsewhere, connected to one or more subsidiary donjons. See also *honmaru.*

**tokonoma.** Shallow alcove in a room, the floor of which is slightly elevated from the main space. Characteristic of *shoin* architecture, it serves as focal point for the display of art, most often a hanging scroll complemented by a flower arrangement.

**torii.** Gate to a Shinto shrine, marking the entrance to the sacred precinct; constructed of two posts capped by two beams that extend beyond the posts, the ends of the upper beam flaring upward.

*tsuke shoin.* Attached study; an alcove with a built-in desk that projects out of a room—as a deep bay window might— onto the surrounding porch. Characteristic of the *shoin* style of architecture.

*tsukuri-e.* Painting technique in which layers of flat color are applied over an underdrawing, after which a fine outline is redrawn; popular in the Heian and Kamakura periods.

**tumulus.** Mounded grave site, customary in Japan before the arrival of Buddhism, especially in the Kofun period.

*uki-e.* Pictures, primarily woodblock prints, using Western-style perspective to achieve a sense of depth; going back to the 18th century, the use of perspective becomes an important feature in 19th-century landscape printmaking in Japan.

*ukiyo-e.* Literally, pictures of the floating world; images of the pleasure districts of Edo and Kyoto that housed entertainment such as the theater and brothels; woodblock prints and paintings—mainly genre scenes and portraits—that were very popular in the Tokugawa period.

*vajra.* Literally diamond, or adamantine; symbol of the indestructible universe, often referred to in **Esoteric Buddhism;** a ritual implement derived

from the god Indra's lightning-bolt weapon from which it takes its shape, a joined pair of metal circles.

**wabi.** Appreciation of austerity, simplicity, and humility; a love of tranquillity and purity that is classically expressed in the tea ceremony's rustic and plain, yet precise and elegant garden, room, appointments, food, manners, and particularly its ceramics. See also *sabi.*

**waka.** Thirty-one-syllable poem written in Japanese, rather than in the more classical and formal Chinese; also known as *tanka,* the form has been used since the 8th century.

**wayō.** Japanese style, primarily in architecture; term for the early style—Nara and Heian periods—of Buddhist architecture, which seemed native in comparison to Chinese styles introduced later; that style, sometimes mixed with newer ones, continued to be employed until the Muromachi period. See also *karayō.*

**yamato-e.** Japanese-style painting, as distinct from Chinese styles, *kara-e;* chiefly, colorful and narrative art of the Heian and Kamakura periods that focused on native themes, more often secular than religious.

**yōfūga.** Literally, Western-style painting; Japanese painting in the Tokugawa period, influenced by Western painting techniques, particularly to provide a sense of depth and volume through the use of shading and Western perspective, but not necessarily using Western mediums.

**yōga.** Literally, Western painting; Western styles of painting of the modern era—from the Meiji period to the present—by either Japanese or Western artists using Western perspective and chiaroscuro, and working in Western mediums as well, principally oil paints; contrasted with *nihonga.*

**yosegi.** Sculpture construction technique in which individually carved blocks of wood are joined together. The carving is then completed and the assembled sculpture finished with lacquer and gold leaf or paint.

**zenga.** Zen painting and calligraphy; a modern term used in two art-historical contexts: broadly, for paintings by Zen Buddhist priests of China, Korea, and Japan; and, more specifically, for work—usually bold and spontaneous—by Japanese Zen priests from about 1600 to the present, in which the emphasis is on presenting teachings on the **Dharma.**

# A Reader's Guide to the Arts of Japan

by Sylvan Barnet and William Burto

Other than some works on prints and netsuke (miniature sculptures), very little was written about Japanese art before World War II. Since the war, however, a substantial library has been created—substantial enough to overwhelm the museumgoer, the student, or the visitor to Japan who wants to know something about its art. It is our intention to supply a guide through the maze and to offer a selection of major writings on the arts of Japan. We exclude material not available in English and (with a few exceptions) most doctoral dissertations, and highly specialized articles in scholarly journals or annuals such as *Archives of Asian Art, Ars Orientalis, Artibus Asiae, Monumenta Nipponica,* and *Oriental Art.* We also exclude, again with a few exceptions, the short articles—usually surveys of exhibitions or of collections—published in two journals aimed at a wider public, *Arts of Asia, Asian Art,* and *Orientations.* In other respects, however, we have cast our net broadly, including material not only on the major forms of art that are the subject of this book but also on arms and armor, folk art, and gardens. We are grateful to Penelope Mason, Elizabeth ten Grotenhuis, Elizabeth de Sabato Swinton, and Cherie Wendelken for valuable suggestions.

Because this list of recommended readings is limited to works in English, names of Japanese authors of translated works are given here in Western style, with the family name last.

Many additional references, including works in Japanese as well as in English, are given in Laurence P. Roberts, *A Dictionary of Japanese Artists* (New York: Weatherhill, 1976), and in *The Kodansha Encyclopedia of Japan,* 9 vols. (New York: Kodansha International, 1983). Regarding the use of macrons in citations, we give titles exactly as the publisher gives them. Even though it appears to be inconsistent, this practice makes for bibliographic accuracy.

The material in this Reader's Guide is organized thus:

## General Works

### Surveys of Japanese Art by Mediums

| | | |
|---|---|---|
| PAINTING | CERAMICS | ARMS AND ARMOR |
| PRINTS | LACQUER AND | FOLK ART |
| SCULPTURE | ENAMEL | ARCHITECTURE |
| CALLIGRAPHY | TEXTILES | GARDENS |

### Studies of Japanese Art by Periods

| | | |
|---|---|---|
| PRE-BUDDHIST | KAMAKURA | TOKUGAWA, OR EDO |
| ASUKA AND | TROUGH | MEIJI |
| HAKUHŌ | NANBOKUCHŌ | TAISHŌ, SHŌWA, |
| NARA | MUROMACHI | HEISEI |
| HEIAN | MOMOYAMA | |

## General Works

G. B. Sansom, *Japan: A Short Cultural History,* rev. ed. (Stanford: Stanford University Press, 1978), and H. Paul Varley, *Japanese Culture,* 3rd. ed. (Honolulu: University of Hawaii Press, 1984) provide useful background, but they can scarcely compete with the splendid *Kodansha Encyclopedia of Japan.* The *Encyclopedia* has excellent long articles on such subjects as Buddhist Art, Calligraphy, Ceramics, and History of Japan, as well as countless short articles on each of the major temples, sects, artists, and schools of art.

Although the quality of the illustrations is poor, the articles in the *Encyclopedia* are the first place to turn for reliable introductions to topics on art. Less useful is *Biographical Dictionary of Japanese Art,* ed. by Yutaka Tazawa (Tokyo: Kodansha International, 1981). Artists are listed not under the names by which they are known in the West (for example, Kōrin) but under their family names (Ōgata Kōrin). Further, the coverage is unpredictable (only forty calligraphers are included, thirteen of whom are contemporary), and bibliographic references are only to works in Japanese. A most dependable unillustrated reference work with basic information about artists, sites, dates, and locations of artworks from the 6th century to the recent past is *Chronological Table of Japanese Art,* ed. by Shigehisa Yamasaki (Tokyo: Geishinsa, 1981).

Readers who seek major documents from the periods, along with helpful modern commentaries, should turn to *Sources of the Japanese Tradition,* 2 vols., comp. by Ryusaku Tsunoda et al. (New York: Columbia University Press, 1958). This excellent two-volume collection of important religious, political, and social documents provides indispensable background material, especially for Buddhist art. Three other works are sources of documents in literature: Donald Keene, ed., *Anthology of Japanese Literature* (New York: Grove Press, 1955); Donald Keene, ed., *Modern Japanese Literature, an Anthology* (New York: Grove Press, 1956); and Helen Craig McCullough, ed., *Classical Japanese Prose: An Anthology* (Stanford: Stanford University Press, 1990).

*Note:* The following works, like the *Encyclopedia,* encompass several or, in some cases, all periods of Japanese art.

They will not be listed again in the more specialized parts of this bibliography, but they are often as informative as the more specialized works.

On history, from prehistory to 1867, see the six-volume (still in process) *Cambridge History of Japan,* ed. by John W. Hall et al. (Cambridge: Cambridge University Press, 1988–, and the three-volume work by Sir George Sansom, *A History of Japan* (Stanford: Stanford University Press, 1958–63). For a concise one-volume history, see John Whitney Hall, *Japan from Prehistory to Modern Times* (New York: Dell, 1970). Another one-volume history, especially useful because it includes more than four hundred illustrations, is Louis Frédéric, *Japan: Art and Civilization* (New York: Abrams, 1969). Martin Collcutt, Marius Jansen, and Isao Kumakura, *Cultural Atlas of Japan* (New York: Facts on File Publications, 1988) is a packed social, cultural, and political history; the text is excellent but the color reproductions are highly inaccurate.

On religious art, especially for Buddhist symbolism, see Dale Saunders, *Mudra* (Princeton: Pantheon, 1960); for discussions of Buddhist art on the continent as well as in Japan, see David L. Snellgrove et al., *The Image of the Buddha* (New York: Kodansha International, 1978); Pratapaditya Pal et al., *Light of Asia: Buddha Sakyamuni in Asian Art* (Los Angeles: Los Angeles County Museum of Art, 1984); and, especially, a fairly short but highly informative book by Dietrich Seckel, *The Art of Buddhism,* trans. by Ann E. Keep (New York: Crown, 1964). Yutaka Mino et al., *The Great Eastern Temple: Treasures of Japanese Buddhist Art from Tōdai-ji* (Chicago: Art Institute of Chicago, 1986) provides an excellent overview of a state monastery; the special strength of the illustrated material is the sculpture of the 12th century. E. Dale Saunders, *Buddhism in Japan* (Philadelphia: University of Pennsylvania Press, 1964) offers a useful introduction to the topic. For a somewhat more detailed treatment, see Daigan and Alicia Matsunaga, *Foundation of Japanese Buddhism,* 2 vols. (Los Angeles: Buddhist Books International, 1974–76). Definitions (admittedly from a Nichiren school point of view) of Buddhist terms, ranging from a few sentences to several pages, are given in *A Dictionary of Buddhist Terms and Concepts* (Tokyo: Nichiren Shōshu International Center). On Shinto art, see two books by Haruki Kageyama and one by Susan C. Tyler, listed below under Kamakura period.

Juliet Piggott, *Japanese Mythology,* rev. ed. (New York: Peter Bedrick Books, 1983), summarizes creation myths and Buddhist, Shinto, and Taoist legends, illustrating them with reproductions of sculpture, paintings, and prints. Motifs from folklore, illustrated chiefly from woodblock prints, are discussed in Stephen Addiss et al., *Japanese Ghosts and Demons* (New York: Braziller, 1985). Also mainly devoted to folklore, but including some Buddhist material, is a much older but still useful encyclopedic volume, illustrated largely with netsuke, Henri L. Joly, *Legend in Japanese Art* (1908; reprint Rutland, Vt.: Charles E. Tuttle, 1967).

For a summary of images of women in Japanese art, see Sanna Saks Deutsch and Howard A. Link, *The Feminine Image* (Honolulu: Honolulu Academy of Arts, 1985). Women—painters and patrons—are discussed in essays by Terukazu Akiyama, Karen L. Brock, Pat Fister, and Stephen Addiss in Marsha Weidner, ed., *Flowering in the Shadows: Women in the History of Chinese and Japanese Painting* (Honolulu: University of Hawaii Press, 1990). On women painters and calligraphers in the Edo and Meiji periods, see Pat Fister's *Japanese Women Artists,* listed under Tokugawa, or Edo, period.

For a readable discussion of the history and the buildings of Kyoto, see Gouverneur Mosher, *Kyoto: A Contemplative Guide* (Rutland, Vt.: Charles E. Tuttle, 1964).

Very short introductory surveys of Japanese art inevitably are highly limited, but something can be learned from Joan Stanley-Baker, *Japanese Art* (New York: Thames and Hudson, 1984) and from Peter C. Swann, *Concise History of Japanese Art* (New York: Kodansha International, 1979), although the reproductions in Swann are notably poor. Langdon Warner, *The Enduring Art of Japan* (Cambridge, Mass.: Harvard University Press, 1952), a more personal work than either of these, is less comprehensive and less up-to-date in its scholarship, but it is unrivaled in its elegance and its evocativeness.

The richest collection of illustrations in one volume (794, of which 176 are in color) is to be found in Danielle and Vadime Elisseeff, *Art of Japan,* trans. by I. Mark Paris (New York: Harry N. Abrams, 1985), a massive book with an erudite text that is organized thematically rather than chronologically. Preoccupied with the cultural background, the Elisseeffs rarely analyze individual works at any length, and although the book is in some ways encyclopedic (including nine triple-column pages of biographies and a six-page chronological table), there are large gaps; for instance, it says nothing about calligraphy or folk art and very little about any Japanese art after 1700. Somewhat more focused on art, but still with an emphasis on the cultural background, is a two-volume, handsomely illustrated work, Seiroku Noma, *The Arts of Japan,* trans. and adapt. by John Rosenfield and Glenn T. Webb (Tokyo: Kodansha International, 1966).

Two other general surveys, more or less midway between Stanley-Baker's compact book and the Elisseeffs' massive book, should be mentioned. The first, and most important, is J. Edward Kidder, Jr., *The Art of Japan* (New York: Park Lane, 1985), an oversize book of some three hundred pages, about half of which are devoted to two hundred twenty-seven large illustrations in color. The pictures, often of objects not illustrated in other books, provide a good introduction to Japanese art up to about 1650; art after 1650 gets only twenty-seven pages, half of which are given to late 18th- and early 19th-century prints. The text contains many fresh comments (some arguments for dates may surprise specialists), but because much of it is devoted to a detailed exposition of the cultural and social background, it is perhaps more suited to intermediate students than to novices. The other general survey, less penetrating than any of the books already mentioned, but nevertheless of some use as an introduction because of its inclusiveness, is H. Batterson Boger, *The Traditional Arts of*

Japan (Garden City, N.Y.: Doubleday, 1966), whose many short chapters include discussions not only of the major arts but also of gardens, fans, dolls, costumes, and armor.

Although it is not a general survey since it is chiefly concerned with art from the 13th through the 18th centuries, *Japan: The Shaping of Daimyo Culture 1185–1868*, ed. by Yoshiaki Shimizu (Washington, D.C.: National Gallery of Art, 1988) can be mentioned here. Illustrated with excellent photographs of major works, and equipped with detailed commentaries, it is indispensable to the study of painting, calligraphy, sculpture, arms and armor, lacquer, ceramics (especially for the tea ceremony), and textiles.

For extended discussions of relatively few objects—but covering the range of Japanese art, early and late, religious and secular—consult the following well-illustrated and highly informative catalogs of private and public collections: Miyeko Murase, *Japanese Art: Selections from the Mary and Jackson Burke Collection* (New York: The Metropolitan Museum of Art, 1975); John M. Rosenfield and Shūjirō Shimada, *Traditions of Japanese Art: Selections from the Kimiko and John Powers Collection* (Cambridge, Mass.: Fogg Art Museum, 1970); *A Thousand Cranes* (Seattle: Seattle Art Museum, 1987); *One Thousand Years of Japanese Art (650–1650): From the Cleveland Museum of Art* (New York: Japan Society, 1981); Yoshiko Kakudo, *The Art of Japan* (San Francisco: Asian Art Museum of San Francisco, 1991), in which the quality of the objects, and of the photographs, is uneven, but the book provides something of an introduction to many of the chief forms and motifs of Japanese art. Lawrence Smith, Victor Harris, and Timothy Clark, *Japanese Art: Masterpieces in the British Museum* (New York: Oxford University Press, 1990) includes two hundred thirty objects, from prehistoric ceramics to contemporary prints, with useful comments. It reflects British interest in its attention to swords and armor (almost always omitted from general American books), and it alone includes money, clocks, and 19th-century secular sculpture, but the quality of the objects and of the reproductions is uneven. Sherman E. Lee, Michael R. Cunningham, and James T. Ulak, *Reflections of Reality in Japanese Art* (Cleveland: Cleveland Museum of Art, 1983) is an important catalog with much information about major works of art from many centuries, but it is limited to paintings and sculptures that the organizers of the exhibition considered to be realistic in one way or another. Other useful catalogs of general collections, valuable chiefly for the illustrations because the texts are very brief, are *Asiatic Art in the Museum of Fine Arts, Boston* (Boston: Museum of Fine Arts, 1982), and *The Freer Gallery of Art: Japan* (Tokyo: Kodansha Ltd., n.d.).

## Surveys of Japanese Art by Mediums

### PAINTING

An old book, Terukazu Akiyama's *Japanese Painting* (Switzerland: Skira, 1961), still provides a good survey of all painting (secular and Buddhist). For a fairly brief but lucid introduction to various schools of Buddhist painting, see John M. Rosenfield and Elizabeth ten Grotenhuis, *Journey of the Three Jewels* (New York: Asia Society, 1979). For a study of one kind of Buddhist painting, chiefly of the 12th and 13th centuries, see Pratapaditya Pal and Julia Meech-Pekarik, *Buddhist Book Illumination* (New York: Ravi Kumar, 1988). Illustrated religious and secular texts (chiefly hand scrolls and albums) from the 12th century to the early 19th century are discussed in Miyeko Murase, *Tales of Japan* (New York: Oxford University Press, 1986). Many of the works in this book are not of high artistic quality, but the commentary is detailed. Another catalog in which the commentary is perhaps more valuable than the illustrations is John M. Rosenfield, *Song of the Brush* (Seattle: Seattle Art Museum, 1979), which is concerned with three schools of ink painting represented in a single private collection (Chinese-style painting [*suibokuga*] of the Muromachi and Momoyama periods, Zen ink painting [*zenga*] of the Tokugawa period, and literati painting [*nanga*] of the 18th and 19th centuries). Elise Grilli surveys screen *(byōbu)* painting (chiefly of the Tokugawa period) in *The Art of the Japanese Screen* (New York: Weatherhill, 1970). On hand scrolls, see below, under Kamakura period.

### PRINTS

On Buddhist prints, see Mosaku Ishida et al., *Japanese Buddhist Prints*, trans. by Charles Terry (New York: Harry N. Abrams, 1964), and Mary W. Baskett, *Footprints of the Buddha* (Philadelphia: Philadelphia Museum of Art, 1980). On secular prints, see the entries below under Tokugawa period and Meiji period.

### SCULPTURE

There are two handsome and informative introductions: J. Edward Kidder, Jr., *Masterpieces of Japanese Sculpture* (Tokyo: Bijutsu Shuppan-sha, 1961), and Nishikawa Kyōtarō and Emily Sano, *The Great Age of Japanese Buddhist Sculpture A.D. 600–1300* (Fort Worth, Tex.: Kimbell Art Museum, 1982). For a detailed but readable discussion of Shinto sculpture from the 9th through the 13th century, see Christine Guth Kanda, *Shinzō* (Cambridge, Mass.: Council on East Asian Studies, 1985).

Numerous books, often designed as handbooks for collectors, have been written about netsuke (miniature carvings, usually of wood, lacquer, bone, or ivory, chiefly made between 1600 and 1860). Raymond Bushell has written eight such books, each with many illustrations, but the color reproductions are often poor. For excellent reproductions of netsuke, along with a fairly brief but useful commentary, see Hirozaku Arikawa, *The Gō Collection of Netsuke* (New York: Kodansha International, 1983). For a survey of the background, and comments of a paragraph or two on each of one hundred netsuke, see Barbra Teri Okada, *Netsuke: Masterpieces from the Metropolitan Museum of Art* (New York: The Metropolitan Museum of Art, 1982). Dolls of all sorts, from

simple folk toys to elegant showpieces created for the elite, are discussed in Jill and David Gribbin, *Japanese Antique Dolls* (New York: Weatherhill, 1984). For toys, see below, under Folk Art.

## CALLIGRAPHY

For a lucid exposition of the Japanese systems of writing, see "Japanese Language and Calligraphy," an introductory essay in John M. Rosenfield, Fumiko Cranston, and Edwin A. Cranston, *The Courtly Tradition* (Cambridge, Mass.: Fogg Art Museum, 1973). A wider range of calligraphy is illustrated and discussed by Yoshiaki Shimizu and John Rosenfield in *Masters of Japanese Calligraphy: 8th–19th Century* (New York: Asia Society Galleries and Japan House Gallery, 1984). These two books provide the reader with valuable commentaries and with reproductions of many pieces, but they are limited to works in Western collections. For a broader selection of illustrations of major works (many in excellent color), see Yujiro Nakata, *The Art of Japanese Calligraphy*, trans. by Alan Woodhull (New York: Weatherhill, 1973).

Shen Fu, Glenn D. Lowry, and Ann Yonemura, *From Concept to Context: Approaches to Asian and Islamic Calligraphy* (Washington, D.C.: Freer Gallery, 1986) includes a helpful introductory discussion and substantial comments on sixteen Japanese calligraphies ranging from the 12th century to the early 19th. *Chinese and Japanese Calligraphy . . . The Heinz Götze Collection*, comp. by Shigemi Komatsu, Kwan S. Wong, and Fumiko Cranston (Munich: Prestel, 1989) discusses, usually in interesting detail, some forty Japanese pieces of varying quality from the 8th to the 19th century. Also valuable are the essays by Yoshiaki Shimizu (chiefly on Chinese influences) and Elizabeth ten Grotenhuis (on the traditions behind contemporary calligraphy) in *Multiple Meanings*, ed. by J. Thomas Rimer (Washington, D.C.: Library of Congress, 1986). Something of the Japanese view of calligraphy can be gathered from a summary of a 17th-century essay on calligraphy, in Makoto Ueda, *Literary and Art Theories of Japan* (Cleveland: Case Western Reserve University Press, 1967).

## CERAMICS

*Ceramic Art of Japan* (Seattle: Seattle Art Museum, 1972) provides an overview and illustrates one hundred masterpieces (thirty-two in excellent color) from prehistory to the early 19th century. Roy Andrew Miller, *Japanese Ceramics* (Tokyo: Charles E. Tuttle, 1960), an adaptation of a book by several Japanese scholars, is a useful general introduction, although most of the illustrations are in black and white and the scholarship has been superseded in some details. Also useful (chiefly for the handsome and abundant illustrations) is Tsugio Mikami, *The Art of Japanese Ceramics*, trans. by Ann Herring (New York: Weatherhill, 1972). A more specialized study, but richly informative, is a detailed book by Louise Allison Cort, *Shigaraki:*

*Potter's Valley* (New York: Kodansha International, 1979). Cort is also the author of an extremely interesting article, "Japanese Ceramics and Cuisine," in *Asian Art* 3:1 (Winter 1990): 9–37.

## LACQUER AND ENAMEL

The standard work on lacquer is Beatrix von Ragué, *A History of Japanese Lacquerwork*, trans. by Annie R. de Wasserman (Toronto: University of Toronto Press, 1976). Works on single collections are inevitably less comprehensive, but still of value. Ann Yonemura, *Japanese Lacquer* (Washington, D.C.: Freer Gallery, 1979) illustrates and discusses some fifty pieces (chiefly Tokugawa, but also two important early lacquer sculptures) in the Freer Gallery; Barbara Ford treats some eighty pieces in The Metropolitan Museum of Art, in James C. Y. Watt and Barbara Brennan Ford, *East Asian Lacquer: The Florence and Herbert Irving Collection* (New York: The Metropolitan Museum of Art, 1991).

For enamels, chiefly of the Tokugawa period, see George Kuwayama, *Shippō: The Art of Enameling in Japan* (Los Angeles: Far Eastern Art Council, 1987), a catalog of seventy-one objects, with an introductory survey.

## TEXTILES

See Kaneo Matsumoto, *Jōdai Gire: 7th and 8th Century Textiles in Japan from the Shōsō-in and Hōryū-ji*, trans. by Shigeta Kaneko and Richard L. Mellott (Kyoto: Shikosha, 1984), for splendid illustrations of pieces, many imported from China. The handsome illustrations in Amanda Mayer Stinchecum et al., *Kosode: 16th–19th Century Textiles from the Nishimura Collection* (New York: Japan Society and Kodansha International, 1984) are limited to Momoyama and Tokugawa works, but the text discusses earlier works as well, and the bibliography is extensive. For additional illustrations of 17th- and 18th-century costumes see Seiroku Noma, *Japanese Costumes and Textile Arts*, trans. by Armin Nikovskis (New York: Weatherhill, 1974). *Robes of Elegance: Japanese Kimonos of the 16th–20th Centuries* (Raleigh: North Carolina Museum of Art, 1988) is handsomely illustrated, and although the text is weakly translated from the Japanese, it is informative. Alan Kennedy, *Japanese Costume* (Paris: Adam Biro, 1990) illustrates a few Buddhist pieces from as early as the 8th century, but chiefly studies Nō robes and high-fashion garments from the 16th century through the 19th. Among the most beautiful Japanese fabrics are those produced in the 15th and 16th centuries by certain methods of tie-dyeing combined with brush painting, embroidery, or rubbed gold or silver leaf. On this method, see a handsome book by Toshiko Itō, *Tsujigahana*, trans. by Monica Bethe (New York: Kodansha International, 1985).

## ARMS AND ARMOR

The subject is treated well in *Japan: The Shaping of Daimyo Culture*, ed. by Yoshiaki Shimizu (see above, under General

Works), and briefly but usefully in *The Great Japan Exhibition* and *The Shogun Age Exhibition* (see below, under Tokugawa, or Edo Period). Each of these books is equal, as an introduction, to Basil W. Robinson, *Arms and Armour of Old Japan* (London: H.M.S.O., 1951), or to H. Russell Robinson, *Japanese Armor and Arms* (New York: Crown, 1969). For extensive discussions of swords, along with briefer discussions of sword guards and other fittings, see W. M. Hawley, *Japanese Swordsmiths*, 2 vols. (1967); Kanzan Satō, *The Japanese Sword*, trans. by Joe Earle (New York: Kodansha International, 1983); and Walter Compton et al., *Nippon-Tō: Art Swords of Japan* (New York: Japan Society, 1976); and, for discussions and excellent photographs of forty-two swords and fifty-eight sword fittings and related accoutrements, *One Hundred Masterpieces from the Collection of Dr. Walter A. Compton*, ed. by Sebastian Izzard (New York: Christie's, 1992). Martin Collcutt has a short, informative essay on swords in *Court and Samurai in an Age of Transition* (New York: Japan Society, 1990), a catalog (no editor is named) illustrating and discussing twenty-three blades. *Spectacular Helmets of Japan: 16th–19th Century* (New York: Japan Society, 1985), illustrating seventy-six helmets (many designed for show), includes excellent essays on Tokugawa military culture.

## FOLK ART

For essays by the father of the folk art *(mingei)* movement in Japan—though he preferred the term "folk craft"—see Sōetsu Yanagi, *The Unknown Craftsman*, adapted by Bernard Leach (Tokyo: Kodansha International, 1972). The best volume for text and for illustrations (not only painting, sculpture, ceramics, and textiles, but also lacquer, wood, and basketry) is Victor and Takako Haugue, *Folk Traditions in Japanese Art* (New York: Kodansha International, 1978).

Also useful is *Mingei: Masterpieces of Japanese Folkcraft* (New York: Kodansha International, 1991), a handsome book illustrating (wih very brief discussions) one hundred fifty-eight exceptionally beautiful objects (textiles, ceramics, lacquer, wood, pictures—including a few that certainly are not folk art, for instance ceramics by Bernard Leach and woodblock prints by Munakata). The book includes a useful discussion of the word *mingei* and of the craft movement (including its indebtedness to William Morris) that Yanagi sponsored. Hugo Münsterberg, *The Folk Arts of Japan* (Rutland, Vt.: Charles E. Tuttle, 1958) is another useful introduction; Kageo Muraoka and Kichiemon Okamura, *Folk Arts and Crafts of Japan*, trans. by Daphne D. Stegmaier (New York: Weatherhill, 1973) illustrates many handsome objects. On some of the chief contemporary craftspersons, see Masataka Ogawa et al., *The Enduring Crafts of Japan: 33 Living National Treasures* (New York: Weatherhill, 1968). Finally, two specialized books should be noted. Toys of all sorts, including kites, dolls, tops, and noisemakers, are illustrated in profusion, with brief comments, in Kazuya Sakamoto, *Japanese Toys*, trans. and adapt. by Charles A. Pomeroy (Rutland, Vt.: Charles E. Tuttle, 1965). On baskets, see the ex-hibition catalog by Toshiko M. Mc Callum, *Containing Beauty: Japanese Bamboo Flower Baskets* (Los Angeles: University of California, 1988). Many of the illustrated objects probably cannot be classified as folk art, but the catalog is usefully informative about basket-making.

## ARCHITECTURE

There is no major survey of Japanese architecture from the beginning to the present, but a good short introduction to traditional Japanese buildings (shrines, temples, residences, places of recreation) from prehistory to the mid-19th century is Kazuo Nishi and Kazuo Hozumi, *What is Japanese Architecture?*, trans. by H. Mack Horton (New York: Kodansha International, 1985). Organized into many short units and equipped with about two hundred fifty descriptive drawings and plans but no photographs, the book sometimes seems to be written for young people, but adults unfamiliar with the topic will be grateful for its simple clarity. An admirable complement to this volume is William H. Coaldrake, *The Way of the Japanese Carpenter: Tools and Japanese Architecture* (New York: Weatherhill, 1990), a beautifully written, hands-on view of the craft of architecture. Coaldrake studies the physical aspects of the building process by discussing the tools of Japanese traditional carpentry and their role in the history of sacred and secular architecture from prehistoric to modern times.

Two fairly short surveys designed for the general reader are: William Alex, *Japanese Architecture* (New York: Braziller, 1963), and Arthur Drexler, *The Architecture of Japan* (New York: The Museum of Modern Art, 1966). Readers who possess some familiarity with the subject may prefer Robert Treat Paine and Alexander Soper's more encyclopedic approach, in *The Art and Architecture of Japan*, 3rd ed. (Baltimore: Penguin, 1981). None of these three books is adequately illustrated; for a splendid picture book that includes good short discussions of the history and architecture of temples, their surroundings, and their contents, see J. Edward Kidder, Jr., *Japanese Temples: Sculpture, Paintings, Gardens, and Architecture* (Tokyo: Bijutsu Shuppan-sha, n.d.). Less monumental, but nevertheless attractive and informative, is Kakichi Suzuki, *Early Buddhist Architecture in Japan*, trans. by Mary N. Parent and Nancy Shatzman Steinhardt (New York: Kodansha International, 1980), which goes to about the year 1000 (that is, from the Asuka into the middle of the Heian period). For a highly technical study of one aspect of temple architecture from the 7th century to the 15th century, see Mary Neighbor Parent, *The Roof in Japanese Buddhist Architecture* (New York: Weatherhill, 1983). On the "folk house," particularly the farm house, see Chūji Kawashima, *Minka*, trans. by Lynne E. Riggs (New York: Kodansha International, 1986).

## GARDENS

Teiji Itō (also Itoh) has written several fairly brief texts to accompany extremely handsome books of photographs and plans: Teiji Itō, *The Japanese Garden*, 2nd ed., trans. by

Donald Richie (New Haven: Yale University Press, 1972); Teiji Itoh, *The Gardens of Japan* (New York: Kodansha International, 1984), which includes splendid photographs of a few gardens and lists, with brief comments, fifty other gardens; Teiji Itoh, *Imperial Gardens of Japan* (New York: Weatherhill, 1970), which is limited to Sento Imperial Palace, Katsura Imperial Villa, and Shugakuin Detached Palace. A smaller but also attractive book, and one that covers many gardens, is Masao Hayakawa, *The Garden Art of Japan*, trans. by Richard L. Gage (New York: Weatherhill, 1973). For a particularly beautiful book on gardens set within buildings, see Kanto Shigemori, *The Japanese Courtyard Garden*, trans. by Pamela Pasti (New York: Weatherhill, 1981).

Readers less concerned with beautiful photographs and more with somewhat fuller historical accounts of the chief gardens and with discussions of principles of design and details of construction should begin with Loraine Kuck, *The World of the Japanese Garden*, corrected ed. (New York: Weatherhill, 1970), or with Mitchell Bring and Josse Wayembergh, *Japanese Gardens: Design and Meaning* (New York: McGraw Hill, 1981). Although the photographs in Bring and Wayembergh are below par, the site and building plans and the analytic diagrams make this book notably important. For further information about the techniques employed in designing gardens (especially "borrowed scenery" and "the great within the small"), see Teiji Itoh, *Space and Illusion in the Japanese Garden*, trans. and adapt. by Ralph Friedrich and Masajiro Shimamura (New York: Weatherhill, 1973), and, for a book emphasizing the author's experience as an apprentice garden designer in Japan, see David A. Slawson, *Secret Teachings in the Art of Japanese Gardens* (New York: Kodansha International, 1987). Somewhere between the poles of splendid picture books with brief commentaries and relatively plain books with fuller commentaries is Irmtraud Schaarschmidt and Osamu Mori, *Japanese Gardens*, trans. by Janet Seligman-Richter (New York: Morrow, 1979), a large, handsome, almost encyclopedic book with a densely packed text that makes it more useful for reference than for browsing. Wybe Kuitert, *Themes, Scenes, and Taste in the History of Japanese Garden Art* (Amsterdam: J. C. Gieben, 1988) is not especially readable but it offers the best summary of the current research in garden history.

## Studies of Japanese Art by Periods

### PRE-BUDDHIST
#### (to circa 550 C.E.)

C. Melvin Aikens and Takayama Higuchi, *Prehistory of Japan* (New York: Academic Press, 1982); Vadime Elisseeff, *Japan*, trans. by James Hogarth (London: Barrie and Jenkins, 1974); Richard J. Pearson et al., eds., *Windows on the Japanese Past* (Ann Arbor: University of Michigan Press, 1986); and Richard Pearson et al., *Ancient Japan* (New York: Braziller, 1992) are chiefly archaeological studies. (Pearson's *Ancient Japan* is es-

pecially handsome, with seventy-one color plates and more than two hundred black-and-white illustrations.) Of more interest to students of art are several books by J. Edward Kidder, Jr., especially *Prehistoric Japanese Arts: Jōmon Pottery* (Tokyo: Kodansha International, 1968), *The Birth of Japanese Art* (New York: Praeger, 1965), and *Early Japanese Art* (Princeton: Van Nostrand Reinhold, 1964). Also useful are Namio Egami, *The Beginnings of Japanese Art*, trans. by John Bester (New York: Weatherhill, 1973), and—limited to Kofun-era sculpture—Fumio Miki, *Haniwa*, trans. and adapt. by Gina Lee Barnes (New York: Weatherhill, 1974). *The Rise of a Great Tradition: Japanese Archaeological Ceramics from the Jōmon through Heian Periods* (10,500 B.C.–A.D. 1185) (New York: Agency for Cultural Affairs, Government of Japan, and Japan Society, 1990) includes six introductory essays (chiefly archaeological) and illustrations of seventy objects, with brief descriptions.

For Shinto architecture, see Yasutada Watanabe, *Shinto Art: Ise and Izumo Shrines*, trans. by Robert Ricketts (New York: Weatherhill, 1974), and especially Kenzo Tange and Noboro Kawazoe, *Ise: Prototype of Japanese Architecture* (Cambridge, Mass.: MIT Press, 1965).

### ASUKA AND HAKUHŌ
#### (552–710)

The best introduction is a handsome exhibition catalog by Bunsaku Kurata, *Hōryū-ji: Temple of the Exalted Law*, trans. by W. Chie Ishibashi (New York: Japan Society, 1981), but also useful (and well illustrated) are Seiichi Mizuno, *Asuka Buddhist Art: Horyu-ji*, trans. by Richard L. Gage (New York: Weatherhill, 1974), and Kakichi Suzuki, *Early Buddhist Architecture in Japan*, trans. and adapt. by Mary Neighbor Parent and Nancy Shatzman Steinhardt (New York: Kodansha International, 1980). Two 7th-century images have been the subjects of detailed studies; on the image in Chūgūji usually identified as Miroku, see Sherwood Moran, in *Artibus Asiae* 21:3/4 (1958): 179–203; on the date, style, and history of interpretation of the *Yumedono Kannon*, see Lucy Weinstein, in *Archives of Asian Art* 42 (1989): 25–48.

### NARA
#### (710–794)

In addition to Suzuki's *Early Buddhist Architecture* (mentioned in the previous paragraph), see Jirō Sugiyama, *Classic Buddhist Sculpture*, trans. and adapt. by Samuel Crowell Morse (New York: Kodansha International, 1982); Minoru Ooka, *Temples of Nara and Their Art*, trans. by Dennis Lishka (New York: Weatherhill, 1973)—the "art" is chiefly sculpture, and despite the title the book examines temples not only in Nara but also in Kyoto and elsewhere; and Takeshi Kobayashi, *Nara Buddhist Art: Todai-ji*, trans. by Richard L. Gage (New York: Weatherhill, 1975) Langdon Warner, *Japanese Sculpture of the Tempyo Period* (Cambridge, Mass.: Harvard University Press, 1959) has been superseded in much of its scholarship, but it

remains a thoughtful and readable book.

Several thousand 8th-century objects, including robes, vessels, musical instruments, paintings, and lacquer boxes, some of which were imported from China, India, Persia, and other countries, were kept until recently in the Shōsōin, a wooden storehouse at Tōdaiji in Nara. On this material, see Ryoichi Hayashi, *The Silk Road and the Shoso-in,* trans. by Robert Ricketts (New York: Weatherhill, 1975), and *The Treasures of the Shosoin,* trans. by S. Kaneko (Tokyo: Asahi Shimbun, 1965), an especially handsome book.

## HEIAN
### (794–1185)

On the cultural background, see a highly readable book by Ivan Morris, *The World of the Shining Prince* (London: Oxford University Press, 1964). The best introduction to the art is John Rosenfield, *Japanese Art of the Heian Period: 794–1185* (New York: Asia Society, 1967). For a more detailed and rather encyclopedic account, see Rose Hempel, *The Golden Age of Japan: 794–1192,* trans. by Katherine Watson (New York: Rizzoli International, 1983).

More specialized studies—all well illustrated and with useful texts—are: Toshio Fukuyama, *Heian Temples: Byodo-in and Chuson-ji,* trans. by Ronald K. Jones (New York: Weatherhill, 1976); Takaaki Sawa, *Art in Esoteric Buddhism,* trans. by Richard L. Gage (New York: Weatherhill, 1972); Hisatoyo Ishida, *Esoteric Buddhist Painting,* trans. and adapt. by E. Dale Saunders (New York: Kodansha International, 1987); and Jōji Okazaki, *Pure Land Buddhist Painting,* trans. and adapt. by Elizabeth ten Grotenhuis (New York: Kodansha International, 1977). Two handsome, excellently illustrated books are devoted to the calligraphy and the illustrations for the *Lotus Sutra;* they are *Art of the Lotus Sutra,* ed. by Bunsaku Kurata and Yoshiro Tamura (Tokyo: Kōsei Publishing, 1987), and Willa J. Tanabe, *Paintings of the Lotus Sutra* (Tokyo: Weatherhill, 1988). Of the two, the former is the more lavish (one hundred seven large full-color plates); the latter (forty-six color and one hundred twenty-six monochrome illustrations) is the more highly detailed.

For secular paintings, see Saburo Ienaga, *Painting in the Yamato Style,* trans. by John M. Shields (New York: Weatherhill, 1973). For excellent full-scale reproductions of all that survives (except for one much-repainted picture) from the earliest extant *Genji* scroll, along with excellent commentaries, see Ivan Morris, *The Tale of Genji Scroll* (Tokyo: Kodansha International, 1971).

Several important Heian sculptures have been discussed at length: See Sherwood Moran on the Eleven-headed Kannon at Kōgenji, the Eleven-headed Kannon at Hokkeji, and the Nyoirin Kannon in Kanshinji, in *Artibus Asiae* 34:2/3 (1972): 119–61; Sherwood Moran on Jōchō's Amida in Byōdōin, in *Oriental Art,* new series 6:2 (Summer 1980): 49–55; Samuel C. Morse on the Yakushi at Jingoji, in *Archives of Asian Art* 40 (1987): 36–55; and Mimi Yiengpruksawan on the Ichiji Kinrin at Chūsonji, in *Monumenta Nipponica* 46:3

(Autumn 1991): 329–47.

For Shinto material, see (in addition to Kanda's book on sculpture) the works by Kageyama and by Tyler listed under Kamakura period.

## KAMAKURA THROUGH NANBOKUCHŌ
### (1185–1392)

For a good, short introduction to Kamakura scroll paintings, calligraphy, and swords, see the handsome exhibition catalog (no editor named) called *Court and Samurai in an Age of Transition* (New York: Japan Society, 1990). Hisashi Mori, *Sculpture of the Kamakura Period,* trans. by Katherine Eickmann (New York: Weatherhill, 1974) offers a survey of this last great age of Japanese sculpture. On the same topic, but with a text that provides Western readers with a better introduction, see Victor Harris and Ken Matsushima, *Kamakura: The Renaissance of Japanese Sculpture 1185–1333* (London: The British Museum, 1991). On a narrower topic, see Hisashi Mori, *Japanese Portrait Sculpture,* trans. and adapt. by W. Chie Ishibashi (New York: Kodansha International, 1977).

For Pure Land Buddhist paintings, see the work by Okazaki listed under Heian period, and also Elizabeth ten Grotenhuis, "Visions of a Transcendent Realm: Pure Land Images in the Cleveland Museum of Art," *Bulletin of the Cleveland Museum of Art* 78:7 (Nov. 1991): 274–300. For secular and religious hand scrolls, see Dietrich Seckel, *Emakimono: The Art of the Japanese Printed Hand-scroll,* trans. by J. Maxwell Brownjohn (New York: Pantheon, 1972); Miyeko Murase, *Emaki: Narrative Scrolls from Japan* (New York: Asia Society, 1983); Hideo Okudaira, *Narrative Picture Scrolls,* adapt. by Elizabeth ten Grotenhuis (New York: Weatherhill, 1973); Hideo Okudaira, *Emaki: Japanese Picture Scrolls* (Rutland, Vt.: Charles E. Tuttle, 1962); and Saburo Ienaga, *Painting in the Yamato Style,* trans. by John M. Shields (New York: Weatherhill, 1973). A Ph.D. dissertation by Karen L. Brock deserves special mention: *Tales of Gishō and Gangyō: Editor, Artist, and Audience in Japanese Picture Scrolls* (Princeton University, 1984).

On Shinto material see two books by Haruki Kageyama: *The Arts of Shinto,* trans. and adapt. by Christine Guth (New York: Weatherhill, 1973), and (an exhibition catalog, and therefore somewhat less comprehensive than the preceding title) *Shinto Arts,* trans. by Christine Guth Kanda (New York: Japan Society, 1976). More specialized is Susan C. Tyler, *The Cult of Kasuga Seen through Its Art* (Ann Arbor: University of Michigan Press, 1992).

## MUROMACHI
### (1392–1573)

Martin Collcutt's excellent essay on the politics, religion, and cultural life of the period 1450–1550 is to be found in an important exhibition catalog, *Circa 1492: Art in the Age of Exploration,* ed. by Jay A. Levenson (Washington, D.C.; National Gallery of Art, 1991). In the same catalog Sherman E. Lee dis-

cusses the art of the period and comments on some fifty paintings, sculptures, masks, examples of metalwork, lacquer, and ceramics.

For further background on the period, including important essays by William Coaldrake on residential architecture and by John M. Rosenfield on Josetsu's picture of "The Three Creeds" (Buddhism, Taoism, and Confucianism), see John W. Hall and Toyoda Takeshi, eds., *Japan in the Muromachi Age* (Berkeley: University of California Press, 1977). Two excellent books on Zen Buddhism should be mentioned, even though the first of these contains almost nothing about art, and the second contains only brief discussions of art: Martin Collcutt, *Five Mountains: The Rinzai Zen Monastic Tradition in Medieval Japan* (Cambridge, Mass.: Harvard University Press, 1981), and (covering a much larger time frame) the second volume of Heinrich Dumoulin, *Zen Buddhism: A History*, trans. by James W. Heisig and Paul Knitter (New York: Macmillan, 1990).

Useful surveys of ink painting (the chief art of the period) are Ichimatsu Tanaka, *Japanese Ink Painting: Shubun to Sesshu*, trans. by Bruce Darling (New York: Weatherhill, 1972); Hiroshi Kanazawa, *Japanese Ink Painting: Early Zen Masterpieces*, trans. and adapt. by Barbara Ford (New York: Kodansha International, 1979); and Takaaki Matsushita, *Ink Painting*, trans. and adapt. by Martin Collcutt (New York: Weatherhill, 1974). Akiyoshi Watanabe, *Of Water and Ink* (Detroit: Detroit Institute of Arts, 1986) is an exhibition catalog of eighty-one works, with an introductory essay discussing the influence of Chinese painting on Japanese artists of the period, and with some emphasis on Sesshū and his followers. For studies of fewer works (but these are discussed in greater detail), see Sylvan Barnet and William Burto, *Zen Ink Paintings* (New York: Kodansha International, 1982); Jan Fontein and Money Hickman, *Zen Painting and Calligraphy* (Boston: Museum of Fine Arts, 1970); and Yoshiaki Shimizu and Carolyn Wheelwright, eds., *Japanese Ink Paintings from American Collections* (Princeton: Princeton University Press, 1976). Helmut Brinker, *Zen in the Art of Painting*, trans. by George Campbell (London: Arkana, 1987) offers a brief survey of motifs in ink painting; unfortunately, the reproductions are poor. Shin'ichi Hisamatsu, *Zen and the Fine Arts*, trans. by Gishin Tokiwa (Tokyo: Kodansha International, 1971) discusses not only paintings but also ceramics and other works of art related to Zen.

On paintings showing the death of Shakyamuni (the historical Buddha), see Carolyn Wheelwright's article in *Archives of Asian Art* 38 (1985): 67–94. On gold-leaf screens, see two detailed articles by Bettina Klein, "Japanese Kinbyōbu: The Gold-leafed Folding Screens of the Muromachi Period," *Artibus Asiae* 45:1 (1984): 5–34, and 45:2/3 (1984): 101–74. For a catalog of an exhibition of late Muromachi art—chiefly screens, but also hanging scrolls, lacquerware, textiles, and ceramics—with an introduction and useful comments on each of the ninety-three objects, see Michael Cunningham, *The Triumph of Japanese Style: 16th Century Art in Japan* (Cleveland: Cleveland Museum of Art, 1991).

## MOMOYAMA
### (1573–1615)

For background, an essay by Carolyn Wheelwright on the paintings of Azuchi Castle, and a substantial "Bibliographic Essay," see George Elison and Bardwell L. Smith, eds., *Warlords, Artists, and Commoners: Japan in the Sixteenth Century* (Honolulu: University of Hawaii Press, 1981). For a wide-ranging exhibition catalog with a useful (though anonymous) text, see *Momoyama: Japanese Art in the Age of Grandeur* (New York: The Metropolitan Museum of Art, 1975). Among other books of interest are: Tsugiyoshi Doi, *Momoyama Decorative Painting*, trans. by Edna B. Crawford (New York: Weatherhill, 1977); Tsuneo Takeda, *Kanō Eitoku*, trans. and adapt. by H. Mack Horton and Catherine Kaputa (New York: Kodansha International, 1977); Yuzo Yamane, *Momoyama Genre Painting*, trans. by John M. Shields (New York: Weatherhill, 1973); and Miyeko Murase, *Byōbu, Japanese Screens from New York Collections* (New York: Asia Society, 1971).

On Westerners in Japan and their depiction in art, see Michael Cooper et al., *The Southern Barbarians* (Tokyo: Kodansha International, 1971), and Yoshitomo Okamoto, *The Namban Art of Japan*, trans. by Ronald K. Jones (New York: Weatherhill, 1972).

Certain kinds of ceramics of the Momoyama and Edo periods are lucidly and authoritatively discussed in Louise Allison Cort, *Seto and Mino Ceramics* (Washington, D.C.: Freer Gallery, 1992). Among the many books on the tea ceremony, the following may be especially singled out: Seizo Hayashiya et al., *Chanoyu: Japanese Tea Ceremony* (New York: Japan Society, 1979); Ryōichi Fujioka et al., *Tea Ceremony Utensils*, trans. and adapt. by Louise Allison Cort (New York: Weatherhill, 1973); T. Hayashiya et al., *Japanese Arts and the Tea Ceremony*, trans. by Joseph P. Macadam (New York: Weatherhill, 1974); Rand Castile, *The Way of Tea* (New York: Weatherhill, 1971); and H. Paul Varley and Isao Kumakura, eds., *Tea in Japan* (Honolulu: University of Hawaii Press, 1989). An older book (it was originally published in 1932) that is less attractive than any of these, but still useful because of its comprehensiveness, is A. L. Sadler, *Cha-no-yu: The Japanese Tea Ceremony* (Rutland, Vt.: Charles E. Tuttle, 1962).

On residential architecture, see Fumio Hashimoto, *Architecture in the Shoin Style*, trans. and adapt. by H. Mack Horton (New York: Kodansha International, 1981). Two well-illustrated books on castles (a form that flourished chiefly from 1576 to 1639) complement each other: Motoo Hinago, *Japanese Castles*, trans. by William H. Coaldrake (New York: Kodansha International, 1986) emphasizes fortification technology; Kiyoshi Hirai, *Feudal Architecture of Japan*, trans. by Hiroaki Sato and Jeannine Ciliotta (New York: Weatherhill, 1973) is somewhat more concerned with residential features within castles. For other architecture, see John B. Kirby, *From Castle to Teahouse* (Rutland, Vt.: Charles E. Tuttle, 1962).

TOKUGAWA, OR EDO
(1615–1868)

Most of the titles listed under Momoyama period are relevant here also. William Watson, ed., *The Great Japan Exhibition: Art of the Edo Period 1600–1868* (London: Royal Academy of Arts, 1981) is an illustrated catalog of a large, comprehensive exhibition of Edo art. It includes useful introductory essays as well as brief comments on some four hundred objects ranging from paintings to textiles, armor, and netsuke. Another handsome catalog, though with a more limited range because it emphasizes the military and the flamboyant tastes of the Tokugawa shoguns, is *The Tokugawa Collection: The Japan of the Shoguns* (Montreal: Montreal Museum of Fine Arts, 1989). This catalog includes valuable essays on such topics as patronage, textiles, lacquer, and the tea ceremony, and it is therefore more useful than an earlier catalog of a very similar exhibition, *The Shogun Age Exhibition* (Tokyo: The Shogun Age. . . Committee, 1983).

Carolyn Wheelwright, ed., *Word in Flower: The Visualization of Classical Literature in Seventeenth Century Japan* (New Haven: Yale University Art Gallery, 1989) is the catalog (six essays, fifty objects) of an exhibition concerned with the early Tokugawa use of late Heian material. *From the Suntory Museum of Art—Autumn Grasses and Water: Motifs in Japanese Art* (New York: Japan Society, 1983) illustrates fifty objects (chiefly screens, textiles, and lacquer from the Momoyama and Edo periods) and includes four essays on "The Japanese Aesthetic." Also limited—in this case chiefly to Tosa paintings of *The Tale of Genji*—are a small catalog, a book, and an essay: Yoshiaki Shimizu and Susan E. Nelson, *Genji: The World of a Prince* (Bloomington: Indiana University Art Museum, 1982); Miyeko Murase, *Iconography of the Tale of Genji* (New York: Weatherhill, 1984); and Julia Meech-Pekarik, "The Artist's View of Ukifune," in *Ukifune*, ed. by Andrew Pekarik (New York: Columbia University Press, 1982). For a summary of a Tosa treatise on the theory of painting, see Makoto Ueda, *Literary and Art Theories of Japan* (Cleveland: Case Western Reserve University Press, 1967).

Miyeko Murase, *Masterpieces of Japanese Screen Painting: The American Collections* (New York: Braziller, 1990), an oversize book with illustrations in color of thirty-seven screens, includes a useful introduction and brief comments on each screen, but the screens as a group do not approach the quality of those in Elise Grilli, *The Art of the Japanese Screen* (New York: Weatherhill, 1970), which illustrates and discusses some major Rinpa ("Kōrin school") screens. There is, however, no first-rate book on the Rinpa school. Howard A. Link et al., *Exquisite Visions: Rimpa Paintings from Japan* (Honolulu: Honolulu Academy of Arts, 1980) has a useful text, but the illustrated works in this exhibition catalog are not of consistently high quality and most of the Rinpa masterpieces are missing. A necessary complement, then, is Hiroshi Mizuo, *Edo Painting: Sotatsu and Korin*, trans. by John M. Shields (New York: Weatherhill, 1972), which includes illustrations of major works not only by Sōtatsu and Kōrin but also by Kōetsu and by Kenzan (who is represented in part by some works of doubtful authenticity).

On literati painting (also called *nanga* and *bunjinga*), see James Cahill, *Scholar Painters of Japan* (New York: Asia Society, 1972); Yoshiho Yonezawa and Chu Yoshizawa, *Japanese Painting in the Literati Style*, trans. by Betty Iverson Monroe (New York: Weatherhill, 1974); Calvin L. French, *The Poet-Painters: Buson and His Followers* (Ann Arbor: University of Michigan Museum, 1974); Stephen Addiss et al., *Japanese Quest for a New Vision* (Lawrence, Kans.: Spencer Museum of Art, 1986); and Stephen Addiss, *Zenga and Nanga: Selections from the Kurt and Millie Gitter Collection* (New Orleans: New Orleans Museum of Art, 1976). Two monographs and three books are devoted to individual literati painters, though all five works also illuminate other figures: James Cahill, *Yosa Buson and Chinese Painting* (Berkeley: Institute of East Asian Studies, 1982); James Cahill, *Sakaki Hyakusen and Early Nanga Painting* (Berkeley: Institute for East Asian Studies, 1983); Stephen Addiss, *Tall Mountains and Flowing Waters: The Arts of Uragami Gyokudō* (Honolulu: University of Hawaii Press, 1987); Stephen Addiss, *The World of Kameda Bōsai* (New Orleans: New Orleans Museum of Art/University Press of Kansas, 1984); and Melinda Takeuchi, *Taiga's True Views: The Language of Landscape Painting in Eighteenth-Century Japan* (Stanford: Stanford University Press, 1992). Yet another literatus, Ishikawa Jōzan, known especially for his calligraphy and for his residence (now a Zen temple), is studied in Thomas Rimer et al., *Shisendo: Hall of the Poetry Immortals* (New York: Weatherhill, 1991), a volume that includes Stephen Addiss's valuable discussion of calligraphy.

The fullest account of *zenga* (ink painting on Zen themes, by priests of the Tokugawa period and later) is Stephen Addiss, *The Art of Zen* (New York: Harry N. Abrams, 1989), a substantial and well-illustrated account of Zen painting and calligraphy from 1600 to 1925. On Zen painting and calligraphy produced by Ōbaku monks, see Stephen Addiss, *Obaku: Zen Painting and Calligraphy* (Lawrence, Kans.: Spencer Museum of Art, 1978). Also useful are the books on ink painting and calligraphy listed above, under Muromachi Period. Patricia J. Graham, in an essay in *Artibus Asiae* 51:3/4 (1991): 275–81, concentrates on a single painting of the historical Buddha by Mori Sosen, but she includes useful comments on late Tokugawa Buddhist painting. Of some value, for its illustrations rather than its text, is Yasuichi Awakawa, *Zen Painting*, trans. by John Bester (Tokyo: Kodansha International, 1970). For ink painting other than Zen works, see Shin'ichi Miyajima and Yasuhiro Satō (this is the English order, but the title page gives the names in Japanese order, surnames first), *Japanese Ink Painting* (Los Angeles: Los Angeles County Museum of Art, 1985), which is especially useful for its illustrations of "eccentric" painters. One "eccentric" or "individualist" painter is the subject of a handsome and thorough book: Money L. Hickman and Yasuhiro Satō, *The Paintings of Jakuchū* (New York: Asia Society Galleries, 1989). On the connection between haiku poetry and paint-

ing, see—in addition to French's *The Poet-Painters*—Leon M. Zolbrod, *Haiku Painting* (New York: Kodansha International, 1982). For a discussion of samurai culture, handsomely illustrated with paintings by samurai, especially by Miyamoto Musashi, see Stephen Addiss and G. Cameron Hurst III, *Samurai Painters* (New York: Kodansha International, 1983). For Ōkyo and his followers, see *Ōkyo and the Maruyama-Shijō School of Japanese Painting* (St. Louis: St. Louis Art Museum, 1980), a well-illustrated exhibition catalog with a useful introduction. See also Jack Hillier, *The Uninhibited Brush: Japanese Art in the Shijō Style* (London: H. M. Moss, 1974). The painting and calligraphy of women artists—ignored in most books—is discussed in detail by Pat Fister, *Japanese Women Artists: 1600–1900* (Lawrence, Kans.: Spencer Art Museum, 1988). Fister examines eighty-eight works by noblewomen, professionals, *ukiyo-e* artists, and literati. Western influences on Japanese painting are thoroughly discussed in Cal French, *Through Closed Doors: Western Influences on Japanese Art (1639–1853)* (Rochester, Mich.: Oakland University Press, 1977). French is also the author of a detailed book about a single Western-style painter, *Shiba Kōkan: Artist, Innovator, and Pioneer in the Westernization of Japan* (Tokyo: Weatherhill, 1974).

Probably more has been written about Edo prints than about any other form of Japanese art; the most useful single volume seems to be Richard Lane, *Images From the Floating World: The Japanese Print* (New York: Dorset, 1978). Other good places to begin are the catalogs of two great collections, the Clarence Buckingham collection (two volumes in print and others in preparation) and the collection of the print room in the Rijksmuseum (five volumes): Helen C. Gunsaulus, *The Clarence Buckingham Collection of Japanese Prints: Volume 1, The Primitives* (Chicago: Art Institute of Chicago, 1955), and Margaret O. Gentles, *The Clarence Buckingham Collection of Japanese Prints: Volume 2, Harunobu, Koryusai, Shigemasa, Their Followers and Contemporaries* (Chicago: Art Institute of Chicago, 1965); *Catalog of the Collection of Japanese Prints*, 5 vols. (Amsterdam: Rijksprentenkabinet / Rijksmuseum, 1977–90). This last title, covering the history of the genre through the mid-20th century, is notable for the accuracy of its information, its glossary, and its indexes of artists and artists' signatures and seals.

Muneshige Narazaki has written eight of the eleven small books in a series called "Masterworks of Ukiyo-e" published by Kodansha International. This series, which includes volumes on such major figures as Harunobu, Hiroshige, Hokusai, Kiyonaga, Sharaku, and Utamaro, ranges from Narazaki's *Masterworks of Ukiyo-e: Early Paintings* (chiefly of the late 16th and early 17th centuries) to Jūzō Suzuki and Isaburō Oka's *Masterworks of Ukiyo-e: The Decadents* (chiefly the second quarter of the 19th century). Each book in this series contains about 60 color plates (often of poor quality) and a brief text. Narazaki has also edited *Ukiyo-e Masterpieces in European Collections* (New York: Kodansha International, 1988–90), a splendid series of twelve volumes devoted to seven major collections (for example, three volumes for the British Museum, two for the Musée Guimet).

Among specialized studies are: Donald Jenkins, *Ukiyo-e Prints and Paintings: The Primitive Period, 1680–1745* (Chicago: Art Institute of Chicago, 1971); D. B. Waterhouse, *Harunobu and His Age: The Development of Color Printing in Japan* (London: The British Museum, 1964); Howard A. Link, *The Theatrical Prints of the Torii Masters* (Honolulu: Honolulu Academy of Arts, 1977); Roger S. Keyes and Keiko Mizushima, *The Theatrical World of Osaka Prints* (Boston: David R. Godine, 1973), on 18th- and 19th-century theatrical prints in the Philadelphia Museum of Art; Dean J. Schwaab, *Osaka Prints* (New York: Rizzoli International, 1989), for a good overview of prints of actors, with some attention also to non-theatrical prints; and, on *surimono* (elegant, limited-edition prints commissioned by connoisseurs), any of several books on the topic by Roger S. Keyes, especially his *The Art of Surimono: Privately Published Japanese Woodblock Prints in the Chester Beatty Library, Dublin*, 2 vols. (London: Sotheby's, 1985). Andrew J. Pekarik has edited a book reproducing a collection of woodblock prints, *The Thirty-Six Immortal Women Poets* (New York: Braziller, 1991), an album of colorful illustrations by Chōbunsai Eshi, a student of Utamaro. Although Pekarik's excellent introduction and commentaries are devoted to the poems rather than to the pictures, the book is of considerable interest to anyone concerned with Japanese prints.

Certain aspects of Tokugawa and Meiji prints are discussed by Sarah E. Thompson and H. D. Harootunian in two essays in a catalog of Tokugawa and Meiji prints, *Undercurrents in the Floating World: Censorship and Japanese Prints* (New York: Asia Society Galleries, 1991). Fifty prints (not always of great aesthetic interest) are illustrated, about half in color. Thompson's essays is chiefly about political censorship; Harootunian's is an anthropological examination, in the language of today's anthropologists, of Edo Japan. For the work of a major late Edo artist, see B. W. Robinson, *Kuniyoshi: The Warrior-Prints* (Ithaca, N. Y.: Cornell University Press, 1982).

Richard Lane's large book, *Hokusai* (London: Barrie and Jenkins, 1989), offers a fairly thorough introduction to the range of Hokusai's works, but the color plates are inaccurate. A more specialized work, *Hokusai: One Hundred Views of Mt. Fuji* (New York: Braziller, 1988), contains a valuable commentary by Henry D. Smith III. Another book devoted to a single series of prints is Hiroshige's *One Hundred Views of Edo* (New York: Braziller, 1986), notable for its handsome illustrations and its introductory essays by Henry D. Smith II and Amy Poster. Also handsome and informative is *Hiroshige: Birds and Flowers* (New York: Braziller, 1988), with an introduction by Cynthea J. Bogel and commentaries by Israel Goldman.

For a study of woodblock prints bound in book form, see Jack Hillier's abundantly illustrated *The Art of the Japanese Book*, 2 vols. (London: Sotheby's, 1987). Hillier includes not only *ukiyo-e* artists but also (in the second volume) Shijō, *nanga,* and Rinpa revival artists.

Richard L. Wilson, *The Art of Ogata Kenzan* (New York: Weatherhill, 1991) is an admirable study not only of

Kenzan but also of ceramic production in the first half of the 18th century and the continuation of Kenzan's tradition. Also useful on ceramics is Masahiko Kawahara, *The Ceramic Art of Ogata Kenzan*, trans. and adapt. by Richard L. Wilson (New York: Kodansha International, 1985), and Masahiko Sato, *Kyoto Ceramics*, trans. and adapt. by Anne Ono Towle and Usher P. Coolidge (New York: Weatherhill, 1973). For brief discussions of some chief types of ceramics, see the oversize single volumes that Kodansha International publishes in its series Famous Ceramics of Japan. Each volume, devoted to one or two types of ware, contains about forty pages, of which twenty are devoted to excellent color reproductions. The twelve volumes issued thus far are: *Nabeshima, Agano and Takatori, Folk Kilns* (two volumes), *Kakiemon, Imari, Tokoname, Oribe, Karatsu, Kiseto and Setoguro, Hagi,* and *Shino*. For a well-illustrated and full discussion of Karatsu, with special emphasis on the materials and technical processes, see Johanna Becker, *Karatsu Ware* (New York: Kodansha International, 1986). On export ware and early European imitations of Asian ceramics, see *The Burghley Porcelains* (New York: Japan Society, 1986). Export ware is also discussed briefly but interestingly by Oliver Impey in Barbara Brennan Ford and Oliver R. Impey, *Japanese Art from the Gerry Collection* (New York: The Metropolitan Museum of Art, 1989).

On sculpture by the itinerant monk Enkū, see two well-illustrated articles by Donald F. McCallum in *Oriental Art* 20:2 (Summer 1974): 174–91, and 20:4 (Winter 1974): 400–13; for some eighty reproductions of Enkū's work, see Kazuaki Tanahashi, *Enku* (Boulder: Shambhala, 1982).

On *inrō* (small medicine kits), netsuke, incense containers, writing boxes, and other small objects, see Andrew J. Pekarik, *Japanese Lacquer, 1600–1900* (New York: The Metropolitan Museum of Art, 1980). On *ojime* (the carved beads used to tighten the double cord attached to an *inrō* or to a pouch suspended from a kimono sash), see a handsome large-format book by Robert O. Kinsey, *Ojime* (New York: Harry N. Abrams, 1991). Kinsey is highly informative about the materials (lacquer, horn, ivory, and so forth) and the subjects—zodiac animals, insects, deities, and the like.

On some of the best-known architecture, see Naomi Okawa, *Edo Architecture: Katsura and Nikko*, trans. by Alan Woodhull and Akito Miyamoto (New York: Weatherhill, 1975); Michio Fujioka, *Kyoto Country Retreats*, trans. by Bruce Coats (New York: Kodansha International, 1983); Walter Gropius et al., *Katsura* (New Haven: Yale University Press, 1960); Teiji Itō et al., *Katsura* (Tokyo: Shinkenchiku-sha, 1983); and especially Akira Naito and Takeshi Nishikawa, *Katsura: A Princely Retreat*, trans. by Charles S. Terry (New York: Kodansha International, 1977).

<div align="center">

MEIJI

(1868–1912)

</div>

The best survey of Meiji art (excluding Western-style painting) is Frederick Baekeland's exhibition catalog, *Imperial Japan: The Art of the Meiji Era (1868–1912)* (Ithaca, N.Y.:

Herbert F. Johnson Museum of Art, 1980). Also useful is *Meiji: Japanese Art in Transition,* ed. by Robert Schaap (The Hague: Haags Gemeentemuseum, 1987), a catalog of an exhibition of lacquer, prints, and Japanese-style paintings.

On Japan's encounter with the West, see Julia Meech-Pekarik, *The World of the Meiji Print: Impressions of a New Civilization* (New York: Weatherhill, 1986), a highly informative book that examines, through a popular medium, Japan's keen interest in Western culture during the late 19th century. Ann Yonemura, *Yokohama: Prints from Nineteenth-Century Japan* (Washington, D.C.: Smithsonian, 1990) is a catalog of an exhibition of 19th-century photographs and newspaper drawings and some eighty-five color prints of Yokohama and its first foreign residents, from 1859 to the 1870s. The interest is chiefly sociological rather than artistic. Elizabeth de Sabato Swinton, *In Battle's Light: Woodblock Prints of Japan's Early Modern Wars* (Worcester, Mass.: Worcester Art Museum, 1991) reproduces in color eighty triptychs of prints of the Sino-Japanese War and the Russo-Japanese War, and informatively discusses the social context as well as the artistry of each work.

On the crisis in Japanese art evoked by opening the door to the West, see John M. Rosenfield, "Western-style Painting in the Early Meiji Period and Its Critics," in *Tradition and Modernization in Japanese Culture,* ed. by Donald H. Shively (Princeton: Princeton University Press, 1971). *Paris in Japan* (Tokyo: Japan Foundation, 1987) is a highly informative exhibition catalog showing seventy-seven Japanese oil paintings (1890 to 1930) influenced by French art. Minoru Harada, *Meiji Western Painting,* trans. by Akiko Murakata, adapt. by Bonnie F. Abiko (New York: Weatherhill, 1974) is valuable for its abundant illustrations.

The sights of Meiji Japan were recorded by the print artist Kobayashi Kiyochika, whose work is abundantly illustrated, with highly informative comments about the scenes, in Henry D. Smith II, *Kiyochika: Artist of Meiji Japan* (Santa Barbara: Santa Barbara Museum of Art, 1988).

Photographers, too, recorded Meiji Japan. See Japan Photographers Association, *A Century of Japanese Photography* (New York: Pantheon, 1980).

<div align="center">

TAISHŌ
(1912–1926),

SHŌWA
(1926–1989),

HEISEI
(1989–present)

</div>

*A Century of Japanese Photography* (see the preceding citation) covers the period 1840–1945. For a broad representation of Japanese woodblock prints (traditional and Western-influenced), see Donald Jenkins, *Images of a Changing World: Japanese Prints of the Twentieth Century* (Portland, Or.: Portland Museum of Art, 1983); Lawrence Smith, *The Japanese Print Since 1900* (New York: Harper & Row, 1983); Margaret K. Johnson and Dale K. Hilton, *Japanese Prints Today* (Tokyo:

Shufutomo, 1980), on contemporary technique; and, for eighty works by living artists, with an introduction on print-making techniques, Lawrence Smith, *Contemporary Japanese Prints* (New York: Harper & Row, 1985). On prints of the early 20th century—both *shin hanga* (new prints, work in the relatively flat traditional style, as opposed to the more painterly prints of Kobayashi Kiyochika) and *sōsaku hanga* (creative prints influenced by Westerners from van Gogh and Gauguin to Kandinsky)—see Helen Merritt, *Modern Japanese Woodblock Prints: The Early Years* (Honolulu: University of Hawaii Press, 1990). Merritt's discussions of the carvers, publishers, and exhibitions are especially useful. Oliver Statler, *Modern Japanese Prints* (Rutland, Vt.: Charles E. Tuttle, 1956) is a highly readable introduction but it is more limited than Merritt's book, since Statler is chiefly concerned with the Western-influenced "creative" prints and he focuses on artists rather than on the social matrix of the prints. For a thorough study of one of the most important *sōsaku hanga* artists, see Elizabeth de Sabato Swinton, *The Graphic Art of Onchi Kōshirō* (New York: Garland, 1986). For one of the best-known artists of the mid-twentieth century, see *The Woodblock and the Artist: The Life and Work of Shīko Munakata* (New York: Kodansha International, 1991).

On cloisonné, see Lawrence A. Coben and Dorothy C. Ferster, *Japanese Cloisonné: History, Technique, and Appreciation* (New York: Weatherhill, 1982).

For a relatively brief survey of all forms of art from 1868 to 1968, see Hugo Munsterberg, *The Art of Modern Japan* (New York: Hacker, 1978). Two books treat painting, sculpture, and architecture: Michiaki Kawakita, *Modern Currents in Japanese Art*, trans. by Charles E. Terry (New York: Weatherhill, 1974), though devoted chiefly to Western-style painting and Japanese-style painting of the late 19th and 20th centuries, also includes some sculpture and architecture; Toru Terada, *Japanese Art in World Perspective*, trans. by Thomas Guerin (New York: Weatherhill, 1976) has abundant illustrations of contemporary painting, sculpture, and architecture, but its text is somewhat baffling. David Kung, *The Contemporary Artist in Japan* (Honolulu: East-West Center, 1966) contains brief interviews with painters, sculptors, and calligraphers, and illustrates their work. William Lieberman, *The New Japanese Painting and Sculpture* (New York: The Museum of Modern Art, 1966) is the catalog of an exhibition of the work of forty-six Japanese artists, some of them living in Europe or the United States. *Contemporary Japanese Art in America: Arita, Nakagawa, Sugimoto* (New York: Japan Society, 1987) prefaces illustrations of the work of two painters and one photographer with a useful essay on "Japanese Artists in the American Avant-garde 1945–1970." For reproductions of some ninety sculptures, see Janet Koplos, *Contemporary Japanese Sculpture* (New York: Abbeville, 1991). The work of a dozen contemporary calligraphers is discussed and handsomely illustrated in *Words in Motion: Modern Japanese Calligraphy* (Tokyo: Yomiuri Shimbun, 1984).

Herbert H. Sanders, *The World of Japanese Ceramics* (Tokyo: Kodansha International, 1967) surveys contemporary ceramic art, paying special attention to tools, materials, forming processes, and decorating processes. Among the works on individual potters of the mid-20th century, two are especially useful: Bernard Leach, *Hamada: Potter* (New York: Kodansha International, 1975) is abundantly illustrated and includes a good deal of talk by Hamada; Sidney Cardozo and Masaaki Hirano, *The Art of Rosanjin* (New York: Kodansha International, 1987) is devoted chiefly to Rosanjin's ceramics, but it includes some of his painting and calligraphy, and a sample of his writings. On contemporary Japanese ceramics, see two thoughtful and well-illustrated essays by Frederick Baekeland in *Orientations* 18:10 (October 1987) and *Orientations* 19:6 (June 1988).

David B. Stewart, *The Making of a Modern Japanese Architecture: 1868 to the Present* (New York: Kodansha International, 1988), a survey of architecture from the Meiji period to about 1980—from the age of eclectic revivalism to Post-Modernism—includes more than four hundred black-and-white photographs and plans, some of which show buildings that are no longer extant. Hiroyuki Suzuki et al., *Contemporary Architecture of Japan 1958–1984* (New York: Rizzoli International, 1985) contains photographs and plans of ninety-two buildings of various types, along with a fairly brief text; Botand Bognar, *Contemporary Japanese Architecture* (New York: Van Nostrand Reinhold, 1985) covers the same period but views modern architecture in the context of earlier culture. Bognar's *New Japanese Architecture* (New York: Rizzoli International, 1991) illustrates a few works by each of twenty-three architects, with the illustrations often accompanied by brief comments by the architects.

## AUTHOR'S NOTE

The three Japanese-language series listed below, while not within the scope of Sylvan Barnet's and William Burto's *A Reader's Guide to the Arts of Japan*, are important sources of illustrations; all provide English translations of the captions. These series may be found in large research libraries.

*Genshoku nihon no bijutsu*, ed. by Akiyama Terukazu et al. (Tokyo: Shogakkan, 1967–80) is thirty-two impressive volumes covering all the arts from all periods.

A newer, twenty-four-volume series, even more spectacular than *Genshoku nihon no bijutsu*, is *Nihon bijutsu no zenshū* (Tokyo: Kodansha, 1990–  ).

An important ten-volume series dealing with Japanese art in foreign collections—mostly in the United States—is *Zaigai nihon no shihō*, ed. by Shimada Shūjirō, Akiyama Terukazu, and Yamane Yūzō (Tokyo: (Mainichi Newspaper Co., 1980–82).).

# Index

Artist entries are shown in CAPITAL letters. Japanese artists and historical figures are generally indexed by family name. Buddhist divinities and religious figures are indexed under the Japanese form of their name. Chinese names and terms are alphabetized according to their *pinyin* spelling. Temple buildings, precincts, and subtemples appear as subentries in the main entry for the temple complex to which they belong. *See* references are provided to assist in locating the correct name, spelling, or temple complex. Here are some examples: UTAMARO, *see* Kitagawa Utamaro; Hideyoshi, *see* Toyotomi Hideyoshi; Kuanyin, *see* Kannon; Po Chü-i, *see* Bo Juyi; Phoenix Hall, *see* Byōdōin. References to figure and colorplate *(cp.)* numbers are shown in *italic* type following the references to text page numbers; the page on which the colorplate is located is provided in parentheses; e.g., Hosokawa mansion, 237; *239, cp. 38* (188). Alphabetization is letter-by-letter except in the case of family names, which are positioned as if a comma separated the family name from the personal name; e.g., MA YUAN is at the "ma" position rather than the "may" position.

# Credits

The author and the publisher wish to thank the libraries, museums, galleries, and private collectors named in the picture captions for permitting the reproduction of works of art in their collections and for supplying the necessary photographs. Photographs from other sources are gratefully acknowledged below.

Aikawa Archeological Museum, Isezaki: page 13; Masuda Akihisa: figs. 331, 332, 334–36, 339, 340, 342, 345; Shibata Akisuke: cp. 37; Architectural Institute of Japan: figs. 330, 337, 338, 343; The Arts Council of Great Britain, London: fig. 29; Asuka-en, Nara: cps. 4, 6, figs. 93, 94, 102, 125, 128, 176, 178, 179, 187; From *The Art of Zen*, by Stephen Addiss, Harry N. Abrams, Inc., 1989: fig. 288; Benrido, Tokyo: cps. 3, 5, 11, 12, 13, 14, 23, 36, 45, 55, figs. 38, 72, 77, 109, 115, 116, 118, 120–22, 129, 140, 148, 150, 154, 155, 159, 167, 189, 199, 203–5, 209, 215, 245, 249, 262, 269, 270, 284, 357; Chōgosonshiji, Nara: cp. 8; The Cleveland Museum of Art: fig. 301; Sheldan Collins, New York: cp. 32; Courtesy Mr. Echigoya, Aomori-ken: fig. 14; Yukio Futugawa: figs. 22, 234; From *Genshoku nihon no bijutsu*, Vol. 18: fig. 290; Courtesy Dr. Kurt A. Gitter, New Orleans: fig. 303; Heibonsha Photo Service: fig. 45; Li Naoyoshi Hikon: fig. 255 a–f; Misawa Hiroaki: cp. 1; The Institute for Art Research, Tokyo: fig. 96; Japan National Tourist Organization: fig. 229; From *Japanese Temples*, by J. E. Kidder, Jr.: figs. 2, 174, 177, 206; Ohnichi Jiichi: fig. 208; Jōdo Shinshu Hongwanji-ha: fig. 194; Kajima Institute Publishing Co., Ltd., Photo: Watanabe Yoshio: fig. 344; Shogakukan: cps. 10, 19; Kodansha Ltd., Tokyo: figs. 43, 81, 127, 148, 168, 221; Korakudo: fig. 211; Kyoto National Museum: figs. 200, 223, 247, 248, 306, 307; Mark Lindquist Studio: fig. 1; Paul Macapia, Seattle: fig. 250; Junkichi Mayuyama, Tokyo: figs. 49, 117, 136, 138, 198, 219; Nagoya Castle: fig. 273; Nara National Museum: fig. 201; National Museum of Japanese History, Sakura City: fig. 253a; Otto Nelson, New York: figs. 303, 308, 381; Nijō Castle Office: fig. 233; Courtesy of Ohmi Laboratory, College of Science & Technology, Nihon University: figs. 341, 346; Onjōji, Shiga prefecture: fig. 243; From *Oriental Architecture*, Electa Editrice, Milan, drawings by Studio of Enzo di Grazie, Milan: fig. 42; Osaka Prefectural Board of Education: fig. 305; Sakamoto, Tokyo: cps. 7, 17, 18, 22, 24, 26, 28, 34, 69, figs. 10, 40, 46, 47, 50, 63, 68–71, 75, 76, 80, 82, 86–92, 95, 97, 99, 101, 103–5, 107, 111, 126, 132, 141–43, 151, 153, 160, 162, 181, 182, 184a and b, 185, 207, 220, 222, 241, 244, 251, 254, 258, 274, 275, 278, 279, 291, 293, 294, 302, 318, 347, 354, 355, 365; Santa Barbara Museum: cp. 71; Okamoto Shigeo: figs. 237, 238, 264; Shōsōin, Nara: cp. 9; Walter Spink, University of Michigan, Ann Arbor: fig. 73; Steve Steckly Photography, Portland, Oregon: fig. 303; Takamura Tadashi: fig. 376; Irie Taikiti: figs. 52, 58, 84, 112; Tokyo National Museum: cps. 27, 34, 70, figs. 156–58, 165, 183, 186 left and right, 190 left and right, 191, 192, 201, 210, 252, 253 above right, 260, 275, 282, 290, 296, 333, 373; Tokyo National Research Institute of Cultural Properties: fig. 350; Wakamiyo-cho Educational Commission: cp. 2; Yoshio Watanabe, Tokyo: fig. 41 (also fig. 344); Yamagata City Office: fig. 253 left below; From *Zen and the Fine Arts*, by Hisamatsu: fig. 287.

Illustrations on pages 66, 110, 138, 196, 218, and 307 were drawn by Lydia Gershey.

We gratefully acknowledge the following for their generous cooperation and for use of these quoted materials:

Barnet, Sylvan, and William Burto, *Zen Ink Paintings*. Copyright © 1982 by Kodansha International, Ltd. Reprinted by permission: p. 285; Fontein, Jan, and Money L. Hickman, *Zen Painting and Calligraphy*, Museum of Fine Arts, Boston, 1970: p. 200; Henderson, Harold G., *An Introduction to Haiku*. Copyright © 1958 by Harold G. Henderson. Used by permission of Doubleday, a division of Bantam Doubleday Dell Publishing Group, Inc.: p. 294; Keene, Donald, ed., *Anthology of Japanese Literature*. Copyright © 1955 by Grove Press, Inc. Used by permission of Grove Press, Inc.: pp. 116, 131, 166, 294; LaFleur, William, trans., *Mirror for the Moon: A Selection of Poems by Saigyō*. Copyright © 1977, 1978 by William LaFleur. Reprinted by permission of New Directions Publishing Corporation; p. 165; McCullough, Helen Craig, *Tales of Ise*, translated, with an Introduction and Notes, by Helen Craig Mc Cullough, reprinted with the permission of the publishers, Stanford University Press. © 1986 by the Board of Trustees of the Leland Stanford Junior University: p. 234; McCullough, William H. and Helen Craig McCullough, *A Tale of Flowering Fortunes*, translated, with an Introduction and Notes, by William H. and Helen Craig McCullough. Two volumes. With the permission of the publishers, Stanford University Press. © 1980 by the Board of Trustees of the Leland Stanford Junior University: pp. 119, 254; Nippon Gakujutsu Shinkōkai, *The Manyōshū* © 1965, New York: Columbia University Press. Used by permission: pp. 63, 64; Takeuchi, Melinda, "'True' Views: Taiga's *Shinkeizu* and the Evolution of Literati Painting Theory in Japan," *Journal of Asian Studies*, pp. 16–20, February, 1989: p. 291; Varley, H. Paul, *Japanese Culture, a Short History*. © 1973 by Henry Holt & Company, Inc.: p. 292; Watson, Burton, *Cold Mountain*. © 1962, New York: Columbia University Press. Used by permission: p. 198.